Small Victories:

One Couple's Surprising Adventures Building an
Unrivaled Collection of American Prints

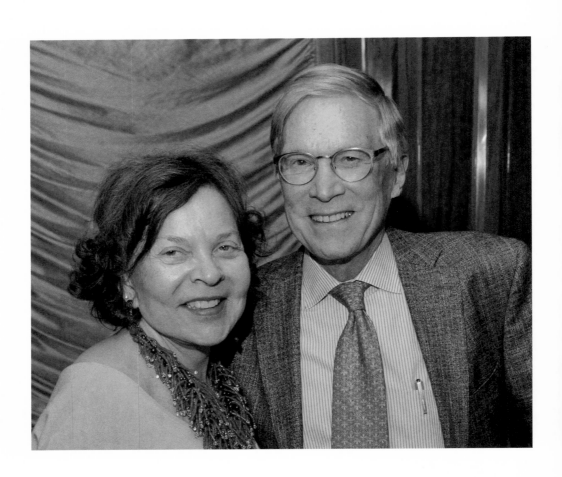

Small Victories:

One Couple's Surprising Adventures
Building an Unrivaled Collection
of American Prints

DAVE H. WILLIAMS

David R. Godine · Publisher

Boston

First published in 2015 by
DAVID R. GODINE, *Publisher*
Post Office Box 450
Jaffrey, New Hampshire 03452
www.godine.com

LIBRARY OF CONGRESS CATALOGING-IN-PUBLICATION DATA
Williams, Dave, 1932- author.
 Small victories : one couple's surprising adventures building an
unrivaled collection of American prints / Dave H. Williams.
 pages cm
Includes bibliographical references and index.
 ISBN 978-1-56792-529-6 (alk. paper)
 1. Prints--Collectors and collecting--United States--Biography.
2. Williams, Dave, 1932- 3. Williams, Reba. 4. Prints, Ameri-
can. I. Title.
 NE59.7.W55W55 2015
 769.973'074--dc23
 2014035110

FIRST EDITION

PRINTED IN USA

To Reba, my wife and print collecting partner.

CONTENTS

Introduction

Collecting prints is an activity generally reserved for the serious, intelligent and persevering collector. And this is somewhat ironic as prints are the most democratic of all art forms. Unlike paintings, prints are multiples, a fact that makes them more affordable, and therefore more available to a wider audience. While paintings exist in only one copy, prints are issued in editions, often with varying states and attendant degrees of complexity. The variability and complexity offer both artistic challenges and collecting opportunities for the discerning. The sheer volume of prints, past and present, provides "art for the people," a slogan borne out of the great surge in printmaking sponsored by the WPA in the 1930s-40s, and still true today. Prints are truly the democratic art form.

This collection, primarily (but not exclusively), of American prints was amassed over decades by Reba and Dave Williams. As discussed and displayed in these pages, it is, as a collection, a unicum, a one of a kind. Not only does it contain the expected, the acknowledged "high points" that every print collector predictably seeks, but just as importantly it includes prints and printmakers who are generally unsung, and often entirely unknown. These were eyes that were always open—to forgotten artists, unfashionable schools, and unrecognized talent. No other collection contains work representing such a broad spectrum of American graphic artists of the last 150 years, and certainly no collectors have been more assiduous in tracking down leads, waiting patiently for work to appear, and pouncing happily as the opportunities arose.

The urge to acquire, to accumulate, is not always accompanied with the urge to share. Here, too, the Williamses have been exemplary in their generosity and the willingness, even eagerness, to make their collec-

tion accessible to the public. They have initiated, edited, supported and published some seventeen exhibition catalogues highlighting aspects of their treasures, displaying their prints in more than one hundred museums worldwide. And these have been on subjects as diverse as depictions of sporting art to images by and of African Americans from the 1930s-40s. These catalogues are testaments not only to their eyes as collectors, but also to the considerable scholarship that attends (and *should* attend) any major collection. The prints may, as a visit to their home or office will attest, be fine for "show", but they were all assembled with a grand scheme in mind, the gathering of a broadly representative and commendably eclectic body of graphic work that would display the scope, styles, and depth of American printmaking through two centuries.

Are there gaps and omissions in this collection, artists who some readers might wish to see included but are nowhere represented? Certainly. A personal favorite of mine, the wood engraver Thomas Nason, is absent. Another favorite, the etcher John Taylor Arms, is discussed, but not illustrated. But as any collector knows, omission is as important as selection. No one can own everything, and not everything holds an equal appeal. And, far more convincingly on the other side of the coin, look at the index and count the number of names completely unknown to you, names ignored and undocumented by the art world. Consider how convincingly the quality of the wide range of prints represented in this book is discussed, and how successfully they have been integrated into the text by the book's designer, Jerry Kelly.

I think it can be safely said that in terms of coverage, taste and sheer collecting courage, there has never been a book of this scope and insight. It stands as a tribute to Dave Williams and his sustained enthusiasm for and knowledge of his subject, and to his wife Reba's energetic scholarship and revelatory research, which is incorporated throughout the discussions of artists and their work. Of the visual books this company has produced over four decades, I can confidently predict that in years to come *Small Victories* will enjoy the longest life and provide the greatest satisfactions.

<div align="right">David R. Godine, Publisher</div>

Before We Begin

Collecting is a series of small victories, making discoveries, acquiring objects over time and learning their histories, and then sharing these objects and their stories with others of similar interests and enthusiasms.

This is exactly what Reba and I did, and this book tells our tale.

However, writing a book about collecting is like the act itself: disorderly and non-conforming to a plan or calendar. Frequently, when I walked into a gallery or print fair with an acquisition goal in mind, an unexpected discovery would take me down a path I hadn't expected to travel. Again and again, a new artist or image would lead to a new field, with new prints to acquire and more opportunities for research and learning.

Collecting always has a beginning, usually a first purchase. And an end: disposing of the collection by gift or sale, or leaving it to the heirs. It's the in-between part that's difficult to describe in a logical order, because collecting seldom happens in a logical order.

A collector must be opportunistic, acquiring anything that comes along that fits anywhere in the intended scope of the collection. Consider: If you set out to create a collection of antiquities, would you start at 2000 BC and not buy a 1900 BC object until you'd acquired one dated one hundred years earlier? If so, the collection would never be built. Or a paintings example: Artists by alphabet? Paintings by date? Order is impossible—the avid collector has to be alert for opportunities and grasp what presents itself, not exactly at random, or indiscriminately, but in no planned sequence.

The reader of this book will find a beginning and an end. The in-between chapters are a series of stories about our collecting experiences, not a chronology, but mostly framed around types and periods of fine art prints. I'll confess it's a bit of a jumble, just like collecting, jumping from opportunity to opportunity—story to story. But read on, think like a collector, and be ready for whatever comes next.

Dave H. Williams

Fig. 1. Reginald Marsh, *Gaiety Burlesk*, 1930. Etching, 11.8 x 9.8 in.

Getting Started

My business partner stuck his head into my office and announced, "I've had an art epiphany!"

"Yes?"

"Prints!"

He waved me toward our conference room, where his newly acquired treasures lay on a table, glowing even in the weak fluorescent light. Black ink on white paper had a beauty I'd never recognized. Nor had I known that such famous artists as the ones displayed—Thomas Hart Benton, Reginald Marsh, John Sloan, Childe Hassam—even made prints.

It was 1968, I was thirty-six years old and just one year into a new job that was make-or-break for my career, following a couple of unlucky or poor employment choices. I had suppressed a potential art interest to focus full-time on my new tasks, and maybe someday be able to collect.

The day was closer than I thought. My partner had acquired his prizes at an exhibition of prints made by American artists in the 1920s and 1930s. I hardly knew what a fine art print was, but I was excited by what I had seen. So I rushed to the same gallery, Associated American Artists, to look and learn firsthand.

I was captivated by the images and the stories they told. There were New York City scenes, burlesque dancers, farmhands, and workers in factories and on construction sites. The small catalogue explained that these were *original* prints—that is, the artist had personally etched the copper plate or drawn on the lithographic stone. Only a limited number of each print was made, and each was hand-signed in pencil, and often numbered, by the artist. After that, the plate or stone was cancelled—the copper plate intentionally marred by scratches, the ink ground off the stone. My prints education had begun. (For the newly converted who would like to know about the various

processes involved in printmaking—lithography, etching, etc.—brief descriptions of the major forms appear later in "Glossary of Print Terms.")

Many were for sale at one hundred dollars or not much more—prices decidedly in my range. I didn't buy anything on that first visit, too unsure of myself to make a decision and too intimidated by my lack of knowledge to question the proprietor, Sylvan Cole. Sylvan was a big bear of a man—tall, broad-shouldered, and with a craggy face that reminded me of Mount Rushmore—and, I would soon learn, reputed to be the reigning expert on American prints. I was also soon to learn that he was, like so many dealers I would encounter, generous with his time and a patient teacher of novice collectors.

Prior to this eye- and mind-opening experience, I had visited the previews of sales at the New York City auction houses. While I had admired many paintings, I was befuddled about what to do and discouraged by my lack of knowledge. I saw images I liked, but I did not know much about the artists and had no way to judge either the quality of the painting or the fairness of the estimated prices, most of which I could not afford anyhow. I'd grown up in Austin, Texas, where, in the 1940s to early 1950s, there was no museum that exhibited paintings. Nor did anyone in my family think of visiting a museum in Houston or Dallas. I "discovered" art in the museums of Europe, thanks to the U.S. Navy, and had even bought a few amateurish paintings from street artists in Paris and Amsterdam. But this hardly satisfied my latent collecting urge, which had to wait for more than a decade while I buried myself in graduate school, a Wall Street career, and helping raise a family.

I became hooked on images when I was five years old. While I was in preschool, my parents gave me a stamp album and packets of cancelled stamps with which to fill it. To this day, I remember many images on old postage stamps, like the herd of elephants wading in a jungle river on the bright pink Ceylon 50c. Or the 1892 Columbian Exposition set, especially the sea-blue 4¢ image of the *Niña*, the *Pinta*, and the *Santa Maria* sailing toward the New World. On summer visits to Beaumont, my grandfather often bought me a new issue stamp when he gathered his lumber mill's daily mail at the local post office, where I was fascinated by its murals of heroic pioneers clearing the East Texas pine forests. This post office was a recent product of the Works Progress Administration (WPA), and its walls had been painted by WPA artists who would eventually become central to my print collecting.

For the image-addicted, prints provide an ideal solution. Nearly all prints made before the revival of printmaking and collecting in the 1960s are small—frequently less than twelve inches in each dimension—so a wall can hold many. Most are less expensive than paintings of equivalent quality by the same artist. Because prints are made in editions of multiple copies (each nonetheless an original work of art), it's usually possible to find the one you want. Sales catalogs published by dealers and auction houses, and the many print exhibitions offered by museums, make it easy to learn by looking, reading, and asking.

That's what I started doing after my 1968 prints revelation, and with the help of Sylvan Cole and other dealers in the late 1960s and into the 1970s, I slowly began to build a collection. An early favorite, which with racing heart and shaking hands I bought at Christie's—my first experience of waving a paddle at an auctioneer and feeling the adrenaline rush of competing for an object—was Reginald Marsh's etching *Gaiety Burlesk* of 1930 (Fig. 1). I framed and mounted the print on my desk at home, and when I should have been reading and critiquing our securities analysts' research reports, I stared at Marsh's dancer and her gawking male audience, marveling at the artist's ability to capture the mood and the moment. The audience, looking like pallid moles crammed into a burrow, has every eye focused on the dancer, but their facial expressions constitute a microcosm of possible reactions—some leering with lust, others frowning with disapproval. The stripper, enjoying her dominance, smiles innocently. Facing her, two balconies hang like large, pendant breasts, complete with nipples: a perfect stage setting for that highly anticipated moment when the dancer will uncover her bosom.

Over the next few years, I acquired about twenty-five prints, which were then caught up in the earthquake of divorce, property division, and settlement. I escaped with half, including *Gaiety Burlesk*. This is the dowry I brought to our union when Reba White and I married in 1975, along with debts, illiquid stock in a brokerage company, alimony obligations, a ten-year-old car, and tuition bills for two children in private schools.

Reba, herself an accomplished financial analyst and very practical about money, vowed to right my foundering financial ship while providing the down payment to buy our Greenwich Village townhouse. This was in the midst of New York City's financial crisis, so real estate was cheap. But so were brokerage commissions on Wall Street, a result of the historic May

1975 breakup of the New York Stock Exchange's price-fixing monopoly. The bear markets of the 1970s and the devastating decline in the rates of stock brokerage commissions had taken a severe toll. The economic environment, not to mention the prospects for my employer and my career, were shaky.

I was forced to put print collecting in low gear, with one exception.

Our new home had a large, loft-like space with red brick walls, tile floors, and high ceilings, just made for big contemporary prints. We sold a few prints from my dowry and splurged on Andy Warhol's *Flowers* of 1970, a portfolio of ten large color screenprints that were a perfect fit, size- and color-wise, for the new space. We had long coveted the portfolio but had neither the money to buy it nor the space to hang it. We saw no point in buying prints and storing them under the bed. Our new space liberated us. Brooke Alexander, recognized as the leading dealer in contemporary prints, personally delivered the portfolio, unframed and still in its original box. With Brooke's help, we laid out these bright beautiful flowers all over the floor, studying and admiring them before framing and hanging them on the wall. We were thrilled with our acquisition, and once the prints were on the wall, the guilt I felt for spending the money vanished.

Light eventually appeared at the end of my financial tunnel, thanks in part to Paine Webber's acquisition of our company, which converted my ownership to liquid assets. With a bit more financial flexibility, we resumed our print collecting.

Further salvation came in a job offer to run Alliance Capital, the investment management subsidiary of Donaldson, Lufkin & Jenrette. Although the finances of Alliance Capital, like all of the Wall Street securities firms and investment management companies, were at low ebb, 1978 was a new dawn for me. Alliance's shabby offices, the result of minimal investment in amenities, provided a new opportunity. The walls were empty but for a few dreadful abstract paintings, which no one would admit to selecting or owning. Reba suggested that we use these empty walls to hang prints. Big prints seemed like the answer for the expansive space, so we gradually added contemporary works by living artists. But this didn't seem to satisfy. Contemporary prints were expensive. Even worse, we were doing what most other collectors were doing in the late 1970s, seeking the big, colorful prints that living artists continued to make following the 1960s "print revival." Moving with the herd offended my investment sensibilities. Living artists and fresh-off-the-presses prints provided little opportunity

to discover new fields or obtain new insights. What could we contribute?

Then came the breakthrough. Reba proposed that we use the Alliance walls to build a big, affordable American print collection, emphasizing less-familiar artists from an earlier time, the first half of the twentieth century. We would seek the work of artists whose signatures were not household names, try to find great prints by lost or forgotten printmakers. Less money, more prints—a different direction.

"Let's make this print collecting a big thing," she declared. "It will give us a common interest aside from work. New horizons, new people. I might even go back to school and take some art history courses. One of my ambitions has always been to get a Ph.D. I'd love to write a dissertation. Remember what David Tunick said?"

I nodded. I could quote the print dealer verbatim since I, too, had been struck when he remarked, "Spend just a few hours researching any aspect of American prints, and you'll become *the* expert on that topic." This was the real beginning of our print collection.

There was another advantage to this idea. Reba had recently worked on Wall Street and was now writing about it, while I was involved trying to turn around an ailing investment firm. A friend commented, "How wonderful it must be—the two of you can talk about the stock market every evening after work." Reba's hackles rose—we didn't talk about the stock market every evening, and Reba was determined that we would not.

"We're in danger of becoming the most boring couple in New York!" she warned. "Or at least people will think so."

I thought she was probably right.

The more we considered the idea, the brighter it looked. I, the avid collector, now had a reason to hunt and find. Reba had always had pictures on her walls, but her real love, and forte, was research. Librarian, management consultant, researcher, securities analyst, contributing editor for *Institutional Investor* magazine—she saw an opportunity not only to beautify our surroundings but also to explore a new field for her research and writing. Her enthusiasm building on itself, Reba announced, "We could assemble the best collection of American prints in the country, outside of a few museums. It would be unique."

I gulped. My formidable wife was getting up a head of steam. This train was about to leave the station, and I was all too willing to swing on board.

* * *

Building a great print collection would require focus, discipline, income, and knowledge. We couldn't acquire all the prints produced around the globe for centuries, so we established rules: only prints made by American—United States-citizen—artists; only prints made in the twentieth century, with emphasis on the first half of the century; and only prints featuring images of America. And the prints would mostly be black ink on white paper, not color.

Why these choices? We learned from dealers that American prints were under-collected by institutions and individuals. We saw them as bargains, compared to Old Master and nineteenth-century European prints. They were mostly American scenes, and they were mainly black and white. We wanted to collect from the largest available universe and maintain a consistency and theme to our collection. Most important, there were many, many possibilities to choose from, and not much competing demand. We dove into our new project headfirst, evading the collector herd.

* * *

"The scales fell from my eyes. She saw things in paintings I'd never known were there, let alone understood them. She's beautiful, smart, and attractive—small, slight, blond, and with a droll sense of humor. The audience hung on her every word."

Reba was telling me about a lecture by Dr. Barbara Guggenheim, art historian, that she'd attended at the Gray Art Gallery, New York University's museum, just across Washington Square from our home.

The lecture began a thirty-year friendship. At the time, Barbara ran Art Tours of Manhattan, which took groups to artists' studios to see their work and hear what they had to say about it. She knew all the artists who were anybody, and had access to their studios. We signed up for several tours and engaged Barbara to take us on private visits. She also lectured at Alliance Capital social events for clients, sprinkling her talk with tidbits like "While we were shopping at the Sixth Avenue flea market, Andy [Warhol] said to me. . . " We nicknamed Barbara our company art historian, an unusual affiliation for an investment management firm. Today she's a dealer in multi-million-dollar paintings, living a celebrity life in Los Angeles, and we see her in both California and New York.

That first lecture, and Barbara, clinched Reba's decision to go back to school, study art history, and earn her Ph.D. What we needed most was knowledge; we needed to become experts in our field. Acquiring that knowledge would be gratifying in itself, and, as it turned out, would take us places we would never have seen otherwise.

At that time, Reba's formal education in art history consisted of a survey course at her alma mater, Duke, in the 1950s. She would have to start at the beginning, but it wasn't easy to find a New York-area university that offered a graduate program in American art. Columbia offered a few courses; the Institute of Fine Arts ignored the subject entirely. This attitude, hardly unique to these institutions, was frustrating to the would-be student. At least, we reasoned, if no one else was studying American art, let alone pre-1960 prints, it appeared more likely that American prints would be ours for the taking.

Hunter College, uptown on East Sixty-Eighth Street, offered an alternative. The admissions staff proposed that Reba enter as an undergraduate, get the necessary credits to enter the masters program, and after she obtained her MA, go on to the Graduate Center at City University of New York for her Ph.D. in American Art. This looked feasible. We were planning to move Alliance Capital from its Wall Street location to midtown in a couple of years; we'd move, too. Our main criterion for a new apartment? A wall large enough to hold the ten Warhol *Flowers*. We found a space on Park Avenue with a suitable wall and a short walk to Hunter (Fig. 2).

Reba signed up for three basic art history courses—Impressionism, Baroque, and Renaissance—somewhat skeptical about the quality of what was to come. Wouldn't a highly accomplished professor prefer to teach at one of New York's prestigious private universities, rather than at city-supported

Fig. 2. Photograph of Dave and Reba Williams, ca. 1985.

Hunter, which had less stringent acceptance standards?

But when classes began, Reba was dazzled by her teachers. She raved about them so much that I sat in on some of her classes and soon became a registered auditor. These art history lectures fascinated me, too, as superstar professors opened new worlds of visual insights and observations.

The professor Reba most admired was Dr. Janet Cox-Rearick, a renowned expert on Renaissance art, especially Mannerism, with its propensity to exaggerate, enlarge, and distort certain elements of the human figure. The style was revived in twentieth-century America, especially in small-scale prints. Reba added more of Cox-Rearick's courses to her schedule and, as she began graduate work, started to flirt with the idea of staying with Renaissance art rather than American. Partly as a test, but mostly for the fun of it, we decided to spend two weeks living in Florence in the summer of 1985, immersing ourselves in the Renaissance.

With the help of Cox-Rearick, friends, and museum curators, we covered the city and much of Tuscany, from the obvious museums to remote churches and several Medici villas, one adventure after another. We arrived in the small town of Volterra, south of Florence, just before the noon hour. Perched on a cliff overlooking a rugged landscape, Volterra is a typically medieval village, with stone buildings and narrow, cobbled streets. The Michelin street map presents a tangle of lines that is virtually useless, so it was a matter of driving around scouting for our destination, the *Duomo*, and a parking space, worried that the church would lock its doors before we arrived. And that was exactly what happened: the large wooden doors were shut tight. *Miracolo!* I spotted a priest just down the street, no doubt walking to a restaurant for his lunch, which of course is sacred in Italy. I ran after him, waving lira notes, and with bribery and sign language persuaded him to turn around and let us into the cathedral. Mariotto Albertinelli's *Annunciation* was right where it was supposed to be, as was the thirteenth-century wood sculpture *Descent from the Cross*. So we were able to check off one obscure artist, and a very rare and early object, from Reba's list.

We visited Villa I Tatti, home of the famed Renaissance scholar Bernard Berenson, now the headquarters of the foundation established after his death, owned by Harvard. I Tatti is a shrine, with Berenson's collection on its walls. The paintings are mostly religious subjects and small, early-Renaissance Sienese, with the trademark gilt background. Berenson's personal

art choices were quite different from the primarily late-Renaissance paint-
ings he authenticated for the dealer Joseph Duveen, who made his—and
Berenson's—fortune selling these works to rich Americans in the late nine-
teenth century.

We luxuriated in a bath of Renaissance art and wonderful restaurants.
Sunny blue skies, the fantastic architecture. We concluded that life in Italy is
glorious. Why not Rome next year? Rome would take us both forward and
backward in art time from Florence: the Greek and Roman statuary of BC and
early AD, and seventeenth-century Italian Baroque painting and sculpture.

The next year, 1986, we were surprised by our nearly empty TWA flight
to Rome. It was the Chernobyl effect: the nuclear power plant in Ukraine
had recently exploded, and the fallout had covered much of southern Eu-
rope. Governments had issued warnings to tourists: the Japanese were even
forbidden to travel in these areas. Many feared the possibility of polluted
water and food.

Our Hotel d'Inghilterra, at the foot of the Spanish Steps, was hardly
occupied. We were in a Rome without tourists, unheard-of in modern times.
No lines at the museums—we just waltzed in wherever we wanted to go.
Nearly inaccessible embassies and private palaces, housing rarely seen
paintings, were welcoming. We'd slip a note under a door requesting entry,
and a call would come into our hotel in about an hour with an invitation.

Our greatest adventure was in the Sistine Chapel, where Michelan-
gelo's fresco was being painstakingly cleaned by art restorers wielding tiny
brushes while standing on a scaffold that reached to the ceiling. Thanks to
the intervention of a curator at the Metropolitan Museum, we were given
access, which meant climbing a ladder partway, then riding a small, open el-
evator to the top. Overcoming a fear of heights, up we went, and were nose
to Noah, who was organizing his passengers amid the deluge. Dizziness fol-
lowed. It wasn't just the height, but the close proximity to the oversized and
brightly colored prophet, animals, and raging sea. One of the art cleaners
restored our perspective: he pointed out a short bristle stuck in the painted
plaster—Michelangelo didn't bother to clean up minor imperfections in his
huge masterpiece.

Thrilled by the art of Italy, and to continue working with Professor
Cox-Rearick, Reba decided to write her thesis on Italian prints. Her plan
was to identify all the prints described or mentioned by Giorgio Vasari, the

sixteenth-century artist and author, in his series of books known in shorthand as the *Vite* (or *The Lives of the Artists*), the most complete contemporary document of artists working in Renaissance Italy of the sixteenth century. This was a complicated task, as there are no illustrations in Vasari, and his descriptions are far from complete. Armed with a tall stack of art texts and sales catalogues, Reba matched images and artists with Vasari's words. Slowly, pieces of the puzzle fell into place. A few months later, Reba presented her "Vasari on Prints" thesis to Cox-Rearick, who praised it, saying, "I don't know how you did it. Now do it again in Italian. Italian scholars will be interested."

This was a challenge. Reba had studied French and Spanish in high school and college, and later picked up enough German to squeeze by art history requirements. But her Italian was limited to menus. So, back at the desk with an English–Italian dictionary, Reba did her own translation, again approved by Cox-Rearick.

Some months later, Reba answered the phone one morning. "This is John Pope-Hennessy," the caller announced. "I wish to compliment you on your work on Vasari and prints. Good day." Reba barely got out "Thank you" before the receiver clicked. "The Pope," as he was known, was the most highly regarded Renaissance art historian in the world, and his call was all the more remarkable because, according to Cox-Rearick, Pope-Hennessy had a telephone phobia and rarely used one.

Despite the love affair with Italy and the Renaissance, Reba stayed with American art, our collecting interest, and transferred to the CUNY Graduate Center for her Ph.D. A pleasant surprise there was Dr. Marlene Park, specialist in American art of the twentieth century. Marlene's courses were a perfect overlap with our collection, and I signed up "for credit"—for the enforced discipline—and attended Marlene's classes with Reba. New artists, new ideas, new collecting opportunities.

As our knowledge grew, so did our confidence. We knew we were onto something with our focus on American prints. Dealers responded to our inquiries, and called us when new inventory was acquired. We discovered more printmaking artists than we'd dreamed existed. Collecting accelerated.

Reba chose for her dissertation the history of a New York gallery that, early in the twentieth century, did more than any other to promote prints by American artists. *The Weyhe Gallery Between the Wars, 1919–1940*, comprised over five hundred pages of meticulous research and seventy-seven

illustrations. The dissertation began before its titled start date with a review
of printmaking in America from 1900 to 1918, including the 1913 Armory
Show that brought Modernism to artists and collectors who had not been
to Europe to see such work. The book ended in 1940, when Carl Zigrosser,
director of the gallery since 1919, left to become curator of prints at the
Philadelphia Museum of Art.

The years between the wars were a glorious time for American print-
making artists, with the Weyhe Gallery frequently the financial and artistic
catalyst. Zigrosser aggressively bought complete editions of prints from
artists and commissioned others to make prints with upfront payments as
incentives. Reba's book details the Weyhe's exhibitions (and those of other
print sellers) and the work of the artists active in printmaking in this period.

In 1923, four years after he had started the gallery, Erhard Weyhe
purchased a four-story building at 794 Lexington Avenue and remodeled
it, installing distinctive, colorful tiles on the façade. He created a bookstore
on the ground floor, a print gallery on the second, and moved his family
into the upper spaces. When Reba began her work in the early 1990s, the
building was little changed. The bright tiles were still a Lexington Avenue
landmark, but the original bare wood floors were worn and creaked, tables
and chairs were "period"—a 1920s architectural time capsule.

Gertrude Weyhe Dennis, manager of the gallery and daughter of Erhard
Weyhe, was a considerable help in researching the dissertation. Gertrude
opened the gallery scrapbooks to Reba. Erhard Weyhe and Zigrosser had
maintained a clippings file and copies of the gallery's sales catalogues, an
invaluable resource that was supplemented by Gertrude's recollections.

Reba was fascinated by Gertrude's appearance. "She looks like she
should be headmistress at a girls' school," Reba said to me. "Tall, thin, and
angular, with sharp facial features, emphasized by gray hair pulled back se-
verely into a bun. Her only concession to fashion is hats. She always wears
a hat, and seems to have a great variety of them." She seemed intimidating
at first, but as their relationship developed, Reba found her kind, generous
with her time, and very helpful.

I had a different relationship with Gertrude. I would go into Weyhe Gal-
lery in a mood to acquire—we knew the gallery had a big inventory of prints
of our period. Gertrude was not forthcoming, hardly responding to queries
or indications of interest. A typical example:

Upon entering Weyhe Gallery, after a formal greeting: "Mrs. Dennis, I am interested in expanding our collection of prints by Rockwell Kent. Could I see what you have available? I'm especially eager to acquire his social-protest images."

Her reply: "I will have to check our warehouse inventory. I don't know offhand."

"When might that be?"

"I hope to get out there next week."

"But you've nothing in the gallery I could see now?"

"Nothing of much distinction in your area of interest."

End of conversation. It was as if she didn't want to sell me anything— very strange behavior for a dealer.

Because Reba and Gertrude got on famously, Reba subsequently solved the mystery. Gertrude confided that she had been selling very valuable paintings from her father's estate, which had left her with a huge tax problem: too much income. Some problem!

We thought the dissertation would be a useful reference, so we had it published in hardcover to give to dealers and curators. Its only flaw is lack of an index. Computer programs available to us couldn't deal with artists' names, titles of pictures, and biographical information, and time pressures didn't permit the tedious process of human indexing. (Print dealer Janis Conner explained how she did it for her own book: "Post-its. My book looks like a yellow porcupine.") Nonetheless, Reba received the ultimate compliment from Sinclair Hitchings, the longtime keeper of prints at the Boston Public Library, who asked for three copies: one each for his office and the library, and one for his bedside table.

Reba defended her dissertation, and we left that same day for a long, restful weekend on a nearly deserted small island near Key West. A few months later, we gave a big celebratory party for Reba's sixtieth birthday and her new title: Dr. White Williams.

The American Century in Prints:
1900 to the WPA

Fig. 1. John Sloan, *Turning Out the Light*, 1905. Etching, 5 x 7 in.

Sex is the story in *Turning Out the Light* (1905, Fig. 1). A smiling woman
kneels and leans across the bed with one hand on the gas lamp valve and
the other holding up her soon-to-be-shed nightgown. Beside her, a man
watches and waits, hands behind his head, anticipating what's not said
in the title of John Sloan's etching. As in other prints in Sloan's *New York
City Life* series, *Turning Out the Light* captures a private moment of ordinary
people doing ordinary things. But these pictures were far from ordinary in
the American art world. They were revolutionary and were part of a new
style: a gritty realism of urban scenes.

A similar art revolution had occurred fifty years earlier in France, where

the painter Gustave Courbet and the political cartoonist Honoré Daumier fathered a new Realism, much in contrast to the prevailing idealistic style. In Courbet's tradition-shattering painting *The Stone Breakers* (1849–1850), two ordinary men in rough clothes are building a stone road. They are painted life-size, without sentiment or idealization, neither heroic nor pathetic. In contrast, Daumier took liberties with the human figure, frequently distorting the features of the targets of his cartoons (e.g., a scowling judge or an obese priest). The distinctive feature of their art was that neither showed any mercy: people were there to be seen, with warts and all, busy with their mundane lives. This was dramatically different from the formal portraits, landscapes, and representations of ancient legends that had dominated much of eighteenth- and nineteenth-century art.

The torchbearer for the new American Realism was Robert Henri, a painter and teacher who studied in France, made frequent trips there, and was much influenced by European Realism. Despite the spelling of his name (which was Americanized in pronunciation to *HEN*-rye), he was not French. His mother had adopted the name after his professional gambler father was indicted for manslaughter. A change of surname and a move from Denver to the East, eventually Philadelphia, provided a fresh start.

Nor was Henri a printmaker. His only effort in this medium was the tiny *Paris Street Scene* (1904, Fig. 2) with the familiar mansard roofs, horse-drawn carriages, broad avenues, and leafy trees favored by so many Parisian artists. Henri's little scene, more Impressionist than Realist in style, was etched ten years after he'd made a similar drawing on a trip to Paris. But it was Henri's Realist paintings, and his teaching, that led to the new American school.

In Philadelphia, Henri met young newspaper illustrators who would form the core of this new school, later called the Eight, and in time, the Ashcan School, a reference to rough reality. Its

Fig. 2. Robert Henri, *Paris Street Scene*, 1904. Etching, 2.7 x 4.2 in.

most prominent members were the painters William Glackens, George Luks, and Everett Shinn, and the painter and printmaker John Sloan. They all adopted Henri's doctrines and approach, and a new style was born: ". . . less effete, less genteel, more energetic and inclusive of the range of modern experience."[1]

John Sloan was well suited for the new American Realism. As a teenager in the 1880s, he had been fascinated by an illustrated edition of Rabelais, and immediately "found within himself a taste for earthy, erotic humor that he would never lose."[2] This taste was reflected in some of his newspaper illustrations, to the discomfort of his editors. With Henri's guidance and friendship, Sloan abandoned the life of a salaried illustrator, moved to New York (where Henri had moved in 1900), and became a full-time artist. Henri, Sloan and their fellow "Eights" were not welcome to exhibit at the National Academy of Art, but they got some notice at private galleries, and Sloan's *New York City Life* etchings were reviewed positively in the press.

Turning Out the Light was the only overtly erotic image in the *New York City Life* series, but there is a sense of sex in many of the prints. Children stare and snicker at a corset on a manikin in a store window. A Peeping Tom on a tenement rooftop spies on a partly dressed woman combing her hair. Unmade beds are prevalent. In *Roofs, Summer Night*, apartment dwellers have carried their mattresses and pillows to the roof, seeking cool air and sleeping communally on a hot night. *Man, Wife, and Child* is an intimate family scene of a friendly wrestling match. Sloan's characters are far from beautiful; they have plain looks and wear plain clothes (and very plain underclothes). This was indeed a new American art.

Sloan's art fit well with our personal surroundings, once we'd exited the subway from Wall Street and returned home to Greenwich Village. Reba had an apartment in the Village when we first met, and I'd longed to live there since the 1950s, when I'd prowled its bookstores and attended plays in tiny theaters while my ship was in dry dock at the Brooklyn Navy Yard. Our first home was on Cornelia Street, and with its Italian bakery, small restaurants, coffee shop, frame shop, and artists' lofts, it could have been a setting for a Sloan print. We were in love and in love with the Village, so it's no wonder that two more Sloan prints became our favorites.

A few steps from our door was Washington Square and its Washington Memorial Arch, memorialized in Sloan's *Arch Conspirators* (1917, Fig. 3). Atop the arch, a group of six people have brought balloons, beverages, and

candles, built a small fire, and are enjoying a mid-winter picnic. Among those present are the artist Marcel Duchamp (wearing a hat and standing at left), the actor Charles Ellis, Sloan with his ever-present pipe, and the

Fig. 3. John Sloan, *Arch Conspirators*, 1917. Etching, 4.5 x 6 in.

instigator of the adventure, the poet Gertrude Drick, who preferred the name of "Woe," claiming she always wished to say "Woe is me." This intrepid group of bohemians had broken into the structure and climbed an internal stairway on a mission to liberate the Village by declaring secession from the United States and the evils of big business and small minds. Their proclamation called on President Woodrow Wilson to provide protection to the new country of Greenwich Village as one of the small nations he so passionately defended as he led America into World War I. Fortunately for us, Wilson ignored the petition, the Village remained American, and we owned a quintessential token of our home "town."

Our other Village print by Sloan is *Snowstorm in the Village* (1925, Fig. 4), the view from Sloan's studio at the time, looking north up Sixth Avenue with the elevated train tracks—the old "El"—below and the brick Jefferson Market building complex at upper right. For New Yorkers, especially the likes of us, who came from elsewhere and adopted the city as home, the El held romantic notions of New York City past, as immortalized by Ogden Nash:

Oh El, thy era is o'er;
I am glad that thou are no more;
But I'd hold myself lower than dirt
Weren't I glad that once thou wert.[3]

The Jefferson Market Library is the current inhabitant of the brick tower and related buildings in the image. This structure, dating to 1875, was a courthouse, the site of Harry Thaw's trial for the murder of architect Stanford White, later dramatized in the movie *The Girl in the Red Velvet Swing*. Mae West was tried there and convicted on obscenity charges. The inmates of the connected women's prison subjected passersby on Greenwich Avenue to shouted taunts. Thankfully, the prison was razed and turned into a garden in 1973. But this environment was all part of John Sloan's life and a new art style.

Sloan's prints were attractive to us as collectors

Fig. 4. John Sloan, *Snowstorm in the Village*, 1925. Etching, 6.9 x 4.9 in.

on several grounds. First, they were the forerunner of the new American Realism, which influenced American art through the first half of the twentieth century. In addition, Sloan made many prints in large editions, so they were available at low prices—mostly under $1000 in the 1980s, and not a lot more today. We liked that his prints were often narrative, such as *Arch Conspirators*, and that they depicted our home, Greenwich Village, in both spirit and appearance—freedom of lifestyle set in a slightly shabby environment.

Fig. 5. John Marin, *Woolworth Building (The Dance)*, 1913. Etching and monotype, 11.9 x 10 in.

Right on the heels of American Realism came another new style: Modernism, again an import from France. The famed Armory Show opened in New York in 1913 and brought Abstract, Cubist, Expressionist, and Fauvist art to a large audience. The public was shocked by, and dismissive of, the new and challenging art at the Armory Show, perhaps best exemplified by Duchamp's *Nude Descending a Staircase* (famously described by one critic as "an explosion in a shingle factory"[4]). John Sloan worked on two committees that aided the show, and he offered five of his etchings and two paintings for display. One of the etchings sold: ten dollars, a handsome price at the time. But Sloan never took to Modernism:

> Sloan's generation were to a man threatened and unnerved by what they saw at the Armory on Lexington Avenue and Twenty-Sixth Street that month. Sloan knew that he was in the presence of something significant and challenging. He told Quinn [the show's main sponsor and organizer] that had he known how important this show was to be, he would have involved himself in it to a greater extent.[5]

In later years, Sloan mocked the movement. His one Modernist-style print is a sarcastic take on abstract art.

Still, many other artists were fascinated by the new styles, and eager to see the art in person. John Marin, who began his career studying art at traditional academies on the East Coast, lived in Europe from 1905 to 1911, where he wholeheartedly embraced Modernism. When he returned to the U.S., Marin affiliated with the dealer and photographer Alfred Stieglitz and his Photo-Secession gallery, known as "291" after its Fifth Avenue address. Stieglitz's 291 was the first commercial gallery to exhibit prints that could be called Modernist, showing such French artists as Matisse, Toulouse-Lautrec, Cézanne, and Picasso. Into this exalted company came John Marin.

Marin found his greatest inspiration in the architecture of New York City, its bridges and skyscrapers. Watercolor was his preferred medium, particularly for seascapes, but in 1913 he had a burst of interest in etching, producing prints of the city, including several versions of the Brooklyn Bridge and the Woolworth Building, at the time New York's tallest.

Woolworth Building (The Dance) (1913, Fig. 5) is Marin at his best. The skyscraper appears to sway, an illusion frequently created when one looks straight up the side of a tall building as clouds pass overhead. In Marin's im-

age, people and trees slant in an opposite direction than the building, and everything seems to move. The tiny humans at ground level, dwarfed by the massive structure, seem almost threatened by the building.

Like John Marin, Louis Lozowick did not require the Armory Show to be introduced to European Modernism. Born in the Ukraine, Lozowick studied at the Kiev Art Institute until he and his family immigrated to New York in 1906. He subsequently studied at the National Academy of Design, got a degree from Ohio State University, traveled around the United States, and returned to Europe, spending two years in Berlin. There he became a member of a Modernist circle that included artists affiliated with the Bauhaus, a short-lived (1919–1933) but highly influential school of art, architecture, and design. Its founder, Walter Gropius, stated that one purpose of the Bauhaus was to ". . . create the new building of the future . . . that will one day rise toward heaven as [a] crystalline symbol."[6] He was describing what came to be called the International Style of architecture, a minimalist approach that made the Neo-Gothic style of the Woolworth Building look ornamental. These same characteristics are found in Bauhaus-influenced art, which came to be called Constructivist—hard-edged, geometric imagery that often featured architecture or elements of machinery. Lozowick returned to the U.S. in the early 1920s to start a career as an artist and stage set designer.

New York (1925, Fig. 6), Lozowick's most famous print, is typical of his Constructivist-influenced art—lights shine from skyscraper windows, and a lighted El train circles the city. The buildings and train are represented in reduced and simplified form, as if all of New York had been recreated as an International Style model city.

I bought *New York* in 1971, an acquisition that reveals the state of the market for early twentieth-century American prints at that time. The leading salesman in our firm, like me enthused by our senior partner's interest in prints, was a budding collector. He lived in New Jersey, not far from both the South Orange home of the Lozowicks and Milburn, where Mrs. Lozowick worked in a frame shop. Our salesman, never shy, approached Adele Lozowick about buying some of her husband's prints. Apparently Lozowick did not have a regular dealer, so Mrs. Lozowick agreed, selling him a lot of fifteen prints, including *New York,* for $580. I was lucky to buy *New York* from him for his purchase price of seventy-five dollars. It was recently on offer at the New York Print Fair for $125,000. This is an extreme example—my expe-

rience was a fluke, and rarely repeated—but it suggests how little appreciated, valued, and collected American prints were forty years ago, particularly those by a forgotten artist.

Fig. 6. Louis Lozowick, *New York*, 1925. Lithograph, 11.5 x 9 in.

Fig. 7. Kyra Markham, *Lady Macbeth (Self-portrait)*, 1935. Lithograph, 11.1 x 8.4 in.

As I read Hilton Kramer's reviews of gallery exhibits in the Friday *Times*—
Kramer was art critic for the newspaper—I knew where I'd be the next morn-
ing: the Witkin Gallery. Quoting Kramer, "If you have never heard of the late
Kyra Markham (she was Theodore Dreiser's mistress) . . . there are some pleas-
ant surprises awaiting you in this show."[7] I'd never heard of Kyra Markham,
but the Dreiser connection was a come-on, and this was all I needed to know.

When I arrived at Witkin, I learned something else. The gallery described
Markham as a "Fantasist," a style new to me, also called Post-Surrealist, or
Magic Realism, or in today's vernacular, Surrealism Lite. The image was real
(no Dalí drooping watches), but not quite real, just the artist adding a touch
of personal fantasy, or juxtaposing real objects in an unreal order.

According to the Witkin brochure, Markham was "a large woman, dy-
namic, strong-willed, vigorous, hardworking, fascinating to watch . . . "[8] Not
lacking in confidence, she turned away from art school and, in 1913, began
acting with the Chicago Little Theatre. She met Dreiser when she was
twenty-one, and moved with him to New York, where they lived together
for three years. Exasperated with his infidelities, she ended the relationship
and resumed her acting career in Provincetown, where friends from Green-
wich Village had founded the Provincetown Players.

For much of her life, Markham alternated between the stage and the ea-
sel (and lithographic stone). Her self-portrait tells all: a veiled *Lady Macbeth*,
(1935, Fig. 7), with a strong jaw, large eyes, and a hint of ample bosom. The
fantasy: Markham transports us to Macbeth's Scottish castle, complete with
flaming sconces on stone walls and looming parapets.

The discovery of Kyra Markham and Fantasy, and what it led to, is a
typical collecting story: one discovery leads to another. Armed with what I
learned at the Witkin Gallery, I went in search of other artists of this style,
and started to notice fantasy in work by artists not associated with it.

Enquiries to dealers uncovered *Enigma (The Mirror)*, 1937 (Fig. 8) by
Helen Lundeberg, who, compared to Kyra Markham, was an overt Fantasist.
A few years younger, and a continent apart, Lundeberg turned from creative
writing to art. At art school in Pasadena, California, Lundeberg was inspired
by her instructor Lorser Feitelson, and they partnered (and later married)
and created a style they called Subjective Classicism. Lundeberg describes
her art as ". . . the effort to embody, and to evoke, states of mind, moods, and

Fig. 8. Helen Lundeberg, *Enigma (The Mirror)*, 1937. Lithograph, 12 x 8.9 in.

emotions."[9] In his compendium on American lithographers, Clinton Adams describes Lundeberg's work as "a personal universe of magic and mystery" and cites *Enigma* as "unsurpassed in its haunting authority."[10] Common objects—a chair, shell, torn paper, wood board, and a mirror reflecting a light bulb, all sharply realistic but bearing no relationship to each other— are carefully arranged like a classic still life. *Enigma*, indeed, provokes the

viewer to wonder. This is very close to conventional European Surrealism, but "purged of its weirder overtones,"[11] according to critic William Wilson, with the realistic portrayal of commonplace items.

All of Wanda Gág's art could be considered fantasy, far removed from normal reality, and rarely a straight line. Buildings, furniture, and small objects curve, warp, and bend. Critics have attributed this feature to Gág's love of nature, especially plants, which appear throughout her imagery, swirling and growing wildly. She loved the outdoors, as her diaries reveal: "I want to tear off all my clothes and lie among the grasses." After a much-hated stay in New York City, Gág lived in the country, in rented farmhouses, some very ramshackle. She "took to the simple life, walking barefoot in the woods and swimming naked in nearby lakes." She wrote extensively about her uninhibited and vigorous sex life: "It is not a matter of morality to me, it is a matter of health and art."[12]

My favorite Gág print puts fantasy atop her already fantastic renderings. In *Lantern and Fireplace* (1931–32, Fig. 9), a scene inside a neighbor's home, the lantern creates a fantasy light. But even more fantastic, the fire is both inside and outside the fireplace. Fantasy flames climb the chimney exterior, creating an even warmer feeling.

Thanks to Kyra Markham and Witkin Gallery, I was alert to fantasy elsewhere, and I would find it often.

Fig. 9. Wanda Gág, *Lantern and Fireplace*, ca. 1931-2. Wood engraving, 7.3 x 5.4 in.

The *Oxford English Dictionary*:

> 2. The theory or practice of the impressionist school in art; the method of painting (or describing) things so as to give their general tone and effect, or the broad impression which they produce at first sight, without elaboration of detail.[13]

While Impressionism is usually associated with color, etchers in black and white on both sides of the Atlantic fell under its sway, and the Etching Revival of the nineteenth century reflects the influence. A later, twentieth-century American Impressionist, Childe Hassam, painted flowers and gardens in glorious color, and beautiful rural, coastal, and urban scenes; his paintings of the flags displayed during the victory parades of New York following World War I are among his most famous.

Hassam was also an accomplished etcher, and his print oeuvre included the American flag images. But my favorite, like so much else in what we collected, was closer to personal experience. *The Lion Gardiner House* (1920, Fig.

Fig. 10. Childe Hassam, *The Lion Gardiner House, Easthampton*, 1920. Etching, 10 x 14.3 in.

10) was located on Main Street in East Hampton, Long Island, New York, near where Reba and I had our (her) first country home. We were married in the First Presbyterian Church of East Hampton, which is surrounded by houses similar to the Gardiners'. Hassam etched many images of eastern Long Island houses, buildings, and churches, but none capture the leafy beauty and the sun and shade of East Hampton quite like *The Lion Gardiner House*. We will return to Hassam's flower paintings and his flags in a later chapter.

RETURN TO REALISM

Despite the onslaught of new European styles, American realistic art did not disappear, but flourished through the nineteen-teens to the outbreak of World War II. There were traces of Modernism in the new Realism, but only touches, and not always with the best result.

George Bellows played semi-pro baseball and probably boxed in his youth, and his best work in prints—and paintings—are his sporting scenes, especially his boxing prints. His *Dempsey through the Ropes* records the dramatic near-defeat of heavyweight champion Jack Dempsey, who was knocked out of the ring in a title fight with Luis Firpo, but with the help of ringside newspaper reporters clambered back up by the count of nine, then nearly killed his opponent in the next round. Un-

Fig. 11. George Bellows, *Preliminaries to the Big Bout* (detail), 1916. Lithograph, 16.2 x 19.5 in.

fortunately, Bellows's attempt at Modernism here leaves the fighters' limbs rigid and stiff; there's an overall lack of dynamism in the image. This same tendency shows up in Bellows's elegant images of tennis played on a grass court in Newport, Rhode Island, but because the prints are more social commentary than sports reporting, the players' awkwardness is less noticeable in the grand surroundings.

For me, Bellows's social commentary was a strong attraction, and my favorite example is *Preliminaries to the Big Bout* (1916, Fig. 11 [detail]). The

ring and boxers are distant, hardly visible, and obviously unimportant. The focus is on the richly dressed spectators just arriving—men in top hat and white tie, women in evening dress with one draped in fox fur. Emma Bellows noted that she and her husband were at Madison Square Garden that night, the first time "society swells" showed up for a boxing match.

Bellows's accomplishments and contributions to American printmaking are considerable. His mastery of black-and-white lithography popularized the process as an artistic medium. With a few exceptions, such as Rembrandt Peale in the early nineteenth century, printmaking artists preferred woodcut, wood engraving, or etching. Lithography is complicated, requiring special stones, crayons, scraping tools, a big press, and usually a professional printer. Bellows bought his own press, but turned to a young commercial lithographic printer, George C. Miller, to use it to make his prints. In 1917, Miller opened his own small shop in New York City and began printing for other artists, as well as Bellows. George C. Miller & Co. became the first lithographic shop in America devoted solely to printing for artists. About a year later, Bolton Brown, an artist who learned lithography skills in London, opened a print shop in Woodstock, New York, to serve other artists. The availability of the Miller and Brown facilities inspired more and more printmaking artists to take up lithography.

Bellows's greatest print (printed by George C. Miller) is *A Stag at Sharkey's* (1917, Fig. 12), in which two boxers are slugging and pushing each other at a men's (stag) night at a saloon-cum-sports arena. (One wonders if there was *ever* a ladies' night at Sharkey's? Doubtful.) We acquired *A Stag at Sharkey's* improbably. Old Master print dealers Lesley Hill and Alan Stone were helping us with a side collection we were assembling. Hill–Stone, as they're known commercially, don't fit the conventional (at least my) stereotyped image of an Old Master print dealer, an ancient connoisseur, humpbacked from bending over drawers of prints, spectacles falling down the nose, somewhat shabbily dressed. Not Lesley and Alan. They are movie-star beautiful, vital and vibrant, and immaculately turned out. But their good looks are matched by their knowledge of their field: old prints and drawings. Thus my surprise when Alan called to ask, "Do you own *A Stag at Sharkey's*?"

We'd long wanted this iconic American print, considered by some to be the best American print ever. But the price was always daunting. I answered, "We've been hoping for an opportunity to get it. Can we see it?" We wasted little time arranging a visit.

"Why would Hill–Stone have this print?" we wondered as we sat in their apartment, both living space and gallery, its walls filled with Old Master prints and drawings. *Stag* was displayed on an easel in front of us, and its larger size and dynamism contrasted strongly with the surrounding Old Master images. Alan explained, "A museum has just acquired a second impression, which they think is better than this one, and they want to deaccession." He turned to examine the print. "This looks like a perfectly good impression to me."

It certainly looked good to me, too. Bellows's ability to use lithography to create tone was much in evidence. Black to white with every imaginable shade of gray in between. The tension in the muscles of the sweating fighters was palpable. The viewer can almost feel the heat of the ring and hear the pounding of leather on flesh and the roars from the crowd. I was almost afraid to ask the price, but I did, and I got the answer.

Relief—I expected much worse news. Reba and I looked at each other. Attempting to maintain composure, I croaked out, "Okay." We owned *Stag*.

Fig. 12. George Bellows, *A Stag at Sharkey's*, 1917. Lithograph, 18.6 x 23.8 in.

Edward Hopper did for etching what Bellows had done for lithography as an American art medium. Hopper attended the New York School of Art from 1900 to 1906. His classmates included several leading American artists-to-be, including Bellows. He supported himself as a commercial artist, traveled to Europe to study the old and new art, and painted in his spare

Fig. 13. Martin Lewis, *Stoops in Snow*, 1930. Drypoint, 9.9 x 14.9 in.

time. He managed to sell a painting in the 1913 Armory Show, but it wasn't until he took up etching that he really made his mark.

Hopper learned to etch almost accidentally, through a friendship with Martin Lewis, an Australian artist who came to New York the same year Hopper entered art school. Lewis, a painter and commercial artist, had started making etchings and drypoints of New York City scenes, and his *Stoops in Snow* (1930, Fig. 13) is typical of his work. A master at achieving atmosphere, Lewis set many of his prints in rain, fog, smoke, twilight, or night, with light creating a dramatic or theatrical quality, usually in a city. In *Stoops in Snow*, he uses the bright white of the fallen snow to illuminate the passersby as they walk through the swirling flakes with hunched backs and downturned faces.

Lewis taught Hopper the basics of etching, offering both technical advice and where to purchase the necessary materials. Starting in 1915 and continuing into the early 1920s, Hopper produced some seventy etchings and drypoints, primarily New York City scenes. Many reflect the sense of isolation for which Hopper became famous: one person alone in a room, an empty landscape, a single house.

David Kiehl, curator of prints at the Whitney Museum, thinks Hopper's *American Landscape* (ca. 1920, Fig. 14) is the artist's greatest print. In a filmed interview, Kiehl calls the print ". . . an abstract work—you can read the image as realistic—the house, the tracks, the cows—but I think it's abstract, and one of the greatest American prints of the twentieth century." Kiehl adds, "And I just love that white cow crossing the railroad tracks."[14]

We collected only a few Hopper prints; money was the issue. Hopper, a famous and successful artist beginning with his prints and continuing with his oils and watercolors throughout and beyond his lifetime, was constantly sought by collectors and museums; his art was never undervalued or inexpensive. This contrasted sharply with prices for prints by Sloan and other early Realists, including Bellows (except for his sporting images). In order to spread our print-acquisition budget over as many images as possible, we

Fig. 14. Edward Hopper, *American Landscape*, ca. 1920. Etching, 7.3 x 12.3 in.

Fig. 15. Edward Hopper, *The Henry Ford*, 1923. Etching, 12 x 15 in.

"under-collected" Hopper. But we did splurge on one unusual Hopper print.

At twelve by fifteen inches, *The Henry Ford* (1923, Fig. 15) is Hopper's largest print. It's also the rarest, with only three known impressions, but print dealer Craig Starr, known at the time as a dealer in prints by living artists, somehow managed to acquire one. The impression was dedicated with a tiny pencil inscription by Hopper to his wife, Jo, and the cramped handwriting was unmistakably the artist's. Starr's offer to us came in 1996, in the midst of the great art boom, but even so the $115,000 price tag seemed steep, and was much more than we'd ever paid for a print. But we'd learned: buy the best and the rarest, and you won't regret it. So we did, and we don't.

But we've never solved the mystery of why Hopper made so few impressions of *The Henry Ford*. The image is very consistent with his other work: a rolling schooner with all sail set, a rocky coast, spectators scattered— mostly alone—on the rocks, one waving. The Whitney Museum owns the copper plate, but not the print. With David Kiehl, we examined the plate and found nothing that might prevent making more impressions. But for some unknown reason, the artist stopped with three.

Or so we thought—until a few years later Christie's turned up a fourth in California. It had been badly stored in an art critic's desk drawer for years, but a restorer brought it back to life, and Christie's offered it in a print auction with an estimate of $10,000–$15,000. What were they thinking? We debated whether to tell them of their mistake, but the catalogue was already printed, so we kept quiet. Sure enough, *The Henry Ford* roared off the auction block and sold for a hammer price (before the buyer's commission) of $185,000.

REGIONALISM

Another important movement in American art before World War II was Regionalism. Although New York dominated the American art scene in the twentieth century, two Midwesterners, Grant Wood and Thomas Hart Benton, spearheaded the creation of a "country" school of art, which came to be known as Regionalism. Wood is best known for his painting *American Gothic*, depicting a homely farmer holding a pitch fork and standing beside his very plain, and clearly Midwestern, wife. It has been frequently reproduced and parodied in countless illustrations and cartoons. But Wood probably would not have been offended, because many of his images are gently satiric, poking a little fun at his Iowa neighbors, and sometimes at himself. A trait of Wood's artistic style is curved or rounded forms, whether hills, roads, barns, vehicles, animals, or people. He also produced a suite of lithographs under the auspices of Associated American Artists, in large edition sizes—typically 250—all rural Midwestern scenes.

Wood's lithographs have remained popular with collectors ever since their original publication in the late 1930s. The images are clear and understandable, comfortable to live with. With one exception: *Sultry Night* shows a naked farmer, frontal view, dousing himself with water from a trough after a hot day's work. The print created a scandal. The U.S. Postal Service even declared it pornographic and barred Associated American Artists from sending the print through the mail, AAA's principal distribution method. So the edition size was reduced to one hundred, making it pricey—maybe twice as high—as Wood's other lithographs. *Sultry Night* also added to speculation and press commentary, however guarded, about Wood's sexual orientation (male nudes had appeared in some of his earlier paintings, albeit more modestly).

Typical of Wood's prints is *Fertility* (1939, Fig. 16). Like much regional art of the 1930s, it is optimistic: the corn is healthy; the barn bright and clean; all the forms are rounded. However, it doesn't require much imagination to observe that *Fertility* is also blatantly phallic, and like *Sultry Night*, it added to the buzz about Wood and sex. Leaving that aside, it's also worth noting that the house on the left is identical to the one serving as background for *American Gothic*.

Fig. 16. Grant Wood, *Fertility*, 1939. Lithograph, 9 x 11.9 in.

Thomas Hart Benton was from a famous Missouri political family, and attended art schools in Chicago, Paris, and New York. His early paintings were Cubist in style, but he soon rejected abstract art—in his work, his writings, and his interviews—and turned to interpreting the American scene in a representational style.

Benton refused to admit any outside influence on his art. Francis V. O'Connor, an art historian, critic and expert on WPA and other art of the 1930s, notes that his first three murals were created about the same time as Diego Rivera's first murals in America, and Benton is sometimes described as a United States counterpoint to, and rival of, Rivera, the acknowledged star of the Mexican muralist movement. Benton's one verbal tribute to Rivera was at best half-hearted: "I respect Rivera as an artist, as a great one, but

I have no time to enter into affairs concerning him, because I am intensely interested in the development of an art which is of, and adequately represents, the United States—my own art."[15] No one ever accused Tom Benton of being overly gracious.

O'Connor thinks that Benton's *America Today* murals (1929), made for the New School of Social Research in New York City (recently at the AXA Equitable building, now at the Metropolitan Museum of Art), represented a "breakthrough," and he believes that in them Benton drew on what he observed in Rivera's work, notably Rivera's successful use of Cubism. Any flaws in the *America Today* murals, O'Connor suggests, derive from Benton's struggle to assimilate Rivera's stylistic influence.[16] It also seems undeniable that Benton's art was influenced by Mannerism, with its exaggerations of the human form and objects. This style is prevalent in the murals that made him famous, most of which depict American myths or the everyday lives of migrant farm workers, sharecroppers, oil-well roustabouts, and city folk.

Like Grant Wood, Benton saw mid-America positively, even in the midst of the Great Depression. An early print, *Going West* (1934, Fig. 17), demonstrates both his style and his optimism.

Benton advocated "going West," deliberately abandoning the effete eastern urban life. His locomotive strains forward, the engine bent like a racing animal's snout. Smoke streams from the boiler furnace, curling off in the

Fig. 17. Thomas Hart Benton, *Going West*, 1934. Lithograph, 12.2 x 23.3 in.

distance. Telegraph poles are left behind, leaning backward. The West (for Benton, the Midwest) is where Benton sees power, dynamism, and good things, even in the Dust Bowl-plagued, Depression-wracked year of 1934.

Benton's positive views may have had something to do with his own situation. Like Wood, he was a financially successful artist, among the few who never sought employment by the WPA or other government programs supporting artists during the Depression.

WALL STREET AND THE DEPRESSION

Fortunately for me and my career, I never experienced a market crash the equal of 1929's. And, by the 1960s, most Wall Street buildings were centrally air-conditioned, with windows that refused to open. Thus, it was not so easy to end it all when the calamitous margin call came during a bear market.

Fig. 18. James Rosenberg, *Oct 29 Dies Irae*, 1929. Lithograph, 13.7 x 10.4 in.

But not impossible.

One morning in the early '70s, that dreary time of political scandal and ruinous economic policy, I arrived at my Wall Street office building early. Blocking the entrance was a human body, just recently covered by a tarp. However, it was not a bankrupted investor but a window-washer whose hanging scaffold had collapsed.

Living with the stock market, and depending on it for life's necessities and pleasures, created a constant tension. It's no wonder that images of the '29 crash fascinated all of us in the business. James Rosenberg was a successful corporate lawyer who worked on Wall Street in the 1920s and 1930s. He was also very interested in art, and later in life gave up the law, turned to painting and printmak-

ing, and opened an art gallery. He was very much present during the great crash, and—the story goes—made the lithograph *Oct 29 Dies Irae* (1929, Fig. 18) on Black Monday (October 29), titling it after the first line of the Requiem Mass, which translates from the Latin as "Day of Wrath." The Expressionist style seems right for the occasion, with falling buildings and bodies and panic in the streets.

This print, and a companion piece by Rosenberg titled *November 13, Mad House, 1929*—another bad market day—hung just outside my office at Alliance Capital, so that everyone, including myself, could be reminded of risk.

Even for the non-investor class, the 1929 stock market was major news. Bernarda Bryson, married to fellow artist Ben Shahn, was acutely aware of the event and its aftermath. According to her dealer, Bryson was living in Ohio at the time and was very concerned that the local bank holding $500 of her savings might close.[17] She made *Crash* (1929, Fig. 19) following Black Monday, capturing her anxiety and fear. Bryson went on to photograph and record in lithographs images of the Depression: people in rural areas who never owned a share of stock or had a bank deposit, but who were as equally devastated as the face portrayed in *Crash*, howling in pain.

The Depression arrived like a storm, a huge hurricane that swept the entire nation. The gloom spread from Wall Street to Main Street, and artists were quick to capture its devastation. A favorite topic was breadlines, those columns

Fig. 19. Bernarda Bryson, *Crash*, 1929. Lithograph, 10.1 x 8.2 in.

of the destitute lining up for free food. But the image that best communicates the human condition of the wounded is Raphael Soyer's *The Mission* (Fig. 20), done in 1933, possibly the very depth of the Depression. The scene is in a church mission, and the hollow-cheeked, near-starvation poor are concentrating on their coffee and bread—except for one. A central figure stares out at the viewer in anger, eyes intense and mouth tightly drawn. I can read his mind: "I'm mad at the world. It's not my fault, but I'm desperate and can't do anything about it."

The Works Progress Administration was established to do something about it.

Fig. 20. Raphael Soyer, *The Mission*, 1933. Lithograph, 12.2 x 17.7 in.

The American Century in Prints: The WPA

Though we remained opportunistic, acquiring anything that fit anywhere in our collecting goals, WPA prints always were our priority.

The Works Progress Administration was one part of President Franklin Roosevelt's New Deal, instituted shortly after his inauguration in 1933. This broad array of programs aimed at reducing unemployment was controversial from the start: should the government get into the business of business? When artists were included, the critics became even more vociferous; to them, it seemed ludicrous to pay people to make pictures to be admired instead of industrial products to be bought and sold and therefore promote economic recovery.

The inspiration to include art in the New Deal came from two improbable sources, Mexico and a rich schoolmate of the president's, George Biddle. Biddle was a member of a prominent and wealthy Philadelphia family and a part-time artist, writer, and traveler. In 1908 and 1909 he was a cowboy in Texas and Mexico, an experience he never forgot, comparing it to Melville's Pacific exploration and Sam Clemens's Mississippi River cruises.[1] In 1928, he returned to Mexico to study with Diego Rivera for six months. Enraptured with Rivera's work, he wondered if murals could find a place in America. On May 9, 1933, Biddle wrote a now-famous letter to the president, who had only been in office for two months:

> Dear Franklin:
>
> I never doubted your ability and courage; and perhaps that is the reason why I have so delayed in congratulating you on your achievements. The sincerest thing I can say to you is that you have grown and will continue to grow with the demands that America and the world puts on you. I am really proud to have known you at school and college.
>
> There is a matter which I have long considered and which some day

might interest your administration. The Mexican artists have produced the greatest national school of mural painting since the Italian Renaissance. Diego Rivera tells me that it was only possible because [President] Obregon allowed Mexican artists to work at plumber's wages in order to express on the walls of the government's buildings the social ideals of the Mexican revolution.

The younger artists of America are conscious as they have never been of the social revolution that our country and civilization are going through; and they would be eager to express these ideals in a permanent art form if they were given the government's co-operation. They would be contributing to and expressing in living monuments the social ideals that you are struggling to achieve. And I am convinced that our mural art with a little impetus can soon result, for the first time in history, in a vital national expression.

You are too busy at present with more serious problems to give this matter any thought. Perhaps during the summer you will let me drive over from Croton-on-Hudson and pay my respects.[2]

The first program inspired by Biddle's letter was the Public Works of Art Project (PWAP), launched in 1933 to decorate nonfederal public buildings with works of art, most prominently murals. Another in this alphabet soup of government agencies, the TRAP (Treasury Relief Art Project) was established for artists to decorate federal buildings in the same vein. But for artists, the big deal of the New Deal was the WPA's Federal Art Project (FAP), which employed artists with a wide range of experience and styles, sponsored a more varied and experimental body of art, and had a far greater influence on subsequent American movements.

Will Barnet, who made his first print in 1931, taught printmaking while working for the WPA in the 1930s. Student artists flocked to his lithography class, partly to learn this complicated process, but mostly to get Barnet, who had a magic touch with lithographic stones, to print their work. He was always accommodating, and he kept a copy, usually signed, of most of his students' work, some of whom became recognized printmakers. Generous Will gave us his entire collection of his students' prints.

Barnet, still making prints in 2012 (and celebrating his one-hundredth birthday with a major exhibit at New York's National Academy Museum), was emphatic about the effect of the WPA on artists. "The WPA was a very exciting period because it gave so many artists a chance to develop—as painters, muralists, sculptors, printmakers. So I feel the WPA was one of the

greatest contributions to the history of American art."[3] The main reason for the outpouring of prints between the wars was the WPA, and WPA prints were among our primary targets.

In addition to their central place in the history of American art, these prints became the cornerstone of our collection because of my childhood memories. For me, nostalgia was always a powerful collecting influence. I was born in 1932 and was able to observe some WPA activities firsthand. My father, working for the Texas Highway Department, oversaw the construction of a WPA-financed highway from Beaumont, our hometown, to Houston, and I often visited the work site. I heard parents and grandparents discuss dust bowls and breadlines. Even in relatively prosperous Beaumont—oil was still being discovered in East Texas—there were out-of-work beggars on the downtown streets.

One great appeal of WPA prints was the history they revealed. We were fascinated by the idea of an American government subsidizing artists despite the vocal opposition of many, and when much government economic policy was contradictory and confusing. To drive up prices, farmers were paid to destroy their crops and livestock, while soup kitchens served hungry, unemployed workers and many children were undernourished. Prints made by artists in the WPA provided insight into the period. Although the WPA administrators demanded an uplifting and optimistic tone in murals, the prints were censored very little, probably because prints are often considered a lesser art.

Lucienne Bloch, who had worked as an assistant to Diego Rivera when the latter painted his famous murals of the Ford Motor Company factory in Detroit in 1932, took advantage of that distinction. Lucienne was commissioned by the WPA/FAP to paint a mural in Detroit of children in a playground that was frequently used by African Americans. She told us the WPA administrators wanted only white children in the mural, so that's what she painted. But she also made a realistic lithograph of the same scene with black children, titled *Negro Playground, Detroit*. That was typical of the WPA/FAP administrators—a 1930s version of political correctness (whites only) for the very public murals, but no censorship imposed on the less public and therefore less important prints.

Another reason we focused on the WPA period was that printmaking in particular benefited from it. Until the establishment of the WPA, many

Fig. 1. Joseph Vogel, *Another Day*, ca. 1937. Lithograph, 15 x 11 in.

artists had no access to the heavyweight presses and special stones neces- sary to make a lithograph. The WPA/FAP established workshops across the country for artists that provided everything, including instructors to teach lithography. And prints rolled off those presses. WPA artists made more than two hundred thousand impressions of eleven thousand different prints, mostly lithographs, during the WPA years of 1935 to 1943. Even more as- tounding than the output was the variety in their style and content. Realism predominated, but all forms of abstraction were represented. Imagery often depicted the lives of people, but through lenses that were sometimes rosy, sometimes dark.

A decidedly downbeat version of the human condition during the Depression is Joseph Vogel's gloomy *Another Day* (ca. 1937, Fig. 1), in which workers march to their labor like discouraged automatons, overwhelmed by the huge factory looming over them. Vogel's workers reveal the influ- ence of Mexican muralist and printmaker José Clemente Orozco, who often depicted the common people as identical, expressionless, and exploited. No happy workers these.

I purchased *Another Day* at Associated American Artists gallery—where I had first encountered prints and the proprietor Sylvan Cole—during a 1983 exhibition titled *The 30s Revisited*. WPA prints were, in fact, Cole's great pas- sion. In a *New York Times* article about the exhibit, he explained: "I started the '30s at the age of 12. When the decade was over, I had graduated from high school, graduated from college, and was one year away from serving in World War II. The '30s had a tremendous impact on my life."[4] Fifteen years after our first meeting, Sylvan called to tell me he was putting up this ex- hibition of WPA prints, and I could have first choice if I came to his gallery posthaste. I did, and left with a dozen prints made under the WPA/FAP.

Sylvan, who not only ran the gallery but also wrote and published books and catalogues about the artists he represented, ranks with Carl Zi- grosser and the Weyhe Gallery as a popularizer of twentieth-century Ameri- can prints. Under his management, Associated American Artists sold prints at affordable prices. He told me that hardly a day passed that he failed to sell a print to a person who'd never before collected art.

In contrast to *Another Day*, we acquired a WPA print from Sylvan that reflects a Depression-era optimism. In John Langley Howard's *The Union Meeting* (1936, Fig. 2) nobody's smiling or laughing, but there's a determina-

tion and confidence in the faces and postures of the union members. The New Deal brought new laws enhancing the power of labor unions, and Howard's protagonists show a sense of purpose, unlike the attitude of the abused laborers in Vogel's *Another Day*. Howard lived and worked in San Francisco, which had a very active WPA/FAP graphic workshop. He was also a muralist, and his work is included in that monument to WPA murals, San Francisco's Coit Tower.

The financing for the tower came from the estate of Lillie Coit, an eccentric heiress whose passion included chasing fire trucks and watching fires. Soon after the tower—reminiscent of a fire-hose nozzle, no less—was completed in 1933, the building's vast interior wall space became the pilot project of the PWAP (the WPA/FAP precursor). As the artists got underway, news arrived that John D. Rockefeller had destroyed Diego Rivera's mural in Rockefeller Center because it contained a portrait of Lenin. This enraged the mostly left-leaning artists, and many of the Coit Tower murals involve images of social protest and anti-capitalism. John Langley Howard not only painted one, a labor march, but he's also pictured in another, seated in a library reaching for a copy of Karl Marx's *Das Kapital*.

Florence Kent Hunter's *Decorations for Home Relief Bureau* (ca. 1938–1939, Fig. 3) combines protest and praise. The eye is immediately drawn to the exhausted woman in the dark circle at lower left; the Depression was as hard on homemakers as it was on wage earners. In the upper left, women approach the relief agency with hands outstretched, and on the right, women volunteer to participate. Hunter portrays all this with distorted figures—reminiscent of the Mannerists of the sixteenth century—and a dream-like quality. The print may have been a design for a mural, since Hunter had been involved in a WPA project to create artwork for the New York City subway stations. Like many murals, *Decorations for Home Relief Bureau* tells a story by taking the viewer's focus around the image clockwise from the exhausted woman in her kitchen. Florence Kent Hunter helped organize the Artists' Union in the 1930s, and her work contains references to her Jewish heritage, social issues, and concern about the environment. Married to a WPA artist, Hunter got around WPA regulations prohibiting a married couple from working in the same WPA project by signing her prints Florence Kent, or F. Kent.

I continued to acquire WPA prints, and other collectors followed suit. As with all markets, increased demand resulted in increased prices, and the

Fig. 2. John Langley Howard, *The Union Meeting*, 1936. Lithograph, 10 x 14.2 in.

Fig. 3. Florence Kent Hunter, *Decorations for Home Relief Bureau*, ca. 1938-9. Lithograph, 13.4 x 19.7 in.

latter increased supply. I usually got first choice from dealers, since I was ready to pay the asking price, with no negotiating. Cost was a consideration, but a lesser one, as our motivations were not financial: we were not buying art for an investment.

Dealers dug WPA prints out of storerooms and from the bottom of flat files. By the late 1980s, we owned several hundred prints with some version of WPA/FAP stamped on the lower margin. (Nearly all prints made under the WPA auspices are stamped in the bottom margin, "WPA/FAP." Some include a location where the print was made, such as "New York City WPA Art Project.") This very specialized collection within our collection grew to be what was probably the largest in the country, outranking any museum.

In 1990, everyone collecting WPA art found themselves with their hearts in their throats for several months. It began at an auction at Sotheby's that included WPA prints, which Sylvan Cole attended. As Sylvan told the story, a total stranger stood up in the audience just as the auctioneer announced the first WPA print. "This sale must stop," he declared. "I represent the General Accounting Office, and you are selling property belonging to the U.S. government." Sylvan reported that nobody knew what to do, including Sotheby's. He had planned to bid, but not in those circumstances, and it was clear that no one else would either. Sotheby's wisely withdrew all the WPA prints from the sale.

The Fed intervener was technically correct: all the prints and other art objects made by artists employed by the WPA were technically owned by the government, although in the case of prints, artists were usually allowed to keep a few impressions for themselves. The WPA art was—theoretically—to be distributed to museums, libraries, and schools as soon as it was produced. But forty or fifty years later, this provenance was ignored by dealers and collectors on the grounds that the government (and many recipients) took abominable care of the objects at best, and at worst, discarded them. A favorite tale is of a Jackson Pollock oil-on-canvas wrapped around a steam pipe in lieu of insulation in a government building. But just the same, the GAO intervention at Sotheby's gave Sylvan—and us—pause. Could the government claim our collection? Would a federal agent strip everything from our walls? For a brief period, the market for WPA prints froze. But because of a twist of fate, nothing came of it. Before it went very far, the GAO employee who had stopped the auction sale died, bringing an end to the bizarre episode.

As we learned more about the WPA Federal Arts Project, we began to
see the gaps in its history. The WPA closed down in 1942–43, after America
entered World War II, and because the Federal Art Project ended abruptly, re-
cords and undistributed art were hurriedly shipped to Washington headquar-
ters and certain art institutions. The complete story of the printmaking side
of the FAP has never been told, due in part to uncatalogued art and scattered
correspondence and records. This led to confusion about the number, loca-
tions, and output of FAP print workshops. Besides these workshops, there
were also clusters of printmaking artists around the country who worked for
the WPA/FAP, and records from these activities are also incomplete.

Reba and I planned to write a full history of WPA prints. To this end,
we financed the cataloging of WPA print collections at several museums,
including the Newark Museum, the Gibbes in Charleston, and the Balti-
more Museum of Art. Strangely, and this was by no means the only time we
encountered what we considered inexplicable behavior by nonprofit insti-
tutions, the New York Public Library turned down our offer of a grant. This
was most unfortunate: the NYPL probably has one of the larger collections
of WPA prints, and, as far as I know, it has never been catalogued.

We also engaged Francis V. O'Connor, America's leading expert on WPA
art, especially prints, to delve deeper into the WPA records. Francis has writ-
ten extensively about WPA art and is well acquainted with where the WPA
bodies are buried. He and art historian and writer Avis Berman spent two
weeks in Washington at the National Archives and the Archives of Ameri-
can Art, exhuming WPA-era clipping files and fifty-year-old documents. A
footnote in their preliminary report provides a telling account of the prob-
lems facing a WPA archeologist.

> . . . it was not possible to find everything we sought. The primary reason
> for this is the fact that the [National Archives] has recently completely
> re-numbered and (often erroneously) re-labeled the WPA/FAP records
> without maintaining, over the vigorous objections of its own Reference
> Department, any concordance to the old system thus discarded. The
> result is the unfortunate circumstance that many records are lost for the
> nonce, until the reference archivists can create concordance after the
> fact. This process has been delayed by the fact that the boxes are not yet
> permanently shelved. Thus many of the state reports have been mis-
> placed, though their existence is clearly indicated by many references to
> them in other materials.[5]

Despite the disclaimer, Francis and Avis discovered new material and were able to penetrate some of the fog obscuring WPA-printmaking history. They were also optimistic about finding some answers Reba wanted, such as whether there were discernible stylistic differences in the prints coming from the workshops located in different parts of the country.

About this same time, the late 1990s, we were approached by the National Gallery of Art to mount an exhibition from our collection. We thought Washington, D.C., would be the perfect venue for our WPA prints, to be accompanied by a catalogue with the definitive story on WPA print-making, written with the very considerable help of O'Connor and Berman. But the National Gallery had other ideas. They wanted an exhibition based on the "highlights" of our collection, which would be predominately the best-known prints by the best-known artists. This had little intellectual appeal for either of us, for we could hardly add any new insight to works that had already been thoroughly researched and documented.

There was also another issue. I was soon to retire from Alliance Capital, which meant our print collection would move out of company headquarters at 1345 Sixth Avenue. We were uncertain about the future of the collection. We might even consider selling all or part of it. Putting our most valuable prints on show at the nation's museum, then turning around and selling them, was for us unthinkable. We declined.

The WPA print exhibition idea went nowhere. The O'Connor–Berman research was suspended just as it was getting started. This stillborn project remains a great opportunity for a collector, a museum, and/or an art historian willing to explore the still-unresolved history of WPA prints.

Like our intended exhibition on WPA prints, the WPA fizzled out. The run-up to World War II saved the American economy, providing a genuine stimulus to productivity, employment, and wealth creation. Rockwell Kent captured these events in a series of advertisements he illustrated with lithographs for the United States Pipe and Foundry Company. *The Big Inch* (Fig. 4), published in 1941 just before the U.S. entry into the war, is a prime example. U.S. Pipe supplied the steel pipe for the Big Inch, a so-named pipeline connecting the oil fields of Texas and Louisiana with the refineries on the East Coast. The Big Inch and similar pipelines were a lifesaver, as tanker ships proved very vulnerable to Nazi submarines, and both it and its siblings are still in use today, moving natural gas from the Gulf Coast to the Northeast.

Fig. 4. Rockwell Kent, *The Big Inch*, 1941. Lithograph, 8.9 x 12.4 in.

Kent's *Big Inch* is a bit more than just laying pipe across a river or lake. Like his personality—and more about him in a later chapter—something is a little strange about the image. The diver resembles an alien creature emerging from the depths, almost threatening the two workers swinging an enormous section of pipe hanging above them. Leave it to Rockwell Kent to add a weird element to a conventional scene.

So marked the end of the WPA.

Fig. 1. Ralston Crawford, *Overseas Highway*, 1950. Screenprint, 10 x 15.7 in.

The Resurrection of the Screenprint

My interest in WPA prints led me to screenprints, which were a common product of many Federal Art Project artists. Screenprints, also known as silkscreens or serigraphs, were a scorned segment of American printmaking until Andy Warhol and Jasper Johns began to utilize and popularize the technique in the 1960s. Although it was a departure from one of our collecting guidelines—screenprints were made in color, not black and white—perhaps my investor instincts persuaded me to go against the tide of popular opinion or, in this case, art orthodoxy, and begin buying screenprints of the 1930s and 1940s.

Indeed, *color* was the primary reason for their evolution in American printmaking. Prior to the emergence of lithographic print shops in the 1960s, there were no fine-art color lithographers in this country after the 1890s poster craze petered out early in the new century. At the same time, printers were learning to transfer photographs—in color—onto lithographic plates, eliminating the need for artists to create original color images. Also, screenprint, a cheaper medium, came into use for advertising posters and displays, further undermining the need for artistic-quality color lithographs. Lithographic print shops specializing in color went out of business, and color lithography as an art form virtually disappeared. As early as 1915, black-and-white lithography became the prime medium for George Bellows and other leading American artists. But the printers who produced beautifully toned black-and-white lithographs never managed to print color of equal quality, and artists tended to stick with black and white.

Reba and I and half a dozen other students attended an evening course, "Understanding Prints," taught by Colta Ives, assistant curator of prints at the Metropolitan Museum of Art. The course went forward from the early history of Western printmaking—from Albrecht Dürer in the late fifteenth

century to Edgar Degas in the late nineteenth century, all European artists. Although the class provided important background, our collecting interests were centered on twentieth-century American, and I was not eager to devote time and energy to a topic in which I had only a passing interest. One evening, sitting at a table in the museum's print room, Colta announced our assignment: write an original research paper on one or more of the prints by one of the artists we'd studied during the semester. I made a special request. Could I do my research paper on the early history of the screenprint? Colta reluctantly agreed, but she was clearly intrigued. As far as we knew, screenprinting as an art form had disappeared with the closure of the WPA in 1943. Subsequently, few screenprints had been made and little had been written about the process until the 1960s, when critics and art historians began to write about Pop Art.

Part of this unpopularity stemmed from the commercial use of the process, which started early in the twentieth century. For example, the earliest commercial screenprint we discovered was an advertising poster for a steamship line, in the collection of the Philadelphia Museum of Art, dated by the museum curator as circa 1916. The commercial association confused collectors, and confusion turned to rejection when screenprints were also utilized to reproduce paintings. Craftsmen learned to photograph a painting, transfer the image and colors onto screens, and print a painting—many copies of a painting. Such a "print" was not an original print, because the artist was not involved in making what was a mechanical copy of a painting. Screenprints became synonymous with reproductions, of no interest to serious collectors.

Artists ignored the screenprint for other reasons. While screenprinted images were brighter and fresher than what printers could achieve with color lithography, the resulting product was less durable. Frequently, the ink or paint would crack or flake off the paper. In lithography, the ink is forced into the paper under great pressure, and is therefore less likely to rub off or be marred. Many screenprints did not survive, and collectors were wary, asking themselves whether or not a print would last. In addition, the earliest artistic screenprints—the first one is thought to have been made in 1932— were typically poorly drawn and with unfortunate color combinations. The unenthusiastic reception for much of this work is not surprising. But artists learned from their mistakes, and persisted.

Screenprinting became a favorite of many artists during the Great Depression, because the required materials were cheap, no press was needed, and it produced color images. Artists could make screenprints in their garages or on the kitchen table: A piece of paper was laid on a flat surface. A screen (sometimes a stocking, perhaps silk but more likely rayon, given the poverty of most artists) was attached to a wood frame and laid over the paper. Areas not to be printed were "stopped out" on the screen with glue. The rest of the screen was covered with ink of the desired color, and a squeegee was passed over the screen, forcing the ink onto the paper. A different screen was needed for each color.

In its simplest form, screenprint produces a flat, unmodulated field of color, but artists learned to put color on top of color to achieve tonal effects and gradations of color. With screenprint, American printmaking artists finally had access to color. But the result could be a crude, rough image with overlapping colors, or, if a ruler and careful measurements were utilized, a very precise, hard-edged image.

Our favorite screenprints were the hard-edged images, because they had a more polished appearance. Perhaps the most famous of this style is *Overseas Highway* (1950, Fig. 1) by Ralston Crawford. The Overseas Highway, a much-admired accomplishment of the WPA, is a series of bridges and roads linking mainland Florida to the Keys. The hurricane of 1935 had destroyed the rail connection between them, leaving ferries the only means of transportation, and tourism had suffered. The Overseas Highway replaced the ferries, reviving Key West as a tourist destination. Crawford had painted the highway at its opening in 1938, and then twelve years later made a similar screenprint, possibly at the urging of a print publisher. Crawford's depiction is a study in depth perception and perspective. An empty, straight bridge road, with pale blue skies above and a dark blue sea below, disappears to a point in the distance. The highway is wide open, the weather fair—a cheerful and optimistic view celebrating a technical achievement.

In the mid-1930s, artists specializing in the medium, among them Harry Sternberg, one of the most successful screenprinters, searched for a means to promote their work. Sternberg's colorful *Riveter* (1935, Fig. 2), showing a worker balanced on an iron beam high over New York City using a heavy pneumatic rivet gun with an air hose curling around his legs, is a fascinating example of the crude technique. The irregular outlines of the forms and the

Fig. 2. Harry Sternberg, *Riveter*, 1935. Screenprint, 11 x 11.4 in. (tondo).

vivid colors create tension and excitement, emphasizing the danger to the riveter. We tracked down Sternberg—we owned several of his prints, thanks to a dealer—and he told us how a new name for screenprint came about:

> We took our marketing problem to Carl Zigrosser [director of the Weyhe Gallery], who was very interested in prints. A group of us sat around with him one evening, talking over the problem. Zigrosser finally said that the problem was the name—we had to have a new name, to distinguish art screenprints from commercial. We asked, "What name?" He said, "Give me a day, and I'll get a name for you." Sure enough, next day, he came up with "Serigraph," and explained its Latin sources (seri, silk and graph, write). That made all the difference. Serigraphs began to get accepted.[1]

But acceptance came slowly, and the new name may not have helped much. A 1940 *Time* magazine article in connection with a screenprint exhibition at Grand Central Art Galleries in New York City described the recent history of the medium and focused on its low cost and low price. *Time*

called serigraph a "flossy name," and noted "one problem they have not yet solved: how to market their product."[2]

A flurry of exhibitions in the early 1940s suggested that interest in screenprints was growing. In 1943, Associated American Artists exhibited 110 screenprints by sixty-one different artists, and at least 240 artists made screenprints in the 1930s and 1940s;[3] there was clearly some kind of market for them. But with the closure of the WPA in 1943, the artistic use of the medium virtually disappeared until Pop artists revitalized it in the 1960s and returned to the use of the generic name, screenprint.

Despite the disdain for these 1930s–1940s screenprints, I plowed ahead with collecting as our admiration for the work grew. When we expressed our interest to dealers, early screenprints, buried for decades in gallery storerooms, began coming to light. Print dealer Mary Ryan was especially helpful to our hunt. Mary had started her gallery, first in Boston, then New York, as a specialist in American prints, with emphasis on pre-1950 work. Our interests meshed, and Mary became our prime supplier of screenprints as well as other types of prints.

Several artists were adept at using screenprint to depict fire. In Harry Sternberg's *Riveter*, the blurry outlines and strong colors do manage to convey a feeling of danger, and can make fire look, well, firey. Elizabeth Olds in her 1945 *Three Alarm Fire* (Fig. 3) depicts a large apartment building with flames pouring out of the top floors. Fire trucks surround the building, firemen climb ladders and haul hoses, and spectators hover nearby. *Three Alarm Fire* is also notable for its size—nearly two feet tall and three feet wide. Early screenprints are usually half that size or smaller, due to the difficulty of stretching a stocking or any porous fabric across a wooden frame.

Ernest Hopf, in *Normandy Fire* (1942, Fig. 4), shows the burning ocean liner *Normandie*, moored to a pier in New York Harbor, capsizing and belching fire and smoke. The French ship had been seized by our government, fearful that the Vichy French government installed by the occupying Germans would use the ship against the Allies. In a nod to "Free French" sensibilities, our government renamed it the *USS Lafayette*, and was converting it to a troop transport when it caught fire and burned in 1942. Since the United States had just entered World War II, sabotage was immediately suspected, but the cause was later determined to be a careless welder. The wreck of the capsized *Normandie* remained in New York Harbor through the

Fig. 3. Elizabeth Olds, *Three Alarm Fire*, 1945. Screenprint, 19.5 x 29.4 in.

Fig. 4. Ernest Hopf, *Normandy Fire*, 1942. Screenprint, 14.1 x 18.1 in.

war years and was eventually sold for scrap. (A footnote to the disaster: The designer of the ship, Vladimir Yourkevitch, was in New York at the time of the fire. Noticing that the fire boats were overloading the ship with water on the port side, he wanted to board the vessel, open its sea cocks to flood the lower decks, and let the ship settle to avoid capsizing. The local harbor police barred him from entering the dock area.)

Many artists in the 1930s were Socialists, and some were even proud members of the Communist Party. It was no coincidence that artists with these political persuasions were attracted to screenprint. After all, it was an economical medium, and the technique was available to all, resulting in low prices for prints. Screenprint was an art medium for the people, perfect for their brand of politics and art.

Anton Refregier was an unabashed Communist. Hired by the WPA to paint a mural on the history of California in the Rincon Annex Post Office in San Francisco, he produced, to their surprise, a radical protest against the forces of capitalism. The mural project was interrupted by World War II, and after the war, right-wing politicians in Washington tried unsuccessfully to abrogate the contract with the artist. After Refregier finished the mural, he made screenprints of several of its scenes. *San Francisco '34 Waterfront Strike* (1949, Fig. 5) shows a union organizer rallying workers to strike, while a thug, hired by the bosses, pays off scabs to keep the port operating. The military and the flag are sardonic symbols, suggesting the government's

Fig. 5. Anton Refregier, *San Francisco '34 Waterfront Strike*, 1949. Screenprint, 11.2 x 22.2 in.

THE RESURRECTION OF THE SCREENPRINT

Fig. 6. Hugo Gellert, *Winning the Battle of Production*, 1943. Screenprint, 15.3 x 13.1 in.

message is "Break the strike and keep the ships moving!"

Hugo Gellert, also an outspoken Communist, took up the American cause when Russia joined the fight against the Nazis. In 1943, Gellert produced a portfolio of nineteen screenprints, *Century of the Common Man*. Most of the images extolled the war effort—some take jabs at greedy capitalists—and all are done Soviet-style, with larger-than-life smiling workers, as in *Winning the Battle of Production* (Fig. 6). In 1967, at the height of the Cold War, Gellert was among the few American artists to be given a retrospective exhibition in the Soviet Union, at the Marx-Lenin Institute in Moscow.

Ben Shahn's screenprint *Prenatal Clinic* (1941, Fig. 7) pictures two preg-

nant women in a hospital waiting room. A poster on the wall reads "Do I Deserve Prenatal Care?"—an early plea for universal health insurance. In other screenprints, Shahn lampooned 1940s business leaders and politicians, and his renderings of Republican bigwigs Thomas Dewey and Robert Taft are unvarnished portraits of evil. Shahn inherited his socialist leanings from his Russian father, who was sent to Siberia for revolutionary activities but escaped to flee to America, where his family soon joined him. I found

Fig. 7. Ben Shahn, *Prenatal Clinic*, 1941. Screenprint, 14.4 x 21.7 in.

these politically motivated images—referred to as "socially conscious" by writers at the time—fascinating as history as well as art. Thanks to the accessibility—both economical and technical—of screenprint, artists were able to picture the world as they saw it and broadcast their views graphically. It was the most immediate of mediums.

Jackson Pollock, who made very few prints, experimented with screenprint. Like most Abstract Expressionist artists, he preferred to work in oil paint (or automotive exterior paint) on canvas—the famous "drip" paintings. The more appropriate terms might have been splashed or poured, as Pollock literally threw paint out of a can onto canvas laid on the floor—and this ap-

proach, energetic and exciting, was obviously impossible for any print media. But he made three screenprints, using different colors in each and over-painting each with India ink and white gouache. The results were impressive. The prints, tiny in comparison to his huge canvases, were representative of his mature style, with swirls and blobs and what appear to be splashes.

Of the three prints, one, which I had seen and coveted, was owned by the Museum of Modern Art in New York. A second had been given to a Pollock family member years ago, and was presumably lost. But I learned from Pollock's nephew, art dealer Jason McCoy, that the third was owned by Jackson's older brother Charles, also an artist, who lived in Paris.

Soon after McCoy told me about the third print, I was in Paris on business. I went a day early to meet with Charles, the appointment arranged by McCoy. About nine o'clock on a Sunday morning in May, 1987, I knocked on the door of Charles's first-floor flat in a shabby building on the—naturally—Left Bank. The eighty-four-year old, hale and hearty, greeted me warmly and welcomed me into his studio apartment—couch, bed, table and chairs, and easel all in one room. Charles graciously offered me a glass of red wine, which I accepted despite the early hour.

He knew I was there to look at this last remaining Pollock screenprint in private hands. Even if he would not sell it to me, I wanted his permission to get it photographed so it could be included in an article Reba was writing about Jackson Pollock's prints for the magazine *Print Quarterly*.

Charles produced the very colorful print, and like the MoMA impression, it was very much in Jackson's mature style. We talked about when and where the print had been made, but Charles's memory failed him. He confused years, addresses, and fellow artists. Nothing conclusive emerged. But he did know how Jackson had applied the white gouache to the screenprint. He dipped a tooth brush into the liquid gouache and flicked the paint onto the print. A new form of drip painting!

Charles offered me a second glass of wine, and in pouring it, two drops of red fell into the margin of the print. *Sacrebleu!* A valuable art object, damaged! Charles looked distressed, so I took a handkerchief out of my pocket, and dabbed at the drops—but two red stains remained. I pretended to be unperturbed. Charles did not want to sell the print—yet—saying he'd have to confer with Jason McCoy. So I left empty-handed, but with the agreement to get a photograph.

Back in New York, I told the story of the red wine to Jason McCoy, who was not amused. I told Jason I'd like to buy the screenprint, if it ever came on the market.

But this fish got away. Jason sold it, but not to me. He didn't even offer it. Perhaps he suspected I'd want to negotiate a lower price, based on the wine damage. I would have probably paid whatever he asked, but I never got the chance.

A few years after he made the three colorful screenprints, Pollock produced a portfolio of screenprints based on his black "drip" paintings. Jackson's half-brother Sanford McCoy, a commercial photographer, took pictures of the paintings, transferred the images to screens, and printed a portfolio of six images in editions of twenty-five each.

The black-and-white abstract images did not sell well at Pollock's dealer, the Betty Parsons Gallery, and the unsold items were returned to the artist, many still unsigned. Over the years Pollock gave away or sold impressions, frequently mis-numbering them, or noting an incorrect edition size. By strict definitions, these are reproductions of paintings, not original prints, but by the 1980s, thirty-plus years after he made them, Pollock's art of all types was in great demand. Many collectors, including us, ignored the original print issue and snapped up the screenprints.

LATER SCREENPRINTS: 1950S TO POP

Screenprint was perfect for the artists of the Op Art movement of the 1950s. The distinguishing feature of Op—short for optical—is brilliant colors presented in a variety of precise, geometrical shapes, so that the image appears to dance, or vibrate. This style originated in France, and its most famous practitioner was Victor Vasarely. We located Vasarely's printer, Wilfredo Arcay, in Paris, and called him to learn more about how the prints were made.

Arcay astonished us by beginning, "We can make a plate [screen] by phone."

"What? How?" I asked, startled.

"Victor tells me the colors and shapes he wants, and I know his work so well, I make the selections."

We couldn't believe what we heard. Talk about non-original prints! Reba asked, "Does he see the print before it's editioned?"

"Sometimes, and he sometimes makes changes," Arcay said. "We work

Fig. 8. Will Barnet, *Woman Reading*, 1970. Screenprint, 36 x 27 in.

together very well. Then I print the plate."

"Who signs the prints?"

"Oh, I ship them to him, and he signs them and sends them on to his dealers."

We were too polite to comment, but we were appalled. Original prints? A total violation of the definition of "original print." Thanks to the likes of the Vasarely–Arcay approach, which was probably familiar to European print specialists, screenprint continued to struggle for acceptance as an artistic medium.

Will Barnet can be credited with helping revive the screenprint as a true art form. Like the hard-edged *Overseas Highway*, Barnet's mature—final—art style employed atonal color blocks, with well-defined borders. His *Woman Reading* (1970, Fig. 8) is a prime example. Will had helped us with our research on screenprints, and as a reward for us bothering him and taking up his time, the gift went in reverse: Will gave us our impression of *Woman Reading*.

But Andy Warhol deserves the lion's share of credit for legitimizing screenprints. He is thought to be the first of the Pop artists to use the medium, initially in his oil paintings. He turned to screenprinting after first using a rubber stamp to apply a series of repeated images. He said that these works somehow looked too crude and "homemade," and he wanted something "stronger that gave more of an assembly-line effect."[4]

As he explained,

> . . . with silkscreening, you pick a photograph, blow it up, transfer it in glue to silk, and then roll ink across it so the ink goes through the silk

but not through the glue. That way you get the same image, slightly different each time. It was so simple—quick and chancy. I was thrilled with it. My first experiments with screens were heads of Troy Donahue and Warren Beatty, and then when Marilyn Monroe happened to die that month, I got the idea to make screens of her beautiful face—the first Marilyn.[5]

He made the first of the screenprinted "Marilyn" *paintings* in 1962. The next year, Warhol produced his first editioned screen*prints*, but it was not until 1967 that he made the famous *Marilyn* portfolio of ten screenprints, each in a different color combination, in an edition of 250. Art critic Roberta Bernstein describes the *Marilyn*s as utilizing

> . . . a wide range of colors (black to day-glo chartreuse) and off-register printing to show an even greater number of variations. . . Marilyn's face is presented as an impenetrable mask . . . in the tradition of a certain style of official society portraiture, they show what the public wants or needs to project onto people who become symbols: people whose "faces seem perpetually illuminated by the afterimage of a flashbulb."[6]

We did not buy the portfolio. By the mid-1980s, when our collecting was in high gear, the *Marilyn* portfolio was selling for around $25,000. We thought it too expensive, particularly given the huge edition size. Little did we understand how popular—iconic—the "Marilyns" would become. Today the set would sell for well over a million. We did acquire the black and the pink (*Marilyn* [pink], 1967, Fig. 9) individual prints, gritting our teeth and paying the piper.

Among the other screenprints produced by Pop artists, one of my favorites is Ed Ruscha's *Standard Station* (red) of 1966 (Fig. 10). It's a minimalist,

Fig. 9. Andy Warhol, *Marilyn (pink)*, 1967. Screenprint, 36 x 36 in.

pristine view of a Southern California gasoline station—one that certainly never looked quite so perfect and spotless in real life. Ruscha grew up in Oklahoma City, but moved to Los Angeles in 1956 after he graduated from

Fig. 10. Edward Ruscha, *Standard Station* (red), 1966. Screenprint, 19.5 x 36.7 in.

high school to study to become a commercial artist. He soon switched to fine art, specializing in views of L.A. Besides his *Standard Station* prints (there are four others in different colors), he made prints of the dilapidated Hollywood sign and published illustrated paperback books with titles such as *Some Los Angeles Apartments* and *Twentysix Gasoline Stations*. The photographs are deliberately amateurish, hardly appropriate for a tourist brochure extolling the beauty of the City of Angels.

The modern master of the screenprint is Jasper Johns. His approach to the medium is meticulous, as is all his work—the antithesis of Warhol's deliberate crudeness and unmodulated colors. Through the use of many screens and many color variations, Johns succeeds in creating a "painterly" screenprint. His *Target* (1974, Fig. 11) has the look of oil on canvas, with tones and nuances of color variations throughout the work, quite miraculously creating the illusion of a third dimension on a flat piece of paper.

The culmination of my research paper on screenprints for Colta Ives's class was a binge of buying, the publication of two articles written with Reba for *Print Quarterly*, and a traveling exhibition titled *American Screenprints*. The exhibition, which we curated, was the first from our collection. It opened at the National Academy of Design in New York City in 1987 and was subsequently shown in twenty-two museums in the United States,

Europe, and Japan. The front and back covers of the catalogue featured Warhol's (pink) *Marilyn* and Harry Sternberg's *Riveter*; illustration number one was *Target* by Jasper Johns. Colta got more than she bargained for, and so did we!

Because we were the first collectors to take early screenprints seriously and do the necessary research, we fulfilled David Tunick's prediction that anyone could become an expert on American prints with just a few hours of effort. We put considerably more than a few hours into screenprints—weeks, if not months—but it's fair to claim we did become *the* experts. We also changed perceptions about early screenprints, rescuing them from the art orphanage and reviving them as sought-after collectibles.

Fig. 11. Jasper Johns, *Target*, 1974. Screenprint, 30.7 x 25.6 in.

Fig. 1. Stanley William Hayter, *Falling Figure*, 1947. Etching, engraving, and screenprint, 17.7 x 14.9 in.

The American Century in Prints:
Famine to Feast

1940S—1960S

"Prints almost totally disappeared. In the late 1940s, there was almost no interest in prints anymore," print dealer Brooke Alexander said in a 2008 interview. Brooke should know. He's had his own gallery for forty years, publishing and selling post-World War II prints and multiples. After attending Yale, Brooke returned to his native Los Angeles and joined the city's art world, meeting artists like Ed Ruscha, who would soon emerge as one of the Pop generation's most successful printmakers. Crossing back to New York in 1965 to manage Marlborough Gallery's print inventory, he opened his successful gallery and print publishing enterprise a few years later.

FAMINE: SURREALISM AND ABSTRACTION

Despite what Brooke said, there was a flicker of interest in print *making*, if not print *buying*, in the 1940s. When World War II broke out, Stanley William Hayter, an Englishman descended from a family of painters, one of whom tutored Queen Victoria, departed his Atelier 17 in Paris and eventually reopened it in New York under the same name. The new Atelier 17 had the identical purpose as the earlier one: an experimental printmaking workshop focusing on Surrealism, emphasizing spontaneous or "automatic" drawing and painting based on dreams and the subconscious. Hayter believed in letting the subconscious control the image, and he encouraged artists to go into a state of self-hypnosis, allowing the hand, pencil, or etching needle find its own path. A less extreme version was to rely on imagination, or dreams, to create images.

Atelier 17, both the Paris and New York versions, was not a commercial fine art print shop, although some artists working there, including Hayter, editioned some of their prints and sold them. Rather, Atelier 17 existed to provide a place for printmaking artists to experiment and learn from each other—and from Hayter.

Hayter's *Falling Figure* (1947, Fig. 1) is an example of Atelier 17 style. The image is an abstraction of a nude woman, identifiable by her breast, falling backwards. With mouth open, teeth bared, and two wide-open eyes staring out at the viewer, it is a picture of fear, a suitable subject for Surrealism, and vividly expressed through Hayter's complicated printmaking technique.

Hayter made *Falling Figure* by first etching and engraving a copper plate, then inking the plate and wiping it so that black ink remained only in the cut grooves. He then screenprinted several different colors directly onto the copper plate, rather than onto paper. Applying the inked and screenprinted plate onto paper, he then pulled the finished print. All of this added up to an innovative, but delicate, operation. Officially *Falling Figure* is an edition of fifty, but I'm dubious there were that many, given the printing difficulties. Although Hayter was not an American and most of his career was based in Paris, we collected his work, at least the prints he made in New York. His influence in America was substantial, especially on the painters who were soon to establish a new school of American art.

Jackson Pollock worked at Atelier 17 in 1944–45 and engraved eleven plates, though he made only a few trial proof impressions. (Some twenty years later, nine of the plates were found and seven were editioned by Pollock's wife, Lee Krasner, in a collaboration with the Museum of Modern Art.) As with his screenprint experiments, Pollock did not find printmaking compatible with his art; he required large volumes of paint and the big format of canvas. However, Pollock did absorb Hayter's emphasis on spontaneity, the subconscious, and automatism, and his painting style reflects his teacher's influence.

Thus was born Abstract Expressionism, the dominant art style of the 1940s and 1950s, with Pollock its most prominent practitioner. The term "Expressionism" was first applied to European artists working early in the twentieth century who were noted for heightened colors and exaggerated images, expressing emotion rather than representing objective reality, but still generally using recognizable figures. Critics added the word "Abstract" to the later style to reflect the absence of representation. Abstract Expressionist artists were grouped together not because their pictures looked alike, but because their art was usually abstract, reflecting their personal feelings. Their popularity with critics and collectors led to the so-called New York School, and during these decades New York displaced Paris as the capital of the art world.

Abstract Expressionism is why Brooke Alexander said printmaking essentially disappeared in the 1940s and 50s. Like Pollock, most Abstract Expressionist artists preferred painting to printmaking. They found it hard to be spontaneous while making a print because so much process is involved, and in any case, the new style was incompatible with the restricted size of a copper plate or lithographic stone. Oil on canvas also offered depth; piling oil paint on top of oil paint adds a third dimension, almost impossible in most print media. The new school of art attracted critics and collectors, and its leading practitioners—the household-name artists—made few prints. Lesser-name artists did make prints, but their work got little attention.

An example was Albert Urban, who was born in Frankfurt, Germany, studied art there, and was building a successful career as an abstract painter until his work ran afoul of the Nazi art police. Several of his paintings were confiscated and displayed in the infamous *Degenerate Art* exhibit in Munich in 1937, which the Nazis staged to scorn and ridicule all types of modern art. Luckily for Urban, he was expelled from Germany, spent a year in London, and came to the United States in 1940. He continued painting, while his wife used screenprint in a commercial venture to reproduce famous paintings.

Urban's screenprints, similar in style to his abstract paintings, are among the earliest abstract color prints made in America, albeit with sometimes recognizable images. *Minnesong* (1944, Fig. 2) takes its title from the German word

Fig. 2. Albert Urban, *Minnesong*, 1944. Screenprint, 7.2 x 11.3 in.

for "love song," and refers to minnesingers, medieval troubadours. The leaning figure in the image at the right is a wandering minstrel, holding his golden lyre. A Romanesque church, probably St. Peter's, is in the background. Surely it is Tannhäuser, the protagonist in the Wagner opera of that same name, returning from his pilgrimage to Rome to seek absolution from the Pope.

Urban's art soon turned to total abstraction, containing no human or identifiable forms. He continued to paint and make screenprints in an Abstract Expressionist style, until he was killed in an automobile accident in 1959, three years after Jackson Pollock met a similar fate.

Well before Abstract Expressionism became the new religion, a group of artists banded together long enough in the 1930s to call themselves the American Abstract Artists, and to mount an exhibit of their work in 1937 at New York's Squibb Galleries. Thirty-nine artists signed up to make a black-and-white lithograph for the exhibit, all of which were to be published in a portfolio. As it turned out, only thirty of the thirty-nine managed to finish their prints. The exhibit received almost no notice, though at the time there was collector interest in prints—just not abstract prints. Few of the portfolios survive. As collectors, we tended to love the unloved, and the American Abstract Artists portfolio fit that category. We were lucky that dealer Martin Diamond had a copy we could acquire.

A similar venture in abstract art was undertaken in 1948 in California: a portfolio of sixteen prints titled *Drawings*. It, too, was a commercial failure, and some would say aesthetic failure, despite the inclusion of leading young artists like Richard Diebenkorn and John Hultberg. The edition was intended to be one hundred; fewer than fifty were made. Even fewer survived. Our friends at Annex Galleries in Santa Rosa found one of the portfolios for us, another victim of a general lack of interest in abstract prints.

Hayter and Atelier 17 returned to Paris in 1950, and, as Brooke Alexander said, prints—or at least the market for prints—almost disappeared. However, a few dedicated Abstract Expressionist painters at least continued to try. Hans Hofmann's early interest in physics led to an interest in light and color, and then to art school in his native Germany. Hofmann subsequently established his own art school in Munich, but after a 1930 visit to California to teach at Berkeley, he permanently moved to New York in 1932, set up the Hans Hofmann School of Fine Arts, and became a U.S. citizen. His paintings, and his philosophy, were anti-representational—only abstract forms—and all about color.

In 1952, one of his students, Esther Gentle, who was starting a business making screenprints of paintings by well-known artists, persuaded Hofmann to make a screenprint. However, *Composition in Blue* (1952, Fig. 3) is in no way a reproduced painting, though its arrangement of forms of color is typical of Hofmann's style. According to David Acton, "Using a brush loaded with lithographic [paint], Hofmann drew directly on two printing screens, improvising the design. During the printing, he varied the application of the ink, alternating rich saturated lines and dry scumbled areas, apparently to test the resultant effects."[1] Because of Hofmann's experimenting, there are slight variations in the impressions of the print.

Fig. 3. Hans Hofmann, *Composition in Blue*, 1952. Screenprint, 16.8 x 14 in.

As our exploration of screenprinting expanded into the 1950s and we discovered more printmaking activity in those years than we had previously thought, a new idea was born: why not see if we could build a 1950s print collection within our collection and prove that the print world hadn't quite died, but had embraced Abstract Expressionism, with occasionally decent results?

Dealers' inventories held very little of this material. But in 1991, David Acton, curator at the Worcester Art Museum in Massachusetts mounted an exhibition, *A Spectrum of Innovation: Color in American Printmaking 1890–1960*, accompanied by a large color-illustrated catalogue. We traveled to central Massachusetts to see the exhibit and discovered several artists new to us who made interesting, high-quality prints in the 1950s. Michael Ponce de Leon, a direct descendent of the Spanish explorer who discovered Florida, attended art school in his native Mexico, but came to New York for further art study and stayed, working as a master printer. On Fulbright fellowships in 1956 and 1957, he traveled to Norway and visited artist Rolf Nesch, an experimental printmaker who had developed a technique he called collagraph. The collagraph printing plate is a relief sculpture—a metal, cardboard, or

wood sheet to which objects have been welded or glued. Very thick printing paper was necessary to accommodate the unevenness of the printing plate.

In Ponce de Leon's *Legend of the Midnight Sun* (1958, Fig. 4) it appears that a type of sieve, welded to the metal plate, was used to create the half-circle, perhaps the sun. Other forms could be trees or mountains. The print, like others he made in 1958, is a reference to the artist's Norwegian stay, with the long summer days and dense spruce forests of the Far North.

I purchased several Ponce de Leon collagraphs from Boston dealer Lyle Sarnevitz, and when I confided our plan to emphasize 1950s prints, he accepted the challenge with enthusiasm, traveling all over the country, especially the West Coast, visiting artists, art schools, and print shops to find this scarce material. Most of the assembled prints were screenprints, as there were no high-quality color lithographic printers in the country until the 1960s. Virtually all the prints he found were Abstract Expressionist.

Fig. 5. Sylvia Wald, *Between Dimensions*, 1950. Screenprint, 20.2 x 15 in.

Sylvia Wald began her art studies at the age of sixteen and got her start as an artist thanks to a WPA-funded job as an art teacher in New York, enabling her to pursue her representational style of painting. She also learned screenprinting from WPA instructors, producing screenprints similar to her paintings in the 1940s.

Around 1950, however, Wald began to experiment with abstraction in screenprints, demonstrating that Abstract Expressionism and the print medium were not completely at odds. An early example is *Between Dimensions* (1950, Fig. 5), with its biomorphic forms and (possibly) maps of constellations. Many critics and curators consider her to be America's premier Abstract Expressionist printmaker.

Fig. 4. Michael Ponce de Leon, *Legend of the Midnight Sun*, 1958. Collagraph, 20.7 x 13 in.

Our 1950s quest spilled over into the early 1960s, and a group of four black-and-white lithographs made in 1962 became our favorite Abstract Expressionist prints. The artist was Lee Krasner, widow of Jackson Pollock. She made the

Fig. 6. Lee Krasner, *The Civet*, 1962. Lithograph, 18.5 x 28.7 in.

prints by drawing on lithographic stones with black crayon, the old-fashioned way. The images reflect energy and confidence, with rhythmic arcs and swirls. In *The Civet* (Fig. 6) a cat's face emerges in the center of the image—two slanted eyes and two pointed ears, staring out at the viewer from behind what may be a screen of jungle foliage. I suspect Krasner titled the work after she studied the finished product and discovered she'd drawn the feline. Krasner, the artist, was much overshadowed by her famous husband. Reba was determined to bring her out of the shadows, and went on a buying binge, acquiring an impression of all of her prints. She followed this with an article in *Print Quarterly*, which to this day serves as a catalogue raisonné of Krasner's prints.

Our collection of prints from the 1950s piled up. Many of the artists were new to us and required further research. Then, surprise! Our plan was trumped by David Acton and the Worcester Art Museum, with yet another exhibition and a gorgeous, informative catalogue titled *The Stamp of Impulse:*

collection, and with a few loans, David had done the job better than we could have. The exhibition, which opened in 2001, included one hundred prints by one hundred artists, dating from 1942 to 1980, with the largest concentration in the decade of the 1950s. So we ended up with lots of color-ful—and a few black-and-white—abstract prints on the walls of the Alliance Capital offices, but no exhibition or catalogue of 1950s Abstract Expression-ist prints from the collection of Reba and Dave Williams.

REALISM STILL LIVES

Representational art with recognizable images was making a slow come-back in the post-war years. In 1952, Leonard Baskin returned from two years of art study in Europe and became instructor of printmaking at the Worces-ter Art Museum. Baskin's images in prints are deeply pessimistic, if not

Fig. 7. Leonard Baskin, *View of Worcester*, 1953. Wood engraving, 10 x 9 in.

despairing, and his gloomy *View of Worcester* (1953, Fig. 7) is typical. Figures with dour expressions, a woman with slumped shoulders, unattractive dogs and a nondescript town in the background—welcome to Worcester! Dore Ashton, writing about the 1953 American Graphic Artists' exhibition, notes that *View of Worcester* won a prize, and praises it:

> . . . certainly one of the most distinguished prints in the show. Baskin, using a meticulous wood-engraving technique, presents three gnarled figures, their faces cartographically lined, posed against a bleak New England background. Subtle character delineation coupled with an effective design produce an authentic graphic power.[2]

Baskin also made some very large woodcuts, unusual at the time for their size. Most notable are *The Hanged Man* (title is descriptive of the image) and *Hydrogen Man*, a mangled human body referring to the hydrogen bomb and nuclear war. Death is a recurring subject in Baskin's art.

View of Worcester is hardly a glowing tribute to his new home town, but it does exhibit Baskin's extraordinary skill with wood engraving, the most physically demanding of the print processes. In his Foreword to *The Complete Prints of Leonard Baskin*, Alan Fern describes his wood engravings as "strong, wiry, trenchant" and

> . . . a complex interplay of black and white forms. Figures are rendered with a network of lines, suggesting but not describing the web of muscle and nerve beneath the skin, and pulling together the forms of the figures in a tense, dramatic rhythm.[3]

Leonard Baskin may be best remembered for his scholarship and his influence on other artists. Following a short stint at Worcester, he moved to Smith College to continue teaching printmaking, a position he held for twenty years. During this time he founded the Gehenna Press, a publisher of fine books, many illustrated with wood engravings—his own and those of other artists whose work he championed.

A review of a Milton Avery exhibition, titled *Industrial Revelations*, begins as follows:

> Milton Avery may be the most frequently rediscovered artist of the 20th century. In a weird ritual of repetition-compulsion, each generation remembers his greatness, and then promptly forgets all about it.[4]

How true. But not forgotten by this collector. Avery, from his start as an artist in the 1920s until his death forty years later, changed some elements

of his style, but never deviated from representational art. His subjects were
still lifes, portraits, and nature scenes. In his own words,

Fig. 8. Milton Avery, *Three Birds*, 1952. Woodcut, 9.5 x 25 in.

> I like to seize the one sharp instant in Nature, to imprison it by means of
> ordered shapes and space relationships. To this end I eliminate and sim-
> plify, leaving apparently nothing but color and pattern. I am not seeking
> pure abstraction; rather, the purity and essence of the idea expressed in
> its simplest form.[5]

In *Three Birds* (1952, Fig. 8), Avery has seized an instant of seabirds in
flight, and presented them in simple form. Seabirds skimming above water
is a familiar sight to me, from fishing on the Texas Gulf Coast in childhood;
from the bridge of a U.S. Navy ship: Ascension Island to Newfoundland,
to the North Sea and the Straits of Gibraltar; to fly fishing on Block Island
Sound, where I chase after birds leading me—hopefully—to a school of feed-
ing striped bass. Avery's stylized and slightly comical seabirds are a remind-
er of a recurring presence in my life.

A figurative image appears in an early work by Ellsworth Kelly, a stu-
dent in Paris when he made his first print, which print dealer Susan Shee-
han sold us: *Untitled (Music Stand* or *Portrait)* (1949, Fig. 9). The lithograph
is a simple line drawing similar in style to Kelly's later images of plants, the
few straight lines appearing to form a stand for sheet music, but there's a
black dot that doesn't quite fit in.

We were later to learn that Kelly had a different conception of his first
print. We were invited to dinner by Tom Krens, then head of the Guggen-
heim Museum. As might be expected, his downtown apartment was filled

with modern paintings, drawings, and prints, and on this occasion Ellsworth Kelly was among the guests. I was seated next to him and quite innocently offered, "Mr. Kelly, we own what we think is your first print, dated 1949, maybe titled *Music Stand*?"

Without hesitating, Kelly replied, "Yes, I made that in Paris, when I was studying under the G.I. Bill." He picked up a place card from the table top, borrowed my pen, and began to sketch. This was forty years later and Kelly had made many, many prints since *Music Stand*, but in seconds, he handed me an exact, miniature version of *Music Stand*. "Your title's wrong. It's not a music stand. It's a portrait. See the eye?" he said.

Fig. 9. Ellsworth Kelly, *Untitled (Music Stand* or *Portrait)*, 1949. Lithograph, 14 x 10.8 in.

"Yes, I wondered about that dot. But a portrait of whom?"

"I'd rather not say. And I never titled the print—it was just a student work, an experiment in printmaking, and I only pulled a few impressions."

"But you remember the image perfectly, how can that be?"

Kelly responded matter-of-factly, without a trace of braggadocio, "I remember every piece of art I ever made, and I've got in my mind what I intend to do over the next couple of years." He laughed, adding, "I confess, I've just been reviewing my catalogue raisonné. But what I said about my memory is true." Kelly's place-card sketch of *Portrait*, *Music Stand*, or *Untitled*—take your choice—resides in our Kelly artist file, complete with a description of the incident.

FEAST AT LAST: POP

The print world was revolutionized and revived around 1960 by two events: the movement known as Pop Art and the establishment of two lithographic workshops for producing fine art prints. The two new lithographic workshops were located on opposite sides of the continent: Universal Limited Art Editions (ULAE) in West Islip, Long Island, New York, and Tamarind Lithography Workshop in Los Angeles. I asked Brooke Alexander to explain,

He began "There was a kind of synergy," and continued:

> The new art [Pop] started to show up in the late '50s, most notably
> that of Bob Rauschenberg and Jasper Johns. It was revolutionary, and
> created a lot of interest and enthusiasm. Looking back, it could be
> seen as an early signal of all the revolutions of the 1960s—the assas-
> sinations, sexual freedom, the Vietnam War protests, the riots in Paris.
> And here's the synergy: about the same time—the early '60s—Tatyana
> [Grosman, founder of ULAE] recruited these same artists to make
> prints, and she and her printers could turn out beautiful lithographs.
> You could own a great Jasper Johns for $100, instead of a few thou-
> sand [for a painting].[6]

Tatyana Grosman was relentless in seeking artists to make prints, and
showing and promoting ULAE prints to curators and gallery owners. The
ULAE website tells the early history:

> Universal Limited Art Editions was born out of one woman's neces-
> sity to make a living and driven by her desire to make a contribution
> to the world. Born in Ekaterinburg, Russia, Tatyana Grosman spent
> almost half of her life fleeing war and revolution that pursued her to
> Japan, Dresden, Paris, and finally New York where she settled in 1943.
> When her husband, Maurice, suffered a severe heart attack in 1955,
> the responsibility fell upon her to support them. She decided that she
> would publish illustrated books, bringing the French tradition of livres
> d'artistes to America. For money, the Grosmans began reproducing
> paintings by artists such as Marc Chagall and Grandma Moses from
> their small cottage on Long Island. However, in 1957, during a visit to
> William Lieberman, then a curator at the Museum of Modern Art, Mrs.
> Grosman learned that although he was impressed by the quality of the
> work, he was not interested in collecting reproductions. He encour-
> aged her to consider collaborating with artists to create original prints.
> By chance, the Grosmans discovered two Bavarian lithographic
> stones in their front yard, a neighbor willing to sell a lithographic
> press, and a local printer ready to demonstrate how to use the press.
> Mrs. Grosman approached a friend at Grove Press, a publisher of
> contemporary poetry, and asked him to suggest a poet that she should
> work with. He suggested Frank O'Hara. She then took the idea to [the
> artist] Larry Rivers, whom she had met in 1950 on a transcontinental
> voyage. O'Hara happened to be visiting Rivers that day and Mrs. Gros-
> man saw it as divine providence. They started a project immediately.

Fig. 10. Larry Rivers, *Ford Chassis I*, 1961. Lithograph, 13.9 x 19.7 in.

"Stones," a thirteen page portfolio/book, took two years to complete and became known as the first ULAE publication. [1959][7]

Larry Rivers became a helpmate, particularly recruiting artists. One of his early ULAE prints is *Ford Chassis I* (1961, Fig. 10), typical of his sketchy, "unfinished" style. The treasurer of Ford Motor Company had an impression of *Ford Chassis I* on his office wall. I knew it well, based on regular visits over many years to Ford's headquarters, to report to Alliance Capital's largest pension fund client. Prudently, I never raised the topic of a second state, *Ford Chassis II,* in which Rivers had added the Hebrew word for "kosher" to the side of the truck, no doubt a reference to his own Jewish heritage and the well-publicized anti-Semitism of the company's founder, Henry Ford.

The Ford truck chassis is not a typical Rivers image. Rather than objects as subjects, Rivers usually appropriated images, such as French franc notes, cigarette package emblems, or illustrated cigar box tops, which he would re-work while retaining much of the original. Printed images must have made strong impressions on Rivers, consciously or subconsciously. A favorite of ours comes from a photograph in a 1959 *Life* magazine story about the death

of the last Civil War veteran. The old soldier was a Confederate, so how could we, as children of the South, not be attracted to the Rivers version? Sufficiently attracted, so that when we stumbled onto an oil study for his large painting of the subject, we bought it. We studied auction sales catalogues of American paintings and visited pre-sales viewings, just to learn, never to buy, except for Study for *The Last Civil War Veteran* (ca. 1970, Fig. 11), which is a rarity—a *painting*—in our collection.

The history of Tamarind is not the up-by-the-bootstraps story of ULAE, but

Fig. 11. Larry Rivers, Study for *The Last Civil War Veteran*, ca. 1970. Mixed media, 12 x 9 in.

it does involve a fairy godmother, The Ford Foundation. June Wayne, a print-making artist, traveled to Paris in the 1950s and marveled at the skill of the lithographic printers there. She knew there was no equivalent in the U.S., and she sought a grant from the Ford Foundation to found Tamarind expressly:

- to create a pool of master artisan-printers in the United States by training apprentices
- to develop a group of American artists of diverse styles into masters of this medium
- to stimulate new markets for the lithograph
- to restore the prestige of lithography by actually creating a collection of extraordinary prints.[8]

The fairy godmother complied, and Tamarind opened its doors in 1960. June Wayne initially sought the services of a master printer from Paris, but unwilling to meet a salary demand settled for Garo Antreasian, who was working as a printer in Indianapolis—a stroke of luck or good judgment. Wayne wrote of Antreasian, "His command of the medium [lithography] is far greater than anyone else I have run into and his color prints are as fine as anything I have seen in France."[9]

Tatyana Grosman also utilized local (U.S.) master printers. Her first was Robert Blackburn (more about him in the next chapter), who had learned the trade in Paris. Blackburn was followed by Zigmund Priede and, eventually, Bill Goldston. ULAE relied on stone for its lithographs, whereas Tamarind returned to the use of metal plates, which led to larger and larger lithographs. Both shops produced color work, which added to collector (and interior-decorator) demand for prints.

New print shops, organized by Tamarind students, quickly formed, and more artists were attracted to lithography. Thanks to ULAE and Tamarind and the popularity of Pop Art, the 1960s print revival was underway.

Today, Pop Art is almost synonymous with Andy Warhol (who worked primarily in screenprint), but the style had many practitioners and imitators. Pop's colorful and recognizable images, without the puzzle of abstraction ("What does it mean?") made the style eminently transferable to printmaking and equally popular with the public. New print shops and professional printers, sired by Tamarind, developed new approaches, such as aluminum plates and handmade paper. Prints grew in size, becoming more colorful and complex, a big change from the small format and black ink on white

paper that had dominated printmaking for five hundred years.

Warhol was far from alone in the Pop genre; three others stand out, each with a different stylistic approach. Roy Lichtenstein's prints are perfect examples of Pop: color, large size, and recognizable images. We collected several, and my favorite—overcome by nostalgia, as I frequently am as a collector—is the 32″ x 57″ *Peace Through Chemistry II* (1970, Fig. 12). The title is DuPont's old slogan, well known to me both as a chemical engineer and as a Wall Street chemical-industry analyst early in my career. The Art Deco style Lichtenstein mimicked is also a throwback to an earlier era, as is the microscope, chemist's test tube, and round-bottom Florence flasks. Much of Lichtenstein's imagery reflects other art styles and incorporates a process formerly used to reproduce photographs in newspapers called BenDay dots.

Lichtenstein's pictures are intentionally simple in construction. He even created a bumper sticker, "Obviate Nuance," that urged the elimination of incomprehensibility in art, and it was among his frequent topics. One evening, we were both in the audience at a MoMA symposium on contemporary art. A speaker analyzed a Lichtenstein, discerning the painter's psychology and purpose in segments of the image, when Lichtenstein spoke up, "Did I *really* mean *that*?" The audience laughed and applauded.

Peace Through Chemistry II, a lithograph, was printed at Gemini G.E.L. in

Fig. 12. Roy Lichtenstein, *Peace Through Chemistry II*, 1970. Lithograph and screenprint, 32 x 57 in.

Fig. 13. Robert Rauschenberg, *Post Rally*, 1965. Lithograph, 44 x 29.6 in.

Los Angeles, a print shop started by graduates of June Wayne's Tamarind. The
master printer at Gemini, Ken Tyler, subsequently moved to Bedford, New
York, and founded Tyler Graphics. Tyler specialized in handmade papers,
colors, and oversized prints, and his Bedford establishment had the most
advanced (and largest) presses and other equipment. It also had apartments
so the artists working with the Tyler Graphics printers had convenient living
space during the days and sometimes weeks required to complete a project.

Robert Rauschenberg combined nuance with the obvious; his litho-
graph, *Post Rally* (1965, Fig. 13) includes both. Many of Rauschenberg's
images have a reportorial aspect, reflecting the world as he sees it. Newspa-
per photos abound. Rauschenberg first learned to transfer newsprint onto
a lithographic stone by soaking the paper in cigarette lighter fluid, though
he used more sophisticated methods in his later prints. *Post Rally* attempts
to capture the turmoil of the times, including President Lyndon Johnson
speaking on TV, undoubtedly about the Vietnam War. Sports imagery adds
excitement and tension. The title and the walking cane are personal refer-
ences: the print was made the day after the artist broke his foot during the
final performance of the First New York Theatre Rally, in which Rauschen-
berg roller-skated while wearing a small parachute; the cane was a gift of St.
Vincent's Hospital, where his broken foot was put in a cast.

Jasper Johns never saw Lichtenstein's bumper sticker, or else chose
to ignore it. His art is anything but simple and direct, and is loaded with
nuance. At a glance, some of Johns's imagery looks like plain everyday
objects—numerals, the target, beer cans, a coat hanger, or the American
flag—but on closer inspection there are deliberate imperfections such as
brush strokes, drips of paint, cracks in paint—whether in oil on canvas or
simulated in screenprint or lithograph. These imperfections pull the viewer
to the image, compel a careful look, and—*voila!*—you actually *see* the com-
monplace object, perhaps for the first time. Some of Johns's images include
a touch of autobiography—an arm, a facial feature, or a handprint.

One of the artist's most famous images is a large four-panel painting
called *The Seasons*. Each panel includes a self-reference, such as a shadow of
himself. Johns also did several versions of *The Seasons* as prints, in etching
and aquatint, both color and black and white. He also made a single small
print of *Summer*, actually *Untitled* (1985, Fig. 14), which is the frontispiece for
a leather-bound book, *Poems*, by Wallace Stevens. Several of Johns's favorite

images can be seen in *Summer*—the artist's arm and shadow, the American flag, crosshatching, a reproduction of *Mona Lisa*, and the target, represented by a 33 rpm vinyl record by his favorite singer. Johns subsequently chopped up the print version of *The Seasons* and rearranged the pieces to form different shapes, such as a cross. Most definitely, these images do not conform to Roy Lichtenstein's admonition "Obviate Nuance."

Fig. 14. Jasper Johns, *Untitled (Summer)*, 1985. Etching and aquatint, 9.5 x 6.2 in.

Alone in a Crowd:
Prints by African Americans

Sam Miller, the museum director, looked around at the many prints on the walls, and asked, "How many of these artists are African Americans?"

It was 1991, and we were in the Newark Museum in Newark, New Jersey, at the opening of an exhibition drawn from our print collection, titled *Graphic Excursions*, featuring 110 prints by 103 artists, all made in the first half of the twentieth century. The exhibition was sponsored and traveled by the American Federation of Arts; we had served as co-curators with the AFA and collaborated with them in preparing the catalogue.

Reba and I exchanged blank stares. Then Reba said, "I don't know, but I'll try to find out."

"If you could put together an exhibition of prints by African American artists, we'd be anxious to show it," Sam said.

Little did we know at the time, but Sam's question and proposal would lead to the most startling and rewarding experience in all our years as print collectors.

We were eager to accept Sam's offer. *Graphic Excursions* had been a less-than-satisfying experience. Initially, we were pleased when the AFA approached us—it would be the fourth museum-circulated exhibition devoted solely to prints from our collection. The imprimatur of the AFA would open doors of museums new to us, and the AFA would handle the dreary logistics of moving the framed prints, obtaining insurance, and handling other administrative matters. However, the AFA wanted to show only the best-known prints by the best-known artists, while we wanted to show great work by lost and forgotten artists, the defining character and pride of our collection—and what was making it unique among private and many public collections. Anyone could collect prints by popular and well-documented artists like Thomas Hart Benton, John Sloan, and Reginald Marsh—and we did—but the

excitement and challenge for us was to find and acquire prints by artists who were not already part of the popular pantheon, and bring their work to light through our exhibitions and published articles. We somewhat unwillingly compromised with the AFA and included the well-known and the less-known. We also vowed not to co-curate in the future, nor to ever let another organization choose which prints from our collection would be shown.

To answer Sam Miller's question, Reba soon found that only one of the artists in *Graphic Excursions*, Sargent Johnson, best known as a sculptor, was African American. His print in the exhibit was *Singing Saints* (1940, Fig. 1), which depicts two robed church choir members singing, one playing a

Fig. 1. Sargent Johnson, *Singing Saints*, 1940. Lithograph, 18 x 11 in.

guitar. The Art Deco-style forms are smooth and simplified, and for no apparent reason, one of the singing saints is wearing a wide-brimmed hat.

A problem immediately arose as Reba tried to create an exhibition: initial research revealed very little information about which artists active in the first half of the twentieth century were African American. The heart of our collection was work done in the 1920s to the 1940s, encompassing the WPA's Federal Art Project. African American artists worked for the WPA/FAP, or took courses in FAP-sponsored workshops, but the WPA did not record the race or ethnic background of its millions of employees, not of laborers, artists, or anyone else.

The WPA/FAP had stimulated interest in printmaking by furnishing its poorly paid (but paid) artist workers with expensive lithographic presses, stones, paper and ink, and, most important, instruction. We surmised that African American artists particularly benefited, as most were too poor to have had much art school education. It seemed logical that many must have gravitated to the WPA/FAP for the learning opportunity, including printmaking.

We discussed the problem with print dealers, and one of them told us about an exhibit at Lehman College in New York City that featured prints by African Americans. With the aid of the phone book and a map, we found the art museum within Lehman College. There in a small room were prints of the 1930s and 1940s by artists we'd never heard of, all African Americans. The work was impressive, the imagery intriguing—mostly about being black during the Depression and World War II. Some prints had the familiar small inked stamp in the bottom left margin, "New York City WPA Art Project." What we were seeking existed, but now the problem was how to find and acquire it. The Lehman College exhibit gave us only the names of a handful, but there must have been more. The several New York dealers we worked with had never seen this particular material or heard of these artists.

Thus began a complicated search: identifying which of the thousands of American artists making prints in the 1930s and 1940s were black. Reba started with the scant existing records, which were frequently wrong. Time after time she found an artist identified as African American because he or she made prints *featuring* African Americans. The compilers of the old directories often leaped to erroneous conclusions. We talked to African American curators at museums and widened our queries to dealers and museum print curators countrywide.

But mostly we identified the lost and forgotten artists through Reba's diligent perusal of published information, some of which proved misleading. For example, previous art historians had categorized Riva Helfond as African American because much of her imagery featured blacks. But Reba determined that Helfond was white, thanks to a dealer who handled her work. The race of her subjects was due to the students she taught at the Harlem Community Arts Center, which included a print shop, supported by the WPA/FAP. Helfond was not an exception; Reba found other white artists also designated African American because of their imagery. We all have stereotypes. David Kiehl, curator of prints at the Whitney Museum, admits to thinking the etcher Fred Becker was black because his images were mostly of jazz musicians. (Turns out Becker was white, although he did play in jazz bands.)

Occasionally we'd get lucky. We heard about an African American art dealer named Corinne Jennings, who had a small gallery in downtown New York. She was the daughter of Wilmer Angier Jennings, recently deceased, one of the artists whose work we sought. We visited Ms. Jennings at her gallery, which specialized in work by young African Americans. Corinne, with large brown eyes in a small brown face, greeted us with caution.

I asked, "Do you have any of your father's prints? We're interested in acquiring."

"Why do you ask?"

"We're print collectors, and we're trying to acquire prints by African Americans who worked when your father did."

No smile. "Tell me about your collection."

We launched into an explanation, trying to establish credibility. We referred to the Lehman College show, in which Wilmer Angier Jennings was included. We named dealers we bought from. We told the story of the Sargent Johnson print in our Newark Museum exhibit and the proposal from the museum's director.

Corinne nodded and went to the rear of her gallery, and emerged in a few minutes with a small stack of Jennings's prints. With noticeable sadness, she said, "These are the only impressions of his prints I own. I don't know the whereabouts of any others. I've got a few duplicates and I'll sell you these."

We had passed the test as serious collectors—one that we would encounter again—and departed with three Wilmer Angier Jennings prints.

Once Corinne decided to trust us, she became very helpful in pursuing the work of other black artists, becoming part of Reba's research effort.

Reba eventually had a list of more than fifty African American artists who were active during the 1930s and 1940s. Now the task was to determine if they made prints, and if so, acquire their work. We took an unorthodox approach— and one we never used again. We sent Reba's list to every art dealer we knew, or had even heard of, and offered to buy any prints made in the 1930s and 1940s by any of the artists on Reba's list for whatever price the dealer asked.

It worked. Sources we'd never dreamed of owned this material and offered us prints. We took them all. We eventually acquired more than one hundred prints from this sweep of the marketplace. Word of our aggressive buying tactics spread, and out of the blue I got a long distance phone call from Raymond Steth, one of the featured artists in the Lehman College collection, whose magnificent prints we had abandoned hope of acquiring as no dealers had them.

Ray introduced himself and said he'd heard we were collecting.

I responded, "Yes, and we'd very much like to acquire your work, especially your great *Beacons of Defense* and *Evolution of Swing*, and, of course, *Heaven on a Mule*."

"I have them, and others I made at the same time, too."

Pulse starting to race, I quickly responded, "We'd like to buy them all. You name a price, and we'll meet it, and you can ship the prints or we'll send someone to Philadelphia to collect them."

"No, I'd rather bring them up to New York and show them to you."

"Christ," I thought, "I've been too aggressive. I shouldn't have raised the topic of price." But at least I didn't frighten him away.

A few days later, slight, small, frail seventy-five-year-old Raymond Steth appeared in my office on Wall Street, thirty-three floors up in a vertical glass box, carrying a bulky portfolio of his prints. He wanted to look us over. Most of the prints in his portfolio were the last impressions he owned. My office walls were covered with WPA-era prints, and this must have reassured Steth. We were deemed worthy: he offered and we bought. He asked us to promise to never sell his prints, and to seal the deal we agreed to eventually donate everything we bought from him to a major museum.

Later, when Reba traveled around the country lecturing on the traveling exhibition she created from our African American prints, if the venue was

commutable from Philadelphia, Ray Steth would be there. Reba returned home from one of these encounters and remarked, "Ray Steth was right there, sitting in the front row as I talked."

"Well, weren't you flattered?"

"Yes, but it's nerve-racking to try to explain an artist's imagery or technique when your subject is staring at you, hanging on every word."

"Did he frown or smile?"

"Neither. He just listened intently. But afterwards he came up and we shook hands. Then he smiled."

Steth's story has a bittersweet ending. Shortly after our exhibit was shown at the prestigious Philadelphia Museum of Art, Ray was named artist-in-residence at the Pennsylvania Academy. His hometown had finally recognized him, but sadly he was unable to enjoy his honor for long. He died two years later. *Heaven on a Mule* (ca. 1935-1943, Fig. 2) graced the announcement of his death.

It is a remarkable print, an emotional experience. A poor family—two children astride a mule, a husband and a wife, and a dog—are on a small hill, bowed in prayer. All wear crude, homemade wings, including the animals.

Fig. 2. Raymond Steth, *Heaven on a Mule*, ca. 1935-43. Lithograph, 8.8 x 11.2 in.

Their scant belongings—a frying pan and a few rags of clothing—lie on the
ground nearby. Steth explained that there was a religious cult that believed
that if you put on wings, went to a hilltop with all your earthly possessions,
and prayed, angels would come and take you to heaven. In the print, a com-
motion in the clouds overhead hints that the angels are on their way.

Fig. 3. Robert Blackburn, *People in a Boat*, ca. 1937-9. Lithograph, 11.1 x 15.6 in.

Reba's relentless research uncovered more and more about the black
artists we collected. Robert Blackburn learned printmaking working on
the WPA/FAP, trained in Paris, and in the 1950s founded the Printmaking
Workshop in New York, which offered free instruction on the craft, funded
by sale of his art and donations from other artists. For this accomplishment,
Blackburn was awarded a MacArthur Fellowship. The Printmaking Work-
shop has continued despite Blackburn's death in 2003.

Reba speculates that Robert Blackburn's *People in a Boat* (ca. 1937-9, Fig. 3)
was a Depression-era version of a Biblical scene familiar to art historians in
Raphael's drawing for his tapestry, *The Miraculous Draught of Fishes*.[1] In both
images, a person leans out of a crowded small boat and reaches into the
water. Blackburn's print demonstrates his skill as a lithographer, with tonal
effects creating and shaping the forms of the boat's occupants. Reba's specula-
tion has been accepted as gospel by later critics writing about the print.

Fig. 4. Allan Rohan Crite, *Five Joyful Mysteries*, 1947. Hand-colored woodcut with gold leaf, 15.5 x 14.8 in.

Religious imagery was a regular feature with African Americans, particularly Allan Rohan Crite, who rarely pictured non-religious topics. He hand-colored his prints and added gold leaf, as in *Five Joyful Mysteries* (1947, Fig. 4). The religious characters in his prints, Mary and Joseph, Christ, Adam and Eve, etc., are all black—a gentle protest against stereotyping.

Several artists during the 1930s depicted lynching of African Americans in their prints. The images were universally brutal, intended as a protest. However, none of these artists proved to be African American. Of all the prints we collected by black artists, not one was of an actual lynching scene. Two made references to lynching, the most obvious being Charles White's ironically titled *Hope for the Future* (1945, Fig. 5), which depicts a black woman holding a baby, seemingly dead. In the distance, over the woman's

shoulder, is a tree with bare limbs and, barely discernible, a hangman's
noose. Reba paused to study the history of lynching in America, and that
jogged her memory: Billie Holiday's horrifying song of 1939, "Strange Fruit."

> Southern trees bear a strange fruit,
> Blood on the leaves and blood at the root,
> Black body swinging in the Southern breeze,
> Strange fruit hanging from the poplar trees . . . [2]

Another lynching reference is a print
by Ernest Crichlow, with its obviously
cynical title, *Lovers* (1938, Fig. 6). The im-
age is a Ku Klux Klansman, in full regalia,
groping a young, wide-eyed and fright-
ened black woman in front of a bed. Many
black artists showed the poverty and hard
times of fellow African Americans in the
1930s and 1940s, and the discrimination
they suffered, but none portrayed grue-
some images of hangings, mutilations, or
burnings. They left this to white artists.

Elizabeth Catlett, the most famous
African American artist in our collection,
is best known as a sculptor and was still
making art right up to her death in 2012.
As a young woman, she won a fellowship
to study in Mexico with the great mural-

Fig. 5. Charles White, *Hope for the Future*, 1945. Litho-
graph, 12.2 x 10.7 in.

ists. Her first marriage was to the artist Charles White, who was with her
during her early visits and stay in Mexico. Catlett's *Mother and Child* (1944, Fig.
7), bears a striking resemblance to White's *Hope for the Future* (Fig. 5). *Mother
and Child* could well be a Madonna and Child, and Catlett's background tree
might represent the cross, while White's is definitely a lynching tree.

Catlett subsequently divorced White, married a Mexican artist and
printmaker, became a Mexican citizen, and made her home in Mexico. Her
art, like that of her Mexican mentors, emphasizes social commentary and
historical narrative, frequently portraying the underprivileged of the south-
ern United States.

We learned little about Carl G. Hill—nothing about his birthplace or

education—but what we did find out was tragic and unfortunately not uncommon for the time. He had been a student of Riva Helfond's at the Harlem Community Arts Center in the late 1930s, enlisted in the U.S. Merchant Marines in the early 1940s, and was lost at sea during the war. His lithograph, *Untitled (Newsboy)* (1938, Fig. 8), which may be the only surviving copy of his only print, was reproduced in a booklet titled *Art in the Armed Forces*. The image is a young boy hawking newspapers in an urban environment—possibly a reference to himself, but we'll never know. Hill dedicated this impression of *Newsboy* to Helfond.

In time, our collection of prints by African Americans grew to over two hundred, and Reba studied the images, determining what, besides the religious references, distinguished these prints from those made by white artists of the same period.

Fig. 6. Ernest Crichlow, *Lovers*, 1938. Lithograph, 13.8 x 11 in.

During the Harlem Renaissance of the 1920s, philosopher Alain Locke urged black artists to turn to Africa for inspiration. Locke went on to build a collection of African art and organize the first full-scale exhibition of this work in the U.S., displayed at the 135th Street branch of the New York Public Library, now known as the Schomburg Center for Research in Black Culture. This was probably the first African art most black artists had ever seen. The Harmon Foundation photographed Locke's collection and made these pictures available to artists, along with Locke's explanatory material.

Only a few African American artists visited Europe, notably Paris, in the 1920s and 1930s where they could see African art in museums. They also saw the Modernist art of Europe of the period, such as that of Picasso, which had strong African influence. Corinne Jennings believes her father saw the Locke exhibit in the mid-1930s, and it inspired some of his imag-

ery, including *Still Life with Fetish*, also
known as *Still Life* (1937, Fig. 9), which
we acquired from Corinne. The fetish,
set among more ordinary objects, is
obviously African sculpture.

Countee Cullen, Harlem's famous
poet of the 1920s, urged African Ameri-
can artists to reflect their African his-
tory in their work. In "Heritage," Cullen
wrote:

> What is Africa to me:
> Copper sun or scarlet sea,
> Jungle star or jungle track,
> Strong bronzed men, or regal black
> Women from whose loins I sprang
> When the birds of Eden sang?
> One three centuries removed
> From the scenes his fathers loved,
> Spicy grove, cinnamon tree,
> What is Africa to me?[3]

Fig. 7. Elizabeth Catlett, *Mother and Child*, 1944. Litho-
graph, 7.8 x 5.8 in.

Fig. 8. Carl G. Hill, *Untitled (Newsboy)*, 1938.
Lithograph, 11.4 x 8.1 in.

Fig. 9. Wilmer Angier Jennings, *Still Life with Fetish*, 1937.
Wood engraving, 9.9 x 8 in.

Fig. 10. Raymond Steth, *Evolution of Swing*, ca. 1943. Lithograph, 12.7 x 16.7 in.

The artists complied. Years later, in 1989, in a catalogue accompanying an exhibition of art by young African Americans, curator Edmund Gaither wrote, "Afro-American artists by and large viewed African art as part of their legacy. For Afro-Americans, Africa was a recurrent theme with implications for all aspects of life—political, social, and religious."[4]

Music is another feature of African American prints. The Sargent Johnson print that started our crusade, titled *Singing Saints*, is both religious and musical. Raymond Steth's *Evolution of Swing* (ca. 1943, Fig. 10), a mural-like narrative, begins in an African village showing a drummer and dancers, moves on to black slaves singing as they load cotton onto a side-wheeler riverboat, and culminates with a black orchestra and singer performing for a jitterbugging couple, with radio waves broadcasting the music out over a modern city. Steth was the only artist among the African Americans who utilized this mural technique to tell a story.

An inspiring story with an unhappy ending is that of William Henry Johnson, who was born in poverty in South Carolina, but somehow saved enough money to come to New York at age eighteen to study art at the National Academy of Design. Despite his obvious talent, he was passed over—

possibly because of race—for a traveling scholarship, but his teacher gave
him $1000, which allowed Johnson a trip to Europe. There he remained for twelve years, supporting himself as an artist. With the start of World War II, he came back to New York with his Danish wife, who died shortly thereafter. Johnson suffered a breakdown, and in 1947 was committed to a mental institution where he lived until his death in 1970.

Fig. 11. William Henry Johnson, *The Blind Singer*, ca. 1940. Screenprint, 16.7 x 11 in.

Johnson's unfortunate story doesn't end there. All of his unsold art was put into storage, but was soon threatened with destruction for non-payment of rent. Friends engaged the Harmon Foundation to take over the art, where it remained until Harmon closed in 1967 and donated the archive to what is now the Smithsonian American Art Museum in Washington.

During his short artistic life in New York in the 1940s, Johnson turned from European Expressionism to a neo-primitive style depicting the life of African Americans; *The Blind Singer* (ca. 1940, Fig. 11) is an example we bought along with other Johnson screenprints from a young Washington-based art dealer, who, also tragically, died shortly thereafter at age forty-four. We had been told that Johnson's African American-imagery art could not be bought—none had sold in the 1940s when he made it, it had gone into storage, then to the foundation, and eventually to the museum. But there must have been some leaks along the way, akin to what we acquired. In time, other of his prints—few in number—trickled into the marketplace. With nearly all of his art in one institution, and little in dealers' inventories, it's not easy to see or buy Johnson's paintings or prints. But at least they were saved.

Like Johnson, many other African American artists depicted daily life. The settings are either urban, mainly Harlem, or the rural South. The two are related: By 1918, in what has been called the Great Migration, a quarter-million black farm workers had left the South for northern cities. When a few of them returned to the South in the 1930s in search of roots, they found poverty and made prints to record what they saw.

Hale Woodruff grew up in Tennessee, moved to Indiana and studied art in Paris. After fifteen years, he returned to America to teach at Atlanta University. He later wrote, "I realized that here was my country again. . . the Southern scene and the people became something I was very much interested in."[5] Woodruff produced a portfolio of woodcuts he named *Views of Atlanta*. One

Fig. 12. Hale Woodruff, *Going Home*, 1935. Linocut, 10 x 8 in.

Fig. 13. Norman Lewis, *Untitled (Southern Landscape)*, ca. 1939. Lithograph, 9.6 x 12.9 in.

Fig. 14. Dox Thrash, *Georgia Cotton Crop*, ca. 1938-42. Carborundum, 8.4 x 9.8 in.

of the prints, *Going Home* (1935, Fig. 12), is an image of a hefty black woman in heels climbing rickety steps up to a dilapidated cabin on stilts. Similar cabins line the road, creating an overall feeling of gloom.

Norman Lewis was a New Yorker, but he was sent to Greensboro, North Carolina, to set up a WPA Art Center. Encountering predictable racial prejudice, he hated the place. His attitude is reflected in *Untitled (Southern Landscape)* (ca. 1939, Fig. 13), another depressing scene—a lonely, empty farmhouse and barn in falling-down disrepair. In his oil painting version of this same image, Lewis added a sign in the front yard of this house, one that reflected his mood and probably his hope. It read "Going Home," and go home he did—back to New York, where he adopted an abstract style, much admired and collected.

Dox Thrash was part of the Great Migration. He was born in Georgia, but settled in Philadelphia after World War I. Thrash refers to his rural birthplace in his *Georgia Cotton Crop* (ca. 1938-1942, Fig. 14), an image of a sharecropper's shabby shack and family, with a few piles of picked cotton strewn around a bleak yard—a realistic view of a black, Georgian sharecropper during the Depression. Thrash co-invented a new technique for his printmaking using Carborundum, a grit composite that can be used to score a copper plate that creates a tonal effect on the printed paper; the result is known as a Carborundum print.

Reba made selections from our collection of African American artists' prints to create an exhibition, which she titled *Alone in a Crowd: Prints of the 1930s-40s by African American Artists*. We included at least one print by every artist we found for a total of forty-two artists. In our opinion, the quality of the work varied greatly, but we wanted this exhibit to serve as a historical documentation, as well as an art show. Reba chose 104 prints, based mainly on the artists' skill, the technique employed, and the relevance of the image to the 1930s-1940s. She wrote most of the catalogue, ballpoint pen on yellow tablets. We were in a hurry to take advantage of the offer of the exhibit at Newark. It was all accomplished in fifteen months—the research, acquisitions, writing, and printing of the catalogue.

On the catalogue cover is a lithograph by John Woodrow Wilson, *Street Car Scene* (1945, Fig. 15). The image is more than the title suggests. An African American defense worker sits on a street car, surrounded by white women, one with a child. The defense worker wears a badge, "Navy Yard

Fig. 15. John Woodrow Wilson, *Street Car Scene*, 1945. Lithograph, 11.2 x 14.8 in.

Boston." He looks directly at the viewer, confident but not defiant. But he's definitely alone.

The Faulconer Gallery at Iowa's Grinnell College was mounting an exhibition of John Wilson's work, and I was asked to interview him and write an essay for the catalogue. He spoke freely of the ambivalence he and other African Americans felt about World War II. Should they join the armed forces to defend freedom when they enjoyed far less than perfect freedom at home? The dilemma was vigorously debated in the Boston ghetto where he grew up. Other of his images of the time reflected this quandary. Wilson was no longer troubled by the question, but he remembered it well.

Alone in a Crowd did indeed open at Newark and proved very popular with other museums as the word spread. Eventually, it was shown at twenty-one museums, including two in Europe, between 1992 and 1997. We had to reprint the catalogue due to unexpected demand (and to correct a few errors pointed out by art historians and dealers who became interested

in the subject and discovered new information). As Reba hoped and expected, museums that featured our exhibit found a new audience: African Americans. Reba lectured on *Alone in a Crowd* at the Gibbes Museum in Charleston, and according to the director, it was the first time at the museum that the audience was overwhelmingly black. This was repeated at other museums. *Alone in a Crowd* opened at the Brooklyn Museum on an Easter Sunday. We attended and witnessed a surge of African American families arrive in Sunday clothes, immediately after church hours.

Alone in a Crowd also started a boom in art by African Americans. Paintings, sculpture, and more prints emerged from attics and storerooms. Several New York galleries began to seek out this work and feature it regularly. Swann's, an auction gallery specializing in prints and books, added a curator just to work in this field, and twice a year holds auctions dedicated solely to the work of African Americans. Prices soared. Supply expanded. New collectors appeared. We started it all.

In 1999, we ended our collecting of this art by donating all our African American prints to the Metropolitan Museum of Art, keeping our promise to Ray Steth and others. The Met mounted an exhibition based on our gift and the few related objects the museum owned. The opening attracted a large African American crowd, and several of the featured artists were there, two in wheelchairs. Just for this event, Cicely Tyson—the film, stage, and TV actress, originally from Harlem—replaced Philippe de Montebello, director and "voice of the Met," as the narrator on the audio guides that lead viewers around exhibitions.

Art by African Americans had arrived. Raymond Steth would have been proud.

Widening the Search

Most of the works we bought in our early years collecting American prints
came from dealers and auction houses in New York City. But when we
heard about dealers elsewhere, our travels took us farther afield. One of our
first non-New York sources was the Bethesda Art Gallery in Maryland. It
was easy to visit because in the early 1980s I was on the board of directors
of the Rouse Company, headquartered just outside of Washington, D.C.,
near Bethesda. Beginning in 1983, I made visits every three months to both
Rouse and the gallery, and after I left the Rouse board a few years later, I
continued to patronize Bethesda by telephone and mail.

The gallery was founded in 1975 by Betty Minor Duffy and her husband,
accountant, and business partner, Douglas. Betty was plump, gray haired,
and matronly, with an outgoing personality and smiling eyes behind huge
glasses. She was very enthusiastic about prints and her favorite artists.
Howard Norton Cook, who had recently died, was at the top of that list. She
was compiling a catalogue raisonné of Cook's prints, which she published in
1984. The first print I bought from Betty was Cook's *Engine Room* (1930, Fig.
1), in which the ship's giant machinery overwhelms the attending engineer-
sailor. The print reminded me of my midshipman duties, a few weeks in the
engine room of a U.S. Navy battleship. I can still look at the image and hear
the deafening roar of giant turbines, feel the heat from boilers. As was often
the case, memory and nostalgia influenced the images I chose.

Memory also influenced my first purchase of the work of Doris Lee,
whose work the Duffys also introduced to me. Lee's *The Helicopter* (1948, Fig.
2) shows a farm family standing beside their garden, staring up in amaze-
ment at a helicopter, probably a rare sight in 1948. I have always believed, but
can't prove, that this image is based on Lyndon Johnson's campaign for U.S.
Senator from Texas that same year. Johnson hired a helicopter, christened

Fig. 1. Howard Norton Cook, *Engine Room*, 1930. Lithograph, 10 x 12 in.

Fig. 2. Doris Lee, *The Helicopter*, 1948. Lithograph, 8.9 x 12 in.

it the "Flying Windmill," and flew all over the state, stopping in small towns
and relying on the spectacle of the helicopter to draw a crowd for him to
meet and greet. It was a campaign technique that helped Johnson win, an-
other step on his road to the presidency.

Bethesda also provided my first
print by Werner Drewes, a drypoint
titled *Chicago-Grain Elevator III* (1926, Fig.
3). Soon after Drewes emigrated from
Germany, he traveled to the Midwest.
He was intrigued less by the architecture
and skyscrapers of Chicago than by the
monumental grain storage silos rising
out of the flat cornfields of Illinois. In his
portrayal of the grain elevator, Drewes
deliberately fills the entire picture plane
with a silo to emphasize its monumen-
tality. The elevator's inward leaning lines
show it as it would be seen by a viewer
on the ground looking up from its base.

Bethesda closed as a walk-in art
gallery in 1987, but the Duffys continued
their work as print dealers, publishing
sales catalogues and operating by ap-
pointment and by phone and mail out
of their home until Betty's death in 2006.
Betty and Bethesda are sorely missed.

Fig. 3. Werner Drewes, *Chicago-Grain Elevator III*, 1926.
Drypoint, 13 x 8.3 in.

COLLECTOR COMPETITION

Our widened search for prints was often accidental, as when business or
pleasure travel took us to new places where we found print sellers previous-
ly unknown to us. But a wider search was also deliberate: we were compet-
ing with other collectors.

The annual New York print fair was a race for material. One November
in the early 1980s, we attended the opening of the fair with friends, a couple
who were also collectors. I'll call them Barb and Jack. I immediately sped for
the Old Print Shop booth, having been told by Bob Newman, the proprietor,

that he would be showing a trove of prints by S.L. Margolies, an artist we wanted to collect. Barb was right behind me.

I pawed through bins, and found the prize Margolies. Triumphantly, I announced to all, "Here's the one, the best!"

Barb reached over my shoulder, grabbed the print, and said "I'll take that." She turned to the surprised Bob Newman, and asked "Is a credit card O.K.?"

We were all surprised, and paralyzed, except for Barb. She got the prize, and I got a lesser Margolies. I also learned to seek material in less competitive environments, and where good manners were the norm.

Collecting ideas can't be patented, and collectors learn from other collectors. But one experience still rankles. As described in a later chapter, one of our early collecting targets was American color woodcuts. We had acquired a small group when we began to search for a new apartment. A real estate broker, Lucille, was showing us spaces and heard us talking about prints. She inquired, and we told her about our recent discovery and acquisition of color woodcuts. Lucille asked to see them, and we proudly showed her our treasures.

A few months later, a dealer casually thanked us for sending Lucille his way. We did? "She bought every color woodcut I had in stock," the dealer reported. We made a few other inquiries—and got similar stories. Lucille was on a color woodcut buying rampage.

Next, a notice arrived from the Century Association, of which I'm a member, that the Lucille X collection of American color woodcuts was soon to be exhibited in the club's gallery. Lucille was the queen of color woodcuts!

No laws broken here, but I'm still miffed. At least we might have gotten a "thanks for giving me a great collecting direction." Or a mention in the brochure accompanying her exhibit. Neither happened.

TEXAS

In the winter of 1987, Reba and I moved to Dallas for six weeks. Alliance Capital had just opened an office there, and as a former Texan, I planned to meet with potential clients—the pension funds of large corporations headquartered in Big D, such as Texas Utilities, Texas Instruments, and several oil companies. There were worse alternatives than leaving New York in January for milder Dallas and devouring the local Tex-Mex food and barbeque. We also enjoyed the local color; on several occasions we shared a hole-in-the-wall Mexican restaurant with Willie Nelson.

In the gift shop of the Dallas Museum of Art, I discovered a 1985 print exhibition catalogue titled *Lone Star Regionalism: The Dallas Nine and their Circle*. It was filled with images of Texas by artists whose names were totally unfamiliar. Here I was, a native Texan and a print collector, belatedly discovering prints of Texas images by Texas artists! I was fascinated, and set out to learn all I could about this new field.

The Dallas Nine were either natives of that city or from nearby towns, and were so named in a 1932 exhibition of paintings by nine local artists, all thirty years old or younger. Several of the artists were employed by the WPA, and painted murals in WPA-built Texas public buildings. But the event that put the Dallas Nine on the map was the Texas Centennial Exposition of 1936, celebrating the one-hundredth anniversary of Texas independence from Mexico. The Dallas Museum of Art had just relocated to its new home on the Dallas Fairgrounds, and local artists, particularly the Dallas Nine, dominated its first exhibition there and achieved national recognition.

Rick Stewart, curator of prints at the Dallas Museum and author of the *Lone Star Regionalism* catalogue, directed me to a likely source for the prints, the American Scene Art Gallery, located in a wood-frame house in a nearby neighborhood. American Scene had prints by most of the Dallas Nine. But one exception was *Grasshopper and Farmer* (Fig. 4) of 1938 by Otis Dozier, an image I

Fig. 4. Otis Dozier, *Grasshopper and Farmer*, 1938. Lithograph, 9.3 x 12.9 in.

badly wanted for its representation of the locust plagues that accompanied the dust storms in the 1930s. No problem: the gallery proprietor phoned the artist, who responded, "Sure, I'll sell you my last impression." In a few days, I owned it.

Rick Stewart described the artistic style of the Dallas Nine as Realism, but in *Grasshopper and Farmer*, Dozier takes substantial liberties with his "real": a giant malignant grasshopper overwhelms a fallen farmer. Another Dallas Nine artist who employed quirky, or slightly surrealistic, Realism was William Lester. Lester's *The Rattlesnake Hunter* (1938, Fig. 5) has an appropriate Texas title, and contains elements of Realism—Texas rattlesnakes nest in the bleak and unpleasant landscapes he portrays—but why is the rattlesnake hunter, with his forked hunting stick, barely visible? And the image is dominated by a coffin-shaped rock. Why? I can't explain. Unanswerable questions are features of the surreal, and the viewer is required to attach his own interpretation. Possibly I'm attracted to the image simply because of the Texas-rattlesnake association, nostalgia at work again.

Because of my interest in Texas prints, Rick Stewart advised that I take a look at the Modernist work of the Fort Worth Circle. Fort Worth? Cowtown? For someone growing up in Texas in the 1930s and 1940s, with no knowledge

Fig. 5. William Lester, *The Rattlesnake Hunter*, 1938. Lithograph, 8 x 10.1 in.

of art, the idea of Fort Worth as a center of any art, let alone Modernist art, would seem ridiculous. My personal "circle" accepted the definition of Fort Worth's Chamber of Commerce, "Where the West begins," so, once again, I was surprised to hear about another group of 1940s Texas printmaking artists.

Rick sent us to Dutch Phillips, who had a small gallery in Fort Worth, twenty-five miles away. What an eye-opener! Surrealist and abstract prints a stone's throw from Fort Worth's sprawling and smelly stockyards!

There was nothing remotely Texan about the work of this group of Texas artists. Their imagery mostly dealt with the bizarre, as in *The Mandrill's Tea Party* (ca. 1945, Fig. 6) by Veronica Helfenstellar. Why the giraffe, a motif that recurs in other works by this artist? And why does a mandrill—a type of baboon—have a tea party? Helfenstellar's dreams? More of the unanswerable questions posed by Surrealism.

I soon learned that my astonishment about Fort Worth being an art center was ill-founded. The Fort Worth School of Fine Arts, which gave the artists who were eventually called the Fort Worth Circle a place to become friends, was established by three local artists in 1931. Dickson Reeder was an early member; an art prodigy, he became a portrait painter at a young age. In

Fig. 6. Veronica Helfensteller, *The Mandrill's Tea Party*, ca. 1945. Lithograph, 13 x 16.8 in.

1936, he toured Europe and studied briefly at Stanley William Hayter's fabled Atelier 17 in Paris, where he learned engraving and etching and came under the spell of Surrealism. His *Untitled (Mysterious Pool)* (ca. 1945, Fig. 7) shows the Hayter influence—the juxtaposition of fantastic creatures and the recognizable ladder and oil drum, the kind of incongruous mix, like Helfenstellar's giraffe and baboon, common to most surrealistic images. I remain unable to explain or interpret this print. If these are Dickson's dreams, it must have been a restless night. In Paris, besides becoming infused with Surrealism and learning printmaking, Reeder also met his future wife, artist Flora Blanc. The Reeders lived in Paris a year, then New York, and in 1940 returned to his native Fort Worth, where they became a part of the Circle.

Fig. 7. Dickson Reeder, *Untitled (Mysterious Pool)*, ca. 1945. Etching, 8 x 7 in.

Fig. 8. Bill Bomar, *Projections*, ca. 1950. Etching, 5 x 7.6 in.

The Circle members had been strict Realists, but the group's style changed with the arrival of the Reeders, and the return of another member, Bill Bomar, from New York, where he and his mother collected European and American paintings and sculpture by Modernist artists. Bomar's work tended toward abstraction, as displayed in his etching *Projections* (ca. 1950, Fig. 8), a study of geometrical shapes set in sharply contrasting lights and darks.

Eventually, all the Circle members took up some form of Fantasy, Surrealism, or Abstraction, and they added dance, music, and theater to their artistic perimeters. The Circle's activities peaked in the 1940s, particularly during World War II. No members were drafted into the armed forces; physical infirmity or important skills exempted them. Several were employed as artists or draftsmen at the nearby Consolidated Vultee Aircraft Corporation factory, a major manufacturer of the B-24, WWII's workhorse bomber.

In 2008, the Fort Worth Circle artists were given a major retrospective exhibition in their hometown, at the Amon Carter Museum, under the leadership of print curator Jane Myers. A lavishly illustrated catalogue accompanied the show and told the history of the Circle. In the introduction, Myers attributes the exhibition to the inspiration of the dealer Dutch Phillips, who for decades promoted the work of the Circle, and, as she puts it, "carried the torch" for the Fort Worth Circle. Reba and I traveled there to see it, which gave us an opportunity for another pleasure, to lunch at our all-time favorite Mexican restaurant, Joe T. Garcia's, with their Tex-Mex enchiladas and tacos.

CHARLESTON

In the late 1980s, we were renovating an oceanfront townhouse on Kiawah Island, just outside Charleston, South Carolina. Kiawah may have the most beautiful beach in America: wide expanses of white sand, gentle surf, warm water. Until it became overrun with golf courses, it was a nature preserve, with rare birds, tiny deer, and bobcats, a major attraction for us. We also liked the proximity to Charleston and its Gibbes Museum, where *Alone in a Crowd* had been so successful.

To decorate our new beachfront condo, where even the reflected light was far too bright for fragile color woodcuts, we focused on black-and-white artwork, mainly etchings, by Charleston artists. No artist, visitor, or permanent resident could resist the beauty of the city's old houses or fail to be fascinated by the African American street merchants, ever present in and around town.

Local galleries accommodated our interests, and we discovered more than ten artists, active before World War II, who made prints featuring the city, its surroundings and residents, or the local flora and fauna. Between the wars, Charleston was a busy artistic center, and a Charleston Society of Etchers flourished. Our favorite prints of the city's architecture were made by Elizabeth O'Neill Verner.

Verner was born, lived, and died in Charleston. Her *Bit of Legare Street* (ca. 1928-31, Fig. 9) is typical of her work: a stone post, a wrought-iron gate, a shade tree, and an African American woman with a basket of flowers on her head. She was also active in a campaign to preserve the street and sidewalk flower and woven-basket vendors when the city government tried, predictably and unsuccessfully, to ban them as a traffic nuisance.

Alfred Hutty was a visitor from Woodstock, New York, who on his first

126 visit to Charleston in 1919 cabled his wife: "Come quickly. Have found paradise." They became seasonal residents, and Hutty succumbed to the charm of the city and its residents. The local African Americans were of particular interest, exemplified in his *Jenkins Orphanage Band* (1937, Fig. 10), a Charleston street setting for a concert by a children's band, players in mismatched or no uniforms, nonetheless blowing and banging away.

Fig. 10. Alfred Hutty, *Jenkins Orphanage Band*, 1937. Drypoint, 10.4 x 9.8 in.

CALIFORNIA

Color woodcuts became the focus of our California print collecting. As described in a later chapter, a group of woodcut artists clustered in the northern part of the state, and their work was regularly featured by California museums and dealers. We frequently journeyed west both to view and acquire.

We never met the work of this Southern California artist in his home state. Rather, I was introduced to the wood engravings of Paul Landacre by Jake Milgram Wien in New York City. Jake was selling parts of his print collection, a prelude to his becoming an independent curator and expert on Rockwell Kent. (Jake is now preparing a catalogue raisonné on Paul Landacre.)

Landacre lived most of his life in or near Los Angeles, and many of his scenes are of Southern California. His technique was wood *engraving* (not woodcut), in which the artist digs into the hard end grain of a block of wood with an engraving tool (versus woodcut where the softer side grain and knives are mostly used). The result is a finer, more polished-looking image compared to the usual roughness of a woodcut. During his lifetime, Landacre was among America's most acclaimed wood engravers, and many of his prints were made for book illustrations.

Fig. 9. Elizabeth O'Neill Verner, *Bit of Legare Street*, ca. 1928-31. Etching, 5 x 3.4 in.

Of all the Landacre wood engravings I acquired from Wien, my favorite has always been *Coachella Valley* (ca. 1935, Fig. 11). A long freight train moves through the deserted valley, overwhelmed by a mountain.

At the time I bought the print, I knew nothing about the Coachella Valley. A few years later, I learned it's in fact the location of Palm Springs, California—for nearly a decade our winter home. When Landacre made the print, Palm Springs was no more than a few springs and palm trees, a far cry from what it later became: a Hollywood celebrity getaway, the venue for an annual music festival, and winter home of escapees from the cold East and North, with green lawns and golf courses—fed by the springs of a gigantic aquifer—and the northern-most point in a string of resort towns, now known as the Desert Cities, home to even more winter refugees and green lawns and golf courses. However, the mountain in Landacre's *Coachella Valley* is unchanged; it is part of the surrounding San Bernardino Range, the often-snow-capped peaks that ring the valley. Due to the intensive development since the mid-1930s, the Coachella is no longer the empty high desert shown in Landacre's print. We're guilty of being part of the problem, along with several hundred thousand other winter and year-round residents. But with the surrounding mountains and desert climate, we love the warmth and beauty of the place, not yet totally destroyed by modernization. Landacre's *Coachella Valley* is a reminder of our home in an earlier time.

Fig. 11. Paul Landacre, *Coachella Valley*, ca. 1935. Wood engraving, 6 x 12.2 in.

Our print collecting was much influenced by the travel that was necessary for my work. Our stay in Dallas was one example; London, the center of international investing in the 1980s, was another. I was a frequent visitor, trying to expand Alliance Capital into this broader arena, and on a trip in 1987, a review in the *International Herald Tribune* caught my eye: David Smith's *Medals for Dishonor 1937-1940* at the Museum of Modern Art in Oxford. Why was a famous American artist exhibiting at an obscure British museum? David Smith was well known as a sculptor of large abstractions, usually in steel. His massive structures, owned by many museums, were usually placed outdoors, in courtyards or on lawns, free of the constraints of ceilings and walls.

But according to the *Trib*, the *Medals for Dishonor* were small bronzes, inches in diameter, slightly larger than military medals. Smith made the medals after he returned to America from Europe, where, seeing firsthand the rising tide of Fascism, he was frustrated by the British and American lack of response to the threat. The medals, which had horrific or cynical titles, such as *Sinking Hospital and Refugee Ships* and *War Exempt Sons of the Rich*, were his protest against the political developments and the apathy of the 1930s, an ironic echo of the long tradition of military medals.

The exhibition catalogue quoted poet W.H. Auden's summation of the 1930s as a "low dishonest decade," and described the period as a time "when the world turned inexorably down the road to war." As a child of the 1930s, an amateur military historian, and someone interested in all aspects of American art, I could not resist. I caught a train to Oxford and found the small Museum of Modern Art on a narrow backstreet. The exhibition and catalogue were interesting history, but the medals themselves were difficult to decipher and unappealing, their imagery confused and hard to read. Each had been cast, and then enhanced with an electric drill. One copy of each— and related drawings—had been loaned for the exhibition by Smith's heirs. The medals hadn't been seen in public since a New York gallery show in 1940; this exhibition had four venues in the British Isles, but none in the U.S.

Shortly after I returned to New York, Pace Gallery exhibited Smith's prints with an extensive catalogue raisonné written by Alexandra Schwartz, then (and still) director of Pace Prints. Three etchings in the exhibition were similar in imagery to the *Medals for Dishonor*. Two of these were single impressions, loaned to Pace and not for sale. Of the third, there were two known

impressions. One of them was for sale. I greedily bought it, even though, like
the actual bronze medals, the imagery was difficult to interpret. Smith was
not a great etcher, or printer, but for me the rarity of the print overcame the
aesthetic issues. The uniqueness and context—the war—attracted me, and

Fig. 12. David Smith, *Study for Medals for Dishonor*, 1939. Etching and engraving, 9.8 x 11.6 in.

discovering that Smith had been a printmaker was a revelation. Pace's title
for the print was *Study for Medals for Dishonor* (1939, Fig. 12), but it was quite
obviously similar to the medal titled *Diplomats: Fascist and Fascist Tending*.
The most telling elements of the image are several umbrellas, a reference to
British Prime Minister Neville Chamberlain, who was often pictured carrying
one, and his acquiescence to Hitler's annexation of Czechoslovakia and his
famously misguided "Peace in Our Time" speech. A balancing act involving a
circus strong man is perhaps a reference to the perils of diplomacy when, in
Smith's view, Hitler's actions and intentions demanded a stronger reaction.

The Pace exhibition included other prints by Smith, which I swept up.
Like so many American artists who traveled to Paris in the 1930s, Smith had
paused at Stanley William Hayter's Atelier 17 and had made an etching, *Rue*

de Faubourg St. Jacques (1935, Fig. 13). On the reverse side of this print, in the handwriting of Dorothy Dehner, Smith's artist wife, is: "This etching was made by David Smith. We were living in a hotel & this scene is of the other side of the street. Rue de Faubourg St. Jacques. Dorothy Dehner." It could be argued that this small etching is not great art—a street scene composed of straight, rigid lines, barely enlivened by some vague Surrealist figures pre-

Fig. 13. David Smith, *Rue de Faubourg St. Jacques*, 1935. Etching and engraving, 4 x 4 in.

sented as wall drawings. But I see the straight lines as precursors to Smith's big sculptures, the Surrealist images an homage to Hayter. And the print tells a personal history.

In 1952, Smith made several lithographs at the Woodstock, New York, studio of another artist, Margaret Lowengrund, aided by her assistant, who admittedly had never made a lithograph, and who was quoted in the exhibition catalogue:

Too impatient to wait for Margaret to arrive, Smith urged me to begin printing the first stone, and, too embarrassed to admit my lack of experience, I complied. There was no running water in the workshop, and rather than fetch some from a nearby stream, David suggested we use beer, which was in plentiful supply. And so we printed . . .[1]

The prints came out well, with beer stains only on the first two impressions. The print was *Don Quixote* (1952, Fig. 14). The image shows Quixote falling off his horse, and the horse falling, too. The year 1952 marked Smith's divorce from his wife of twenty-five years, Dorothy Dehner, became final, perhaps influencing the artist's choice of subject—chaos and collapse.

It was no accident that I was reading art columns in London newspapers during my regular visits there. I had once again lost control and violated our collecting policy—American artists' prints featuring American imagery—and started buying prints by British artists. My wife accused me of collecting British prints to have something to do in London when I wasn't working. She was right, but the collecting urge was hard to suppress. A fever can be treated and cured, but the only relief—temporary, of course—from the desire to acquire, is to acquire.

Fig. 14. David Smith, *Don Quixote*, 1952. Lithograph, 17.8 x 23.7 in.

I quickly succumbed to the appeal of what is called British Modernism. The British Modernist movement got underway around 1914, with the founding of *Blast* magazine by the artist Wyndham Lewis. Poet Ezra Pound is credited with christening this first phase of British Modernism "Vorticism," because, as Pound elaborated, ". . . the vortex is the point of maximum energy. It represents, in mechanics, the greatest efficiency. We use the words 'greatest efficiency' in the precise sense—as they would be used in a text book of Mechanics."[2] Vorticist art reflected movement, machinery, or other aspects of the Industrial Age, and aimed to represent the new, post-Victorian century. This style arrived, in prints, right in the midst of collector and critic enthusiasm for the nineteenth-century Etching Revival's focus on landscapes, cityscapes, and portraiture. English artists who worked in this style found a huge appetite for their prints, in both Britain and the United States.

The Etching Revival did not end abruptly—and Modernism begin—with the opening of the twentieth century. Rather, British Etching Revival prints were subject to extreme investor/collector speculative acquisition right up

to the stock market crash of 1929, and demand for and prices of those prints collapsed in sync with equities and other assets.[3] World War I shut down the Vorticist movement soon after its start. Glorification of modern machinery paled with the slaughter of war, thanks to accurate artillery and machine guns. By 1920, Vorticism was over, but other forms of modern art developed.

It's no wonder I fell under the spell of Vorticist images, with their mechanical-engineering orientation and strong design patterns. An early acquisition was Edward Wadsworth's *Drydocked for Scaling and Painting* (1918, Fig. 15). It is wartime, and the bold stripes on the ship's hull were called "dazzle" camouflage, used not to hide ships at sea but to confuse an enemy submarine with the course and speed of its potential target. A perfect Vorticist image.

BUDAPEST

England was not the only overseas destination I visited trying to acquire clients and, when the opportunity presented itself, prints. Reba and I traveled to Vienna for the first board of directors meeting of the Austria Fund, a mutual fund Alliance Capital had launched to invest in companies we thought would benefit from the recent collapse of the Soviet Union and the shift of former satellite countries—Poland, Czechoslovakia, Hungary—to a capitalist economic system. After the meeting, we had decided to try to obtain a print that had perhaps traveled with Hungarian-American artist Jolán Gross-Bettelheim when she returned to her native country after years of living in the U.S. On a morning just before Christmas in 1989, we drove across the snow-covered plain from Vienna to Budapest on what could very well be a wild-goose chase, the possible acquisition of Gross-Bettelheim's *Home Front* of 1942.

In the early twentieth century, Cleveland was a major destination for Hungarian immigrants, including Gross-Bettelheim and her Hungarian husband. Before coming to the U.S. in 1925, Gross-Bettelheim studied art in Vienna, Berlin, and Paris. She

Fig. 15. Edward Wadsworth, *Drydocked for Scaling and Painting*, 1918. Woodcut, 8.8 x 8 in.

resumed her art studies in Cleveland and exhibited in the annual shows at the Cleveland Museum of Art. She soon turned from watercolor and oil painting to printmaking, possibly learning the technique while working for the WPA. Her style also changed, to a streamlined, sleek version of Art Deco, including the repetition of certain motifs to create patterns.

Print dealer Mary Ryan introduced us to her work in 1986, and we bought the two prints she offered us. Two years later, we bought another eight from the Susan Sheehan Gallery. But Gross-Bettelheim's greatest print, *Home Front* (1942, Fig. 16) eluded us; neither Susan nor Mary had been able to find an impression.

Home Front was of special interest because it had been entered and accepted in the "Artists for Victory" contest sponsored by the Metropolitan Museum of Art. The purpose of the exhibition was to encourage artists to create images in prints intended to boost civilian morale, and it resulted in print exhibitions held simultaneously in twenty-six cities. Because of my interest in the history of World War II, we had acquired most of the prints in the contest, but not *Home Front*.

We interpreted this print as a patriotic homage to American war workers, especially women. This was quite a leap for the Communist Gross-Bettelheim, as many of her mid- and late-1930s images were anti-capitalist, anti-Fascist, and anti-American. In her *Civilization at the Crossroads* (1936, Fig. 17), the armored skeleton wears a helmet with a Nazi swastika but also medals with dollar and pound sterling symbols. By 1943, the Allies included the Soviet Union, and *Home Front* was her salute to the (partly capitalist) war effort.

Very little was known about Gross-Bettelheim. Reba found some skimpy records in the Cleveland Public Library. We learned that the head of the Cleveland WPA was a Communist and that the Hungarian community there was similarly inclined, probably infuriated by the—to them—treachery of the Hungarian government joining the Nazi cause early in the war.

Reba noted that Gross-Bettelheim had entered prints in group exhibitions at the Cleveland Museum of Art annually through the 1930s, but her work did not appear in the 1933 exhibition. In 1934, she entered an etching depicting Russian Orthodox churches, *Untitled (Russian Church Towers)* (Fig. 18). Because of the hiatus, Reba suspected that Gross-Bettelheim had visited Russia. Further research indicated that the left-wing John Reed Club, of which Gross-Bettelheim was a member, organized a trip to the Soviet Union

in 1933, and that Gross-Bettelheim sold some of her prints to the Museum of Revolutionary Art in Moscow that year.

Fig. 16. Jolán Gross-Bettelheim, *Home Front*, 1942. Lithograph, 15.9 x 11.9 in.

Fig. 17. Jolán Gross-Bettelheim, *Civilization at the Cross-roads*, 1936. Lithograph, 12.8 x 10 in.

In 1938, Gross-Bettelheim and her psychiatrist husband moved to Queens, New York. The reason for their relocation—as well as their life there—is a mystery; none of the New York printmaking artists of the 1930s-40s period we knew remember meeting her. She did not work for the New York WPA. The last known exhibition of her work was in New York in 1945. After that, she disappeared, and for many years no one knew where she was, or even if she was still alive.

Shortly before our departure for Austria from New York, we were introduced to Dr. Miklós Müller, a research scientist at Rockefeller University. Dr. Müller had emigrated to the U.S. from Hungary, and for nearly twenty years had collected prints by Jolán Gross-Bettelheim. He told us that the artist remained a committed Communist who, perhaps feeling social pressure and ostracism during the McCarthy era in America, had moved back to Hungary in 1956. For U.S. art historians and collectors, she had been missing for years, but thanks to Müller, we learned that she had arrived in

Fig. 18. Jolán Gross-Bettelheim, *Untitled (Russian Church Towers)*, ca.1934. Etching, 6.9 x 7.9 in.

Budapest one month before the Hungarian Revolution, the attempted overthrow of the Soviet system in which she so passionately believed. For most of her life, she was almost predictably opposed to popular political opinion, with consistently poor timing. Müller offered to introduce us to Akos Vorosvary, a collector/dealer in Budapest who had acquired what was left of the artist's estate after her death in 1972. Our purpose was to suggest that print dealer Mary Ryan, who planned to visit in a few weeks, could serve as an intermediary, and honest broker, for the prints we wished to buy.

Armed with Müller's introduction and driving directions in Budapest, we found Vorosvary's home, a single-story brick house unusual only for the tall cyclone fence surrounding it and the presence of a large, menacing black dog. Vorosvary assured us in halting English that the dog would not attack, but we entered with some trepidation nonetheless. The frigid house was crammed with Vorosvary's collections: rocks, statuary, porcelain, glass— nothing that looked valuable. Vorosvary wore a constant frown and eyed us with suspicion. He reluctantly showed us his large pile of Gross-Bettelheim prints, which included *Home Front*. We inquired about the artist's other belongings, and were shown her easel, some paintings, and furniture, piled amidst the clutter of the house.

The atmosphere was strained. Despite our protests that we only wanted to introduce Mary Ryan, Vorosvary treated us like potential burglars. The ice never broke, and we departed, discouraged about the prospects for acquiring *Home Front* or any other Gross-Bettelheim prints from the suspicious Vorosvary. Reba muttered as we drove away, "He must be a thief, or

he wouldn't think everyone's trying to steal from him. Normal people don't think all visitors are there to rob them."

Mary Ryan had the same experience a few weeks later. No one has a more appealing, open personality than Mary, but she, too, was unable to penetrate the Vorosvary fortress, leaving empty handed. Our Eastern European print adventure was a complete bust, but twelve years later we finally managed to acquire *Home Front* from an American print dealer who was retiring from the business.

HELL

I once bragged to Reba and a gallery-owner friend that I'd deal with the devil to get the print I wanted. I never expected to, but I did. And the devil was a little old lady.

I was fascinated by the early—1930s and '40s—prints by Alexander Calder, he of mobile fame. He made few early etchings, most in tiny editions, and they reflected the style of his bent-wire sculptures and his mobiles. The champion of this group is *Score for Ballet 0-100* (1942, Fig. 19), whose title reveals Calder's association of mobiles with dance. The image is a partial "how-to-make-a-mobile" blueprint, albeit, like much of Calder's

Fig. 19. Alexander Calder, *Score for Ballet 0-100*, 1942. Engraving and drypoint, 11.3 x 14.8 in.

work, tongue-in-cheek. Winding trails of dashed lines are numbered, reminiscent of an instruction booklet. Mobile "petals" are noted with color designations. Calder is having fun. The edition size is officially fifty, but just try finding one! Almost surely, fewer were printed.

Word of our interest in these early Calders got around, and on October 2, 1988—I well remember the date—I answered my office phone.

"This is Agatha Andrews. You may know I'm an art dealer."

"Yes, I do know your name." Did I ever. Andrews was notorious for a theft, actually two, several years ago. For all I knew she was no longer in business. Why was she calling me?

"I understand," Andrews continued, "you're collecting early Calder prints, the ones before he turned to the big color lithographs?"

I gulped. Why and how would she know this? I'd never met her, or had any dealings with her. But curiosity and the ever-present urge to acquire overcame me, and I replied, "Yes, we've managed to find a couple."

"Well, I've got *Score for Ballet* and I'd be happy to show it to you."

Score for Ballet! The best early Calder print. Overcoming any scruples, I got her address and made a date to visit, fully aware of her history.

Agatha Andrews did not look like a criminal, at least based on newspaper photos and gossip—a little old lady, sixty-ish, gray hair piled high in bird's nest fashion, long droopy skirts, black sneakers—but what I remembered best from a close-up picture in the *Times* was a paperclip holding her glasses frame together.

The newspaper was 1976. She had delivered some artwork to the apartment of Ingrid Bergman, and had lingered to assist the new owner in hanging it. Soon enough, an autograph dealer reported to the police that Andrews had offered him a cache of letters Bergman had received from her former husband, Roberto Rossellini, written long after their scandalous affair, marriage, and divorce. The police were not surprised: the reclusive Bergman had overcome her fear of publicity and reported the theft just days after she was visited by Andrews.

Andrews denied the theft, but pleaded guilty to an arcane New York law about possessing stolen property and was given a slap-on-the-wrist fifty-dollar fine. The *New York Post* headlined "Secret Bergman Letters Worth $50."

Two years later, Andrews was arrested on the steps of the Metropolitan Museum following a stakeout. According to the press report, she carried into

the museum's print room a large portfolio that was rigged so that she could slip the museum's prints into it. The police had investigated for more than a year, even monitoring Andrews's trips to other cities. After press reports of the theft from the Met, the police responded to a tip and found prints valued at $300,000 in a locker at Penn Station. Other museums soon identified missing objects also found in the locker, but a definitive link was never established connecting Andrews to the train station locker. Nonetheless, she again pled guilty to possession of stolen property, and was sentenced to ten years' probation. At some point she must have returned to dealing.

With great trepidation, I ascended into Hades, Andrews's apartment on an upper floor of an East Side building, nervous about the coming encounter and feeling guilty for dealing with the devil (here female). Surprise! She could not have been nicer, and the old glasses had been replaced with a newer, stylish model. Even the gray hair was combed and tidy. Agatha Andrews certainly did not look like a devil, just a prim, little old lady. The atmosphere was friendly and welcoming, not hot, but just the same, I was definitely damp in the armpits. *Score for Ballet* was pricey. Maybe the price—but more likely my growing fear of spending life in hell—made me think better of it. I left Andrews's apartment, mumbling excuses as I fled.

Another impression of *Score for Ballet* eventually came my way and for that one I paid dearly. My bragging about dealing with the devil to get the print I wanted was not true after all.

PARANOIA

I did not visit paranoia, but it visited me more than once. Paranoia is a common affliction with collectors. It's very easy to believe that another collector, or a malevolent force of some sort, is competing unfairly for a particular object, or interfering with the open market process.

My worst attack came with my search for Charles Sheeler's *Yachts* (1924, Fig. 20). Artists love to paint or draw sailboats, and why not? What is more beautiful than a sailboat underway, with billowing sails and heeling hull? Beautiful to watch, too, from shore or on a stable, dry power boat, avoiding the miserable wet and cold of actual sailing. Or just look at artists' renditions, even easier.

Known as a Precisionist painter, for the stark clarity and perfection of his still lifes, Sheeler's prints have many of these same qualities. His take

on sailboats is in the style of his (very few) other lithographs: a light touch,
few lines, and minimum toning. With little ink expended, in *Yachts* Sheeler
provides the viewer with a thrilling sensation of sailing, all wind, curving
canvas, and grace.

Fig. 20. Charles Sheeler, *Yachts*, 1924. Lithograph, 8.4 x 10.4 in.

Fascinated by the artist's ability to produce a compelling image with so
little, we determined to acquire all of Sheeler's lithographs, five in total, and
this we did—with one exception: *Yachts*.

That's when paranoia visited. Twice I bid for the print at auction, and
twice some irrational buyer paid far more than what I considered a reason-
able price. I spotted the print in a dealer's catalogue, called, and was too late:
sold. Someone was trying to corner the market for *Yachts*, not easy to do
with an edition of sixty, large by Sheeler's standards. Obviously, a conspiracy
was underway.

I told Reba of my concerns, and she was sympathetic. There seemed to be no answer, and no way to complete our Sheeler collection.

I was surprised on my next birthday to unwrap what was clearly a framed picture. It was *Yachts*. Reba had simply called a dealer we knew well, inquired, and bought an impression, right out of the dealer's inventory. There was no market manipulation or monopoly, just my imagination—or paranoia.

AUSTRALIA

Down Under is a long way to go to buy prints, and that was not our mission. I was there to show the Alliance Capital flag, as we were trying to expand our clientele to include the pension funds of this large country. Reba came along as a dutiful workmate, but her main interests centered on nature. She planned to hold and cuddle a koala bear, see kangaroos in their native environment, and watch the fairy penguins come in from the ocean to the Melbourne beaches in the evening.

As an incentive for us to make this trip, the Alliance sales rep for Australia, who happened to be a collector of avant-garde paintings, had arranged museum tours for us. We visited the public museums of Sydney, Melbourne, and Canberra. The big painting on view was the country's pride-of-place, *Blue Poles* of 1953 by Jackson Pollock, one of his largest and most acclaimed "drip" canvases. The art world had been astounded when the National Gallery of Australia paid $1.3 million in 1973 to buy the painting from Ben Heller, the New York real-estate investor and art collector/dealer. The amount of money seemed huge at the time (a pittance by today's standards), but the Aussie government spent it to expand the image of the country beyond koalas, kangaroos, and penguins. Like the Sydney Opera House, the Pollock announced (especially to tourists), "We have culture, too." (Reba preferred the animals to the Pollock.)

Our last day in Melbourne was a Sunday. Strolling the deserted art district of the city, glancing in gallery windows, we spied two prints that were unmistakably American. We could read the pencil signatures on both. One was by an artist whose work we had acquired only a few months previously, Alexander Stavenitz. The other was by Edith Bry, a new name, but its title, *Burlesque* (ca. 1938, Fig. 21), was decidedly American. We scribbled down the gallery name, Peter Gant Fine Art, and back in New York telephoned the gallery and bought both prints. They had been brought to Australia by an American transferred by his employer to Melbourne who, when the time

came to return to the United States, didn't want the trouble of moving his art and consigned it to the gallery.

Edith Bry turned out to be of considerable interest because of her ability to capture the slightly seamy side of life, and we subsequently acquired more of her prints. A favorite is *Woman of the World* (ca. 1938-40, Fig. 22) featuring an exhausted and partially dressed woman, presumably a prostitute, wearing a large hat and fox furs. Bry, best known for her fused glass, had a seventy-five-year artistic career, and worked in many media. In New York at age fifteen, she was printing batik fabrics in a commercial shop. She married a wealthy financier, and with the architect Ely Jacques Kahn, designed and furnished an elaborate and acclaimed Art Deco apartment in the Beresford, a chic building on Central Park West. Sadly, we never met Ms. Bry or saw the apartment—she died in 1991, shortly after our return from Down Under.

Next stop, Mexico.

Fig. 21. Edith Bry, *Burlesque*, ca. 1938. Lithograph, 12.2 x 8.7 in.

Fig. 22. Edith Bry, *Woman of the World*, ca. 1938-40. Lithograph, 12 x 9 in.

Fig. 1. Diego Rivera, *Zapata*, 1932. Lithograph, 16.2 x 13.1 in.

The Mexican Muralists and Prints:
Teaching Gringos

Alliance Capital's elegant New York City office space, decorated with
framed black-and-white prints set off against gray fabric-covered walls, was
ideal for entertaining clients. Time and again, as I gave a "gallery tour," I
was asked "What is your favorite print?" My usual answer to this inevitable
question was "My most recent purchase," but it wasn't true. It was easier
to point to one on the wall, and say, "This was once my favorite," and why.
But there was another reason. My favorite print wasn't American, so it was
outside our collecting boundary. It was Mexican: *Zapata*, a 1932 lithograph
by Diego Rivera (Fig. 1).

I rank *Zapata* with other memorable images such as Botticelli's *Birth of
Venus* and God extending his hand to touch Adam's in Michelangelo's fresco
in the Sistine Chapel. Despite its small size and lack of color, I find the
picture of the revolutionary leader Emiliano Zapata holding his white horse
unforgettable. Like God and Adam and Venus, there's a mythological qual-
ity to Zapata, framed by the pure white of the revolutionary peasants' cloth-
ing and the noble white horse set off against the black of the background.

Zapata survived my divorce settlement in 1974 and came into my sole
possession along with a handful of other prints that had no coherent theme
or rationale: I'd bought them simply because I liked them, and I really liked
Zapata. Reba and I married a year later, and we wisely decided to concen-
trate our collecting on U.S. scenes by American citizens. For nearly fifteen
years, *Zapata* was the only work by a Mexican artist we owned.

However, my interest in Great Depression imagery of the 1930s and
WPA artists provided an interesting link to Mexico. Looking at illustrations
of Mexican murals, Reba noticed a stylistic similarity with many pictures in
our collection. The Mexican murals were painted in the 1920s and 1930s;
the American prints in the 1930s and early 1940s. The stylistic similarities

strongly suggest that the Mexican murals might well have influenced a generation of north-of-the-border artists.

With a little more investigation, she learned that the influence was not just from the Mexican murals, but in many cases directly from the Mexican artists who painted them. Budding U.S. artists went south to assist, and learn from, the Mexican muralists. A surprising number of these Yankee novices were young, single women, attracted by not just the Mexican art but by exotic Mexico and the Mexican masters, particularly Diego Rivera. Reba, who came of age in the conservative and restrictive atmosphere of Southern small-town America in the 1950s, marveled at—and envied—the freedom with which twenty-year-old girls in the 1920s and 1930s took off alone for the bohemian life across the border. Both of us had missed that life, but we lived it vicariously through prints.

The migration wasn't only southward. Mexican artists came north, with commissions to paint murals from California to Detroit to New York. Carl Zigrosser, director of the Weyhe Gallery, sought out these Mexican muralists, especially the three most famous, called *Los Tres Grandes*—Diego Rivera, José Clemente Orozco, and David Alfaro Siqueiros—and persuaded them to make prints for the gallery to sell. Zigrosser provided lithographic stones and the specialized black crayons, and the Three Greats took to the medium, constantly traveling from the United States to Mexico and back, depending on the location of their mural commissions. Zigrosser solved this logistical problem by mailing—regular U.S. mail—lithographic stones from New York to wherever the artist might be working. The artist would draw an image on the stone, and mail it back to Zigrosser or directly to Zigrosser's preferred print shop—that of George Miller—for printing. Never mind that the stones might weigh up to forty pounds. Miller's shop would print the edition and mail all the prints back to Mexico for signing. And back they would come to the Weyhe Gallery, signed and ready for sale. This long-distance printmaking continued until the late 1930s, when an artistic lithographic print shop was finally established in Mexico City.

Fifty or more years later, the Weyhe Gallery still had a stock of prints made by *Los Tres Grandes*. We decided to acquire this work, particularly images that were mural details or that reflected mural style, because of its link with and influence on American art. Reba defined the style as narrative, usually with heroic figures and often with a social message and a full

picture plane—no blank sky or open spaces—and a high horizon line or none at all, little or no perspective or depth, and crammed with people, or animals, or objects, or all of these.

There was little doubt about the influence. The artist Will Barnet told me:

Orozco was one of my great gods—he was a great genius, I loved his work. You could say Orozco was my mentor. He has these straight, prominent lines and direct forms, which I incorporated in my 1930's prints. And Orozco's inspiration was mine, too—social themes, the problems of the poor, laborers, social strife.[1]

Jackson Pollock fell under the spell of two of *Los Tres Grandes*. When he saw Orozco's murals at Pomona College in 1930, Pollock remarked, "The real man is Orozco, and his *Prometheus* at Pomona is the thing to look at."[2] Pollock later worked with Siqueiros at the latter's Experimental Workshop in New York, established to explore the use of new and different materials and tools, such as using an airbrush to spray paint onto a canvas or wall. It can be argued that this freedom of technique, encouraged and developed at the Experimental Workshop, influenced Pollock towards his drip, or poured, paintings.

The Mexican muralists' influence on American art of the 1930s was unmistakable. We just didn't know enough about the Mexican murals themselves. Illustrated art books, in print or out of print in the late 1980s, gave short shrift to what was actually happening in Mexico—with murals or any other art. There was only one way to learn: go to Mexico and look at the murals themselves.

Our knowledge of the country was limited. I'd visited the Texas border towns in my youth, and Reba and I house-partied in Acapulco—all of these visits more oriented to margaritas than art. We could find no published guide to Mexican murals. Fortunately, the Metropolitan Museum of Art was organizing a big exhibit of Mexican art—mostly pre-Columbian—to be opened in 1990, and had established a small office in Mexico City. The office head, Wendy Schonfeld, agreed to give us a several-day tour of the murals.

Wendy did as much research as she could on what murals by which artists could be found, but even her information was sketchy. Mexico's great twentieth-century art was hardly documented. Forget about learning which days or hours churches, office buildings, schools, restaurants, union halls, and other locations where murals were rumored to exist could be seen. We were jumping off into the unknown.

THE MEXICAN MURALISTS AND PRINTS

Undaunted, we and a small group of art-interested friends flew to Mexico City in early 1990, braving the city's notorious permanent cloud of smog. Wendy had found us a driver with an ancient limousine, so with watery eyes and hacking coughs, we lined up with the other zillions of cars in Mexico City's clogged streets (nothing like government-subsidized 5¢-per-gallon gasoline to create a perpetual health hazard and traffic jam), to begin our quest.

Our initial destination was the first mural commissioned by the Mexican federal government: Diego Rivera's *Creation*, completed in 1922, in the building known as *Prepa*, which was at the time a school for upper-class boys—uniformly Catholic privileged children of the Establishment. Rivera, along with Orozco and Siqueiros, who were also paid to paint murals in the building, produced works that were mostly anti-Establishment, anti-Church, and anti-capitalist. The students protested in 1924 and defaced some of the images. The murals were restored; the school eventually closed.

This protest was a microcosm of the political divide that has racked Mexico since its independence from Spain in 1810 and as recently as the near civil war in Oaxaca in 2006, with revolutions, uprisings, coups, and wars with the U.S. in between. The mural movement was itself sparked in the aftermath of the 1910 revolution, when the victors launched a propaganda campaign to extol the revolutionary virtues, defined as the triumph of the downtrodden over the exploiting capitalists. Artists were paid to express these ideals in murals, art for a population that was largely illiterate but could understand pictures.

For five days, we crisscrossed Mexico City, as well as Cuernavaca and Guadalajara, finding murals in both obvious and obscure places. As we went, we compiled our own location guide. Fortunately, in recent years the government has awakened to the tourism potential of the murals, so that published guides and art books illustrating the murals are now available.

A must on our list was the 1930 Zapata mural on which the print *Zapata* is based, part of an extensive *History of Mexico* mural in the Palacio de Cortes in Cuernavaca, once known as a city of flowers. By 1990, the flowers were all behind high walls. Although Cuernavaca is a smaller version of Mexico City, it has identical problems: traffic jams, pollution, and crowded sidewalks. The high walls serve a purpose.

The Palacio de Cortes is relatively serene, perhaps because the days and hours it is open are erratic and unreliable. But the minor frustrations are

worth the bother: Rivera's murals are grand. To view the mural—which is outdoors and protected by a cantilevered roof—one walks alongside it and starts with the early history: the wars between indigenous peoples and the conquest of central Mexico by the Aztecs, including the human sacrifice required by their religion. Next come the Spaniards and their priests, spreading the word of God, pillaging for gold to keep the Spanish Empire intact, and enslaving and killing the native population. The American ambassador to Mexico at the time, Dwight Morrow (the father of Anne Morrow Lindbergh), who financed the mural, insisted on including one noble priest. Rivera complied, but left the figure unfinished as a protest. Final steps bring the viewer to the 1910 Mexican Revolution and Emiliano Zapata holding his white horse. Unfortunately, because the Zapata panel is at the end of the line, it is less well protected from rain and has faded. The Plexiglas that now covers the mural came late.

There remains one improbable mural location that even today isn't frequently visited by art aficionados: the Mercado Abelardo Rodriguez, a big, sprawling marketplace right in central Mexico City. The Mercado was an urban renewal project that replaced a blight of street markets and was named in honor of an interim *presidente* who had made his wealth as a bootlegger and casino owner.

In 1934, an American-turned-Mexican citizen, Pablo (born Paul) O'Higgins, won a commission to cover the walls of the Mercado with murals. O'Higgins hired other artists, both Mexican and American, to do the job. The artists, mostly little known, included two American sisters in their mid-twenties, Grace and Marion Greenwood, who were considered by Rivera the greatest female mural painters. The Greenwood sisters were also quite good looking, a feature surely not lost on the womanizing Rivera. It's difficult to see the murals in the Mercado—food stalls, piles of merchandise, light fixtures, counters of all types of goods, and swarms of sellers obscure the walls—but the works on those walls are worth the journey: rarely seen, and created by artists lost to history.

Wendy said that she had spoken to Señora Pablo O'Higgins, widow of the artist, during her search for murals and mentioned that some members of our group were print collectors. We were delighted to hear that Señora O'Higgins was eager to invite us to her home and show us some of her husband's prints. In fact Maria O'Higgins not only showed us prints by her husband but also

prints by other lesser-known Mexican artists owned by a neighbor, including several whose murals we'd seen at the Mercado. A real find! These were prints that had never traveled to the Weyhe Gallery or anywhere else north of the Rio Grande, and we were back in familiar collecting territory, wonderful images by obscure artists. We departed with a dozen prints.

These prints were made at Taller de Gráfica Popular, founded in 1937 and which supplanted George Miller in New York as a lithographic print shop for Mexican artists. A series of noted printmakers had worked in Mexico over the centuries, including José Guadalupe Posada, just preceding *Los Tres Grandes* and the mural movement. Posada's prints have been called the initiator of the modern spirit in Mexican art, with their critical and humorous commentary on politics and social mores. All muralists were certainly familiar with Posada, and despite their mission to uplift the populace with stirring images, they let a little cynicism creep into the murals, and more particularly their prints.

We visited the famous Taller, now shabby and down at heel, but still active. This rather pitiful print shop, with its small and ancient machinery, was probably little changed from its late 1930s origins. The leading printer had only one arm, a distinct handicap for handling the rolling-pin-type device customarily used to spread ink on a lithographic stone. He overcame this disadvantage by attaching a device to his shoulder that connected to the rolling pin and inked away! The Taller still had some of its pre-1950 (our target period) prints for sale, so we added a few more to our inventory.

As satisfied as we were with our new acquisitions and the thrill of having seen so many magnificent murals, we concluded our trip with a sense of melancholy, remembering that the first printing press in the Western Hemisphere was installed in Mexico City in 1537, and thousands of secular and religious images have emerged from this great cultural center. The decrepit Taller, its one-armed lithographer, and the scarcity of documentation on mural locations all spoke volumes about the decline of art appreciation in and about Mexico in the late twentieth century. It was a far cry from the glory days of the muralists fifty years earlier. Economic stagnation and inept, corrupt government had taken their toll on the arts.

Now we had to get our stack of newly purchased prints home. I was more than a little anxious. Exporting art items is forbidden by Mexican laws aimed at stopping the illegal sale of pre-Columbian artifacts ransacked from

ancient tombs. Did these restrictions apply to prints of the 1930s and 1940s? I
decided not to ask. So into our largest suitcase went about twenty prints, not
a comfortable fit. We had to curl some edges, which was sure to induce wrin-
kles, but good paper is very durable and I was confident restoration could fix
whatever damage ensued. In an era before X-ray scanners, we were waved
through customs at the airport, and we and our bag of prints were quickly
and with great relief on Aeroméxico en route to JFK. I never wanted to be a
criminal print collector, and to this day I don't know if I was or was not.

Visiting the murals in Mexico reinforced our conviction about their
influence on American artists, and we returned to the prints in our collec-
tion, trying to discover mural characteristics. Howard Norton Cook's *Fiesta*
(Fig. 2), which we had acquired some years earlier, is a prime example of
mural influence, or what Reba began to call *muralismo*. In *Fiesta*, the image
is crammed with people and things—there's no open space. Sombreros,
bottles, tent tops, and flags are carefully arranged to fill all available space,
to create the lively patterns and movement in the crowds that one would
expect in a busy fairground.

Cook made *Fiesta* in 1933, during his first visit to Mexico. That visit
was financed by a Guggenheim Fellowship to study fresco techniques that
would allow him to paint public murals in the U.S. Cook also planned to
make prints, and he took an etching press and plates with him. He visited
the major mural sites, concentrating particularly on work by Rivera. His pre-
Mexico images were precisely drawn New York buildings and New England
landscapes, but in Mexico he concentrated on the human figure. He settled
for a while in Taxco to make prints, of which *Fiesta* is one. When he re-
turned to the U.S., his artistic style continued to reflect mural influence.

George Biddle, progenitor of the WPA Federal Art Project thanks to
his letter to President Roosevelt, was also an artist, and in 1936 he spent a
year teaching and making prints at the Colorado Springs Fine Arts Center.
One of these is *Sand!* (Fig. 3), an image with social implications: a desolate
scene of an abandoned farm, cow skeletons and wagon wheels on a pile of
dirt, and dark, dusty skies overhead. Carl Zigrosser described it as Biddle's
"contribution to the Dust Bowl phase of American art."[3]

Biddle continued to visit Mexico regularly. In 1945, he won a commis-
sion to paint a mural in the Supreme Court of Justice building in Mexico
City, which we visited during our trip. The image is identical to *Sand!*, only

Fig. 2. Howard Norton Cook, *Fiesta*, 1933. Drypoint, 14.3 x 10.7 in.

Fig. 3. George Biddle, *Sand!*, 1936. Lithograph, 9.9 x 13.8 in.

SMALL VICTORIES

multiplied in size and in color. From a small lithograph to a huge fresco, ten
years later.

Fletcher Martin worked with Siqueiros in 1932 on the mural *Portrait of Present Day Mexico* in the Santa Monica, California, home of film director Dudley Murphy. Martin painted many murals, often reflecting Siqueiros's thinking and his art, notably in his 1938 print *Trouble in Frisco* (Fig. 4). Both in Mexico and the United States in the 1930s, conflict and violence were common in labor relations, particularly among longshoremen: workers attempted to strike and unionize; bosses hired scabs to break strikes and discouraged unionization with intimi-

dation and physical violence. *Trouble in Frisco* also reflects Siqueiros's Mannerist style, with the exaggerated fist swinging out towards the viewer and the falling fighter about to topple off the wharf and out of the picture plane. Martin knew his subject well; he had been a boxer while serving in the U.S. Navy.

My favorite mural-style print by an American artist probably has more to do with the subject matter than the quality of the art. *Spindletop-1901* (Fig. 5) commemorates the discovery of the first major oil field in Texas at Spindletop. The artist was Alexandre Hogue, and he made the print in 1941, forty years after the event. Hogue spent his life in Texas

Fig. 4. Fletcher Martin, *Trouble in Frisco*, 1938. Lithograph, 11 in. (diameter)

and Oklahoma, and here he tells the Spindletop story in the narrative style of Mexican murals.

The central figures in the mural-like print are Captain Anthony Lucas, with mustache and goatee, shaking hands with Pattillo Higgins—these men were partners, and had run out of money before they could complete drilling their first well. Unbeknownst to Higgins, Lucas—an Austro-Hungarian who de-Germanized his name, took American citizenship, and commissioned himself "Captain"—went north for financing. He found money in Pittsburgh (the Mellon family), secretly brought Yankee dollars to Texas, and diluted

Fig. 5. Alexander Hogue, *Spindletop-1901*, 1941. Lithograph, 12 x 16.1 in.

Higgins out of their partnership. The drilling resumed, and in came the Lucas Gusher—the first well on Spindletop. The fire is history: oil from the gusher ran wild for days and was drained into a depression, forming a lake, which accidentally caught fire. Spectators, probably from nearby Beaumont, can be seen at the right viewing the spectacle. In the upper right corner of the image, time has passed and the Spindletop field has been more fully developed with more wells. Taken together, the print is a perfect example of a simultaneous narrative—a single image telling a story that stretches over years. The Mexican muralists utilized this technique, but it had its origins as far back as the Middle Ages and was widely employed in Italian Renaissance frescoes.

My high regard for this image goes back to my birth and youth in Beaumont, Texas. My grandmother's favorite fishing hole in southeast Texas was Hildebrandt Bayou, and to get there from town we drove through the Spindletop field, still pumping oil then as it does today. The wooden derricks in the upper right corner of *Spindletop-1901* were a familiar sight.

As soon as we got home with our prints purchased from Maria O'Higgins and the Taller, Reba went to work selecting American prints that met her

definition of mural style, matched them with our Mexican prints, wrote a catalogue, and created an exhibition she titled *The Mexican Muralists and Prints*, thematically the influence of Mexican muralists on American art. And sure enough, about a year after our trip to see the Mexican murals, we were back in Mexico City to see an exhibition she had created. It was shown at the Franz Mayer Museum, a converted monastery, now a private museum in a lovely old building complete with a courtyard with flowering trees. The director had Reba's catalogue translated into Spanish, and the Mexicans obviously enjoyed the idea of their artists teaching the gringos how to do something. A critic for a local newspaper wrote a long review emphasizing that point.

The Franz Mayer Museum exhibit was noticed by Mexico City art dealers, and we were soon being offered prints by artists new to us. Once started, we couldn't stop acquiring. In a few years, we had some two hundred prints

by more than fifty Mexican artists, dating from the late 1920s to the early 1950s. Among our prizes was Frida Kahlo's only print, *Frida and the Miscarriage* (Fig. 6) a lithograph she made in 1932 in Detroit while her husband was painting his famous murals of the Ford Motor Company factory. Diego Rivera wrote about the events that led up to her making the print:

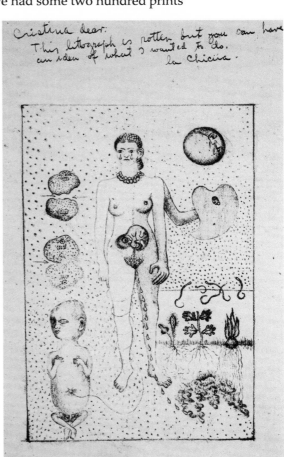

Fig. 6. Frida Kahlo, *Frida and the Miscarriage*, 1932. Lithograph, 8.7 x 5.6 in.

> Three years before, in Mexico, Frida had been one of the victims in a horrible traffic accident. A bus in which she was riding had collided with a trolley car. Only five passengers in the vehicle had escaped with their lives. Frida was carried from the scene literally in pieces. Her vertebral column, her pelvis, and her left arm were fractured. Her right leg was broken in eleven places. Still worse, an iron rod had pierced her body from one side to the other severing her matrix.
>
> The doctors were unable to understand how she had survived. But

she had not only survived, she became her lively self again. However, as a result of the accident, she would never be able to carry a baby, and the doctors warned her not to attempt to conceive.

For Frida this was a terrible psychological blow. Since the age of twelve, as a wild and precocious schoolgirl, she had been obsessed with the idea of having my baby. When asked her greatest ambition, she would announce to her flustered teachers and schoolmates, "To have a baby by Diego Rivera just as soon as I can convince him to co-operate."

Frida was not deterred by the doctors' warnings. While we were in Detroit, she became pregnant.

Her pregnancy was painful. The many women with whom Frida had made friends in Detroit, who had come to love her, did everything in their power to help her have the child. With the best of care, however, she suffered a torturous miscarriage. She became so ill that I forbade her ever to conceive again.[4]

Kahlo was three-and-a-half months pregnant on July 4, 1932, when she lost her baby. She was dangerously ill and spent nearly two weeks in the hospital. While she was recuperating, she began to work out her pain in her art. She begged for a medical book so she could see what the lost child would have looked like. When Rivera brought it to her, she sketched a male fetus, an image she would incorporate in other work.[5]

After she left the hospital, Kahlo remained profoundly depressed, creating a series of paintings and drawings about her loss. For the only time in her life, she turned to lithography. As she wrote to Mrs. John D. Rockefeller on January 24, 1933, ". . . and sometimes I go to the crafts school and I made two lithografs [sic] which are absolutely rotten."[6]

Apparently, only one of these lithographs—*Frida and the Miscarriage*—survives. Lucienne Bloch was assisting Rivera, and she and Kahlo became good friends. Bloch, an accomplished lithographer, helped Kahlo with the print and reported that twelve impressions of *Miscarriage* were pulled.[7] (We were able to identify the location of seven, including ours.) However, as indicated by Kahlo's handwritten inscription at the top of the sheet, she was not pleased with the outcome. Despite the artist's disparaging comments about her own work, we were thrilled to own a copy of the only print made by this iconic artist. The image and style are very similar to her paintings of later years, so she must have developed greater confidence in her ability.

Lucienne Bloch recorded Rivera's work in Detroit in her 1933 lithograph,

Muralist at Work (Diego Rivera) (Fig. 7). It captures the artist very realistically—
round of figure and hefty (note the slightly sagging board on which he sits).

In just a few years, we had assembled a group of Mexican prints comparable in size, breadth, and quality to our American collection—adjusted for the relative sizes of the two countries. Reba geared up to create her *magnum opus*: a traveling exhibition of Mexican prints and a catalogue that would contain much of the research we'd accumulated on the topic. The illustrated catalogue documented the twelve (of a total of thirteen) prints made by Rivera, all of Rufino Tamayo's 1920s woodcuts (acquired from Weyhe Gallery), extensive examples of work by Orozco and Siqueiros, a total of 156 prints by forty-seven artists. The exhibit opened at the Fitzwilliam Museum in Cambridge, England, and traveled to six other museums, including Madrid, Brooklyn, and Cleveland, from 1997 through 1999.

Fig. 7. Lucienne Bloch, *Muralist at Work (Diego Rivera)*, 1933. Lithograph, 12 x 9.4 in.

The Mexican prints returned home, and with their arrival came the realization that we had to do something about the future of the collection. My retirement, and an eventual move out of the Alliance Capital building—meaning our personal offices and all of the prints on the walls and in storage, the library, the files—had to find a new home, someday soon.

We always knew we'd have to slim down the collection. We had more American prints than we could possibly house, let alone all the Mexican, now sitting in moving crates. We had a similar problem in London, with over two hundred of our British prints on the office walls there . . . and no place to take them. The easiest way to whittle down the holdings was to start with the Brits and Mexicans. The most efficient and quickest means to deaccession was auction, and Sotheby's was eager to get both collections. A year or so later, my retirement date set, we committed, and in the fall of 2001 the Mexican prints would be sold in New York, followed by the British in London. Decisions made and contracts signed, off we went on holiday to France.

We spent September in Sainte-Maxime, France, on the Riviera—we could stay the entire month now that my responsibilities at work were easing.

One day our afternoon nap was disturbed by a phone call from the New York office, and a secretary with quaking voice said, "Turn on your TV—it's terrible!" The call, of course, was on September 11. Like the rest of the world, we glued ourselves to the television set and followed the entire horror electronically. But as we were to learn, we were more detached from the event than people in the U.S., particularly New York. Life went on as usual on the Riviera, except for a few American flags, U.S.A. T-shirts, and words of sympathy from acquaintances in the marketplace. The sun, blue sea, good food, and casual Riviera life insulated us from the shock felt in America.

We stayed the entire month and arrived home just in time for our Mexican print auction. At the sale, we were surprised and concerned at the scant attendance—there were no more than fifteen people in the room—and only one Sotheby's employee on the phone. The auction house had front-end loaded the sale, so that the most desirable items came up early, a technique to get buyers into the sale from the start.

The sale started slow, with no bids for a few items, and others barely reaching their reserve prices. I was stunned; a disaster was in the making. The Kahlo came up, and even this rarity was getting only grudging bids. Reba nudged me, "Dave, buy it back!"

I was paralyzed. I did nothing but sit in a trance, horrified at the results we were seeing. The sale lumbered on, and in the end only about two-thirds of the lots sold.

I've replayed those moments in my mind, and dearly wished I'd stood up and announced to the room that the sale was cancelled. But I did not, and we were stuck with a miscellany of about sixty Mexican prints. The Kahlo, all but one of the Riveras, and most of the Tamayos, Orozcos, and Siqueiroses were gone at give-away prices. We were furious at Sotheby's— they should have warned us that there was little buyer interest. Art sales in America had gone into deep freeze following 9/11, and we didn't know it. We were too long away from New York to comprehend the 9/11 effect. But I was mostly mad at myself for not intervening and stopping the sale.

A week later, the results were very different in London. Peter Watson, the art journalist who had recently published his exposé of the Sotheby's-Christie's price-fixing scandal, wrote a glowing review of our upcoming sale

in the *Times*, identifying ours as the largest collection of British Modernist prints in private hands. The auction was a blowout, just the opposite of what happened in New York. SRO in the auction room—we were lucky to get seats. Lot after lot sold above the high estimate, and every single lot sold—a rare circumstance. No 9/11 effect in the London art market.

We donated the remains of our Mexican print collection to the British Museum. With this group of prints, the museum decided to create a Mexican print exhibit to add to a major exhibition titled *Moctezuma: Aztec Ruler*. Both exhibits opened a few years later in 2009; the print exhibition was titled *Revolution on Paper: Mexican Prints 1910-1960*. We attended the opening, happy to see many of our old friends on the walls. Appropriately, the catalogue cover illustration was *Zapata*. Thanks to our donation and those of others, the British Museum now has the most complete collection of Mexican prints from the first half of the twentieth century in Europe and one of the best worldwide. So some good came out of our disastrous sale at Sotheby's.

A little more good came, too. The Philadelphia Museum of Art mounted a major exhibition of Mexican prints in 2006. It was the right venue for this. Following his career as director of the Weyhe Gallery, Carl Zigrosser became print curator at Philadelphia. He donated his own collection of Mexican prints to the museum and acquired more, making the Philadelphia Museum of Art the major holder of this work. The exhibition was *Mexico and Modern Printmaking: A Revolution in the Graphic Arts, 1920 to 1950*, and John Ittmann, print curator and an expert on Mexican prints, wrote and edited the large, scholarly catalogue. He wrote in the "Acknowledgements" section:

> . . . the authors have made full use of the research of many scholars and curators in an expanding field. In particular, they wish to acknowledge the scholarly endeavors of the collectors Dave and Reba White Williams, who in recent years have made such substantial contributions to modern American and Mexican print studies.[8]

A bit of redemption—at least Reba's research was recognized. But it's a painful memory for us both, scattering parts of our Mexican collection for minor financial reward, and wishing we had the Kahlo *Miscarriage* back. This is one case where there will not be another copy available for acquisition. Ours went to a museum.

Fig. 1. Paul Revere, *The Bloody Massacre perpetrated in King Street, Boston, on March 5th, 1770, by Party of the 29th Reg*, 1770. Engraving, 9.8 x 8.8 in.

Early American Prints: Revolution, Audubon, and the Etching Revival

Thanks to Longfellow, Paul Revere is best known as a Revolutionary War messenger, but his primary occupation was silversmithing, as shown in John Singleton Copley's famous portrait of him holding a silver teapot and stroking his chin. Revere is little known as a printmaking artist, yet he was—one of America's earliest and best. The strong, steady hands required for working and engraving silver are equally effective at engraving a copper plate. The Revolutionary War was his subject, and his most famous print—indeed, the most famous eighteenth-century print by an American—is *The Bloody Massacre* of 1770 (Fig. 1), depicting a squad of British soldiers firing on a rowdy mob of American civilians. Revere printed this engraving in black ink on white paper that he and other artists later colored by hand, using watercolors—mainly to show the red of the British Redcoats, clearly marking the enemy.

In the nearly forty years of our print collecting, *The Bloody Massacre* came up for sale only once, as far as I recall, in the early 1980s. We were so concentrated on twentieth-century work, we let it pass—to our regret. In print collecting—indeed, any collecting—as in much else in life, it's the errors of omission, not commission, that linger painfully in memory. When we had a chance at another famous eighteenth-century American print, we did not pass up the opportunity.

Some ten years later, Joe Goddu, head of the print department at Hirschl & Adler Gallery, called. "We've just acquired what I think is the only copy of Charles Willson Peale's only engraving. You should own it. It comes with the copper plate as well. It's impossible to get any of his prints—they're all in museums."

Having vowed to focus on the twentieth century, we were well on our way to creating our collection. But just the same, we raced to Seventieth Street, then the home of Hirschl & Adler, intrigued by the possibility of own-

ing a rare eighteenth-century print by one of America's most renowned artists, a true Renaissance man—scientist, philosopher, and author as well as artist.

Fig. 2. Charles Willson Peale, *Untitled (Entrance Ticket to the Peale Museum)*, 1788. Copperplate and engraving, 2.5 x 3.5 in.

Hirschl & Adler, then as now, is the ultimate "Uptown" gallery, a beautiful, immaculate space filled with paintings and sculpture, mostly nineteenth-century American, each object carefully placed and lighted to present the art at its best: a high-quality museum that also sells art. Joe Goddu greeted us at the door, led us upstairs to the print department, and produced the small print (1788, Fig. 2) and the matching copper plate, explaining, "This is an actual ticket to Peale's museum of natural history, the first of its type in America, located in Philadelphia. Look at the animals and exotic plants in the border. The pelican has a fish in its bill. They are extremely well made, and amusing. The inscription on the ticket advertises 'containing the WONDERFULL works of NATURE and CURIOUS works of ART.' It's dated 1788. He printed his own entry tickets from his own engraved plate—you see the entry price is twenty-five cents, pretty rich for the time. His son, Rubens, signed and numbered the ticket—No. 2015. Rubens was helping his father run the museum."

Reba looked at me. "We've got to have it. It doesn't work with our collection, but it's a great historical object."

"Peale made his first prints—mezzotints—in 1787, portraits of famous Americans, like Washington and Franklin."

I was surprised to hear this. "Don't you mean someone else made the mezzotints, copying his paintings?" I couldn't envision the elegant Charles Willson Peale, always portrayed in immaculate colonial dress, sweating as he ground away on a copper plate—a very messy job—to prepare a mezzotint.

"No, he did all the work himself. He must have been tireless. He scored the copper plates, then burnished them to bring out the image. Maybe a professional printer ran them through a press. He also made an etching—only one, I think. It's interesting."

"You've seen it?" Reba asked.

"I saw a copy at Winterthur, the decorative arts museum in Delaware. I don't know of any others. It's a clever image."

Taking out one of his reference books, Joe found the illustration, titled *The Accident in Lombard Street*. The caption added that it was the first of a planned series of Philadelphia street views, but this was the only one Peale ever made. It showed a maid who had dropped a platter of food, breaking the dish and strewing the food in the street. Spectators are mocking her and dogs are barking.

Reba reached for the book and read out the inscription on the print, no doubt written by Peale himself. "The pye from Bake-house she had brought/ But let it fall for want of thought/And laughing Sweeps collect around/The pye that's scatter'd on the ground.' It rhymes. Peale's a poet, too."

"He stopped making prints after 1787-1788," Joe continued. "He devoted all his time to oil painting and his natural history museum. This ticket is the last print he made."

I confirmed Reba's instinctive reaction about the print. "Not only is it good quality art, however small, but it's a token of a major American Enlightenment figure. We can't resist." And so it became ours.

What made *The Bloody Massacre*—and Revere made other prints as well—and the Charles Willson Peale prints so valued by collectors was their uniqueness: American artists making prints of American scenes in America before and just after independence. Most of the prints made and sold in the late eighteenth and early nineteenth centuries were by European artists, not Americans. There just weren't very many American artists, and even fewer American printmaking artists. But European printmakers were attracted to America and American subjects: new images and a new market. An example is John Trumbull, an American artist whose prints were made in Europe.

Trumbull was a painter of historical scenes. His most famous painting is possibly the dramatic *Death of General Warren at the Battle of Bunker's Hill*, made in 1786, eleven years after the event. The sky is dark with low rolling clouds. Opposing soldiers stand tense, swords drawn and muskets pointed. At center stage is the dying General Warren, the first significant casualty of the American Revolution, serving as a private solder because his commission was not effective until two days after the battle. The heroic Warren is emblematic of the event: America lost the battle and was forced to retreat, but not before inflicting great losses on the British. The victorious British commander, General Henry Clinton, wrote in his diary that "A few more such victories would have surely put an end to British dominion in America."[1]

Fig. 3. James Mitan, *The Battle of Bunker's Hill*, 1808. Engraving, 14.4 x 19.5 in.

Trumbull created this painting for the purpose of having a print made *after* it; he believed that this stirring image would be popular with patriotic Americans, and prints were multiples, much more affordable and available. He carted the painting to London, where he engaged a publisher, Antonio de Poggi, who took the painting to the studio of engraver Johann Gotthard von Müller in Stuttgart, Germany—there was probably no independent publisher of prints, or printers, in America, only the artists themselves. Von Müller copied the painting and printed the engraving in 1808 (Fig. 3). With a Franco-German war approaching, Trumbull journeyed to Stuttgart, retrieved his painting and the engraved plate, and brought them home to America.

The point of this story is twofold. One, global travel moving paintings around is not strictly a recent phenomenon. Second, and most important, is *after*. This term is ascribed to a print that is a copy of a painting, but the print is made by an artist or craftsman other than the artist who painted the picture.

Once we stuck our toes into eighteenth-century prints, I acquired *The Battle of Bunker's Hill*, despite it being an obvious "after." But it turns out that our copy of the print is an after *after* an after. The name James Mitan appears as the engraver, John Trumbull as publisher, and it is dated 1808, New York City. The suspicion is that Mitan made an engraving based on von Müller's engraving, given that there are small differences between the two prints.[2] Afters

became popular—and widely collected—as the nineteenth century progressed.

A famous example of "after" prints is *The Birds of America*, which replicate the watercolor paintings of John James Audubon, artist and ornithologist. The "after" designation doesn't quite tell the story here, because like John Trumbull and *Bunker's Hill*, Audubon made his bird paintings to be used as models for prints. Somewhat more involved with the process than was Trumbull, he selected the printer and supervised the first few of the images printed and colored by hand. Collecting these prints is such a specialized, complex field, with images so startling and different from everything else, that collectors of Audubon prints usually collect nothing else, and collectors of other types of prints rarely collect Audubons. Though we never collected Audubons, Audubon and his art are important in the history of American printmaking and deserve mention here.

Audubon was born in Haiti in 1785, grew up in France, came to America in 1803, and became an American citizen in middle age. He couldn't find printers and artists in America who could create the prints he wanted, so he took his watercolors to England, and the prints of *The Birds of America* were made there by Robert Havell and his son, Robert, Jr., over the period 1827 to 1839. The Havells utilized several printing techniques, including etching and engraving, to copy the paintings, then had the prints hand-colored by expert (English) watercolorists. All the birds are depicted life-size and represented in exquisite detail.

The complete portfolio consists of 435 prints on large—39" x 29"—high quality, sturdy Whatman paper. The paper is called "double elephant," a term used by book printers to emphasize unusually large size. Audubon himself sold the prints by subscription in the United States, England, and France. Subscribers paid as the prints were delivered—or failed to pay. Among the notable deadbeats was Daniel Webster, "The Great Orator," who left a trail of unpaid creditors in his wake as he devoted his energies to politics and statecraft. Webster received the first three hundred sheets of the Audubon portfolio, for which he only partially paid. Speculation is that Audubon never delivered the remaining prints because of Webster's delinquency. As a result, Dartmouth College's Rauner Special Collections Library, where the Webster-owned prints eventually landed, owns an incomplete set. Audubon needed a professional bill collector. He also got stiffed by King George IV.[3]

With some subscribers like Webster owning only partial sets, and many

portfolios being broken up for various reasons, complete sets are rare today and most are in museums. Nor is the total number of impressions of each print known; experts estimate 175 to 200 of each print were made. There have been subsequent editions made from the original copper plates, but these are only partial sets because many of the plates were lost or destroyed. These later editions complicate collecting and valuing issues, due to lower-quality printing and coloring. Audubon's son John commissioned a small-scale color lithography version, the so-called Bien edition—Julius Bien was a New York printer—but the Civil War interrupted the project, and less than one-half of the original series was reproduced.

The original 1827 subscription price for the 435 prints was 175 British guineas, or $870 at the then-official exchange rate. In 2010, Sotheby's in London auctioned off a complete Havell set for $11.5 million, setting a record (since eclipsed) for the most expensive printed book sold at auction, bought by Michael Tollemache, a London art dealer and avid bird watcher.[4] The original owner was the botanist Henry Witham, subscriber number eleven as recorded in Audubon's ledger. Audubon noted in his journal that he dined with Witham on December 3, 1826, writing "I determined in an instant that this gentleman was a gentleman indeed."[5] Witham probably paid in full.

Charles Willson Peale stayed in our minds, partly because of his progeny. As art historians know, he named all his children after famous artists, including Rubens Peale, the signer of the museum ticket. Another son, Rembrandt Peale, was an active printmaker, suggesting that the art-making impulse in this family was very strong. Several generations later, his descendant Ella Sophonisba Hergesheimer made prints. We had collected Hergesheimer's floral lithographs, done in the 1920s and 1930s, and Reba was intrigued with the family's long printmaking history, so we decided to go back in time with our collecting and look at Rembrandt Peale's work—if we could find it.

Find it we did at the aptly named Old Print Shop, located downtown on Lexington Avenue at Twenty-Fifth Street. There's nothing modern or slick about the décor in this old-fashioned place. On its creaking wood floors stand bins and drawers of prints, while others are hung frame-against-frame on the walls, or stacked on tables. There is barely room for a customer to move around its huge inventory of prints. This is a place for a serious collector to search for and acquire prints. Although the owner and proprietor, Robert Newman, was not in the gallery the morning of our hunt for

PATRIÆ PATER

Washington.
From the Original Portrait Painted by Rembrandt Peale.

Fig. 4. Rembrandt Peale, *Patriae Pater (Father of His Country)*, 1827. Lithograph, 19.1 x 15.3 in.

Rembrandt Peale, we were invited to paw through the bins and stacks by a gallery assistant who helped us search.

We soon uncovered two portraits of George Washington, a Rembrandt Peale specialty, both with inscriptions noting that Peale had himself drawn on the lithographic stones. The prices seemed too low at $750 and $1500. We were assured that these prints weren't all that rare, and the condition wasn't perfect for either. Reba believed otherwise about one of them, *Patriae Pater* (Fig. 4), in which the portrait of the Father of Our Country is seen through a stone surround covered with a garland of leaves and topped by a mask. She thought

this a very rare print, and as usual, Reba had done her homework. She was busily researching the Peale family lineage, searching for a family of printmakers, Charles Willson to Rembrandt to whom? to Sophonisba Hergesheimer . . . a typical American print research opportunity, still waiting to be exploited.

Patriae Pater was early—made in 1827. Lithography was invented in 1798 in Germany, and this was less than thirty years later in frontier America. We argued with the dealer assistant about the rarity of *Patriae Pater*, asking, "Are you sure this is priced at only $1500?" The last thing we wanted to do was take advantage of a dealer on whom we depended for future supply. We were assured the price was fair, so we paid and went away with both Rembrandt Peale prints.

A few years later, the Childs Gallery's annual sales catalogue arrived. On the front cover was *Patriae Pater*. The catalogue had this to say about the print:

> The Washington image is rare—Peale said the stone was spoiled after only a few impressions. This exceedingly rare print was one of the first major lithographs made in America during the first two years of American lithography by the important American artist Rembrandt Peale.[6]

Childs was offering the print for $9500.

We have not always been so clever. We made many mistakes, mostly early in our collecting activities, and we did learn a few things the hard way.

In 1974, we were furnishing our first country house, a small place in Amagansett, Long Island, that Reba had bought before we married, in late-nineteenth-century style. We had acquired some furniture and a few objects of the period, and a couple of late-nineteenth-century American advertising posters. What better to add to this than an original Currier & Ives print?

Currier & Ives, a printmaking firm active from 1834 to 1907, was a major force in making prints of interest to the American public. Employee artists drew on lithographic stones, usually copying a drawing or painting by another artist. The company specialized in images such as landscapes, frontiersmen, farms, patriotic scenes, trains, and riverboats—idealized visions of sometimes harsh realities. The firm turned out thousands of impressions of over seven thousand images, and these served as favorite decorative items in many American homes and business offices, colorful distractions from the humdrum and symbols of pride in the nation. Large numbers of impressions were run off and turned over to a battery of other artists, mostly women, who hand-colored the images in assembly-line fashion, following a strict formula—similar to the paint-by-numbers painting kits popular with children and ama-

teurs some years ago. Like *The Birds of America*, there were later editions, both by Currier & Ives and by other publishers, who either bought the copyrights or simply reprinted the images from the original stones illegally.

We scanned auction catalogues, and luckily Sotheby's—then named Sotheby Parke-Bernet, having just acquired the competitor—was holding an American print sale that included a beautiful Currier & Ives floral still life. We went to the pre-auction viewing, liked the image, and two days later bid on it and bought it.

The following week Hirschl & Adler had an exhibit of flower paintings and prints, which we visited with no intention of buying anything, just to see some pretty pictures. Reba spotted our Currier & Ives print on the wall. "Dave, that's our print, but it's not our print!"

I was stunned by the image. It was bright, very colorful, sparkling. "You're right. It's our print, but there's a problem. A big problem."

We brought in our copy next day and consulted Hirschl & Adler's Joe God-du. He said, "Return this. It's either badly faded or a later edition—Sotheby's should take it back and refund your money. The description in their catalogue is incomplete about condition or edition." We felt like fools, mad at ourselves and at Sotheby's. So we followed Joe's advice and were told by the Sotheby's print department head that if an expert on Currier & Ives confirmed the opinion of Hirschl & Adler, they'd give us a refund. They offered two options for experts, not including Hirschl & Adler or any other commercial gallery.

Of the two options, the curator at the Museum of the City of New York, which had the most complete Currier & Ives collection, was nearest to us. So there we trooped with the print we were learning to hate. It took the curator about fifteen seconds to pronounce our copy a later edition, maybe not even published by Currier & Ives, and of no value. We felt even more foolish, but with this opinion, Sotheby's took back the print and returned our money. That was our first and last brush with Currier & Ives. Too much time, study, and expertise would be required to learn about something we just wanted for decoration.

There were two lessons in this: first, don't completely trust auction-house catalogue descriptions; second, be very careful about buying some-thing in a field you know nothing about.

Unfortunately, it took two experiences to teach us the second lesson. Sometime later, a friend told us that an art dealer friend of his had an Henri

de Toulouse-Lautrec poster he wanted to sell. The dealer was Louis Meisel, a gallery owner in Soho who specialized in photo-realist paintings. He'd bought this Lautrec poster years ago, but it didn't fit with his gallery's offerings, so he wanted to dispose of it. After a several-glasses-of-wine dinner with our friend, we went to Lou's apartment to see the Lautrec, which Lou pulled out of a closet. It looked good to us, and a nice fit with our country house décor. We paid and went away with the poster.

At work the next day, I showed the print to my partner, he of the prints epiphany. He had charged ahead with print collecting, and had bought a couple of Lautrec posters. His reaction was immediate. "That's a copy, a reproduction. The paper's not right. The size isn't right. You've been cheated."

Groan. Once again we were fools. So back I went to the Louis K. Meisel Gallery with the "Lautrec." Lou was defensive. He refused to take back the print and return our money. Buyer beware was the policy. After arguing, he finally agreed to take it and give me credit on a future purchase from his gallery, which had nothing I wanted.

So I relearned lesson number two. And added a third: beware of friends being helpful when it comes to an art deal. And a fourth: limit wine intake to a single glass when you buy art. And a fifth: buy from a reputable art dealer—one who will accept a return and give a full refund, as Sotheby's did in the case of our Currier & Ives.

Our acquisition of the eighteenth-century prints and the Rembrandt Peale lithographs sparked our interest in expanding the collection more fully into nineteenth-century work. We applied some of the lessons we learned from the Currier & Ives and Lautrec misadventures when we set out to acquire Winslow Homer's best-known print.

Towards the end of his career, in the late 1880s, Winslow Homer made a small group of etchings, most of which were based on paintings he'd done previously. The prints escape the "after" designation because there was no other artist as copier, and the images differ in some small details from those of the paintings. *Eight Bells* (1887, Fig. 5) is an American icon. Both the painting and the print depict two sailors, shipboard, wearing their oilskins and holding sextants. A storm has just passed over, clouds are breaking up, the sun is coming out, and the sailors are "shooting the sun" in order to get a fix on their ship's position. Homer was surely referring to *Eight Bells* when he remarked about his watercolors, of which he was very proud, that they were

Homer is thought to be America's greatest nineteenth-century artist. Art historian Lloyd Goodrich begins his book on Homer with this:

> Of all American artists of the nineteenth century, Winslow Homer was the most vital and colorful, and the most varied, with the widest range in subject and style. In his day he was an innovator, as every strong artist is. He saw things in American life that no other artist had seen, and he painted them in new ways. He appeals equally to the artist and the layman, by his picturing of stirring aspects of nature and humanity, by the freshness of his vision, and by his degree of artistry.[8]

We wanted to add *Eight Bells* to our collection. In 1985, an impression of this famous print was coming up for sale at Christie's, so we engaged David Tunick to inspect, evaluate, and buy the print for us at auction. David is a leading print dealer whose interests span centuries, with concentration on the best images by the best artists. He inspected the Christie's *Eight Bells* during the viewing period before the auction and pronounced it in perfect condition, an excellent impression, and the signature authentic.

This is the expertise we needed because in the early 1940s restrikes of *Eight Bells* were printed from the original plates, some after the copper plates

Fig. 5. Winslow Homer, *Eight Bells*, 1887. Etching, 18.9 x 24.3 in.

were steel-faced to prevent wear, but sacrificing detail. A few of these restrikes were even signed with faked signatures. False signature or not, a restrike is of much, much lesser value than a print from the artist-authorized edition.

The most comprehensive collection of Homer's art is in the Sterling and Francine Clark Art Institute in Williamstown, Massachusetts. Sterling Clark, fueled by his Singer sewing-machine fortune, collected Homer exhaustively for forty years: oil paintings, watercolors, drawings, prints, book illustrations, and what appears to be all of the wood engravings (published in seven different nineteenth-century magazines). However, the Clark's impression of *Eight Bells* is a restrike, unsigned, from one of the early-1940s posthumous printings. Strange that this obsessive collector would settle for a less-than-perfect version of Homer's greatest print.

We met David at Christie's and sat down together in the auction room. Our hearts were pounding, and Reba gripped my hand. Each lot was selling higher than the estimates, adding to our anxiety—we were on the brink of paying more than we ever had to buy a print. And we wanted it badly. David was to bid and buy for us, but he didn't even have a paddle with an identifying number. When the bidding on *Eight Bells* started, David seemed to be in a trance, or drowsing. Up, up went the bids, as raised paddles blossomed across the room. The bidding seemed to be coming to a close, and Reba looked at me with wide eyes: What's happening? Why isn't David bidding? As the auctioneer announced "Going, going. . . ," David raised his finger, just within sight of the podium, and the auctioneer quickly said, "We have a new bidder at $25,000."

Silence in the room. The previous high bidder was obviously disheartened by a late entrant at a higher price. There were no other bids. We owned *Eight Bells*! We both shook with relief and excitement. David had obviously briefed the auctioneer: keep your eye on me during the *Eight Bells* bidding. It helps to have a pro on your side.

Winslow Homer is a good place for a beginning print collector to start, if images of nineteenth-century America appeal, because one type of his prints is available at a very low price. He began his artistic career as an illustrator for magazines and books and became famous as a Civil War artist when *Harper's Weekly* commissioned him to go to the battlefronts and draw soldiers in their day-to-day activities, both boring and peaceful and exciting and violent. Skilled craftsmen in New York transferred Homer's drawings to wood blocks, engraved them, and created printed illustrations for the magazine, which had a large circulation.

The artistic quality and variety of these pictures prompted many readers to save them; they are not rare. Nor are they considered original prints, as Homer only did the drawings. He did not engrave the boxwood or have anything to do with the printing, which was commercial, newspaper quality. The prints were issued in huge numbers, and, of course, none were signed by Homer. Since they are not "original," the *Harper's Weekly* (and other magazine) illustrations have much lower value than Homer's original etchings. Just the same, these woodcuts are excellent art and fine examples of Homer's skill. They will last; the ink and paper used for newsprint at the time were of high quality and do not deteriorate, in contrast to those of the twentieth century. We've acquired two dozen of these woodcuts. Only one or two sell for as much as $1000, even in the art boom of the early twenty-first century.

The more we looked at our Homer etching and the woodcuts we were gradually acquiring, the more we became interested in American prints of the nineteenth century. We dabbled. At Hirschl & Adler, we saw a brilliant Thomas Moran etching, titled *Morning, Hook Pond, Easthampton* (1886, Fig. 6). We knew that Thomas Moran was considered one of the best American etchers of the period, but little else did we know about nineteenth-century prints. Still, we had recently departed our country home in Amagansett for a beach house in North Carolina, and Moran's depiction of sunrise in eastern Long Island had a nostalgic appeal above and beyond its beauty. We

Fig. 6. Thomas Moran, *Morning, Hook Pond, Easthampton*, 1886. Etching and roulette, 11.1 x 17.1 in.

bought *Hook Pond* and began a cram course on nineteenth-century etching.

In the decades between 1880 and 1900, the United States entered an extended period of prosperity, as modern factories and office buildings were built, railroad lines crossed the continent, and groundbreaking advances in communications and the sciences took place. New York, the financial center of this activity, boomed. The Gilded Age had arrived, and with its prosperity and unprecedented growth, an interest in art of all types. So was born the American "Etching Revival," echoing that which had started in England and France a few years earlier. Artists whose medium of choice was oil painting, frequently done *en plein air*, turned to etching because with a needle on a wax-covered copper plate, both highly portable, an artist could sketch directly from nature.

Perhaps more than any other artist, the American James McNeill Whistler had the most to do with launching the Etching Revival in both Europe and America. But was he really an American? As collectors, we thought not. Although Whistler was born in Massachusetts in 1834, most of his young life and schooling were in Europe. He returned to America with his family, and, thanks to his Army father, was appointed to West Point. He was ill-suited to military discipline, and it's believed that he deliberately flunked out by failing an easy chemistry exam:

> When asked to discuss silica, Whistler began "silica is a gas . . . " "That will do, Mr. Whistler," the examiner replied. In later years, Whistler liked to say "If silica had been a gas, I might have become a general."[9]

Whistler was nearly as well known for his quips and clever retorts as for his art. His too-clever and provocative remarks sometimes resulted in brawls and lawsuits, described in his autobiography, *The Gentle Art of Making Enemies*. Freed from West Point, Whistler found short-term employment at the United States Coast Survey Office, drawing maps. His first etchings were topographical maps of the coastline. With his family's help, he managed to escape this job, which he considered boring, to move to Paris, then London, and pursue the fine arts. At this he excelled.

He painted in oil and turned to printmaking, mostly etching, as an income source. His etchings were instantly popular with collectors on both sides of the Atlantic. He was especially attracted to the sights and architecture of London and other European cities, and particularly to scenes of Venice. He made popular a new idea: he signed his prints in pencil, eventually replacing his signature with a butterfly logo. This signing was a successful

marketing technique, suggesting originality, and enhancing collector inter-
est in his work. Other printmaking artists followed suit, and virtually all
American Etching Revival artists signed their prints. (In the case of "afters,"
the artist of the copied painting often signed the print, too.)

Why did we not collect Whistler? We had decided early on to focus, fo-
cus, focus and try to build the greatest American print collection of its kind.
This required some arbitrary decisions, and declaring Whistler non-Ameri-
can and excluding his work were among these.

With the example and inspiration of Whistler and other European print-
making artists, a boom in American etching ensued. Publishers, primarily
based in New York, competed to acquire editions from artists, as collec-
tor appetites seemed unquenchable. Clubs were formed, by both artists
and collectors, to promote and study prints. Interest in the Etching Revival
started to wane as art style began to shift to what came to be known as Real-
ism and Modernism, coincident with the arrival of the new century. Nearly
one hundred years later, there was still little collector interest in this work
aside from that of the superstars, Winslow Homer and Thomas Moran. Just
the kind of collecting opportunity we liked!

We soon encountered a collector of Etching Revival work, the wunder-
kind of prints, Matthew Marks. Matthew had started collecting prints in his
early teens—so early that auctioneers wouldn't always accept his bids. He
planned to become a dealer in Modernist art and work by living artists, so
when he opened his gallery he wanted to sell his nineteenth-century print
collection. He called to tell us that his first exhibition was his own collection
of Etching Revival prints and suggested we visit. Arrayed around his walls
were forty or so beautiful etchings—ships at sea, landscapes, portraits, but
there were very few red dots on the frames, suggesting little sales activity.

Buying forty prints all at once seemed extreme, but I had an idea. The
owner of the subsidiary I headed was the Equitable Life Assurance Society
of the United States. Equitable was founded in the nineteenth century, but
in 1987 had just moved into its very new office building on Seventh Avenue
and Fifty-Second Street. Wanting to emphasize its heritage, the company
had a large oil painting of a group of bearded nineteenth-century business-
men looking down over the Equitable boardroom. Among the group was an
Equitable director, and the picture referenced Equitable's financing of the
first Atlantic undersea telegraph cable. The company's CEO did not want to

lose this distinguished history. Pari Stave, Equitable's art curator, was turning to prints to fill the new, expansive walls.

Why shouldn't Equitable and I buy Matthew Marks's prints, and divide them? This could jump-start us in a new field and simultaneously fill a big void at Equitable, appropriately and quickly. We still had a lot to learn about the material, but I trusted Matthew, relying on his keen eye and judgment.

Pari agreed with my plan, got the necessary approvals, and Equitable and the Williamses immediately acquired a substantial nineteenth-century collection, some twenty prints each, chosen by taking turns. We were on our way to repeating in Etching Revival prints what we'd done with the early-twentieth century—a new opportunity to rediscover the work of long-forgotten artists.

There was no shortage of forgotten artists. There was just the problem of finding their work. Only one dealer in the New York area specialized in this field, Rona Schneider, who was also the editor of *Imprint: The Journal of the American Historical Print Collectors Society*. We acquired several prints from her.

In the meantime, Reba began to do more research on the family of Thomas Moran, intrigued since so many of them made etchings, all in this Revival period: Thomas's wife, Mary Nimmo Moran; his younger brother Peter Moran; his older brother, Edward Percy Moran; and his nephew, the son of Edward, John Leon Moran. Reba focused initially on Peter, because unlike the rest of the family and most Etching Revival artists who remained in the East, he had ventured west, like Thomas, and etched images of Indians. Matthew Marks had told us that he believed one of the Peter Moran prints we'd bought from him was the only extant impression. Just the type of challenge Reba liked—true or false? She set out to see if she could locate another impression or even a reference to another impression.

Titled by the artist in a pencil inscription, *Santa Fe, 1883* (Fig. 7) pictures burros in a dirt street with adobe houses in the background. After looking at many books and records, Reba confirmed Matthew's opinion—there was almost certainly no other impression. *Santa Fe, 1883* was probably a proof that was never editioned. Since another author had written a couple of sentences about the print in *Imprint*, Reba sent comments about her research to Rona Schneider. In the next edition of *Imprint*, Reba's contribution—word for word—appeared over the name of the person who had made the original comment. No reference to Reba's research. Blatant plagiarism. Incensed, Reba called Rona immediately.

When she demanded an explanation, Rona replied, "An oversight, I guess,"

but did not offer any suggestions as to whose oversight it might have been.

"What are you planning to do about it?"

"Reba, these things happen. It's not all that important." No apology, and a curt dismissal of Reba's complaint.

"It is to me."

"I'll try to get something into the next issue."

The next issue came, but no correction. As a result, we chose not to buy work from the only dealer we'd found who specialized in Etching Revival prints. (Years later, Schneider applied to our foundation for a grant for research. We passed.)

Fig. 7. Peter Moran, *Santa Fe, 1883*, 1883. Etching, 4.5 x 6.9 in.

Soon however, a partnership of print dealers came to our rescue. Based in Boston, Bill Carl and Lyle Sarnevitz probably had the best access to Etching Revival prints in the United States, both because so much of the imagery is New England-based and because nineteenth-century Boston had many wealthy citizens interested in nineteenth-century art. Bill and Lyle brought us a steady stream of prints, most of which we acquired.

The culmination of our nineteenth-century collecting came in 2005. Dulwich Picture Gallery in London was mounting the first-ever museum show of Winslow Homer's paintings in England. It was extraordinary that America's greatest nineteenth-century artist had never been exhibited in Britain. Even though Homer had spent two years painting and making prints in northern England, he was still little known. The director of Dulwich asked us to create an exhibition to accompany the Homer show that would provide a context for Homer's work with prints by his American contemporaries. We assembled a group of fifty prints by forty-six artists for the exhibition we called *In the Age of Winslow Homer: American Prints 1880–1900*, and shipped them off to London.

Dulwich put on a gala opening, attended by our ambassador to the Court of St. James, Robert Tuttle, and his wife, Maria. Both exhibitions—the Homer and ours—were reviewed favorably in the English art press, and we were pleased to play some part in introducing Winslow Homer and other nineteenth-century American etchers to our British cousins.

Fig. 1. Margaret Jordan Patterson, *Swans*, ca. 1915. Color woodcut, 10.2 x 7.5 in.

Birds and Flowers

The long history of printmaking in Western culture, from the fifteenth century up to the 1960s print boom, is primarily a story of black-and-white images—engravings, etchings and woodcuts with black ink on white paper. Artists sometimes colored a black-and-white print by applying, by hand, watercolor with a brush. But generally speaking color in printed material didn't start to appear in Europe until around 1830, with color lithography for book illustrations and ephemera. Larger format prints—posters—showed up in the 1860s and 1870s, and immigrant lithographers brought their skills to America at the same time. However, color lithography died out as an art form with the demise of the poster craze early in the twentieth century. European artists perfected color woodcuts starting about 1880, and American artists followed suit around the turn of the century. Screenprinting developed as an art form starting in the 1930s, but as we've seen, it was not well accepted. Woodcuts were the only type of color prints that persisted in popularity until the 1960s.

Each color woodcut is handmade, a labor of love for the printmaking artist. Typically, a separate wooden block is cut for each color, requiring a lot of carving in wood, repeated inkings, and difficult registration so paper on the wood blocks line up perfectly. There is the hard physical work of pressing the paper against the cut blocks with a wooden spoon or similar device. This pressure on the paper, repeated for each color, can give the print an embossed quality, almost a third dimension. The appearance of a woodcut print is very different from the flat, atonal colors of screenprint or the mechanically produced poster, and impressions of the same print may vary slightly.

Our collection of color woodcuts began in 1983 with Reba falling in love with a print she chanced to see at a pre-auction viewing, a small color woodcut titled *Swans* (ca. 1915, Fig. 1) by Margaret Jordan Patterson. Reba

was much taken with the image and the bright colors of its white birds gliding across blue waters. We had started collecting swan images for our bedroom, because the birds mate for life, and the romantic in Reba liked both the symbolism and the imagery. We had acquired several swan prints made by European artists; swans have been described as the "mascots" of the European Art Nouveau movement, and the graceful birds appear frequently in posters and other illustrations of this style and period.

The Patterson *Swans* would have been our first swan by an American artist, and we were venturing into new territory in more ways than one. As we were just discovering color woodcuts, the artist was only vaguely known to us. Janet Flint, curator of graphic arts at the National Museum of American Art in Washington, was mounting an exhibition titled *Provincetown Printers: A Woodcut Tradition*, and the catalogue for the show had arrived only a week earlier. Here was an entire new world of prints and artists, and Reba—lover of color, birds, and flowers—was entranced. Patterson's *Swans* wasn't in Flint's catalogue, but two of her floral still lifes were.

Unlike me, Reba rarely coveted a print, so I was determined to buy it for her as a birthday surprise. But how to make it a surprise? She knew I was going to the auction to buy it, and I knew she'd be waiting at the door on my return for a report that I had acquired it. There was only one thing to do.

"Some crazy buyer was determined to get it, no matter what the price," I lied to her. "I gave up at $900, already more than twice the high estimate. Whoever it was paid $1000, and seemed determined to keep bidding. I'm sorry, but maybe another will come along,"

It was not a complete fabrication, however. There *was* a crazy buyer who overpaid for *Swans* at Christie's that morning: me. I hid it away, and presented it to Reba for her birthday three months later. My failure at auction was forgiven. Swans now sail around our bedroom, with Margaret Patterson's leading the flotilla. Thank goodness I was able to buy it—I've never seen another impression for sale in an auction or dealer's catalogue. After this initial foray into color woodcuts, we eventually came to own about three hundred.

Inspired by *Swans* and Janet Flint's beautifully illustrated catalogue, we undertook a self-administered crash course. We learned that the American color woodcut movement began with Arthur Wesley Dow, a New England Yankee who discovered Japanese color woodcuts of the nineteenth century in art books in the Boston Public Library. Dow had studied art in France,

but somehow missed the Japanese print influence much in evidence in the
work of Gauguin, whom he knew personally, and other French printmakers.

After his belated discovery of Japanese prints, Dow virtually gave up painting and turned to color woodcuts. In an 1895 lecture, "Some Reasons for Studying Japanese Art," he summarized his views:

> 1. Japanese art is "true" art; 2. it is an art that is simple and direct and less encumbered with science and realism; 3. it exhibits the great universal principles of art near the surface—one doesn't have to search to ascertain what those are; 4. it is concerned solely with the beautiful and is not obfuscated by concerns of truth, accuracy, sincerity, or conscientiousness; 5. it is concerned with flat relationships of form and color like the early Italian primitives . . .[1]

In 1895, Dow had his first exhibit of color woodcuts, appropriately in the Japanese corridor of the Boston Museum of Fine Arts—the first public showing of color woodcuts by an American artist. *Lily* (1898, Fig. 2) was made a few years after Dow's first exhibit, but it displays the qualities of Japanese art Dow admired: beauty and simplicity.

Margaret Patterson studied with Dow, as did many other American printmaking artists of the early twentieth century, but she made her first color print under the tutelage of Ethel Mars in 1912 or 1913 in Paris. Mars and Patterson were among the numerous American artists living in what was at that time the center of the art world. Paris offered them direct observation of modern art, art schools, and the chance to meet and talk with the world's most famous, and soon-to-be famous, artists. Paris also offered freedom from Puritanical America, and welcomed what today we call "alternative lifestyles." An artist of the time, Anne Goldthwaite, describes two American artist friends in Paris:

Fig. 2. Arthur Wesley Dow, *Lily (Water Lily)*, 1898. Color woodcut, 9 x 2.4 in.

I had two friends, Miss Mars and Miss Squire, who were habituées of L'Avenues [Lavenue, a café] . . . When I first met them we were all new to Paris, having lived there only a month or so. They were nice Middle Western girls in tight, plain gray tailor-made suits, with a certain primness. This was in September [1906]. By May you would never have thought they came from Springfield, Indiana [sic]. Miss Mars had acquired flaming orange hair and both were powdered and rouged with black around the eyes until you could scarcely tell whether you looked at a face or a mask. The ensemble turned out to be very handsome, and their conversation, in public that is, became bloodcurdling.[2]

Janet Flint later wrote that Mars and Squire became part of the Gertrude Stein circle, and they appear in one of Stein's essays, "Miss Furr and Miss Skeene," rechristened as the title characters.[3]

The outbreak of World War I in 1914 chased most of these ex-pat American artists home, among them Mars and Squire and their longstanding friends and avid printmakers Ada Gilmore Chaffee and Mildred McMillen. They all found their way to Provincetown on Cape Cod in 1915. Provincetown was beginning to attract artists—painters, printmakers, writers, actors—and the old fishing port at the tip of the Cape, like Paris, offered a freedom that would have been impossible in American cities. Sun on sand dunes and ocean, gray-shingled cottages, and nearby pine forests provided artists beauty and inspiration, but the lack of strictures on personal behavior was probably the town's greatest attraction. Bohemian life by the sea.

The four women printmakers from Paris were soon joined by another American from Paris, B.J.O. Nordfeldt, who made a major contribution to color woodcut printmaking. Ada Gilmore Chaffee described Nordfeldt's invention:

> [he] soon became impatient with the mechanical labor of cutting so many blocks of wood (one for each color) before he could express his idea; one day he surprised the others by exhibiting one block with his complete design on that, instead of parts of it being cut on five or six blocks. He had cut a groove in the wood to separate each color, and, in printing this left a white line which emphasized the design. With his invention he had produced a more beautiful picture and eliminated much work.[4]

Nordfeldt's innovation came to be known as "white-line prints" or "Provincetown prints," of which Blanche Lazzell became a particularly gifted practitioner. Working mainly in Provincetown between 1915 and 1956, Lazzell made more than one hundred white-line color woodcuts in several artistic

styles, including Realism, Cubism, and abstraction, with a broad range of subjects—people, landscapes, townscapes, and floral still lifes. *Tulips* (1920, Fig. 3) reflects her interest in the abstract and her ability to mix harmonious colors. Originally from West Virginia, Lazzell thoroughly enjoyed Provincetown, where, in that summer of 1915, ". . . everything and everybody was new, it was glorious indeed . . . creative energy was in the air we breathed."[5]

Fig. 3. (Nettie) Blanche Lazzell, *Tulips*, 1920. Color woodcut, 12 x 11.7 in.

Women led the color-woodcut movement in both Paris and Provincetown. Hand strength, patience, and persistence—and artistic talent—were the required qualities. I visualize Margaret Patterson, Blanche Lazzell, orange-haired Ethel Mars, and their cohorts in a crowded garret in cloudy Paris or in an open shed with a worktable in sunny Provincetown, attacking a pine board with knife and chisel, painstakingly inking wood blocks with

brushes dipped in colors, carefully pressing paper onto the blocks, then at-
tacking again, this time with wooden spoons, registering the papers firmly
on the blocks—time and time and time again.

Another Provincetown artist in the years after World War I turned out to
be our favorite, along with Margaret Patterson, of the Provincetown printers
who specialized in flower images. According to my gardener wife, "These
women really knew their flowers."

Edna Boies Hopkins, like Patterson, had studied under Dow, and on an
around-the-world honeymoon trip in the early 1900s, made a lengthy stay
in Japan in order to study woodblock printing. She joined the other Ameri-
can artists in Paris until 1914, when she and her museum-director husband
returned to Cincinnati, then spent the summers between 1915 and 1920 in
Provincetown, a part of the colony of color-woodcut printmakers.

Print dealer Mary Ryan acquired a stock of color prints by Hopkins,
including six florals, which we were quick to acquire. As usual, we stored
these unframed prints in an empty office at Alliance Capital, where we ac-
cumulated pictures until we had a sufficient number for a trip to the framers.
When we went to retrieve them a week later they were gone—stolen!—a
disaster, a heart-breaker. Mary Ryan had no duplicates of these images—we
had bought them all. Nor did any other dealer. Most of Hopkins's prints are
in editions of ten or fewer, and most are in museums or lost. Replacing our
stolen prints seemed impossible, and Reba was particularly despondent
over the disappearance of her favorite florals. This was the only instance of
artwork theft from the Alliance Capital offices in more than twenty years of
storing and hanging prints there.

A few months later, Riva Castleman, at that time curator of prints and
drawings at New York's Museum of Modern Art, called and asked, "Do you
know a dealer who might be interested in acquiring a group of color wood-
cuts by an artist named Edna Hopkins?"

"Yes, for sure," I answered. "What's this about?"

"We've been offered a group of Hopkins prints, in Paris. They're not right
for MoMA. You and Reba are collecting this type of material, aren't you?"

"Yes, and we know the right dealer."

Castleman passed on the contact information for the person in Paris,
which we gave to Mary Ryan, who called immediately and confirmed
Castleman's story. Mary was on the plane to Paris in days. We heard right

Fig. 4. Edna Boies Hopkins, *Butterflies*, ca. 1915. Color woodcut, 10 x 9 in.

away: a big batch of Hopkins's color woodcuts, including duplicates for all our missing florals. Hopkins had returned to France in the early 1920s, and apparently took some of her Provincetown prints with her. Among them was the most beautiful of the batch, *Butterflies* (ca. 1915, Fig. 4), in which four Monarch butterflies are sampling purple flowers set against a pale blue sky. While Hopkins also worked in the Japanese style of woodcut, *Butterflies* shows the outlines around each color distinctive to the white-line technique.

We told Mary to sit tight. We'd join her. Luckily, we had to be in Europe for business reasons, and a short diversion to Paris was hardly extravagant. But an extravagant amount of champagne was required for toasting Mary and giving thanks to Riva Castleman. What better place to celebrate this small miracle than in France at the famous Le Pré Catalan restaurant in the Bois de Boulogne, Paris's wooded park, all about woodcuts and in the woods!

The influence of Arthur Wesley Dow's dedication to the Japanese style

of color woodcuts is also evident in the work of Bertha Lum, an accomplished color-woodcut printmaker. She made several trips to Japan and worked with Japanese printmakers. The influence was so great that her imagery was mostly Asian as well—Japanese people, scenes, and landscapes. For this reason, we did not collect her work, as we defined the collection we were building as not only by American artists but also of American images.

However, print dealer Lyle Sarnevitz presented a very unusual Lum, *Parrot* (1924, Fig. 5). It is actually in three dimensions, with a depth much more distinct than the embossed quality found in some woodcuts such as

Fig. 5. Bertha Lum, *Untitled (Parrot)*, 1924. Color woodcut, 18.7 x 10.4 in.

Margaret Patterson's *Swans*. We eventually learned that Lum's technique was called a "raised line" print, invented and named by her and kept secret during her lifetime. It involved pressing damp colored paper into a carved block, letting the block mold a raised portion of the paper when it dried. Next, either the raised or flat portion of the paper could be hand colored. There were sometimes several raised elements of different heights and colors, and parts of the paper might be printed from one or more wood blocks in the conventional manner. In *Parrot*, the result is life-like feathers, very slightly ruffled. The bird, eyeing the viewer warily, looks as if it could fly and is indeed poised to take off.

The range of the Japanese woodcut style extended beyond Arthur Dow's direct influence. Alice Ravenel Huger Smith lived her entire life in Charleston, rarely leaving the city, and never studied art except for a few lessons in watercolor from a local instructor. A friend and distant cousin of Smith's, Motte Alston Read, a retired Harvard professor and occasional traveler to Paris, brought a collection of Japanese woodblock prints and a few of the actual wood blocks back to Charleston, and Smith learned to make prints by studying them. She also made impressions from the old blocks. In

addition, two women printmakers who had studied the technique in Japan,
Helen Hyde and Bertha Jacques, met, tutored, and encouraged Smith when

they visited Charleston in 1916.
It's no surprise that Smith's few
color-woodblock prints convey
the same spirit as Arthur Wes-
ley Dow's dicta on Japanese art,
although it is doubtful that Smith
ever saw a Dow print or read his
text on the topic.

Hyde and Jacques managed
to get one of Smith's prints, *Moon,
Flower and Hawk Moth* (ca. 1917-
8, Fig. 6), into an exhibition at
Chicago's Art Institute, where the
curator of Japanese prints, Freder-
ick W. Gookin, called it an "artistic
triumph."[6] In this night scene,
a moth glides toward a flower,
illuminated by and silhouetted
against a full moon. But even

Fig. 6. Alice Ravenel Huger Smith, *Moon, Flower and Hawk Moth*,
ca. 1917-8. Color woodcut, 8.7 x 7.8 in.

with her early success, Smith turned away from printmaking and con-
centrated on watercolors, mostly of Charleston and the surrounding area.
These works, described as Tonalist in style for their blending of colors, are
mostly in the private collections of Charleston families or in Charleston's
art museum, the Gibbes. Few copies of her color-woodblock prints survive.
Thanks to Gala Chamberlain of the Annex Galleries across the continent in
Northern California, we were lucky to find a print by this artist whose work
and background were so well suited to our interests.

Another Charleston printmaker, Anna Heyward Taylor, was an accom-
plished woodcut practitioner of colorful floral images on a black back-
ground. Like many Southerners, she was captivated by the beauty of the
magnolia, as pictured in her *Magnolia Grandiflora and Fruit* (1933, Fig. 7). In
this print, the blossom is shown with a pod with red seeds, while the black
background dramatizes the colors, including the white.

Like Alice Smith, Taylor was born to a prominent family, but after

graduating from a South Carolina college in 1897, she left Charleston, embarking on an art career that included teaching, attending art schools, and traveling around the world. She lived in New York, toured Europe extensively, and was in Asia in 1914. She spent summers in Provincetown and was part of the color-woodcut community. Taylor returned to Charleston in 1929, becoming a member of the art scene that came to be known as the Charleston Renaissance. She continued to work mainly in color woodcut, emphasizing local scenes and still lifes.

At the New York Fine Art Print Fair in 1983 where we first met her, Gala Chamberlain also introduced us to the color woodcuts of William Seltzer Rice. Rice grew up and attended art schools in Pennsylvania but moved to California in 1900 to teach art. He was enraptured by the California flora and thrilled with the Arts and Crafts movement and its active woodcut

Fig. 7. Anna Heyward Taylor, *Magnolia Grandiflora and Fruit*, 1933. Color woodcut, 11.4 x 9.4 in.

artists. Many of his images celebrate the wind-bent trees common to the California coast, and his color woodcuts, including his still lifes of flowers—many made in the 1920s—are as boldly colored as the flowers themselves.

Gala suggested that we visit the Annex Galleries in Santa Rosa, north of San Francisco, and see their extensive inventory of Rice prints. We needed little urging. Besides liking the Rice prints Gala showed us at the fair, we were also occasional visitors to the Ventana Inn, a resort in the hills of Big Sur overlooking the Pacific Ocean. While staying at the Ventana a few months later, we readily made the three-hour trip north to Santa Rosa.

Gala and her husband Dan Lienau are dedicated print dealers. They don't just acquire and sell pictures, they become experts on the material they handle, and on the basis of their knowledge have earned the right to represent the estates of leading Western printmaking artists active in the first half of the twentieth century. Gala had not overstated the quantity and quality of their inventory of Rice color woodcuts. We discovered flowers upon flowers and soon owned about twenty of Rice's color woodcuts, including *Hollyhocks* (ca. 1925, Fig. 8).

Through the Annex Galleries we also discovered the work of Gustave Baumann, a New Mexico color-woodblock artist. Baumann lived in Provincetown in 1916 and 1917, where he made a few color

Fig. 8. William Seltzer Rice, *Hollyhocks*, ca. 1925. Color woodcut, 14.5 x 12.5 in.

woodcuts but did not adopt the white line method. He went west, visited Taos, and settled in Santa Fe. The change of scene had a dramatic impact on his art, which blossomed into a riot of color. Writing in *El Palacio* magazine, Juliet Currie observes:

> Something happened to Baumann when he hit New Mexico. His work tells the story. Previously, he had begun to use touches of bright color, but his efforts were timid. His shyness dissolved in the purifying New Mexico sunlight. His color went wild. An electrifying explosion of hot golds, magentas and greens spilled in ecstasy straight from his heart . . . He mastered luminosity and with it captured the mystery of the Southwest.[7]

Ms. Currie might well have been describing *Autumnal Glory* (1921, Fig. 9), in which aspen trees, with their bright autumnal yellow leaves, line a creek, while a mountain looms in the distance.

Fig. 9. Gustave Baumann, *Autumnal Glory*, 1921. Color woodcut, 13 x 12.7 in.

Baumann was a wood-carving fanatic. He sculpted in wood and made
more than sixty wooden puppets, with which he and his opera-singer
wife staged productions. The marionettes reside in the Museum of New
Mexico and are still used in performances in Santa Fe. But his primary ar-
tistic energy went to color woodcuts, and he made many—mostly western landscapes and images of Indians and pueblos—and *Hopi Corn* (1938, Fig. 10) is probably a homage to the Southwest he embraced so fervently. The simplicity of the image against the black background emphasizes the importance of corn to the Indian culture.

Light and dark were a fascinating aspect of some printmakers' work. Again thanks to Gala Chamberlain and Annex we learned that William Seltzer Rice

Fig. 10. Gustave Baumann, *Hopi Corn*, 1938. Color woodcut, 8.2 x 8.3 in.

made black-and-white prints of flowers, mostly aquatints, as well as color
woodcuts. This is no small feat, capturing the essence of a colorful flower
without using color. Aquatint is an ideal medium for black-and-white flow-
ers, with its soft tonal effects mimicking the texture of blossoms, for exam-
ple in Rice's *Pond Lilies* (ca. 1935, Fig. 11), one of a group we acquired.

Rice's success in making a black-and-white flower appear real and
somehow true to color inspired Reba, who ventured, "Let's see if other art-
ists tried this trick."

We discovered that many did, simply to prove they could meet the chal-
lenge of making the viewer see color when looking at black ink on white
paper. We sought out examples of this work, and we acquired enough to
mount a small exhibit titled *Flowers in Black and White*. A traditional treat-
ment of black-and-white flowers is to utilize the tonal capabilities of litho-

Fig. 11. William Seltzer Rice, *Pond Lilies*, ca. 1935. Drypoint with sandpaper ground, 9 x 7 in.

Fig. 12. Ella Sophonisba Hergesheimer, *Southern Magnolias*, ca. 1938-40. Lithograph, 17 x 14 in.

graph. Ella Sophonisba Hergesheimer, the Peale family descendant, lived
her adult life in Tennessee and specialized in floral still lifes of southern
United States flowers, such as her *Southern Magnolias* (ca. 1938-40, Fig. 12).

Donald Sultan's approach is quite different. His 1987 portfolio of six
aquatints on stark white paper displays freesias in solid black ink as if "float-
ing on a large white field"[8] and is exemplified in *Freesias* (Fig. 13). Sultan,
who works in several media, said in an interview, "Printmaking for me is as
important as painting and drawing. It's another medium; I don't use it just
to reproduce what I've done before."[9] *Freesias* proves his point.

We anointed Charles Sheeler's *Roses* (1924, Fig. 14) the champion of this
exercise. Like his *Yachts* and other lithographs, his small bouquet of roses
has a lightness of touch that suggests both the delicacy of rose petals and
the transparency of a crystal vase.

But probably the pinnacle of our floral collection is *Three Red Roses* (1942,
Fig. 15) by Luigi Rist. *Three Red Roses* was like no color woodcut we'd ever
seen. It gives the impression of a soft, velvety texture, just like a rose. The
colors are deep, and seem to glow. The extremely fine-cut lines and careful
inking of the blocks facilitate this hyper-realistic image.

We'd never heard of Rist, who was active as a printmaker from the 1930s
until his death in 1959, until dealer/collector Martin Diamond showed us the
print in 1984. Rist is a prime ex-
ample of a "lost" artist, the kind
we loved to collect, learn about,
and celebrate. He never had
a dealer and was out of step
with the art world for his entire
career. In the 1930s, popularity
centered on figurative social-
protest images or cheerful
views of rural mid-America.
Abstraction took hold in the
1940s and into the 1950s. At
no time in these decades were
pretty pictures, such as Rist's
florals, in vogue.

Three Red Roses gained

Fig. 13. Donald K. Sultan, *Freesias*, 1987. Aquatint, 14.5 x 15.5 in.

Fig. 14. Charles Sheeler, *Roses*, 1924. Lithograph, 11 x 9.2 in.

some recognition in 1942, the year it was published, as the presentation print of the American Color Print Society. The accompanying brochure, written by Rist's artist friend Morris Blackburn, explained that the print required ten separate woodblocks and meticulous brush painting of colors onto the blocks. Rist put large edition numbers on his prints, perhaps planning to make huge numbers of each, but the market never developed and even if it had, the amount of labor required to make them would have been impractical. Many of his prints were marked as issued in one hundred impressions, and *Three Red Roses* would have been at least that large, given its prominence. Cutting ten blocks as finely as Rist did, then making at

least one hundred prints, each with ten impressions from ten separate color
blocks—just thinking about the physical work required is exhausting!

Rist also made still lifes of vegetables, fruit, and fish with titles such as *Scallions*, *Smoked Fish*, *Corsage* [a bunch of radishes], and *Dry Corn*. Morris Blackburn opined, "People would say 'technically marvelous,' but I don't like his subject matter—Why do a bunch of radishes?"[10]

Our next Rist acquisition was one of these odd images, titled *Sea Shell and Garlic*. This was three years after we'd bought *Three Red Roses*. No dealer had any inventory of Rist prints, and despite diligent searching, we were unable to find any. However, a friend alerted us that *Sea Shell and Garlic* was coming up for sale at an auction in Cleveland. Determined to acquire the print, we flew to Cleveland and bought it for $220, plus two round-trip airfares and a night in a hotel. Rist prints were rare because they were so undervalued (contrary to the conventional laws of economics); dealers just didn't bother to handle them—it wasn't worth their time. But this was soon to change.

Gradually, Rist prints began to appear on dealers' lists, probably a result of our constant inquiries. Over a several-year period, we acquired another thirty of his color woodcuts from ten different dealers. This made us the largest holder of Rist woodcuts; even the museums in his home state of New Jersey had incomplete collections of his work. By the time we had finished our acquisitions, Rist prints were selling in the $2000–5000 range, and the higher prices brought out supply.

This discovery of Rist prompted Reba to create an exhibition of his woodcuts and to write and publish an illustrated catalogue raisonné. She managed to borrow copies of the prints we did not own to be photographed for our book. In two cases, only photographs were available, not the actual prints. The Montclair Art Museum of Montclair, New Jersey, mounted the exhibition, and Luigi Rist was no longer lost.

Fig. 15. Luigi Rist, *Three Red Roses*, 1942. Color woodcut, 10.4 x 8.3 in.

Fig. 1. Philip Pearlstein, *Two Nudes on Old Indian Rug*, 1971. Etching and aquatint, 29.5 x 36.4 in.

Sharing: Creating Exhibitions

As our print collection grew in size, we began to develop exhibitions from its contents and circulate them to museums. It began in 1987 with *American Screenprints*, thanks to the director of New York's National Academy of Design, a friend who knew about our research on early screenprints and liked to exhibit unconventional art in his museum. Word of mouth—museum curators and dealers talk to each other frequently—led to more venues for *American Screenprints* and to other exhibits from our collection. We also enlisted the American Federation of Arts to help us find venues, and I served on its board and helped with financial support. Between 1987 and 2008, seventeen different exhibitions from our collection were mounted at over one hundred museums, mostly in the United States, but also in Mexico, Canada, Japan, Great Britain, Spain, France, Germany, Poland, and Italy. In nearly all cases, we were the sole curators, and Reba wrote or edited the exhibition catalogues, sometimes including essays from other print experts. Once we got moving crates made and the shipment arranged to the first venue, the exhibiting museums handled most of the logistics.

Some of our exhibitions were based on a type or style of print, or particular artists—like *American Screenprints* or *Mexican Prints* or *Alone in a Crowd: Prints of the 1930s–40s by African American Artists*—where we had a group of prints that were comprehensive, rare, or rarely seen. But we also organized themed exhibits, in which a group of prints related to a non-art topic—using a variety of print media, artists, and periods to tell a story.

THE 1960S–70S PRINT RENAISSANCE: THE NEW REALISM

Pop Art and the establishment of fine art lithographic print shops—ULAE and Tamarind, and Tamarind's offshoots—are credited with sparking a renewed interest in printmaking and print collecting in the 1960s. This inter-

est spread to other types of print media and to other art styles.

Besides Pop, and continuing the trend toward representational art, a New Realism began to show up in prints. Printmaking artists utilized different processes to create super-sharp images, an anti-Impressionism. Usually this was done in color, which contributed to the growing popularity of prints. Master Printer Judith Solodkin explained, "Huge, colorful prints are substitutes for paintings, and that's what most people want to buy."[1]

Richard Estes worked in brightly colored screenprint, and his urban scenes are noted for their meticulous detail. For example, reflections in storefront windows appear almost too real to be true, as are his spanking clean streets of New York. This hyper-realistic approach, sometimes too perfect in its representation, came to be known as Photo-Realism, and several print artists worked in this style. A less extreme realism, with images still sharply defined, lent itself well to prints, and is now called the New Realism.

We celebrated the Print Renaissance, and its many styles and types, with a travelling exhibition titled *Black and White Since 1960*. Because color prints were so popular, and seemed to be everywhere, we went the other way. Practically every printmaking artist produced some work in black and white, perhaps simply to be part of the printmaking tradition. Black-and-white prints are superior to color as a demonstration of an artist's drawing skill, so there may be an element of showing off as well.

Our exhibit included several art styles, but the emphasis was on the New Realism, with our favorites prominently on view. Topping that list is Philip Pearlstein's *Two Nudes on Old Indian Rug* (1971, Fig. 1), which is typical of the artist's oeuvre: dispassionate, distant, and startlingly realistic nude women. No narrative, no emotion. This print hung in my office until I realized it was detracting from my professional effectiveness. I would be droning on about our investment strategy and note that the listener, usually a client, was no longer listening; his eyes had wandered to *Two Nudes on Old Indian Rug*, and it wasn't the old Indian rug that was the problem. I moved *Two Nudes* to a less distracting location.

How close is this print to Pop Art? In my judgment, very close. Women's bodies displayed like everyday objects, without a storyline or explanation. Not that different from a Campbell Soup can, or a Brillo box, or a portrait of an electric chair. Perhaps I see this congruence knowing that Pearlstein and Andy Warhol were friends and attended art school together.

Fig. 2. Jack Beal, *Brook Trout*, 1976. Lithograph, 25.5 x 20 in.

Jack Beal and I shared an interest: fly fishing. He and his artist wife Sondra Freckelton lived in upstate New York on a farm with a trout stream. Many of his (and her) subjects were scenes of and about the place—plants, landscapes, farm objects—but I was attracted to *Brook Trout* (1976, Fig. 2) for the acute detail of all the objects, particularly the precise, almost tangible depiction of the trout. No wonder. Beal studied biology and anatomy in college, and his knowledge of bodies, human or animal, living or recently dead, is reflected in his very realistic, figurative art.

Reba was writing the occasional article for *American Artist* magazine, and its editor, Stephen Doherty, suggested that we might be interested in attending a symposium Beal was conducting, "Aspects of Realism," on the French Riviera. The artist, the topic, and the location were all appealing, so off we went to Mandelieu-la Napoule, a small beach town near Cannes.

Jack Beal was his usual friendly and very generous self, treating our group to a grand welcoming dinner at the then three-star Moulin de Mougins. The symposium was held at the Henry Clews Memorial, a fourteenth-century chateau that Clews and his wife had bought early in the twentieth century, renovated, and turned into a showcase for Clews's unusual sculpture. Clews had attached his strange and exotic creatures to walls, columns, and ceilings

of the old castle. Seeing this place—now owned by the La Napoule Founda-tion—was alone worth the journey. Getting to know Jack Beal was even better.

New York City subway riders are able to view two of Beal's outstanding works. Imbedded in the Forty-First Street-Seventh Avenue Mezzanine of the Times Square MTA Subway Station are two glass-tile mosaics updating the Greek myth of Persephone, the goddess who spent half her life under-ground, half above. In the panel titled "The Return of Spring," Persephone emerges from a subway exit to buy flowers from a Korean greengrocer.

Alex Katz is a prolific printmaker, working in many media, and nearly always in color. His style is spare, with little detail, and images defined by sharp-edged atonal blocks of color. His subjects are mainly portraits, fre-quently of his wife, Ada. The subjects he portrays are motionless, almost frozen; there's no sense of movement. Katz also produces landscapes, set near his summer home in Maine, and totally consistent with his simplified style, still and quiet, like the portraits.

Our choice of *The Swimmer* (1974, Fig. 3) for *Black and White Since 1960*, departs from typical Katz. Besides the obvious lack of color, the portrait is of Vincent, Katz's son and rarely the subject of his father's art. The medium is aquatint, which creates tonal qualities and softer, fuzzier edges to the im-age than are usually found in Katz's prints. This was deliberate. The artist is

Fig. 3. Alex Katz, *The Swimmer*, 1974. Aquatint, 28 x 35.7 in.

but I never had to."[2] In other words, Katz liked the softness of the image, con-
trary to most of his work. Finally, *The Swimmer* is an action picture. Vincent,
just emerged from underwater, is seen with water spurting from his mouth.

An art-collecting maxim is to stick with the artist's main and mature
style and subjects. *The Swimmer* is a worthy departure from this rule.

Neil Welliver's art, paintings and prints in all types of media, is focused
on what he observes in the Maine woods. Quoting art critic Jeremy Sigler,

> I picture Welliver alone in the woods, somewhere on his 1600-acre
> property in mid-coastal Linconville, Maine, clad in khaki pants and
> a pair of waders at the edge of a fast moving stream . . . precariously
> balanced alongside the slippery riverbed . . . out in his element he'd be
> squinting at the fish, the birds and the far-off horizon . . . [3]

Welliver moved to Maine in 1970, and by the mid-70s the human figure
disappeared from his art. At the same time, a series of misfortunes oc-
curred. A fire destroyed his house, studio, and many of his paintings. Next
year, a baby daughter succumbed to sudden infant death syndrome, and
shortly thereafter his wife, aged thirty-seven, died from a strep infection. A
few years later his twenty-one-year-old son was murdered while on a trip
abroad. Life went on for Welliver, with new marriages and more children.
But it's still tempting to link the terrible events in Welliver's life to an art that
omits people, to visualize the loner out in the forest, staring into a stream.

In *Brook Trout (Second State)* (1978, Fig. 4), a solitary fish is motionless in
moving water, behaving just as trout do, waiting for an insect to drift into
range. Welliver made two versions of *Brook Trout*, one a hand-colored etch-
ing, and Fig. 4, in which he added aquatint to create shadows in the rocky
bottom of the stream. Welliver was interested in fish. Besides *Brook Trout*,
he did a salmon, a brown trout, a rainbow, a school of smelt, and five other
prints of trout of undefined specie.

Every fisherman knows that water magnifies; fish in water look larger
than they truly are. Welliver accomplishes this effect by nearly filling the
picture frame with his trout—they look huge. Mark Strand, a former student
of Welliver's and a former U.S. poet laureate, describes the fish prints:

> The water in the prints acts as a window . . . It lets one in, even enlarg-
> ing, what lies beneath its surface . . . subjects are singled out, regarded,
> and given, finally, a painstaking mortal presence . . . [4]

Fig. 4. Neil Welliver, *Brook Trout (Second State)*, 1978. Etching and aquatint, 19.8 x 29.5 in.

Assembling *Black and White Since 1960* was great fun, and eye-opening in terms of quality and quantity—fifty-five prints by fifty artists. Color, after all, is the parvenu in the world of prints, widely available only since the early nineteenth century, and not hugely popular until the post-1960 Print Renaissance. It was satisfying to return to the classic black-and-white print.

PLAYING GAMES

In the summer of 1994, we were in the Herbert F. Johnson Museum of Art at Cornell University at a pre-opening of *The Mexican Muralists and Prints*, an exhibit from our collection that Nancy Green, the museum's print curator, had requested. As we walked through the exhibit, Nancy lamented, "We can't attract enough students into the gallery. Only those required by their instructors come—art and art history majors—they'll show up. But we need an exhibition that will attract *all* students. Can you come up with one?"

Reba pondered this problem and concluded with what was for her an unlikely solution: sports images. She was a bored spectator at most sports, claiming that when forced onto the field hockey turf at her boarding school, she'd always stayed at the far end of the field, hoping to avoid the action. However, she reasoned that college kids could be attracted to a show about athletes and athletics. So was born the exhibition Reba christened *All Stars: American Sporting Prints*.

The first step was to go through our existing collection of sports images.
Our catalogue system had a Fact Sheet for every print in our collection that
contained pertinent information—a description of the print; data about the
artist, source, and price of acquisition; and keywords, like "sports," "base-
ball," "hockey," etc.—to help us search and find types of images. Scanning
our records for these keywords, we were able to identify and retrieve over
one hundred relevant prints in the collection. We spread them around a
conference room at Alliance Capital and called in experts to help us make
decisions about which would go into *All Stars*.

The experts didn't have far to travel. They mostly sat at phone and
computer stations in the Alliance Capital trading room. Our equity trading
staff, some ten or twelve men, were all former or current jocks. They did
not lack for opinions about which pictures were true, or not, to the sport
represented. They also pointed out omissions; for example, we owned no
prints featuring soccer (which was not a surprise, as the sport was just start-
ing to be popular in America, and little known to or portrayed by American
artists). But our homegrown experts thought we should have images of all
the major sports, and we agreed. But how to find a soccer print?

Due to its Italian language title—and my failure to translate it to its English
equivalent for the fact sheet—*Calcio* (or soccer) did not show up as we searched
sports keywords in our system. But fortunately I remembered the image—Ital-
ian kids kicking a ball—and the artist, Clare Romano, who spent time in Italy
and painted and printed images of that country. So we retrieved *Calcio/Soccer*
from storage, and included it—the only non-American scene in the exhibit.

Reba was determined to include a croquet image in the show—after
all, this was probably the only sport she ever enjoyed playing. But she had
another motivation. She had been particularly amused by a curator's inter-
pretation of a Winslow Homer painting that included a picture of young
girls playing croquet, which we'd seen at a small exhibition. Looking deeply
into this image of a group of prim nineteenth-century girls wearing long
dresses and holding mallets on a green, the curator claimed that these girls
were acting out of repressed anger at the male sex. They were bashing balls,
but not simply to send them through little metal loops. Instead they were
taking out the emotional frustrations that resulted from social and personal
constraints on a tender part of the male anatomy. "My mother would faint,
if she heard this," Reba said. "I was even allowed to play croquet on Sunday,

because it was considered such a genteel and ladylike game." But Reba was absolutely right in thinking this sort of story would amuse college students.

If Winslow Homer had painted a croquet scene, he had almost surely made a similar print. Consulting the Homer print catalogue raisonné, we found an illustration of the print, titled *Summer in the Country*, published in *Harper's* in 1869 (Fig. 5). Now we had to find the print. Reba asked Julie, her secretary and solve-every-problem assistant, to start calling dealers who specialized in Homer wood engravings.

Fig. 5. Winslow Homer, *Summer in the Country*, 1869. Wood engraving, 4.4 x 6.3 in.

In no time Julie announced, "I've found it! Don Pitcher has the print for sale."

We hadn't heard of Don Pitcher; he was not a mainstream dealer. "How much?" Reba asked.

Julie consulted and came back. "Fifty-three."

Fifty-three what? Fifty-three hundred? Way too expensive. Fifty-three dollars? Way too cheap. Besides, prints were usually priced in round numbers, not odd dollar amounts. Julie, too embarrassed to ask the first time, went back to her interlocutor and returned with an answer that surprised us almost as much as the first one. It was fifty-three dollars, plus mailing costs. We didn't ask for a discount, common practice in buying from a dealer, and were happy to pay the extra three dollars plus the necessary stamps. We checked croquet off the "to-get" list.

Hearing the Alliance trader-jocks tell their own sports stories gave Reba another idea. We planned to travel the exhibition to other university museums, thinking they probably had the same problem as Cornell. Reba figured that top athletes at colleges with an art museum might be invited to talk about the pictures—surely college stars giving gallery lectures about *All Stars* would attract a crowd. As the exhibit went from school to school—fifteen between 1997 and 2001—museum directors who followed this advice attracted the crowds they hoped for, and *All Stars* turned out to be a hit on campus. I was especially gratified that the exhibit went to the Forsyth Center Galleries at Texas A&M. Aggies are sports crazy, and A&M was the alma mater of my father, my uncle, and one of my closest old friends, a high-school classmate. Reba and I and my friend trooped to College Station, Texas, in the late summer heat for the opening—football practice had already started. It was a great pleasure to donate three sports-image prints to the Forsyth Galleries, dedicated to my father, my uncle, and my old high-school friend.

The images in *All Stars* represented more than thirty sports in sixty-six prints by fifty-two artists, and covered over one hundred years of sports history, from Winslow Homer's croquet girls to baseball in the late 1980s. A favorite of the latter type came from Jim DeWoody, who made prints and paintings of athletes as metaphors for the heroic impulse. His *Pitch* (1987, Fig. 6) is a portrait of New York Mets pitcher Ron Darling, and the determination evident in Darling's face says everything there is to say about sports. We were so attracted to DeWoody's Ron Darling that we reproduced it on the catalogue cover. The text started with a quote from former Supreme Court chief justice Earl Warren, who would "turn to the sports pages first, which records people's accomplishments. The front page has nothing but man's failures."[5]

We put *All Stars* to bed after its final venue in 2001 and returned the prints to storage. Six years later, a call came from Sean Ulmer, curator at Iowa's Cedar Rapids Museum of Art. Sean had liked the exhibition years ago and asked if Cedar Rapids could have it. Not the type of museum *All Stars* was designed for, but flattery got Sean everywhere, and visiting the home of Grant Wood, one of America's great artists of the early twentieth century, wasn't a bad idea. So we agreed, dug out all the prints, and reread the catalogue.

A glaring omission leapt out: there wasn't a single African American artist represented or even one image of an African American athlete. How could we have been so insensitive? And stupid? One explanation was that most of

the prints were made in a time when there were few black athletes in college or professional sports, but in 2011 the collection looked—at best—dated. So

Fig. 6. James DeWoody, *Pitch*, 1987. Pochoir, 15.3 x 18.4 in.

I started making calls to dealers. We found a 1940 WPA print of two black professional wrestlers by African American artist Elmer Brown, *The Wrestlers*, and another by an artist we never should have overlooked: Elizabeth Catlett, probably the leading black woman visual artist of both America and Mexico (her home after 1947). Catlett depicted children playing kickball in a 1992 print, *Playmates*. But the prize was a poster by Jacob Armstead Lawrence, who studied painting at the Harlem Art Center and is famous for his paintings and prints of black life in Harlem. His *Olympic Games Munich 1972* (Fig. 7)—the text is in German on the poster—portrays African American sprinters in a relay race taking huge strides and grimacing with exertion as they stretch for the finish line. We put *Olympic Games* on the cover of the new catalogue we published, and having brought the exhibition into the twenty-first (actually late twentieth) century, we sent the pictures off to Iowa.

Olympische Spiele München 1972

Fig. 7. Jacob Armstead Lawrence, *Olympic Games Munich 1972 (Olympische Spiele München 1972)*, ca. 1971. Screenprint, 34.4 x 25.4 in.

We were in Vienna frequently in the 1990s, attending board meetings of Alliance Capital's Austria Fund. Knowing of our collection, Austrian friends asked if we could prepare an exhibit to be shown in conjunction with a music festival in Vienna. The answer was a very definite yes. Our collection of prints—particularly those made in the 1920s, '30s and '40s—contained large numbers of musical images. As early as 1910, Wassily Kandinsky was writing about the association of visual art with music, and making abstract markings in color on canvas to portray sound. Many artists have some affinity with music, and the intensity, energy, postures, contortions, and antics of musicians at work present great material for images. My art-historian wife, well acquainted with the work of Kandinsky and other European abstract artists who'd tried to portray the sound of music, named our project *The Sight of Music*, and we set out to delve more deeply into what Americans had produced to visualize music in prints.

We had lots of material; the question was what to include. The easy part was jazz, irresistible to artists, and what better place to start than New Orleans, birthplace of American jazz? Early in the nineteenth century, African slaves on Sunday, their (sometimes) day off, gathered at what was named Congo Square and made the music that became known as jazz. Caroline Durieux's *Bourbon Street, New Orleans* (1943, Fig. 8) is a perfect example of music-making in New Orleans. Two African American singers are entertaining sailors at a nightclub while World War II rages. Not surprisingly, the sailors are smiling. The women are not singing "Anchors Aweigh." What I hear is "Boogie Woogie Bugle Boy of Company B," just as the Andrews Sisters performed it.

Fig. 8. Caroline Durieux, *Bourbon Street, New Orleans*, 1943. Lithograph, 10.6 x 10 in.

(See below)

Fig. 9a. Frederick Becker, *Arrival of Brass Section*, c. 1938. Etching, 11.7 x 6.5 in.

Fig. 9b. Frederick Becker, *Home Cooking*, c. 1938. Etching, 11.7 x 5.2 in.

Durieux was an expert on southern Louisiana culture. In 1936, after a stint in Mexico and a friendship with Diego Rivera—he praised her work for its "deliciously wicked quality"—Durieux settled in New Orleans, served as director of the Louisiana WPA-Federal Art Project, and for years taught art at Louisiana State University.

Another great visual chronicler of jazz was Fred Becker—the artist whom the Whitney's David Kiehl mistakenly believed was African American, thinking no white person could capture the image of jazz with such sensitivity. Becker was a frequent visitor to New York City nightclubs in the 1930s, and his powers of observation are evident in the saxophone player and the pianist in his two etchings (intended to be joined), *Arrival of Brass Section* and *Home Cooking* (ca. 1938, Fig. 9). The sax player's dissipated face and the piano player's hands bring back the sound of jazz to anyone who has heard and watched jazz combos.

Fig. 10. Andy Warhol, *Debbie Harry*, ca. 1980. Screenprint, 40 x 60 in.

Fig. 11. John Cage, *Global Village 37 – 48*, 1989. Etching and screenprint, 17.5 x 25.8 (each – diptych)

Our collection was full of images similar to *Bourbon Street* and Fred Becker's jazz players, but we had virtually nothing later than the 1940s—no Elvis, no rock 'n' roll, no contemporary music. For this material, we turned to print dealer Brooke Alexander, who promised to search his inventory for music images, and contact other contemporary print dealers to see what he could find. We visited Brooke's Soho gallery a few weeks later and were confronted with an imposing pile of relevant prints, small to huge in size.

The largest one was my top choice: Andy Warhol's larger-than-life-size *Debbie Harry* (ca. 1980, Fig. 10), a knockout at 3½ by 5 feet. Her bright red lips, blond hair, and seductive eyes, well, they seduced me. We soon learned that her punk band was called Blondie (for obvious reasons) and it had broken up in 1982. Were we out of it! But Blondie was attempting a comeback and was on tour in 1998 when we were buying the print. We never went to see Blondie perform. The Warhol version was quite enough.

Few contemporary printmakers attempted to portray sound only, with no performer or instrument in the image. Jasper Johns took a very direct approach—he made a lithograph of a record—a 33 rpm vinyl. The title of the work is *Scott Fagan Record*, 1970, and it's a close copy of Fagan's first album, *South Atlantic Blues*, 1968. It also looks just like one of Johns's favorite images, the target. But it's personal: Scott Fagan, a blues and rock singer, was Johns's favorite performer and he listened to the record while he worked.

It's no surprise John Cage, best known as a composer, but also a music theorist and printmaker, took an abstract route. The randomly placed forms of his *Global Village 37-48* (1989, Fig. 11) echo his aleatory (chance or indeterminate) music. He often used the *I Ching*, an ancient Chinese book of philosophical and oracular texts, to pose questions about his composition, which the *I Ching*, in a sense, would answer. In a lecture, Cage described music as "a purposeless play," "an affirmation of life—not an attempt to bring order out of chaos nor to suggest improvements in creation, but simply a way of waking up the very life we're living."[6]

Global Village 37-48, an etching with aquatint, is not just abstract art attempting to recreate the sound of abstract music, but art created by the same abstract methods as the music. Its construction techniques are as quirky as they are original. To make *Global Village*, Cage smoked sheets of blank paper by burning newspapers on the bed of a press, extinguishing the fire with dampened sheets of printing paper, then running those sheets

through the printing press immediately. Thus, each impression of the edition has varied brown and yellow smudges and is unique.

The Sight of Music toured from 1999 through 2008 to museums in cities noted for music. After Vienna, the exhibit went to Salzburg, Warsaw, and Milan, where it was exhibited in the Teatro alla Scala Museum at the same time La Scala put on its first-ever American musical, *West Side Story*. The Italians went all out. The museum was located in a large space connected to the opulent opera house, its walls painted vivid red to highlight the vitality of American music (and Debbie's lips!). We attended with friends, thrilled to see the exhibition and musical from an Italian point of view. In the U.S., *Sight* similarly was exhibited in music cities. In New Orleans, we were thrilled to learn that Fats Domino, whose image was featured in the exhibition, was one of the visitors. The most original display was at the Cheekwood Museum of Art in Nashville. The museum installed CD players with earphones alongside a dozen of the pictures, so the viewer could hear the music that inspired the print. In Tennessee, we finally heard Blondie sing.

CONTACTING PABLO PICASSO

Although Pablo Picasso spent most of his life in France, the director of New York's Queen Sofía Spanish Institute wanted to remind everyone that the artist's mother country was Spain. The director, who had viewed our collection often, suggested an exhibition in 2003. We were delighted to help. Reba's essay for our exhibition catalogue began:

> When, in 1930, Stuart Davis, a major U.S. painter of the first half of the twentieth century, was attacked by the critic Henry McBride for being over-influenced by Picasso, Davis wrote "[Picasso] has been incomparably the dominant painter of the world for the last twenty years and there are very few of the young painters anywhere who have not been influenced by him." Indeed, many U.S. prints of the 1930s and 1940s reflect Picasso's influence, especially in their use of cubism. Davis, who was also a master printmaker, in *Barber Shop Chord* [1931, Fig. 12] combined cubism with words and images as Picasso often did.[7]

As we assembled an exhibition from our collection, Davis's assertion of Picasso's dominance was driven home in spades. We selected fifty-five prints by forty-eight artists and could have included many more showing traces of the master's influence, but we wanted to keep it small to accommodate the space in the initial venue. We publicized the event by hanging

Fig. 12. Stuart Davis, *Barber Shop Chord*, 1931. Lithograph, 14 x 18.9 in.

Fig. 13. Adolf Dehn, *Contacting Pablo Picasso*, 1940. Lithograph, 15.9 x 19.8 in.

a large banner—*Contacting Pablo Picasso*—across the façade of the Spanish Institute's elegant Park Avenue townhouse and had great fun interpreting the eponymous print for our exhibition, Adolf Dehn's *Contacting Pablo Picasso* (1940, Fig. 13). David Kiehl, our frequent consultant on matters like this, helped by identifying the lecturer wearing glasses and gesturing with an upraised arm as Alfred H. Barr, Jr., founding director of the Museum of Modern Art. In 1940, MoMA had just opened *Picasso, Forty Years of His Art*, a show that set the New York art world abuzz. Dehn took a jaundiced view of Picasso's deification, and in his print the Picasso monster is biting the hand (Barr's) that feeds her, as Barr's assistant (the angular and dark-haired Dorothy Miller) looks on in horror from the left; the "fat cats" (museum patrons) in the audience are simply entranced with the scene.

We found artists happy to talk about the topic. Roy Lichtenstein described the years 1949 to 1960 as his "sort of Cubist period" and said, "In my early Cubist work, I was always afraid of looking like Picasso. The more I tried to evade his influence, the more self-conscious the paintings got and the more evident was the source."[8] An artist friend whose work we collected, Dean Meeker, recalled:

> When I first came to [the Art Institute] from Montana—1939 or 1940—the first Picasso retrospective came to Chicago. Students, including me, were hired to hang the show. I was appalled! I noticed on *Guernica* that Picasso hadn't even erased some of his chalk marks and charcoal drawing. It was all so crude! I was upset! But by the time the show came down, I was enthralled by Picasso. It explained a lot to me—how one departs from academic training to a more expressive, a broader approach to art.[9]

Harry Sternberg summed up the nearly universal opinion:

> It was a matter of freedom. Picasso made prints, did ceramics, shifted styles from blue period to the red period to Cubism to abstraction. He said you could do anything you wanted to. It was inspirational.[10]

GOING UNDERGROUND

The New York Historical Society planned to celebrate the one-hundredth anniversary of the New York City subway and asked us to create an exhibition of subway images for the event. The show would open on October 27, 2004—exactly one hundred years after the first subway rumbled from City Hall to Forty-Second Street, across Forty-Second, and up Broadway to Ninety-Sixth.

This would be fun for two transplanted New Yorkers, subway riders for

Fig. 14. Fred Becker, *Rapid Transit*, ca. 1937. Wood engraving, 10.4 x 13.9 in.

decades. We owned many subway-related prints, attracted to them by our own experience. Artists were intrigued with the human interest aspects of subways, especially the crowding, jostling, shoving passengers, and we decided to title the exhibition *Around Town Underground*. Fred Becker expressed this well in his linocut, *Rapid Transit* (ca. 1937, Fig. 14), where passengers cram into a station entrance while others simultaneously tumble out of the exit—arms, legs, and hats flying in a spray of airborne bodies. Everything's askew in the background of this image: distorted buildings, crooked advertising signs, confusing directional arrows—all evoking the disorientation one feels when emerging from underground accompanied by a stampeding horde of fellow riders onto the city's frantic streets.

As familiar as Fred Becker's seventy-five-year-old *Rapid Transit* looks to the subway rider of today, what is now the familiar landscape of New York would not exist without the subway. Peter Derrick, author of *Tunneling to the Future: The Story of the Great Subway Expansion That Saved New York*, explains in the opening essay of our exhibition catalogue:

> Without the subway, the skyscrapers of Lower and Midtown Manhattan could not have been built, because no other form of transportation can efficiently carry so many people into such a small area of land. The

rapid transit system was also essential in facilitating the move of millions of New Yorkers to new and better housing in the "subway suburbs" of Upper Manhattan, the Bronx, Brooklyn and Queens. Until the 1950s, the New York subway was the symbol of a dynamic and growing metropolis—the leading business center in the United States and the headquarters of the new United Nations.[11]

David Kiehl elaborated on Derrick's theme when I interviewed him for our catalogue:

Fig. 15. Claire Mahl Moore, *Modern Times*, 1940. Lithograph, 17.1 x 13.9 in.

These subway images of the 1920s, '30s and '40s are a reflection of urban optimism. Look at the print on the cover of your catalogue, *Modern Times* [1940, Fig. 15] by Claire Mahl Moore. A workman's rough hand thrusts out of the modern city—New York—and across the lifeline of the palm runs the subway—the lifeline of the modern city.[12]

This urban optimism is also reflected in Reginald Marsh's *Penn Station* (1929, Fig. 16), where people stride purposefully through the underground station, hurrying and bustling about their business. New York, the world's most modern city of the 1920s through the 1940s, sustained a positive, progressive, and upbeat attitude despite Depression and war, and nothing reflected these sentiments better than its subway lifeline.

She's not quite Marilyn Monroe standing over a grate, trying (perhaps) to hold down her skirt against an updraft, but the woman of John Sloan's *Subway Stairs* (1926, Fig. 17) tells a similar story. Sloan's heroine, like Marilyn, is not trying too hard to avoid showing a little leg. There's a very interested observer at lower right in the image—he's so engaged that he's forgotten to tip his hat. The young girl doesn't look all that embarrassed; just look at that glint in her eyes.

When I interviewed David, I saved Eva Hesse's *Subway* (1954, Fig. 18) for last. Soon after the date of this print, Hesse began to be recognized as a sculptor of great originality especially because of the unusual materials she worked with. "Wow! That's a rarity," David responded, continuing:

Fig. 16. Reginald Marsh, *Penn Station*, 1929. Lithograph, 11.1 x 15.6 in.

I've never seen it except in reproduction. Almost no one knows she made a print. She must have done that while she was in art school at Cooper Union. The image is hard to read—it's almost a collage of subway images, Impressionistic in style. The large head is waking up. People are walking downstairs. One down-and-out person may be sleeping on a subway bench. Another slumps on the platform. Subway straps hang at the upper right. It's like glimpses you might get from inside a moving subway car. *Subway* is a long, long way from the string sculpture that made Eva Hesse famous, but it's a great picture—it sums up the subway experience.[13]

Fig. 17. John Sloan, *Subway Stairs*, 1926. Etching, 6.9 x 4.9 in.

CREATING EXHIBITIONS

Fig. 18. Eva Hesse, *Subway*, 1954. Lithograph, 14.3 x 10.2 in.

Our big print collection, numbering nearly six thousand, provided more opportunities for research and potential exhibitions than we had time or energy to exploit. We left a number of possible projects unfulfilled. An exhibit I regret having never completed—although I put a small version on the office walls of Alliance Capital—dealt with Indian Space, an unusual art style that flourished briefly in the 1940s, described by the artist Will Barnet as "the need to go beyond Cubism and find an authentic Native American voice."[14] Indian Space style appeared for only a few years, soon overshadowed by the rise of Abstract Expressionism.

Howard Daum is credited with coining the term Indian Space, which was influenced by the art of the Pacific Northwest Indians. The distinguishing characteristic is similar to Native American art: the distinction between figure and background is eliminated, giving the art a scrambled look. Daum painted and etched in Indian Space style. His untitled print of 1945 (Fig. 19) is typical. Swirls and totemic figures, with no hint of a third dimension, can be seen in this small example.

Fig. 19. Howard Daum, *Untitled (Indian Space Composition)*, 1945. Etching, 2.9 x 2 in.

The leading practitioner of Indian Space was Steve Wheeler, who strongly denied a kinship to the style, notwithstanding visual evidence to the contrary. Wheeler portrays people in mundane pursuits, and titles the pictures accordingly. He then puts each image into a broader, cosmic context, utilizing Indian symbols for that purpose. In his *Little Joe Picking His Nose* (1947, Fig. 20), a human face and perhaps limbs are vaguely visible among a jumble of Indian motifs.

Indian Space art appeared just as the world, led by the United States, entered the atomic age. In an effort to explain the nuclear phenomenon, scientists lectured and the media published articles, familiarizing the public with quantum physics and the aptly named Uncertainty Principle developed by the German physicist Werner Heisenberg. Indian Space artist Gertrude Barrer recalls that in the 1940s she

> was influenced in [my] appreciation of ambiguous positive and negative spatial relationships developed by the New Physics. [I] was referring

to quantum physics, developed by Niels Bohr and Werner Heisenberg, among others, in the late Twenties. Heisenberg's uncertainty relations show that it is impossible to do anything but estimate the position of an atomic particle at any given moment, while Bohr's principle of complementarity demonstrates that atomic particles cannot be distinguished from their paths of action. Correctly understood, quantum theory forced one to see the universe not as a collection of physical objects, but rather as a complicated web of relations between the various parts of a unified whole.[15]

Fig. 20. Steve Wheeler, *Little Joe Picking His Nose*, 1947. Photo-screenprint, 11.1 x 8.7 in.

I was intrigued by the possible intersection of quantum theory and Indian art, as expressed in Indian Space. From an artist's viewpoint, Indian art's blending of past and present is much like quantum theory's inability to distinguish between movement and physical presence . . . and all are part of the definition of Indian Space. We had collected over two dozen prints by ten artists that I identified, by image and date, as Indian Space. But that research was never completed, and the exhibit never happened. Time ran out on me.

THE LAST PICTURE SHOW

In late 2007, as we were considering alternatives for disposition of the collection, the Greenwich Historical Society proposed an exhibition of Connecticut scenes and Connecticut artists, all prints from our collection. In our minds, the collection was already gone, and neither of us had the interest or desire to create one more exhibit. But this was, after all, our hometown; we couldn't refuse. So we broke a vow—to only self-curate our exhibits—and turned to professional art curator Kathie Bennewitz to gather prints for what would be our last exhibition.

Neither of us had ever given much thought to grouping artists by home states. Other common characteristics seemed more important. But why not? Worth a try. We did know that Connecticut had been home to a major American Impressionist colony, located in what is now part of Greenwich. Otherwise, we knew little about "Connecticut artists."

We had a head start on Connecticut scenes. In the late 1980s, a key Alliance Capital employee who lived in New Canaan suffered a heart attack, and the daily commute to New York was deemed too stressful. We responded by establishing a small office in Greenwich, for him and everal other staff members who lived in the area and were more than happy to skip the daily train rides. To decorate the office, we scoured the collection for scenes of the state and managed to find a surprisingly large number, more than enough to fill the few walls.

With this beginning, Kathie Bennewitz began a thorough search of our collection, including artists' bios—Reba had collected the histories of each artist in the collection. Kathie found forty-seven who lived part of their lives in the state and sixty-six of their prints, dated from the 1830s to the 1960s. She titled the exhibit *From Harbor to Haven,* and it was on show at the Historical Society for most of 2008.

I was quite surprised to find that certain artists had been, or were, Connecticut residents, such as John Steuart Curry. Critics firmly place him in the Regionalist school, and link him and his Midwestern rural scenes with Thomas Hart Benton and Grant Wood. Having never studied his biography, despite our very adequate

Fig. 21. John Steuart Curry, *Danbury Fair*, 1930. Lithograph, 13 x 9.8 in.

file on him, I too assumed Midwest. But Kathie looked at our archives carefully, and although Curry was born in Kansas, and went to art school there and in Chicago, she found he met his wife in Westport, Connecticut, and settled there. He continued to paint and make prints of life in Kansas, images such as a farm family racing to a tornado shelter, or a farmer driving his mule team pulling a hay wagon ahead of a rain storm. But Curry also found inspiration in the local scenes, as depicted in *Danbury Fair* (1930, Fig. 21). The image has always amused me, and I empathize with the observer in the lower left corner.

In retrospect, it's fitting that our last exhibit was held in the town where we lived.

Fig. 1. Anonymous, *The Battle of Zonchio (Navarino)*, ca. 1499. Woodcut with stencils, 21.6 x 31.5 in.

Artists in War

For centuries, the military, patrons, and private publishers have all com-
missioned artists to go to war to create and record visual images of soldiers
and battles. One of the earliest examples of war art in Western culture is the
Bayeux Tapestry, over two hundred feet in length, that depicts the Battle
of Hastings, key to the Norman conquest of England in 1066. The tapestry
(actually, an embroidered cloth) was made only a few years after the battle
and is likely a reliable visual chronicle of the event. Among the scenes is
the death of the English King Harold, who succumbed to an arrow in his
eye. The tapestry is on display at the Musée de la Tapisserie de Bayeux, in
Bayeux, Normandy.

A very early *print* of a war scene, and perhaps the first print of a naval
battle, is *The Battle of Zonchio (Navarino)* (ca. 1499, Fig. 1), artist unknown
but thought to be Italian as the battle is between the navies of Venice and
the Ottoman Empire. The image is of three large ships, grappled together.
Roger Crowley, in *City of Fortune*, describes the battle:

> As the three superhulks closed, both sides opened up with broadsides
> from their heavy cannon in a terrifying display of gunpowder weaponry:
> the roar of the guns at close range, the smoke and spitting flashes of
> fire astonished and unnerved those watching from the other ships.
> Hundreds of fighting troops, protected by shields, massed on the decks
> and fired a blizzard of bullets and arrows; forty feet higher in the crow's
> nests, crested by the lion flag of Saint Mark or the Turkish moon, men
> fought an aerial battle from top to top, or hurled barrels, javelins, and
> rocks onto the decks below; a swarm of light Turkish galleys worried
> the stout wooden hulls of the Christian round ships that reared above
> them. Men struggled to climb the sides and fell back into the sea.
> Despairing heads bobbed among the wreckage. [1]

Fig. 2. Francisco de Goya, *Por que? (Why?)* from *Los Desastres de la Guerra (The Disasters of War)*, 1863. 6.1 x 8.1 in.

This print, owned by the British Museum, is the only extant copy. However, an impression (now lost) was owned by Ferdinand Columbus, son of Christopher, as indicated by an inventory in Seville. The print technique is woodcut colored by hand with stencils, used so that many impressions could be produced quickly. Yet only one remains.

Francisco Goya's *Los Desastres de la Guerra* (*The Disasters of War*) is the largest and most extensive portfolio of prints relating to war by a single artist before or since. The eighty prints in *The Disasters* series tell the complete story of the Peninsular War, instigated by Napoleon's invasion of Spain in 1808. Although it contains scenes of the actual fighting, the main focus rests on the innocent victims and the atrocities committed by the ruthless and brutal French army.

Goya claims to have witnessed some of the scenes he etched. One print of a group of fearful civilians fleeing an oncoming cavalry is titled *Yo lo vi (I saw it)*. In *Por que? (Why?)* (Fig. 2), which is representative of Goya's many depictions of war horrors, three French soldiers torture a captive. Goya began working on the plates in 1810, before the war had ended, but only a few proofs were made until the first edition (of five hundred impressions) was published by Madrid's Royal Academy of Fine Arts of San Fernando in 1863, well after

Goya's death. The Royal Academy published four subsequent editions, the most recent in 1937. At some point the copper plates were steel-faced to preserve the etched lines, but the quality of printing in these later editions is inferior to the original. Nonetheless, the large number of impressions resulting from the five editions makes prints from *The Disasters* very collectable.

I am an avid collector of prints about war. The reason: World War II taught me to read. Like many of my generation (born in the 1930s), newspaper accounts of the Nazi invasion of Poland, the London Blitz, Corregidor, the great tank battles in Russia were considerably more compelling then Dick, Jane, and Spot. Maps enlivened war reports, and *Life* magazine photographs of the action gave visual meaning and authenticity to the world-shattering events. I clipped these articles and pictures, mounting them in scrapbooks—my personal history of the war—now long lost, but not forgotten. These childhood memories, and the impressions they formed, are indelible, and, like my fascination for WPA prints, carry over to an interest in art depicting war.

America's first war artists were Indians, who painted stories of wars on cave walls, animal skins, and tree bark. Paul Revere was, in a way, a war artist. His engraving *The Bloody Massacre*, illustrated in Chapter 9, recorded a battle of sorts and was used as propaganda to arouse public opinion against the British and inspire the American Revolution. Winslow Homer became famous as a war artist, and his *The Army of the Potomac-A Sharp Shooter on Picket Duty*, published in *Harper's* on November 15, 1862 (Fig. 3), is a chilling example: a sharpshooter sits in a pine tree to get a better look at the Confederate lines, aiming his rifle through a telescopic sight, about to pull the trigger and pick off an unsuspecting Reb.

The British government employed dozens of artists during World War I, and there was no shortage of scenes to be recorded during the four-plus years of terrible conflict. The pictures of devastated landscapes turned to mud—tree stumps and buildings reduced to rubble by the fire of thousands of guns—are as haunting and sad as the rows of gravestones in national cemeteries scattered across northern France and Belgium. Paul Nash's lithograph *The Void of War* (1918, Fig. 4) tells much of the story with simple forms: a bleak, destroyed, wet landscape, with no human habitation in sight. Nash enlisted and served in the infantry at Ypres until he was invalided home following an accident. Commissioned as a war artist, he returned to the Western front, recording what he saw in paintings, prints, and this letter to his wife:

Fig. 3. Winslow Homer, *The Army of the Potomac-A Sharp-Shooter on Picket Duty*, 1862. Wood engraving, 9.1 x 13.7 in.

I have just returned, last night, from a visit to Brigade Headquarters up the line, and I shall not forget it as long as I live. I have seen the most frightful nightmare of a country more conceived by Dante or Poe rather than by nature, unspeakable, utterly indescribable . . . Sunset and sunrise are blasphemous, they are mockeries to man, only the black rain out of the bruised and swollen clouds all through the bitter black of night is fit atmosphere in such a land. The rain drives on, the stinking mud becomes more evilly yellow, the shell-holes fill up with green-white water, the roads and tracks are covered in inches of slime, the black dying trees ooze and sweat and the shells never cease. They alone plunge overhead tearing away the rotting tree stumps, breaking the plank roads, striking down horses and mules, annihilating, maiming, maddening they plunge into the grave which is this land; one huge grave and cast up on it the poor dead. It is unspeakable, godless, hopeless.[2]

Fig. 4. Paul Nash, *The Void of War*, 1918. Lithograph, 14.5 x 17.4 in.

America did not employ war artists as such during our short involve-
ment in the Great War. However, some soldiers on active duty in Europe sketched what they saw, and later turned their works into finished drawings, paintings, or prints. Kerr Eby enlisted in the U.S. Army in 1917 and, because he had attended art school and embarked on a career as an artist, was as-signed to the camouflage unit of a regiment of engineers. During his time off from painting guns and vehicles, he drew what he observed and after the war came home to New York and Connecticut, resumed his art career, and turned his sketches into etchings. Eby's ability to create art from on-the-scene drawings and memory was admired by Dorothy Keppel of the F. Kep-pel print publishing firm:

> I have a theory that Kerr Eby's mind is like a sensitive recording instru-ment that stores up vivid impressions which, one by one, come to matu-rity and with infinite toil and trouble emerge as drawings and etchings. This quality seems most clearly shown in the series of war subjects; the scenes of the Great War, though long past, still march on with no flagging vitality in his visual memory, and will march, as he has told me, right up to the Pearly Gates. [3]

The most remarkable of Eby's World War I prints is titled *September 13, 1918, St. Mihiel (The Great Black Cloud)*, printed and published in 1934 (Fig. 5). It shows American soldiers moving to the front in the St. Mihiel Drive, one of

Fig. 5. Kerr Eby, *September 13, 1918, St. Mihiel (The Great Black Cloud)*, 1934. Etching, 10.2 x 15.8 in.

the last campaigns of the war (the date in the title of the print is only about two months before Armistice). This huge, ghostly cloud, composed of fog and gun smoke, hovered for days. The image could be read as a metaphor for the war: tiny ant-like creatures marching to their death, under the control of a malevolent force—the great black cloud. Eby did a mural study of the same scene, and a former German soldier upon seeing the drawing remembered that from the German side, the cloud looked red and was called "the Cloud of Blood."[4]

The rise of the military in Japan and of Fascism in Europe was of interest to several politically inclined artists, including Mabel Dwight. Dwight was an avid printmaker, and her images typically portrayed the humorous side of the human condition—awkward situations, embarrassing moments that would make the viewer smile. But after the Japanese invasion of China's Manchuria province in 1931 and the rise of Adolf Hitler in Germany in 1933, Dwight's style changed and she produced *Danse Macabre* (1933, Fig. 6).

Fig. 6. Mabel Dwight, *Danse Macabre*, 1933. Lithograph, 9.4 x 13.6 in.

Death is a skeleton in a helmet and gas mask, watching a puppet show. John Bull, as the personification of England, mops his brow in bewilderment. Mussolini raises his right arm in the Fascist salute, and Hitler, in full armor, salutes with one hand and holds a severed head—certainly Jewish—with the other. France is fearful, and China attacked by Japan. Uncle Sam raises his

hands in a gesture of disgust and draws back, careful to keep his distance.

Dwight's political point of view about Uncle Sam's position is unknown and unclear. Did she think the U.S. should have intervened and put a stop to all this? Or did she think the U.S. should have just registered disapproval and remained neutral—reflecting the popular isolationist mood of the country? Many artists, particularly in the years leading up to the Second World War, simply offered protests to the unfolding events while enjoying the luxury of not having to offer a solution. One of my favorite examples, in another anti-war print, is a protestor holding a sign that reads "Against War and Fascism." Was there any effective way to be "against Fascism" except war? F. Scott Fitzgerald—borrowing from Keats's "Negative Capability"—is credited with defining the artist as a person who can hold two inconsistent ideas at once, and this particular artist is not the least troubled by the contradiction!

In 1935, Sinclair Lewis published a bestselling novel titled *It Can't Happen Here*. The year before, Werner Drewes had produced a portfolio of woodcuts under the same name, among the earliest abstract prints made in America. Like the American Abstract Artists portfolio issued a few years later, very few sold.

The two works shared similarities (apart from the surely coincidental titles) and some differences. Sinclair Lewis's *It Can't Happen Here* is a cautionary tale, and the title is ironic. The novel concerns an imagined catastrophic incident in American history: a charismatic but dishonest Democratic senator is elected president and turns the country into a cruel dictatorship. The model was possibly Huey Long, governor of Louisiana and a potential threat to President Roosevelt's reelection.

Drewes's impetus was, he asserted, quite different. In an interview nearly fifty years later, Drewes explained, "I wanted to convey my feeling of the joy of being free to express myself as I wanted, in contrast to my fellow artists left behind in Germany. That it couldn't happen here [was because] we [don't] have a dictatorship."[5]

Perhaps, as Drewes said, joy inspired the prints. However, I'm skeptical, because the images reflect violence and destruction and can be interpreted as a warning; the portfolio cover image is a fractured swastika. *Composition VIII-The Two Fighters Fight* (1934, Fig. 7) is typical: two highly abstracted human forms struggle, with curved lines running across and around the image suggesting motion.

The outbreak of the Spanish Civil War in 1936 further inflamed intellectuals, including artists, and particularly those of a leftist or Communist persuasion, which included a great many. Stories of indiscriminant civilian bombings were quickly reported, inspiring Picasso to paint his famous *Guernica* canvas.

Seymour Fogel responded to the war in Spain with a protest image titled *Spain* (1937, Fig. 8). In it a woman in a dark shawl—presumably Spanish—holds the body of a lifeless baby. Another dead body has a broken bayonet in its back. Bricks, rubble, an upturned cart, and a wagon wheel form the backdrop. Fogel had worked as an apprentice to Diego Rivera on murals in New York, and *Spain* shows the influence: it tells a story, and the image fills the entire picture frame (or wall, in the case of a mural). Rivera's attitude about the Spanish war was probably a factor, too. He was firmly on the Republican side, aghast at the German bombing of Spanish towns.

Fig. 7. Werner Drewes, *Composition VIII-The Two Fighters Fight*, 1934. Woodcut, 12.5 x 9.3 in.

The Spanish Civil War marked a turning point for war artists. They no longer needed to carry pencils and a sketch pad. Improved technology had reduced the size and weight of cameras, and new lenses and more sensitive film made it possible to freeze action in a photograph. The war artist gained a new name, too: photojournalist. The individual most responsible for this new medium of war art was Robert Capa, and his most famous picture was his 1936 photo of a Spanish militiaman collapsing in death, having just been shot in the head. The picture is officially titled *Death of a Loyalist Militiaman, Córdoba front, Spain* (1936, Fig. 9) and is also known as *Falling Soldier*. Published in *Life* magazine, it ushered in a new era and a new profession: photojournalism.

The German invasion of Poland in 1939, Britain's immediate entry into the war, and the German invasion of France coupled with the German army's swift victories across Continental Europe raised consciousness and sounded the alarm even in slumbering America. However, most in our country re-

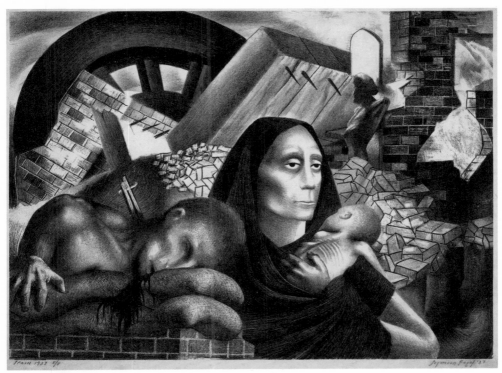

Fig. 8. Seymour Fogel, *Spain*, 1937. Lithograph, 13.5 x 18 in.

Fig. 9. Robert Capa, *Death of a Loyalist Militiaman, Córdoba front, Spain (Falling Soldier)*, 1936. Gelatin silver print, 9.7 x 13.4 in.

mained unconvinced of the potential danger or were resolutely opposed to our involvement. Some artists both understood and responded to the unfolding world events, trying to arouse Americans to action with pictures.

Al Hirschfeld was one. His fame came as a cartoonist for the *New York Times*. His drawings of celebrities and actors are noted for their gentle touch and for his trademark "Nina," his daughter's name, embedded somewhere in his sketches.

As his art dealer Margo Feiden wrote,

> By the ripe old age of 17, while his contemporaries were learning how to sharpen pencils, Hirschfeld became an art director at Selznick Pictures. He held the position for about four years and then in 1924 he moved to Paris to work, lead the Bohemian life, and grew a beard. This he retained—the beard, not the flat—for the next 80 years, presumably because you never know when your oil burner will go on the fritz.
>
> In 1943, Hirschfeld married one of Europe's most famous actresses, the late Dolly Haas. They were married for more than 50 years—in

Fig. 10. Albert Hirschfeld, *Peace in Our Time (Neville Chamberlain)*, 1939. Lithograph, 14.5 x 19.5 in.

addition, they produced Nina. Nina is their daughter, and Hirschfeld engaged in the "harmless insanity," as he called it, of hiding her name at least once in each of his drawings.[6]

Having spent time in Europe, Hirschfeld was attuned to the threat of war and was concerned by the passivity and indifference he saw in America that greeted Hitler's rise and the spreading web of Fascism. British Prime Minister Neville Chamberlain's "Peace in Our Time" speech, which suggested that long-lasting peace had been achieved by acquiescing to Hitler's takeover of part of Czechoslovakia, inspired Hirschfeld to make the print of the same title in 1939 (Fig. 10). The image is of Chamberlain speaking in a bombed and ruined Parliament building while members sit and listen in their gas masks amid spirals of smoke. David Leopold, Hirschfeld's archivist, explains further:

> Hirschfeld produced this print just before Parliament was bombed. He was not trying to prophesy the future, rather he was upset by Chamberlain's inability to understand the politics of the time. He first took the image to the *New York Times*, [to] which he had been supplying theatrical drawings since January 1928; they rejected the work since they believed, Hirschfeld's words, that lithography was "communist art." The image was eventually reproduced in *The New Masses* on January 31, 1939.[7]

Benton Spruance, another artist alarmed about events in Europe, spent most of his life in Philadelphia, but was inspired to pursue fine art lithographic printing during a trip to Paris. He taught at Pennsylvania art schools and made lithographs, some on his own press, throughout his life. His *The 30s-Windshield*, (1939, Fig. 11) is a vivid warning about the future. In the print, the viewer is driving a car. The rearview mirror reflects a placid rural scene being left behind—a farmer plowing, and a couple at ease on a lawn. Through the windshield, death—a skeleton wearing a soldier's uniform and carrying a rifle— is hitchhiking for a ride. Refugees drag a cart, trying to escape air raids. In the distance we see destruction and desolation—falling bombs, fire and smoke. (And, the future did indeed become the present, exactly as Spruance saw it.)

The work of photojournalists dominated the media and the American public's perception of World War II. *Life*, *Look*, *Collier's*, and the *Saturday Evening Post*, all weekly magazines, featured photographically illustrated articles about the conflict on both theaters and were widely read. *Life* was the leading national purveyor of war pictures, with Robert Capa as its key photographer. He was in a landing craft at Omaha Beach on D-Day, and

his pictures of American soldiers wading ashore and dying under fire are among the most memorable of the war. In 1954, while photographing the First Indo-Chinese War for *Life*, Capa stepped on a landmine and was killed.

Despite the prominence of photojournalists and their cameras, the U.S. Armed Forces—separately, the Army, Navy, and Marine Corps—employed artists to accompany troops and record scenes of war. Typically, the war artist made a pencil or ink sketch while observing action, then retired from the front lines to create an oil painting based on the sketch. Some twelve thousand war-artist paintings and drawings were received by the respective military branches during and after the war. However, few artists were able to make prints, close to impossible in the field or on a warship.

Howard Cook, whose Mexican-influenced art we saw in Chapter 7, was employed as a war artist and assigned to the Solomon Islands in the South Pacific. He was among the very few who made prints (back in the U.S.) based on what he observed. His lithograph, *Weary Men*, also known as *Tired GIs* (1945, Fig. 12), is one example. His war prints, like the thousands of paintings by war artists, were of little interest to the public after the war and didn't sell. Thousands of war paintings, after a few exhibitions, were retired to military museums, where they remain in storage today.

Fig. 11. Benton Spruance, *The 30s-Windshield*, 1939. Lithograph, 8.9 x 14.3 in.

Fig. 12. Howard Norton Cook, *Weary Men (Tired GIs)*, 1945. Lithograph, 11.3 x 15.5 in.

Fig. 13. Benton Spruance, *Riders of the Apocalypse*, 1943. Lithograph, 12.7 x 16.5 in.

Artists who remained at home painted or made prints depicting war scenes, basing their images on written reports or photographs. But for the most part, these pictures lacked the dramatic impact of the World War I paintings and prints produced by artists who had seen action with their own eyes. Photographs were more successful in taking the viewer to the front line, in nearly real time. An anxious and involved public had no patience to wait for a finished painting or print, especially of war scenes created by stay-at-home artists.

Benton Spruance's *Riders of the Apocalypse* (1943, Fig. 13) is an exception. In the lithograph, in a faintly Cubist style, American bombers are on a mission, probably over Continental Europe. Enemy searchlights scan the night skies, trying to pinpoint the attacking planes to aid ground-based anti-aircraft guns. Spruance's *Apocalypse* refers to the destruction on the ground caused by the bombs. Less well known at the time was that the airborne riders of the apocalypse, the pilots and their crews, suffered an appalling casualty rate.

John Taylor Arms was an unusual World War II artist. He volunteered to make four large etchings of U.S. Navy warships and to donate 500 impressions of each print and the plates to the Navy's Bureau of Ships to be sold (for $5 each) to raise funds for the war effort. Arms was motivated, at least in part, by his two sons having entered the armed services.

Arms's gift of his own etchings was no small matter, as he was generally considered the finest practicing etcher-artist at the time. Most of his oeuvre consisted of architectural images, notably ancient churches and buildings in France or Venice. These prints were distinguished by their incredible detail: fine etched lines trace every element in a gargoyle, or column, or thatched roof. Nothing escaped his eye or his etching needle. The warship series, a battleship, a cruiser, a group of three destroyers and a submarine, reflect this same quality of etching. It was a lengthy process. Arms recorded in his diary that he spent 1352 hours preparing the etching plate for the *U.S.S. Columbia*—the cruiser—and this does not include traveling to and from a shipyard, and the time spent on the drawing before etching, or the proofing and printing of the more than 500 impressions.[8]

The plates are larger than conventional etchings, approximately 1' x 1 ½', yet the etched lines are as dense as on a tiny Arms print of the decoration above a church door. Alas, the etching quality of the warships cannot be reproduced in a small illustration, so you, the reader, will have to be content with this description. (However, the huge edition size, and the unfashion-

able status of prints relating to war, make acquisition of an Arms warship easy and affordable.)

Painters and printmakers mostly stayed home serving the military at tasks other than being an artist. Those who remained stateside often created art focused on the home front. In 1943, the government sponsored a competition, Artists for Victory, in which one hundred prints were chosen to be shown in each of twenty-six exhibitions held simultaneously across the country. The purpose was to inspire confidence and patriotism in the civilian population. One category in the contest was "Heroes of the Home Front," and the best efforts are found in this group.

Ira Moskowitz immigrated to America with his family from Poland in 1927, was soon a scholarship student at the Art Students League of New York, and became an expert in lithography. On a trip west, he became interested in the Indian culture of New Mexico, and his finest prints are of Indian dances, done in the 1930s and 1940s. But he entered the "Home Front" section of the Artists for Victory contest with *War Worker* (1943, Fig. 14) and

Fig. 14. Ira Moskowitz, *War Worker*, 1943. Lithograph, 10 x 13.7 in.

won the overall second prize. The *War Worker* is an African American in a machine shop, operating a drill press. His posture and facial expression convey energy and urgency—the very attributes our government hoped to instill in factory workers making war material.

Robert Gwathmey won the Artists for Victory serigraph prize for his *Rural Home Front* (1943, Fig. 15). Gwathmey, whose family had lived in Virginia for many generations, was well acquainted with the poverty-stricken life of the rural South. His father had died in an accident before he was born, and Robert and his siblings took on money-earning jobs, including farm work, at early ages. Gwathmey developed a strong social consciousness while young, and his art frequently portrayed the rural poor, both black and white. He was so consumed with this topic that he used his Rosenwald Foundation Fellowship to live on a North Carolina sharecropper's tobacco farm for a year.

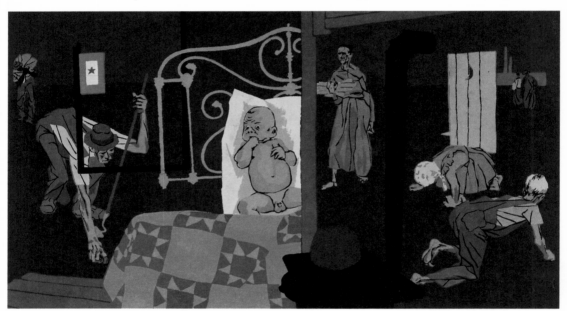

Fig. 15. Robert Gwathmey, *Rural Home Front*, 1943. Screenprint, 10.2 x 18.3 in.

Creating the imagery for *Rural Home Front* was a natural for Gwathmey. Because of the war and the draft of the able-bodied into the military, only the old and young were left to tend the farm. The small flag with a star indicates a family member away in the armed services. An ancient farmer bends forward holding a hoe, while an African American approaches from behind with a heavy sack tossed over his shoulder. At right, an old woman carries firewood and a bucket of water and young children are on their hands and knees, possibly sowing seeds. In the upper right, workers—probably once farmhands, now producing materials for the war—walk to a factory, leaving the farm totally dependent on the over- and under-aged. In the center is a new baby, said by Gwathmey's dealer, Terry Dintenfass, to be Robert's son

Charles, later to become a famous New York–based architect.

But America's favorite World War II artist was undoubtedly Norman Rockwell, who never once either observed or painted a battle scene. His paintings were all centered on the home front and were consistently patriotic and inspirational, such as his indomitable *Rosie the Riveter* (1943, Fig. 16). Rockwell's paintings were frequently reproduced as covers for the *Saturday Evening Post*, adding greatly to the magazine's popularity. *Rosie*, resting her penny-loafer-shod feet on a copy of Hitler's *Mein Kampf*, was especially popular. An alert art critic for the *Kansas City Star* newspaper observed that Rockwell had posed his model for *Rosie* to echo Michelangelo's painting of the prophet Isaiah on the Sistine Chapel ceiling, and the paper illustrated both, side-by-side, to prove the point.

Sadly for the print collector, Rockwell never made original prints. Art critics were quick to denigrate his work—its intense realism and saccharin quality—despite, or maybe because of, the public's admiration.

For whatever reason, paintings and prints of World War II, particularly of the home front, marked the end to the popularity of realism in American art. With the war over, the art world turned definitively away from realism to a new religion, abstraction and Abstract Expressionism, with realistic images declining in favor until Pop Art arrived in the early 1960s.

Fig. 16. Norman Rockwell, *Rosie the Riveter*, 1943. Oil on canvas, 52 x 40 in.

Miniatures

We stepped out of our battered and filthy Ford into mud, but the muck underfoot did not compare to the smell. The dirt-mud road leading to the house was adjacent to a pig sty. We remarked to each other, "Happy as a pig in shit."

This is print collecting under extreme conditions. Mud and the stench of a pig sty are not usually associated with prints. Print galleries and museum print rooms are generally clean, antiseptic, and climate controlled. But not this place. We were visiting the new quarters of the London print dealers N.W. Lott & H.J. Gerrish Ltd., who, for reasons that never became clear, abandoned their urban location for a rural retreat in the far west of England by a village called Foxfield, near Marlborough.

We were on a new quest, once again violating our own policy of concentrating on building the biggest and best collection of American prints. We had recently moved out of our loft-like space in Greenwich Village to a formal apartment on Park Avenue, and bought a piano for a large drawing room. Instead of covering the piano's top with family portraits in silver frames, why not small prints? This took us away from American artists, who rarely made cigarette-package-sized prints, to Europe and to older material, where small size was common. Large sheets of paper and large plates of copper were expensive in the fifteenth- and sixteenth-century European Renaissance, and the tradition of smaller prints persisted long after, particularly among British artists of the nineteenth and early twentieth century.

That brought us to Lott & Gerrish and their new location, when in March 1986 we were on a one-week vacation in England's West Country, staying at an elegant country-house hotel, Ston Easton Park. A severe storm had just struck, with rain and high wind across the south of the nation, downing limbs and scattering debris everywhere. Once the wind calmed, we visited Longleat, one of the finest extant examples of Elizabethan architecture, to see

the house, its art collection, and visit the safari park that an eccentric owner had created. It was the first safari park outside Africa and greatly admired for letting its African animals roam freely while visitors were caged in cars. However, the animals were understandably unnerved by the recent hurricane. A crazed dromedary blocked the road as we drove through the park, refusing to move until it had slobbered all over our car's hood and windshield. Then, as we waited for a gate to open, a maddened rhinoceros attacked the back of our car, battering and denting the trunk hatch and rear bumper. I did not look forward to the return to Hertz. Next day, we arrived at Lott & Gerrish, our ravaged car apt for visiting a print gallery on a farm with a muddy road and a pig sty.

We scraped our shoes as best we could and entered the farmhouse-turned-gallery. We'd called ahead, and Nick Lott was ready for us. Barely saying hello, he greeted us with: "I've got something you'll want." Producing his prize, he enthused, "It's Samuel Palmer's first print—the one he used to get elected to the Etching Club in 1850."

This jewel was a small rectangle titled *The Willow* (Fig. 1), and a beauty of a scene: a massive willow tree leaning out over a pond, on which swam a single swan. We knew just enough about Palmer and the legendary Etching Club for Nick to get our attention. "The early proofs—and it wasn't editioned in 1850— were poor," Nick explained. "This one was printed by A.H. Palmer, Samuel's son, in the 1870s. He put more tone on the plate, which brought out the willow tree very distinctly. As you see, Samuel signed it, proving he liked it."

Fig. 1. Samuel Palmer, *The Willow*, 1850 (printed 1870s). Etching, 3.5 x 2.8 in.

We squinted at this small particle, and I asked, "Was it ever editioned?"

"Not in Palmer's lifetime. That's what makes this copy rare." Speaking as if Palmer's son were a friend, Nick added, "A.H. published a book on his father in 1892 that included this image, but the only edition was done in 1926. Palmer died in 1881."

With that instant education, we paid and carried off our rare and signed copy of *The Willow*, carelessly wrapped in tissue paper, back to our muddy, camel-spit-covered, and battered car to return to the comforts of Ston Easton.

A few years later, thanks to an exhibit of Palmer's etchings at the Fine Art Society in London, we learned much more about the artist. According to Gordon Cooke, writing in the exhibition catalogue, "Palmer has come to be seen as the vital figure in pastoral art who links [William] Blake with the later generation of English Romantics . . . "[1] We would later encounter that generation of pastoral English Romantics.

Our decision to collect a small number of miniature prints for piano-top decorating had been made the year before our visit to the Lott & Gerrish farmhouse gallery. It started with me buying at auction *The Wine Glass* (1858, Fig. 2), a small etching by James McNeill Whistler, the expatriate American who lived and worked in England and who, in my opinion, did the most to set off the etching craze in our country. Whistler was a notorious showoff and braggart, and *The Wine Glass* exemplifies these personal qualities. He did it just to prove how good he was. And he was.

Today, we would call *The Wine Glass* a champagne glass. It sits half full on a circular cloth, and a few drops of its contents have run over the rim onto the base of the glass. The drops sparkle with reflected light. But for its small size, the viewer could reach out and pick up the glass for a sip of bubbly. Having declared Whistler not an American artist for our collection-building purposes, we now had Whistler in our collection. Rules are made to be broken.

We knew that the mother lode of small prints was the Renaissance. So-called Old Master prints were those made in the sixteenth to eighteenth centuries or earlier, mostly in Germany or Italy. For these we turned to David Tunick, the print dealer upon whom we'd relied to buy our Winslow Homer *Eight Bells*. David introduced us to the Little Masters, a group of German printmaking artists of the early sixteenth century who worked almost exclusively in small-size engravings. Their subjects were frequently religious or taken from pagan myths.

The first print David showed us was *Leda and the*

Fig. 2. James McNeill Whistler, *The Wine Glass*, 1858. Etching, 3.4 x 2.2 in.

Swan (1548, Fig. 3), in which the nude Leda is stroking the neck of a swan
with outspread wings. Reba announced, "Perfect for our swan collection in
our bedroom!"

Many print collectors specialize in images; one of our specialties is
swans. The huge variety of prints, and their relative cheapness compared to
most other art, makes it possible to build collections
of particular types. We know a collector whose only
interest is prints of people reading. Another buys only
a style and medium: color woodcuts in English Vorti-
cism—dynamism in color of speeding double-decker
buses, London street crowds, country fêtes, and the
like. Specializing in specific images or artistic styles is
another way for the beginning print collector to start.

Fig. 3. Hans Sebald Beham, *Leda and the Swan*, 1548. Engraving, 1.8 x 2.3 in.

David Tunick's *Leda,* less than two inches tall and
just over two inches wide, was engraved by Hans Sebald Beham, the best
known and most highly regarded of the Little Masters. Another member
of the group was Sebald's younger brother Barthel. Natives of Nuremberg,
both brothers were expelled from the city for their confessed agnosticism
and disbelief in the holy sacraments. Their banishment was short, and their
work in both oil painting and engraving continued to reflect their ambiva-
lence about established religion and their interest in ancient legends.

Collecting prints made in the fifteenth to eighteenth century (the period
of the Old Masters) is a very complex—and sometimes expensive—field. The
quality of the impressions varies and expert knowledge and a critical eye are
needed to differentiate wheat from chaff. One of the most famous prints of the
period, Albrecht Dürer's *Melencolia I* of 1514, would vary hugely in value de-
pending on the quality of the impression and the overall condition of the print.
An impression made early in the "life" of the copper plate, say ca. 1514–15, with
brilliant inking and in pristine condition, might sell for $1.5 million. An im-
pression made ten years later, towards the end of the artist's life, would prob-
ably have lost a bit of definition due to plate wear, and would sell for under
$500,000. A posthumous impression, made perhaps in the early seventeenth
century, would go for $25,000–30,000. Copper plates and the lines etched or
engraved on them wear with usage, and this shows up in the print.

Our only foray into Old Master prints was for miniatures, which are val-
ued much lower than larger-scale Old Masters. With these tiny bits of paper,

we could acquire some of the images that had intrigued us during Reba's study of Renaissance art.

Particularly appealing to me is a picture of a priest or saint holding a model of a church—a metaphor for a shepherd protecting his flock. In early 1985, we were on a self-conducted art tour through western Germany and Holland, the home country of the leading northern Renaissance printmaking artists, visiting the museums and churches in a half dozen cities. Working with published museum guides and art history textbooks, we had a long list of must-see paintings and sculptures.

We arrived in Düsseldorf in the early evening, having spent a long day visiting the museums in Cologne. Reba collapsed in bed in our room at the Breidenbacher Hof, suffering from museum feet. I ventured out, as we'd been told the hotel was in the antique-shop district and near the Old Master print dealer C.G. Boerner (not yet established in New York), which could be expected to have a good stock of Old Master prints. When I asked for miniatures, several were produced, including one with my favorite image: the saint holding his church.

Old Master prints—and Renaissance art in general—offer challenge and opportunity to figure out the iconography and identify the individuals depicted. The imagery of *The Holy Severin* was far from obvious to me, a Presbyterian who rarely attended church and whose religious education ceased with Sunday school. But what fun to search it out! The print is titled *Der Heilige Severin*, or *The Holy Severin* (Fig. 4), estimated to have been made in the mid-1500s. St. Severin, identified by name in the print, was elected pope when already elderly, and reigned for only two months in 640. He is shown holding a model of a cathedral in one hand and a staff in the other. He was named for a hermit, Severin, who figured in sixth-century church history by persuading the grandson of King Clovis of the Franks to take holy orders.

Fig. 4. Jacob Binck, *Der Heilige Severin*, mid-1500s. Engraving, 3 x 2 in.

Why would an artist make, or a patron commission, a print of a pope who held office for only two months, even if named after a noted hermit? Well, it seems that Pope Severin was a hero of the church. Awaiting confirmation, he withstood intimidation, even the sacking of the Lateran Palace by the Roman Emperor, who attempted to force cer-

tain compliances from the pope-to-be. The emperor eventually capitulated, Severin became Pope, and even in his short reign, built the apse in old St. Peter's church, where he was buried.[2]

I've not yet been able to identify the cathedral St. Severin holds. It's possibly one of several that have been built, and rebuilt, on the site of the original church dedicated to the hermit Severin, near the Cluny Museum in Paris. The artist, Jacob Binck, was peripatetic and probably passed this way. Nowhere in his history have I been able to find a connection with a cathedral known to be like the one under St. Severin's arm, so the sixteenth-century predecessors of the church near Cluny, now called Saint-Séverin Saint-Nicholas and located on Rue Saint-Séverin, remain the best bet.

Binck was not known as a Little Master, although many of his prints are small. He was born in Cologne around 1500, but worked throughout the Low Countries, Scandinavia, and elsewhere in northern Europe during a long career, mainly as a portraitist of royalty and the nobility.

This example illustrates the potential for exploration, scholarship, and learning that go hand in hand with print collecting, particularly Old Masters, which are loaded with symbols and people only understood by and known to certain art historians. Or not known at all—once again illustrating David Tunick's precept that just a little knowledge can make you an instant expert in the field of prints.

As we spread word among dealers of our interest in miniatures, Carl Zigrosser's little duodecimo *Multum in Parvo: An Essay in Poetic Imagination* was recommended. By 1965, Zigrosser had retired as curator of prints at the Philadelphia Museum of Art, where he had gone after his tenure at the Weyhe Gallery. *Multum in Parvo* is little known, even among dealers and curators. Its publication coincides with the early years of the print revival, which saw artist and collector interest focus on large, colorful images. Zigrosser's ode to miniature prints was hardly noticed. The Latin title translates as "much in little," which Zigrosser defines by saying:

> Abstraction, conciseness, symbolism and imaginative potential are basic in the concept. A multiplicity of detail is concentrated into a unified principle, the particular is transformed into the universal, a largeness of meaning is conveyed with the utmost economy of means. This large-ness of meaning should be accompanied by a dramatic impact, in a word: insight with a gasp.[3]

Zigrosser finds this quality in math, short poems, and miniature prints. He does not dwell on math, only quoting Einstein's $E = mc^2$. His poetry ranges from haiku to Greek to Latin and finishes with Ogden Nash:

> The trouble with a kitten is
> That
> Eventually it becomes a
> Cat.[4]

Multum in Parvo remains the bible and guide for anyone interested in miniature prints. The book illustrates and discusses fourteen small prints, dating from the early sixteenth century to 1932. In these small works, Zigrosser finds the visual expression of "a dramatic impact, in a word: insight with a gasp."

With book in hand, I set out to find the very prints illustrated in *Multum in Parvo*, believing that, with print collecting, there's always another impression. My first victory in this quest was Adam Elsheimer's etching known as *Landscape with Satyrs and a Nymph Dancing with a Tambourine* (ca. 1600-1610, Fig. 5). The title describes the scene, although it would be prudent to add that the nymph is high-stepping to her own rhythm and the nearby satyr looks to have more than music on his mind.

Elsheimer's small print is totally consistent with his paintings, most of which are small scale, oil-on-copper plate, which was his principal medium. His prints were, according to Zigrosser, ". . . only extemporized out of the inspiration of the moment." But most of his imagery, like this print, is ". . . in the world of the imagination, and [he] saw sights not visible to ordinary folk, the demigods of the fields and forests, Pan, the nymphs and fauns, who still live furtively and half-forgotten in out-of-the-way places."[5]

Fig. 5. Adam Elsheimer, *Untitled (Landscape with Satyrs and a Nymph Dancing with a Tambourine)*, ca. 1600-1610. Etching, 2.4 x 3.9 in.

Careful reading of print auction catalogues is a basic step in collecting. The Elsheimer showed up in a forthcoming Christie's sale, and although I

was out of town and unable to bid personally, the ever-reliable David Tu-
nick stood in, and we bought *Satyrs and a Nymph* for $3600—the price of a
small piece of paper was not always commensurate with its size.

The acquisition of Samuel Palmer's *The Willow* whetted our appetite
for the early English Romantics, and that two appeared in *Multum in Parvo*
stimulated my interest and collecting urge, never dormant. The Romantic
Movement in art, music, poetry, and literature arose in the late eighteenth
century as a reaction against the Enlightenment: feelings and emotions ver-
sus reason, a return to nature versus industrialization and material progress.
William Blake is the recognized leader of the movement in England, and
his imagery, mostly created in colored prints, includes Biblical scenes and
dreams populated by demons, all with a homoerotic element.

Two wood engravings in *Multum in Parvo* are a perfect pair, William

Blake's *Sabrina's Silvery Flood* (1821, Fig.
6) and Edward Calvert's *The Chamber
Idyll* (1831, Fig. 7). We soon found the
Calvert in London at a modest price;
miniscule prints by English Roman-
tics were not in great demand in the
late 1980s. However, the Blake proved
elusive, probably because an image as

Fig. 6. William Blake, *Sabrina's Silvery Flood*, 1821. Wood
engraving, 1.3 x 2.8 in.

calm as *Sabrina's Silvery Flood* is unusual
in his oeuvre. Sabrina's silvery flood
is a stream running alongside a sheep
meadow and a rustic cabin. The sheep
are grazing peacefully, one nursing a
lamb. Calvert, like Palmer, a disciple of
Blake, looks inside Blake's rustic cabin in
his *The Chamber Idyll*, which I consider
one of the most erotic images in art. Tim
Blanning wrote in *The Romantic Revolu-*

Fig. 7. Edward Calvert, *The Chamber Idyll*, 1831. Wood
engraving, 1.6 x 3 in.

tion, "the introspection that became one of Romanticism's most prominent
defining features ensured that sex was never far away, no matter how much
it might be dressed up in a respectable vocabulary. Indeed, it might be said
that Romanticism was institutionally erotic."[6]

In *The Chamber Idyll*, two lovers are preparing for bed, him nude and

seated. She stands, back to viewer, removing a flimsy garment. His left hand grasps her garment at the hip, as if to assist the undressing. They gaze at each other. All this on a one-inch-by-three-inch bit of paper . . . and a lot of interior decoration as well! Zigrosser is as enthusiastic as I:

> It is one of the most exquisite prints in the history of graphic art. Every detail of the interior is delineated with loving care and inspired craftsmanship—the beams, the casement windows, the implements of the pastoral life. There are glimpses of sheep and cattle bedded for the night, and of the serene starry sky. Here, then, are poesy and romance—romanticism at its very best. Two human beings are the central theme of the picture. Never has the intimacy and tender rapport of man and woman together been suggested with more touching and unaffected simplicity. Calvert has admirably expressed the innocence of sex, wholesome and natural.[7]

It's no surprise that Zigrosser included Rembrandt van Rijn in his *Multum in Parvo* selections. Not only did the Dutch artist make prints of many dimensions, he seemed to delight in small scale. He was also a highly influential printmaker, in that he used the etching plate to experiment, creating

many states of a single image, testing different papers, changing a few lines, or adding or subtracting plate tone. Rembrandt encouraged printmakers to vary their images and embrace the freedom of expression that etching offers. Zigrosser's choice for his book, among the large number of Rembrandt plates, is *The Goldsmith* (1655, Fig. 8).

In this etching, Rembrandt presents an allegory of the artist as creator, for it is obvious that the goldsmith could be any sculptor or indeed any artist. The setting is simple and unpretentious, merely a workshop with a forge and the usual tools. What is impressive beyond measure is the intense absorption of the creator in his work. Rembrandt has not portrayed the conventional idea of the artist, but rather the simple homely workman, middle-aged and careworn, who is creating something more beautiful and enduring than himself. This possibly is a more significant allegory of the artist's vocation than is generally presented. Rembrandt does not exhibit a mannered elegance of style; his aim is for character and psychological truth.[8]

Fig. 8. Rembrandt van Rijn, *The Goldsmith*, 1655. Etching and drypoint, 3 x 2.2 in.

Many of Rembrandt's prints were made in multiple impressions over time by the artist himself, but posthumous editions were issued as late as the early twentieth century. Copies of *The Goldsmith* are not uncommon. I again turned to David Tunick, who gave me the go-ahead on an impression coming up at Swann's, which I acquired for $2500. Rembrandt's most sought-after and famous prints, religious scenes in large format, sell for upwards of $1 million. Size, quality of printing, imagery, and rarity are all major factors in Rembrandt, as in other Old Master prints.

The last of the fourteen prints illustrated in *Multum in Parvo* is an airmail stamp, an object whose very conception as well as its creation reflect the quirky personality of the artist, Rockwell Kent. Kent produced *Greenland Air Mail Stamp* (Fig. 9), a wood engraving in red ink, in 1932 while he was a resident in the small village of Idglorssuit in the Umanak district of Greenland. The stamp was used as postage for mail carried by the German celebrity aviator and former World War I ace fighter pilot, Ernst Udet, who was in the same part of Greenland in connection with the filming of a motion picture, which required him to make trips to Europe as well as other locations in Greenland. Kent explains in a 1947 letter:

Fig. 9. Rockwell Kent, *Greenland Air Mail Stamp*, 1932. Wood engraving, 1.5 x 1.3 in.

> One night, at my house, with Udet as usual pretty high with brandy, we conceived the idea of getting out a postage stamp to stick on the occasional letters that would be consigned to him when he flew to Umanak.
>
> The proceeds of the stamps were to go toward the building of a community house which I was financing and building for the people of the settlement of Idglorssuit. I may have printed about seventy-five of these stamps, and some of them were undoubtedly used by some of the Germans to stick on their letters. Besides the few Kroner raised from the stamps, which was, of course, a tiny drop in the bucket toward the goal, and 100Kr, contributed by the Fanck expedition, the house was paid for and erected by me and the people of Idglorssuit. All the money for the stamps was paid directly to me and went into the funds for the building of the community house.[9]

A footnote on Ernst Udet. He joined the Nazi party in 1933 and rose to a senior position in the Luftwaffe, reporting directly to Reichsmarschall Hermann Göring. He objected to Hitler's invasion of Russia, fearing defeat, and protested Göring's obfuscations about Germany's air-force capabilities. Udet

died in 1941, officially a suicide brought about by stress, but some historians suspect a Göring-ordered assassination, eliminating a nuisance and potential traitor.

Kent was in Greenland because it was his favorite place to escape from financial and/or marital scandals. He had tried other bolt holes, including Alaska and South America, but he loved the rough and cold seas of the North Atlantic. He was shipwrecked—out of Newfoundland on a thirty-three-foot sailboat with two other crew—on this first trip to Greenland on a remote part of the island. Aided by Greenlandic Eskimos, he salvaged supplies and made camp. His two companions quickly returned to America, but Kent stayed on. He painted images of Greenland, and after coming home to New England, made regular return visits, months at a time, to the island.

Kent had become an artist of note in the late 1920s by virtue of the wood engravings he created to illustrate a high-priced, limited edition of Melville's *Moby Dick*. Lavishly illustrated and bound limited edition books were popular in the booming twenties, and Kent's Art Deco-style drawings and prints were perfect for the period and into the 1930s; he illustrated many. His success was such that he was indifferent when his investment advisor lost his total savings of $50,000 in the 1929 crash.

World War II and its aftermath changed life for Kent. Always a radical, a combative and outspoken friend of the Communist Party, and defender of the virtues of the Soviet Union, Kent was soon in hot water. The Soviet blockade of Berlin had just been broken (in 1949), and the next year Kent went off to a "peace conference" in Moscow. His passport was seized upon his return. A few years later, in the wake of Russia's successful launch of several space satellites, including one with a dog passenger, Kent said on Chicago television, "We will launch a better and bigger rocket, putting into it not a harmless little puppy, but John Foster Dulles [the U.S. secretary of state, Kent's arch enemy because of U.S. policy of restricting passports of suspected Communists]."[10] Kent remained a friend of the Soviet Union, finding nothing objectionable about the Russian invasions of Hungary and Czechoslovakia. In 1957–58, he loaned a number of his paintings for exhibitions in Russia, and in 1960 donated paintings, drawings, prints, and writings "to the Soviet Peoples." Russian museums are the largest holders of Kent's art.

Aside from the specialists in the Little Masters, to my knowledge Reba and I are the only collectors who have deliberately created a collection of

miniature prints. These tiny black-and-white etchings and engravings (and
Zigrosser's book about them) got little notice at the time of the big, color-
print revival, and they haven't since. But our enthusiasm for them led us to
acquire more and more as we discovered that many artists had, at one time,
tried small scale. Micro prints have spilled beyond our piano top to several
mantels to miscellaneous shelves—around seventy-five in total.

Lack of knowledge, even among the cognoscenti, about small prints en-
couraged us to play a trick on art experts. On a mantle in our library, framed
like our miniatures, are two slightly larger-than-miniature etchings of dogs,
one a sleeping greyhound with the letters *EOS* and *VR* nearby, the other a
highland terrier with the words *Islay* and *Albert*. Both are dated 1840. We ask
the visiting expert, "What are these?"

Few knew. The dogs are the pets of Queen Victoria and Prince Al-
bert—the greyhound, named Eos, etched by the Queen, and the terrier Islay
etched by Prince Albert.

In 1840, Queen Victoria was twenty-one years old, as was Prince Albert,
and she had been on the throne three years. They were married at the
beginning of the very year they etched their favorite dogs. Like all well-edu-
cated people of their time, they had been taught art, including drawing and
etching, by their tutors. The Queen recorded in her diary of August 28, 1840,
"We spent a delightful peaceful morning,—singing, after breakfast, and etch-
ing together—our first attempt!"[11] Victoria's diary mentions etchings over the
next several years, and she and Albert made a total of ninety-three prints,
some printed on a press installed in Buckingham Palace specifically for the
royal couple. Victoria eventually lost interest in the medium and turned to
watercolor and sketching, and became more engaged in affairs of state.

We acquired *Eos* (Fig. 10) and *Islay* (Fig. 11) in London in 1989, one a
gift from a dealer, the other a purchase for a small price. Apparently there
are few of the Queen's and Prince's prints in private hands, as they were not
editioned, except in one case illegally. A workman at the print shop that had
been engaged to make several proofs of the royal etchings stole some of
the prints and plates and sold them to a publisher with the strange name of
William Strange. Mr. Strange printed a catalogue preparatory to conducting
a sale, which was quickly discovered. Prince Albert sued, the Lord Chancel-
lor enjoined Strange and the prints and plates were recovered, and all (but
one) of the sales catalogues destroyed. The single extant catalogue, simple

and not illustrated, is in the Royal Collection at Windsor Castle. Thanks to an introduction from friends at the British Museum, we visited the castle's print room, and inspected this rare document.

How did our royal prints come into the marketplace? A tutor to the royals disposed of his art collection in a public sale; it likely contained impressions of royal etchings. It's possible that Victoria and Albert gave prints to friends. There is no other known note for any of these royal prints to have reached dealers or collectors.

We consider ourselves lucky to have acquired these royal assets. The quality of the art is quite good, but their real appeal to me is the historical context. In my mind's eye I see the young Victoria and Albert, in formal dress, sitting beside one another, each holding a copper plate and needle, etching and singing.

Fig. 10. H.M. Queen Victoria, *Eos*, 1840. Etching, 5.9 x 3.9 in.

Fig. 11. Prince Albert, *Islay*, 1840. Etching, 6.1 x 4 in.

Art That Sells

Forty years ago Reba and I, as a couple, bought our first prints: two posters. Our purpose was to decorate Reba's small country house in Amagansett, Long Island, which we were furnishing in a late nineteenth-century style. Our prize possession was a flower-bedecked Tiffany-style glass lampshade, hung prominently over our dining table. Colorful late nineteenth-century American advertising posters, many decorated with flowers, were a perfect match with Tiffany. And these posters—originals, not reproductions—were each priced for less than fifty dollars in 1973, about what a reproduction poster would cost today.

Collectors do not view original posters the same way they do original prints, because posters are produced in large, sometimes unlimited, editions, and they are rarely signed by the artist. "Original" in this case means printed and distributed in the year the poster was made for the first time. Frequently the artists have nothing to do with the printing process—they simply submit a drawing or painting that a professional printer transfers to a lithographic plate for mechanical reproduction. Just the same, posters are widely collected and are handled regularly by specialized dealers and auction houses.

The age of the illustrated advertising poster began in the 1860s in Europe, with the perfection of color lithography, some fifty-plus years after the basic process was invented. Credit French artists and lithographers with popularizing posters as an art form. Henri de Toulouse-Lautrec, active in the 1890s, was and remains the most popular poster artist. He was commissioned to make advertising posters for Paris nightclubs and performers, which were then displayed on fences and billboards around the city. His posters quickly became collectors' items. Eager collectors followed on the heels of workers who were mounting Lautrec posters, and removed them

as soon as they were glued to a wall. Lautrec's posters are notable for their uncomplicated images of people, strongly outlined in black. The strange and exotic characters Lautrec portrayed are memorable, the vivid colors bringing them to life. If protected from sunlight, the colors remain true. Paris lithographers used durable inks and tough, sturdy paper that did not deteriorate. Lautrec's most popular posters, in good condition, sell from $50,000 to $300,000–400,000 today.

The phenomenon of illustrated advertising spread across Europe, with posters promoting branded foodstuffs, art exhibitions, sporting events, and various consumer goods. The Czech artist Alphonse Mucha, working in Paris, made some posters simply for the purpose of decoration, featuring fancily dressed—and partly undressed—beautiful women surrounded by Art Nouveau swirls of garments and flowers.

Publication of illustrated posters has continued ever since. With the age of travel—automobiles, passenger trains, luxury liners, airlines—poster production exploded in the Americas and Europe, luring potential travelers to see the world. The World Wars brought forth patriotic posters in all the countries engaged in the conflicts. The Imperial War Museum in London boasts a collection of about twenty thousand war-related posters from more than eighty nations.

Color lithography came to America coincident with its development in Europe, brought by immigrant printers from Germany, France, and England. The technique was first used to illustrate box labels and sheet music. Posters soon followed, and poster collecting started immediately. In a letter to the editor of *Poster Lore* dated 1895, a collector noted that he had amassed fifteen hundred American posters.[1] In other words, in roughly twenty years, at least fifteen hundred American posters had been published. Today, worldwide, the number of published illustrated posters must be in the millions.

Poster Auctions International is a leading dealer and auctioneer of all types of posters, dating from the nineteenth-century French, including Lautrec and Mucha, to posters made as recently as a decade ago. The firm publishes two catalogues each year for its New York sales. The 2014 Winter Book contained color illustrations of more than six hundred posters, and sold for forty dollars. Poster Auctions International has published similar catalogues since 1985. A visit to view the offerings prior to an auction is overwhelming. The display space is filled with arresting images in large

sizes hung closely together. Bins are loaded with unframed posters. Not for
the weak or easily muddled by an overdose of pictures, but there is beauty
everywhere. This is no small enterprise.

Poster collectors tend to specialize, with travel-related images being the
favorite. Other categories include patriotic, often war-related, images; par-
ticular artists, such as Mucha; entertainment, performers, and celebrities;
and nationalities, such as British or American.

The style of the first American (and European) posters is characterized
by highly detailed illustrations and then lots of text, conscientiously explain-
ing the product or service being advertised. French poster artists, particularly
Lautrec, broke this pattern with simplified drawings and minimal text, letting
the image carry the message. This style migrated to the U.S. immediately.

We did not set out to build a poster collection, but from time to time I
could not resist buying one. The colors and the Art Nouveau curves of the late
nineteenth century are seductive to this image-addicted collector. Like our
print collection, I acquired American posters, those published in the 1890s.
It was in this decade that American advertising posters had their moment of
glory. David Kiehl opened his essay in *American Art Posters of the 1890s* with:

> In April 1893 something new was spotted in the shops of American
> news vendors and booksellers. Amid the handbills and letterpress
> notices of topical interest, there was a small poster that pictured a man
> in a green overcoat and a hunter's cap, intently reading a magazine
> and heedless of the falling rain. The only lettering on the poster was
> "HARPER'S FOR APRIL." The magazine that captured the man's undivided
> attention was *Harper's Monthly Magazine*.
>
> This was unprecedented. There was no listing of contents, no
> headline stressing an important story or new serialized novel. Moreover,
> nothing in the image made any reference to a holiday season. It was just
> April. The poster was bold in its simplicity: the singular, isolated figure
> of the man; the magazine; a mere suggestion of the weather proverbi-
> ally associated with the month; and bold lettering carefully integrated
> into the design. The implication was quite clear. *Harper's Monthly Maga-
> zine* was worth a walk to the news vendor even in the pouring rain. [2]

In May, *Harper's* produced a poster of a young girl wearing a floral
wreath and holding a copy of the magazine, and each month thereafter was
a new image of some symbol of the season and a person holding a copy of
Harper's. In less than a year, other publishers of periodicals followed suit

with their own posters. "The race had begun," Kiehl noted, "and, with the added encouragement of collectors, the enthusiastic interest in the poster already rampant in Paris accelerated across the United States during the rest of the decade."[3]

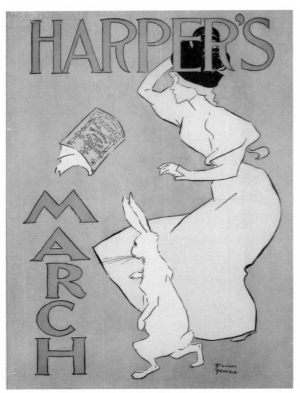

Fig. 1. Edward Penfield, *Harper's/March*, 1895. Lithograph, 19.3 x 13.8 in.

Edward Penfield created the monthly posters for *Harper's*, and like the most successful posters, the ones he provided *Harper's* were simple and direct, composed of line drawings and blocks of color. The viewer had but to glance at the image and the lettering to get Penfield's and *Harper's* message. Many contained a touch of humor, as in *Harper's/March* of 1895 (Fig. 1), with its wind-blown March hare.

American poster art quickly moved beyond the simple lines and color blocks of Penfield and his followers. In 1894, Will Bradley was hired to make cover designs for a Chicago-based magazine, *Inland Printer*. The game changed with Bradley's Art Nouveau-inspired designs, which may have been the introduction to most Americans of this style of sinuous curves, implied movement, exotic plants and flowers, and the androgynous human form. Bradley's style and skill is best demonstrated in *The Blue Lady* (1894, Fig. 2), his advertisement for *The Chap-Book*, a house organ of the Chicago fine-printing-and-design house Stone & Kimball. The firm hired other artists to make posters for their publications, but Will Bradley brought the magazine lasting fame. In *The Blue Lady*, a woman stands in strange dress in a forest of thin, tall bare trees. Her skirt swirls at the bottom of the image, and in the distance a white river crosses the landscape. There is no obvious narrative, only an original and enigmatic scene. *The Blue Lady* is made with only three colors—blue, red, and black— and this simplicity emphasizes the design.

Bradley's *When Hearts Are Trumps* (1894, Fig. 3), published by Stone & Kimball to advertise a book, is more traditional Art Nouveau. Curves are

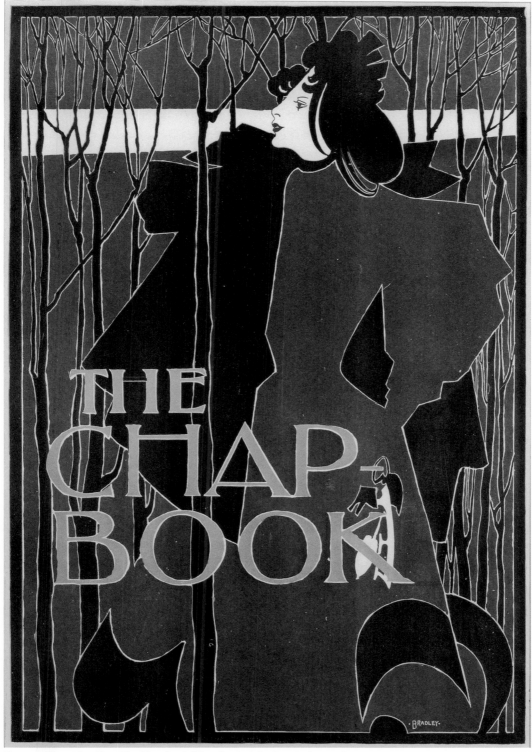

Fig. 2. William Bradley, *The Chap-Book (The Blue Lady)*, 1894. Lithograph, 19.6 x 13.2 in.

everywhere: flowers, the hair of the figures and their limbs and garments, and vines with flowers. Overcome with this romantic vision of a satyr and a beautiful woman, I soon added *When Hearts Are Trumps* to our small group of posters. Who could resist?

Reba and I explored Art Nouveau, mainly in Vienna and London. In Austria, architecture and the interior design of famous and landmarked buildings provide the best examples. In London, we knew the source was the Victoria and Albert Museum, repository of much nineteenth-century art acquired by undaunted and acquisitive British explorers and adventurers. It was early in our Art Nouveau and print-collecting quests, so with nonexistent credentials as collectors or art historians, we ventured into this big Victorian pile of terracotta brick, the V&A, and asked to see posters, particularly those of Toulouse-Lautrec. We were sent to a room provided with what Americans call a dumbwaiter, while a museum assistant in a lower storeroom threw some Lautrec posters onto the elevator's tray. With rope pulleys, we hoisted them up. None were on mats or even covered with cellophane for protection. Edges were curled and torn.

London was a mess in the early and mid-1970s. World War II debts and thirty years of socialism had wrecked the economy. Museums were understaffed, while the government tried to rein in expenses and protect the wobbling pound sterling. Economic recession seemed permanent, unemployment was high, inflation raged. The coal miners' strikes had forced power and heat reductions—shops and public spaces were dark and cold. We stepped on broken glass, the result of an IRA bombing, on a sidewalk outside a restaurant. Museums could be excused for a lot, but it seemed extreme to both of us that the V&A was so cavalier about the preservation of these valuable prints; we probably could have walked out with a few tucked under our arms. We did not, but we did have a conservation problem of our own, years later.

We learned the hard way that the red ink in many American posters of the 1890s fades if exposed to even a small amount of sunlight. We acquired *When Hearts Are Trumps* in the early 1980s, and although it was framed in ultraviolet-proof Plexiglas, as are all our prints, it was too close to a southern-exposed window in an Alliance Capital office. Over the course of twenty years, the red turned gray. Great art lost forever by my carelessness— but this was the only work we ever owned that was light-damaged.

There was no choice for me: in love with this picture and its association
with Reba's and my fascination with the romantic impulse of Art Nouveau
that we discovered together in the early years of our courtship, I couldn't
live without *When Hearts Are Trumps*. We bought our replacement impres-
sion, red color intact, in 2004 for about five times the price we had paid for
our now-faded copy twenty-five years earlier. Today, it's on a wall in a safely

Fig. 3. William H. Bradley, *When Hearts are Trumps by Tom Hall*, 1894. Lithograph, 16.4 x 13.3 in.

sunlight-protected place. To me, it remains the essence of Art Nouveau imagery and evokes romance, with swirls and curls surrounding lovers, and hearts trumping everything—advertising a long-forgotten book published in that not-so-romantic city, Chicago.

Over the years I added a few American 1890s posters to our collection—this was a digression, outside the mainstream of our collection. But any potential for exploring these posters on a scholarly basis was squelched when the Metropolitan Museum mounted a huge exhibition, *American Art Posters of the 1890s* in 1987. We were too late. The acquiring and the research had already been done. The best of this genre had been found and assembled by Leonard Lauder and donated to the Metropolitan Museum of Art, and the associate curator of prints, David Kiehl, with two other art historians, had written and edited an impressive catalogue raisonné. The book illustrated and briefly described each of the 290 posters donated by Lauder, included a short biography of each artist, and provided many color illustrations. There was nothing left for us to do if we wanted to pursue collecting or researching this field. So my poster collecting amounted to an occasional impulse purchase, and the few posters I accumulated ended up in a storeroom, or occasionally on an office wall.

In his introduction to *American Art Posters*, Lauder wrote that he most admired the poster art of Will Bradley and Edward Penfield, and:

> I have tended to be less interested in artists such as Maxfield Parrish, whose roots were more firmly established in magazine illustration than in the production of the art poster. According to Penfield, "a design that needs study is not a poster no matter how well it is executed." I have taken these words to heart. The most successful poster is one that elicits an immediate response. The concise wording and simplified forms employed by these artists [Bradley and Penfield] work together to create a narrative with strong impact. [4]

One can't argue with Lauder's observations about posters, but two by Maxfield Parrish have always ranked high among collectors' favorites. The designs do, in fact, "need study" and the images attract study. Both are of attractive nude women, each sitting alone in a woodland. *Scribner's Fiction Number/August* (1897, Fig. 4) breaks all the poster rules. Every part of it is quite detailed: the nude's headband of flowers, her facial features, the background foliage. Even more anti-poster is the tonal dawn sky. Unlike practically any other poster of the period, in this one Parrish created a sunrise

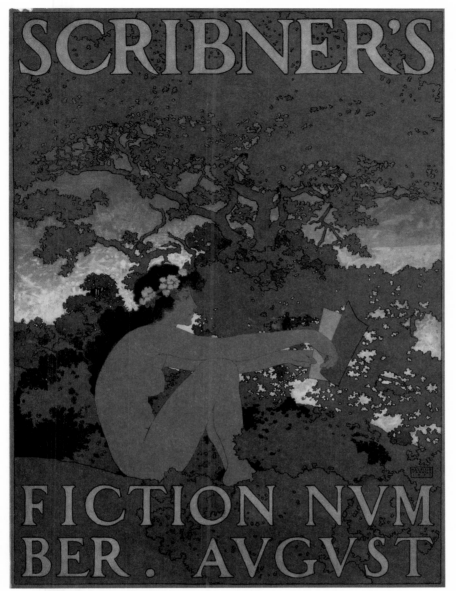

Fig. 4. Maxfield Parrish, *Scribner's Fiction Number/August*, 1897. Lithograph, 19.5 x 14 in.

with light at the horizon fading into a darker sky above.

Parrish made few posters, but one was a prize winner, and it conformed to the poster conventions. *Poster Show* (1896, Fig. 5) depicts two young women, each holding a poster show exhibition catalogue. The figures are outlined in black, and their dresses are in shades of gray and brown. There's only a touch of detail in the women's faces. This image was both the catalogue cover and the advertising poster for the exhibition. Some impressions

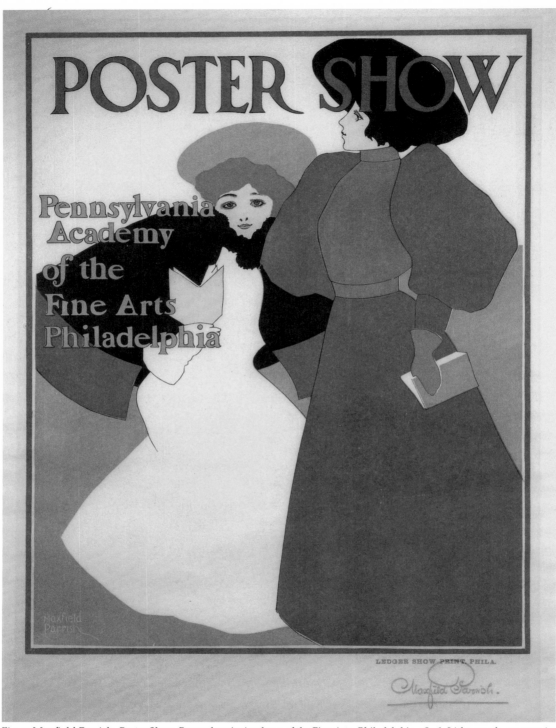

Fig. 5. Maxfield Parrish, *Poster Show, Pennsylvania Academy of the Fine Arts, Philadelphia*, 1896. Lithograph, 30 x 23 in.

have lettering in the bottom panel, advertising the exhibit. Ours is blank, but for Parrish's signature in pencil. This version was probably printed after the poster show opened and after the prize had been awarded, but it's original enough for this collector.

Almost without exception, art posters of all nations/countries were made with color lithography. Screenprinting was not discovered until early in the twentieth century, and screenprinted posters proved fragile—the ink was easily marred, and it cracked and flaked off the paper.

A rare exception to the lithographed format were the woodcut posters by Florence Lundborg. A Californian, Lundborg was very influenced by that state's Arts and Crafts movement, which emphasized the woodcut and Japanese style: minimal detail and simplicity, artistic beauty more important than reality. These qualities are exemplified in Lundborg's *The Lark-November* (1895, Fig. 6): three colors, the bird against an empty sky, set in Northern California with Mt. Tamalpais and the Marin Peninsula in the background. True to her art, Lundborg cut her own woodblocks, including the lettering, and oversaw the printing. (Like many of the books and periodicals advertised by posters, *The Lark* was a short-lived literary magazine.)

Fig. 6. Florence Lundborg, *The Lark-November*, 1895. Color woodcut, 16.3 x 9.9 in.

One of the most successful—and mysterious—poster artists of the period was Ethel Reed. Her *Miss Träumerei* (1895, Fig. 7) is the perfect poster: a simple and charming design with only three colors, yellow, black and gray. There's an Art Nouveau influence in the curved shape of Miss Träumerei's back and dress as she leans forward across the piano keys, and in the flowers—yellow chrysanthemums splashed across the foreground.

Most of Reed's illustrations conformed to the poster convention of simple forms and few colors, and most included a young girl. One of her admirers, the author and poster authority Victor Margolin, praised Reed's work but offered a mild criticism. "The preciosity of her coy young women and arch little girls does pall a bit, however."[5]

Reed's last poster departed from her usual style; *The Quest of the Golden Girl* (1897, Fig. 8) is Impressionist, with color tones and indistinct forms. A shower of gold falls on a hooded female figure who is touching the shoulder of a dark-haired man kneeling before her. A gray background lends a somber feeling, unrelieved by touches of red. The poster was made in London to advertise a book written by Richard Le Gallienne and published by John Lane's The Bodley Head.

During its heyday in the 1890s, The Bodley Head was the leading publisher of literary works, such as the plays of Oscar Wilde. The Bodley Head also published a periodical, *The Yellow Book*, which was noted for its articles and short stories by writers such as Max Beerbohm, Henry James, and William Butler Yeats. But *The Yellow Book* was best known for its notorious illustrations, the erotic drawings of Aubrey Beardsley. Even when not overtly sexual, the Beardsley drawings always contained a salacious touch, which, combined with the writings of avant-garde novelists and poets, made The Bodley Head the talk of the town and outraged the Victorian literary establishment.

Fig. 7. Ethel Reed, *Albert Morris Bagby's New Novel/Miss Träumerei*, 1895. Lithograph, 18.4 x 12.5 in.

Ethel Reed's reputation as a poster artist brought her into this hotbed of England's artistic and intellectual elite at the age of twenty-three. Reed was born in 1874; conventional wisdom has it that she was never seen or heard from again after 1898. David Kiehl explains in his short biography:

> In a two-year period, Ethel Reed of Boston emerged from obscurity, blossomed as an artist with an international reputation, and then disappeared completely. Her biography is fairy-tale material. Reed was not only very young but also strikingly beautiful; she was often described in poster-like terms. Many of the women in her posters and illustrations were probably self-portraits. Her engagement, after a passionate whirlwind romance, to another Boston artist, Philip Hale, was publicized in the literary journals and poster magazines. Yet she sailed alone for Europe in May 1896, "to study in the broad school of life." In 1897, she was in London working on her last known poster, for Richard Le Gallienne's *Quest of the Golden Girl*. She was reportedly in Ireland in 1898, resting; then she disappeared.[6]

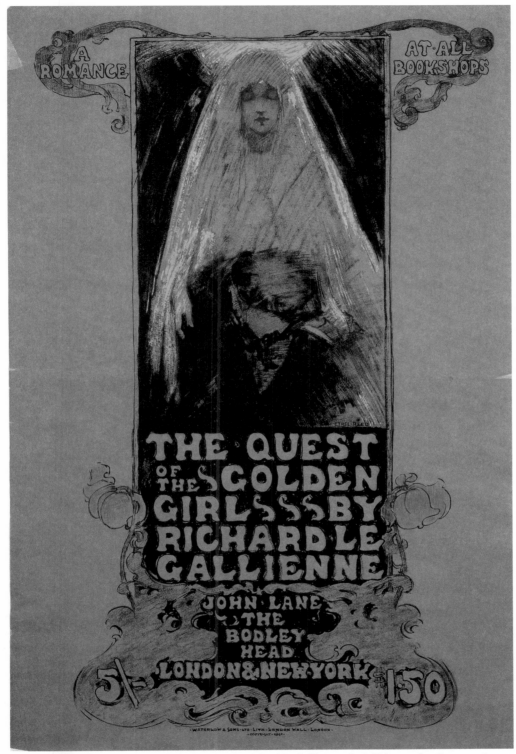

Fig. 8. Ethel Reed, *The Quest of the Golden Girl by Richard Le Gallienne*, 1896. Lithograph, 28.1 x 17.2 in.

Not so, it turns out. Writing in the *Woodstock Times* in 2008, John Thorn, who admits to being in love with Ethel Reed on the basis of a poster of hers he acquired, and loving a good mystery, did the research and learned more about Reed's fast but tragic life. According to Thorn, Reed was part of bohemian Boston:

> involved in a ménage à trois with the architects Goodhue and Cram . . . [and] would pose nude for photographer Fred (Holland) Day . . . she had ridden the new wave: a fad of Orientalism, experiments in free love and hashish . . . She would become engaged to one of the Hub's most eligible bachelors, artist Philip Hale . . . and then disengaged [jilted], fleeing to Europe in heartbreak and shame.[7]

A London census reveals she was living in that city in 1901 with a four-month-old son. Yet the saddest chapter was to come. According to John Thorn, Le Gallienne, with whom she'd had a love affair (and who was perhaps the father of her son), wrote a poem to her in 1910 titled "To One Who is Blind," suggesting that after all of her adventures, Ethel Reed, the prodigy poster artist, had become blind. Here the story ends.

My occasional purchase of a single American art poster eventually led to an accumulation of more than a dozen, without a place to hang them. But by 2006 we'd decided, because of our frequent visits to London, that it made more sense to rent an apartment than continue to stay at hotels, and Reba offered the clincher, as far as I was concerned: "Wouldn't it be fun to decorate a London flat with American nineteenth-century posters? You'd finally have a place for these things you love and have been squirreling away for years."

In no time, we'd set up housekeeping in a large, red-brick apartment building on Grosvenor Square, right across from the United States Embassy, and I'd crowded our walls with posters.

We, too, were crowded, as the flat wasn't large, and we both needed work space—desks, office equipment, and the like. So we rented a room two blocks away, which provided blank walls for more art. These we decided to decorate with British posters, but finding them wasn't easy. Nowhere in London, or in all of England, was there a dealer who specialized in British posters.

This was surprising, because, much like America, Britain experienced a late nineteenth-century poster craze. English posters mostly advertised consumer goods, but in 1908, the first poster advertisement for the Lon-

Fig. 9. Dora Batty, *By Underground/From Country to the Heart of Town for Shopping*, ca. 1920s. Lithograph, 25 x 40 in.

don Underground, or subway, was printed. The Underground had over-expanded and was facing bankruptcy unless the volume of riders could be increased. Something worked—perhaps the poster-based marketing campaign—and the London subway survived and thrived to the point of ridership exceeding capacity. But Underground advertising posters continued to be produced—over five thousand in just over one hundred years since the first one was issued.

Both famous and unknown artists were employed to create the posters. Most emphasized destinations, or the ease of getting from one location to another. The posters were displayed inside the trains and stations, and above ground on billboards. Collectors immediately began to save the posters, and like many advertising posters of all nations, London "Undergrounds" are very attractive and decorative, and show up in auction sales—just not in London dealer galleries.

The New York art world came to our rescue, with several dealers who carried British travel posters. Thanks to these dealers, especially Chisholm Gallery and the auction houses, we soon acquired the requisite ten or so to fill our new London office.

Dora Batty's posters were our favorite. She was one of many women poster designers during the 1920s and 1930s, when following the Great War, employment opportunities of all sorts opened up for women in Britain, perhaps the only benefit from the loss of the many male lives in the war. Batty, a textile designer, taught at and headed the textile department at the Central School of Arts and Crafts. Her poster designs usually featured well-dressed women, as in *By Underground/From Country to the Heart of Town for Shopping* (ca. 1920s, Fig. 9). Batty's shopper wears a geometric-patterned jumper with matching hat, scarf, and gloves. The fabric twists at the waist as the woman turns, and wind blows the scarf, all demonstrating the artist's understanding of textiles and her skill as a fashion illustrator.

At last we had posters on our walls that could be seen—the American 1890s and British travels in London, all offering a cheerful greeting when we arrive groggy after the overnight flight.

It's a Wrap!

Chris Noey didn't announce the completion of our film on print collecting with those classic movie-making words, but he was happy to tell me *All About Prints* was finished. The idea to make this video came from a college roommate from fifty-plus years ago, who, following a visit to one of our exhibitions, asked me if there was a good DVD on prints to use in the classroom. When I investigated, I found there were none, and when Reba urged me to make one, I didn't hesitate. I knew it would be, at the very least, an interesting experience. Making a film about prints and print collecting offered a new outlet for our longtime avocation and an opportunity to learn about making a film, not just watching one.

I wrote a script, and Reba suggested the title, *All About Prints*. Inquiries to friends led us to Chris Noey, whom we were lucky to engage to direct, edit, and produce our video. Chris makes films for the Metropolitan Museum of Art and also freelances. He's tall, handsome, and alert, quick to offer a humorous, wry comment. He was understandably diffident about taking on our project:

"I don't know anything about prints," he said.

"I do, and I can assemble the cast," I said.

With that, he agreed, and we divided the tasks: Chris read my script, and rearranged it, which vastly improved the program. I collected the "actors," all print experts whom Chris would interview.

Chris emphasized the importance of location, believing that his interview subjects would respond best in their natural habitats. He also thought that visual backgrounds would be critical for setting a scene and encouraging enthusiastic responses. Home bases would provide access to prints. This would require Chris, his three-person crew, and their equipment—cameras, lights, audio recorders—to travel around the country and even abroad. I was quickly learning why movies cost so much to produce.

My great coup was recruiting Antony Griffiths, Keeper of Prints at the British Museum, to be the primary narrator. To induct Antony, I approached his boss—Neil MacGregor, director of the museum—and asked for his help. The educational purpose of the film appealed to Neil, whose blockbuster exhibitions at the BM were always learning experiences. Antony said yes, although I was sure he'd have preferred to go about his usual business of researching prints. Thanks to the clever animation Chris employed and Antony's charm and skill with words, the film's explanations of how prints are made, which can be tedious, are brief and clear.

Tall, lanky, with chiseled facial features and alert blue eyes, Antony is an Oxford graduate with a polished English accent to match. (When we premiered *All About Prints* in London, a guest described Antony as "the Jeremy Irons of the print world.") The principal elucidator of print processes in the film, he manages to avoid the usual eye-glazing discussion. It was not hard for him: his *Prints and Printmaking: An Introduction to the History and Techniques* is an outstanding book on prints and print collecting. It includes concise and understandable descriptions of how the myriad varieties of prints are made. Antony's knowledge of all types and periods of prints is encyclopedic. He's tireless in his pursuit of information about prints, a relentless researcher. He has uncanny recall of images, artists, dates, and locations. No detail about prints is too small to escape his attention. And, like most genuine enthusiasts, he never stops learning.

Chris, camera crew, and gear traveled around the eastern United States and to London, interviewing the curators, artists, and print dealers I'd signed up, and some he persuaded to participate. All turned out to be superb performers who responded well to Chris's interviewing. His focus on location was absolutely right. Antony Griffiths's Oxford accent was perfect among the polished mahogany tables, print drawers, and easels in the British Museum print room.

Christie's allowed us to film part of a print auction, so Chris and team moved into their Forty-Ninth Street auction room, aiming to catch the moment when Hopper's *The Henry Ford* would come up (its sale is covered in Chapter Two). The bidding was fast and furious, paddles waving all over the room, and the camera captured the record-setting price for a Hopper print as the gavel slammed down. After the auction, Chris interviewed an excited Kelly Troester, head of Christie's print department, who noted that several

The artist Will Barnet, appearing in his Maine studio and surrounded by paintings and prints, emphatically and passionately promoted prints as an important artistic medium. Early in the film, he hit a table with his fist, and declared, "Prints! You can't beat 'em!" Dealer Brooke Alexander, cool and relaxed in a solitary Eames chair in his white-walled, spare gallery, became animated and persuasive about Jasper Johns's prints, gesticulating to demonstrate how the artist dismembered an etching plate to rearrange an image. The Old Print Shop was a cozy contrast to the Brooke Alexander Gallery, with proprietor Bob Newman telling Winslow Homer stories while standing among tables stacked with prints, and walls hung with prints frame to frame.

David Kiehl, the reticent Whitney Museum print curator, was cautious about taking the interview stage, but once underway, wouldn't stop talking about Hopper. Print dealer Susan Teller covered WPA prints, her commentary enlivened by 1930s film clips of Depression scenes. Reba provided a segment on how Mexican muralists affected the work of American printmakers, filmed in the Orozco Room of New York's New School, with its perfect backdrop of its namesake's murals. We were especially proud of these murals, despite their glorification of Lenin, Stalin, etc., because we had persuaded Equitable Life (with a small personal contribution) to finance their restoration. They looked good, colors bright, images distinct.

The graphic artist Kiki Smith was recruited by Chris, with help from Susan Dunn at Pace Gallery. Smith was not comfortable with the physical arrangement of her interview, set in her East Village studio, but when Chris suggested moving a stool next to a sculpture she was working on, all felt right. Smith explained one of her early prints while working on a small clay sculpture, her eyes focusing on the print on an easel, and talking while her hands modeled clay—multitasking! Chris, who had become quite knowledgeable about prints, also arranged an interview in Harlan & Weaver, the fine art print shop. Master printer Carol Weaver is making a color lithograph by the artist Joanne Greenbaum, who is working on the plate between proofs. They explain the process—artistic and mechanical. In another scene, MoMA print curator Debbie Wye explains the work of Swoon, a street artist, who makes large-scale woodcuts and surreptitiously, at night, pastes them onto buildings and storefronts in downtown New York.

Collaborating with Chris on the film, even in a very junior capacity, opened a new world to me. Though the film was to be nonprofit, Chris and lawyers advised that we must get approval from artists and artists' estates to reproduce the prints in a film, even though Reba and I owned them.

This obstruction brought back an old, and painful, memory.

In 1983, we financed an exhibition of Frank Stella's prints at the Whitney Museum. For a lavish dinner at the museum honoring Stella, which we also paid for, we reproduced one of his prints on the cover of the invitation. How clever! Until Frank Stella saw the invitation, and he was furious.

"Who gave you permission to use this print? Nobody reproduces my art without my agreement!"

Taken aback by his anger, I mumbled "I thought you'd be pleased; it's a perfect copy. It brings attention to your wonderful work and this exhibit."

With a grumble, he turned on his heel, and those were the last words between us. No thanks for what we'd done, no evidence of any gratitude—then, or ever.

To avoid repeating this episode, and to conform strictly with artists' wishes and rights, Chris engaged Lizzy McGlynn to get clearances for the fifty or so prints that would appear, however briefly, in *All About Prints*. Lizzy spent hours on the telephone, wrote countless letters, and handed out our money for the releases. Living artists were gracious and quickly agreed to our filming their work, without compensation (we did not include a Stella print). Estates, usually represented by one or another arts organization, charged between $100 and $400. Everything was proceeding smoothly, until the afternoon Lizzy called.

"The Mexican bank that represents Diego Rivera is being difficult. '$2,000, *por favor.*' I tried to negotiate, but they won't budge. Claims that's the standard. What should I do?"

Annoyed, I asked, "Are you sure they're for real? Do they really have the estate?"

"Yes, there's no doubt. It's in the reliable records. No *dinero*, no Diego, I'm told."

Exasperated and out of patience, I told Lizzy to pay. In truth, I was furious. Reba had saved the Rivera estate $2000 many times over by some advice she gave Gertrude Weyhe. Gertrude, exploring one of the Weyhe Gallery's warehouses, came upon a Diego Rivera lithographic stone, the

image still intact and usable. Reba's advice: Get that stone to a good museum to avoid the risk of it falling into unscrupulous hands that would make restrikes and ruin the value of the image. Gertrude complied, and the lithographic stone is now in the Philadelphia Museum of Art, repository of the finest collection of Mexican prints in the world.

A filmmaking issue I'd never considered was the background music. Of course, there has to be sound, not just voices and images. Chris knew where to turn for a specialist and engaged Ed Bilous, an instructor at the Juilliard School, to compose an original score for the film. Little did I dream we'd have our very own music, but what a difference it made: the video took on a new importance when music was added. The film opens in the lobby of our Print Research Foundation (more on this in the next chapter), with people viewing prints—no conversation, just lively music. The scene shifts to the New York print fair, people milling about in exhibitors' booths, and the tempo picks up. Excitement! Interest!

The project took nearly a year, but at the end, thanks to Chris's patience, energy, and expertise, we had a polished and professional fifty-five minute program, made to Public Broadcasting System specs. (Chris had contacted PBS early in the project and received strong interest.) *All About Prints* tells the story of printmaking and print collecting from Renaissance artists in Europe to contemporary printmakers in America, but it mainly focuses on the history of prints in the United States, with emphasis on the twentieth century. The accompanying DVD was divided into chapters for use in art history classes.

All went very smoothly until we sent the video to PBS and encountered its unexpectedly formidable bureaucracy. We were *giving* the film to PBS, and that seemed to make them suspicious. We were treated as if we were ExxonMobil proposing to sponsor a show advocating drilling for oil under the White House. First, we were told, the Print Research Foundation (meaning Reba and me) could not both have paid for the film and hold the copyright. We were told this was a "conflict of interest." That made no sense—What conflict? What interest?—but we went along with it, assigning the copyright to the National Gallery of Art. If need be, one entrenched Washington institution—the museum—could deal with another—PBS.

Next, PBS said that Reba couldn't appear in the film. No matter that she holds a Ph.D. in art history and is one of few experts in the U.S. knowledge-

able and able to discuss the influence of the Mexican muralists on American printmakers. This was bad news, as the film was finished and Reba's Mexican segment was right in the middle, the linchpin for the whole story. Chris was dismayed at the thought of remaking the film, and he was determined to turn PBS around.

Fig. 1. Still of Reba White Williams from *All About Prints*

"I'm going to Washington and get face-to-face with these people," he vowed. "Why are they being so unreasonable?"

None of us had an answer to that question. Could they not deal with us because we were donating the film, not trying to profit from it? Was philanthropy unknown to PBS? Surely not. We had no profit motive, no clandestine self-interest—was this unheard of in the halls of this organization? Years later, it remains a mystery.

Chris became a diplomat, journeyed to D.C., and returned with a partial victory. The powers of PBS agreed that Reba's picture could appear once (Fig. 1—and note the Orozco murals). Otherwise she was only able to provide voiceover—her face supplanted with images from prints. This was hardly a disguise, given her distinct and easily identified Southern accent, but that's how the film was shown when *All About Prints* began appearing

on PBS stations nationwide during the summer of 2009—with only the
briefest glimpse of Reba's face. The DVD remains the original take, with
Reba playing her part in full.

Our initial screening was an invitation-only event during the New York
print fair in the autumn of 2008, and more than a hundred curators, dealers,
and collectors gathered to watch. We replicated the event a month later in
London.

We have a distributor for the DVD, and it's being offered to schools
and museum shops, and can be bought online from assorted vendors, in-
cluding Amazon. Proceeds go to the distributing museum or the National
Gallery of Art.

My film career reached its zenith and conclusion simultaneously. Once
was enough. Like certain great athletes, I decided to retire at the top of my
game.

The Final Wrap

Making *All About Prints* was one of our last acts as print collectors. The date for my retirement from Alliance Capital, where I had been CEO for twenty years, was set. Big changes lay ahead. First and foremost, we needed to move the collection out of the office—actually, out of several offices.

The primary one, the Alliance Capital building, had evolved into a wonderful space to display our print collection. As the company expanded, so did the real estate, eventually occupying eight large floors at 1345 Sixth Avenue, where I roamed early mornings, revisiting favorite images and acquainting myself with new acquisitions. The London office also grew, relocating to a bigger space with more walls for British prints, and hallways where I could admire them. We exported a dozen big, colorful prints to our Tokyo office, and a select few to the Johannesburg subsidiary. We had a global print museum, most of it available for private viewing—but not for much longer.

Our first inclination was to create a print collection at an established, well-regarded museum that didn't have one, or much of one. We wanted our prints close to where we lived and worked, New York. We envisioned having access to the collection and our art library and files so that we could continue our research on prints and create traveling exhibits from the collection. But this wasn't feasible. New York's main museums—the Met, MoMA, and the Whitney—had print collections similar to ours—too much overlap. The Guggenheim's physical space limitations and art orientation made it unsuited. Nothing in nearby Connecticut fit our needs and wishes. The Newark Museum was feasible, due to its excellent collection of American paintings and sculpture. The drawback was location—New Jersey was not an easy commute from midtown New York or Connecticut. But we had positive feelings toward the Newark Museum and its director, Sam Miller, who had launched us on our quest for prints by African Americans.

I called Sam and outlined our idea: create a print museum within the museum, with a curator and space for display, storage, and study, modeled on those of the Met and MoMA. Sam was receptive, so off we went to Newark, encouraged.

The plan looked even better upon inspection. There was open land adjacent to the main building, where constructing an extension or small wing should be easy and economical, even with the necessary climate control and special lighting. But Sam hesitated.

"What I really want is a cafeteria. We need that to attract visitors."

Surprised, I responded, "But our idea is a print room. That's what we're prepared to do."

Sam pressed on. "How about some print storage above a cafeteria?"

Reba spoke, "Where would prints be displayed?"

Sam was insistent. "You could hang prints in the cafeteria."

Reba, temper rising, said, "We have no interest in financing a cafeteria. That's not why we're here."

Groping for words, I tried to explain again that we wanted a duplicate of the print rooms at leading museums—a part of the main museum, easily accessible with walls devoted to prints, and space for files and research. But Sam wouldn't stop talking about a cafeteria.

We couldn't believe our ears. Sam was looking the proverbial gift horse in the mouth. The conversation became tense; we were talking without hearing each other. We departed on not very friendly terms. It was no-go for us at Newark. Sam's strange decision was inexplicable to us then, and still is.

With alternatives exhausted, we concluded we would make our own print museum, recreating in our own smaller space what we had in the Alliance Capital building. We would call it the Print Research Foundation and turn it into a center for the study of American prints. But where?

New York City is overpopulated with museums, but I had a dream: the old Weyhe Gallery building on Lexington Avenue. Gertrude Weyhe Dennis was closing the gallery and planned to retire and relocate the inventory to her daughter's gallery in Maine. This seemed like the perfect situation, establishing ourselves in the very space whose history was the topic of Reba's dissertation.

Dare I take on a building constructed in I-don't-know-when and last renovated in the 1920s? I enlisted a friend who specialized in commercial buildings, and with Gertrude's agreement, he and I began to prowl the base-

ment. We didn't have to go far. My friend almost immediately offered, "Dave, don't do this." He pointed out ancient, cracked and rotting timbers supporting the first floor. Brick walls were crumbling. The Weyhe Gallery building was a tear-down, beyond repair.

And torn down it was, a few years later. Micky Wolfson rescued the famous color tiles from the façade and took them to his Wolfsonian, a museum of decorative and propaganda arts in Miami, which he later donated to Florida International University. The site of Weyhe Gallery is now a nondescript new building, home to a beauty parlor amongst other things. (Later, Gertrude told Reba that she really didn't want to sell the building to us. If it couldn't exist as the Weyhe Gallery, she did not want it to survive, even as a print museum.)

Rudely awakened from my Weyhe Gallery dream, I returned to reality. It was decision time. A space closer to our main residence in Greenwich, thirty miles outside New York City, made more sense. However, Greenwich was ruled out by zoning regulations that required a large number of parking spaces for a building with the square footage we needed. The last thing we wanted or needed was expensive land for cars to greet the scant visitors we anticipated arriving in ones and twos. We knew from earlier experience that getting a waiver through the Greenwich zoning authorities was an invitation to delay and frustration. We turned to nearby Stamford.

We quickly found an ideal location, in the heart of downtown. The building dated from the 1890s and was the former office of the local newspaper, the *Advocate,* its name carved in stone on the façade. Reba, a preservationist since her days as president of New York City's Art Commission, arranged for a temporary faux stone sign, PRINT RESEARCH FOUNDATION, to cover the original.

Renovation involved clearing out a rabbit warren of small offices to create galleries and viewing space. We hired a small staff and established their responsibilities. The move was difficult and complicated—all of the prints, files, and the extensive library had to be relocated. We hung about five hundred prints on the walls, some high in a two-story atrium, where a cherry picker was required. This clumsy—and scary—machine became part of the standard furnishings, hidden in a large closet when not in use. We put another five thousand prints into a storage area easily accessible to visitors.

The facilities of the Print Research Foundation made it eminently suit-

able for the study of and research on American prints. The files included
material on the more-than-two-thousand artists in the collection. The
library held the essential relevant books, artists' monographs, and many
print-related journals and special publications, some dating back to the
nineteenth century. Scholars, print specialists, and small museum groups
were free to use these resources by appointment. Much of the information
was put online, openly accessible to qualified scholars. A staff member was
available to deal with phone inquiries. The Print Research Foundation also
supported print projects financially—for example, underwriting an annual
prize for the best essay on American prints, or donating illustrations of
prints to be included in a publication on the etching revival.

Even with this building in Stamford, we couldn't handle expansion.
But this was not a tragedy. We did not particularly enjoy the art made after
Pop and the 1970s New Realism. We had always collected with enthusiasm
what we deemed the best of these artists and styles, but we acquired little
work dating later than the early 1980s. To us, the generation of printmaking
artists who followed the Masters of Pop and the New Realism seemed to
echo the recent past, or turned to shocking or outrageous imagery. Noth-
ing seemed to appeal. Our print acquisitions dwindled down to what was
necessary to fill out exhibitions.

Our heroes of the print world were moving on. One of the first was
David Landau, founder and editor of *Print Quarterly*. David had announced
his resignation as editor and was relocating with his family from London to
Venice for a new art venture. Besides having created *Print Quarterly*, David
is a successful venture capitalist. He had also found time to teach art history
and co-author *The Renaissance Print, 1470–1550*, described on its back cover
as "... the most complete account ever written of the ways in which Renais-
sance prints were produced, distributed, and acquired."

I first met David in 1984, shortly after he founded *Print Quarterly*, when
he visited my Wall Street office to talk about prints. Afterwards, we rode
the subway uptown together, and I asked "What do you do when you're not
editing *PQ*?"

"I sell ice cream," replied Dr. Landau.

"Really?"

"I started a retail store in what I think is a good location, near Harrods.
We British are crazy for sweets, you know."

Not crazy enough, apparently; a cold, wet summer killed the ice cream project. But his next initiative was a home run. David founded *Loot,* a daily free-ads newspaper. It prospered mightily and fifteen years later, with exquisite timing, David sold it—for cash—to a high-tech company just before the high-tech stock market bubble burst. David sponsors many other arts activities (for which he was made an honorary CBE), but our connection with him had been prints and *Print Quarterly.*

The magazine is modeled on *Burlington Magazine,* the scholarly journal on visual arts. Like *Burlington, PQ* contains essays and reviews of exhibitions and catalogues, but is restricted exclusively to prints. The editorial board was made up of a group of distinguished print curators and scholars, including Reba, and this group contributed much of the writing.

Antony Griffiths serves as de facto vice-chair of the editorial board. But he, like David Landau, decided to move on and retired from his day job at the British Museum in order to write books about prints. These two superstars of the print world, both good friends, were taking new paths. We began to consider new paths we might take.

The art world was no longer as appealing as it once had been. The frantic art boom, which lasted into the autumn of 2008, was a deterrent to our collecting. It wasn't just the prices, but the atmosphere; a successful hedge fund manager advised that he was "going to take a position in Stella"—that's as in Frank Stella, the artist. Art was traded like securities and commodities. A carnival of excess. We weren't interested in being a part of it.

Andy Warhol sometimes quoted Marshall McLuhan, who said, "Art is anything you can get away with."[1] Warhol would know; Pop Art got away with a lot. There was even more "getting away with" in the early twenty-first century. Art was manufactured in factories, such as those of Jeff Koons and Damien Hirst, whose artists' hands rarely touched a "product" that was accompanied by a marketing campaign, akin to any retail product. Hirst is the master marketer, to wit the September 15, 2008, sale at Sotheby's of exclusively Hirst works, 223 lots. The sale grossed $270 million, a great success for Hirst, the seller, but not so great for the buyers. The *Economist* reports that the average price of a Hirst was $831,000 in 2008 versus $136,000 in 2010.[2]

Notwithstanding the occasional Hirst-type hiccup, the art market bounced back from the Great Recession. High-priced, post-WWII paintings by artists with household names found favor with the nouveau riche,

including the billionaire oligarchs of the developing world, who needed to move their dubiously gained fortunes from their local currencies to countries ruled by established law. Add in the American and European new superrich, not the one percent, but the .01 percent, who can afford to invest in assets that don't pay dividends. All were seeking social respectability and, in many cases, recognition. As David Kusin, a former Met curator, noted, ". . . if you leave the price tag dangling from the frame, so much the better."[3]

The contemporary art world—dealers, artists, collectors, auction houses—seemed all about branding, self-promoting PR, social climbing, and money, money, money. The art dealer David Zwirner captured it all when he told the *New Yorker*, "One of the reasons there's so much talk about money is that it's so much easier to talk about than the art."[4] Agreed. We had little to say about a Hirst shark pickled in formaldehyde, or a Jeff Koons balloon puppy. It's a short, incoherent, and immaterial conversation that inevitably reverts to a language everyone understands: money.

Maybe it was always so, and the early twenty-first century just an exaggerated version of past art bubbles, but for us it wasn't a comfortable place to be, even in the print world. No longer placid, prints joined the bubble. It just wasn't fun anymore.

Other interests crowded in, taking up the time we had once devoted to print collecting, and providing the same sense of learning and excitement our former avocation had brought us. My retirement gave us new freedom, and new doors opened. We could be away from home for extended periods. We were in Europe for six months in 2003, including a long stay in Oxford attending school in Christ Church. I discovered British literature and poetry—the World War I poets especially appealed—and wondered if I could learn to write. Reba was tired of writing non-fiction and turned to mysteries. (It's perhaps no surprise that her books are set in the New York art world.) We planned more time for school.

Reba signed up for a distance MFA writing course offered by Spalding University, and I tagged along to the first annual residency, unable to resist a couple of weeks in Bath and London. As a lark, I signed up for the course, too. It was no lark. I was startled when I walked into my first workshop to be greeted by the seven other students, all women, and all published writers. Compounding my discomfort, the instructor called on me to lead off, analyzing a classmate's essay. I have no recollection of what I managed to say as I

struggled for words. But I do remember the blood rushing to my face.

At lunch with Reba, following this humiliating morning, I told her, "I'm the dumbest person in the class!"

Her unsympathetic response: "It's about time. Most of us had that experience earlier in life."

It was true. I'd always been a (mostly) A student. But creative writing was new. Still, with the help of seven sympathetic female companions and a talented and dedicated instructor/mentor, I began to get the hang of it. Encouraged, I began to write the story of our print collecting. Old dogs can learn new tricks, and mine was turning to yellow tablets and pens.

Busy with our new interests, Reba and I were neglecting the Print Research Foundation. We knew it was time to part with the collection.

With New York museums ruled out due to collection overlap or orientation, the National Gallery of Art in Washington offered itself as the logical place for our prints. It had an outstanding Old Master and modern European print collection, thanks to gifts from Lessing Rosenwald beginning in the 1940s and throughout his lifetime, as well as many other benefactors. Our collection meshed nicely, and we liked the idea of so many unknown and uncollected American artists entering the collection of the nation's museum.

The only person we knew at the National Gallery was Rusty Powell, the director. We'd had no contact with its curators, because of minimal collection overlap. Rusty was immediately available for a meeting, and a quick trip to Washington was all it took to set up a transfer—a partial sale and a partial gift. A few months of lawyer time followed, and the transaction was completed at the end of 2008—some five thousand prints, the files, the library, and the Stamford building. We attached no strings—no named gallery, no limits on what the National Gallery could or could not do with the prints or archives. A year later, when on the panel at the Los Angeles Fine Art Show, a co-panelist, the curator from the Huntington Library, who had heard how we had handled our gift to the National Gallery, was asked what type of gift, or donation, he most liked to receive. He nodded toward us and said, "Unrestricted."

About the same time, we received a photograph of a stone mason engraving our names, along with those of other patrons and donors, on a wall at the National Gallery. It was our "thank you." But how long would it be there? I was reminded of an episode recalled by the late Leon Levy, who

with his wife Shelby White had made a large financial donation to recreate an antiquities wing at the Metropolitan Museum, to be named for them, according to Met director Philippe de Montebello, "in perpetuity."

When Leon asked, "How long is perpetuity?" Philippe replied, "At least fifty years."

Before giving away the major part of our collection, we held back a few prints for other gifts. James Rosenquist's *F-111*, twenty-five feet in length and framed in four panels, went to the British Museum to honor Antony Griffiths and as a cornerstone for their next American print show. To the Bruce Museum in Greenwich went the Andy Warhol portfolio of *Flowers* (black and white). Our African American prints had already gone to the Metropolitan Museum; our Mexican prints to the British Museum.

We retained some five hundred prints, all on walls of our residences, sentimental favorites we couldn't part with. Collecting didn't completely die. I managed to replace the Raymond Steth *Heaven on a Mule* we donated to the Met and gave it to Reba for her birthday. We found another copy of Diego Rivera's *Zapata*. Alas, Frida Kahlo's *Frida and the Miscarriage* hasn't surfaced and isn't likely to. We miss it.

A last collecting fling included many media contrary to our obsessive print collecting. American flags sprouted everywhere after September 11, 2001. We were no exception to this patriotic enthusiasm, inspired by the gift of a flag flown in Afghanistan from a cousin of Reba's who was an Air Force pilot. Around this time we were abandoning our South Carolina beach house to become New England Yankees in the summer—in Stonington, Connecticut, site of a historic battle against the British fleet in the War of 1812. It all added up. We would decorate our new beach house with American flag images.

We had admired the beauty of these flags in many artists' works, especially the paintings of Childe Hassam, who was attracted to the scenes of flags hanging on the façades of New York buildings. His *Washington's Birthday, Fifth Avenue & 23rd Street* (1916, Fig. 1) shows two flag-adorned tall buildings flanking the Flatiron Building, cars and pedestrians on Fifth Avenue in a late-winter snow shower. Our post-9/11 decision to decorate with American flags had roots.

Childe Hassam had other effects on us, too. We were in Stonington mostly because of him. Early in her study of American art, Reba had fallen in

Fig. 1. Childe Hassam, *Washington's Birthday, Fifth Avenue & 23rd Street*, 1916. Etching,
7 x 12.8 in.

love with Hassam's flower paintings. She was particularly fond of his depictions of seaside flower gardens, those cultivated by the poet Celia Thaxter, located on Appledore, one of the Isles of Shoals, small rocky specks off the coast of New Hampshire. Hassam's palette of multicolored flowers set against a blue sea entranced her. Frequently, Reba would say, "Someday I'm going to have a seaside flower garden." This could never happen in her childhood on the North Carolina beaches—too much wind and sand.

But that day came when we drove up to Stonington to visit the borough's biennial garden show. Another vow, "If one of these houses on the water ever comes on the market, we should buy it," became reality, when, as it inevitably happens, one of those houses *did* come on the market. And Reba got her seaside garden.

In decorating the house with flags, we included prints, but also other types of art. Our flag collection includes Navajo weavings of Old Glory, Navajo carvings of Uncle Sam, World War I and II posters, election banners and ephemera, *New Yorker* magazine covers, souvenir weavings from the Philippines brought home by Spanish-American War sailors—anything with an American flag. A particular favorite is *The Spirit of '76* (circa 1950s, Fig. 2), artist unknown, a gouache probably prepared by an advertising agency for the Campbell Soup Company. It resonated with us. The Campbell Soup Kids were ever present on can labels and magazine pages in our youth. Nostalgia influenced collecting to the very last.

We are no longer acquiring prints or doing research on printmakers or printed images, but there's a warm afterglow. In our forty years of active print collecting and researching, we learned far more about art and history than reading books, taking courses, visiting museums, and even collecting paintings would have provided.

We acquired more than six thousand prints, and probably looked at ten, or twenty, or fifty times that number we did not buy. Multiple images and multiple impressions are the great advantage of print collecting. We could not have afforded to buy six thousand paintings, let alone display them. And we did read books, take courses (e.g., Reba's Ph.D.), and visit museums— all as part of print collecting. It was a marvelous learning experience, a major lifetime event.

We wanted to do something different, to be leaders, not followers. We strove for distinction and originality, both in what we bought and what

we studied. Collecting prints in our areas of interest, at the time, gave that opportunity. We were also able to contribute to the art-historical body of knowledge. We enjoyed being on a less-traveled road.

We met people—and became friends with many—in a world little known to us before we began collecting. Gallery owners, curators, critics, and other collectors opened new vistas, gave us new insights and under-standings, helping to balance our work-obsessed lives.

It was a grand experience. Nostalgia and memory have proved irresist-ible, so we kept a small group of prints and continue to be surrounded by them, with color woodcuts and miniatures in New York, posters in Lon-don, American flags in Stonington, and favorite black-and-white images in Greenwich and in our small New York office. But as print collectors and scholars, it's all wrapped up, and we don't regret a single minute. In fact, we look back on our years of print collecting with joy and pride.

Fig. 2. Unknown, *The Spirit of '76 (Campbells Kids)*, ca. 1950s. Gouache, 11.5 x 13.5 in.

Epilogue

> "... this passion for prints, which is one of the hallmarks of
> the finest minds, could not be held in greater esteem."
>
> FLORENT LE COMTE, 1699[1]

If you have read this far, you may be thinking of beginning to collect prints. I urge you to give it a try.

Why? Collecting prints is fascinating (and definitely not restricted to the finest minds), but it can become a passion, because it's absorbing and fun.

Part of the joy is in discovery. There are so many prints, by so many artists, of so many nationalities, over so many years. The collector is always finding something new: an unusual impression, an unknown state, an unrecorded print, an overlooked artist. Discovery can come in exploring a back story: Why did the artist make this print? What message, if any, is the artist sending? How does this print relate to other works by the artist? Or relate to another artist's work? Or to a particular style or school?

A strong impetus to collecting art of any type—paintings, sculpture, drawings, prints—is private access to beauty. Prints are an easy route to this beauty, because of their wide availability and relatively lower cost. Since prints usually cost much less than paintings by the same artists, the same amount of money will buy more images. The images may be smaller, but that can be an advantage: more images will fit on a wall. The availability of multiple impressions allows the collector to search for and find a sought-after print. (Think of the fun of a treasure hunt.)

Other collectors may own the same print, so there is opportunity for exchanging information, observations, and opinions. Print experts may have written about the print. The print might have appeared in museum exhibitions or sales catalogues, with useful commentary. Opportunities to learn and meet people who share your new interests never end.

Doors will open, and adventure will beckon. Meeting museum curators,

1. Florent Le Comte (1655-1712) was a French writer about art and artists, and an engraver.

dealers, artists, and other collectors may lead to new friendships. The hunt for a print may take the collector to new places, and travel may lead to an accidental print acquisition.

How does one begin? By looking and learning. Reproductions of print images are found in many books, and print exhibitions abound. The beginning collector can study many prints before making the first purchase. Several illustrated publications specialize in prints: *Print Quarterly* (London), *The Print Collector's Newsletter*, and *Art in Print*. The essential book for the beginning collector is Antony Griffiths's well-illustrated *Prints and Printmaking* (London: British Museum Press, 1996). The classic book on prints, also illustrated, is A. Hyatt Mayor, *Prints and People: A Social History of Printed Pictures* (New York: The Metropolitan Museum of Art, 1971). Print dealers publish catalogues, both in print and on-line, and mount exhibitions of prints in their galleries. Auction houses publish illustrated sales catalogues and hold presale viewings before the actual auction. Museums regularly exhibit prints, usually with descriptive wall labels and catalogues or check lists. Many cities host annual print fairs, where dealers display their wares. There are hundreds of original prints to look at, at little or no cost.

The beginning collector's first purchases should be from a dealer. Finding a dealer is simple, thanks to the International Fine Print Dealers Association, or IFPDA, which publishes on its website a list of its members, their location and other contact information, and sometimes a reference to a specialty. All IFPDA members have expertise in prints and are bound by certain ethics. A dealer will provide information and advice about rarity, quality of printing, overall condition of the print, and other factors that affect the price of a print under consideration.

Once the collector has some knowledge and experience, he or she should add the auction houses as possible sources. Buy with care. Auction houses have limited resources for describing and inspecting objects, and their estimated price ranges can be wrong. Seeing the print first-hand before bidding is a must. Many dealers will, for a fee, act at auction for a buyer, and certify the quality of the print, propose a price limit, and do the actual bidding.

Art admiration is part emotion, so the collector should let some feelings into the decision. The cliché "I only buy what I love" is not to be scorned. Without passion for the objects collected, the exercise becomes investing, a decidedly unemotional activity.

Many collectors specialize, or create collections within collections, and the vast number of prints makes specialty collections feasible. A collector may acquire prints by only one artist (e.g., George Bellows, or Picasso); a single print medium (e.g., etching, or color woodcut); specific images (e.g., animals, or people reading); style (e.g., Surrealism, or Vorticism); period (e.g., nineteenth century); nationality (e.g., Japanese, or Scandinavian). The possible directions are endless. Cohesion in a collection is advisable. A natural instinct may be to acquire impulsively, willy-nilly, but the result will be less satisfying than a collection built around a theme.

Cost is a major issue, and nothing cools a love affair faster than learning five years later that what originally cost one thousand dollars is worth one hundred—and is unsaleable even at that lower price. That is unfortunately the fate of much work by living artists who have no history of critical recognition and economic success. Collecting work by virtually unknown living artists can be exciting and aesthetically rewarding, but the collector should be aware of the financial risks.

Do not buy prints (or any art) strictly for investment. Art is illiquid. It will probably take time to find a buyer for what you want to sell, and you may not find a buyer willing to pay as much as you did. The collector is usually buying at a retail price, while the seller—a dealer—has bought at a wholesale price. The spread is large, and if the collector sells, it will probably be at the wholesale price. Buy what you have a passion for. If you love your print, or your collection, there's a good chance that someone else will, too. And if you must sell it, you will probably—eventually—find a buyer.

If cost (and investment return) is an overriding issue, buy like a stock market investor: low. Easier said than done, but there are wide swings in prices in all art media, including prints. These price swings may take decades between highs and lows, and are therefore difficult to discern at purchase time. Dealers can be helpful; most will know price history, which may or may not be a guide to price future. The surest route to financial disappointment is buying what's faddish; don't collect what everyone else is buying. Seek what's out of fashion. For example, religious scenes are often "out," which is ironic because some of the world's most famous paintings are religious (e.g., the Sistine Chapel ceiling). Nothing is certain in investing, whatever the vehicle, and art is especially unsuited for investment because of its illiquidity and huge retail-wholesale price spread.

Finally, plunge into print collecting, but only with at least a little knowledge and at least with some professional (dealer) help. Be a collector, not an investor. Fall in love with a print, and experience a lifetime of collecting pleasure.

Afterword

Dave Williams first acted on what he calls his "latent collecting urge" in 1968 when he was just thirty-six. Ten years later, when Dave was named chief executive of Alliance Capital, he and his wife, Reba, shifted their collecting activity into high gear. Their ambition, according to Dave, was "to build the greatest American print collection of its kind." The emphasis would be on prints made during the first half of the twentieth century—a period that, until the mid-1970s, had hardly been explored, even by print scholars.

Dave describes collecting as "a series of small victories." With respect to collecting prints, however, he and Reba never thought small. The Williamses amassed more than 6,000 prints, and their collection has to be considered the largest of its kind in private hands. Between 1987 and 2008 they organized from their holdings seventeen diverse exhibitions that traveled to more than one hundred museums worldwide. They co-authored essays in exhibition catalogues, and Reba, in particular, published on a variety of scholarly topics, including articles and reviews for the journal *Print Quarterly*. Small thinkers they are not.

In 1999 Dave and Reba donated more than two hundred prints by African American artists to the Metropolitan Museum of Art, which mounted an exhibition celebrating their gift, and in 2001, the Williamses parted with their holdings of Mexican prints, many of which they donated to the British Museum. The National Gallery of Art was the very fortunate recipient in 2008 of the major portion of the Williams Collection.

For the National Gallery, this acquisition was transformative, immediately giving us a new standing in the field of American prints. Ranging in date from around 1875 to 1975—from the etching revival to Pop—the more than 5,250 prints in Reba and Dave's collection beautifully complemented

the Gallery's holdings and filled innumerable gaps, especially in Depression-era and Works Project Administration (WPA) prints. Furthermore the Williams Collection was distinctive in representing not only great works by canonical artists but also exemplary works by lesser-known artists. For every illustrious print by Thomas Moran, George Bellows, John Marin, or Jasper Johns, the Williamses acquired remarkable prints by Mary Nimmo Moran, Peggy Bacon, Jolán Gross-Bettelheim, and Luigi Rist.

Rarely do private individuals collect with such serious intent, determination, and success as shown by Reba and Dave's example. Guided by their intellectual curiosity, passion for art, and, in no small measure, Dave's impulse to acquire, they built an outstanding and wonderfully focused collection. Dave admits to being "image-addicted," and he offers advice for the similarly afflicted: "A fever can be treated and cured, but the only relief—temporary, of course—from the desire to acquire, is to acquire." Fortunately, Dave's desire never diminished.

EARL A. POWELL III
Director, National Gallery of Art

Acknowledgements

This collection would not have been the same collection without the collaboration of my wife, Reba White Williams. Her scholarship, research skill, art appreciation, and creativity brought consistency, purpose, and originality to what otherwise would have been just a lot of prints. My gratitude to her for all she did and for our many years of this great adventure.

Thanks to my publisher, David R. Godine, for putting his distinguished name on *Small Victories*. David is a formidable editor, and his contribution to the book has made it more readable, interesting, and much larger. David encouraged me to tell more and include additional artists and illustrations.

My appreciation to Walter Bode, Elisabeth Norton, and Dan Howard, who labored over my manuscript, and to Lizzy McGlynn, who obtained reproduction rights for the prints. I also thank mentors, early readers, and fact checkers, who offered encouragement and ideas and saved me from embarrassing errors: Brooke Alexander, Judith Brodie, Gordon Cooke, Kathleen Driskell, Robert Finch, Richard Goodman, Antony Griffiths, Roy Hoffman, David Kiehl, William Kinsolving, Kim Dana Kupperman, Christopher Noey, and David Tunick.

Small Victories is a true story, with names, places, and dates as accurate as possible, although in a very few cases I have changed names and circumstances to provide privacy to the individuals involved.

DAVE H. WILLIAMS

CHAPTER 2 THE AMERICAN CENTURY IN PRINTS: 1900 TO THE WPA

[1] John Loughery, *John Sloan: Painter and Rebel* (New York: Henry Holt, 1995), 24.

[2] Ibid., 12.

[3] Ogden Nash, "What Street Is This, Driver?" in *Good Intentions* (Boston: Little, Brown, 1942), 118.

[4] Milton W. Brown, *The Story of the Armory Show* (New York: Abbeville Press, 1988), 137.

[5] Loughery, 186.

[6] Charles W. Haxthausen, "Walter Gropius and Lyonel Feininger Bauhaus Manifesto. 1919," in *Bauhaus 1919–1933: Workshops for Modernity*, eds. Barry Bergdoll and Leah Dickerman (New York: The Museum of Modern Art, 2009), 64. Exhibition catalog.

[7] Hilton Kramer, "Art: Expressionism from Italy Arrives," *New York Times*, June 5, 1981, http://www.nytimes.com/1981/06/05/arts/art-expressionism-from-italy-arrives.html.

[8] Lee D. Witkin, *Kyra Markham, American Fantasist, 1891–1967* (New York: Witkin Gallery, 1981), 3. Exhibition Catalog.

[9] Helen Lundeberg, interview by Jan Butterfield, July 19–Aug. 29, 1980, Archives of American Art Oral History Program, Smithsonian Institution, Washington, DC.

[10] Clinton Adams, *American Lithographers 1900–1960: The Artists and Their Printers* (Albuquerque: University of New Mexico Press, 1983), 84, 92.

[11] William Wilson, "Art Review: Helen Lundeberg's Quest for Purity, Reality, Illusion," *Los Angeles Times*, September 25, 1995, http://articles.latimes.com/1995-09-25/entertainment/ca-49743_1_helen-lundeberg.

[12] Clinton Adams, *Second Impressions: Modern Prints & Printmakers Reconsidered* (Albuquerque: Tamarind Institute, 1996), 59–64.

[13] *Oxford English Dictionary Online*, s.v. "Impressionism," accessed February 15, 2013, http://www.oed.com/view/Entry/92731?redirectedFrom=impressionism.

[14] "David Kiehl on Hopper's *American Landscape*," *All About Prints*, directed by Christopher Noey (Washington, DC: The National Gallery of Art, 2009), DVD.

[15] Francis V. O'Connor, "The Influence of Diego Rivera on the Art of the United States during the 1930s and After," in *Diego Rivera: A Retrospective*, ed. Cynthia Newman Helms (Detroit: Detroit Institute of Arts, 1986), 166. Exhibition catalog.

[16] Ibid.,170.

[17] Bridget Moore (director of Midtown Payson Galleries), telephone interview by Dave H. Williams, June 18, 1991.

CHAPTER 3 THE AMERICAN CENTURY IN PRINTS: THE WPA

[1] George Biddle, *The Yes and No of Contemporary Art: An Artist's Evaluation* (Cambridge: Harvard University Press, 1957), 4.

[2] George Biddle, *An American Artist's Story* (Boston: Little, Brown, 1939), 268-269.

[3] "Will Barnet on the WPA," *All About Prints*, directed by Christopher Noey (Washington, DC: The National Gallery of Art, 2009), DVD.

[4] Sylvan Cole, interview by Michael Brenson, *New York Times*, August 12, 1983, http://www.nytimes.com/1983/08/12/arts/art-people-how-galleries-put-on-shows.html.

[5] Avis Berman and Francis V. O'Connor, "The Graphic Art Workshops of the WPA Federal Art Project" (unpublished Report of Research, June, 1996), 3.

CHAPTER 4 THE RESURRECTION OF THE SCREENPRINT

[1] Harry Sternberg, telephone interview by Reba and Dave H. White Williams, April 5, 1986.

[2] "Art: Silk-Screen Prints," *Time*, 11 November 1940, 78.

[3] Reba and Dave Williams, *American Screenprints* (New York: National Academy of Design, 1987), 13, 16. Exhibition catalog.

[4] Pat Hacket and Andy Warhol, *Popism: The Warhol Sixties* (New York: Harcourt, 1980), 22.

[5] Ibid.

[6] Roberta Bernstein, "Warhol as Printmaker," *Andy Warhol Prints*, eds. Frayda Feldman and Jorg Schellman (New York: Distributed Art Publishers, 2003), 15.

CHAPTER 5 THE AMERICAN CENTURY IN PRINTS: FAMINE TO FEAST

[1] David Acton, *The Stamp of Impulse: Abstract Expressionist Prints* (Worcester, MA: Worcester Art Museum, 2001), 102. Exhibition catalog.

[2] Dore Ashton, *Art Digest* 27, No. 10 (15 February 1953): 23.

[3] Alan Fern and Judith O'Sullivan, *The Complete Prints of Leonard Baskin* (Boston: Little, Brown, 1984), 8.

[4] Ariella Budick, "Milton Avery, Knoedler Gallery, New York," *Financial Times*, April 21, 2010, http://www.ft.com/cms/s/0/9704e6d8-4d5d-11df-9560-00144feab49a.html.

[5] Robert Carleton Hobbs and Milton Avery, *Milton Avery: The Late Paintings* (New York: Harry N. Abrams, in Association with the American Federation of Arts, 2001), 53.

[6] Brooke Alexander (print dealer), telephone interview conducted by Dave H. Williams, July 9, 2013.

[7] "History," Universal Limited Art Editions (ULAE), June 24, 2013, www.ulae.com/history.aspx.

8 "About Us," *Tamarind Institute: Lithography Workshop and Gallery*, June 24, 2013, tamarind.unm.edu/aboutus.html.

9 June Wayne, a letter to Clinton Adams dated November 30, 1959, in Clinton Adams, *American Lithographers 1900–1960: The Artists and Their Printers* (Albuquerque: University of New Mexico Press, 1983), 201.

CHAPTER 6 ALONE IN A CROWD: PRINTS BY AFRICAN AMERICANS

1 Reba White Williams, "Themes and Images," *Alone in a Crowd: Prints of the 1930s–40s by African-American Artists* (New York: American Federation of the Arts, 1993), 27. Exhibition catalog.

2 Billie Holiday, vocal performance of "Strange Fruit," by Lewis Allen [Abel Meeropool], recorded April 20, 1939, on Lady Sings the Blues, Verve 833 770-2, 1990, compact disc.

3 Countee Cullen, "Heritage," *On These I Stand* (New York: Harper & Brothers, 1947), 24.

4 Edmund B. Gaither, "Heritage Reclaimed: An Historical Perspective and Chronology," *Black Art, Ancestral Legacy, The African Impulse in African-American Art* (Dallas, TX: Dallas Museum of Art, 1989), 19. Exhibition catalog.

5 Albert Murray, "An Interview With Hale Woodruff," *Hale Woodruff, 50 Years of His Art*, ed. Helen Shannon (New York: Studio Museum in Harlem, 1979), 72, 76. Exhibition catalog.

CHAPTER 7 WIDENING THE SEARCH

1 Alexandra Schwartz, *David Smith: The Prints* (New York: Pace Prints, 1987), Ill. 30. Exhibition catalog.

2 Richard Cork, "Vorticism," *Grove Art Online* (New York: Oxford University Press), August 1996, www.moma.org/collection/theme.php?theme_id=10964.

3 Frances Carey and Antony Griffiths, *Avant-Garde British Printmaking 1914–1960* (London: British Museum Publications, 1990), 9.

CHAPTER 8 THE MEXICAN MURALISTS AND PRINTS: TEACHING GRINGOS

1 Will Barnet, telephone interview by Dave and Reba Williams, June 5, 1990.

2 Jeffrey Potter, *To a Violent Grave: An Oral Biography of Jackson Pollock* (New York: Putnam, 1985), 49.

3 Carl Zigrosser, *The Artist in America, Twenty-Four Close-ups of Contemporary Printmakers* (New York: Knopf, 1942), 98.

4 Diego Rivera, *My Art, My Life* (New York: Citadel, 1960), 200–202.

5 Hayden Herrera, *Frida, A Biography of Frida Kahlo* (New York: Harper & Row, 1983), 142.

6 Frida Kahlo to Mrs. Rockefeller, 24 January 1933, OMR, Ill 2C, Business Interests, Box 94, Folder 706, Rockefeller Archive Center, Sleepy Hollow, NY.

7 Lucienne Bloch, interview by Dave and Reba Williams, January 1991.

[8] John Ittmann, ed., *Mexico and Modern Printmaking: A Revolution in the Graphic Arts, 1920 to 1950* (New Haven: Yale University Press, 2006). Exhibition catalog.

CHAPTER 9 EARLY AMERICAN PRINTS: REVOLUTION, AUDUBON, AND THE ETCHING REVIVAL

[1] Henry Clinton, *The American Rebellion: Sir Henry Clinton's Narrative of His Campaigns, 1775-1782* (New Haven: Yale University Press, 1954), 19.

[2] My thanks to Antony Griffiths, Keeper of the Department of Prints and Drawings at the British Museum, for providing the explanation of Trumbull's role and the two engravings of *The Battle of Bunker Hill*.

[3] Richard W. Morin, "Statesman and Artist," *Dartmouth College Library Bulletin* 10, no. 1 (November 1969): 5–9.

[4] Ellen Gamerman, "'Birds' Book Soars to Record," *Wall Street Journal*, December 8, 2010, online.wsj.com/article/SB10001424052748704250704576005751646141670.html.

[5] "Books, at a Price," *New York Times*, September 11, 2010, www.nytimes.com/2010/09/12/weekinreview/12grist.html.

[6] Childs Gallery, *Childs Gallery Print Annual*, vol. 27 (Boston: Childs Gallery, 2005), 3.

[7] Winslow Homer, as quoted in Marc Simpson, *Winslow Homer: The Clark Collection* (Williamstown, MA: Sterling and Francine Clark Institute, 2013), 162. Exhibition catalog.

[8] Lloyd Goodrich, *Winslow Homer* (New York: Braziller, 1959), 11.

[9] Katherine A. Lochnan, *The Etchings of James McNeill Whistler* (New Haven: Yale University Press, 1984), 12. Exhibition catalog.

CHAPTER 10 BIRDS AND FLOWERS

[1] Arthur Wesley Dow, as quoted in Nancy E. Green, *Arthur Wesley Dow and His Influence* (Ithaca, NY: Herbert F. Johnson Museum of Art, Cornell University, 1990), 9. Exhibition catalog.

[2] Anne Goldthwaite, as quoted in Adelyn D. Breeskin, *Anne Goldthwaite: A Catalogue Raisonné of the Graphic Work* (Montgomery, AL.: Montgomery Museum of Fine Arts, 1982), 25. Exhibition catalog.

[3] Janet Altic Flint, *Provincetown Printers: A Woodcut Tradition* (Washington, D.C.: Smithsonian Institution Press, 1983), 11. Exhibition catalog.

[4] Ada Gilmore Chaffee, "Cape End Early Cradled Gifted Group of Print Makers Who Added to Art," *The Provincetown Advocate*, October 30, 1952.

[5] Blanche Lazzell, as quoted in "The Provincetown Print," 2, undated, in a collection of letters and memorabilia, James and Janet Reed, Morgantown, West Virginia.

[6] Martha R. Severens, *Alice Ravenel Huger Smith: An Artist, a Place and a Time* (Charleston, SC: Carolina Art Association, 1993), 40.

[7] Juliet Currie, "Gustave Baumann: A Century of Delight," *El Palacio* 87, No. 1 (Spring 1981): 28–29.

[8] Barry Walker, *Donald Sultan, A Print Retrospective* (New York: AFA/Rizzoli, 1992), 12.

[9] "David Sultan on printmaking," *All About Prints*, directed by Christopher Noey (Washington, DC: The National Gallery of Art, 2009), DVD.

[10] Barbara Whipple, "Biography of Luigi G. Rist, American Printmaker, 1888–1959" (unpublished manuscript, 1971), microfilm roll 286.

CHAPTER 11 SHARING: CREATING EXHIBITIONS

[1] Judith Solodkin, interview by Dave and Reba Williams, March 8, 1988.

[2] Alex Katz, as quoted in Nicholas P. Maravell's *Alex Katz: The Complete Prints* (New York: Alpine Fine Arts Collection, 1983), 75.

[3] Jeremy Sigler, "ArtSeen: Neil Welliver: The Absent Painter," *The Brooklyn Rail*, Dec 06–Jan 07, http://www.brooklynrail.org/2006/12/artseen/neil-welliver

[4] Mark Strand, as quoted in *Neil Welliver: Prints* (Camden, ME: Down East Books, 1996), 2.

[5] George Plimpton, ed., *The Norton Book on Sports* (New York: Norton, 1992), 470.

[6] John Cage, "Experimental Music," (lecture, Evergreen State College, Olympia, WA, 1957).

[7] Diane Kelder, ed., *Stuart Davis: A Documentary Monograph in Modern Art* (Westport: Praeger Publishers, 1971), 110.

[8] Joseph E. Young, "Lichtenstein Printmaker," *Art and Artists* 10 (March 1970): 50.

[9] Dean Meeker, telephone interview by Dave and Reba Williams, August 30, 1995.

[10] Henry Sternberg, telephone interview by Dave and Reba Williams, July 22, 1995.

[11] Reba and Dave Williams, *Around Town Underground: The New York Subway in Prints* (Stamford, CT: The Print Research Foundation, 2004), 1. Exhibition catalog.

[12] Ibid, 8.

[13] Ibid, 13.

[14] Joseph Jacobs, "Indian Space Painters," *Art and Antiques* 30, no. 2 (February 2007): 63.

[15] Ann Gibson, "Painting Outside the Paradigm: Indian Space," *Arts Magazine* 57, no. 6 (February 1983): 101.

CHAPTER 12 ARTISTS IN WAR

[1] Roger Crowley, *City of Fortune: How Venice Ruled the Seas* (New York: Random House, 2012), 359.

[2] Paul Nash, a letter to his wife dated November 13, 1918, in Frances Carey and Antony Griffiths, *Avant-Garde British Printmaking, 1914–1960* (London: British Museum Publications, 1990), 62–63.

[3] Dorothy Keppel, "Kerr Eby," in *Print Collector's Quarterly* XXVI, no. 1 (February, 1939): 83.

[4] Ibid, 91.

[5] Martina Roudabush Norelli, *Werner Drewes: Sixty-Five Years of Printmaking* (Washington: National Museum of American Art, 1984), 21. Exhibition catalog.

[6] "Some Brief Biographical Notes Lovingly Set Forth," *The Margo Feiden Galleries LTD.*,
accessed March 26, 2012, http://www.alhirschfeld.com/bios/alhirschfeld.html.

[7] David Leopold, letter to Dave and Reba Williams, October 21, 2002.

[8] S. William Pelletier, "John Taylor Arms: An American Mediaevalist," in *The Georgia Review* 30, no. 4 (Winter 1976): 931–2.

CHAPTER 13 MINIATURES

[1] Gordon Cooke, *Samuel Palmer, 1805-1881: The Complete Etchings* (London: The Fine Art Society, 1999), iii. Exhibition catalog.

[2] *The Catholic Encyclopedia*, s.v. "Pope Severinus," by Horace Mann, accessed March 26, 2012, www.newadvent.org/cathen/13742c.htm.

[3] Carl Zigrosser, *Multum In Parvo*, (New York: Braziller, 1965), 11.

[4] Ibid, 18.

[5] Ibid, 21.

[6] Tim Blanning, *The Romantic Revolution* (New York: Modern Library Chronicles, 2010), 65.

[7] Zigrosser, 42–43.

[8] Ibid, 47.

[9] Dan Burne Jones, *The Prints of Rockwell Kent: A Catalogue Raisonné* (Chicago: The University of Chicago Press, 1975), 91.

[10] Fridolf Johnson, ed., *Rockwell Kent: An Anthology of His Works* (New York: Knopf, 1982), 72.

[11] Marina Warner, *Queen Victoria's Sketchbook* (New York: Crown, 1979), 96.

CHAPTER 14 ART THAT SELLS

[1] Wilbur C. Whitehead to Frederic T. Singleton, as quoted in David W. Kiehl, *American Art Posters of the 1890s* (New York: The Metropolitan Museum of Art, 1987), 97. Exhibition catalog.

[2] Kiehl, 11.

[3] Ibid, 11.

[4] Ibid, 10.

[5] Victor Margolin, *American Poster Renaissance* (Secaucus, NJ: Castle Books, 1975), 29.

[6] Kiehl, 191.

[7] John Thorn, "Poster Girl," *Woodstock Times*, December 25, 2008, woodstock. ulsterpublishing.com/view/full_story/11404361/article-Poster-Girl.

CHAPTER 16 THE FINAL WRAP

[1] Marshall McLuhan and Quentin Fiore, *The Medium is the Massage: An Inventory of Effects* (New York: Bantam Books, 1967), 132–136.

[2] Sarah Thornton, "Hands up for Hirst," *The Economist*, September 9, 2010.

[3] James B. Stewart, "Record Prices Mask a Tepid Market for Fine Art," *The New York Times*, December 7, 2013, B1.

[4] Nick Paumgarten, "Profiles: Dealer's Hand," *The New Yorker*, December 2, 2013, http://www.newyorker.com/reporting/2013/12/02/131202fa_fact_paumgarten.

EPILOGUE

[1] William W. Robinson, "This Passion for Prints" in *Printmaking in the Age of Rembrandt*, Clifford S. Ackley (Boston: Museum of Fine Arts, 1981), xxvii.

Illustrations

Key:
- BM — British Museum
- MMA — Metropolitan Museum of Art
- NGA — National Gallery of Art
- RDW — Collection of Reba and Dave Williams

ARTIST	TITLE and reproduction credit (if applicable)	CURRENT LOCATION
Albert, Prince	Islay	RDW
Avery, Milton	Three Birds © 1952 The Milton Avery Trust / Artists Rights Society (ARS), New York	NGA
Barnet, Will	Woman Reading Art © Estate of Will Barnet/Licensed by VAGA, New York NY, Alexandre Gallery, New York, NY	NGA
Baskin, Leonard	View of Worcester Estate of Leonard Baskin	BM
Batty, Dora M.	Underground, From Country to the Heart of Town for Shopping © London Transport Museum	RDW
Baumann, Gustave	Autumnal Glory © Copyright The Ann Baumann Trust.	RDW
Baumann, Gustave	Hopi Corn © Gustave Baumann, Courtesy The Annex Galleries	RDW
Beal, Jack	Brook Trout © 2014 Jack Beal	NGA
Becker, Frederick Gerhard	Arrival of Brass Section © Estate of Frederick Gerhard Becker	NGA
Becker, Frederick Gerhard	Home Cooking © Estate of Frederick Gerhard Becker	NGA
Becker, Frederick Gerhard	Rapid Transit © Estate of Frederick Gerhard Becker	NGA
Beham, Hans Sebald	Leda and the Swan	RDW
Bellows, George Wesley	Preliminaries to the Big Bout (detail) Courtesy Laurie Booth	RDW
Bellows, George Wesley	A Stag at Sharkey's Courtesy Laurie Booth	RDW
Benton, Thomas Hart	Going West Art © T.H. Benton and R.P. Benton Testamentary Trusts/UMB Bank Trustee/Licensed by VAGA, New York, NY	RDW

Biddle, George	Sand!	NGA

Courtesy Estate of George Biddle and the Susan Teller Gallery,
New York, NY

Binck, Jacob	Der Heilige Severin (The Holy Severin)	RDW
Blackburn, Robert	People in a Boat	MMA

© Robert Blackburn Foundation

Blake, William	Sabrina's Silvery Flood	N/A
Bloch, Lucienne	Muralist at Work (Diego Rivera)	RDW

Original Lithography by Lucienne Bloch, 1933 courtesy Old
Stage Studios, Gualala, CA

Bomar, Bill	Projections	NGA
Bradley, William H.	The Chap-Book, The Blue Lady	RDW
Bradley, William H.	When Hearts are Trumps	RDW
Bry, Edith	Burlesque	NGA
Bry, Edith	Woman of the World	NGA
Bryson, Bernarda	Crash	NGA

Art © Estate of Bernarda Bryson Shahn/Licensed by VAGA,
New York, NY

Cage, John	Global Village 37-48	RDW

© bpk, Berlin / Hamburger Kunsthalle /Elke Walford)/ Art
Resource, NY

Calder, Alexander	Score for Ballet 0-100	NGA

© 2013 Calder Foundation, New York / Artists Rights Society
(ARS), New York

Calvert, Edward	The Chamber Idyll	RDW
Capa, Robert	Loyalist Militiaman at the Moment of Death, Cerro Muriano, September 5, 1936 (Falling Soldier)	N/A

Robert Capa © 2001 by Cornell Capa and Magnum Photos.

Catlett, Elizabeth	Mother and Child	MMA

Art © Catlett Mora Family Trust/Licensed by VAGA, New York, NY

Cook, Howard Norton	Engine Room	NGA
Cook, Howard Norton	Fiesta	NGA
Cook, Howard Norton	Tired G.I.s	N/A
Crawford, Ralston	Overseas Highway	RDW

Courtesy Ralston Crawford Estate and Polar Fine Arts

Crichlow, Ernest	Lovers	MMA

© Ernest Crichlow Estate

Crite, Allan Rohan	Five Joyful Mysteries	MMA

Estate of Max Crite

Curry, John Steuart	Danbury Fair	NGA

© Estate of John Steuart Curry

Daum, Howard	Untitled (Indian Space Composition)	RDW

Howard Daum Estate

Davis, Stuart	Barber Shop Chord	NGA

Art © Estate of Stuart Davis/Licensed by VAGA, New York, NY

Hirschfeld, Albert	Peace in Our Time © Albert Hirschfeld	RDW
Hofmann, Hans	Composition in Blue © 2014 Artists Rights Society (ARS), New York	NGA
Hogue, Alexander	Spindletop-1901 © Estate of Alexandre Hogue	RDW
Homer, Winslow	Eight Bells	RDW
Homer, Winslow	Summer in the Country	RDW
Homer, Winslow	The Army of the Potomac-A Sharp Shooter on Picket Duty, November 15, 1862	RDW
Hopf, Ernest	Normandy Fire	NGA
Hopkins, Edna Boies	Butterflies	RDW
Hopper, Edward	American Landscape Whitney Museum of American Art, NY; Josephine N Hopper Bequest © Heirs of Josephine N. Hopper, licensed by the Whitney Museum of American Art"	RDW
Hopper, Edward	The Henry Ford Whitney Museum of American Art, NY; Josephine N Hopper Bequest © Heirs of Josephine N. Hopper, licensed by the Whitney Museum of American Art"	RDW
Howard, John Langley	The Union Meeting John Langley Howard Estate	NGA
Hunter, Florence Kent	Decorations for the Home Relief Bureau	NGA
Hutty, Alfred Herber	Jenkins Orphanage Band	NGA
Jennings, Wilmer Angier	Still Life with Fetish	MMA
Johns, Jasper	Target Art © Jasper Johns and ULAE/Licensed by VAGA, New York, NY, Published by Universal Limited Art Editions	NGA
Johns, Jasper	The Seasons (Summer) Art © Jasper Johns and ULAE/Licensed by VAGA, New York, NY, Published by Universal Limited Art Editions	NGA
Johnson, Sargent	Singing Saints	MMA
Johnson, William	Blind Singer	NGA
Kahlo, Frida	Frida and the Miscarriage Kahlo & Rivera © 1932 Banco de México Diego Rivera Frida Kahlo Museums Trust, Mexico, D.F. / Artists Rights Society (ARS), New York	Unknown
Katz, Alex	The Swimmer Art © Alex Katz/Licensed by VAGA, New York, NY	NGA
Kelly, Ellsworth	Untitled (Music Stand or Portrait) © Ellsworth Kelly	NGA
Kent, Rockwell	Big Inch © Rockwell Kent and The Plattsburgh State Art Museum	NGA
Kent, Rockwell	Greenland Airmail Stamp © Rockwell Kent and The Plattsburgh State Art Museum	RDW

My thanks to the National Gallery of Art (particularly Peter Huestis) and the Metropolitan Museum of Art for the many photographs of prints in their collections.

Also, thanks to the following for images provided:

> Art Institute of Chicago, Autumnal Glory (Baumann) and Brook Trout (Beale)
> Bridgeman Art Library, Sabrina's Silvery Flood (Blake)
> British Museum, The Battle of Zonchio (Unknown)
> Brooke Alexander Gallery, Brown Trout (Second State) (Welliver)
> Cleveland Museum of Art, View of Worcester (Baskin)
> Curtis Publishing, Rosie the Riveter (Rockwell)
> Hirschl & Adler, The Bloody Massacre (Paul Revere)
> Indianapolis Museum of Art, Hopi Corn (Baumann)
> Museum of Modern Art, The Swimmer (Katz)
> Smithsonian American Art Museum, Weary Men (Tired GIs) (Cook)

Glossary of Print Terms

With thanks to Antony Griffiths, *Prints and Printmaking: An Introduction to the History and Techniques* (London: British Museum Press, 1996)

AQUATINT

An intaglio (see below) method to create tone in a print, typically used in conjunction with etching. A special variety of etching ground, or resin, consisting of small particles, is fused to a metal plate to act as a resist to acid. Since this ground is porous, the acid bites into the plate around each resin particle. The resin is then removed, and the acid-bitten depressions in the plate hold ink for printing.

CARBORUNDUM PRINT

A process similar to aquatint, except a grinding stone, such as Carborundum, is used to score the metal plate

COLLAGRAPH

A print taken from a printing plate that has elements collaged onto it or is in some way marred or distorted.

DRYPOINT

An intaglio method in which a copper plate is directly scored by a needle. The ridge of copper raised by the needle, called burr, is left on the plate, which prints as a rich smudge.

ENGRAVING

The oldest type of the intaglio processes. A burin (a chisel-like tool with a "v"-shaped point) is used to incise a metal, usually copper, plate. The curls of copper thrown up by the furrows are removed, and ink is rolled onto the plate, filling the incisions. The plate is wiped clean, but ink remains in the grooves. Damp paper is pressed against the plate, and the ink transfers to the paper.

ETCHING

The most-used intaglio process in today's printmaking. In essence, acid does the work of the burin. A metal plate is covered with a waxy resin, or ground, and the art-

ist draws on this material with a sharp tool, exposing the metal. The whole plate is then immersed in acid until the lines are sufficiently bitten into the metal. The resin is then removed and the plate is printed as in an engraving.

INTAGLIO

The class of metal plate printing processes in which the ink is pulled out of the grooves made in the plate by applying damp paper under pressure.

LINOCUT

An abbreviation for linoleum cut; the same process as woodcut except that linoleum is used instead of a block of wood.

LITHOGRAPH

Lithography is based on the fact that grease and water repel each other. If marks are drawn on a suitable printing surface with a greasy crayon, the surface can be printed by first dampening it with water, which settles only on the unmarked area since it is repelled by the greasy drawing. Secondly, a roller with greasy printing ink on it is rolled over the surface; the ink now adheres only to the drawn marks, the water repelling it from the rest of the surface. Finally the ink is transferred to a sheet of paper by running paper and the printing surface together through a press.

Such in essence is the principal of lithography. The actual operations are much more complicated. The printing surface used was originally stone capable of absorbing grease and water equally, and the only really suitable type was the limestone quarried in Bavaria. Later zinc and aluminum were employed as substitutes. The disadvantage of stone is its bulk and weight, but artists have usually preferred to use it because it allows a richer range of tones.

MEZZOTINT

An intaglio process that works from dark to light. A metal plate is completely ground down; if printed, the paper would be totally black. To create an image, the artist scrapes away portions of the ground plate—these spaces print white.

SCREENPRINT (also known as silkscreen or Serigraphy)

A variety of stencil printing. A fine-mesh screen, fixed tautly onto a rectangular wooden frame, is laid directly on top of a sheet of paper. Printing ink is spread over the upper side of the mesh and forced through it with a squeegee (a rubber blade) so that the ink transfers to the paper on the other side. The material of the screen is usually silk, but can be cotton, nylon or a metal mesh.

The design is applied to the screen in various ways. The earliest technique was simply to cut out a masking stencil of paper and attach it to the underside of the

screen. The most common device is to paint out areas of the screen with a liquid that sets and blocks the holes in the mesh. One important development is the use of photo-stencils, which allow the artist to incorporate photographic images into the print. The screen is coated with bichromated gelatin and placed in contact with a photographic negative or diapositive. Light is then shone through the transparency onto the gelatin, which hardens under exposure but remains soft where protected by the black areas of the transparency. When the exposure is completed, the soft areas can be washed away with warm water, leaving the hard exposed gelatin to act as a stencil.

Artists' screenprints have almost always been in color. Since a single screen cannot easily be inked in more than one color, this is usually done by successive prints, using a different screen for each color.

WOODCUT

Contrary to the intaglio processes, the actual surface from which the printing is done stands in relief above the rest of the wood block, which has been cut away. A fairly soft wood is normally used, and the artist's design is either drawn directly on the block, or a sheet of paper which is glued to the block. The cutter then uses a small knife to cut the wood away from the sides of the drawn lines. Chisels and gouges are used to remove large unwanted areas. Ink is typically applied with a roller, and the printing ink is of a stiff consistency, so as to remain only on the raised parts of the block and not flow into the hollows. The printing can be done with a press or by hand with a burnishing instrument such as the back of a spoon.

WOOD ENGRAVING

A form of woodcut that provides for greater detail in the print. A burin (see Engraving) is used to cut the wood across the grain ('end-grain') rather than along it, as in a woodcut. The inking and printing is the same as woodcut, not like engraved metal: the ink remains on the raised portion of the wood block, not in the cut groves.

Bibliography

About Us." Tamarind Institute: Lithography Workshop and Gallery. Accessed June 24, 2013. http://tamarind.unm.edu/aboutus.html.

Ackley, Clifford S. *Printmaking in the Age of Rembrandt.* Boston: Museum of Fine Arts, 1981. Exhibition catalog.

Acton, David. *The Stamp of Impulse: Abstract Expressionist Prints*. Worcester, MA: Worcester Art Museum, 2001. Exhibition catalog.

Adams, Clinton. *American Lithographers 1900–1960: The Artists and Their Printers.* Albuquerque: University of New Mexico Press, 1983.

———, ed. *Second Impressions: Modern Prints & Printmakers Reconsidered*. Albuquerque: Tamarind Institute, 1996.

All about Prints. DVD. Directed by Christopher Noey. Washington, DC: The National Gallery of Art, 2009.

"Art: Silk-Screen Prints." *Time*. November 11, 1940.

Ashton, Dore. "Graphic Society Annual." *Art Digest* 27, no. 10 (February 15, 1953): 23.

Bergdoll, Barry and Leah Dickerman, ed. *Bauhaus 1919–1933: Workshops for Modernity.* New York: The Museum of Modern Art, 2009. Exhibition catalog.

Berman, Avis and Francis V. O'Connor. "The Graphic Art Workshops of the WPA Federal Art Project." Unpublished Report of Research. June 1996.

Biddle, George. *An American Artist's Story*. Boston: Little, Brown, 1939.

———. *The Yes and No of Contemporary Art: An Artist's Evaluation*. Cambridge: Harvard University Press, 1957.

Blanning, Tim. *The Romantic Revolution*. New York: Modern Library Chronicles, 2010.

"Books, at a Price." *New York Times*, September 11, 2010. http://www.nytimes.com/2010/09/12/weekinreview/12grist.html.

Breeskin, Adelyn. *Anne Goldthwaite: A Catalogue Raisonné of the Graphic Work.* Montgomery, AL.: Montgomery Museum of Fine Arts, 1982. Exhibition catalog.

Brenson, Michael. "Art People; How Galleries Put on Shows." *New York Times*, August 12, 1983. http://www.nytimes.com/1983/08/12/arts/art-people-how-galleries-put-on-shows.html.

Brown, Milton W. *The Story of the Armory Show*. New York: Abbeville Press, 1988.

Budick, Ariella. "Milton Avery, Knoedler Gallery, New York." *Financial Times*, April 21, 2010. www.ft.com/cms/s/0/9704e6d8-4d5d-11df-9560-00144feab49a.html.

Cage, John. "Experimental Music." Lecture at Evergreen State College, Olympia, WA, 1957.

Carey, Frances and Antony Griffiths. *Avant-Garde British Printmaking 1914–1960*. London: British Museum Publications, 1990. Exhibition catalog.

Chaffee, Ada Gilmore. "Cape End Early Cradled Gifted Group of Print Makers Who Added to Art." *The Provincetown Advocate*, October 30, 1952.

Childs Gallery. *Childs Gallery Print Annual 27*. Boston: Childs Gallery, 2005.

Clinton, Henry. *The American Rebellion: Sir Henry Clinton's Narrative of His Campaigns, 1775–1782*. New Haven: Yale University Press, 1954.

Cooke, Gordon. *Samuel Palmer, 1805–1881: The Complete Etchings*. London: The Fine Art Society, 1999. Exhibition catalog.

Cork, Richard. "Vorticism." MoMA. Accessed June 4, 2013. http://www.moma.org/collection/theme.php?theme_id=10964.

Crowley, Roger. *City of Fortune: How Venice Ruled the Seas*. New York: Random House, 2011.

Cullen, Countee. *On These I Stand: An Anthology of the Best Poems of Countee Cullen*. New York: Harper & Brothers, 1947.

Currie, Juliet. "Gustave Baumann: A Century of Delight." *El Palacio* 87, no. 1 (Spring 1981): 25–32. http://www.nmartmuseum.org/assets/files/BaumannElPv87.pdf.

Feldman, Frayda and Jorg Schellman, ed. *Andy Warhol Prints: A Catalogue Raisonné 1962–1987*. New York: Distributed Art Publishers, 2003.

Fern, Alan and Judith O'Sullivan. *The Complete Prints of Leonard Baskin: A Catalogue Raisonné 1948–1953*. Boston: Little, Brown, 1984.

Flint, Janet Altic. *Provincetown Printers: A Woodcut Tradition*. Washington, D.C.: Smithsonian Institution Press, 1983. Exhibition catalog.

Gamerman, Ellen. "'Birds' Book Soars to Record." *Wall Street Journal*, December 8, 2010. http://online.wsj.com/article/SB10001424052748704250704576005751646141670.html.

Gibson, Ann. "Painting Outside the Paradigm: Indian Space." *Arts Magazine* 57, no. 6 (February 1983): 98–104.

Goodrich, Lloyd. *Winslow Homer*. New York: Braziller, 1959.

Green, Nancy E. *Arthur Wesley Dow and His Influence*. Ithaca, NY: Herbert F. Johnson Museum of Art, Cornell University, 1990. Exhibition catalog.

Hacket, Pat and Andy Warhol. *Popism: The Warhol Sixties*. New York: Harcourt, 1980.

Helms, Cynthia Newman, ed. *Diego Rivera: A Retrospective*. Detroit: Detroit Institute of Arts, 1986. Exhibition catalog.

Herrera, Hayden. *Frida: A Biography of Frida Kahlo*. New York: Harper & Row, 1983.

Hobbs, Robert Carleton. *Milton Avery: The Late Paintings.* New York: Harry N. Abrams, in Association with the American Federation of Arts, 2001.

Holiday, Billie, "Strange Fruit," by Allen, Lewis [Abel Meeropool], in *Lady Sings the Blues*, Verve 833 770-2, 1990, compact disc.

Ittmann, John, ed. *Mexico and Modern Printmaking: A Revolution in the Graphic Arts, 1920 to 1950*. New Haven: Yale University Press, 2006. Exhibition catalog.

Jacobs, Joseph. "Indian Space Painters." *Art and Antiques* 30, no. 2 (February 2007): 58–65.

Johnson, Fridolf, ed. *Rockwell Kent: An Anthology of His Works*. New York: Knopf, 1982.

Jones, Dan Burne. *The Prints of Rockwell Kent: A Catalogue Raisonné*. Chicago, IL: Univ.
of Chicago Press, 1975.

Kelder, Diane, ed. *Stuart Davis: A Documentary Monograph in Modern Art*. Westport, CT:
Praeger Publishers, 1971.

Keppel, Dorothy. "Kerr Eby." *Print Collector's Quarterly* XXVI, no. 1 (February 1939):
83–95.

Kiehl, David W. *American Art Posters of the 1890s*. New York: The Metropolitan
Museum of Art, 1987. Exhibition catalog.

Kramer, Hilton. "Art: Expressionism from Italy Arrives." *New York Times*, June 5, 1981.
http://www.nytimes.com/1981/06/05/arts/art-expressionism-from-italy-arrives.
html.

Lochnan, Katherine A. *The Etchings of James McNeill Whistler*. New Haven, CT: Yale
University Press, 1984. Exhibition catalog.

Loughery, John. *John Sloan: Painter and Rebel*. New York: Henry Holt, 1995.

Mann, Horace. "Pope Severinus." In *Catholic Encyclopedia*. Robert Appleton, 1912.
Accessed March 26, 2012. http://www.newadvent.org/cathen/13742c.htm.

Maravell, Nicholas P. *Alex Katz: The Complete Prints*. New York: Alpine Fine Arts
Collection, 1983.

Margo Feiden Galleries LTD. "Some Brief Biographical Notes Lovingly Set Forth."
Bios, accessed March 26, 2012. http://www.alhirschfeld.com/bios/alhirschfeld.
html.

Margolin, Victor. *American Poster Renaissance*. New York: Watson-Guptill, 1975.

McLuhan, Marshall and Quentin Fiore. *The Medium is the Massage: An Inventory of
Effects*. New York: Bantam Books, 1967.

Morin, Richard W. "Statesman and Artist." *Dartmouth College Library Bulletin* 10, no. 1.
(November 1969): 2-9.

Nash, Ogden. "What Street Is This, Driver?" In *Good Intentions*. Boston: Little, Brown,
1942.

Norelli, Martina Roudabush. *Werner Drewes: Sixty-Five Years of Printmaking*.
Washington, D.C.: National Museum of American Art, 1984. Exhibition catalog.

Paumgarten, Nick. "Profiles: Dealer's Hand." *The New Yorker*, December 2, 2013.
http://www.newyorker.com/reporting/2013/12/02/131202fa_fact_paumgarten.

Pelletier, S. William. "John Taylor Arms: An American Mediaevalist." *The Georgia
Review* 30, no. 4 (Winter 1976): 908–938.

Plimpton, George, ed. *The Norton Book of Sports*. New York: Norton, 1992.

Potter, Jeffrey. *To a Violent Grave: An Oral Biography of Jackson Pollock*. New York:
Putnam, 1985.

Rivera, Diego. *My Art, My Life*. New York: Citadel, 1960.

Schwartz, Alexandra. *David Smith: The Prints*. New York: Pace Prints, 1987. Exhibition
catalog.

Severens, Martha R. *Alice Ravenel Huger Smith: An Artist, a Place and a Time*. Charleston,
SC: Carolina Art Association, 1993.

Shannon, Helen, ed. *Hale Woodruff, 50 Years of His Art*. New York: Studio Museum in
Harlem, 1979. Exhibition catalog.

314 Sigler, Jeremy. "ArtSeen: Neil Welliver: The Absent Painter." *The Brooklyn Rail*, Dec
06–Jan 07. http://www.brooklynrail.org/2006/12/artseen/neil-welliver

Simpson, Marc. *Winslow Homer: The Clark Collection*. Williamstown, MA: Sterling and
Francine Clark Institute, 2013. Exhibition catalog.

Stewart, James B. "Record Prices Mask a Tepid Market for Fine Art." *The New York
Times*, December 6, 2013. http://www.nytimes.com/2013/12/07/business/
record-prices-mask-a-tepid-art-market.html.

Thorn, John. "Poster Girl." *Woodstock Times*, December 25, 2008. http://www.
woodstock.ulsterpublishing.com/view/full_story/11404361/article-Poster-Girl.

Thorton, Sarah. "Hands up for Hirst," *The Economist*, September 9, 2010, http://www.
economist.com/node/16990811.

"Universal Limited Art Editions/History." Accessed June 24, 2013. ULAE. http://www.
ulae.com/history.aspx.

Walker, Barry. *Donald Sultan: A Print Retrospective*. New York: AFA/Rizzoli, 1992.
Exhibition catalog.

Wardlaw, Alvia J. *Black Art, Ancestral Legacy, The African Impulse in African-American Art*.
Dallas, TX: Dallas Museum of Art, 1989. Exhibition catalog.

Warner, Marina. *Queen Victoria's Sketchbook*. New York: Crown, 1979.

Welliver, Neil. *Neil Welliver: Prints*. Camden, ME: Down East Books, 1996.

Whipple, Barbara. "Biography of Luigi G. Rist, American Printmaker, 1888–1959."
(Unpublished manuscript, 1971), Barbara Whipple Heilman papers relating to
Luigi Rist, microfilm roll 286, Archives of American Art, Smithsonian Institution,
Washington, DC.

Williams, Dave and Reba. *Alone in a Crowd: Prints of the 1930s–40s by African-American
Artists*. New York: American Federation of Arts, 1993. Exhibition catalog.

Williams, Dave and Reba. *American Screenprints*. New York: National Academy of
Design, 1987. Exhibition catalog.

Williams, Dave and Reba. *Around Town Underground: the New York Subway in Prints*.
Stamford, CT: Print Research Foundation, 2004. Exhibition catalog.

Wilson, William. "Art Review: Helen Lundeberg's Quest for Purity, Reality, Illusion."
Los Angeles Times, September 25, 1995. http://articles.latimes.com/1995-09-25/
entertainment/ca-49743_1_helen-lundeberg.

Witkin, Lee D. *Kyra Markham, American Fantasist, 1891–1967*. New York: Witkin Gallery,
1981. Exhibition Catalog.

Young, Joseph E. "Lichtenstein Printmaker." *Art and Artists* 4, no. 12 (March 1970):
50–53.

Zigrosser, Carl. *Multum in Parvo: An Essay in Poetic Imagination*. New York: Braziller,
1965.

———. *The Artist in America, Twenty-Four Close-ups of Contemporary Printmakers*. New
York: Knopf, 1942.

Index

NOTE: Illustrations are indicated by titles and page numbers in **bold type**

Small Victories has been set in Palatino nova type,
a face designed by the distinguished German typographer, type designer
& calligrapher Hermann Zapf, and named after Giambattista Palatino,
a sixteenth-century Italian writing master.

A modern interpretation of the humanistic Renaissance roman & italic letter,
it was designed in 1948, with the complete Palatino family issued
between 1950 and 1952. The Palatino type family was
completely revised under Zapf's direction a few years ago, and released
as "Palatino nova," which is the version used in this book.

The book was printed by GHP of West Haven, Connecticut,
on Cougar Natural, an acid-free sheet, and bound
by New Hampshire Bindery.

The book, binding, & jacket were designed by Jerry Kelly.

BETTER RÉSUMÉS FOR EXECUTIVES AND PROFESSIONALS

Second Edition

by
Robert F. Wilson
President, Boswell Associates
New Haven, Connecticut

and

Adele Lewis
Former President and Founder,
Career Blazers Agency, Inc.

BARRON'S EDUCATIONAL SERIES, INC.

All inquiries should be addressed to:
Barron's Educational Series, Inc.
250 Wireless Boulevard
Hauppauge, New York 11788

Library of Congress Catalog Card No. 90-48502

International Standard Book No. 0-8120-4629-3

Library of Congress Cataloging in Publication Data

Wilson, Robert F.
 Better résumés for executives and professionals / by Robert F. Wilson and
 Adele Lewis. — 2nd ed.
 p. cm.
 Rev. ed. of: Résumés for executives and professionals.
 ISBN 0-8120-4629-3
 1. Résumés (Employment) I. Lewis, Adele Beatrice, 1927–1990.
II. Wilson, Robert F. Résumés for executives and professionals.
III. Title.
HF5383.W485 1991 90-48502
650.14—dc20 CIP

PRINTED IN THE UNITED STATES OF AMERICA
 34 100 98765

Contents

Introduction

If you are reading these words in a bookstore or library, trying to decide whether this book is worth your time and money, let us help you telescope the decision-making process.

We assume that, having turned to this page, you are either an executive or a professional with an interest in improving or changing your career. We assume you know that a powerful, effective résumé is one essential tool toward accomplishing your goal.

We assume also that you want to continue working in your current career area; or you are changing career fields but know precisely in what new area you want to apply past career interests, skills, and accomplishments. (If you are less than sure of your next career move, you will find valuable tips in Chapter 5. You may want to read that chapter first and conduct further research on your own before using the rest of the book.)

From these assumptions we frame our entire universe of prospective readers, and we welcome you among them. Good luck in your new or improved career.

Taking Care of Business Before You Write Your Résumé 1

Satisfied job holders don't need résumés and rarely feel the need to update their old ones. The rest of you—either unhappy in your current position or having just left your last job—should read on.

But even the best written résumés and marketing plans won't by themselves propel job seekers into the best next job; other important issues must be considered and controlled to allow enough time and peace of mind for the actual job hunt. Those of you in either of the categories mentioned in the first paragraph will have to harness all of your concentration powers to launch a successful job search—without rushing the process. So before getting to the nuts and bolts of creating a résumé, every job seeker should be sure that three possible trouble areas are under total control:

☐ Job-loss stress
☐ Family communications
☐ Financial crunch

Having these problems under control, understand, is not necessarily the same as *eliminating* them. Complete solutions may not be possible without outside assistance—which obviously is beyond the scope of this book. What we can do, however, is suggest ways of dealing with these problems to minimize any interference with your paramount task—finding the best next job as quickly as possible.

Job-loss stress. If you have just lost your job, or feel that termination is imminent, a sharp sensation just below your rib cage may be one of several constant reminders that all is not well. This minor discomfort, however, is the least of it.

The psychologist who compared job-loss-associated trauma with that of divorce or the death of a loved one was on to something. Knowing the seven stages illuminating the tortuous path through this nightmare can help to keep your feelings in sharp focus—even push you through the process more quickly. As delineated in a self-administered employment transition program called *Job-Bridge*, these stages can be identified as follows:

1. *Shock.* You probably don't know what hit you. More extreme cases include panic, confusion, and an inability to take positive action.

2. *Denial.* You may refuse to believe what has happened, and think instead that a terrible mistake has been made.

3. *Relief.* If your dismissal releases you from pressures building weeks or months ago, you may view your new-found "freedom" as an opportunity that would have presented itself only if you had quit instead—to a timetable *you* created.

4. *Anger.* Some of those recently fired fantasize about getting even with former bosses or colleagues they perceive to be responsible. Others become angry with themselves for not correcting a situation that became intolerable. Still others—and don't feel guilty if you're one of them—do both.

5. *Bargaining.* Some people, in a futile and often panic-motivated attempt to "right a wrong," appeal to their employer for a second chance or possible reassignment. Actually, there is often justification for assignment to a more appropriate position elsewhere in the firm. In your case, however, the time for negotiating such an alternative has irrevocably passed.

6. *Depression.* When the reality of the lost job finally sinks in, this emotion is almost invariably the result. It can mean lost sleep, anxiety, or even a withdrawal from family and friends. Such depression usually lasts from a few days to three weeks. If it persists much longer than three weeks, it could mean *clinical* depression—in which case you should call a physician.

7. *Acceptance.* The time it takes to accept the loss of a job varies, but it will happen. Only at this point can you begin to think ahead and start to design your marketing plan in a comprehensive way. Understand, however, that if it takes longer than you think it should to find employment, mild depression probably will reappear. Knowing this may help you fight through it when it returns.[1]

Family communications. Two characteristics you'll require in significant quantity during a job transition period are energy and confidence. To be sure you can draw on both of these resources at will, you'll need the support of your family. A spouse, a brother or sister, an uncle—virtually any interested family members—can be a part of your best support team, provided they are up to speed on your progress and problems.

Many job seekers make the mistake of shielding their families from problems that, after all, affect everyone and not just the primary salary earner. Protecting one's family from some fairly tough truths (such as a possible loss of income for an indefinite period) helps nobody. Not only are potentially viable alternatives for bringing in supplementary income never considered, but carrying so great a burden alone tends to drain both energy and confidence at a time when they are needed desperately.

Cash crunch. Knowing you may be without a paycheck within the next few weeks or months should be the trigger for implementing an expense-cutting and resource-husbanding plan to get you through what could be a tough period. Start with the elimination of frivolous spending; cut everything but the essentials. Call a family meeting to be sure everyone is aware of the realities, and decide what measures are best for the entire family. Most importantly, get a commitment from everyone in the family for short- and long-term efforts to conserve. Consider what family resources can be converted to available cash for payment of unavoidable expenses as many as six to nine months down the road. Make it a rule to share any deteriorating

[1]*Job-Bridge.* © Wilson McLeran, Inc., Fairfield, CT 06430

financial condition with the bank that holds your mortgage, your credit card companies, and other major creditors who have more than a passing interest in your ability or willingness to make monthly payments. Most people think that keeping a low profile will cause creditors to somehow forget about them or overlook their indebtedness for an indefinite period. Quite the contrary. Such an attitude invariably is the prelude to disaster. The only solution is to communicate with those you owe. It is the only way to avoid the embarrassing phone calls, personal visits, and, finally, the lawsuits and liens against your personal holdings that all collection agencies reserve as their ultimate weapon.

In Search of the Perfect Résumé

2

Your fourth consideration—after dealing effectively with the three possible trouble areas discussed in Chapter 1—is to attend to your image-building tools, your résumé being foremost among them.

A résumé is the single most important self-advertisement any executive or professional on the move can own. It is your advance communication to generate interviews. It is your mini-dossier, to be distributed among prospective colleagues for review, comment, and—the ultimate goal—recommendation to hire. It is your statement of self, which says as much to a potential boss about your tastes and values as it does about your responsibilities and accomplishments.

If you are not known to a prospective employer, a good résumé—or under some circumstances, just a good letter of introduction—is essential to getting the interview. Without the opportunity of meeting a possible boss face to face, your chances of getting hired are nonexistent.

Some career counselors recommend withholding the résumé as a trump card in generating interviews. If asked, they advise, stall. The longer you can avoid showing your résumé, apparently, the better.

The supposition seems to be that once an employer has seen your résumé, all your weaknesses will have been exposed, putting you just moments away from rejection. Anyone as reluctant as this to use a résumé, though, must not know how effective a good one can be.

This is not to say that résumés should *always* be used. One legitimate reason for not using a résumé, or delaying its use as long as possible, would be that you want to make a career change so drastic that previous experience bears no relationship whatsoever to the intended new direction.

For just about every other situation, however, we emphatically recommend the preparation, use, and occasional updating of the best written and designed résumé possible. If you are going after more than one kind of job, you may need more than one résumé. But you do indeed need a résumé. In today's business and professional world, the résumé is viewed as indispensable—almost as much so as the calling card.

Don't leave your old job without it.

The Experts Rate Resumes

Résumés are used, for the most part, in only three kinds of situations: 1. to generate an interview for an open position; 2. to determine whether an opening exists—either immediately or in the near future; or 3. as part of a presentation to *create* a position.

But no matter which of these situations applies to you, the only effective résumé is one that leads to interviews. The résumés you will see in this book—including the one you learn to write—are designed to generate interviews.

Several years ago we took a survey to find out how line and staff executives evaluated résumés. We interviewed the interviewers themselves; more than fifty corporate officers, line managers, and human resource executives in a wide variety of Fortune 500 and smaller companies. Here's what we asked them:

☐ How many résumés do you receive a day?
☐ How much time do you take to read each one?
☐ What determines how much time you spend on each one?
☐ How long do you believe a résumé should be?
☐ What information do you think a résumé should convey?
☐ What résumé format do you prefer (chronological, functional, other)?
☐ How would you describe a "good" résumé?
☐ How would you describe a "bad" résumé?
☐ What do you think are the most frequent mistakes people make when writing résumés?
☐ What information do you think a cover letter should contain?

The point about which there was virtually unanimous agreement was this: *A résumé must communicate—totally and instantly.*

Let's say you're responding to an advertisement, or have knowledge from other sources about a position known also to other candidates. By definition you are in competition with anywhere from several dozen to many hundreds of other men and women who want the job. Under these circumstances, our experts say, ten to twenty seconds is about all the time you have to persuade a prospective employer to read every word—or at least to absorb most of what you have to offer. It must be clear immediately, they say, that you know precisely where you are going with your career, and that you have just the right background at your current level to qualify for the position.

Or let's say you're making a "cold call" on a company—either because you've heard there was an opening, or because your capabilities and experience uniquely qualify you for an opening you've heard is likely to break. Here too a strong résumé, backed up by an equally strong cover letter, is the first step you need to get in the door.

Chronological vs. Functional

Before getting to specific résumé components that help to achieve total communication, let's spend a few paragraphs comparing the two most common résumé formats: the chronological and the functional.

The basic difference between the two is that the chronological résumé stresses accomplishments and responsibilities tied closely to specific positions and employers, and the functional résumé stresses a profile

of your experience based on professional strengths or skills groupings, irrespective of any particular jobs held while attaining them.

With few exceptions, the chronological résumé format was preferred by the corporate executives we interviewed as doing the best job of indicating an individual's direction, skills, accomplishments, and promotion record.

The only situations in which the chronological format should be modified or discarded in favor of the functional, say our experts, are these:

☐ You have a spotty work record—four jobs in six years for example.
☐ You are re-entering the corporate or professional world after several years of freelancing, consulting, homemaking, or unemployment.
☐ You are making a dramatic change of careers—from personnel management to computer sales, as an extreme and unlikely example.

One of our clients, a wife of a career diplomat, had done only volunteer work twelve years before returning to the United States. She wanted to use her pre-marital travel experience (with a tour company, an airline, and a trade association) in some way to get back into a salaried position in travel sales or sales promotion. As it turned out, after she had completed our questionnaire (parts of which are quoted in Chapter 3) we had enough data—including her three years as president of the International Women's Club of Copenhagen and as Business English lecturer at a Brussels secretarial school—for a résumé that led to an interview and subsequent promotion job for a major international hotel chain. As you can see from her résumé (all résumé identities in this book have been changed) on pages 176-177, she was able legitimately to list the magazine she founded and published for the women's club, including the thousands of dollars of advertising she sold to keep it going and the managerial experience she gained by supervising a staff of twelve.

A freelancer's accomplishments can be chronicled the same way; likewise the consultant and the self-employed entrepreneur. An impressive client list, detailing specific accomplishments and an ability to bring projects in on time and to budget, can offset the stigma of a largely noncorporate work history. (See pages 22-23 for examples.) Similarly, a business sold for a profit is a rare phenomenon. If you can count it among your accomplishments, highlight it prominently.

If you've held too many jobs in too few years, however, you face a more challenging problem; similarly so if you have not worked for some time—either for pay or in volunteer positions. In these instances you will be better off with either a functional résumé or no résumé at all.

The functional résumé stresses career-wide accomplishments, responsibilities, and skills, and it avoids a complete chronology of employment—with a list of employers and inclusive employment dates often the last entry.

Even though your reasons for going to the functional résumé are sound, you face a risk in using it. According to most of the corporate executives we surveyed, it raises more questions than it answers, and makes many prospective employers suspicious. Functional résumés

should be used only in situations where the "whole truth"—that is, an all-inclusive chronological format—will kill any chance of an interview.

What Makes Good and Bad Résumés

To do its job—get you the interview—a résumé must clearly and force-fully make the best possible case for your ability to meet the needs of the targeted prospective employers. Obviously there are other factors to consider. One résumé cannot be an all-situation solution. Occasionally a specially written résumé is called for. An individual going after two different but related types of positions may want to distribute two or three variations of the same résumé. The list of individuals receiving the résumé of course is key, as is the letter that accompanies the résumé. These two stages we'll cover in Chapters 5 and 6, respectively.

None of this, however, takes away from the power of a well written, well designed résumé. Put in the form of negative example (and taken directly from responses to the corporate survey discussed earlier), let's imagine an employer "Hit List" of résumé characteristics, any one of which will ensure that a candidate is a candidate no more. For ease of discussion, we'll divide the characteristics into the categories of Appearance, Clarity, and Content. They break down like so:

Appearance
- [] Tacky typing or reproduction job
- [] Poor paper quality
- [] Vibrant, bizarre, or otherwise offbeat paper color
- [] Typographical errors
- [] Gratuitous, attention-getting visual effects (wild or mixed type styles, brochure format, photographs)
- [] Paper size other than 8½ by 11 inches
- [] Length of more than two pages (with exceptions, of course; see Chapter 3)
- [] Inappropriate format for level (middle manager with typeset body copy; corporate vice-president without same)

Clarity
- [] Description of jobs or accomplishments longer than four lines, causing difficult reading
- [] Position objective or experience summary not clearly stated
- [] Grammatical or syntactical errors or inconsistencies
- [] Personal data (name, address, phone numbers) not immediately identifiable
- [] Job history not stated in reverse chronological order

Content
- [] Excessive space devoted to items not directly related to career (hobbies, detailed personal data, detailed descriptions of jobs related to former careers)

☐ Employment gaps not sufficiently played down or explained

☐ Sequence of major headings inappropriate to level (for example, education listed first for person with solid, career-related experience)

☐ Career-related volunteer experience not effectively treated or developed

☐ Accomplishments insufficiently treated, or not quantitatively stated, where appropriate

In Chapter 3 we'll go into more detail about these characteristics and the inevitable exceptions to the rule, take a look at predominant résumé types and styles, and determine when to use them.

Résumé Nuts and Bolts 3

All successful authors write with a specific audience in mind. A successful résumé writer should be no less selective. Your target may be an individual hiring for the only position in the world for which you would consider leaving your present job. Or, it could be every vice-president of marketing in the bottled water industry with sales over $10 million in Southern California, Texas, and Florida. No matter. Know him, her, or them as well as you can, and write a résumé addressing specific needs.

An ability to write directly to needs rests on the mastery of three essential levels of information: 1. knowledge of industry; 2. knowledge of company; 3. knowledge of position or function.

The simplest, most easily managed goal is to move up the ladder in a relatively straight line—assuming more or broader responsibilities in your function and staying within your industry. If this is so, your job is to demonstrate—either directly or indirectly—your awareness of industry trends, problems, and promise. The "knowledge-of-company" level should be dealt with only in terms of your present company. Your awareness of the idiosyncrasies of other specific companies can be handled in the cover letter accompanying the résumé.

As to "knowledge-of-position," chances are the job you want is much like the one your boss has. In this case you need to be clear your *prospective* boss can see which of your *current* boss's responsibilities you either have handled or can handle. This, we repeat, is the simplest, most easily managed challenge. Those of you changing functions, industries, or both will find it tougher, but the strategy remains the same.

Writing your best résumé requires the assemblage of all pertinent professional, personal, and educational data. Most good career counselors use a detailed questionnaire, completed by each client and augmented by a one-on-one "drawing out" session based on responses to specific questionnaire questions.

Objective

After identifying yourself by name, address, and phone number at the top of page one, the first item of information should be your immediate career objective. This and the entry that follows—the Summary—provide the direction, tone, and major emphasis of the entire résumé. Every succeeding word will be read in light of these few words at the beginning of the document.

We ask clients to identify both short- and long-term objectives on our questionnaire to determine whether the individual has thought about a career path. In some instances (especially for younger execu-

tives), it may be wise to mention your immediate objective *in terms of* your long-range objective. ("Telemarketing Sales, leading to sales management position," for example.)

In many instances, though, it may be that just a specific title will serve. If this is precisely what you want and fully suits your needs, you are lucky and this is all you *should* use. For example:

Operations Vice-President
Senior Corporate Counsel
Foundation Executive Director

They have a certain crisp purity to them, don't they? Let's hope it's this easy for you—but it may not be. If you have most recently held a vice-presidency, for example, some well-paying positions of power may be perfectly acceptable to you and not carry a company or corporate officership. Corporate structure may not so warrant, or it may be that industry-wide the job may not necessarily call for a vice-presidency, division presidency, or whatever. If this is so, broaden your base. For example:

Senior Management—Sales/Merchandising
Health Care Financial/Administrative Management
Orchestral Conductor or Choral Director

If your field is relatively new or quickly evolving, you may need to cast your net wider still:

Telecommunications Programming Management
Director of Development, Major University
Information Systems Management

The maxim to remember, though, no matter what your objective, is to state it broadly enough to embrace all acceptable closely related positions, but not so broadly that you diffuse your focus and appear to be willing to accept anything out there. A prospective employer may infer lack of direction—or worse, that you're in a panic situation and will take anything you can get. Better to write two or three résumés, varying the objectives as necessary.

Summary

The purpose of the objective is to succinctly describe the position you want, by level, function, and/or industry. The Summary (or "Background," or "Professional Highlights") section is a companion entry indicating those achievements and skills justifying your ability to handle the position sought.

Anywhere from two to five brief, powerful sentences will be enough, highlighting those aspects of your background of most appeal. The beauty of a Summary is that it offers the advantages of a functional résumé with none of its disadvantages. You have the opportunity to combine and build on similar aspects of your work experience that may go back ten or twenty years.

The real possibility exists that an achievement you are particularly proud of may date back far enough—if you are using straight reverse chronology—to appear on the second page of the résumé and thus never be seen by a large number of prospects.

One of our clients had a strong financial background spanning three industries over eighteen years. Among his achievements was that of originating the airline credit card which was eventually imitated by every major airline. The problem was that his airline experience came immediately after his M.B.A., and would have been buried near the end of the résumé if treated chronologically. We decided to use a one-sentence general summary, followed by a Highlights section that would cause selected accomplishments to "pop out" visually. It read like this:

SUMMARY: Fourteen years experience in financial and business planning, marketing, and controlling functions for a manufacturer, an airline, and a brokerage firm.

HIGHLIGHTS:
- Conceived and implemented TWA "Getaway" credit card system, now the most popular of all airline credit cards
- Assisted in negotiating the transfer of TWA control away from the Hughes organization
- As media liaison, used marketing and advertising to make general public aware of negotiability of industrial diamonds
- Developed capacity for improving relations between factory and office workers to increase production and cut costs
- As general manager, tightened financial controls and directed short- and long-term business planning

The best way to get a handle on writing a good Summary is to go back over your career and list all of the skills, responsibilities, and achievements that you feel will qualify you for your next position. Pare down your list to the top six or seven points, and then combine those that are similar in scope or function so that you wind up with a brief narrative that has a little bit of flow to it.

Choose your words carefully. If your Summary sustains the reader's interest, more likely than not the rest of the résumé will, too. Don't be flowery. Your chances of getting the interview will not be improved by any records set in the use of adjectives or polysyllables. Make every word count. Rewrite your first drafts, striking out unnecessary words and phrases and tightening sentences until they say exactly what you mean. Then have one or more friends who know you well professionally read what you've written, and suggest accomplishments you either have forgotten or perhaps have dismissed as unimportant.

If you are changing careers—even slightly—don't mention the function or industry *being* changed. One client with a strong sales and marketing background wanted to minimize the fact that his excellent record had been compiled for the past seven years in the catering industry, a field he wanted to leave. So although we went into consid-

erable detail relating his experience in terms of specific employers later in the résumé, it was more effective to write the Summary stressing more generic skills and accomplishments, as follows:

SUMMARY: Extensive experience in sales and service of major industrial and commercial accounts. Outstanding record in acquiring direct accounts and initiating client contact at top management levels. Comprehensive background conceptualizing and implementing advertising campaigns.

An industry-changing executive, then, can encourage a prospective employer to consider his "pure" strengths first—at the top of the résumé—before revealing that those strengths were attained in what might be viewed as an alien industry.

Such a Summary, in fact, can be used with two or more specific Objectives to provide résumés with as many differing orientations as opportunities warrant. Two used by the marketing executive whose Summary appears above are:

> Executive Management, Hotel Industry
> Television Time Sales/Marketing Management

So in essence he has three résumés, to be used for situations that have already come up, with the option of preparing others pointed toward slightly differing situations as needed.

Experience

The heart of the résumé is the organization and presentation of your job history. If you have selected the chronological format as the one best for you, your goal is to make as much as you can out of every position you have had. Describe your major responsibilities, to be sure, but concentrate most heavily on accomplishments you can legitimately own or share. As a memory refresher, most questionnaires use a "Problem/Action/Results" inquiry for every position held and with every employer for whom a client has worked.

The key (to quote from the questionnaire) is to "think of as many problems as you can that you both faced and were able to solve to some satisfaction. Briefly describe the problem; next, the action you took to solve or alleviate it; then, the results or consequences of that action. Specifically mention, for example, situations or conditions that improved, dollars saved or earned for the firm, ideas adopted by the firm, dollars in increased sales for the firm, etc."

This will give you a nucleus of data from which to frame a powerful, achievements-oriented Experience section. Concentrate on utilizing achievements consistent with your career direction, and spend as little space as possible on aspects of previous positions that have no bearing on the kind of job you're after now. Similarly, devote more attention to current or recent career-related positions than on those held earlier in your professional life. Don't appear to be dwelling in the past. If you attained similar goals early in your career as well as more recently, load

them in your current experience and keep the past relatively spare.

The obvious exception to this advice is if you are in the process of a career change back to one held when you were younger. In this instance the wiser course is to list first those positions, responsibilities, and accomplishments from the career you want now under a heading such as RELEVANT EXPERIENCE, and try to use the entire first page to chronicle this part of your professional background. You will then be following your stated Objective and Summary with experience that backs up your intentions. The only possible negative to this strategy is that the inclusive dates in the margin relative to employment may go back a decade or more. Defuse this by a parenthetical note or asterisked footnote after the dates, such as: "See page 2 for current experience."

One of our clients had spent five years managing restaurants after a successful retail career, and wanted to go back to the field he realized was his first love. We accomplished this by filling the entire first page with retail experience without ever referring to his more recent restaurant experience on page 2—except for a footnote. Page one of the résumé is shown on page 16.

Sequence is important not just for career changes, however, but for anyone interested in the most effective possible résumé. Think of your résumé as a script, for both you and the interviewer. This is particularly true of the Experience section. Each entry is a cue to be picked up by the interviewer as he or she wishes, and singled out for elaboration if it piques interest and as it relates to the position available.

The accomplishments should be broken up in bite-size entities for the interviewer to spot and absorb quickly. The interviewee, on the other hand, should view each entry as the basis for a leading question, about which he or she has rehearsed responses of anywhere from one to fifteen minutes, determined by interviewer interest.

This being so, it is extremely important not only to include those points of maximum appeal, but to sequence them by degree of importance—almost the way you learned to write a topic outline in your first composition course. Where appropriate, buttress or quantify an accomplishment to further whet the reader's interest. Follow a main point with appropriate sub-points. Let's take an example from another retail executive.

- Developed marketing programs to reposition corporation as necessary
 —Created 120-store test to analyze customer buying patterns for purpose of maximizing inventory investment (later implemented in all 320 stores)
 —Initiated and implemented merchandise line plan to fully develop previously nonformalized corporate policy

and later in the résumé:

OBJECTIVE:	RETAIL SENIOR MANAGEMENT
SUMMARY:	Eight years strong retail managerial experience – including two years ownership of own gift shop – embracing sales promotion, inventory control and purchasing responsibilities. Multilingual.

RETAIL
EXPERIENCE:

J. W. MAYS DEPARTMENT STORE, New York, NY
Senior Buyer

1980 to 1983*

* Supervised ordering, pricing, display and marketing of all giftware, crystal, glassware, silverware, china figurines and imported merchandise

* Devised incentive plan responsible for sales increase of 15% on volume of $3.5 million annually

* Supervised 10 assistant buyers and sales personnel

* Identified and assigned new vendors to anticipate market trends

LINAS GIFT SHOP, Oakhurst, NJ
Owner

1978 to 1980

* Overall bottom-line responsibility; established and maintained overhead; supervised bookkeeping

* Hired, trained, and managed three salespeople

* Attended regional and national gift shows to determine trends and generate merchandising and marketing ideas

MOHANS, LTD., Cedar Grove, NJ
Sales Manager

1975 to 1978

* Ordered, displayed, priced and advertised all ladies' and men's clothing

* Supervised 18 salespeople

* Increased sales by 30% in first year; responsible for 25% of volume of $2.5 million

* Achieved 13½% profit sharing, highest in company

* For current experience, see page 2

- Assumed total responsibility for start-up and opening of individual store
 —Led and managed all areas (merchandising, operations, personnel and inter-community relations) to achieve sales volume and profit objectives
 —Trained, developed, and managed Assistant Managing Director, 6 Operational Department Managers, 13 Merchandising Managers
 —Established environment of full employee input preparatory to store opening, keeping motivation and morale at optimum levels

The chief point to remember in writing and laying out this section is: Make all key aspects of every entry as visible as possible to permit the reader to take in your strengths at a glance, and to select for more careful reading those that relate closely to the target position. The layout, in fact, is as important as the writing. Don't underestimate it. Sound data presented in a sloppy or unclear manner are as ineffective as a badly written résumé. As you go through the sample résumés in this book, look as closely at the design as you do the writing.

Education

Start with your most advanced degree, and include the name and location of the institution, your major, year of graduation (if you're under 45), and all career-oriented scholarships and academic awards. Mention of any fraternity or sorority affiliations may hook you into the social-academic version of an Old Boy network; on the other hand, it may irritate a former Independent who considers all college social organizations snob factories. You might want to wait and work this into the interview if you think you're being interviewed by a Brother or Sister.

List any career-related extracurricular activities. Include all career-related courses or programs completed, whether company-sponsored or paid for by you. If you are a non-college graduate, list institutions attended anyway, with inclusive dates but without additional comment; this may be perceived as defensive.

Licenses and Certifications

Include only those that are career-related, without elaboration.

Additional Personal Data

Career-related hobbies—yes.

Marital status, height, weight, number and ages of children, state of health (it's always "excellent" anyway; at least on résumés we've seen), availability of references (when they want them they'll ask)—

no. Exception: Sales managers sometimes impute a greater sense of stability to married candidates than to the single. Taking advantage of this bias may be enough reason for salespeople to trumpet their married status, where applicable.

Sample Résumés

The résumés reproduced in this chapter have been categorized among the following standard corporate functions and services:

Communications
Finance
Human Resources and Development
Information Systems
Legal
Marketing
Operations
Research and Development

This creates a few awkward catchalls, among them the inclusion of all educational and health care positions under "Human Resources and Development," and some engineering and science-oriented positions under "Research and Development." Similarly, we have included under "Communications"—perhaps arbitrarily—most art and design, public relations, film, television, museum, music, editorial, and writing positions.

Check the back cover to see if the particular job you are after is included in the appropriate function or service area—or perhaps one or more close to it—and you will likely be able to draw what you need from more than one example. Better yet, if you have the time, skim all of the samples in this chapter. It may well be that suggestions for several of your résumé entries will appear in career fields completely different from your own.

Several specific problem situations have been addressed in a number of these résumés. The more common among them are delineated below by category and page number. If you don't find your situation here, labeled as you diagnose it, read through all the résumés anyway. A crossover solution may occur to you for a problem you might never have identified as similar to your own.

Communications

PAUL TOWNSAND 118 West 87th Street, New York, NY 10024 212-873-7721

OBJECTIVE <u>PRODUCTION EDITOR</u>

SUMMARY Editor with production expertise and the ability to schedule and
 manage the activity of art, editorial and production staffs. Knowledge-
 able in all phases of production editing including consultation with
 authors and work assignments for in-house and free-lance staff members.
 Able to remain unruffled and maintain a steady, concentrated work flow
 despite tight scheduling and other pressures. Background in medical,
 scientific and foreign language books and periodicals.

EDITING EXPERIENCE

1985 - 1991 FREE-LANCE EDITOR, New York, NY

 * In-house editorial production supervisor for Macmillan's Medical
 Books Division, Free Press, Schirmer and other publishers

 - Managed projects from design survey on concentrated
 manuscript through all phases of proof, to final checks of
 blueprints and press sheets
 - Assigned work to free-lancers and in-house copy editors
 - Corresponded and consulted with authors
 - Collaborated with manufacturing supervisors

 * Copy editor of 12 to 15 titles per year for such clients as Jason
 Aronson, Inc.; Time, Inc.; and Arthur D. Little, Inc.

 - Copy edited manuscripts, jacket copy and promotional
 material
 - Handled proofreading, slugging and checks on repros,
 blueprints and press sheets

 * Guided and supervised editorial staff of 12 on four-volume
 <u>Encyclopedia</u> <u>of</u> <u>Bioethics</u> (a popular title at a $250 price tag)

 - Drew up five-page style guide, which was widely copied
 and circulated throughout parent company
 - Checked over all copy editing of 3,000-page manuscript

 * Reviewed and corrected manuscripts copy edited by others whose
 work did not meet professional standards

1979 - 1985 PRAEGER PUBLISHERS, New York, NY
 <u>Copy Editor</u>

 * Production and copy editing for 15 to 18 projects annually

 - Copy edited manuscripts, jacket copy and promotional material
 - Handled proofreading, slugging and checks on repros,
 blueprints and press sheets
 - Assigned work to free-lancers and in-house copy editors
 - Corresponded and consulted with authors

 * Responsible for two of Praeger's most popular titles: <u>The Life</u>
 <u>and</u> <u>Death</u> <u>of</u> <u>Adolf</u> <u>Hitler</u> by Robert Payne and <u>The</u> <u>Wall</u> <u>Street</u> <u>Gang</u>
 by Richard Ney

1967 - 1979 CURRENT DIGEST of the SOVIET PRESS, New York, NY
<u>Managing Editor, Current Digest/Co-Editor, Current Abstracts</u>

* As Managing Editor, <u>Current Digest of the Soviet Press</u>
 - Supervised staff of 12 translators, copy editors and indexers
 - Selected and abridged material in Russian for translation
 - Wrote headlines and captions

* As Co-Editor, <u>Current Abstracts of the Soviet Press</u>
 - Instrumental in the inauguration of new monthly magazine
 - Surveyed about 24 Soviet periodicals for articles of compelling interest to academic, government and media subscribers
 - Capsulized selected material and copy edited other articles
 - Selected graphic art for reproduction
 - Wrote headlines and captions

EDUCATION COLUMBIA UNIVERSITY GRADUATE SCHOOL of JOURNALISM
1969 - MS, Journalism

PRINCETON UNIVERSITY
1965 - BA, Art and Archeology (graduated <u>cum laude</u>)

US ARMY LANGUAGE SCHOOL, Monterey, CA

US ARMY INTELLIGENCE SCHOOL, Fort Holobird, MD

LANGUAGES Russian - Reading, writing, conversation, translation
French - Reading, conversation

WILLIAM A. POST

20 Waterside Plaza, New York, NY 10010 212/889-1427 (home) 212/867-0530 (office)

OBJECTIVE: EDITORIAL/MARKETING MANAGEMENT, EDUCATIONAL
 PUBLISHING

SUMMARY: Comprehensive experience editing and publishing
 educational textbooks at elementary and secondary levels.
 Recruit, contract and motivate authors; direct, motivate
 and correlate work of editors and writers on multi-
 grade projects running concurrently. Initiate conceptual
 programs and designs. Demonstrated ability to solve
 problems, meet challenging goals and expedite production.

EXPERIENCE:

1982-Present ACADEMIC PUBLISHING, INC.
 New York, NY
 Editorial Director, Reading and Language Arts Departments
 Text Division (1987-Present)

 * Recruit and supervise senior authors for development
 of text programs in basal reading, spelling, grammar
 and composition.

 * Directed four editors and 25 freelance writers in
 development and publication of industry-leading
 remedial reading system.

 --Comprises 150 published novels and seven instructional
 kits for grades 4-10 (additional 25 novels in work)

 --First program to offer high-interest reading material
 to elementary school students reading at first grade
 level

 * Conducted teacher focus groups and worked with outside
 consulting firm to prepare market research study
 reports for presentation to senior management.

 * Explore and research programs produced by other publishers
 in the field.

 * Represent company at state and regional curriculum and
 subject area meetings; conduct state and regional
 workshops in reading and language arts.

 * Effectively discharge responsibility for implementing
 projects accounting for 50% of division revenue.

<u>Associate Editorial Director</u>, Reading Department
School Division (1986-1987)

* Supervised material for and publication of "Kicks,"
 elementary level reading magazine

* Initiated and developed "Speed," a secondary level
 magazine

* Developed and published remedial math program for
 grades 4-6 (Academic has no math department)

<u>Supervising Editor</u> (1984-86)

* Directed staff of three division editors in Kicks
 Libraries, Kicks Reading Skills Program and
 Academic Listening Skills program, from manuscript
 acquisition through publication

<u>Editor, Kicks Libraries</u> (1982-84)

* Acquired manuscripts, assessed readability level and
 edited material for publication

1981-82 NEWTON COLLEGE OF THE SACRED HEART
 Newton, MA

 * Assistant Professor of Education

1978-79 CLINTON JOB CORPS
 Clinton, IA

 * Teacher, basic education

1977-78 J.B. YOUNG JUNIOR HIGH SCHOOL
 Davenport, IA

 * Teacher, 8th Grade English

EDUCATION:

1981 Harvard Graduate School of Education, M.A.T.,
 English Education

1979 University of Nebraska, Lincoln, NE
 B.S., English Education

AFFILIATIONS:

 American Association of Publishers, Social Issues Committee

 Chairman of Education Committee and member of
 Publications Committee, St. Peter's Church

HENRY EDMONDS
400 East 85th Street New York, NY 10022
(212) 688-2251

OBJECTIVE: EDITORIAL MANAGEMENT

SUMMARY: Fifteen years' experience in production of texts, magazines and multimedia instructional programs for leading publisher. Excellent understanding of components controlling manufacturing costs and generation of editorial revenues. Responsible for significant number of text publishing success stories.

EDITORIAL EXPERIENCE:

**1975 to
Present**

McGRAW-HILL, INC., New York, NY
Project Editor, Text Division (1981-Present)

* Plan and budget multimedia instructional programs accounting for more than 10 percent of divisional revenue

* Achieve product goals through supervision of staff varying from 14 to 25 on any given project, including free-lance writers and consultants

* Participate in sales campaigns aimed at securing text adoptions in key states

* Conduct workshops for secondary teachers; led two statewide seminars and conducted five regional National Council of Social Studies workshops

* Member, typesetting computer committee charged with streamlining and scheduling of text typesetting and production

* Work closely with rights and permissions department both in drafting of authors' contracts and in obtaining permissions from other publishing houses

* Now developing on-level, basal text entry for high school U.S. history market, possibly the most competitive social studies market in pre-college text publishing; program tested positively in 1989 field surveys

* Refashioned American Adventures, best-selling multimedia history program, into basal format (both soft and hard cover) without sacrificing popular appeal

 - Extensive rewriting, re-editing and additions resulted in adoption by 15 states and most dramatic sales increase on a text program in company's history

 - Convinced upper management that regional variations were unnecessary, thus decreasing manufacturing costs by approximately 50 percent

* Produced simplified world history multimedia program, which is a steady seller with loyal following among teachers

 - Selected and guided ten writers, ten consultants, a designer, illustrator, and several indexers and caption writers, all working against tight deadlines

* Co-authored Tropical and Southern Africa (currently in seventh printing), one of seven original volumes in World Cultures Program

Concurrent Free-Lance Projects

- Contributing editor for 250-page book on basic legal principles for lay public in association with American Bar Association and scheduled for publication by Elsevier/Dutton

- Author, Junior Scholastic articles on California history and government (1989) and Presidential qualifications (1986)

- Wrote and produced four-page adult discussion guide for NBC-TV News to accompany three-hour telecast on American foreign policy, 1986

- Editor for one unit of Webster McGraw-Hill world history, Echoes of Time

- Wrote numerous Scholastic teleguides on such subjects as Alistair Cooke's America, David Copperfield, and New York City ca. 1880-1990

- Co-authored nine "map-paks" for W.H. Sadlier, Inc., 1983-1984; more than 370,000 copies of these skills-oriented study materials are still in print

Senior Associate Editor, School Division - Magazines (1975-1981)

* Hired as Assistant Editor in 1975; in quick succession of promotions, became Associate Editor, Managing Editor, then Senior Associate Editor within five years

* As Senior Associate Editor of American Observer, researched and wrote one or two articles weekly

* As Managing Editor of Junior Scholastic, brought about circulation turn-around of one of company's two highest-circulation magazines

 - Worked to give magazine a clear, lively style and brighter appearance; edited lead articles

 - Supervised staff of twelve including writers, artists and production personnel

1973-1975 MEDICAL ECONOMICS, INC., Oradell, NJ
 Associate Editor

1972-1973 TIME, INC., New York, NY
 Head Copy Boy, TIME Magazine

EDUCATION: STANFORD UNIVERSITY, Palo Alto, CA
 M.A., United States History (University Scholarship)
 B.A., History

 COLUMBIA UNIVERSITY, New York, NY
 Course work in Accounting

LANGUAGES: Some Spanish and very limited Japanese

AFFILIATIONS:

 Sigma Delta Chi Professional Journalism Association

 Willing to relocate

ROBERTA LOWREY

21 Fairfax Gardens, Hackettstown, NJ 07840 Home: (201) 852-6413
 Office: (201) 852-4225 Ext. 51

OBJECTIVE NEWSPAPER EDITOR

 To apply my newspaper experience in a position offering variety of
 assignments and challenge with opportunity for growth

SUMMARY Astute interviewer and reporter capable of handling varied assign-
 ments. Experienced in editing and page makeup. Creative assessor
 of story ideas and material and able to visualize concepts for news
 value publicity. Knowledge of basic photography. Willing to ac-
 cept and carry out travel assignments.

EXPERIENCE

2/87 - THE FORUM - Bi-Weekly Newspaper
Present State Publishing Company
 Hackettstown, NJ

 Copy Editor

 * Edit copy for four reporters, write headlines, size pictures and
 help with page makeup

 * Cover municipal beat

 Special Sections Writer

 * Charged with responsibility for three sections of the paper:
 Real Estate, Leisure, Fashions

 - Covered and wrote stories, rewrote releases and took photos
 - Made up sections

2/84 - ARGUS OBSERVER - Daily Newspaper
8/86 Matheur Publishing Company
 Ontario, OR

 Reporter

 * Covered county beat and improved coverage (and subsequent cir-
 culation) by introducing additional beats

 - Economic Development
 - Health Planning
 - Municipal
 - Extended Zoning and Planning

 * Wrote feature stories and took own photos

 * Filled in for wire editor and did other desk work as needed

 * Filled in for editor last 6 weeks

 Society Editor

 * Put together daily Family Page from the bottom up

 - Covered and wrote stories, edited releases, took photos
 - Handled correspondents' news
 - Made up page and wrote headlines

EXPERIENCE
(Cont'd.)

5/83 - 2/84	STATE OF OREGON, Disability Prevention Division Portland, OR

 * Typed psychology reports for therapy program

EDUCATION Willamette University, Salem, OR
1983, BA, English

 - Received Helen S. Pearce Award as outstanding senior woman
 English major
 - Worked as reporter and composition manager for newspaper
 - Worked as aide in public information office
 - President, Alpha Phi Sorority
 - Secretary, Mortar Board

Portland State University, Portland, OR

 - Course in Reporting I

MEMBER Ontario Press Club - served as secretary

TRAVEL Backpacked through England, Ireland, Scotland, Germany, Italy,
Spain, and Austria (8/82 - 12/82)

TEARSHEETS SUBMITTED UPON REQUEST

MARTIN DUPRÉ 20 Oakwood Court Home (516) 764-1520
 Rockville Centre, NY 11570 Work (516) 536-7500

OBJECTIVE: <u>NEWSLETTER EDITOR</u>

SUMMARY: Writer and editor with ability to simplify the complex, and solve publi-
 cation and scheduling problems. Record of successful new publication
 introductions. Expertise in taxes, fringe benefits, pensions, personal
 finance, estate planning, insurance, trusts.

EXPERIENCE: BARNSWORTH PUBLISHING, Rockville Centre, NY
 <u>Director of Publishing</u>

1987 to * Write and edit three highly successful monthly newsletters of steadily
Present increasing circulation through better coverage of material.

 * Positioned company in banking field by creating a pamphlet program,
 thus expanding market beyond insurance field.

 * Placed company in lucrative pension and profit-sharing market via
 creation of sophisticated syndicated pension trust letter.

 * Revitalized previously lagging pamphlet program by editing on-shelf
 material.

 <u>Free-lance Writer</u> (Concurrent with position at Barnsworth)

 American Institute of Certified Public Accountants; Warren, Gorham &
 Lamont; Main, Hurdman & Cranstoun; Estate Planner's Quarterly; Dental
 Management; Physician's Management.

 MATTHEW BENDER & COMPANY, New York, NY
 <u>Chief Editor - Insurance & Pensions</u>

1980 * Created and wrote four-page syndicated monthly insurance newsletter
to accompanied by 50-page technical analysis, which became leading news-
1987 letter in field.

 * Created and wrote pension trust syndicated monthly newsletter for
 banks--despite lack of in-house expertise--by thoroughly researching
 field and interviewing experts. Circulation grew to 50,000 (40 banks)
 within one year.

 * Wrote classic, highly successful booklet for insurance industry after
 Tax Reform Act of 1984 by utilizing in-house material and special
 knowledge of insurance.

 * Aided in writing bank (non-pension) trust letters.

DUNKIRK ASSOCIATES, Latham, NY
<u>Vice President, Editor-in-Chief</u> (1978-1980)

1975
to
1980

* Editor-in-Chief directing staff of 15 editors; responsible for all aspects of 12 insurance publications, including writing, editing, production scheduling and promotion.

* Raised quality and consistency of copy while maintaining tight production schedule.

* Increased productivity and accuracy of staff by assigning key writers to subject areas rather than publications.

COPLEY INTERNATIONAL, New York, NY
<u>Editor</u>

1973
to
1975

* Wrote weekly newsletter and brochures on topics of international business investment throughout world.

BUSINESS INTERNATIONAL, New York, NY
<u>European Editor</u>

1972
to
1973

* Wrote portion of weekly newsletter and brochures dealing with investments in Europe.

1968
to
1972

LEHMAN BROTHERS, New York, NY
<u>Economist</u> (1970-1972)
<u>Trainee Economist</u> (1968-1970)

NEW YORK STATE DEPARTMENT OF LABOR, New York, NY
<u>Labor Speechwriter</u>

1964
to
1966

* Wrote policy speeches for Gov. Nelson Rockefeller Industrial Commissioner Isador Lubin.

INTERESTS: Biking, walking, jazz, reading

Writing samples available on request

SUSAN JANE CLEMONS 415 West 96th Street #3H Home: 212-666-5216
New York, NY 10027 Work: 212-694-0200

OBJECTIVE TECHNICAL WRITING: Position closely allied with research department of pharmaceutical manufacturer

SUMMARY Technical writer with sophisticated medical and chemical laboratory experience. Talent for comprehensible and stimulating presentation of highly complex technical data. Doctorate in Chemistry and post-doctoral research at Columbia University College of Physicians & Surgeons. Co-authored four articles in the field of bio-organic chemistry published by Journal of the American Chemistry Society and Photochemical Photobiology.

PUBLICATIONS S.J. Clemons, V. Haughton, J.S. King, K. Blevins, "A Non-bleachable Rhodopsin Analogue Formed from 11,12-Dihydroretinal," J. Am. Chem. Soc., 89, 6210 (1988).

K. Blevins, V. Haughton, S.J. Clemons, M. Cole, M. Lukens, B. Randall, "Double Point Charge Model for Visual Pigments; Evidence for Dihydrorhodopsins," Photochem. Photobiol., 39, 875 (1988).

B. Randall, U. Goettl, K. Blevins, V. Haughton, S.J. Clemons, M. Cole, M. Lukens, "An External Point Charge Model for Wavelength Regulation in Visual Pigments," J. Am. Chem. Soc., 201, 6684 (1989).

R. Linder, S. West, K. Blevins, S.J. Clemons, V. Haughton, "Incorporation of 11,12-Dihydroretinal into the Retinae of Vitamin A Deprived Rats," Photochem. Photobiol., 43, 91 (1990).

RESEARCH AND TECHNICAL COMMUNICATIONS EXPERIENCE

1986 to Present COLUMBIA UNIVERSITY COLLEGE OF PHYSICIANS & SURGEONS, New York, NY
Postdoctoral Fellow, Arteriosclerosic Research Training Program

* Summarize experimental work in one-hour semi-annual presentations for medical doctors, biologists and other researchers

 - Developed format which dramatically increased comprehension and interest in experiments by audience with little knowledge or enthusiasm for synthetic chemistry

 - Wrote and distributed summaries which emphasized objectives, expected and observed results, and explanations of possible discrepancies in and interpretations of experiments

 - Supplemented written work with flow charts and tables

* Design and conduct independent experimental research on Vitamin A metabolism; evaluate results

 - Successfully isolate critical factors affecting experimental results through careful recording and analysis of procedures followed in sensitive process not easily duplicated

SUSAN JANE CLEMONS/2

 * Equipped unused biological/clinical laboratory with instruments to
 perform synthetic reactions and other chemical procedures

 - Negotiated for instruments specially designed and produced by
 Chemistry Department; acted as liaison between Director and
 Chemistry Department and set up account for payment

1982 - 1984 COLUMBIA UNIVERSITY, DEPARTMENT of CHEMISTRY, New York, NY
 <u>Teaching Assistant</u>

 * Closely supervised 15 students in general chemistry lab, evaluating
 students' mastery of general laboratory techniques and giving help
 where needed

 * Prepared sample time schedule and suggestions for saving time to
 encourage timely, neat and organized completion of student work

1983 - 1987 <u>Writing & Research Experience</u> gained in conjunction with work for
 doctorate, Columbia University, New York, NY

 * Presented paper at 1985 meeting of American Chemical Society in
 Chicago under title of "A Nonbleachable Rhodopsin Analogue Formed
 from 11,12-Dihydroretinal"

 * Prepared and referred manuscripts for publication in technical
 journals

 * Presented two departmental seminars

 * Prepared 190-page doctoral thesis on "Bio-Organic Studies in Visual
 Pigments; Formation of 11, 12-Dihydrorhodopsin from 11,12-Dihydroretinal"

 - Thesis included background of project, literature review, descrip-
 tion of original research and results, and detailed experimental
 section

EDUCATION COLUMBIA UNIVERSITY, New York, NY

 1986 - Present Postdoctoral Research Fellow, College of Physicians
 And Surgeons

 1987 Ph.D., Chemistry

 1984 M.S., Chemistry

 DOUGLASS COLLEGE of RUTGERS UNIVERSITY, New Brunswick, NJ
 1982 B.A., Chemistry
 Graduated with High Honors
 Elizabeth Laudenslager Clark Scholarship
 President, Rutgers Chapter, Iota Sigma Pi Chemistry
 Society

 WATERS ASSOCIATES, New York, NY
 1987 Course in use of high pressure liquid chromatograph

LANGUAGES Working knowledge of French and German

MICHAEL HERRICK • 214 47th Street • Lindenhurst, NY 11757

Res: (516) 226-1829 Bus: (212) 374-3254

OBJECTIVE: To transfer my expertise and experience as a FORENSIC COMMUNICATIONS SPECIALIST to the private sector

SUMMARY: Highly skilled in administration and operation of audio laboratory with special emphasis on techniques of voice identification and tape enhancement. Intimate knowledge of uses and adaptation of technical equipment to investigations. Practiced and effective lecturer. Creative designer of strategic training programs. Thorough researcher. Capable organizer and implementer of innovative systems and procedures.

CAREER HIGHLIGHTS:

1960 to Present

NEW YORK POLICE DEPARTMENT, New York, NY

Commanding Officer - Tape and Records Unit (1978-Present)

<u>Administration</u>

* Proposed, researched, established and currently supervise Forensic Audio Laboratory of the Communications Division

 - Provide NYPD with speaker identification and tape enhancement capability

 - Provide prosecutors with admissible evidence

 - Procedures have resulted in cost saving of more than $250,000 over past three years; more effective utilization of investigator man-hours in major criminal investigations and terrorist activities

 - Supervise 15 tape and audio technicians and voiceprint examiners

* Responsible for 911 Tape Logging System (largest in world - 200 channels)

 - Organized, refined and maintain system which supplies more than 5000 tape recordings per year in cooperation with investigators and officers of the court

* Proposed, established and supervise correlated records unit enabling efficient and timely pinpoint recovery of specific crime information (from 911 master reels and computer printouts reduced to microfiche)

* Maintain efficiency and integrity of specialized electronics equipment valued at more than $300,000; initiated, implemented and maintain security procedures

<u>Training/Lectures/Presentations</u>

* Coach attorneys in effective introduction of sound recordings to assure their admissibility as evidence; instruct employees in use and application to investigative and prosecutorial process

 - Conducted on-going 911 seminar program for district attorneys resulting in more effective use of 911 tapes and records in New York criminal court proceedings

* Lecturer - forensic communications course: biennial Homicide Investigations Course attended by FBI and State Police personnel from all over country; biennial Criminal Investigators' Course structured for local law enforcement agencies

MICHAEL HERRICK/2

<u>Training/Lectures/Presentations</u> (cont'd)

* Guest lecturer at 1987 NY State District Attorneys' Assn. workshop

* Co-authored status report on development of audio laboratory for presentation at 1987 convention of American Academy of Forensic Sciences in New Orleans

<u>Investigation and Consultation</u>

* Act as departmental consultant on forensic and 911 communications with all departments and with officers of the court

* Act as consultant in liaison with state and federal agencies

* Continue research in legal and scientific considerations through consultation with private sector and academic researchers to maintain state-of-the-art technological proficiency

* Conducting investigation into technique of using sound spectrograph to determine if subject is actually under hypnosis

* Conducting investigation on the effects of aging in speaker identification

<u>Career Progression - NYPD</u>

1960 - Joined department - assigned to routine patrol duties
1967 - Assigned to Emergency Service Division - rescue and sniper work
1970 - Assigned to Detective Division - served in Bureau of Identification
 as fingerprint technician
1975 - Promoted to sergeant-supervisor of tactical patrol force unit of
 30 officers charged with riot control and special weapons tactics
1976 - Transferred to Communications Division with supervision and training
 of 911 operators and dispatchers

EDUCATION: Specialized Training and Certification

1986 - Advanced Voice Identification Course, Michigan State Police
1983-86 - Annual International Association of Voice Identification
 Seminar (different location each year)
1985 - Magnetic Tape Analysis Course, FBI Laboratory, Washington, DC
1985 - Security Management Course, New York Police Academy
1984-85 - Specialized Spectrum Analysis, Queens College
1983-85 - Annual Carnahan Crime Countermeasures Conference
 University of Kentucky
1984 - Spectrum Analysis Techniques, FBI Course, New York City
1983 - Voice Identification Techniques, Voice Identification, Inc.
 Laboratory, Somerville, NJ
1980 - Management Techniques and Principles, New York Police Academy
1979 - American Management Association Course, New York Police Academy
1968 - Basic and Advanced Fingerprint Identification, NYPD
Criminal Justice Courses, John Jay College

MILITARY: 1963-64 and 1967-68 - U.S. Army, Sergeant First Class
NCO Academy, Munich, Germany - 6-week Leadership Course
Communications Section Leader

MEMBER: International Association of Voice Identification
Acoustical Society of America

QUALIFIED: Certified Voice Print Examiner

JACK L. GRIMES
670 MANNAKEE STREET ROCKVILLE, MD 20850
Home: (301) 340- 4801 Office: (202) 389-1602

OBJECTIVE

**MANAGER, DEPARTMENT of PUBLIC AFFAIRS
or GOVERNMENT RELATIONS**
Scientific or other technologically oriented corporation

SUMMARY

Extensive experience working directly with heads of Fortune 500 corporations, federal agencies and the Congress. Skilled in assessing importance of specific issues and designing successful issues-oriented actions.

PROFESSIONAL HISTORY

1981-Present

NATIONAL ASSOCIATION of SCIENCES/NATIONAL RESEARCH COUNCIL, Washington, DC
Executive Director, Board on Minorities in Engineering & Sciences

- Direct planning, organization and administration to implement science manpower policy utilizing $4,000,000 annually
 - Coordinate efforts of 65 corporations, 15 federal agencies and 112 universities participating in program
 - Establish national priorities and initiatives, guide development and allocation of resources, and monitor achievement of goals

- Influence federal policy and action through communications, negotiation and the creative utilization of human resources
 - Work with Cabinet and agency heads, and members of Congress, in formulating and implementing appropriate laws and regulations
 - Provide significant linkages between academic research facilities, The National Science Foundation and federal departments

- Increased corporate contributions to university minority engineering projects to $11 million, effecting a 400% expansion in corporate participation within six years
 - Facilitated participation of AT&T, DuPont, Exxon and General Electric as corporate pace-setters

- Established national initiatives which increased minority undergraduate engineering enrollment to 7% from 4.5% of the total undergraduate engineering population within six years

- Organized national symposium with 800 prominent leaders from government, industry, academic institutions and civic organizations; coordinated semi-annual meetings for 35 corporate leaders to address national manpower problems
 - Produced national reports used as guides by corporations and funding agencies in establishing funding priorities

- Prepare budgets and plan and staff all functions

Part-Time Consultant
- Assisted in key management at AT&T, Ford Motor Company, Olin Corporation, General Electric Company, RCA Corporation, Rockwell International and Xerox Corporation

—Advised corporate leadership on recruitment of employees to expand technical base, distribution of funds in minority-related areas, regional manpower development activity and corporate-academic linkages

—Organized corporate-financed regional and professional engineering societies

1976-1981 NEW YORK INSTITUTE of TECHNOLOGY, Albany, NY
Director, Engineering Opportunity Program

- Conceived and developed first successful university recruitment and educational program in engineering for women and minority students; created model written up by Departments of Labor and Education for use as national referent

- Placed minority enrollment at NYIT within country's top ten institutions by implementing 75% increase in successful minority matriculation

- Expanded services while maintaining quality through development of first external fundraising activity for university minority programs

 —Obtained $15,000 from Alfred P. Sloan Foundation and other corporations

 —Established financial aid office and received federal grants for needy students; obtained grant from New York Department of Higher Education

1972-1976 EXPERIMENTAL EDUCATION PROJECT, Paterson, NJ
Director (Part-time)

1967-1976 EASTSIDE HIGH SCHOOL, Paterson, NJ & C.A. JOHNSON HIGH SCHOOL, Columbia, SC
Chairman — Mathematics Department, Science Instructor, Guidance Counselor

EDUCATION SYRACUSE UNIVERSITY, Syracuse, NY
1975: MS, Chemistry—National Science Foundation Fellowship
ALLEN UNIVERSITY, Columbia, SC
1967: BS, Chemistry

Management Training

General Electric Management Development Institute: Management of Time, Manpower & Money, 1981
University of California at San Diego: Institute for Management Training (sponsored by Department of Defense), 1980

PUBLICATIONS "Parity for Minorities in Engineering: Myth or Reality," **Engineering Issues,** April, 1987
"The Image and Relevance of Engineering in the Black and Puerto Rican Community," **New Jersey Science Teachers Journal,** 1978.
"Engineering Opportunity Program: A Special Program for Disadvantaged Students," April, 1980 issue of **Engineering Education.**

PROFESSIONAL AFFILIATIONS

Arthur S. Flemming Awards Committee
American Society for Engineering Education
American Association for the Advancement of Science
National Society of Black Chemists and Engineers

ELIZABETH R. LINTON · 302 North Chestnut Avenue, Livingston, NJ 07039 · (201) 992-9726

OBJECTIVE: PUBLIC RELATIONS/CORPORATE COMMUNICATIONS
To apply my expertise in publicity/public relations in the editorial, music and arts field to a position with a corporation involved in community affairs.

SUMMARY: More than 15 years' experience in writing, publicity, public relations and media placement. Ten years with publishing houses. Creative designer of promotional concepts. Excellent coordinator of diverse groups working toward single goal. Discerning interviewer and organizer of material and campaigns.

CAREER HIGHLIGHTS:

1986 to CLOVER PUBLICATIONS, INC., New York, NY
Present Director of Publicity

* Conceive and follow through on promotional campaigns for major books

* Place publicity in national publications; set author interviews on radio and TV; negotiate store tie-ins

 - First full-length Clover review in New York Times; national recognition of Clover

 - Special in-store displays at FAO Schwarz and Lord & Taylor

 - Constantly develop reviewer lists

* Work closely with editorial and sales

1984-85 AMERICAN FEDERATION OF TELEVISION AND RADIO ARTISTS, New York, NY
Committees Coordinator

* Established committees of varied segments of membership; successfully attained positive communication

 - Maintained liaison between local members and executive staff and between AFTRA and "outside" influences

* Worked with highly confidential information

1982-83 DISTRICT COUNCIL 37, EDUCATION DEPARTMENT, New York, NY
Writer/Administrative Assistant

* Publicized courses offered by Council to its members; coordinated with educational institutions relative to scheduling and registration

* Wrote and published course handbook (became standard literature for department)

1979-82 SIMON & SCHUSTER, New York, NY
Associate Director of Publicity

* Wrote and designed all publicity and sales promotional material; selected and placed visuals

 - Increased press coverage and sales through copy frequently acclaimed by reviewers and authors

* Booked authors on network and local television and radio shows

Continued

ELIZABETH R. LINTON/2

 SIMON & SCHUSTER (Continued)

 * Promoted from Assistant Director in 1981

1981-84 SCHRIMER BOOKS, New York, NY
 <u>Freelance Editor</u>

 * Handled all editorial production functions for this division of
 Macmillan Company, from manuscript through blues

1976-78 MERCURY PHILLIPS RECORDS, New York, NY
 <u>Director of Publicity, Classical Division</u>

 * Brought relatively unknown label to attention of national music media

 - First complete recording of Berlioz' <u>Les Troyens</u> named "Recording
 of the Year" for 1978

 * Set up interviews with newspapers and magazines, appearances on
 radio and TV for recording artists; promoted open recording sessions
 and parties

 * Maintained still existing liaison with press agents, reviewers, radio
 stations and press agents

1974-76 WASHINGTON NATIONAL SYMPHONY, Washington, DC
 <u>Editor, Program Book</u>

 * Wrote 95% of program notes for concert repertoire and laid out weekly
 program book published for concert audiences

 * Maintained liaison between printer and concert office

1973-74 THE CHRISTIAN HERALD, New York, NY
 <u>Assistant Editor</u>

 * Read manuscripts for publishing potential; read books and manuscripts
 for Book Club potential

 * Edited articles: copyreading, proofreading, rewriting, cutting

1971-73 AVON BOOKS, New York, NY
 <u>Editorial Assistant</u>

 * Read hardcovers and manuscripts for potential paperback publication

 * Wrote cover copy

 * Put together two anthologies: opera, vampire literature

EDUCATION: Columbia University, New York, NY
 1971 - MA, Music/English

 Hofstra University, Hempstead, NY
 1969 - BA

SCHOOL Represented Music Department at Long Island Contemporary Arts Festival
ACTIVITIES: Worked on college newspaper and literary magazine
 Participated in symphony orchestra and chorus

LANGUAGES: Read, speak and translate German

MEMBER: Publishers Publicity Association

KIT LOUX

33 West 95th Street, New York, NY 10024 212/580-6620

OBJECTIVE: RECORDING INDUSTRY - PUBLIC RELATIONS/PROMOTION
To offer my recent experience and my training in the music business in an entry level job leading to a position at the level of assistant in promotion, with growth potential in the promotion area.

SUMMARY: Knowledgeable in area of artist promotion. Trained in music and stagecraft, including writing of lyrics for special occasions. Relate well with people. Competent director of employees and contract talent. Eager to learn music business "from the ground up." Free to travel.

RELEVANT EXPERIENCE:

1985-1986 MUSICBOX, INC.
London, England

Managing Director, U.K. Branch

* Introduced firm to United Kingdom and managed entire operation: consisting of personal delivery of singing telegrams for special occasions.

* Auditioned, hired, and directed singer-artists.

* Arranged for and secured radio and television appearances/ interviews as publicity and procured and placed all advertising.

* Sold service to prestigious clients many of whom were in the recording business in London.

* These included: Polydor Records, Pink Floyd Music, The Who, Island Records, CBS Records, EMI Screen Gems Music, BBC Radio & Television, Chrysalis Records.

* Wrote successfully received lyrics for songs used in telegrams.

* Handled all office procedures and finances and secured and trained replacement director.

1984-1985 MUSICBOX, INC.
New York, N.Y.

Courier/Lyrics Writer

* Initiated and promulgated innovative singing telegram service for company and delivered first in-person message in costume.

* Appeared on TV and in press interviews in recognition of service's news value.

* Sold orders over phone and wrote lyrics for customers.

1984 Part Time	AMERICAN MANAGEMENT ASSOCIATION New York, N.Y.

Market Research

* Secured information for sales department.

1979 Summer	VOCATIONAL FOUNDATION, INC. New York, N.Y.

Job Developer

* Phone communication with top management of business firms to secure jobs for unemployed youth. (Successfully placed about 100 youths during summer.)

1976-1979 While in School	CHILDRENS HOSPITAL Washington, D.C.

Volunter - 4-10 year olds

* Worked well with debilitated children, getting them to eat and keeping them entertained and happy.

U.S.CONGRESS
Washington, D.C.

Office Assistant

* Attended Senate and House meetings with Congressman Jack Lee (Arkansas). Worked office machines under supervision of his secretary.

FAIRFAX COUNTY PUBLIC SCHOOLS
Fairfax, Va.

Teacher's Aide

* Supervised children and gave them extra scholastic aid.

EDUCATION:

Chatham College, Pittsburgh, Pa.
 Drama major; Music and French minor
Royal Academy of Dramatic Art, London, England
Graduated 1982

CAREER RELATED COURSES AND ACTIVITIES:

Theater Productions - performing and stage managing
Choir Touring - performing and managing
Photography - Pittsburgh Film Institute
Acting/Scene Study - Lee Strasberg Theatre, New York
Acting/Scene Study - HB Studio, New York
French - Read, Write, Speak
Also, have traveled extensively

MEMBER OF: Actors Equity

CHARLES A. SLABAUGH
930 Third Avenue, New York, New York 10022
(212) 758-9929

OBJECTIVE: **MEDIA PLACEMENT SPECIALIST/ACCOUNT SUPERVISOR**

SUMMARY: Six years public relations experience in both private and public sectors. Excellent broadcast and print media placement record. Good writer and researcher with strong orientation to deadline and detail. Familiar with state-of-the-art technology in film, video and multimedia. Particularly skilled in organizing and managing special events. Maintain consistent reputation for integrity with producers and editors.

EXPERIENCE:

1986 to Present

CHARLES SLABAUGH ASSOCIATES, INC., New York, NY
President

- **National Marine Manufacturers Association** — Initiate radio, television and print promotion for eight industry-owned and operated boat shows nationwide

 —Supervised National Boat Show broadcast media coverage four consecutive years, culminating in 16 placements in 1983 (local, network and syndicated, including CBS Morning News, INN, PM Magazine, Entertainment Tonight, Satellite News Channel, Cable News Network; ABC, NBC and Mutual radio networks; etc.)

 —Generate economic/business stories and publicity for boat shows in Norwalk (CT), Chicago, Philadelphia, Baltimore, Minneapolis/St. Paul, including the Today Show and Good Morning America

 —Created ticket giveaway programs to increase market penetration of regional boat shows; developed Boating Radio Network, providing audio material on boating industry

- **Worrell 1000** — Handle pre-race publicity and press operation of 1,000-mile sailboat race from Ft. Lauderdale to Virginia Beach with extensive print and broadcast coverage in Florida, North Carolina, South Carolina, Georgia and Virginia; supervise television crews and print media traveling with race, including CBS Sports, *Sports Illustrated,* 60 Minutes, AP, UPI, *Miami Herald* and various boating publications

- **The Rath Organization** — Total responsibility for two monthly newsletters (writing, editing, design and production, photography supervision, article solicitation); created seminar program for Pitney Bowes

- **Direct national publicity tours** — for variety of clients:

 —Gerry Spiess (*Yankee Girl,* smallest boat to cross Atlantic and Pacific)
 —Curtis and Kathleen Saville (hold transatlantic rowing record)
 —David Ganz, *World of Coins and Coin Collecting* (Scribners)
 —Jim Hendricks, owner of *African Queen*
 —Joe Franklin, "Memory Lane Nostalgia Convention"

EXPERIENCE:
(Cont'd)

1984 to **SLABAUGH'S RARE COINS, New York, NY**
1986 **Manager,** Sales Promotion

- Bought, sold and cataloged rare coins to wholesale and retail clientele

- Trained in auction sale promotion, including advertising, releases, catalog preparation and coin photography

1982 to **GERALD A. ROGOVIN PUBLIC RELATIONS, INC., Boston, MA**
1984 **Writer/Researcher**

AGNEW ASSOCIATES, INC., Boston, MA
Account Coordinator

REP. PETER HARRINGTON (MA)
Legislative Aide

GOV. MICHAEL DUKAKIS (MA)
Student Intern

EDUCATION: **UNIVERSITY OF PENNSYLVANIA, Philadelphia, PA**

- Wharton School of Business, Executive Education Program, 1989

SYRACUSE UNIVERSITY, Syracuse, NY

- Master's Candidate in PR Administration

BOSTON UNIVERSITY, Boston, MA

- B.S., Public Relations (Cum Laude), 1984

NEW YORK UNIVERSITY, New York, NY

- Film Production Workshop
 (200-hour intensive program)

NEW YORK INSTITUTE OF TECHNOLOGY, New York, NY

- Television Production Workshop
 (200-hour intensive program)

AFFILIATIONS: Public Relations Society of America
Publicity Club of New York (Recipient of Distinguished Service Award)
International Association of Business Communicators

ANDREW GARVERICK • 900 West End Avenue, 8E • New York, NY 10025 • (212) 865-6690

OBJECTIVE PRODUCER/MEDIA PROGRAMMING

SUMMARY Experienced media producer with high degree of artistic and technical
 expertise. Trained in total approach to use of media. Fully informed
 on state-of-the-art in media production, including the latest video
 editing techniques. Excellent interpersonal skills. Experienced writer,
 producer and supervisor of creative and technical personnel.

EXPERIENCE

1985 to MERCER MC DONALD (Public Relations), New York, NY
Present <u>Manager, Audio-Visual Department</u> (1986-1988)

 * Organized and developed Audio-Visual Department of nation's
 third-largest PR firm

 * Direct day-to-day operations of department, including preparation
 of budgets, purchase of new equipment and supervision of both
 creative and administrative personnel

 * Produce, direct and script media programs, including videotapes
 and multi-projector slide shows

 - Clients include Sun Company, Inc.; Honeywell; Children's
 Television Workshop; U.S. Department of Energy (Solar
 Energy Project); Merle Norman Cosmetics; Emery Air Freight

 - Awarded John Starr Writing Award - 1987

 * Work intensively with clients to develop programs to fulfill
 publicity objectives within scheduling and budgeting requirements

 - Present array of concept proposals from which
 clients can choose most suitable program

 - Develop production budgets and schedules, in-
 cluding services of photographers, graphic
 artists, video editors and other media vendors

 - Rated consistently high by clients for expertise,
 on-schedule performance and follow-up

 * Instrumental in generating substantial new business by working
 closely with both internal account staff and clients

 * Select, supervise and coordinate efforts of vendors in film and
 video; work with top-quality editors, utilizing state-of-the-art
 facilities

 <u>Technician</u> (1985-1986)

 * Wrote proposal outlining methods for improving Audio-Visual
 Department's profitability and capabilities based on analysis
 of client needs; resulted in promotion to Manager

1987 to Present	FREE-LANCE MEDIA PRODUCER, New York, NY

* Client list includes CBS Publications Group, <u>Interface Age</u> Magazine, Park Avenue Mall Association and Chacma, Inc.

* Produced radio commercial campaigns for nationally distributed computer magazine

 - Scripted, edited and coordinated all aspects of production

* Directed and wrote sales and motivational slide presentations

 - Scripted, edited and coordinated talent, recording, photography, production of special effect slides, sound mixing and cueing

* Produced promotional videotape for management consulting firm

 - Co-wrote script and coordinated all aspects of production

1982-1983	PACE UNIVERSITY, Pleasantville, NY <u>Media Coordinator</u>

* Coordinated production-oriented program to develop nursing media curriculum; developed and wrote scripts; designed program and supervised television production

1981-1982	UNIVERSITY OF WISCONSIN MEDIA CENTER, Madison, WI <u>Assistant Coordinator, Multi-Media Laboratory</u>

* Produced media programs, including color videotapes and multi-image slide programs; acted as cameraman in color studio and co-produced several productions

* Supervised use of sound studio and four-room presentation facility

* Proposed ideas for new work and methods for improving programming

EDUCATION	Columbia University, New York, NY 1985 - MS, Public Media University of Wisconsin, Madison, WI 1981 - Graduate courses in film production University of Wisconsin, Madison, WI 1979 - BA, Philosophy/Psychology

PROFESSIONAL AFFILIATIONS:

National Academy Television Arts and Sciences

JOE GUARINO • 150 Great Pine Lane • Pleasantville, NY 10570

OFFICE: [212] 765-2967 HOME: [914] 769-3296

OBJECTIVE	**PROGRAMMING/MANAGEMENT — TELECOMMUNICATIONS INDUSTRY**
SUMMARY	Ten years' experience developing and managing international artists for live performances and television programming. Skilled administrator and supervisor of creative and technical personnel. Excellent track record creating and expanding domestic and international markets. Thorough knowledge of media advertising and publicity. MBA in International Marketing.

MANAGEMENT EXPERIENCE

1980 to Present

JOE GUARINO ENTERPRISES, LTD. (entertainment management), NY, NY **President**

- Management and Marketing Development—promotion, publicity, touring and production—for over 20 contemporary recording artists

- Budget, plan and organize record productions and concert tours; negotiate recording and publishing contracts, personal appearances, advertising endorsements and TV appearances

- Supervise staff of eight, including five account executives; initiated successful system for providing full service to clients while reducing overhead

- Executive producer for precedent-setting engagement of major comedian on Broadway

- Created separate TV division for additional client exposure

 —Produced, packaged or created concept for more than two dozen international and domestic television programs or series, sponsored by BBC, CBC, French Television, German Television, Japanese Television, Australian Television and Los Angeles Cable Television

 —Booked various artists for more than 30 television appearances, including Merv Griffin Show, Dinah Shore Show, Dick Cavett Show, Mike Douglas Show, Don Kirschner's Rock Concert (NBC), Midnight Special (ABC) and Dick Clark's New Years Rock & Eve (ABC)

1978 to Present

GREAT SOUNDS, LTD., NY, NY
President (1979-Present)
Director, Business Affairs (1978-1979)
- Chief Administrator of 20-person staff responsible for organization and planning of concert tours, personal appearances, record production, publicity and marketing campaign

- Determine annual budgets and both short- and long-range cost projections to sustain profit levels

GREAT SOUNDS, LTD. (Continued)

- Instrumental in expansion of gross revenues to peak of $4 million
 - —Developed video productions and advertising endorsements, creating $250,000 in new income; obtained world video rights for distribution to national independent TV stations
 - —Generated $450,000 in guaranteed annual income after analyzing audience demographics of major rock group
 - —Executive Producer for rock group's appearance at New York Metropolitan Opera
 - —Developed international markets, coordinating personal appearances with record exports and publicity campaigns, increasing revenues by $500,000 annually
 - —Arranged three-week tour behind Iron Curtain sponsored by Department of State

1985 to Present

ATV MUSIC (publishing), NY, NY
Management Consultant

- Supervise and guide ten songwriters and arrangers through creative and production problems
- Develop and implement marketing strategies
 - —Arranged for writers to co-write songs with artists who have recording contracts
 - —Increased ad agency awareness of coterie of song writers available for creation of original jingles
 - —Brought about 50% increase in advanced income by negotiating international publishing agreements

EDUCATION

NEW YORK UNIVERSITY GRADUATE SCHOOL OF BUSINESS, NY, NY
1978 — MBA, International Marketing

ADELPHI UNIVERSITY, Garden City, NY
1976 — BBA, Business & Finance

Dean's List, 1975-1976
President, School of Business Student Council
Vice President, Marketing & Advertising Club

ALICE BRANDEL 225 East 86th Street, #8-B Home 212-755-0434
 New York, NY 10022 Work 518-474-1029

OBJECTIVE TV WRITING/PRODUCING/DIRECTING - Commercial, cable, public or
 industrial television

SUMMARY Award-winning writer/producer/director of televised programs, public
 service announcements and closed-circuit programs employing nationally
 known talent. Skilled at developing production budgets and hiring and
 directing creative staffs. Adept at designing program packages and
 software to fulfill specific client requirements.

TELEVISION EXPERIENCE

1976 to CENTER FOR LEARNING TECHNOLOGIES, NEW YORK STATE EDUCATION DEPARTMENT
Present Albany, NY

 * Write, produce and direct television and closed-circuit training
 programs for adults and children combining studio and electronic
 field production

 - Administer budgets of $3,000 to $100,000
 - Hire and direct production and creative staffs

 * Created, produced and directed award-winning, three-part media
 package to promote good nutrition

 - Package included 15 radio and 15 TV announcements, 30-minute
 public TV program and 20-minute closed-circuit TV program
 - Received medal of excellence, International Film and TV
 Festival of New York

 * Designed, produced and implemented interactive 40-hour children's
 TV series

 - Broadened and modernized curriculum through use of entertainment
 - Positive response by students evidenced in significant learning
 results

 * Developed and produced ongoing statewide teleconferences

 - Programs are "live" and broadcast by all New York State
 public television stations
 - Toll-free call-in provides direct answers to viewers'
 questions

 * Consulted with diverse school districts, providing in-service
 training and recommending software and hardware specifications
 to achieve instructional objectives

 * Created the "video memo" format as a way to disseminate information
 to staff at 756 locations

1968-1975	ROCHESTER CITY SCHOOL DISTRICT, Rochester, NY TV Instructor (1974-1975) Business Education Instructor (1968-1974)

* Conceived, wrote and served as on-camera host for 42-lesson, self-instructional TV series in business education used by 100 districts statewide

 - Wrote three manuals to accompany the series
 - Series was telecast by public and cable TV stations and is used by the State Education Department employee training center
 - Established reputation of Rochester Televised Instruction Center and resulted in further awards of contracts for videotape production
 - Series resulted in effective replacement of classroom instruction with 79% pass rate and reduction of instructional costs by almost 50%

* Assistant Producer for five videotapes featuring the Rochester Philharmonic

EDUCATION
Syracuse University, Syracuse, NY
1971 - MS, Business Education

Russell Sage College, Troy, NY
1968 - BS, Business Education
 Graduated cum laude with high honors in Business

University of Hawaii, Honolulu, Hawaii
1974 - Six credits in Television Production

Indiana University, Bloomington, Indiana
1973 - Nine credits in Television Production
 Awarded H. Wilson Scholarship

New School for Social Research
1983 - Developing Programming for Children's Television

AWARDS
Ohio State Broadcasting Award for "Visual Learning" with Gene Shalit, Walter Cronkite, and Betty Furness
International Film and Television Festival of New York Medal for "The Breakfast Connection" with Lendon Smith, MD, and Marilyn Michaels

Partial list of productions available upon request

WILLIAM MONROE
417 E. 58th Street, Apt. 18D, New York, N.Y. 10022 (212) 935-1725

OBJECTIVE COMMERCIAL INTERIOR DESIGN

SUMMARY Interior designer with ten years of commercial and residential design experience. Thorough knowledge of trade sources. Understanding of city codes and building department routine and bureaucracy. Comprehensive knowledge of commercial planning systems and office landscaping.

DESIGN EXPERIENCE

1984 to DANIEL STERLING, INC., New York, NY
Present Head Designer (1985-Present)
 Assistant Designer (1984-85)

 * Design commercial and residential spaces and direct all facets leading to completion of projects. Supervise assistants, assuring on-schedule production of quality work. Negotiate with architects, vendors and tradesmen, scheduling and coordinating their activities.

 * Achievements

 The Discotheque Parfait, New York City
 Executive business offices, Exemplar International Insurance Co.
 Fort Lee, NJ
 Rare Form contemporary restaurant, New York City
 Solarium for president of Perrier Water Co.
 (featured in TOWN & COUNTRY magazine)
 Private residences for leading social figures in New York City
 Solarium for Richard Todd of the New York Jets, New York City

1986 to FREE-LANCE PROJECTS
Present
 * Packaging concept for Alan Fortunoff (owner of Fortunoff's),
 New York City

 * Textile design collection for Schumacher Decorators Walk,
 Riverdale Fabrics, New York City

 * Kent Bragaline, New York City

 * Album cover logo and publicity T-shirts for Darryl Hall and John
 Oates, Arista Records, New York City

 * Skating Club set and costume design - Utica Figure Skating Club,
 Clinton Figure Skating Club, Hamilton Figure Skating Club, Ice
 Club of Syracuse

WILLIAM MONROE/2

1983-1984 TABER INTERIORS, New York, NY
 Assistant Designer

 * Developed designs, conceptualizations and renderings of floor
 plans, elevations and layouts under tutelage of Head Designer.
 Coordinated design elements and became acquainted with trends
 in design field.

1982-1983 BLOOMINGDALES, New York, NY
 Designer

 * Created residential interiors, utilizing existing retail
 product lines

1980-1982 SELF-EMPLOYED DESIGNER
 (Concurrent with pursuit of MFA)

 * Designed and conceptualized various boutiques, shopping plazas
 and restaurants

1977-1979 CARRIER CORPORATION, Syracuse, NY
 Assistant Designer, Corporate Planning

 * Drawing, drafting, rendering

EDUCATION COLUMBIA UNIVERSITY, New York, NY
 1988 - MFA (GPA - 3.8/4.0)

 SYRACUSE UNIVERSITY, Syracuse, NY
 1977 - BFA, Interior Design (GPA - 4.0/4.0)
 Dean's List, eight semesters

CERTIFICATION

 Permanent Certified Design Instructor, New York State Board of Regents

SALLY MARCUS
340 EAST 57th STREET
New York, N.Y. 10022
(212) 730-2196

OBJECTIVE

To employ my professional training in
<u>architectural design</u> in the area of
planning and designing private residences
and public spaces.

SUMMARY

Creative spatial planner with ability for com-
bining function and aesthetics in a variety of
environments. Broad background in architectur-
al history and theory, human factors and urban
studies. Studied under prestigious experts in
fields of city planning, contract, residential
and lighting design, and landscape architecture.

EDUCATION

Parsons School of Design, New York, NY
1987 - BFA Program, Environmental Design

Columbia University, New York, NY
1982-83 - Urban Studies

DESIGN EXPERIENCE
1982-87

o Spatial planning for bazaar: The Burke
 Institute fund-raising

o Interior design consultant to Mrs. Rebecca
 Noonan, New York

o Design consultant and spatial planner for
 Deanne, Bellow and Roth, Inc.

o Apprentice to Rita Blass, AIA, South Salem,
 NY

DESIGN ASSIGNMENTS
1984-87

PINE ISLE RESORT HOTEL, Gainesville, Georgia
 Design of Winter/Summer resort

MIDTOWN POCKET PARK, Newark, NJ
 Design of two-level public plaza in center
 of business district

SEAMEN'S RESTAURANT, New York, NY
 Renovation of three-story residence, Upper
 East Side

SOLAR ENERGY-EFFICIENT HOUSE
 Typical two-family brownstone home adapted
 for energy efficiency

OTHER EXPERIENCE
1981-86

Stony Brook Day Camp, Dover, NJ
Camp counselor (four summers)

YW/MHA, West Orange, NJ
Hotline Phone Counselor

St. Louis, MO Public Schools
Tutor

Extensive travel throughout Europe and
United States

Yvonne C. Miller

207 Hudson Street, Apt. 5N, New York, N.Y. (212) 226-5525

GRAPHIC ARTIST AND ILLUSTRATOR

OBJECTIVE: To apply my artistic talent as an illustrator in a position with growth potential to design responsibility

SUMMARY: Experienced in broad spectrum of commercial art including technical and advertising graphics. Have capacity for fast learning.

EXPERIENCE:

1987-89 Technical Illustrator - VOLT INFORMATION SCIENCES, INC., Syosset, NY

* Coordinated in-house and farmed-out steps in production process, including assigning artists, camera and proofing

* Illustrated viewgraphs, flowcharts and forms; adapted photos as graphic illustrations; cartooning, flipcharts, lettering and posters

* Did layout, page makeup and paste-up for manuals and graphs; paste-ups for trade magazine and telephone company publication ads

* Charged with responsibility for complete production of company display from rough layout to finished art

1986 to SELECTED FREELANCE ASSIGNMENTS
Present
Graphs - CBS Radio Sales Research Department, New York, NY
Brochure and consumer ad illustration - Jasper Industries, Oyster Bay, NY
Ink illustrations, Xerox and color photo adaptation - New Community
 Theatre, Huntington, NY
Murals - Gent's World, Madison, WI
Posters and murals - Concourse Hotel, Madison, WI
Display ads and billboards - Sel Metals Corporation, Holbrook, NY
Textbook illustrations - McGraw-Hill Book Company, Inc., New York, NY

EDUCATION: University of Wisconsin, Madison, WI
1982-84 - Fine Art

Technical College, Old Westbury, NY
1982 - Course in Photography

State University of New York, Farmingdale, NY
1980-81 - Art Advertising

MARGARET YORK

78-20 Austin Street Kew Gardens, New York 11415 (212) 847-6721

OBJECTIVE: Long-term commitment to reputable consumer magazine as an associate, assistant, copy or contributing editor.

SUMMARY: Skilled in all aspects of handling manuscripts: rewriting, copy editing and proofreading. Experienced in judging manuscripts and dealing with authors. Expert speller and grammarian.

RELEVANT EXPERIENCE:

Nov. 1986-Present

Associate Editor, MACFADDEN WOMEN'S GROUP

* Evaluate, rewrite and edit new manuscripts

* Proofread galleys, check page proofs and final pages

* Maintain close liaison with Home Service, art and production departments

June 1986-Nov. 1986

Production Editor, JOHN WILEY AND SONS

* Edited and proofread copy for four technical magazines

* Checked final pages and incorporated authors' corrections onto proofs

* Logged manuscripts, used Greek symbols and type specifications

April 1982-June 1985

Production Editor, AMERICAN SOCIETY OF MECHANICAL ENGINEERS

* Solely responsible for journal

--Copy editing, proofreading, transferral of authors' corrections onto final pages

--Page layout, sizing of figures and photographs, pagination, check of final pages

Jan. 1981-June 1981

Traffic Editor, SIMPLICITY PATTERN COMPANY

* Controlled flow of pages to and from printer

* Informed art and design departments about changes in page sequence

April 1980-Oct. 1980

Assistant Copy Editor, AMERICAN INSTITUTE OF AERONAUTICS AND ASTRONAUTICS

(Duties similar to those at John Wiley)

EDUCATION: Molloy College, B.A. in English, 1977

LANGUAGES: French and Latin

FRANK LOYKOVICH

3275 West 33rd Street
Brooklyn, NY 11224

Home: (212) 946-6695
Office: (221) 889-2875
Ext. 246

OBJECTIVE: ART DIRECTOR/CORPORATE COMMUNICATIONS

Seeking corporate position where my expertise in editorial design will be employed in communications media for both external and internal circulation.

SUMMARY: More than 12 years experience in graphic design for production of magazines, brochures, annual reports, conference displays, newsletters, book jackets, house organs, and other collateral units. Capable production strategist in selecting freelance talent, interfacing with vendors, editorial and public affairs departments, and overseeing production budgets. Knowledgeable of broadcast media advertising and public relations requirements. Discerning in adapting research to specific markets.

CAREER HIGHLIGHTS:

1985 to
Present

EARL E. GRAVES LTD. & SUBSIDIARIES
New York, NY

Associate Art Director

* Assist Art Director in producing visuals for total packaging of 260,000 circulation magazine

* Select freelance talent, negotiate fees, oversee average $15,000 monthly budget, supervise five-member staff

* Expedite workload traffic flow to meet camera ready processing deadline

* Conceive and design print ads and collateral for company-owned radio stations

* Conceive and design brochures and other collateral material for station public affairs director for exhibitions and presentations

* Conceive and design material for publisher's public policy presentations

* Research demographics and create chart material in marketing to the community

1982 to
1985

FREELANCE GRAPHIC DESIGNER
New York, NY

* Sold own talents successfully to clients for design of corporate stationery, promotional brochures, book jackets, inside book design, conference displays, newsletters, house organs, trade ads and general advertising

* Maintained customer relations with advertising agencies, publishers and corporate art directors

| 1981 to 1982 | LIVING TOGETHER PUBLICATIONS, INC. |
| | New York, NY |

Media Representative

* Advertising account executive for 200,000 circulation magazine supplement in top 20 markets newspapers

* Established new major accounts for personal care and cosmetic products (including Clairol) as new entries into ethnic market

| 1980 to 1981 | VIZMO PRODUCTION, INC. |
| | New York, NY |

Staff Designer

* Created and designed graphic presentation for NBC-TV including national and local newscasts and The Today Show

* Created and designed weather maps, slide titles and promotional material for media sales department

| 1979 to 1980 | PERFECTION PHOTO, INC. |
| | New York, NY |

Associate Designer

* Designed typography for packaging, print ads, direct mail, brochures and magazines

| 1976 to 1978 | MCGRAW-HILL, INC. |
| | New York, NY |

Staff Designer, Corporate Art Department

* Correlated book jacket and sales collateral with editorial, advertising and marketing departments

* Designed annual reports and slide presentations

OTHER ACTIVITIES:

- Worked with editor in refocusing editorial content of NAACP's "The Crisis"; redesigned and restructured features and departments of the publication

- Consulting art director and lecturer, New York University - editorial design; production of magazine as term project

EDUCATION: New York City Community College, Brooklyn, NY
Advertising and Design Theory

School of Visual Arts, New York, NY

MEMBER: Graphic Artists Guild
Society of Publications Designers
New York Type Directors Club

AWARDS: New York Art Directors Club, 1987 Merit Award

HOWARD D. PAPPAS
10 Hall Avenue
Freehold, NJ 07728
(201) 780-1576

OBJECTIVE: <u>CHORAL DIRECTOR - COLLEGE OR UNIVERSITY</u>

SUMMARY: Ten years experience as choral director in schools at elementary, secondary and college levels, including three years as church minister of music. Creative teacher with ability to motivate students in appreciation of and participation in all phases of music. Skillful conductor in training and performances. Active and artistic performer.

RELEVANT EXPERIENCE:

1983 to Present

MARLBORO TOWNSHIP PUBLIC SCHOOLS, Marlboro, NJ

<u>Teacher of Music</u>

* Train and direct school chorus and prepare students for assembly and public performances

 - Also teach classes for trainable impaired children

 - Assist classroom teachers in program preparation

* Initiated change in curriculum to include related arts approach to teaching music as prescribed by the Orff-Schulwerk Method

 - Coordinate the study of singing, dance, speech, playing musical instruments and ear and sensitivity training

* Compose and arrange songs for children (both words and music)

* Introduced conceptual approach to general music program, giving students a more defined insight into music

* Served as curriculum consultant to school district in Orff techniques; served on Related Arts Committee to develop multi-discipline, multi-media experiences

Concurrent 1986-87

FAIRLEIGH DICKINSON UNIVERSITY, NJ

* Directed university chorus (25 students for credit courses) on part-time basis; conducted two public concerts

1982-83

MOORESTOWN FRIENDS SCHOOL, Moorestown, NJ

<u>Teacher of Music</u>

* Directed high school and junior high school chorus; taught music as elective to high school students and general music in grade school

* Created a course in 8th grade general music based on Rock history, through both styles and performers

1983-84

PLACERVILLE PRESBYTERIAN CHURCH, Placerville, NJ

<u>Minister of Music</u>

* Trained and directed adult choir; developed outstanding repertoire of sacred music; trained and directed junior choir

* Conducted choir for Sunday services; presented two cantatas at Christmas; presented Bach motet at Spring Concert

HOWARD D. PAPPAS/2

1979-81 JUILLIARD SCHOOL, New York, NY

 Teaching Fellow

 * Assisted choral director in all aspects of managing department (served
 in his stead during several four-to-six week absences)

 * Charged with responsibility for concert arrangements, library, attendance,
 grades and interoffice communications

 * Conducted and rehearsed Juilliard Chorus while director was on tour for
 professional engagements

 * Prepared Juilliard Chorus for historic production of opera "Macbeth" by
 Ernest Block

 * Instructed classes in choral conducting

 * Only candidate accepted for enrollment in 1977

 - Recipient of Frank Damrosch Prize

1978-81 THE NEW JERSEY CHORALE, Rutherford, NY (While attending school)

 Conductor

 * Developed chorale into a prestigious company with a repertoire that
 attracted sponsors for more lucrative contracts

 * Conducted chorale's first concert featuring a full length classical work
 with orchestra

 * Substantially improved chorale's financial condition through removal of
 deficit by increased bookings

OTHER WORK: * Professional freelance soloist and choral singer

 * Recordings of educational records for:

 - Victor Kayfetz Productions, 1979

 - American Book Company, 1981

 * Solo recital for Monmouth Symphony League, March 1986

 - Eight sound filmstrips for HEW-funded elementary music program

 * Private instruction in voice, piano and theory

EDUCATION: The Juilliard School, New York, NY
 1981 - MM, Choral Conducting

 Trenton State College, Trenton, NJ
 1976 - BA, Music Education (Vocal)

 1976 - Conducting Fellowship, Aspen Music Festival; Singer Aspen Choir

 Concert Westminster Choir College, Princeton - Orff-Schulwerk Courses

MEMBER: College Music Society
 Music Educators National Conference
 New Jersey Music Educators Association
 National Education Association
 New Jersey Education Association
 American Orff-Schulwerk Association
 Central New Jersey Orff-Schulwerk Association

CERTIFICATE: New Jersey Permanent Teaching Certificate

RICHARD SPOSITO . 200 East 33 Street Apt 6A . New York, NY 10016 . (212) 532-4455

OBJECTIVE: To offer my expertise in the field of music to a publishing house
 as editor or technical consultant

SUMMARY: More than 15 years experience in all phases of music: Composer,
 Arranger, Conductor, Performer, Instructor and Business Manager.
 Compositions have been performed in Carnegie Hall. More than ten
 students have become stars, hundreds have become professional
 musicians and singers. Play piano and flute; knowledgeable about
 all instruments.

PROFESSIONAL HIGHLIGHTS:

1980 to NEW YORK SCHOOL OF MUSIC, New York, NY
Present
 Chairman of Music Theory Department/Instructor

 * Instruct both graduate and undergraduate students in music theory

 - Organized courses of study

 - Originated new courses in Advanced Ear Training

 * Oversee auditions for prospective applicants

 * Recommend instructors and substitutes for hire

 * Train new instructors

 * Hundreds of former students have gone on to play or sing pro-
 fessionally

 * Currently in joint authorship of a music theory workbook for
 beginning high school students in the Preparatory Division of
 Manhattan School of Music (September, 1991 projected publication
 date)

Concurrent Leader of Jazz Combo
1984 to
Present * Write and arrange compositions, direct appearances and perform on
 the piano and flute

 * Book appearances in New York Metropolitan Area for weddings, bar
 mitzvahs, cocktail parties and holiday events

 * Manage all financial affairs and arrangements for group, including
 billing and collection

Concurrent BROOKLYN COLLEGE, Brooklyn, NY
1981-88
 Adjunct Lecturer

 * Taught assigned music theory and music appreciation courses to
 music and non-music majors

1973-87 SEAMAN'S METHODIST CHURCH, Brooklyn, NY

 Music Director

1978-80 NEW YORK CITY COMMUNITY COLLEGE, Brooklyn, NY

Adjunct Lecturer

* Taught assigned music appreciation courses to non-music majors

1970-77 NEW YORK CITY BOARD OF EDUCATION, Brooklyn, NY

Teacher of Orchestral Music (1974-77)

* Trained students on all orchestral instruments

* Instituted home use of instruments to increase interest in orchestra

* Developed orchestra from ten poorly trained players into well disciplined musical group of 60 instrumentalists

General Music Teacher (1970-74)

* Taught music appreciation to general classes

* Trained and rehearsed school Glee Club

EDUCATION: Manhattan School of Music, New York, NY
1980 - MM, Music Theory/Piano
 Thesis: "Ear Training Program for College Freshmen"

New York University, New York, NY
1975 - MA, Master of Music Education

Howard University, Washington, DC
1967 - BA, Music Education (cum laude)

HONORS: - Inducted into Pi Kappa Lamda, Howard University
 - Elected president of student council
 - Received Lucy E. Moten Fellowship for European study and travel - 1966
 - Achieved highest score on Regular Teacher Examination (orchestral music), Board of Education of New York - 1974

ORIGINAL COMPOSITIONS:

Serenity for Solo Flute
Theme and Variations for Piano and Bassoon
Piano Sonata in One Movement
Woodwind Quintet No. 1
Woodwind Quintet No. 2 (performed at Carnegie Hall)
Theme and Variations for Woodwind Quintet

MEMBER: American Music Center
 Music Theory Teachers of New York State

CERTIFIED: Music Teacher for New York State

SEYMOUR GOLDMAN • 1500 York Avenue, Apt. 5B • New York, NY 10021

(212) 249-6625 (212) 249-1523

OBJECTIVE: **ORCHESTRAL CONDUCTOR/CHORAL DIRECTOR**
To devote my broad experience and expertise to conducting an established orchestra, or to developing and conducting a concert orchestra and/or chorale that may only be at the conceptual stage

SUMMARY: More than 15 years as musical director and conductor for prestigious organizations including symphony orchestras, opera companies and university and church chorales. Frequently toured Europe and South America for concert engagements. Possess full repertoire of classical and semi-classical scores.

EXPERIENCE

CONDUCTOR:
Current
WHITTENBURG CHOIR COLLEGE, Princeton, NJ
Music Director
- Conduct University Symphony Orchestra
- Member, piano faculty

NATIONAL COUNCIL OF THE ARTS, New York, NY
- Commissioned to organize Latin-American Symphonic Choir

1980-84
THE MONTAUK ORCHESTRA, Long Island, NY
- Music Director and Conductor

FIRST METHODIST CHURCH, Setauket, NY
- Choral Director with 10-15 concerts per year

1981-83
HOPE OPERA COMPANY, Long Island, NY
- Orchestral and Choir Director
- Directed and conducted operatic performances including *I Pagliacci, Tosca, Magic Flute* and *Cavalleria Rusticana*

1978-80
STATE UNIVERSITY OF NEW YORK AT STONY BROOK, NY
- Served as Assistant Conductor for four semesters

1970-73
BUENOS AIRES CONSERVATORY, Buenos Aires, Argentina
- Conductor for orchestra and chorale; piano instructor

TOURING CONDUCTOR:
1980 to
Present
- Guest conductor in South America and Europe (Italy, France, Poland)
 - Conducted 15 concerts in South America (July/August, 1979) with engagements in Chile, Argentina, Uruguay, Paraguay and Bolivia

INSTRUCTOR:
1974 to
Present
PRIVATE INSTRUCTOR, New York, NY
- Instruct in piano and conducting; coach voice
 - Currently coaching 15 professionals; have coached 60-65 professionals
 - Have instructed more than 120 non-professionals

1975-78	NEW YORK INSTITUTE FOR THE EDUCATION OF THE BLIND, New York, NY
	• Member of the piano faculty
1973-74	PRIVATE INSTRUCTOR, St. Louis, MO
	• Taught piano and solfege
1969-73	PRIVATE INSTRUCTOR, Buenos Aires, Argentina
	• Taught piano, solfege, ear training and harmony
JUDGE:	NEW YORK STATE SYMPHONIC MUSIC ASSOCIATION
	• Annual Spring Festival for entries in piano, chorus and orchestra
	NEW YORK STATE MUSICAL EVALUATION CENTER
	• (First National Competition, 1988-1989)

EDUCATION

DEGREE PROGRAMS:
STATE UNIVERSITY OF NEW YORK AT STONY BROOK, NY (Full Scholarship)
1980 — MM, Orchestral Conducting/Choral Conducting

CONSERVATORY NACIONAL OF MUSIC GENERAL URQUIZA, Buenos Aires, Argentina (Full Scholarship)
1973 — PhD, Conducting
1972 — MM, Music, Orchestral and Choral Conducting
1969 — BM, Piano/Analysis

ADDITIONAL TRAINING:

STATE UNIVERSITY OF NEW YORK, Oneonta, NY
1987 — Seminar in Choral Conducting and Analysis

MARIANO SIJANEK, Buenos Aires, Argentina
1985 — Opera seminar (6 weeks)

PRIVATE INSTRUCTION, St. Louis, MO
1972-78 — Orchestral and Choral under professional directors

PROFESSIONAL AFFILIATIONS:

American Symphony Orchestra League
Musical Educators National Conference
Musicians Club
Piano Teachers of New York

LANGUAGES: Fluent in Spanish, Italian and French; working knowledge of Portuguese and German

CITED: *Reader's Digest*, Oct., 1987 (Also published in all 15 foreign language editions)
People Magazine, June 5, 1988
To Live Again, Ana Maria de Bottazzi, Dodd, Mead, 1986
Various magazine and newspaper articles, U.S. and abroad

RAYMOND W. CLANCY . 6518 Grant Place . West New York, NJ 07093 . (201) 867-7777

OBJECTIVE: <u>MUSEUM DEVELOPMENT/PROGRAM ADMINISTRATOR</u>

A position employing my experience in educational program development and knowledge of anthropology, classical antiquity and presentation and promotion.

SUMMARY: MA, Anthropology. Experienced in program development in anthropology, American History, language and humanities and enrichment programs for gifted and talented students. Adept at negotiation, persuasion and promotion. Knowledge of fund raising, budget development, organization and production.

HIGHLIGHTS: - Magazine Production - coordinated all aspects including design, layout, editing and printing

- Film and Theatrical Production - from conception to production including scripting, casting, lighting and direction

- Fund Raising and Special Promotions - conceived and directed money raising events through use of film, sales, and theatre

TECHNICAL SKILLS:

* Audio visual equipment (super 8 film and 1/2" video cameras, projectors, voice recorders, copy stands, Repronar, slides and filmstrips)

* Darkroom facility: 35 mm color and black and white (develop and print)

* Holography

PROGRAM DEVELOPMENT EXPERIENCE:

1977 to
Present

DUPONT BOARD OF EDUCATION, Dupont, NJ

<u>Instructor</u>

* Anthropology, Latin, American History, Humanities

* Developed and implemented six new curricula in Anthropology, Latin and Political Science

* Conceived, developed, and initiated first school wide anthropology course

* Achieved full enrollments in elective courses through intense promotional campaigns; maintained enrollment by combining humor and drama with solid exposure to subject matter

* Assisted with development of humanities program

DUPONT SCHOOL DISTRICT

* Participated in setting district and school-wide goals to ensure enhanced education and special programs for gifted and talented children

- Developed specialized curricula in science, art and communications

- Conducted intensive research into existing programs for gifted and talented students

(continued)

DUPONT SCHOOL DISTRICT (continued)

* Advisor to school literary and art magazine:
 - Directed unique fund raising ventures
 - Prepared budget and selected vendors within budgetary outlines
 - Supervised staff of 20
 - Coordinated production, including design, layout, editing and printing
* Active in school organization:
 - Elected chairman of eight-member Faculty Council
 - Member of committee on development of educational goals for entire district
 - Member of Committee for Faculty Evaluation
 - Advise and oversee budget distributions of student language, science, theatre, athletic, newspaper and chef's clubs
 - Secured favorable increases and benefits in negotiations with district Board of Education
 - Convinced Board of Education to publish official policy book to clarify personnel policies
* Produced three 15-minute films and directed two full-scale theatrical productions for fund raising and promotion

RESEARCH AND WRITING EXPERIENCE:

1976 STATEN ISLAND INSTITUTE, New York, NY

Foundation Researcher

1975 WNYC RADIO, New York, NY

Free-Lance Writer/Researcher

* Researched and wrote programs on consumer frauds and exposés on home service industries and food pricing

EDUCATION:

Montclair State College, Montclair, NJ
1984 - MA in Anthropology

St. Peters College, Jersey City, NJ
1977 - BA in American History
 Multiple minors in English, Latin, Philosophy and Education

LICENSES:

Licensed to teach American History, English, Latin and Anthropology
by the State of New Jersey 5

LANGUAGE: Latin - Reading and Translation

INTERESTS: Photography, classical music, jazz

ELEANOR GOLDMAN

250 West 89th Street New York, NY 10025 (212) 580-6692

OBJECTIVE: <u>MANAGEMENT - OFFICE/PERSONNEL</u>

SUMMARY: More than ten years experience in supervision of office procedures and
 personnel recruitment and management. Creative designer of work flow
 systems to eliminate duplication of effort and increase proficiency and
 productivity of staff. Administer confidential projects with dispatch
 and discretion. Astute negotiator with vendors of supplies, equipment
 and services.

BUSINESS HIGHLIGHTS:

1981 to INTEGRATED RESOURCES, INC.
Present New York, NY

 Office Manager and Personnel Manager

 <u>Office Manager</u>

 * Supervise staff of 152 secretarial and clerical personnel

 - Serve as liaison for middle management with executive suite

 - Train clerical personnel in procedures and office equipment

 - Administer vacation policies and schedule vacations

 * Purchase office supplies, equipment, furniture and services

 - Supervise maintenance crew for two floors and suites on
 four other floors of 41-story building

 - Maintain liaison with New York Telephone Company relevant to
 equipment and service for this office and 14 subsidiaries of
 company

 - Supervise all communications invoices

 * Initiated Mag card system of word processing

 * Have complete responsibility for special projects

 - In process of moving offices: supervising decor, purchasing
 furnishings, consulting on phone installation, allocating office
 assignments, arrangement of files and equipment, selection and
 supervision of movers and expediting printing of new stationery

 - Administer maintenance of corporate apartment for visiting VIP's

 <u>Personnel Manager</u>

 * Recruit, interview and hire clerical personnel (in last six months,
 interviewed 300, hired 50 and trained 15)

 * Negotiate contracts with personnel agencies

 * Maintain confidential records; supervise benefits; process insurance
 claims

 * Prepare payroll (EDP), bi-weekly input sheets, quarterly reports for
 WHT and unemployment insurance and W-2's

 * Designed and implemented smoothly operating personnel system

 * Wrote personnel manual and developed records systems

| 1976 to 1981 | RESTAURANT ASSOCIATES INDUSTRIES, INC.
New York, NY |

Central Files Supervisor

* Set up central files system and supervised clerical personnel

* Maintained confidential employment and labor contracts

| Summer 1976 | BOARD OF EDUCATION, CITY OF NEW YORK
Brooklyn, NY |

Teacher's Aide

* Supervised school students on day camp trips; assisted in classroom work

| 1975 to 1976 | UNITED STATES TESTING COMPANY
Hoboken, NJ |

Consumer Tester

* Administered consumer testing program for food items

* Persuaded casual shoppers to participate by responding to test and filling out questionnaire

| 1973 to 1974 | WILBUR ROGERS DEPARTMENT STORE
Port Authority Bus Terminal, New York, NY |

Cashier/Sales Clerk

* Assisted customers with purchases

* Handled cash and ran register check at close of business

SKILLS: Train employees in typing, dictaphone, telecopier, Mag 2, memory typewriter

EDUCATION:

Allen University
Katherine Gibbs School of Business
W & J Sloan School of Interior Decorating
American Management Association: Getting Ahead in Personnel

INTERESTS:

Fashion, interior decorating, dancing, sports and travel

KATHERINE SINORADZKI
River Bend Road, New Canaan, Ct. 06840
(203) 966-0318

OBJECTIVE: CRUISE DIRECTOR

SUMMARY: Six years intermittent experience as cruise director and
 passenger on voyages of from 18 to 90 days in Caribbean,
 Mediterranean, South Seas, Trans-Pacific and the Greek
 Islands. Strong background planning, budgeting and super-
 vising daily on-board activities. Assist passengers in
 familiarization of ship's facilities and activities, as well
 as ports of call. Particular facility for "people matching"
 to see that greatest number of passengers meet those of
 similar interests and tastes, thus ensuring enthusiastic
 repeat passengers and referrals. Widely traveled in Europe,
 Near and Far East, Caribbean, South America, Australia,
 New Zealand and South Sea Islands. Nine-year resident of
 Japan. Fluent in Spanish; read and interpret Japanese.

RELEVANT FINNISH AMERICAN LINE, New York, NY
EXPERIENCE: Cruise Director, SS Kungsholm

(while em- Planned, budgeted and supervised eight to ten recreational
ployed at and social activities daily for approximately 500 passengers
New York of widely varying interests and energy levels.
Stock Ex-
Change--see - Scheduled and oversaw ship-wide tournaments (cribbage,
page 2) deck tennis, shuffleboard, scrabble, etc.).

 - Dropped or added activities in mid-cruise as necessary
 to accommodate unique passenger interests.

 - Provided activity information and other "ship's news"
 to passengers through cabin-delivered daily programs,
 posters and public address announcements.

 Developed ability to introduce passengers of like interests
 to one another, thus encouraging friendships that led to
 large number of repeat passengers and referrals.

 - Organized "Captain's sit-down cocktail parties," so
 arranged to permit optimum passenger introductions.

 - Conducted "special interest" parties bringing together
 "Repeaters," "Singles," "Masons," etc., to permit meeting
 of people of like interests.

 Acted as "liaison officer" between passengers and ship's
 staff, conveying questions, complaints, comments and sugges-
 tions; worked closely with purser, dining room staff, etc.

 Also worked closely with entertainment staff, special activi-
 ties staff and land tour staff in disseminating information
 to passengers about their various functions.

NEW YORK STOCK EXCHANGE, New York, NY
Gallery Director, Public Relations Department

1960
to
1966

Served frequently as Exchange spokeswoman in contacts with media; worked with print and broadcast media representatives to keep Exchange functions and brokerage office procedures in public eye.

- Worked with newsmen and feature writers on articles on Exchange.

- Wrote and delivered daily radio broadcast on WNYC on various aspects of Exchange and financial operations; gave daily price quotations on selected list of stocks.

- Made guest TV and radio appearances on behalf of Exchange (e.g., the "Today" show).

Designed, organized and supervised Stock Exchange exhibit in U.S. Pavillion at Exposition International in Brussels.

Supervised 13 tour guides in overseeing operations of Visitors' Gallery, including conducting tours for up to 2,000 visitors daily.

- Escorted special individual and group visitors on in-depth tours of Exchange and financial area; entertained individuals and groups during visits to New York (as escort to shops, theatres, restaurants, etc.).

- Arranged luncheons for guests of the Exchange, working with chefs on menus and occasionally working as hostess.

CURRENT
EXPERIENCE:

SELF-EMPLOYED, New Canaan, CT
Landscape Designer

Design, execute and supervise construction of gardens and garden structures (principally Japanese), such as rock gardens, pool houses, tea houses, bridges, waterfalls, decks, dams and swimming pools for clients nationwide.

EDUCATION:

PARSON'S SCHOOL OF DESIGN, New York, NY
NEW YORK INSTITUTE OF FINANCE, New York, NY
MISS PORTER'S SCHOOL, Farmington, CT

LICENSES AND
CERTIFICATIONS:

Registered Representative and Security Analyst,
 New York Stock Exchange
Private Pilot's License
Radio Operator's License

LANGUAGES:

Fluent in Spanish; speak and read Japanese.

Finance

COLLEEN MC DONALD
4021 Snyder Avenue
Brooklyn, New York 11203

Home: (212) 856-7321 Office: (212) 489-6300

SUMMARY Fifteen-year banking career with eight years in branch operations
 management capping seven years in varied ground-floor services.
 Adept at control of cash losses and forgeries and able to structure
 work assignments for maximum efficiency and customer service.
 Fully knowledgeable of NOW accounts, money market accounts and
 safe deposit procedures. Experienced in use of NCR 270 and IBM CRT.

BANKING AND FINANCE EXPERIENCE

1976 to UNITED MUTUAL SAVINGS BANK, Brooklyn, NY
Present Branch Manager and Officer (1987-Present)

* Structure and supervise functions of 20 branch employees to ensure
 maximum efficiency and security

 - Charged with direction of daily work assignments of nine tellers,
 new accounts and safe deposit personnel, clerical, maintenance
 and security staffs

 - Restructure work flow depending on daily requirements

 - Conduct salary reviews

* Decreased annual overtime costs by nearly $10,000 and increased
 efficiency by revamping Tellers' Department

 - Trained tellers in all facets of unit; wrote training outline
 for execution by Head Teller

* Eliminated cash losses and forgeries over past five years through
 vigorous implementation of security measures

 - Conduct bi-monthly meetings to assure good security practices
 among tellers

 - Maintain minimum total cash and working drawer levels

 - Execute frequent internal audits of cash, travelers' checks and
 bonds

* Able to take on expanded responsibilities and troubleshoot during
 emergencies

 - Assume Assistant Vice President's functions during periodic
 absences of up to three weeks' duration

 - Substitute for managers in other branches on emergency basis

 - Troubleshoot computer malfunctions and improper data entries

* Performed above responsibilities since 1981, beginning as Banking
 Operations Assistant; promoted to Assistant Manager in 1984 and
 Manager in 1987

Head Teller (1978-1981)

* Supervised 11-member Teller Department, completely restructuring Department to increase efficiency and customer service

 - Organized work flow and staggered hours based on analysis of customer traffic patterns

 - Centralized equipment and supply locations for increased utility

New Accounts Clerk (1976-1978)

* Opened regular savings and society accounts; sold travelers' checks and bonds; stopped payments on checks and money orders

* Administered estate and guardian accounts, securing and completing necessary tax waivers, letters of administration and court orders

* Issued personal savings and demand loans; proved daily balances for all loans

Teller (1976)

* Performed full range of teller services: Conducted deposit and withdrawal transactions; issued money orders and tellers' checks; cashed checks and travelers' checks; accepted loan payments

* Maintained bank security through close scrutiny of all transactions

1967 - 1969 MERRILL, LYNCH, PIERCE, FENNER & SMITH, New York, NY
Cashier

* Accepted payment for stock margin accounts; acted as liaison with salespeople; operated teletype and PBX switchboard; responded to telephone and mail inquiries from customers

1965 - 1967 MANUFACTURERS HANOVER TRUST COMPANY, New York, NY
Operator, Check Sorting Machine

EDUCATION Professional Seminars (study sponsored by United Mutual Savings Bank)

Financial Institute of Studies, Fairfield, CT
1988 - Intensive one-week seminars on Branch Management, Women in Management

AIB, New York, NY
Six-week course in Life Insurance

1965 - Graduate, Bishop McDonnell High School, Brooklyn, NY

CERTIFICATIONS

Certified by State of New York as Notary Public and Life Insurance Agent

AFFILIATIONS Savings Bank Women

ANDREW K. MELON . 1600 Hitchcock Road . Wantagh, NY 11793 . (516) 781-7321

OBJECTIVE: <u>VICE PRESIDENT - COMMERCIAL/INDUSTRIAL LENDING</u>

(Commercial bank, commercial finance company or leasing company)

SUMMARY: 14 years industrial lending management experience, including 10 as vice president with three major commercial banking institutions. Thoroughly experienced in all aspects of credit, administration, development, collection and legal. Particular expertise in equipment financing and leasing. Managed $74 million portfolio, which increased 250% over five-year period.

EXPERIENCE:

1983 to
Present

LONG ISLAND TRUST COMPANY, Garden City, NY
<u>Vice President - Commercial/Industrial Credit</u>

* Develop, originate and administer direct and indirect loans; successfully increased portfolio from $30 million (1983) to $74 million (1988)

* Develop major customers and new business in coordination with branches

* Serve as member of credit committee acting on commercial and industrial loan requests and line of credit renewals

* Administer all activities of department; prepare and monitor budget; oversee collections; direct solicitation of new business

* Direct personnel administration; supervise staff of five

* Conceived and implemented simplified procedures and improved communications with resulting increased work flow and departmental capability

1983

JANLIN LEASING CORPORATION, Melville, NY
<u>Vice President - Credit/Marketing</u>

* Initiated credit investigations and established documentation procedures for processing lease and finance paper

- Arranged for discounting paper

1979-1983

SECURITY NATIONAL BANK, Melville, NY
<u>Vice President - Monthly Payment Business Loan and Equipment
 Finance Departments</u>

* Originated, coordinated and processed direct branch loans, and indirect loans through equipment dealers and leasing companies (lending authority, $250,000)

* Increased loan portfolio from $14 to $33 million; achieved balanced mix of industries

* Prepared and periodically analyzed budget

* Reviewed recommendations on loans which exceeded staff authority limits

* Coordinated legal, accounting and personnel functions within department; supervised staff of nine

(continued)

SECURITY NATIONAL BANK (continued)

* Directly negotiated loans with other bank officers, bank customers, attorneys and accountants

* Evaluated computer reports; implemented new forms, reporting procedures and follow-up systems; created departmental operating manual

1975-1979 FRANKLIN NATIONAL BANK, New York, NY
<u>Assistant Vice President - Metropolitan Division of Industrial Credit</u>

* Managed loan portfolio of $25 million, increasing loan volume by 25%

* Solicited new industrial loan customers; introduced new loan customers to other bank services including payroll accounts, trust services, letters of credit, accounts receivable financing and real estate financing

* Supervised staff of six

1967-1975 FEDERATION BANK AND TRUST COMPANY, New York, NY
<u>Assistant To Vice President - Industrial Credit Department</u>

* Beginning as credit investigator and documentation clerk, was promoted to assistant cashier with medium five-figure line of credit; then to assistant vice-president with low six-figure line of credit

* Responsibilities included budget preparation, development of branch loans, overall management and personnel direction

EDUCATION: New York Institute of Credit, New York, NY
1971 - Business and Banking courses

New York Junior College, Moberly, MO
1964-1966 - Business Administration

New York Institute of Technology, New York, NY
Business courses (continuing professional education)

JOHN TUMINO, 25 NORTHRIDGE ROAD, OLD GREENWICH, CONNECTICUT 06870
Home: (203) 637-6653 Office: (212) 980-8573

OBJECTIVE: **SENIOR MANAGEMENT — BANKING**

SUMMARY: Highly motivated and creative international banker with distinguished service and profitability record in New York, London, Paris and Amsterdam.

CAREER HIGHLIGHTS:

1983 to CITICORP INTERNATIONAL
Present New York, NY

Vice-President for Europe, Mideast and Africa
New York, NY (December 1986 to Present)

- Direct all Edge Act marketing and account service for EMEA-New York

- Control demand balances in excess of $75,000,000 and 90% of 40,000-plus monthly transaction volume

- As senior credit officer for both parent bank and Edge Act subsidiary, govern EMEA-New York exposure

- Contributed substantially to design of deposit-based earnings credit system for Islamic clients, offsetting cost of future credit services

- Principal force in redesign of accounting and profitability models

Vice-President and Representative (December 1985 — December 1986)
Assistant Vice-President (January 1984 — December 1985)
Amsterdam, The Netherlands

- Managed corporate and correspondent relationships throughout 23-nation area, coordinating efforts with U.S. associates

- Directed compilation and analysis of data relative to the economics of developing nations; wrote acceptable business plans accordingly

- Met with senior ministers and heads of state throughout Africa, and developed strategies for establishment of credit limits with French West Africa

- Designed and implemented special correspondent agreements with compatible European banks, effectively creating a branch network overseas for Citicorp

- Consistently surpassed annual goals set for deposit gatherings, loan volume, profitability and staffing

Assistant Vice-President, Corporate Finance
London, England (February 1983 — January 1984)

- Responsible, as part of team effort, for origination and implementation of new merchant and corporate capabilities for Citicorp in Europe

June 1982 to Jan. 1983	BANK OF AMERICA INTERNATIONAL, LTD. London, England

Manager

- Set up and managed umbrella administration for credit, loan services and syndication areas

Jan. 1980 to June 1982	BANK OF AMERICA INTERNATIONAL S.A. (LUXEMBOURG) Paris, France

Assistant Vice-President and Loan Officer
Banque Ameribas

- Member of original team that formed aggressive new merchant bank. Assembled portfolio in excess of $250,000,000 over three-year period, on nominal capital

Sept. 1977 to Jan. 1980	IRVING TRUST COMPANY New York, NY

Assistant Manager

- Coordinated, with treasurers and finance vice-presidents, bridge loans and stock option financing programs for major corporate relationships

Oct. 1976 to Sept. 1977	TRADE BANK AND TRUST COMPANY New York, NY

Assistant Credit Manager

Feb. 1975 to Sept. 1976	BANKERS TRUST COMPANY New York, NY

Retail Platform Associate; Branch Operations Supervisor; Collection Clerk; Teller

EDUCATION: Columbia University, BA Economics, 1979
University of Geneva (Switzerland), 1970 — Certificate French Language and Civilization

Joint Studies Program, Stanford University/Crocker National Bank: Advanced Techniques of Credit and Financial Analysis

New York Institute of Credit: Accounting Survey Lecture Series; Credit and the Uniform Commercial Code Lecture Series

National Credit Office: Applied Course in Credit and Financial Analysis

LANGUAGES: Bilingual French-English; read Dutch and Spanish

CITATION: **Who's Who in the World**

MEMBERSHIPS: New York Institute of Credit (former)
New York Credit and Financial Management Institute (former)
American Chamber of Commerce (NL) (present)

FRED BUXTON • *212 West 79th Street* • *New York, N.Y. 10024* • *(212) 873-5123*

<u>CONTROLLER/FINANCIAL MANAGER</u>

OBJECTIVE: To fully utilize my experience in management, planning and financial control.

SUMMARY: Fourteen years in financial and business planning, marketing and controller functions for a manufacturer, an airline and a brokerage firm.

HIGHLIGHTS: * Conceived and implemented TWA "Getaway" credit card system, now the most popular airline credit card

 * Assisted in negotiating the transfer of control of TWA away from the Hughes organization

 * As media liaison, used marketing and advertising to make general public aware of the negotiability of industrial diamonds

 * Developed capacity for improving relations between factory and office workers to increase production and cut costs

 * As a general manager, tightened financial controls and directed short- and long-term business planning

EXPERIENCE: 1983 to <u>Controller</u> reporting to the President
 1987 SCOMILL MANUFACTURING COMPANY,
 Brooklyn, NY

 --Responsible for entire financial structure in a manufacturing environment

 --Managed $22.3 million budget for both manufacturing and administration

 --Implemented ADP data processing system for payroll and for A/P-A/R: system reduced time interval between shipment and receipt of payment

 1989 to <u>General Manager</u>, reporting to President
 1982 & Executive Vice President
 GEMCO EQUITIES, INC., New York, NY

 --Developed and managed $4.6 million budget

 --Guided long-range planning as well as day-to-day operations, reporting to the Executive Vice-President and President

EXPERIENCE: --Directed new product development and product
(con't.) introduction strategies

 --Established liaison between the industry and the
 public through effective marketing and advertising

1973 to	**Director of Corporate Planning**
1979	reporting to Operations VP
	TRANS WORLD AIRLINES, New York, NY

 --Analyzed business trends and profits on short- and
 long-term basis

 --Designed and implemented profit plans and control
 systems

 --Developed and implemented TWA "Getaway" credit card

EDUCATION: Columbia University, New York, NY
 MBA in Business Finance (1974)

 Georgetown University, Washington, DC
 BBA Magna cum laude in Business Finance (1972)

 --President of student body

 LaSalle Extension University
 Dale Carnegie Course

MILITARY 1965 to U.S. Navy
SERVICE: 1969 Rank: Lieutenant (JG)

SPECIAL Licensed pilot (Multi-engine instrument rated)
SKILLS:

SUSAN FISHER 1400 Ocean Avenue • Brooklyn, New York 11230 • (212) 258-6575

Financial officer and operating executive with expertise in institutional administration and financial development. Functional experience in human resources management and computer accountancy.

PROFESSIONAL
EXPERIENCE:

1985-1987 <u>Director of Business & Financial Operation</u>, BENNINGTON COLLEGE
Bennington, VT

As chief financial officer of the college reporting directly to the President, I administered all non-academic financial services including personnel, budget, data processing, plant administration, auditing, purchasing, investments, real estate and insurance administration.

--Effected savings of $250,000 annually in plant maintenance by adopting sub-contracting system

--Instituted energy conservation program that reduced use of oil by 50% (300,000 barrels annually--a current cost avoidance of approximately $200,000 per annum)

--Elected Treasurer of Board of Trustees (first time in school history a non-trustee named to this position)

--Re-negotiated food service contract resulting in $12,000 annual savings, a 25% cost reduction

--Revised health and pension package to provide improved coverage at reduced cost

--Member or Chairman of 14 operational, planning or advisory committees

--Served as ERISA coordinator and Affirmative Action Officer

1974-1984 QUEENS COLLEGE, Flushing, NY

<u>Business Manager (1979-1984)</u>

In this position I acted as Bursar and was responsible for all accounting functions, purchasing, budget, payroll, personnel, benefits administration, auxiliary enterprises and warehouse operations.

--Chief operations manager during period of operational budget growth from $16 million to $60 million in 5 years

--Personally supervised office staff of 180 people including 4 Assistant Business Managers and 10 other professionals

--Planned and implemented Queens College's first computerized budget; negotiated unionization of food service staff

--Negotiated HUD contract for $15 million as part of three-man team

--Member or Chairman of 21 operational, planning or advisory committees

--Established principles for joint faculty-student action, and supervised revision of college legislative structure as administrative member of the Ad Hoc Faculty-Student Committee of campus governance; prepared final draft of college restructuring plan

SUSAN FISHER/2

QUEENS
COLLEGE
(Con't.)

Assistant Business Manager (1975-1979)
Assistant to Business Manager (1974-1975)
(Budget Officer)

--Completely revised budget system, purchasing procedures and accounting
methods to comply with newly passed CUNY Construction Fund Law.
Overhaul required close collaboration with all university departments

1973-1974

WOODMERE ACADEMY, Woodmere, NY
Assistant to Headmaster (Business Manager)

--Administered all fiscal affairs

--Responsible for budget, payroll, purchasing, food service, plant
maintenance, student transport, general accounts

--Administrative member of Parents' Board, requiring empathy with
non-academic viewpoint

1966-1972

ADELPHI ACADEMY, Brooklyn, NY
Assistant to Headmaster

--Appointed acting Chairman of English Department (1968)
Within a year was made Director of Development and Fund Raising

--Conceived and directed program for tracing lost alumni:
boosted funds raised by 1000%; revived contact with more than
1,000 potential donors

--Supervised financial affairs and physical plant

OTHER
EXPERIENCE:

1972-1973

BROWN UNIVERSITY CLUB

--Elected to Board of Governors as full-time volunteer

--Organized 3 fund raising performances--raised more than $25,000

--Chairman of Brown University Bicentennial Program in New York

EDUCATION:

Columbia University: Graduate Study in School Administration

University of Michigan Graduate School of Business: Institute in
Program Budgeting

Brown University: AB, English and American Literature

PROFESSIONAL
MEMBERSHIPS:

National Association of College and University Business Officers

Eastern Association of College and University Business Officers

Practicing Law Institute

American Association of Higher Education

PETER SEATON
60 East Tenth Street
New York, NY 10003
(212) 673-7321

OBJECTIVE: FINANCIAL ANALYST

SUMMARY: Three years with active and diverse private trust. Emphasis on investment and management of assets. Evaluate investment potential of venture capital situations and going concerns, monitor holdings, troubleshooting assignments. Exposure to financial analysis in many industries and business situations.

EXPERIENCE:

1986 to Present

A.T.C. COMPANY, New York, NY
Asset and Investment Analyst

VENTURE CAPITAL PROJECTS

Evaluate opportunities for equity participation in new ventures; comprehensive project analysis; analyze long-run growth and profit potential; recommend action.

Example: Recommended financing cosmetics company with innovative product concept

Result: Company now making an operating profit on annual sales of over $1,000,000; employs 600 sales personnel in 13 states. (Subsequently appointed to board of directors with full participation in financial planning and policy decisions)

Example: Advised creation of a company to utilize patented Biophonics technology in greenhouse food production.

Result: Twenty-five production units now in operation; cost-efficient technology gives company international franchise potential.

REAL ESTATE ASSIGNMENTS

Cash flow and R.O.I. analysis, purchase and sale evaluations, pro forma and operating statement preparation, and determination of real estate development potential, and troubleshooting.

Example: On-site in Anchorage, AK, developed turn-around plan for 19 building apartment complex with 55% vacancy rate.

Result: Improved financial procedures, negotiated financing, repositioned property for the market. Vacancy rate reduced to 40% after only three months; purchase offer under consideration is $1.5 million higher than offer received prior to turn-around plan. (Definitive market survey now used by Anchorage banks)

Example: Evaluated offer for one of the trust's shopping centers in Pennsylvania

Result: Analysis utilized in negotiating 29% increase in offer; resulted in sale of the property.

INVESTMENT MANAGEMENT	Charged with monitoring the performance and security of current holdings and analyzing other investment opportunities.

Example: Evaluated acceptability of common stock offered in lieu of note repayment by manufacturer of Pay-TV hardware

Result: Identified financial weaknesses caused by confused management and marketing efforts; recommended holding the note to secure priority claim on promising technology in case of default or bankruptcy

Example: Analyzed opportunity to invest in regional operations of national fast food chain.

Result: Showed profit-margin projections of investor group to be greatly overstated. Prevented potential $700,000 loss.

OTHER ASSIGNMENTS

Acquisition analysis of company engaged in air and ground transport for the entertainment industry

Monitor and manage securities portfolio

Negotiate distribution of assets in order to dissolve a corporation

Evaluation of proposal to develop Florida Cable-TV station

PRIOR EXPERIENCE

Court Liaison for New York County, Court Referral Project, New York, NY
Supervised staff of 14 (1981-1984)

Supervisor, Legal Department, Samaritan Halfway Society, Inc., New York, NY
Supervised staff of eight (1978-1981)

High School Graduate Trainee Program, Citibank, New York, NY
Trusts and Securities Operations (1976-1978)

EDUCATION:

New York University, New York, NY (1/84 - 2/88)

Jan. 1988 — BA, Economics/Philosophy
Recipient, Arts and Sciences Scholarship
Earned 100% living expenses; worked 30 hours per week

Jan. 1989 — Candidate for January admission to MBA Program at NYU

DONALD CHU . 100 Hidden Lake Drive Apt. 18L . North Brunswick, NJ 08902
Home: (201) 297-4340 Business: (215) 293-5261

OBJECTIVE: <u>MANAGER OF FINANCIAL/ECONOMIC PLANNING</u>

SUMMARY: Directed and trained an economic and financial planning group which
 functions as internal consultants to senior management. Demonstrated
 expertise in:

 - financial analysis and management reporting
 - systems design and development
 - short range budgeting, expense control and forecasting
 - productivity analysis; long range asset and resource utilization
 - operations consolidation and divestiture
 - oral and written communications to senior management

 Group activities have resulted in significant regional productivity
 improvements and direct expense savings of over $500,000 in the
 past six months alone.

<u>EXPERIENCE HIGHLIGHTS:</u>

1985 to Present MOBIL OIL CORPORATION
<u>Supervisor, Systems and Financial Analysis</u> Valley Forge, PA (1987-Present)

Manage, train and develop group of eight MBA analysts responsible for systems
development and financial planning to optimize return on investment, review long
range resource requirements and coordinate management sciences activities

* Successfully implemented politically sensitive departmental reorganization
 which consolidated all economic planning within controller's portfolio

* Initiated proposal to optimize manufacturing facility, which, when implemented,
 will pay back in 1 1/2 years and realize savings of $400,000 annually

* Achieved 200% productivity gain within planning unit by computerization of
 delivery fleet statistical reporting

* Proposed centralization of internal and external computer activities with
 anticipated saving of $40,000 annually

<u>Senior Financial Analyst</u> Scarsdale, NY (1987)

* Developed computer model to analyze profitability of existing business
 - Application resulted in a service station divestment program and district
 consolidation
 - annual savings of $300,000 in overhead and salaries

* Designed and implemented a control system to ensure efficient utilization of
 outside timesharing vendors and internal operations; savings of $5,000 annually

* Restructured supervisory span of control within credit department to improve
 internal communications. As a result:
 - firm priorities were established
 - past due balances were sharply reduced

* Established credit appraisal system for evaluating financial risk which was
 implemented by regional controller

MOBIL OIL CORPORATION (continued)
Staff Analyst (1986)

* Increased unit productivity by over 100% through computerization of routine
 management reports

* Monitored regional service station operations budget and introduced computerized
 reporting system which pinpointed variances and trends
 - provided sales management with improved tools for sensitivity analysis

* Significantly improved sales forecasting techniques

Controller Trainee (1985)

* Prepared budget forecast of $11,000,000 depreciation expense, 18 months in
 advance; actual 1978 expense was under projection, with variance of .2%

* Developed control and monitoring procedures for new engineering maintenance
 centers which:
 - reduced administrative workload and paperflow
 - established financial controls

9/82 to 5/89 KENDALL, BOWERS & COMPANY, INC.
Consultant Stamford, CT (Part-time)

Performed statistical analysis for management consulting firm specializing in
employee relations counseling

9/80 to 8/82 MOBIL PIPELINE CORPORATION
Pipeliner Rochester, NY

Supervised 5-10 contracted hourly employees and was responsible for planning,
organizing, directing and controlling a five-month pipeline maintenance project.
Surpassed management objectives.

EDUCATION: New York University, New York, NY
 1986 - MBA, Corporate Finance - Quantitative Analysis
 Thesis: An Analysis of the Impact of Vertical Divestiture on the
 Financial Environment of a Fully Integrated Petroleum
 Organization

 New York University, New York, NY
 1984 - BS, Operations Management/Behavioral Science

 University of Miami, Miami, FL
 1978-80 - Statistics/Psychology

HONORS: Founders Day Award - New York University
 Deans Honor Roll - New York University

PROFESSIONAL Beta Gamma Sigma Honorary Business Society
ASSOCIATIONS: Alpha Kappa Psi Professional Business Fraternity

John Hawkins, C.P.A. • *250 Main Street, Apartment 3-G* • *Millburn, New Jersey 07041*
Home (201) 379-4761 Office (212) 790-5206

OBJECTIVE

A senior financial management position with a publicly owned company or a large privately owned company which will utilize my experience in financial accounting and reporting, auditing, and administration.

EXPERIENCE SUMMARY

Twelve years' experience with Deloitte Haskins & Sells, an international public accounting firm. For the past two years assigned to Executive Office in New York where responsibilities include writing for publication and departmental administration. The previous ten years assigned to the Audit Department of the Memphis office with client responsibilities, teaching assignments and office administration.

EXPERIENCE

Executive Office of Deloitte Haskins & Sells **1986-1987**
1114 Avenue of the Americas
New York, New York 10036
212-790-0716

- Wrote the firm's booklet *Audit Committes: A Director's Guide* describing the activities of the audit committee and presenting the firm's view toward its evolution.

- Assisted international and domestic offices in such activities as writing proposals, making contacts, and furnishing information on other firms.

- Edited practice development publications about the firm, its services, and topics of current interest to the profession and clients.

- Participated in the development of the Deloitte Haskins & Sells advertising campaign, including research in connection with the benchmark study.

- Prepared practice development programs for presentation at all national and regional firm meetings.

- Assisted in the supervision of the department, including assignments of personnel, budget preparation, and coordination of departmental activities with other departments.

Deloitte Haskins & Sells
165 Madison Avenue
Memphis, Tennessee 38103

1975 – 1985

- Supervised audit engagements of publicly and privately owned companies. Client industries included manufacturing, insurance companies and agencies, real estate development, leasing, agricultural, retail and professional athletic organizations.

- Prepared constructive service letters and internal control comments for presentation to officers and directors.

- Supervised engagements for registration statements on Form S-1 and for annual reports on Form 10-K.

- Performed a special investigation for a brokerage client into the use of bond proceeds by a public utility district.

- Taught at six of the firm's national and regional seminars. Topics included technical accounting, auditing, and management training.

- Designed uniform accounting system and ticket sales system for each franchise of a professional athletic league. Wrote audit programs and supervised engagement to audit gate receipts for each game played.

- Handled various administrative responsibilities for the office including manager in charge of recruiting, assignment director, and staff counsellor.

EDUCATION

Bachelor of Science Degree with major in Accounting, Mississippi State University, 1975.

Member of Beta Alpha Psi and Beta Gamma Sigma honor societies.

ORGANIZATIONS

American Institute of Certified Public Accountants and Memphis Chapter of Tennessee Society of CPA's.

Junior Achievement of Memphis; former Member of Jaycees, Kiwanis, and Planning Executives Institute; Vice President and Treasurer of a private school.

MARY OLSON
2660 Sedgwick Avenue
Bronx, NY 10468

Home: (212) 298-7725

OBJECTIVE: Responsible position with an organization specializing in taxation and/or accounting

SUMMARY: More than 20 years experience in tax accounting, preparation and consultation with full knowledge of federal, state and local compliance statutes. Proven ability to interact with company presidents and controllers in effecting compliance with regulations. Expert investigator and interviewer. Capable motivator of personnel with definitive training experience. Additional experience as insurance field representative and assistant sales manager.

PROFESSIONAL HIGHLIGHTS:

1978 to
Present

NEW YORK STATE TAX DEPARTMENT, White Plains, NY
Tax Agent

One of 18 agents to service five-county area of Westchester, Rockland, Putnam, Sullivan and Orange Counties

* Investigate and interview taxpayers, taxpayers' representatives and corporate executives regarding problems in compliance with tax laws

 - Secure and verify financial statements; analyze statements for accuracy; investigate claims of indebtedness

 - Interview relevant parties (bank officers, attorneys, county clerks, landlords, etc.) to determine validity of statements

 - Handle caseload of more than 1,000 annually (majority are business clients)

* Upon completion of investigation, write reports with recommendations (accepted 95% of time)

 - Payment Arrangement: lay out all terms for payment

 - Seizure Procedures: notify taxpayer; complete warrant; participate in confiscation actions; reverse seizure order when payment plan with sufficient control has been instituted

* Complete returns for taxpayers without accounting help

 - Assures compliance and helps them avoid prosecution

* Assist in training new agents in enforcement proceedings

(Continuing involvement in tax return preparation and record keeping for family and friends on gratis basis)

1969-1978 TAX CONSULTANT (Self-employed), Bronx, NY

Kept business records and prepared tax returns for clients throughout New York metropolitan area and various other states

* Consulted with clients on all types of taxes; completed returns
 - Forms included federal, state and local returns for taxes on payroll, sales, withholding, real estate and personal property
* Developed clientele of more than 50 clients concurrent with Prudential employment

1957-1978 PRUDENTIAL INSURANCE COMPANY, Bronx, NY
<u>Assistant Manager</u> (1967-1969)

* Motivated staff to stimulate sales
 - Gave descriptive and motivational speeches to 50 agents in office dealing with aspects of successful sales techniques
* Recruited and trained new agents
* Served as mediator of complaints against agents
* Directly supervised six representatives

<u>Field Sales Representative</u> (1957-1967; 1969-1978)

Sold policies for Life and Health Insurance and pension plans

* One of youngest agents ever hired by company
* Wrote more than $100,000/week four times; received numerous awards for superior salesmanship
 - Invited to annual business meeting and convention (restricted to top 20% of representatives) every year, 1957-1978
* Became No. 1 salesman in New York in one year; remained in top category all 20 years of employment

EDUCATION: Westchester Community College, Valhalla, NY
1982-1985: Two years of Accounting

PROFESSIONAL CERTIFICATIONS:

New York State Life Insurance License
New York State Insurance Broker's License

MILITARY: U.S. Marine Corps

INVESTMENT BANKER

MORGAN JONES, 250 Central Park West, New York, N.Y. 10010 PL 3-4370

OBJECTIVE INVESTMENT/MONEY MARKET PORTFOLIO MANAGEMENT

SUMMARY Money market economist with background in Commercial/Investment banking; areas
 of expertise include: Financial futures markets; Cash markets; Foreign ex-
 change; Interrelationships among domestic and foreign markets; Development of
 quantitative techniques as aids to trading

EXPERIENCE

1988 to PETERS-JONES, INC., New York, NY
Present Vice President, Director of Research

 PRODUCT DEVELOPMENT:

 * Yield value of 1/32nd for GNMA's of different coupons and paydown rates
 Product useful for cash/futures positioning

 * Futures parity table for various deliverable T-Bonds for futures contracts

 * Hedge ratio table for cash/cash arbitrage taking into account yield and
 maturity effects

 * Developed new formula for hedge ratio for T-Bond spread vs. T-Bill futures
 trades

 * Developed innovative weekly chart package for firm's trade/sales personnel
 permitting "ahead of the pack" Fed's policy monitoring

 * Developed Implied Repo Rate table for deliverable T-Bonds taking into
 account accrued interest

 * Analyst and strategist on use of multiple hedging simultaneously of Euro-
 dollar time deposit, T-Bill, CD, T-Bond futures

 RELATED PROFESSIONAL ACTIVITIES:

 * Lecturer to financial professionals under the auspices of the American
 Management Association and the Financial Executives Institute

 * Designed and implemented course on money markets for firm's trainees

 * Conducted weekly information sessions for firm's trade/sales personnel
 on Fed's monetary policy and economic developments and their impact on
 financial markets

 * Authored articles on short-term money market investments, use of financial
 futures, and SDR's for The Money Manager, Pension And Investment Age, Cash
 Flow Magazine and Lombard-Wall's in house-financial markets newsletter

1974 to MORGAN GUARANTY TRUST COMPANY, New York, NY
1988 Vice President, International Money Management Group (1978-1980)

 * Conducted international cash management studies

 * Introduced innovative procedures -

 - quantitative technique useful to MNC's
 exposure management function
 - a new approach to evaluation of a firm's cash
 management phase (resulting in indicated potential
 savings to client up to $125,000 annually)

 * Performed risk analyses of hedging decisions which utilized forward
 foreign exchange markets

MORGAN GUARANTY TRUST COMPANY (Continued)

Vice President/Money Market Economist
Treasurer's Division, Portfolio Investment Research Group (1981-1986)

* Performed trade-off analysis of borrowing/lending decisions for bank's international treasury management

* Developed interest rate tracking models and forecasting techniques applicable to foreign exchange, domestic Euro/currency, and foreign money markets as aids to traders

* Organized seminar on fundamentals of portfolio management including spread and risk analysis and interest rate forecasting resulting in increased effectiveness of sales staff

Senior Operations Research Officer-
Consultant to Treasurer's Division
Operations Research Department (1974-1981)

* Supervised and motivated staff of analysts charged with research into aspects of portfolio management

* Developed simulation models-

 - for U.S. government bond market, used by portfolio manager for optimum bidding
 - for federal funds market as aid to managing bank's daily money position

* Advised pension trust department on portfolio performance evaluation techniques

1971 to 1974	GRUMMAN AIRCRAFT ENGINEERING CORP., Bethpage, NY Research Mathematician
1969 to 1971	UNITED AIRCRAFT RESEARCH LABORATORIES, East Hartford, CT Senior Mathematician
1966 to 1969	STEVENS INSTITUTE OF TECHNOLOGY, Hoboken, NJ Research Engineer/Lecturer
EDUCATION	1975 - MBA, Economics, New York University 1966 - MS, Applied Mathematics, Stevens Institute 1964 - BS, Mechanical Engineering, Stevens Institute Additional studies include: 1966-1969 - PhD studies in Applied Mathematics, NYU; 1969 - Credit and Financial Analysis Course, Dun & Bradstreet
LANGUAGES	Fluent in Russian and German Familiar with French and Yugoslavian
MEMBER OF	New York Association of Business Economists

LUCY OSTRAHAND
250 Oak Drive
Philadelphia, PA 19012
(215) 547-1234

OBJECTIVE: SECURITIES MANAGEMENT

To employ my expertise in stock research and trading
portfolio investment and estate management in the
trust department of a major bank.

SUMMARY: - Ten years experience in marketing and sale of
 industrial and bank stocks as member

 - Exhaustive researcher of growth potential of
 particular stocks in complete customer relations
 service

 - In-depth knowledge and marketing expertise of
 industrial and bank issues

 - Ninety-five percent successful selling stocks
 considered unmarketable

BUSINESS HIGHLIGHTS:

1978 to MANN SECURITIES Philadelphia, PA
Present <u>Bank Stock Trader</u> (1981 to Present)

 * Initiated and instituted bank stock trading
 company in 1981, in addition to industrial stock
 trading

 * Developed list of prospective customers;
 responsible for start-up and management of
 department

 * Locate markets for inactive regional bank
 issues

 * Trade stocks of 3,500 banks throughout country

 * Maintain liaison with Commerce Clearing House
 in keeping bank quotes current and customer
 service timely

 * Advise bank trust departments on buy/sell
 feasibility of illiquid issues

* Research and evaluate stocks for growth
 potential

* Responsible for increase in departmental profit
 from $15,000 in 1981 to more than $150,000
 in 1986 with negligible additional expense to
 company and minimum increase in capital

Industrial Stock Trader (1978 to 1981)

* Traded inactive industrials for clients

* Researched companies for appreciation in growth,
 seeking out undervalued issues and marketing
 to investment buyers with in-depth studies of
 company operation and production

* Located and traded expired tender offers

1973 to OTIS MARSHALL, INC. New York, NY
1978 Over-the-Counter Trading Department

EDUCATION: Wagner College, Staten Island, NY
 1973 - BA, Marketing/Accounting

 Pace College, New York, NY
 Advanced study in Industrial Psychology and Marketing

MEMBER: National Association of Security Dealers

 will relocate; will travel

STEPHEN BOGS · 91-48 79 Road, Apt. 6G · Woodhaven, NY 11421 · (212) 441-6620

OBJECTIVE: INVESTIGATOR - CLAIMS/COLLECTIONS
 To apply in-depth experience with highly sophisticated collection
 and investigation procedures on behalf of corporate financial
 institution

SUMMARY: More than seven years with Internal Revenue Service as an officer in
 charge of investigation and resolution of business and personal tax
 problems. In-depth understanding of businesses, including collection,
 investigation, interviewing and bookkeeping procedures. Knowledge of
 computer programming. Capable administrator and supervisor of personnel.
 Skills transferrable to corporate application.

HIGHLIGHTS OF EXPERIENCE:

1980 to INTERNAL REVENUE SERVICE
Present New York, NY

 Revenue Officer

 Charged with independent responsibility for investigation and deter-
 mination of tax claims against large accounts ($50,000 or more) with
 full authority to resolve problems

 * Perform complex credit analyses in connection with tax liens,
 collateral agreements and uncollectable accounts

 * Conduct intensive investigations of large corporations and prominent
 high-income individuals to uncover hidden assets, analyze financial
 condition and determine valuation of properties

 * Maintain comprehensive and practical knowledge of current collection
 techniques including -

 - Laws on rights of creditors
 - Forced assessment and collection
 - Lien priorities and bankruptcies
 - Summons procedures
 - Interpretation of public records

 - Application of such laws and procedures in extremely complex and
 often delicate situations

 * Originated new techniques and creative approaches in application of
 general tax and collection guidelines

 * Developed keen ability to influence, motivate, interview and educate
 persons who are generally fearful and uncooperative, through use of
 sophisticated interpersonal skills

 * Assist taxpayers in understanding of regulations; negotiate payment
 schedules to fulfill obligations

 * Serve as technical expert in matters before the tax court

 * Serve as classroom instructor in training of IRS personnel; evaluate
 courses and recommend changes

 * Received steady promotions to highest level in job category

3/79-7/79 DEPARTMENT OF SOCIAL SERVICES
and New York, NY
8/76-3/77
 <u>Caseworker</u>

 * Investigated and assisted people on welfare

 - Determined need for assistance and made recommendations

 * Worked independently in the field

MILITARY: United States Army, West Germany
 4/77-1/79 - Personnel and Administrative Specialist (Spec/5)

EDUCATION: St. John's University, Jamaica, NY
 1976 - BA, Social Sciences

 1979 - Graduate School (courses in Accounting, Statistics,
 Business Management)

 Control Data Institute, New York, NY
 1979-80 - courses in Computer Programming (FORTRAN, COBOL)

PAUL CHANG

625 West 110th Street
Apt. 10E
New York, NY 10025

Tel. Numbers:
(212) 866-2513
(212) 483-9875

OBJECTIVE: <u>PORTFOLIO MANAGER/FINANCIAL MANAGEMENT</u>

SUMMARY:
- Three years experience as an aggressive, sales-oriented brokerage house account executive

- Creative securities manager in developing options trading strategies in profitable customer service activity

- Thorough and definitive researcher into viability of market as a whole and of individual stocks

- Bilingual: English-Chinese

BUSINESS HIGHLIGHTS:

1986 to Present

MOORE & SCHLEY, CAMERON & CO., New York, NY

<u>Account Executive</u>

* Initiate research and development of options trading strategy for list of 50 clients; advise on covered writing

* Develop special portfolio strategies for individual customers

* Inaugurated advertising campaign in Chinese media; doubled market in Chinese community from 100 to 200 clients ($60,000 in earnings)

* Successfully developed strong leads from general advertising with 20% conversion to sales

* Redesigned brokers' desks for maximum utility at minimum cost

1985 to 1986

MERRILL, LYNCH, PIERCE, FENNER & SMITH, New York, NY

<u>Account Executive</u>

* Promoted to account executive after short training period and charged with developing options trading strategy for account executive group

- Completed training program in least time of any trainee

EDUCATION:
Columbia University, Graduate School of Business
1985 - MBA, Finance/Accounting

Columbia University, Graduate School of Arts and Sciences
1983 - graduate study, Mathematical Sociology
President, Columbia Pine Society

National Taiwan University
1977 - BA, Sociology/Economics

OTHER EXPERIENCE (in Taiwan):

1978-80 CHINA AIRLINE - Supervisor, Traffic Department

1975-77 ACADEMIA SINICA - Quantitative analysis of population survey of Taiwan

1973-75 CHINA DAILY NEWS - Frequent analysis of foreign press articles

Human Resources & Development

JUDITH AARONSON 84 Apple Road, Jamaica, N.Y. 11432 (212) 523-3082

OBJECTIVE: PENSION SPECIALIST

To fully utilize my experience in the field of pension benefits in a challenging position as a pension consultant or administrator.

EXPERIENCE: HARRY ALLAN CONSULTANTS, INC., New York, NY
Research Assistant

Current Conduct pension and actuarial research as it relates to company's actuaries, consultants and clients

- Review, digest and abstract articles from newspapers and magazines pertaining to pension law

- Read and review articles from wide variety of industry and government publications dealing with health, life insurance and actuarial studies

- Conduct telephone and written surveys based on client needs

METROPOLITAN LIFE INSURANCE COMPANY, New York, NY
Issue Technician (January 1988 to July 1988)

June
1987
to
June
1988

Issued Deposit Administration and Immediate Participating Guarantee contracts for roster of corporate clients

Drafted specimen plans, summary plan descriptions, plan amendments to comply with client request for IRS final regulations

Prepared IRS forms 5300, 5301, 5302

Heavy ERISA research and analysis, utilizing experts in the field, and government regulations

Valuation Technician (June 1987 to January 1988)

Prepared actuarial valuation reports, summary annual reports, employee benefit statements, employee census reports

Worked with Entry Age Normal and Frozen Initial Liability methods

Prepared IRS Schedules A, B and 5500-C

Used EDP input/output for valuation analysis

NEW ENGLAND LIFE INSURANCE COMPANY, New York, NY
Pension Benefit Analyst

1984
to
1987

Analyzed pension benefit plans and contracts

Calculated benefits for quotations and retirements

Worked with deferred annuities and deposit adminis-
tration cases

Trained new employees in calculation formulas and
benefits purchase

EDUCATION: LONG ISLAND UNIVERSITY, MA, Political Science, 1985
JOHN JAY COLLEGE, BA, American Government/Constitutional
Law, 1984

DORA MARTINEZ
80-12 180th Avenue
Howard Beach, NY 11414
212-845-6695

OBJECTIVE: DIRECTOR OF HUMAN RESOURCES

Personnel Manager with nine years' experience in human resources administration. Demonstrated ability to work effectively and congenially with employees at diverse levels. Comprehensive knowledge of recruitment, screening and interviewing; policy implementation; benefits administration; and staff supervision. Adept at labor negotiations. Innovator with ability to increase employee morale and improve communications. Experience includes management, staffing and establishment of personnel procedures for two new facilities of a major corporation.

PERSONNEL EXPERIENCE:

1980 to PERMITRON ULTRASONICS, DIVISION OF PERMITRON CORPORATION
Present Long Island City, NY
 Major manufacturer of bio-medical, dental and surgical equip-
 ment and industrial applications of ultrasonic technology
 (union shop with 160 employees)

 Personnel Manager
 * Responsible for recruitment, screening and interviewing of
 exempt, non-exempt and hourly personnel for diversified
 employment areas

 - Maintain staffing of technical, electronics, research,
 medical, production instrument assembly, plant management
 and general clerical functions

 * Also responsible for staffing of New Jersey acquisition and
 new Connecticut facility while handling full personnel manage-
 ment functions in Long Island City office

 * Extensively involved in labor relations, including participation
 in contract negotiations, administration and interpretation
 of union contract and close interface with union

 * Interpret and oversee implementation of all personnel policies;
 control administration of comprehensive employee benefit
 programs

 * Introduced measures to improve communications and establish
 employment incentives

 - Created and issued first policy manual

 - Established ten-year service award club to promote better
 relationship between labor and management

 - Initiated company newspaper

 * Establish and maintain EEO guidelines, ensure compliance with
 federal and state regulations

Continued

PERMITRON ULTRASONICS (Continued)

* Conduct wage and salary analyses to assure competitive compensation position in industry

* Regularly achieve 30% under budget allocation for placement advertising and employment agency commissions

* Supervise three-person department; delegate work flow to 15-person clerical staff

1979-1980 THE SINGER COMPANY, New York, NY
 Assistant, Compensation & Benefits Department
* Assisted Director of Compensation & Benefits with office administration; processing of benefit action forms and payroll action forms on terminations, transfers, salary increases and new employees; and all related correspondence

* Oriented employees relocating overseas regarding cultural, social and psychological adjustments

1973 EQUITABLE LIFE ASSURANCE COMPANY, New York, NY
 Administrative Assistant
* Assisted Director of Group Insurance Department

* Tour guide responsible for orientation tours for new employees and visitors

EDUCATION: Queens College, Queens, NY
 Business Major

 1980 - Present - Numerous seminars on personnel and management
 sponsored by AMA and other institutions

PROFESSIONAL AFFILIATIONS:

 International Association of Personnel
 Women Queens Personnel Management Association

MAY NELSON
10 Maple Avenue
Bedford Hills, NY 10507
Home: (914) 241-3420 Office: (212) 719-9233

OBJECTIVE <u>CORPORATE PERSONNEL</u> - Position in recruitment coordination with
excellent potential for growth into personnel management

SUMMARY BA in Psychology/Business and continuing record of successful
personnel experience. Adept at interpersonal and interdepart-
mental communications. Fully knowledgeable of laws governing
recruitment procedures. Exceptional recruitment and counseling
abilities. Strong organizational skills.

PERSONNEL EXPERIENCE

1980 to CAREER BLAZERS PERSONNEL SERVICES, New York, NY
Present <u>Branch Manager, Career Blazers Learning Center</u> (Feb. 1989 to Present)

* Recruit permanent and temporary word processing specialists,
 administrative assistants, secretaries, and other clerical
 personnel for client corporations

 - Screen and interview applicants to match
 client specifications

 - Have achieved exceptionally high level of client
 satisfaction through astute recruitment and
 perceptive counseling of personnel

* Enhance marketability and curriculum of Learning Center by
 counseling graduates regarding business etiquette and
 procedures

 - Increase confidence levels of graduates through
 placement in low-risk temporary employment slots
 in client companies

 - Coach graduates in telephone etiquette, proper
 dress and grooming, and behavioral expectations

* Call on clients and assist in coordinating evening seminars
 to establish awareness of Learning Center, create climate of
 acceptance, and increase utilization of available facilities

 - Reactivated approximately 25 resigned accounts
 as direct result of calls

<u>Assignment Manager, Career Blazers Temporary Services</u> (10/88 to 2/89)

* Recruited temporary applicants for client firms in areas of
 finance, marketing, advertising and manufacturing

* Coordinated long-term project for R.J. Reynolds Tobacco Company
 requiring 50-60 models weekly for large-scale public relations
 project

1987 - 1988 UNIONMUTUAL INSURANCE COMPANY, Elmsford, NY
 Disability Benefit Specialist

* Interviewed approximately 40 prospective employees through company's College Recruitment Program and hired 15 for entry-level positions in sales and disability benefits

* Conducted full field investigations to determine validity of questionable claims

 - Worked closely with physicians, lawyers and other professionals to determine eligibility of claims

* Upgraded communications between sales and benefits departments, bringing about substantial improvements in client services

 - Set up monthly meetings between sales and benefits departments at 12 district offices and clearly defined long-term goals and short-term objectives

 - Gave lecture and participated in sales seminar for 200 employees

* Simplified insurance policy terminology for benefit of policy holders and claimants

* Invited to apply for supervisory position normally requiring a minimum of three years after only one year with company

EDUCATION

State University of New York at Oneonta
1986 - BA, Psychology/Business and Economics

Willing to relocate

LISA HOHMANN · 73 Bleecker Street, #4-B · New York, NY 10012 · (212) 260-8950

OBJECTIVE: <u>TRAINING COORDINATOR</u>

SUMMARY: Ten years experience as trainer, manager and occupational therapist designing rehabilitation and training programs for individuals and corporations. Knowledge of affirmative action legislation as it applies to both private and public sectors

BACKGROUND: NEW YORK UNIVERSITY, Current

<u>Coordinator, National Interpreter Training Consortium</u>

$300,000 grant program for training development throughout the U.S.

* Responsible for collection, evaluation and dissemination of information

 - Provide resource information

 · On national level conceived on-site internship program for Executive Director of National Registry of Interpreters for Deaf

 · On local level conducted training workshops throughout Northeast area

 · Preparation of quarterly and annual reports to H.E.W.

* Designed policy guidelines for disabled students and interpreter services involving all the schools adjunct services of New York University

* Supervise staff of 20

* Production of training videotapes (produced by Ted Estabrook) available commercially throughout the U.S. to state and civic service organizations and private business sector

 · Wrote script for 35 minute tape

 · Cast tape using over 20 people

GOODWILL INDUSTRIES, New York, NY, 1985-86

<u>Program Development/Deafness Specialist</u>

* Served as liaison between Office of Vocational Rehabilitation and Goodwill Industries

 · Responsible for counseling 60 clients regarding employment, training, medical and other support services

 · Supervised internship program for graduate students

* Developed program for disabled clients and employees

 · Secured cooperation from business sector in providing individualized job orientation

 · Secured interpreters for clients and arranged for special tutors at no cost to Goodwill through effective use of available human resources

 · Developed human resource orientation program for corporations

FEDERATION EMPLOYMENT & GUIDANCE SERVICE, New York, NY, 1984-85

Rehabilitation Counselor

* Managed programs of New York State rehabilitation clients
 - Provided evaluation and counseling services to adults with all disabilities
 - Developed all services for deaf clients
 - Administered in-service training for staff

CROTCHED MOUNTAIN CENTER, Greenfield, NH, 1978-82

Occupational Therapist

* Evaluated clients' physical and emotional needs; devised individ-ualized programs for all ages, all disabilities
 - Supervised all therapy aides, assistants and students
 - Was instrumental in establishing departmental staff meetings between school and rehabilitation center
 - Served as acting director of department in 1982
 - Developed pioneer therapeutic horseback riding program for 40 students
 - As Secretary-General for Northeast Wheelchair Games was responsible for housing, meals and qualifying events for over 120 participants

OTHER EMPLOYMENT:

NEW YORK UNIVERSITY

Adjunct Instructor

Sign language for graduate students in School of Education and adults from School of Continuing Education (1983-86)

Sign Language Interpreter

Deaf graduate students (1983-84)

EDUCATION: New York University
MA - 1984, Deafness rehabilitation

Awarded full fellowship

Utica College of Syracuse University
BS - 1978, Occupational Therapy

PROFESSIONAL CERTIFICATIONS:

Rehabilitation Counselor, Certified Rehabilitation Counselor
National Registry of Interpreters for the Deaf, Sign Language
 Interpreter, C.S.C.

AFFILIATIONS:

American Deafness & Rehabilitation Association (Chairperson, 1985-86)
American Society for Training and Development

JOSHUA HARRIS · 220-01 124th Road · Laurelton, NY 11413

Business: (212) 978-4515 Home: (212) 580-9950

OBJECTIVE: SECURITY MANAGEMENT

SUMMARY: Ten years experience as an officer with award-winning record in crime prevention and apprehension of perpetrators in New York City subways. Worked in both uniform and plainclothes divisions. High conviction record. Established community relations which effectively reduced neighborhood crimes. Business experience includes training and motivating personnel.

HIGHLIGHTS OF POLICE WORK:

(See Page 2 for Business Experience)

1976-86 NEW YORK CITY TRANSIT POLICE DEPARTMENT

Plainclothes Patrol (1984-88)

* Initiated and conducted training programs for employees of New York Telephone Company in self-protection from robbery and assault in Grand Concourse Station

 - Approximately 100 employees attended each of three seminars in Telephone Company offices

 - Resulted in demonstrably appreciable rate of reduction of platform crimes, especially on paydays

* Investigated numerous robbery and assault complaints

 - Resulted in 25 to 30 arrests

 - Supplied District Attorney's office and grand jury with hard evidence resulting in conviction of perpetrators

 - Testified successfully in court

* Worked closely with community organizations to decrease neighborhood crime

 - Strategy of coordinating patrol patterns with self-protective measures created dramatic drop in robbery and assault offenses

Uniform Patrol (1976-84)

* Responsible for revenue protection in mid-town Manhattan (protection of coin booths)

* Rode subway patrol; was responsible for apprehension of approximately 75 robbery suspects over period of service

* Practiced crime prevention on one-to-one basis by warning individuals of incorrect self-protective measures on subway platforms and on trains

* Was awarded decorations for distinguished police duty

 - Received 3 Meritorious Service Awards
 2 Distinguished Service Awards
 2 Honorable Mentions
 2 Letters of Merit

BUSINESS EXPERIENCE:

1986 to
Present

O-M OFFICE SERVICES/SUPPLIES COMPANY
New York, NY

<u>Senior Buyer</u>

* Purchase all office supplies and equipment at wholesale for resale at retail
 - Maintain correspondence by mail and telephone with manufacturers
 - Administer bid procedure for quantity and large ticket items
* Supervise staff of four employees

1973-76

CBS TELEVISION
New York, NY

<u>Purchasing Expeditor</u>

* Responsible for accurate processing of all purchase orders and timely delivery of equipment and supplies
* Communicated with vendors; maintained liaison between vendors and departmental purchasing authorities
* Followed through on all purchase orders; handled problems smoothly
* Trained three additional expeditors

EDUCATION:

Modesto Junior College, Modesto, CA
1971 - Associate in Accounting

MILITARY:

U.S. Air Force; Honorable discharge with rank of Airman 2/c
1969-1973

THELMA L. CUMMINGS · 175 West 73rd Street, #8G · New York, N.Y. 10025

WORK 212-960-2137 HOME 212-496-4142

OBJECTIVE <u>HOSPITAL ADMINISTRATOR</u>

 Managerial/administrative position at the departmental level or in core administration

SUMMARY M.P.A. degree and four years experience in health care administration. Prepare and review budgets up to $500,000. Adept at trouble-shooting and formulating systems to solve operational problems. Extensive personnel experience including ability to supervise, motivate and counsel employees

HEALTH CARE ADMINISTRATION EXPERIENCE

1986 to
Present
 ST. JOSEPH'S HOSPITAL CENTER, New York, N.Y.
 <u>Administrative Manager</u>, Emergency Services Department (1979-Present)

 Administer all aspects of Emergency Department including line super-vision of clerical staff of 21. Prepare budget and review expenditures; formulate and interpret departmental policies for all personnel; purchase and maintain equipment; M.D. staffing of Screening Clinic

* Reduced projected overtime requirements by 40% annually through institution of relief position with staggered hours; cut overtime costs and improved staff morale

* Department came within budget in 1980 for first time in three years due to: careful budget preparation based on actual spending adjusted for projected growth and inflation; monthly review of expenditures; investigation of unusual expenses

* Upgraded levels of supervisory personnel in order to clarify lines of authority and improve accountability for clerical performance

* Conceived and implemented weekly multi-disciplinary conference for review of problems and recommendation of appropriate actions, significantly improving both communication and staff cooperation

1985 - 1986 MONTESSORI HOSPITAL AND MEDICAL CENTER OF BROOKLYN, Brooklyn, N.Y.
 <u>Manager/Personnel Grants</u>

 Organized and administered operations of CETA on-the-job training program for 34 employees including orientation, counselling and partial supervision; assured conformity with governmental regulations and effective liaison with outside agencies; initiated and maintained all data systems.

* Hospital grossed more than $65,000 in nine months due to careful program implementation and monitoring

* Compiled and wrote CETA Manual; clarified and systematized Hospital's responsibilities for participation and reimbursement; provided continuity for program administration

* Participated in Personnel employment and wage/salary activities; e.g., communicated with union hiring hall, screened applicants, conducted salary surveys, and wrote job descriptions

THELMA L. CUMMINGS/2

1985 NEW YORK HOSPITAL, New York, N.Y.
 Administrative Resident

 Rotated through Hospital departments; line responsibility as
 Administrator-on-Call; completed special projects as assigned.

 * Successfully coordinated and collected Medicaid and Blue
 Cross surveys required for reimbursement in 1/12 normal
 time; resulted in recommendation for employment at MHMCB

 * Proposed systematization of photocopying operations and
 equipment for projected savings of 30%; data generated
 from this study was used to help equip new hospital under
 construction

BUSINESS AND PUBLIC SERVICE EXPERIENCE

1985 DAVID DONLAN FOR COUNTY EXECUTIVE (political campaign), Garden City, N.Y.
 Office Manager/Bookkeeper

 Set up systems for cash flow and fiscal operations; prepared
 financial statements for submission to Board of Elections;
 arranged meetings with community and political leaders.

1983 PILOT FABRICS CORPORATION, New York, N.Y.
 Assistant Convertor/Shipping Supervisor

 Assisted in directing conversion of raw goods to finished textiles;
 liaison and trouble-shooter to assure on-schedule activity of mills,
 dyers, and truckers; and effective communications with customers.

1980-1981 UNITED WAY OF GREATER NEW YORK, New York, N.Y.
 Fund Raiser

 Organized and assisted campaign committees and groups; arranged
 promotional, educational, and fund-raising events.

EDUCATION NEW YORK UNIVERSITY, GRADUATE SCHOOL OF PUBLIC ADMINISTRATION, New York, N.Y.
 1985 - M.P.A., Health Policy, Planning and Administration (4.0 cum. avg.)

 NEW YORK UNIVERSITY, WASHINGTON SQUARE COLLEGE, New York, N.Y.
 1979 - B.A., Religion (Founders' Day Honors Certificate; 3.9 cum. avg.)

 VASSAR COLLEGE, Poughkeepsie, N.Y.
 1974 - 1976, 64 credits towards B.S., Religion & Biology (Dean's List)

 Additional Professional Study:

 1986 - Grants Writing Seminar, The North Group of Falls Church, VA
 1982 - Group Dynamics in Human Relations, New School for Social Research

AFFILIATIONS American Public Health Association
 American Hospital Association

HELEN SCOFIELD
25 Hill Street
Boston, Massachusetts 02105
(617) 266-2575

OBJECTIVE: FOOD SERVICE MANAGEMENT

SUMMARY: Three years experience in institutional food service and
 dietary consultation. Strong skills in supervision, menu
 planning, food preparation, forecasts and cost control.
 Ability to plan nutritious meals within budget, including
 dietetic and vegetarian dishes.

PROFESSIONAL HIGHLIGHTS:

Aug 1988 HARVARD UNIVERSITY DINING SERVICES
 to Cambridge, Massachusetts
Present
 Dining Services Supervisor

 * Supervise 35 persons in operation of college residence
 dining hall

 * Write monthly marketing newsletter directed to dining
 service consumers

 * Prepare data in forecasting orders, menu planning and
 inventory control for computer system

 * Upgraded nutritional value of meals for 500 college
 students

 * Developed menu cycle, lowering food cost and boosting
 profits for unit

 * Established sanitation schedule

Sep 1987 BUREAU OF SCHOOL FOOD SERVICES OF BOARD OF EDUCATION
 to White Plains, New York
Aug 1988
 School Lunch Manager

 * Supervised food service staff in four public schools

 * Redesigned forms for evaluating employee performance

 * Responsible for menu planning, food preparation service,
 scheduling, purchasing, inventory, payroll and sanitation.

 * Designed food preference questionnaire (adopted and used
 by 19 schools)

School Lunch Manager (Cont'd)

* Set up nutrition committee to promote nutrition education and to obtain feedback from students, faculty and parents

EDUCATION: Hunter College, New York, N. Y.
1986 - B.S., Foods and Nutrition

Additional Courses:
Vegetarian Cookery, Yoga Institute, New York, N. Y.
Educational Writing, Pace University, White Plains, N. Y.

AFFILIATIONS: American Home Economics Association
American Dietetic Association

VILMA COVINAS
25 Locust Street
New York, New York 10040
(212) 304-6090

OBJECTIVE: **EXECUTIVE POSITION AS NURSING ADMINISTRATOR OR DIRECTOR OF OPERATING ROOM/RECOVERY ROOM SERVICES**

SUMMARY: Eighteen years progressive leadership and administrative experience in a large, technologically advanced operating and recovery room complex. Strong background in planning, organizing, coordinating, directing and evaluating patient care programs, management and operational systems, orientation and staff development programs, as well as facilities expansion and renovation. Experienced in developing and analyzing patient scheduling, staffing and management information systems. Skilled in budgetary and fiscal management, with responsibility for administering $10 million budget. Expert in labor relations and contract administration. Well-versed in interdisciplinary project management, problem solving and communications. Knowledgeable of regulatory standards, medico-legal considerations, quality assurance and cost reimbursement processes.

EXPERIENCE:

1971
to
Present

FLOWER FIFTH AVENUE HOSPITAL, New York, New York

Assistant Director of Nursing, O.R./R.R. Division (1986 - Present)

Manage delivery of safe and effective patient care in 35 Operating Rooms and 28-bed Recovery Rooms, requiring supervision of 225 professional and auxiliary nursing personnel and coordination with appropriate medical and hospital services.

- Responsible for strategic planning, implementation, coordination and evaluation of patient care programs and network of management and operational systems.
 - Instituted nine new clinical programs in 1990 alone
 - Organized ambulatory surgery program
 - Devised synchronized system for O.R. scheduling and bed reservation
 - Planned and operationalized O.R./R.R. transport system
 - Designed and implemented O.R.-C.S.S. case cart exchange system, including standardization and cataloging of all instrument sets
 - Instituted system to expedite blood reservation and delivery for O.R.
- Establish and maintain effective staffing patterns, recruitment, retention, staff development and labor relations programs.
 - Devised formula for determining staffing requirements, with target of professional nursing staff providing intra- and post-operative care
 - Developed and implemented orientation programs for nursing staff, residents, medical and nursing students
 - Initiated the clinical preceptor and specialty rotation programs
 - Reduced staff turnover rate from 10% to 1% by providing for expeditious fulfillment of vacancies and establishing atmosphere conducive to high morale and retention
 - Co-conducted Philippine recruitment resulting in hiring of 100 nurses

- Develop and implement policies and procedures; monitor compliance.
 - Wrote and compiled specialty procedure/policy manuals for O.R., R.R., Cystoscopy, Endoscopy, Hyperbaric Chamber, and Ambulatory Surgery
 - Wrote job description for all categories of divisional personnel
 - Initiated and maintained surgeons' preference card system
 - Developed and implemented risk management/quality assurance programs
 - Directed activities relative to three successful JCAH inspections
- Project, prepare and monitor capital and operating budget ($10 million) for ten cost centers; established O.R./R.R. charging system.
 - Administer materials handling and cost containment program
 - Negotiated contracts for procurement of high-usage/expenditure items
 - Initiated standardization and development of perpetual suture inventory system, with consolidation of back-up and ordering through C.S.S.
 - Initiated inventory system for grafts, implants and orthopedic prostheses
 - Initiated program for preventive maintenance and repair of specialized equipment
 - Formalized mechanism for processing new program/product requests with budgetary impact
- Develop effective system for maintaining clinical and administrative records and reports.
 - Designed and implemented patient operative records
 - Devised statistical system for reporting caseload and utilization
 - Participated in development of computerized management information system, in conjunction with systems analysts, computer consultants and programmers
- Plan, organize and coordinate facilities expansion and renovation.
 - Participated in planning, functional programming and establishment of current O.R./R.R. facility, including selection/installation of equipment, as well as reorganization and expansion of staffing system
 - Coordinated renovation of ambulatory surgery and endoscopy suites
 - Planned for expansion of current R.R. facility
 - Participated on hospital advisory committee, ambulatory and surgical working groups in planning new hospital, including nationwide on-site survey of major tertiary care hospitals
- Represent the nursing department in hospital and community activities.
 - Participated on Medical Board Committees on Surgery, Medical Standards, Infection Control and Disaster Planning, as well as various hospital project management teams and task forces
 - Represented the hospital on the New York City Health and Hospital Corporation—Emergency Medical Services Hyperbaric Advisory Council

Nurse Coordinator, Operating Room/Recovery Room Division (1985 - 1986)
35 Operating Rooms and 28-Bed Recovery Rooms

Clinical Supervisor, Gaisman Surgical Suite (13 Rooms) (1983-1985)

VILMA COVINAS/3

Asst. Supervisor, Administration & Staffing, O.R./R.R. (1978-1983)

Asst. Supervisor, Inservice Education, O.R. (1974-1978)
Started as Staff Nurse in 1971 and promoted to Assistant Head Nurse in 1973, then to Head Nurse in 1974.

1970-1971 **ENGLEWOOD HOSPITAL,** New Jersey
Staff Nurse, Operating and Recovery Room

1968-1970 **MARGARET HAGUE MATERNITY HOSPITAL,** Jersey City, N.J.
Exchange Visitor, Labor and Delivery/Operating Room Units

1967-1968 **UNIVERSITY OF THE EAST MEDICAL CENTER,** Manila, Philippines
Staff Nurse, Surgical Unit

EDUCATION: **COLUMBIA UNIVERSITY, TEACHERS COLLEGE,** New York, NY
1978—Master of Arts in Nursing Service Administration
UNIVERSITY OF THE PHILIPPINES, COLLEGE OF NURSING, Manila, Philippines
1967 B.S., Nursing (College Scholar, 2 semesters; Entrance Scholar)

Completed numerous career-oriented continuing education courses sponsored by AORN, American College of Surgeons, American Society of Anesthesiologists, American Management Associations, Ethicon, AMSCO, etc.

LICENSURE: Professional nurse licensure in New York and New Jersey.

CERTIFICATION: Professional Achievement in O.R. Nursing Practice, 1987-1990 (AORN)

AFFILIATIONS: American Nurses Association and New York State Nurses Association

Association of Operating Room Nurses, Inc.: Various offices held in New York City Chapter, including President, Vice President, Secretary and Board Member; chairman of various committees; Chapter Delegate to AORN Congress 13 years (Delegate Chairman two years); Test Pool Item Writer, AORN Certification Examination; Chapter Liaison to National AORN Research Committee, 1989 to present

Advisory Council of National AORN Committee for Collaboration with Industry

Medical-Surgical Industry Product Development/Evaluation Panels

Philippine Nurses Association of New York, Inc., President, 1990-91

PRESENTATIONS: "Documentation of Patient Care in the O.R."; AORN Conference, New York, NY, 1982

"O.R. Scheduling"; AORN Conference, New York, NY, 1989

"Surgery, Then What? Patterns of Disfigurement"; AORN Regional Workshop, New York, NY, 1989

"Developing the Operating Room Module for a Hospital Disaster Plan"; 25th National AORN Congress, New Orleans, LA, 1986

"Ethical, Moral, and Legal Aspects of Organ Homotransplantation"; American Association of Critical Care Nurses Seminar, New York, NY, 1980

"Hazards of Ethylene Oxide Sterilization," AORN-NCE Regional Institute, New York, NY 1983

"Developing, Implementing, and Evaluating Nursing Care Plans for Patients in Surgery"; AORN, NYC Chapter Workshop, 1981

PENNY MORGAN

210-20 Village Road, Apt. 80A Home: (212) 591-9791
Parkway Village or (212) 723-7244
Jamaica, NY 11435 Business: (212) 592-4180

OBJECTIVE: SENIOR CHILD CARE COUNSELOR

SUMMARY: Highly experienced in counseling/consultation with adolescents in institutional setting designed on campus plan, or in a group home setting. Firm though sympathetic toward personal problems. Expert in motivating youngsters to complete education and aspire to vocational independence. Capable administrator, achieving satisfactory results within limited budget.

HIGHLIGHTS OF PROFESSIONAL EXPERIENCE:

1984 to
Present

ST. JOSEPH'S CHILDREN'S SERVICES, Brooklyn, NY
Senior Child Care Worker

* Manage household, administer budget, supervise staff

* Care for physical, emotional and spiritual needs of adolescent residents, aged 14 to 18; give support and affection

 - Consult on goal orientation; emphasize religion as a positive force in their lives; help them see parents as positive role-models; establish idea of organized and productive living (budgeting time and money for short- and long-range planning); how to help their younger siblings

 - Motivated at least 12 residents to return to school full time

 - Motivated at least three to overcome alcoholic problems

* Provide alternate activities - take them to plays; involve them in drama classes

* Motivate residents to learn vocational trades; become self-reliant and self-supporting rather than rely on welfare for support

 - One recent resident completed course in pattern-making; is now lucratively employed

* Interact with community as agency representative; interpret policies and principles of agency

1978-83

LEAKE & WATTS CHILDREN'S HOME, Yonkers, NY
Senior Child Care Worker

* Duties similar to those at St. Joseph's

1977-83

IRVING TRUST COMPANY, New York, NY
Bank Clerk

1949-76

GEORGE F. HUGGINS & CO., LTD., Trinidad, WI
Shipping/Insurance Clerk

EDUCATION: Oxford and Cambridge Senior School Certificate

LICENSES/CERTIFICATES:

University of North Carolina
- 1987-88, Group Child Care Consultant, School of Social Work
- General Certificate, Child Care Work
Swedish Institute, Stockholm, Sweden
- General Practices, Emotionally Disturbed and Handicapped Children

Information Systems

GARY GRAY · 86-11 94th Ave. · Jackson Hts., NY 11372 · (212) 672-6606

POSITION: <u>COMPUTER PROGRAMMER</u>

HARDWARE: IBM 3033, IBM 360/22, IBM 370/168, AMDAHL 470/V6
 1403 Printer, 2540R Reader, 2311 Disk Drive, 2415
 Tape Drive, Digital Decwriter II, Datamedia Elite
 CRT, PDP 11/40 minicomputer, Singer ten, Prime mini-
 computer, Nixdorft minicomputer

SOFTWARE: COBOL, ASSEMBLER (BAL), ASSEMBLER (DMF-II); working
 knowledge of PRG II, PL-1, BASIC, FORTRAN, IBM/OS,
 Teleprocessing, Hardware Systems and Systems
 Analysis

EXPERIENCE:

Current BASIC RESEARCH AND DEVELOPMENT, Long Island, NY
 <u>Minicomputer Assembler Programming/Data Processing Coordinator</u>
 (Report directly to Senior V.P. in charge of Engineering)

 * Designed and implemented customized data entry programs
 for clients including a major New York utility

 * Assist Chief Systems Analyst in design of upcoming
 projects

 - Set up computerized library control system
 for use in and out of house

 - Worked on the development of softwear for users
 with turnkey expectations

 - Attended regular meetings with D.P. personnel at
 utilities companies to assess their softwear
 needs

1988 HARDACH TRAVEL SERVICE, New York, NY
 <u>Mini-Computer Operator</u> (On-line system)

 * Directed department responsible for computation and issuance
 of invoices, credit and debit statements

 * Issued international airline tickets on Nova system connect-
 ed to Sabre system

 * Developed accounting program in COBOL; saves company 500
 work-hours annually

 * Worked independently; set own schedule and work hours

1987 SMITH, BARNEY, HARRIS, UPHAM & COMPANY, New York, NY
 <u>Lead Operator - Data Entry</u>

 * Responsible for verification of work of 40-member
 computer staff

 * Within four months, achieved speed levels which
 surpassed all others in department

1982-1987 1001 DISCOUNT STORES, DBA EA DISCOUNT, Richmond Hill, NY
<u>Manager</u>

* Increased annual revenues from zero base of $500,000 per store in six year period

* Installed NCR electronic digital cash registers in both branches

(Worked while attending school)

EDUCATION: BARUCH COLLEGE, New York, NY
1988 - Certificate: Computer Programming and Systems Design

NEW YORK UNIVERSITY, New York, NY
1/88-5/88 - COBOL

QUEENSBOROUGH COMMUNITY COLLEGE, Queens, NY
1983-84 - Course concentration: Business Administration

YORK COLLEGE, CUNY, New York, NY
1981-83 - Course concentration: Music Composition

Working knowledge of Spanish

PERSONAL: Willing to relocate; free to travel

ROY CHURNUTT
40 Maple Road
Princeton, New Jersey 08540
(609) 921-2329

OBJECTIVE: To apply my expertise in computer programming, mathematical analysis and problem solving to new and challenging projects.

SUMMARY: More than 20 years participation in government-funded research toward developing a new source of energy through controlled thermonuclear fusion. Expert in scientific computer programming and mathematical analysis. Designer of mathematical models for problem interpretation and solution. Author and contributor to published technical papers.

KNOWLEDGE OF AND EXPERIENCE IN:

- FORTRAN, PL/1

- Interactive computer systems: CDC Cyber 172 (NOS)
 vm370, DEC PDP 10
 NMFECC at Livermore, CA

- Batch systems on IBM 360/91, CDC Cyber 172

- Libraries and packages: IMSL, SSP, SORT, PERT

PROFESSIONAL EXPERIENCE:

1968 to PLASMA PHYSICS LABORATORY, PRINCETON UNIVERSITY, Princeton, NJ
Present
 Scientific Computer Programmer/Mathematical Analyst

* Member of support team for government-funded controlled thermo-nuclear fusion research

* Analyze raw output from a data acquisition system connected to a large fusion machine

* Write and run FORTRAN programs to solve differential equations, make numerical approximations and produce graphic output

* Interpret problem, establish method of solution and translate data to computer language for intermediate and final analysis

 - Interact with physicists and engineers

 - Produce necessary documentation for programs

 - Meet deadlines for material to be included in papers published in technical journals and/or presented at conferences by senior researchers

1965-68 UNIVERSITY OF WISCONSIN

 Graduate Teaching Assistant

* Taught mathematics to undergraduate students

1964-65 RAND CORPORATION, Santa Monica, CA

 Programmer/Analyst

* Checked out and wrote programs in the Air Force's SAGE computer system on the IBM ANFSQ/7

ROY CHURNUTT/2

1960 U.S. NAVY (NEW YORK NAVAL SHIPYARD), Brooklyn, NY

 <u>Physicist</u>

 * Conducted photometric tests of lighting devices prior to purchase by
 U.S. Navy

MILITARY: UNITED STATES ARMY, Guided Missile Equipment (Radar)
 12/61 - 9/63 (Honorably discharged)

EDUCATION: University of Wisconsin
 1965-68 - Post-graduate work toward PhD in Mathematics

 University of Wisconsin
 1964 - MS, Mathematics

 City College of New York
 1960 - BS, Physics

LANGUAGES: Read some French, German and Spanish

RECOGNITION IN PUBLICATIONS (Partial List):

1988 - T.L. Chu and Y.C. Lee: "Energy Confinement Comparison of
 Ohmically Heated Stellarators to Tokamaks"
1987 - S. Suckewer and H. Fishman: "Conditions for Soft X-Ray Lasing
 Action in a Confined Plasma Column"
1987 - J. Sredniawski, S.S. Medley and H. Fishman: "Vaccuum System
 Transient Simulator User's Manual for PPLCC Cyber System"
1983 - S. von Goeler et al: "Thermal X-Ray Spectra and Impurities in
 the ST-Tokamak" (Nuclear Fusion)
1982 - M. Porkolab: "Theory of Parametric Instability Near the Lower
 Hybrid Frequency" (Physics of Fluids)
1980 - M. Porkolab: "Magnetic Instabilities in a Magnetic Field and
 Possible Applications to Heating of Plasmas" (Nuclear Fusion)
1978 - M. Porkolab and R.P.H. Chang: "Non-Linear Decay and Instability
 of a Non-Uniform Finite Amplitude Plasma Wave" (Physics of Fluids)
1970 - J. Dawson and C. Oberman: "High Frequency Conductivity and the
 Emission and Absorption Coefficients of a Fully Ionized Plasma"
 (Physics of Fluids)
1965 - H. Fishman: "Numerical Integration Constants" (MTAC)
 Tables reprinted in Handbook of Mathematical Functions, U.S.
 Department of Commerce, 1972

CHARLES KISER . 115-05 76th Avenue . Kew Gardens, NY 11418 . (212) 847-0413

OBJECTIVE: PROGRAMMER/SYSTEMS ANALYST

HARDWARE: IBM S/370, S/360; Assorted Peripherals

SOFTWARE: Fortran, Cobol, GPSS, SPSS, STATPACK

EDUCATION: MBA, Operations Research, 1988
Baruch College, Queens, NY
Thesis: "Bimatrix Game Theory"

BA, Computer Science, 1983
Queens College, Queens, NY
Dean's List, 1982, 1983

Regents Scholarship, 1979
Bronx High School of Science, Bronx, NY

IBM Course in ANSI Cobol

EXPERIENCE:

1986 to Present

BARUCH COLLEGE, New York, NY (9/88-Present)
Research Assistant, Educational Computer Center

* Troubleshoot, define and resolve problems regarding new and existing programs in Fortran, Cobol, SPSS, GPSS and any intervening software needs

* Facilitate debugging of programs; review logic sequence and flowcharting; analyze SPSS output

Research Assistant, Statistics Laboratory (9/87-6/88)

* Assisted in applied mathematical and statistical problem solving; programmed for IBM S/370

Research Assistant, Academic Computer Center (9/86-6/87)

* Wrote Cobol programs to analyze other Cobol programs

1985 to 1986

U.S. DEPARTMENT OF HEALTH, EDUCATION & WELFARE, Flushing, NY
Claims Adjuster Trainee

* Charged with judgmental decisions for recipients of social security benefits on basis of submitted evidence

* Researched 15-volume para-legal library to arrive at decisions and compute benefit rates

1983 to 1984

CT CORPORATION SYSTEMS, New York, NY
Programmer Trainee

* Wrote and documented Cobol programs

1981 to 1982

INTERPUBLIC GROUP OF COMPANIES, New York, NY

* Bursted and decollated computer output into report form IBM S/360

* Assisted computer operators: mounted tapes, typed responses on operator console, cleaned tapes, used card sorter

BERNARD LENAPE
135-31 112th Street . South Ozone Park, NY 11420 . (212) 529-8203

OBJECTIVE: SENIOR COMPUTER OPERATOR

HARDWARE: IBM 360/30 RCA SPECTRA 70/35
 BURROUGHS B3500 and 4800 HONEYWELL 100 Series

OTHER SKILLS: Keypunch, Unit Record Equipment, Adding Machine, Manual
 and Electric Typewriter, Record-Keeping

EDUCATION: Elizabeth Seton College, Yonkers, NY
 1988 - AAS, Business Administration

 Borough of Manhattan Community College, New York, NY
 1979-81 - Liberal Arts/Data Processing

 Northeast Region Education Center, New York, NY
 1978 - RCA Computer Systems Certificate in TOS/TDOS

 Institute of Computer Technology, New York, NY
 1977 - Certificate in IBM Punched Card Data Processing
 1972 - Certificate in ABM Keypunch and IBM Keypunch

EXPERIENCE:

1985 to BOWERY SAVINGS BANK, New York, NY
Present Computer Operator

 * Run bank applications on daily cycle; create tape and turnover
 log sheet
 - Use online thrift system (B4800)

 * Debug COBOL programs
 - Compile, test and execute (if program has bug, take memory
 dump and send back to programming)

 * Fill in as lead operator during vacations and absences

1980-1985 AMERICAN INSTITUTE OF CERTIFIED PUBLIC ACCOUNTANTS, New York, NY
 Lead Computer Operator (1983-1985)
 Computer Operator (1980-1983)

 * Used B3500 online accounting system
 - Updated membership records, including names and addresses
 - Maintained records on publications
 - Ran all accounting applications

 * Balanced reports (located errors when reports were out of balance);
 debugged COBOL, RPG and FORTRAN programs

1980 SOCIETY OF AUTOMOTIVE ENGINEERS, New York, NY
 Computer Operator

 * Ran entire computer operation on IBM 360/30; designed in-house
 job request form

1977-1980 BOROUGH OF MANHATTAN COMMUNITY COLLEGE, New York, NY
 Computer Operator

 * Trained students in operation of IBM 360/30, RCA SPECTRA 70/35
 and keypunch machines; supervised student aides; tutored students
 in COBOL programming (BASIC) in basic and advanced applications;
 evaluated performance

 * Compiled and debugged COBOL, ALP, RPG, BAL programs for admini-
 stration and students; maintained tape library

 * Given opportunity to experiment with system to determine extent
 of applications available

JAMES LERO
90 East Compo Road Westport, CT 06880 (203) 226-4014

OBJECTIVE: INFORMATION SYSTEMS MANAGEMENT

SUMMARY: More than 10 years data processing experience in both management and technical areas, with emphasis on systems analysis, troubleshooting and design. Strong background in proposal preparation and presentation.

PROFESSIONAL
EXPERIENCE: DATA COMPUTING, INC., Darien, CT
<u>President</u>

1985
to
Present

* Contract with diverse industry client base to identify, analyze and solve corporate MIS problems of varying magnitudes

* Representative assignments and clients:

 - <u>North American Reinsurance Co.</u>--Managed loss fund accounting system project to permit reserve fund control of potential liabilities

 . Supervised staff of programmers through completion of project after defining functional requirements and providing an approved system documentation

 - <u>Citicorp Industrial Credit</u>--Designed, coded, tested and documented series of on-line finance programs for automatic processing of leasing agreements from proposal through booking stages

 . Programs were written in COBOL using Command CICS and accessing an IDMS data base

 - <u>Marine Midland Bank</u>--Designed, coded and tested most of on-line print programs for international money transfer system

 . Program browsed a data base for completed transactions, generated contracts and confirmations for pre-printed forms, and then routed documents to appropriate printers

 - <u>Drexel Burnham</u>--Designed and programmed Alpha Sort Key Generation system after bidding successfully against several other firms

 . System consisted of COBOL module and four BAL sub-routines that generated sort key by scanning several name and address fields

 - <u>Blue Cross/Blue Shield</u>--Acted as troubleshooter during system testing of batch COBOL medical claims system

 . Researched problem reports generated by testing group and made necessary program modifications

 - <u>U.S. Trust Co.</u>--Modified stock transfer system to conform to Canadian banking regulations

 . System written in BAL using Macro CICS, including numerous user-written macros

 - Currently producing turnkey practice microcomputer software package using most sophisticated data base package in existence as nucleus of management system for psychiatrists and psychologists

TOUCHE ROSS, New York, NY
Systems Analyst

1984
to
1985

* Implemented a Macro CICS data entry system with responsibility for writing all on-line COBOL and BAL programs to collect billing entry and print proof listing on entering branch's printer

 - Maintained CICS control tables for entire development system

SONY, INC., New York, NY
Senior Programmer/Analyst

1983
to
1984

* Evaluated user requests for system modifications and worked with programming staff to implement same

 - Consulted with user to develop program specifications and related operations documentation

 - Wrote batch and CICS Macro COBOL programs for in-house accounts receivable system

METROPOLITAN LIFE INSURANCE COMPANY, New York, NY
Programmer/Analyst

1981
to
1983

* Designed batch COBOL system to collect data for company's Psychological Testing Service, and programmed major portion of it

 - Researched existing 360/20 card system and consulted with user to determine desired enhancements

* Supervised correlation studies on effectiveness of testing system evaluating sales representatives

 - Managed research, discussion, negotiation, presentation, approval, programming and testing of entire system

* Promoted from Programmer Trainee after three months on job

MANAGISTICS, INC., New York, NY
Computer Payroll (Manager)

1978
to
1980

* Authorized printing of payroll checks after validating client input data

 - Dealt directly with clients regarding use of standard input documents and correction of errors arising from previous payroll runs

EDUCATION

QUEENS COLLEGE, SUNY, Queens, NY
1979 - B.A., Anthropology

NEW YORK UNIVERSITY, New York, NY
Intensive 37A Assembler; Advanced 370 Assembler; OSLVS Supervisor
Services & Macros; Introduction to Microcomputers; CICS/VS Macro Programming

CAPABILITIES

Languages: COBOL; 370 Assembler; RPG; Z80 Assembler; Basic Teleprocessing
 Packages; CICS/VS Macro & Command
Data Bases: IMS; IDMS; MDBS (Z80 Microcomputer version)
Timesharing Packages: TSO (with SPF); CMS; On-line Librarian; ICCF
On-line Debugging Packages: EDF; Intertest (On-line Software International)
Hardware: IBM 370; 3030 series; 4330 series, North Star Horizon

Legal

ROWENA SCOTT, Esq.
111-46 96th Drive
Forest Hills, NY 11375

Home: (212) 793-2063 Business: (212) 840-8151

GOAL

Corporate Counsel or equivalent level business position

BACKGROUND

Associate Counsel MANDELBAUM & SCHWEIGER, Esqs.
1987 to Present New York, NY

- Prepared agreements and corporate documents, commercial and
 personal real estate transactions, litigation, some estate
 work in general practice with emphasis on corporate, commer-
 cial and international business law

Associate Counsel/Assistant Corporate Secretary SEIKO WATCH COMPANY, INC.
1974 to 1987 Jackson Heights, NY

INTERNATIONAL - Handled all matters related to international marketing, manufac-
RELATIONS turing and intercorpate relationships

 - Negotiated and prepared contracts and distribution agreements

 - Set up and later divested operation in American Samoa, including
 all negotiations with Samoan government, U.S. Departments of
 Commerce and Interior

 - Represented company in problems involving customs and tariffs

RESEARCH/ - Established and was member of patent policy committee to study
DEVELOPMENT development of new products and improvements to determine whether
 to file patent applications

 - Screened ideas for new products submitted to company; negotiated
 with inventors and prepared legal documents for contractual
 arrangements

LICENSING/ - Initiated in-house patent licensing, trademark licensing
PROTECTION
 - Supervised preparation of and managed litigation in infringement
 matters

CORPORATE - Approved all press releases and advertising
COMMUNICATIONS/
GOVERNMENT - Conducted media interviews; assisted CEO in conducting others
RELATIONS
 - Assisted CEO in public appearances on problems of multi-national
 corporations and corporate case history

 - Wrote speeches and articles for CEO

 - Maintained contact with legislators, administrative and trade
 agencies on national and local levels in all matters affecting
 watch industry

 - Represented company in legislative and administrative hearings

JOINT - Performed all legal work in connection with joint ventures and
VENTURES establishment of subsidiaries, both in United States and abroad

 - Negotiated all agreements, including shareholders' agreements

ROWENA SCOTT/2

MARKETING	° Studied competition (in cooperation with marketing survey specialists) on matters of product quality and brand image, dealer and consumer acceptance
ASSISTANT SECRETARY	° Served as officer of parent corporation and various subsidiary and affiliated corporations
	° Attended all meetings of Board of Directors
REAL ESTATE	° Negotiated real estate transactions including leases, property sales and sale/leaseback contracts; prepared legal documents
EMPLOYEE RELATIONS	° Negotiated and prepared employment contracts; interacted with all departments in personnel relations
	° Represented company's legal position in contact with human rights agencies
	° Maintained legal aid service for employees
	° Served as Director of Bulova Credit Union
GOVERNMENT CONTROLS AND REGULATIONS	° Monitored compliance with trade regulations, including anti-trust, FTC and Wage/Price Control
LITIGATION	° Represented company in proceedings and hearings before administrative agencies, e.g. Human Rights Commission and Environmental Protection Agency
	° Supervised counsel in multi-million dollar litigation (anti-trust, contracts and general business problems); handled some of own trial work
INSURANCE	° Handled all legal matters related to insurance, including directors' and officers' liability

Associate Counsel, Managing Attorney GARY PACKWOOD, Esq.
1973 to 1974 Woodbury, NY

Associate Counsel HART & IRVIN, Esqs.
1968 to 1973 Long Island City, NY

 ° Full range of trial practice: all aspects of pleading and
 practice, client interview, negotiation of settlements, pre-
 trial, appeals

EDUCATION

Brooklyn Law School, Brooklyn, NY
1967 - LLB

Hunter College, New York, NY
1962 - BA, Political Science

BAR STATUS

Admitted to practice in New York State, U.S. Eastern and Southern
District Courts, U.S. Customs Court

BRUCE BONDURANT
35 Nob Hill Avenue
Bridgeport, CT 06610

Home: (203) 335-9077

OBJECTIVE: To employ my tax, legal and business experience in a position with growth potential in a corporate legal department or a law firm.

SUMMARY:
- More than two and one-half years general legal experience involving real estate contracts and titles, estate planning and administration, personal injury litigation and criminal law.

- Experienced in analyzing matters involving personal income taxation.

- Contributed, by invitation, material for 1987 edition, Connecticut Practice Book, Kaye and Effron, West Publishing Company.

Admitted to the Connecticut Bar and United States District Court for the District of Connecticut - 1986.

EXPERIENCE:

June/87 to Present

STEWART S. KLEIN, Attorney-at-Law, Bridgeport, CT

Associate Attorney

* Interview, advise and represent clients in matters pertaining to civil and criminal litigation, collections and domestic relations.

* Draft real estate contracts and leases; negotiate real estate sales/ purchase agreements; conduct title searches.

* Research and prepare pleadings and memoranda.

* Generate new business for firm.

January/86 to June/87

FRANK A. GRIFFITH, Attorney-at-Law, Darien, CT

Associate Attorney

* Worked on matters pertaining to personal income taxation, estate planning and administration; prepared wills.

* Prepared real estate contracts.

* Generated new business; represented clients in criminal, civil and probate court; researched and prepared pleadings and memoranda.

May/85 to January/86

LAWSON & GRIFFITH, Attorneys-at-Law, Darien, CT

Legal Assistant

* Conducted title searches, prepared contracts, pleadings and wills; interviewed clients and performed legal research.

* Joined Frank A. Griffith upon dissolution of partnership.

1981-1982

TAX MAN, INC., Cambridge, MA

Income Tax Consultant

* Interviewed and advised clients on matters relating to personal income taxes; prepared tax returns of varying complexity.

* Clients included students, employed and self-employed individuals.

ADDITIONAL EXPERIENCE (while attending school) - 1983 to 1985

UNIVERSITY OF LOUISVILLE, SCHOOL OF LAW
Louisville, KY

<u>Research Assistant</u>

* Researched questions pertaining to estate law, commercial law and domestic relations.

* Performed legal research of issues involving criminal law and procedure and constitutional law.

* Selected by law professors for this job during last three semesters before graduation.

GEORGE MUNSING, Attorney-at-Law
Bridgeport, CT

<u>Legal Clerk</u>

* Conducted legal research, answered court calendars, performed title searches and prepared pleadings.

FAIRFIELD COUNTY LEGAL SERVICES
Bridgeport, CT

<u>Legal Assistant</u>

* Researched and prepared memoranda for cases involving indigent clients.

EDUCATION:

University of Louisville School of Law, Louisville, KY
1985 - Juris Doctor

Boston University College of Business Administration, Boston, MA
1982 - BS, Business Administration/Economics, Dean's List

Member, Society for Advancement of Management
Representative to Student Government

MEMBER:

Connecticut Bar Association
American Bar Association
ABA Section of Real Property, Probate and Trust Law
ABA Young Lawyer's Section
Stamford-Darien Bar Association
Greater Bridgeport Bar Association

DIANE LOVENDAHL
304 Brooklyn Avenue
Brooklyn, NY 11213
(212) 493-6053

OBJECTIVE: LABOR RELATIONS ATTORNEY

SUMMARY: Experienced and deeply interested in EEO and other personnel considerations with demonstrated ability to arrive at equitable solutions through intense investigative and interpretative procedures. Proven expertise in drafting, developing and amending pension plans; drafting and developing language for group annuity contracts and research/analysis of federal regulations from point of view of employee/management relations. Effective in communication; perceptive and sensitive to socio/job-related problems. Work well under pressure.

EDUCATION: University of Akron School of Law, Akron, OH
1985 - Juris Doctor

Brooklyn College, Brooklyn, NY
1982 - BA, Political Science/English, Economics

RELEVANT EXPERIENCE:

1985-1987 NORTH AMERICAN PHILLIPS CORPORATION, New York, NY
Labor Relations/EEO Department

* Prepared and handled employment discrimination cases

 - Mounted full investigation of each case; interviewed supervisors, department managers and other employees

 - Examined personnel records and documents; researched applicable areas of law; filed briefs and affidavits with appropriate State Administrative Hearings and Appellate Review Boards

* Charged with responsibility for writing affirmative action plans, assisting personnel managers during on-site audits by government agents and acting as consultant in re Federal Maternity Act, Age Discrimination in Employment Act and effects of 1978 ADEA Amendments on Company Benefit and Pension Plans

* Effected reversal of unfavorable charge by compliance officer during one on-site audit, based on alleged violation of Equal Pay Act in regard to female employees (one of several such instances)

 - Researched problem; represented company at hearing; produced documents and records showing that female employees requested certain jobs requiring less facility in English

 - Designed program to instruct non-English-speaking employees in English to provide position upgrading and chances for promotion

 - Instituted craft-apprenticeship programs for women

 - Company was awarded government contract; affirmative action program was approved

* Designed and implemented techniques for maintaining personnel records

Fall 1984	SUMMIT COURT PRE-TRIAL RELEASE PROJECT, Akron, OH Legal Intern

Fall
1984

SUMMIT COURT PRE-TRIAL RELEASE PROJECT, Akron, OH
Legal Intern

* Performed interviewing research and counseling; made recommendations

SUMMIT COUNTY PROSECUTOR'S OFFICE, Consumer Fraud Division, Akron, OH
Investigator

* Investigated consumer complaints; prepared detailed reports

Spring
1984

SUMMIT COUNTY LEGAL AID SOCIETY, Akron, OH
Interviewer/Researcher

* Worked in Family Law, General and Housing Divisions; interviewed
petitioners, researched relevant matters

* Assisted in writing briefs, filing motions and affidavits

Fall
1983

APPELLATE REVIEW OFFICE, University of Akron, Akron, OH
Staff Member

* Performed research; wrote briefs

Summer
1981

NEW YORK CITY DEPARTMENT OF CONSUMER AFFAIRS, New York, NY
Volunteer Complaint Counselor

OTHER EXPERIENCE:

1987 to
Present

BOWNICK, INC., Brooklyn, NY (Family-owned enterprise)
Assistant Manager

* Supervise operations and personnel; enforce company policies and
procedures

* Provide on-the-job training for employees; process weekly payroll
and unemployment insurance claims; maintain excellent employee
relations

* Resolve customer relations problems

PROFESSIONAL AFFILIATIONS:

Association for Black Women Attorneys
Bedford-Stuyvesant Lawyers Association
Council of New York Law Associates

MARILYN GARBER . 344 West 52nd Street, #9R . New York, NY 10023 . (212) 873-6320

OBJECTIVE: Seeking position in social service agency in which I may utilize my legal education and experience as well as my experience in social service situations

SUMMARY: Knowledgeable about legal aspects of community-oriented services and institutions. Experienced in counseling in a variety of situations including drug abuse, mental health, prisoner welfare, retarded adults and income maintenance for public assistance applicants.

EDUCATION: Yeshiva University, Benjamin Cardozo School of Law, New York, NY
1989 - JD

Cornell University, College of Arts and Sciences, Ithaca, NY
1985 - BA, History (Dean's List) New York State Regents Scholarship

EXPERIENCE:

Summer 1988 OFFICE OF THE DISTRICT ATTORNEY, KING'S COUNTY, Brooklyn, NY
Intern (Eugene Gold, District Attorney)

* Assigned to aid Assistant District Attorneys in investigations, Supreme Court, Criminal Court and Sex Crimes bureaus

- Researched legal issues, drafted motions and bills, wrote memoranda of law, helped prepare cases for trial, contacted and interviewed witnesses and complainants

* Participated in research/writing of Methods of Obtaining Physical Evidence from the Defendant (published Fall, 1988)

Fall 1987 FAMILY COURT, BRONX COURT HOUSE (Hon. Gertrude Mainzer), Bronx, NY
Judicial Clerkship

Took notes of trial testimony; did legal research; summarized and catalogued current domestic relations case law

BENJAMIN CARDOZO SCHOOL OF LAW, New York, NY
Law Library Assistant

* Assisted students in use of library, microfilm and microfiche

Summer 1987 HOFFINGER, FRIEDLAND & ROTH, Attorneys at Law, New York, NY
Legal Assistant

* Researched and wrote memoranda regarding criminal, matrimonial and health law; drafted and served motions

1985-1986 TOMPKINS COUNTY DEPARTMENT OF SOCIAL SERVICES, Ithaca, NY
Social Welfare Examiner

* Interviewed public assistance applicants; determined welfare, food stamp and medicare eligibility; supervised income maintenance for 100-household caseload

1983-1985 THERAPIST/YOUTH WORKER/COUNSELOR, Ithaca, NY (While attending school)

Crisis Counselor, Mainline Drug Center - walk-in and phone-in

Youth Worker, Ithaca Youth Bureau - coordinated street theatre group

Therapist, Tompkins County Mental Health Clinic - counseled jail inmates and long-term clinic patients

<u>Aide</u>, Meadow House Center for Retarded Adults - directed dance movement in music

INTERESTS: Singing, sewing, dancing, cooking

PROFESSIONAL AFFILIATIONS:

New York Women's Bar Association
American Bar Association
Rochester Folk Art Guild (clothing design)

Marketing

ROBERTO SEPULVEDA
150 East 40th Street, Apt. 7-J
New York, NY 10020
Home: (212) 687-9000 Ext. 250 Business: (212) 997-8738

OBJECTIVE: INTERNATIONAL BOOK PUBLISHING LINE MANAGEMENT

A line management position in international book publishing with
general management responsibilities

SUMMARY: More than twenty years experience in sales management and admin-
istration in domestic and international book publishing with major
publishing houses. Heavy experience in hiring, training and moti-
vating successful salesmen, new market development, advertising
and promotion.

EXPERIENCE: OPTIMUM INTERNATIONAL BOOK COMPANY, New York, NY

1976-1991 Group Marketing Director - Asia (Based in Tokyo 1983-1991)

* Responsible for sales of all book company products

* Hired, trained, motivated and supervised sales and promotion
 staff of 30 people

* Supervised local sales managers and representatives; coordinated
 sales activities in offices in Tokyo, New Delhi, Singapore, Kara-
 chi, Hong Kong, Bangkok, Manila, Jakarta and Nairobi

* Created and established sales promotion and advertising campaigns
 for Asia and East Africa; calculated and established budgets and
 expenses

* Became first known U.S. publishing representative to open nego-
 tiations with Mainland China; sales there increased from $0 in
 1984 to $500,000 in 1987

* Analyzed potential new markets and established new sales terri-
 tories in Hong Kong/Taiwan, Thailand/Burma, East Africa, Indone-
 sia and Korea

* Increased sales by average of 20% annually since assuming sales
 management position

Manager of Editorial Optimum LatinaAmericana
(Based in Bogota, Colombia, 1982-1983)

* Responsible for sales and distribution of Spanish language books
 throughout South America, except Brazil; for the Caribbean and
 Central America

* Supervised and coordinated 60 warehouse personnel, salesmen,
 editors and order service people

* Supervised publishing of 40 university level Spanish language
 textbooks

* Attained annual sales of $2 million during both years as Manager

Continued

OPTIMUM INTERNATIONAL BOOK COMPANY (Continued)

<u>Manager International Book Co.</u> (Based in Singapore 1978-1981)

* Set up sales and distribution center, which was responsible for sale of all book company products to Asian, East African and some Middle Eastern countries

* As sales manager, also directed and coordinated efforts of ten sales representatives for these areas

* Achieved 25% increase in sales in each of four years in position

<u>Sales Manager/Export</u> (Based in New York 1977-1978)

* Hired, trained and supervised 12 resident sales representatives to sell to markets primarily in Asia, Africa and Middle East

* Planned, organized and conducted sales meetings

* Directed promotion and advertising from New York into those export areas

* Established credit and pricing policies in export market covering 45 countries and 600 accounts

* Increased sales volume by 15%

1970-1976	JOHN WILEY & SONS, New York, NY <u>Sales Manager - Mexico</u> (1974-1976) <u>Sales Representative - Northern California</u> (1970-1973)
1966-1970	ALLYN & BACON INC., Boston, MA <u>Regional Sales Manager - College Division</u> (1969-1970) <u>Sales Representative - Northern California</u> (1966-1968)
1962-1966	THE MENNEN COMPANY, San Francisco, CA <u>Sales Representative</u>
1959-1962	COLGATE-PALMOLIVE COMPANY, St. Louis, MO <u>Sales Representative</u>

EDUCATION:

St. Louis University, St. Louis, MO
1959 - BA, Political Science - History

LANGUAGES:

Fluent Spanish
Speak Japanese

LUTHER BURNS · 300 East 63rd Street, 25C · New York, NY 10016 · (212) 532-3707

OBJECTIVE: DIRECTOR OF SALES/MERCHANDISING - FASHION INDUSTRY

SUMMARY: Ten years experience in successful buying and selling of fashions for men and women at wholesale and retail. Highly knowledgeable of European designs for the American market with proven ability to forecast trends and educate customers to changes in styles. Experienced at working with designers to create selling collections. Have traveled to Italy and France several times a year to study collections and make astute purchases.

PROFESSIONAL HIGHLIGHTS:

1984-1988 RAFAEL FASHIONS, New York, NY
Sales/Merchandising Manager (1986-1988)

* Supervised five-person sales force in developing major accounts for men's and women's fashions ($10 million annual sales)

* Instigated and implemented intensive customer relations program to improve company's position with store buyers

* Worked with designers to create sales-oriented designs
 - Established procedures for controlling design expense

* Accurately projected sales/volume to exercise control over fabric purchases
 - Reduced fabric inventory through program of special cuttings and sales to selected outlets for piece goods

* Effected increase in profit/cost ratio through increase in markup

* Established advertising program in cooperation with stores

* Improved coordination of fabric delivery to factory and finished orders to stores

* Exercised quality control over line design, manufacturing and overall company performance

Merchandise Manager (1985-1986)

* Supervised three people handling key accounts in establishing quality control of designer lines and factory performance

* Acted for company in liaison with manufacturers of piece goods in Italy to exercise control over manufacturing and distribution

* Instigated and implemented records systems for piece goods to coordinate delivery with projected date of manufacture of finished product

* Worked with pattern cutters, technicians and production personnel to ensure excellence of product and on-time readiness of sample line for showing to buyers

* Worked closely with owner/designer to create saleable product at good price for most favorable profit/cost factor

Continued

140

RAFAEL FASHIONS (Continued)

<u>Salesman</u> (1984-1985)

* Opened and developed major accounts with high-ticket stores (Saks, Neiman-Marcus, I. Magnin and Bloomingdale's)

* Responsible for increase in volume from $2.5 million to $8 million

* Guided clients in merchandise selection; projected sales for more effective production

1982-1983 BARNEY SAMPSON, New York, NY
<u>Salesman</u>

* Opened and developed major accounts doubling sales volume to $3 million

 - Brought in Bonwit Teller, Saks and Bergdorf-Goodman

* Educated customers to styling and design of European clothing

* Studied collections in Europe and selected parts of collections for the American market

1978-1982 TYRONE MEN'S APPAREL, Cedarhurst, NY
<u>Salesman</u>

(Started as stockboy while in high school and emerged as top salesman while in college)

* Learned men's European clothing business at retail level giving me opportunity to judge customers' tastes and reaction to style and style changes

EDUCATION: Hofstra University, New York, NY
1982 - History/Political Science

Speak Italian

ARTHUR BERTUZZI　.　66-25 100th Street　.　Forest Hills, N.Y. 11375

(212) 897-7311

SALES MANAGEMENT (TEXTILES)

1984-Present　　President, SPECIAL IMPRESSIONS
　　　　　　　　　Flushing, New York

* Achieved $800,000 average annual sales

* Supervised manufacture of T-shirts, including sell-
 ing, financing, marketing, and establishing overhead

* Reporting to me at the Lindenhurst Plant were:

 1) Production Manager
 2) Shipping Manager
 3) Bookkeeping Department
 4) Accountant
 5) 5 Salesmen
 6) 50 Employees of the cutting and sewing
 department

* Improved working relationships with mills and cut &
 sew staff, resulting in reduced cost of manufacturing
 by approximately 10%

* Developed working relationships with wholesale distrib-
 utors, chain stores, department stores, media sales
 promotion situations, sales reps, individually owned
 T-shirt retailers, and boutiques

* Managed and extended credit to customers when warranted

* Promoted independent contractor reciprocation

* Liquidated company July, 1989

1983-1984　　Sales Manager, GOTHAM KNITTING MACHINERY
　　　　　　　Glendale, New York

* Handled in-house sales

* Gained 35-40 new accounts, at an average billing of $50,000 each

* Maintained gross sales of $5 Million

* Delegated work to 4-5 salesmen worldwide

* Traveled to mills throughout country in order to evaluate
 machinery needs and update and service existing system

* Established long-lasting customers through good will and public relations

* Worked part-time during senior year in college

* Resigned from firm to go into business for myself

EDUCATION

BS (Sociology/Psychology), Queens College 1983

Far Rockaway High School 1978
 Dean's List, 2 years
 Student advisor to school newspaper, <u>The Phoenix</u>

SPECIAL INTERESTS

Languages: French--read/speak; Spanish--read

Member, New York City Chamber of Commerce Board

1983-Present:

 Basketball Coach for last four years, Forest Hills Jewish Center
 Basketball League for 17 year olds

PERSONAL

Age: 27 Married Will Travel
 Own Car

MARLENE PARKS . 725 Ocean Parkway, Apt. 1C . Brooklyn, NY 11218

(212) 941-9759 (212) 870-8210

OBJECTIVE: To employ my expertise in clinical chemistry in a position as a technical representative for a pharmaceuticals or laboratory equipment manufacturer

SUMMARY: More than ten years experience as a graduate biochemist with in-depth knowledge of clinical laboratory procedures and equipment. Proven capability in establishing and implementing work-flow processes for expedited, integrated hospital record-keeping. Specialist in accurate testing techniques.

PRIMARY Gamma Counting Spectrometer Auto Analyzer
INSTRUMENTS Flame Photometer Micro-Centrifugal Analyzer
USED: Atomic absorption Blood gas machine
 Micro Sampler Spectrophotometer

HIGHLIGHTS OF EXPERIENCE:

1978 to ST. LUKE'S HOSPITAL, New York, NY
Present
 Laboratory Technologist

 * Developed and established standards for accuracy of hospital tests and quality control of special procedures

 * Assisted with development and implementation of successful installation of Gamma Counter for use in radioimmunoassay procedures

 - Trained staff, established standards for use of Gamma Counter

 * Perform standard and special clinical tests including analyses of whole blood serum, fluids and urine, using both manual and automated methods

 * Trained and supervise staff of five technicians; maintain good relationship with co-workers; distribute daily workload in high pressure atmosphere

 * Trouble-shoot equipment and serve as consultant on new procedures

 * Drug identification tests

 * Member of IV team

1977-78 ELIZABETH SEATON'S HOSPITAL, Cochabamba, Bolivia

 Biochemist

 * Established and implemented laboratory procedures in new hospital

 * Assisted in introduction of new manual methods; set up laboratory equipment and prepared reagents

 * Performed routine tests in hematology, chemistry, urine, bacteriology and serology and blood bank

1976-77 MINISTRY OF PUBLIC HEALTH-CENTRAL LABORATORY, Cochabamba, Bolivia

Biochemist Trainee

* Worked under supervision of group leader

* Performed routine detailed tests in hematology, serology, para-sitology, bacteriology

Concurrent: FARMACIA COCHABAMBA, Cochabamba, Bolivia

Pharmacist Trainee

* Organized and filled prescriptions

* Prepared special compounds not available from manufacturer: tablets, suppositories, suspensions, solutions and lotions

EDUCATION: University of St. Simon, Cochabamba, Bolivia
1978 - Degree in Biochemistry/Pharmacy
 (Annual Best Student Award with 4.0 grade average throughout five-year program)

Hunter College, New York, NY
1973 - Course in Histology

The American Institute, Cochabamba, Bolivia
1971 - Graduated among five top students

CERTIFIED: Biochemist and Pharmacist
Laboratory Technologist

LANGUAGES: Trilingual: Spanish/English/German
Working knowledge of Italian

STEPHEN FURMAN
150 West End Avenue
New York, New York 10023
Home: (212) 873-6512 Messages: (212) 787-4900

OBJECTIVE: INFORMATION INDUSTRY: MARKETING REPRESENTATIVE

SUMMARY: Seven years of sales and merchandising experience, including technical products. Consistent track record of sales volume increases. Trained sales team. Willing to travel extensively if necessary. Have completed Lockheed Information System's basic course in DIALOG and Radio Shack's TRS-80 Mini-computer course.

EXPERIENCE:

1987 to 1989

ALEXANDER'S DEPARTMENT STORE, INC.
NEW YORK, NY

Assistant Buyer, Appliance Department

* Purchased appliances for retail chain; $7 million annual appliance volume

* Assisted with store merchandising to create additional departmental traffic for 15 stores

* Follow-up on delivery of merchandise

* Monitor distribution of goods to various stores

* Check competitive retailers for comparative pricing

* Act as troubleshooter in solving store management problems pertaining to appliances

1979 to 1987

Assistant Manager of Radio and Television

Promoted to Manager of Calculator Department

* Responsible for operation of calculator department

* Tripled the department's sales from $125,000 to $500,000 during period of sharp price competition

* Increased sales volume each year as manager

* Trained commission team with high morale and low turnover

* Sold (personally) over 15,000 calculators during an eight year period

* Made recommendations to buyers on merchandise selection

* Sold programmable calculators to end "users" including business and technically oriented customers (priced as high as $500)

EDUCATION: DeWitt Clinton High School, New York, NY
 1974 - High School Diploma

 American International College, Springfield, MA
 1979 - BA, History

 Additional Skills and Interests:

 Logic Seminar Mechanics
 Philosophy Statistics
 Communications Financial Research - gold,
 foreign currency markets

PERSONAL: Wish to be based in New York, but will travel.

BARRY ROGERS · 25-25 Parsons Boulevard · Whitestone, NY 11357 · (212) 445-5300

OBJECTIVE: SALES/TECHNICAL REPRESENTATIVE

SUMMARY: Experienced as wholesale and retail salesperson, buyer and technician. Extensive knowledge of photographic market, product lines and product maintenance. Excellent sales track record. Familiar with sales, promotion, merchandising and forecasting of market trends.

EXPERIENCE:

1988 to Present

L.J. CRANSTON CORPORATION, New York, NY
(Rep organization for manufacturers of photographic equipment)

Manufacturers' Representative

* Represent the following manufacturers in Connecticut and Westchester County, NY

 - Holson: photo albums
 - M.W. Carr: photo frames
 - Amphoto: photographic books
 - Harwood: movie and video lighting equipment
 - Taprell Loomis: picture folders

* Opened up 35 to 40 new accounts, increasing sales volume by $100,000

* In first year, sold $300,000 in supplies and equipment

1985 to 1988

ALEXANDER'S DEPARTMENT STORES, New York, NY

Assistant Buyer

* Purchased photographic products and equipment for 15 camera departments with $7 million combined annual volume

* Researched and evaluated new products; identified and defined changing trends in consumer preference

* Analyzed sales figures; planned advertising and sales promotions

* Conducted weekly personal visits to stores to check inventory; supervised display and merchandising

* Extensive vendor contact

1980 to 1985

ALEXANDER'S DEPARTMENT STORES, Rego Park, NY

Camera Department Manager

* Managed camera and calculator departments; supervised and motivated staff of 19

* Purchased bulk of camera department inventory; monitored stock levels

* Advised management on changes in customer preferences and buying trends

ALEXANDER'S DEPARTMENT STORES (Continued)

Book and Stationery Department Manager 1981-1985

* Managed staff of 9
* Purchased and merchandised 95% of all books and stationery; made all merchandising and ordering decisions
* Showed consistent 10% seasonal increase in sales; demonstrated success in targeting merchandise to the needs of the community

Camera Sales Clerk 1980-1981

* Sold cameras and accessories to retail customers

1971 to 1977
HOFSTRA UNIVERSITY, Hempstead, NY
Audio/Visual Technician/Photographer/Darkroom Technician

1977 to 1980
Elementary School Teacher

EDUCATION: Hofstra University, Hempstead, NY
1974 - BA, English/History
1981 - MS, Education

EXTRA CURRICULAR ACTIVITIES:

Hofstra University - Photo Club, Campus Newspaper, Yearbook and Radio Station

Member of Fresh Meadows Camera Club, NY

EARL ORR

150 Lark Court (404) 953-0705 (home)
Marietta, Georgia 30067 (404) 266-8259 (office)

EXPERIENCE TRAVELERS INSURANCE CO. October 1976 to Present

Regional Assistant Vice President/Marketing Operations Officer
Southeast Region Atlanta, Georgia 12/87 to Present

Management responsibility for General Managers of regional branch
offices; areas of supervision include marketing, underwriting,
claims handling, and administrative support.
Directly accountable for results in seven of region's 13 branch offices;
offices produce $125 million in revenues, require operating budget of
approximately $20 million, and employ 750 people.

* Youngest in company to hold position of Market Operations Officer.

* Initiated management actions necessary to change and upgrade
 ineffective leadership in critical branch offices.

* Maximized revenue opportunities through successful producer
 management actions.

* Minimized expense deterioration by developing and implementing
 needed expense control actions.

* Analyzed product and pricing needs, state by state, and worked
 successfully with technical staff to achieve desired filings,
 particularly in commercial lines.

* Effectively represented assigned offices in the annual negotiations
 with Regional Headquarters.

Regional Assistant Vice President/Management Services
Southeast Region Atlanta, Georgia 12/85 to 12/87

Responsible for all administrative support functions including budgeting,
expense control, credit and collections, internal audit, manual and
computer processing operations, employee relations, training and
development, purchasing and real estate.
Provided support to 13 branch offices in 11 southeastern states;
offices produced $225 million in revenues, required operating budget
of approximately $30 million, and employed 1300 people.

- Established decentralized regional operation; management had been centralized prior to 12/85.

- Selected as top region in 1986 and 1987 from an overall administrative support perspective.

- Directly responsible for the corporate wide implementation of a more effective compensation program.

- Developed and implemented computerized monitor and control system for all regional training and developmental activities.

Manager/Administrative Operations
White Plains Service Office White Plains, New York 10/76 to 12/85

Comprehensive management responsibility for Financial Services, Administrative Operations and Personnel.
Prepared, allocated and distributed office operating budget in excess of one million dollars.
Directed personnel in collections, data processing, filing, mail, supply, telecommunications, and typing departments.
Supervised all employment activities; included recruiting, screening, and testing for staff of 120.

- Consistently exceeded assigned productivity standards.

- Functioned as in-house Management Consultant for General Manager.

- Reduced outstanding receivables from $100,000 monthly to only $1,500 without any adverse effect on sales.

- Created a formal orientation program for new employees.

EDUCATION MASTER OF BUSINESS ADMINISTRATION 1980 Iona College
 Major in Organizational Behavior
 Graduated Cum Laude

 BACHELOR OF SCIENCE 1976 University of Bridgeport
 Major in Marketing
 Attended on athletic scholarship

REFERENCES Provided upon request.

R.D. GRANEY · 35 East 46th Street · New York, NY 10016 · (212) 889-9920

OBJECTIVE: __MANUFACTURING/MARKETING COORDINATOR__

SUMMARY: More than five years' experience in competitive design and marketing of brand-name clothing for boys and girls. Highly expert in close coordination of marketing and manufacturing divisions. Demonstrated excellence in supervision of design staff and management of showroom. Possess conceptual acuity in interpreting buyer ideas into saleable designs.

EXPERIENCE:

1986 to Present

PERKY PRINT TEXTILES, INC., New York, NY

Corporate Design Director/Showroom Manager (1/88 to Present)

* Direct design and merchandising of domestic and international line of children's wear with corporate volume of $60 million

* Maintain close and constant communication with marketing executives in establishing achievement of marketing plans

* Coordinate manufacturing and marketing divisions for most effective production of seasonal and standard merchandise

* Manage New York office including showroom, design department and all administrative functions for international division

* Maintain retail-client relations in the field in determination of local and regional taste and demand

* Instigate use of available machinery to produce new lines

* Company maintaining strong market position in recessional climate

* Also carried full responsibilities of Senior Design and Merchandising Coordinator (see below)

Senior Design and Merchandise Coordinator (7/86-12/87)

* Researched market for merchandise mix and capacity for introduction of Perky Print products in particular stores and/or locales

* Established and implemented systems to improve design, color and fabrics of line

Design and Merchandise Coordinator (1/86-7/86)

* Dealt directly with national chain store accounts in development of private label lines

* Established input into models and colors from results of market research

* Designed children's garments for mass production for private label accounts

* Designed line of children's clothing (models, colors, fabrics) for Infants to Girls 7-14, Boys 8-16

7/85-12/85 COLONIAL CORPORATION OF AMERICA, New York, NY

<u>Consultant</u>

* Set up coordinates program for line of boys' and youths' garments from conception to final production
* Structured division based on the development processes of the program for private label sales to J.C. Penney and K-Mart
* Participated in design of men's knit and woven shirt line
* Conducted market research for colors, models, stripes and plaid formations

10/82-6/85 GARAN, INC., New York, NY

<u>Head Designer - Girls' 7-14 Division</u> (7/83-6/85)

* Designed and merchandised Garanimal line
* Designed four collections annually (400,000 dozen - $35 million in retail sales)
* Improved coordination between design, production planning and manufacturing divisions
* Developed new size specifications to increase marketability
* Expanded previously minimal girls' line through development of more feminine silhouettes

<u>Associate Designer - Girls' 7-14 Division</u> (10/82-7/83)

* Assisted head designer in all areas listed above

EDUCATION: Fashion Institute of Technology, New York, NY
1981 - AAS, Major: Apparel Design; Specialization: Children's Wear

CERTIFICATIONS:

Dale Carnegie Institute: Dale Carnegie Personal Development Course
Diploma, July, 1985

MICHAEL REMINGTON, 2 Franklyn Avenue, East Brunswick, NJ 08816 · (201) 238-6201

OBJECTIVE SALES/MARKETING or DIVISION MANAGEMENT

SUMMARY Record of significant contributions to profit levels and productivity in every position held. Capable leader and motivator with broad overview of sales and marketing. Adept at market analysis and conceptualization. Able product spokesman.

PROFESSIONAL ACHIEVEMENTS

1982-1989 FEARON CORPORATION, Piscataway, NJ
Vice President, Fearon Tool Group Division (1988-89)

* Control sales, marketing, P&L, inventory and purchasing for five tool lines with annual sales of $22 million and staff of 250

 - Developed and managed nationwide sales organization of 92 manufacturers' rep firms, 10 direct sales managers and 35 inter-office personnel

* Established sales incentive program resulting in 13% increase in annual sales and previously unparalleled gross profit levels

* Reorganized marketing and creative departments, resulting in increased efficiency and improved market analysis

* Through analysis of item costs, market and competition, increased gross profit share of three assumed lines by 10% in one year

* Resolved marketing difficulties through reorganization to encourage total market penetration

* Expanded merchandising productivity almost 200% through analysis and redesign of merchandising aids after studying competitive aids and consumer acceptance

* Established new product concept and conducted market tests; supervised design, pricing, item selection and selling program

Vice President, Delco Division (1985-88)

* Directed division with annual sales of $13 million; oversaw inventory, quality control, sales and marketing of two tool lines

 - Managed 45 rep firms, 5 direct sales managers and 20 inter-office personnel

* Established and organized national advertising campaign to penetrate all markets

* Increased gross profit share 5% through market analysis and reformulation of marketing program

* Improved product quality and expanded all categories for favorable competition with domestic tool manufacturers, raising sales by 25%

National Sales Manager, Delco Division (1984-85)

* Directed sales force of 45 rep organizations

* Upgraded Delco image from small import to top-quality line, permitting favorable competition with domestic manufacturers; formulized and marketed Pro-Mate as secondary line

<u>Western Regional Sales Manager, Delco Division</u> (1982-84)

* Directed 8 rep organizations throughout 12 states

* Ranked number one in regional sales during 1982 and 1983; sales volumes more than doubled between 1982 and 1984

* Originated merchandising aids and pricing structure ideas which were adopted by home office for implementation throughout company

1976-1982 ALBERTO CULVER COMPANY, New York, NY
<u>District Sales Manager</u> (1980-82)

* Supervised one assistant and 10 salespeople working throughout seven northwestern states

* Awarded President's Cup for highest district sales increase in 1972; in 1973, scored within top third of total districts in company

* Ranked number one district salesman between 1980 and 1982

* First manager in company to hire saleswoman to represent women's health and beauty products

<u>Assistant District Sales Manager</u> (1978-80)

* Supervised five salespeople and headed Len Dawson (Kansas City Chiefs quarterback) promotion program

<u>Sales</u> (1976-78)

* Represented company among drug wholesalers, food trade, mass merchandisers and rack jobbers in Kansas City, Missouri

1972-1976 SHEAFFER PEN COMPANY, Fort Madison, IN

<u>Sales</u>

* Called on retailers and wholesalers in Oklahoma, Kansas and Missouri

EDUCATION BA, Business - Northeast Missouri State University

Professional Seminars:
 Dale Carnegie Sales/Management Program
 American Management Associations

PROFESSIONAL AFFILIATIONS

American Management Associations
National Association of Service Merchandisers
General Merchandise Distributors Conference
Automotive Service Industries Association
Automotive Warehouse Distributors Association

Willing to relocate and free to travel

PETER CHEUNG
32 Burton School Avenue
Westport, Ct 06880
(203) 226-7721

OBJECTIVE: To employ my expertise and experience in international marketing in a senior management position for a manufacturer of industrial or consumer goods

SUMMARY:

— More than 20 years experience in international marketing between Asia and USA-Europe, including industrial and farm equipment and consumer goods

— Thirteen years as manager for consumer goods exporter in Hong Kong

— Expert in locating markets in Asia, negotiating contracts and expediting shipping details and government documentation

— Completely fluent in English, Mandarin Chinese, Shanghai and Cantonese

— Have MBA in International Business

— Intimate knowledge of entire East Asian marketplace with specific knowledge of China

BUSINESS HIGHLIGHTS:

1983 to
Present

C.K. CHAN CO.,INC.
Westport, CT

President

• Have developed market for tannery equipment, chemicals and raw materials in Taiwan, Hong Kong, Bangkok, Singapore and Malaysia

• Conduct market analysis surveys through personal contact with buyers and agents and on-site exploration in trading countries

• Negotiate contracts with suppliers and buyers

• Exploring markets in China proper; negotiations proceeding

• Maintain financial intelligence through correspondence and personal investigation relevant to exchange rates and credit requirements

• Maintain excellent customer service relations through correspondence and in-plant visits

• Transact shipping details: letters of credit, freight forwarding, customs clearances and delivery verification

1979 to 1983	**SHANGHAI TRADING CORPORATION** New York, NY

Vice-President/Executive Manager

- Charged with responsibility for shipment of materials to Vietnam and Cambodia under US Government Aid Program

 - Machinery shipped included: textile fabrication machinery, tractors and tractor-drawn implements for small farms

 - Tools included: digging and chopping tools for farmers; hand tools for factory and construction workers

 - Raw materials included: farm chemicals and fertilizers, plastics for use in manufacturing

 - Full range of consumer products

- Directed all export procedures and processing of US Government documents

1966 to 1979	**WELLMING TRADING CO., LTD.** Hong Kong

Export Manager

- Exported products manufactured in Hong Kong to importers in United States, England, West Germany, Belgium, Italy and France

 - Products included men's and women's garments, gift items, costume jewelry and toys

- Analyzed markets, negotiated sales, maintained customer relations through correspondence and personal visits and processed shipping documents

EDUCATION:

Hong Kong University
1971 — MBA, International Business

Regional College, Hong Kong
1966 — BA, Philosophy

Able and willing to travel extensively

STACY HALL
42 Knot Road
Tenafly, NJ 07670
(201) 567-6987

OBJECTIVE: ADVERTISING ACCOUNT EXECUTIVE

SUMMARY: Ten years' experience in advertising with direct client contact throughout, three years in account management. Demonstrated expertise in budget management. Creative copywriter on variety of industrial, consumer and corporate campaigns including print ads, direct mail, and collateral material. Proven ability to supervise production, assist in new business development, and maintain excellent client relations with all levels of management.

Clients included Conrac Corporation, Maserati Automobiles, McGraw-Hill Publications Company, North American Philips Corporation, Thomas J. Lipton Company, "21" Brands, U.S. Industries, Xerox Corporation and Zeiss-Ikon.

EXPERIENCE:

1984-1988 DOBBS ADVERTISING COMPANY, INC., New York, NY
 Account Executive (1984-1988)

* Successfully planned and administrated advertising and promotion for several clients, in many cases maximizing limited funds through knowledge of media and production (i.e. utilizing free media publicity to support insertions, negotiating most advantageous rate structures and getting the most efficiency from production expenditures)

* Conceived, developed, and directed advertising and promotion programs for numerous industrial and consumer accounts

* Planned and supervised selection and purchase of print and broadcast media

* Wrote or directed copy on all accounts handled

Copy Director (1984-1986)

* Created concepts and wrote copy for print and broadcast media as well as collateral, sales material, direct mail literature, and publicity releases

* Supervised all in-house and free lance copywriting

* Served as client contact on several accounts

* Recommended media schedules

Highlights

* During tenure as account supervisor and head writer, one account experienced 20% sales increases on numerous products

* Developed print ad for leading surveying equipment manufacturer that completely repositioned client in the market, increased sales, and influenced the "look" of future advertising in publication in which it appeared

* Created and directed a campaign which reaffirmed client, the Bank of Toms River, as the number one bank based in Ocean County, NJ

1979-1984 MULLER JORDAN HERRICK/N.J., Inc., Fort Lee, NJ and New York, NY
(Formerly Richard James Associates)
Copywriter and Assistant Account Executive

* Conceived and wrote advertising and promotion copy for print ads and collateral material for industrial and consumer accounts

* Served as account executive for numerous clients

* Planned and purchased media

Highlights

* Created a coupon-response newspaper campaign for retail tire dealer; as a result, client had to restaff and reorganize to handle increased business

* Produced print ad for new account that generated more inquiries from the first insertion than had been achieved by former agency's year-long campaign

1977-1979 KALMAR ADVERTISING, INC., Englewood Cliffs, NJ
Copywriter

* Wrote advertising and promotional copy for consumer and industrial accounts

* Served as copy contact

* Recommended and purchased print and broadcast media

* Developed numerous public relations programs for clients

1976-1977 PRENTICE-HALL, INC., Englewood Cliffs, NJ
Assistant Production Editor

* Planned and coordinated book production from manuscript to completed bound book

* Copyedited and supervised same

* Acted as liaison with authors, suppliers and internal personnel

* Checked galleys, page proofs, blueprints

* Generated advertising copy for book jackets

EDUCATION: Fairleigh Dickinson University, Teaneck, NJ
1976 - Bachelor of Science

LANGUAGE: French

JOHN POWELL . 154 East 49th Street . New York, NY 10011 . (212) 684-8820

OBJECTIVE: <u>CORPORATE ADVERTISING DIRECTOR</u>

SUMMARY: Proven track record in creating and developing comprehensive advertising campaigns, with special emphasis on sales promotion materials, direct response advertising and direct mail. Experienced in negotiation for cooperative advertising. Ability to design and coordinate trade show activities. Highly skilled in all production techniques, creative direction, account management and media selection.

PROFESSIONAL HIGHLIGHTS:

1988 to Present

MKP, INC., New York, NY (Graphics Studio)
<u>Manager</u>

* Direct, coordinate and exercise quality control of production activities

 - Four creative departments: Design, Art, Typesetting and Color Proofing

Clients include: United Technologies, Hearst Publications, Union Carbide

1986 to 1988

INTERSIGHT DESIGN, INC., New York, NY (Packaging Design)
<u>Art Director</u>

* Charged with responsibility for studio production and final art for product packaging

* Selected and coordinated outside services: typesetting, photography/retouching, printing, color proofing

* Knowledgeable about product packaging and marketing

Clients include: Bristol Myers, Pilsbury, Mennen, Hoescht

1983-1986

THE WENK ORGANIZATION, INC., New York, NY (Advertising Agency)
<u>Creative Director/Account Executive</u>

* Managed, directed and supervised creative production

 - Specified and purchased outside support services: typography, photography, printing, mailing lists and media

 - Provided creative concept and direction to 15-member staff including in-house and freelance artists; supervised and personally designed and produced material; edited and wrote copy and headlines

* Assumed management of media department

 - Upgraded department operation through initiation of improved production/traffic systems and contract negotiations

 - Handled an increase in media sales of approximately 200% without additional staff

 - Developed media budgets with most effective allocation for radio, print and some TV

Continued

THE WENK ORGANIZATION, INC. (Continued)

* Managed direct response and coupon advertising campaigns
 - Developed campaigns for various clients; targeted audiences; suggested appropriate media; made account presentations
 - Followed through with total production after client approval
* In-depth experience in direct mail
 - Targeted audiences based on specific criteria
 - Researched list companies; purchased lists for test markets and full scale efforts
 - Designed printed material to be mailed, including personalized letters
 - Monitored responses and fulfillment of campaigns ranging from 5,000-piece test market to half-million piece general mailing

Clients included: Chase Manhattan Bank, Mego Toys, New School, Parsons School of Design, New American Library

1981-1983 THE TYPE FACTORY, New York, NY (Advertising and Graphic Design Studio)

* Directed all creative activities: print campaigns, catalogs, trade show exhibits and sales promotional material

Clients included: R.R. Bowker Company, Library Bureau Division of Sperry, New Process Steel

1981 OTTINO/SOLOMON, INC., New York, NY (Design and Typography Studio)

* As Studio Manager/Designer, was responsible for production including concept, design, type direction, boardwork and process lettering

1976-1978 BOROGRAPHICS, INC., New York, NY (Design and Typography Studio)

* Instituted, directed and promoted growth and operation of full-service graphics and typography studio

EDUCATION John Jay College, New York, NY - Marketing Major

Served apprenticeship in graphics in several art and graphics studios in New York and Los Angeles

GEORGE HALKIADES . 100-55 77 Drive . Forest Hills, NY 11375 . (212) 896-3275

OBJECTIVE: <u>MANAGEMENT - RETAIL OPERATIONS</u>

To apply my experience and expertise in retail management, organization and merchandising in a position with growth potential to general management/executive management level

SUMMARY: More than ten years experience in retail/customer service management with four years definitive experience in full management responsibility and accountability. Skilled in selection of merchandise to attract local customers, merchandising and cost control. Creative in traffic-stopping displays and promotion with keen eye to profitability. Excellent in customer and employee relations.

HIGHLIGHTS OF PROFESSIONAL EXPERIENCE:

Current MAXI-DISCOUNT DRUGS, Richmond Hill, NY
<u>Manager</u>

* Solved problem of confusion over price changes by proposing price-coding system to be circulated to managers of eight stores in chain

 - Proposal adopted by general management has developed into orderly presentation of imminent price changes on merchandise to allow all store managers a method to put changes into effect simultaneously

* Developed creative merchandising plan for Christmas sales

 - Proposed codification of Christmas display set-up to enable local managers to effect same or similar merchandising displays

 - Personally supervised set-up for five of the eight stores

 - Through grouping of Christmas items for easy access, merchandise is moving well in every store in chain with profitable outlook anticipated

1981-1988 F.W. WOOLWORTH COMPANY
<u>Manager - Rego Park, NY</u>

* Developed, instigated and maintained fluid merchandising policy to meet the demands of a changing neighborhood

 - Stocked merchandise to attract different ethnic groups

 - Improved profit picture to turn around operation which was scheduled for closing

* Recommended removal of lunch/fountain operation which was losing money through poor sales and high maintenance costs

 - Instituted expansion of horticultural, shoe and hosiery departments which produced large increases for the year (25% to 50%)

* Initiated merchants' committee of 40 local store managers to install special Christmas lighting to improve night traffic, which had declined considerably over four-year period

 - Night business showed large increase over previous year with minimal cost to all concerned

(Continued)

F.W. WOOLWORTH (Continued)

Manager - Rye, NY (1985-1986)

* Hired dynamic individual to replace retiring operator of lunch fountain that had been steadily losing sales over long period

 - Lengthened hours of operation; hired additional, competent help

* Developed reputation of being "the place to eat" in Rye, especially at breakfast; sales took upward turn and increased dramatically

Positions of Increasing Responsibility - Various Stores (1981-1985)

* Was accepted into Management Trainee program, which included training in merchandising, office procedures, lunch operations and overall management of store

* Was steadily promoted to Assistant Manager, Advanced Assistant Manager and Specialized Assistant Manager prior to official appointment as Manager of Rye store

1977-1981 GLATT TRAVEL, Hicksville, NY
Tour Coordinator

* Managed arrangements for world-wide tours of 20-30 people

 - Scheduled tours; booked members into hotels; dealt directly with carriers for most timely and economical travel accomodations

* Interacted with people at all levels on a one-to-one basis

* Booked in excess of $20,000 per year in general and customized tours

EDUCATION:

Queens College, Flushing, NY
1977 - Majored in History

SPECIAL INTERESTS:

Reading, stamp collecting, sports events

BETTY AMES • 24-54 Lancaster Avenue Jamaica, New York, NY 11432 • (212) 521-7240

OBJECTIVE: Product management position utilizing diversified marketing
 experience and strong analytical skills

EXPERIENCE: STATLER-MORRISON, INC., New York, NY
 1988 Account Executive
 to Supervised marketing and advertising of two major accounts:
 1989
 HAIRCARE, INC.

 * Developed and implemented $10 million advertising budget

 * Created new product "Le monde" and new color line
 "Corsage D'Amour," increasing both market share and
 profitability

 * Supervised research, media, creative and production
 staffs

 * Designed media plans for placement of print and network
 advertising

 * Developed all necessary production estimates and cost
 analyses for advertising campaigns

 * Prepared and presented product strategy statements to
 senior management

 STILL SPIRITS, INC.

 * Prepared and implemented $3 million advertising budget

 * Planned, positioned and launched major new product
 "Bourbon Royal" in response to market need, including
 packaging, pricing and merchandising

 * Developed promotional packages, point-of-purchase
 displays and sales force incentive programs

 SIMMONS AND STERNS INC., New York, NY
 1987 Senior Research Analyst
 to
 1988 * Formulated and implemented quantitative questionnaire to
 forecast marketing trends

 * Prepared and presented marketing recommendations to
 clients, based on survey feelings

 * Predicted potential market share for new product entries
 based on qualitative and quantitative analyses of con-
 sumer response

Summer 1985	CHESEBROUGH POND'S INC., Greenwich, CT

Summer
1985

CHESEBROUGH POND'S INC., Greenwich, CT
<u>Research Analyst</u>

* Conducted design testing for product packaging

* Developed and prepared commercial evaluation reports

EDUCATION:

UNIVERSITY OF PENNSYLVANIA, Wharton School
1986 - BS, Marketing
1986 - BA, Psychology

* Dean's List, 1984 - 1986

HARVARD UNIVERSITY, Graduate Program in Clinical Psychology
1985 - Study of Small Group Communication

PERSONAL:

* President, Juvenile Diabetes Foundation

* Extensive travel throughout Europe and Middle East

WAYNE PENDERGRAFT . 4121 Seaview Avenue . Brooklyn, NY 11203 . (212) 469-4725

OBJECTIVE: SALES/SALES MANAGEMENT

SUMMARY: Five years experience in sales and production management with
 effective, low-key approach to promotion of business appreciation.
 Demonstrated expertise in staff motivation for quality production
 of product in highly competitive industry. Strong ability to
 establish and maintain excellent customer relations in turn-around
 of company image. Fully knowledgeable about account management
 from point of initial contact to impact on bottom-line profitability.

EXPERIENCE:

1984-1988 ALL PURPOSE IDENTIFICATION, LTD., Kingston, Jamaica
 Sales Manager

 * Charged with effecting turn-around of company that was losing
 sales and revenue due to poor image

 * Established and maintained excellent customer relations program

 - Heeded customer complaints on product quality and took steps
 to institute major quality control system

 - Negotiated contracts to ensure adherence to orders by the
 customer and delivery by company

 * Directed activities of five salesmen in promotion of identification
 badges

 - Motivated, routed and monitored staff efforts; established
 incentive system for surpassing set quotas

 - Traveled with each salesman on periodic basis to assess per-
 formance and customer acceptance of personality and sales
 presentation; offered suggestions for improvement where needed

 * Instituted and systemetized sales call program to ensure regular
 visits by representatives with positive service attitude

 - Customers responded through increased orders

 * Administered collection process

 - Worked with slow-pay customers to establish reasonable base
 for time payments

 - Improved collections by 45%

 * Opened several new major accounts

 * Improved overall sales volume by 35% each year

 * Set incremental pricing policy to cover constantly rising costs
 of imported materials

 - Sold policy to customers who agreed to abide by it

 * Developed effective advertising campaign with ads in local
 papers and on radio; wrote all copy

 (continued)

ALL PURPOSE IDENTIFICATION, LTD. (continued)

Production Manager

Charged with re-establishing rapport with customers with serious complaints on quality of product

* Called on each dissastified customer; ascertained problem customer was having with product and/or company performance

* Quietly persuaded each customer to "bear with us" and that as new Production Manager I would take necessary steps to improve quality and delivery times

 - Initiated, established and maintained systems for improving quality of product and high degree of quality control on a continuing basis

 - Initiated, established and maintained shipping systems to ensure on-time delivery to customers

 - Program resulted in keeping the accounts in-house and receiving larger and more frequent orders and referrals to new customers

* Increased productivity and efficiency of production staff

 - Set clear standards of performance in regard to punctuality and responsibility

 - Established incentive program for adherence to rules

 - Attracted higher quality of personnel to work in plant

* Improved performance, again, resulted in increased sales volume and better customer relations

1983-84 GOODYEAR TIRE, LTD., Kingston, Jamaica
Sales Manager (while attending school)

* Directed activities of three salesmen; set sales quotas and performance standards

* Personally opened 12-15 new accounts (local firms and gas stations)

EDUCATION: College of Art, Science and Technology, Kingston, Jamaica
 Personnel Management

 Jamaica School of Business, Kingston, Jamaica
 Accounting

SKILLS: Knowledge of laminating and pouching machinery, embosser, Polaroid Land ID-2 and 4-way ID cameras

JANICE WHITE
205 Bushnell Avenue, Hartford, CT 06103
Home: (203) 522-2193 Office: (203) 241-4202

OBJECTIVE SENIOR BUYER FOR AGGRESSIVE, MULTI-STORE RETAIL OPERATION

SUMMARY Highly motivated buyer with four years domestic and import experience in various retail furniture departments. Strong color and design sense with ability to identify market winners. Creative and effective merchandiser; good advertising and budgeting skills. Nation's youngest casegoods buyer.

EXPERIENCE STERN AND COMPANY, Hartford, CT
Buyer, Bedroom, Dining Room, Occasional and Lifestyle Furniture

1987 to Present
* Purchase for and manage $2 million inventory throughout eight stores representing average of $22 million in annual revenues
 - Supervise all aspects of retailing from product purchasing through merchandising to floor presentation
 - Hire, train and supervise assistant buyer and sales staff of eight
 - Formulate and administer departmental objectives; prepare long-range plans

* Increased volume of Lifestyle Department from $200,000 to $800,000 in one year (Ranked #1 Lifestyle Buyer for all Stern and Company stores)

* Personally selected program for importing profitable, high-volume line of European chairs, with assistance of head marketing representative for the Stern and Company
 - Visited nine Italian factories to assure best product and value, with goal of achieving additional $3 million in sales

* Organized cooperative publicity venture with Museum of Modern Folk Art in conjunction with marketing effort for new casegoods line
 - Worked up seminar/slide show conducted by museum director of collection on which product line was based, and which attracted 50 potential customers

* Promoted from Assistant Buyer to Buyer after only three months on job

1986 to 1987
W & J DOANE, New York, NY
Assistant Buyer

* Assisted buyer for bedroom and dining room, mattresses and sleep sofas, and contemporary and occasional furniture departments

* Promoted from Trainee Assistant Buyer after only four months on job, as part of University of Massachusetts Internship program

1985
W & J DOANE, San Francisco, CA
Floater (summer, junior college year)

* Assigned to various departments: Advertising, Accounts Payable and Accounts Receivable, Personnel, Decorating Studio, Executive offices

1983
STERN'S DEPARTMENT STORE, Boothbay Harbor, ME
Salesperson, Women's Specialty Operation (summer, freshman college year)

1983
CLOTHES CORNER, Acton, MA
Salesperson, Women's Discount Operation (between high school and college)

EDUCATION UNIVERSITY OF MASSACHUSETTS, Amherst, MA
1987 - BS, Retail Merchandising

INTERESTS Photography, Sailing

DAVID BENCKE . 300 East 93rd Street . New York, NY 10028 . (212) 737-6620

OBJECTIVE: <u>MEDIA SALES - PRINT/BROADCASTING</u>

SUMMARY: Results-oriented salesman with proven ability for productive effort. Broad background in self-education through employment in different types of industries as well as extensive travel throughout United States, the Caribbean, Latin America and Europe. Excellent verbal skills. Proficient in French. Strong in interpersonal relations.

RELEVANT EXPERIENCE:

1988 TREND NEWSPAPERS, INC., Boston, MA
<u>Account Executive</u>

* Serviced established accounts; contacted and sold new accounts

* Presented prestige concept of publication to prospects; assisted clients in ad design and composition

* Worked with clients in establishing new format for ads when publication changed size from tabloid to magazine

* Maintained excellent customer relations with established accounts through reinforcement of magazine concept

* Brought in two important accounts in first week

Concurrent TIME/LIFE LIBRARIES, INC., Boston, MA
<u>Telephone Sales Representative</u>

* Developed sales of Home Improvement Series through phone contact with people in their homes

 - Established nineteen new accounts in four days (200 calls, 50 pitches - working four hours per day)

1987
(Christmas
Season) BARNES & NOBLE BOOKSTORE, Boston, MA
<u>Sales Clerk</u>

* Maintained company policy of instant and courteous assistance to customers; set up displays for best attraction; helped with inventory

OTHER EXPERIENCE:

1987 73 MAGAZINE, INC., Peterborough, NH
<u>Book Production Assistant</u>

* Edited manuscripts and other copy; proofread and corrected galleys; selected type; produced rough pasteups; participated in research

1980-1986 SUMMERTIME AND PART-TIME JOBS WHILE GOING TO SCHOOL

- Lumber Industry, Missoula, MT - sawmill assistant
- Management Consulting Firm, Durham, NH - groundskeeper
- Construction Industry, Lee, NH - swimming pool installation
- Laundry Industry, Portsmouth, NH - delivery driver
- Prescott Park Arts Festival, Portsmouth, NH - art instructor
- Also: crewed on 65 ft. ketch; housepainter, Alaska; landscape gardener; grape harvester in France

EDUCATION: UNIVERSITY OF NEW HAMPSHIRE, Durham, NH
1986 - BA, English; Minor: French
ALLIANCE FRANCAISE, Paris, France
1984 - French

RUSSELL CARTER • 2-20-4 KUDAN KITA, CHIYODA-KU • TOKYO 102, JAPAN

Home Phone: (011-81-03) 262-3412

OBJECTIVE: **MAGAZINE PUBLISHING MARKETING CONSULTANT**
SALES MANAGEMENT

SUMMARY: More than 20 years of high productivity in sales, sales management and market-
ing for major magazine/book publisher. Demonstrated expertise in direction of
Far East operations with in-depth knowledge of Australasian business practices
and procedures. Highly successful track record in creation, training and motiva-
tion of sales force. Proven ability to generate exceptional increases in circulation
and advertising sales.

HIGHLIGHTS OF EXPERIENCE

1965 - 1988 UNIVERSAL INDUSTRIES, INC., New York, NY

UNIVERSAL PUBLICATIONS CORPORATION, Tokyo, Japan
Director of Asia Pacific Operations (1986-1988)

Directed all business operations in Japan, Australia, Singapore, the Philippines, Taiwan, Hong
Kong and South Korea; supervised space sales and circulation for 28 publications; investigated
and researched business and joint-venture potential throughout Asian and Australian markets

- Managed definitive sales effort resulting in 21% ($500,000) increase in advertising space
during first year in Japan

 — Supervised staff of 20 sales, promotion and clerical personnel; conducted regular motiva-
 tional meetings to establish and examine strategies for deeper market penetration

 — Accompanied Japanese salesmen in calls on customers and prospects in direct sales pre-
 sentations to top management; traveled throughout Asian and Australian territories to
 work with independent sales representatives in Hong Kong, Melbourne and Sydney

- Investigated, researched and drew up presentations of potential acquisition or joint venture
investments for corporate consideration

 — Met with scores of other publishers, entrepreneurs, writers and correspondents throughout
 Asia to assess publishing ideas

 — Determined value of and recommended four new Asian ventures worthy of presentation
 (two are pending, two others tabled for future reference)

 — Interfaced with executives of two major Asian joint ventures: Nikkei Universal, Tokyo;
 The American Industrial Report, Hong Kong (monthly publication directed to People's
 Republic of China)

- Met periodically with Japanese counterparts to advise them on promotion tactics, circulation
development and advertising sales strategies; advised Hong Kong group on special projects
(personal efforts helped Japanese associates generate $100,000 in current new business)

- Facilitated closer cooperation between corporate office in New York and Far Eastern/
Australian representatives (was first person from Universal management Australian rep-
resentatives had seen in seven years)

 — Assessed problems in Australia; instituted new procedures resulting in $100,000 new
 business.

Continued

UNIVERSAL PUBLICATIONS CORPORATION (Continued)

- — Advised corporate management on advertising/promotion programs for *Business Week*'s new Asian Edition (programs covered both advertising and circulation strategies)

- — Successfully assisted and advised Hong Kong representatives on special *Business Week* sections featuring Korea and Taiwan

- — Instrumental in contributing to sales increases in Hong Kong, Singapore, Melbourne and Sydney

- Explored circulation problems and opportunities throughout Asia in relation to all 28 Universal magazines with particular emphasis on *Business Week*

 - — Consulted with customers, sales organizations, distributors and air freight companies; improved delivery service through elimination of shipping bottlenecks

- Selected by United Nations, Geneva, to participate in Singapore seminar (1979); discussed advertising, sales promotion and research with export management

UNIVERSAL (BUSINESS MONTH), Houston, TX
Account Manager (1968-1976)

- Successfully sold both product and corporate advertising campaigns in tough, competitive market including South Texas, Louisiana and Mississippi

 - — Demonstrated outstanding achievement in face of strong competitors — *Fortune, Forbes, Wall Street Journal, Time, Newsweek, U.S. News and World Report*

UNIVERSAL PUBLICATIONS COMPANY, Houston and Dallas, TX
Advertising Sales Representative (1963-1968)

- Sold space in as many as 28 different publications covering such fields as power, construction, electronics, aviation, computers, mining and electric utilities

 - — Uncovered technical equipment manufacturers serving specific industries (presented them with marketing data to aid them in marketing their products)

EDUCATION: University of Illinois, Urbana, IL (Attended on merit scholarship)
1963 - BS, Journalism, Advertising
Member of Alpha Delta Sigma (Advertising Fraternity); Illini Marketing Club

PROFESSIONAL AFFILIATIONS:

Tokyo: American Chamber of Commerce in Japan (Served on China Trade Committee; directed Publication Advertising Committee)
Foreign Correspondents Club of Tokyo
Forum for Corporate Communications
Tokyo American Club
Pacific Area Travel Association

Hong Kong: Hong Kong Press Club
American Chamber of Commerce in Hong Kong (Served on China Trade Committee)

Other: Chamber of Commerce, Houston, Texas
Houston Advertising Federation
Business and Professional Advertising Association
Houston Illini Club (University of Illinois alumni); President four years

ESTHER BURNS 300 Adelphi Street Brooklyn, NY 11205 (212) 795-1657

OBJECTIVE: BROADCAST MEDIA BUYER

SUMMARY: Experienced buyer in both national and local radio and TV. Skilled in negotiations, client relations, planning and market analysis

HIGHLIGHTS:

1987 to
Present

ZEA MARKETING COMMUNICATIONS, New York, NY
Media Director

* Planned and selected media campaigns in agency with billings of 3 million annually. Client list included:

 - FSC Corporation
 - ABC-FM owned stations
 - Fall's Poultry
 - Handleman's Garden Center

* Participate in all phases of planning, including client contact, negotiations with media and payment of affidavits

* Successfully negotiate client/media relations:

 - Obtain favorable rates for clients
 - Convince well-known media personalities to endorse client services
 - Secure favorable positioning of announcements during prime time at no extra cost

* Planned and administer all details of $40 thousand Yellow Page budget for a national telecommunications client

* Established in-house specialty trade research library which ensures speed and accuracy of information delivery to client companies

* Perform continuing and ongoing liaison between agency, media and clients, resulting in excellent rapport and improved service

1984-1987

FOOTE CONE AND BELDING, New York, NY
Broadcast Buyer

Client list included:

 - Bristol Meyers
 - Noxell Lestoil
 - Frito-Lay
 - Campbell Soup Company

* Monitored rate, affiliate and programming changes

* Negotiated favorable radio and television rates and buys

* Developed improved reporting system to provide clients with faster GRP information; (system was adopted by buying group and remains in current use); this significantly improved client relations

* Worked closely with clients to coordinate contests and merchandising promotions

 - Coordinated 40+ stations for Long & Silky promotion

* Established format for facilitating the provision of aircheck and GRP information to clients; "sold" new procedure to both stations and clients, cementing client/agency relations

* Organized contract book and monitored buys for clients and agency

* Charged with approval of make-goods and spot preemptions

(Continued)

FOOTE CONE AND BELDING (Continued)

<u>Estimator Print/Broadcast</u>

* Coordinated buys and issued media estimates which contained:

 - Total gross dollars spent
 - Number of stations used
 - Total GRPs
 - Length of announcements
 - Scheduled flight dates

* Issued discrepancy reports; maintained continuing rapport between station reps and billing department

* Organized various computer reports and distributed finished estimates to clients

1983 KENYON AND ECKHARDT, New York, NY
<u>Accounts Payable Clerk</u>

* Disbursed payments and processed vouchers

1980-1982 WILLIAM ESTY ADVERTISING, INC., New York, NY
<u>Print Estimator</u>

* Coordinated planners' insertion orders and compiled print estimates through use of Standard Rate and Data books

* Checked tearsheets; made lineage adjustments; facilitated payment of invoices

* Handled rebates, short rates and compiled final lineage reports

EDUCATION: Junior College of Albany
Business Marketing

JOSEPH WANG
822 North Sixth Street
Brooklyn, NY 11211
Home: (212) 387-5420 Business: (212) 763-9571

OBJECTIVE: SALES/MARKETING - CABLE TV/TV SYNDICATION
To employ my time sales/marketing experience in a
position with growth potential in the industry

SUMMARY: Extensive experience in broadcasting industry as
account executive in sales and service of major
accounts. Successful track record in acquiring
direct accounts as well as additional business through
advertising agencies. Adept in creation of adver-
tising campaigns to sell sponsor's product. Worked
extensively with TGI, Simmons and Scarborough market
research.

PROFESSIONAL
HIGHLIGHTS: WYZO/AMERICAN GENERAL, New York, NY
 1984 to Account Executive
 Present * Beginning at zero base, created list of accounts
 with annual billing of $250,000

 * Presented marketing studies and created campaign
 that brought Berdorf-Goodman to the use of radio
 advertising for the first time

 - Designed special Columbus Day coat sale
 promotion (proved more successful than sponsor
 had anticipated)

 - Consulted with Berdorf-Goodman executives;
 advised on buying time on other radio stations
 in New York, Chicago and Philadelphia

 * Deal with account people at all levels of
 advertising management both in client and agency
 contact

 * Communicate promotional ideas to retailers
 utilizing radio/in-store promotion tie-ins

 - Created successful radio campaign and
 commercial for La Mode Fashion; designed
 co-op campaign for Minolta, Polaroid and
 Goodyear; developed major campaign for Macy's
 Shoe Department

* Established major cooperative advertising programs between manufacturers and dealers

* Design marketing research to position station demographics (specifically to the 18-34 age group)

* Developed and presented marketing research to Westinghouse

 - Resulted in first buy of a contemporary radio station

KRMI RADIO, Oakland, CA
1982 to
1984
Account Executive

* Beginning at zero base, developed account list with $100,000 annual billing

* Designed marketing research and evaluated merchandising concepts for client use

* Worked with clients in determining marketing problems; provided successful promotional ideas

KRAC RADIO, Alameda, CA
1981 to
1982
Account Executive

* Handled all record industry accounts and major advertising agencies in San Francisco Bay area

 - Increased billing by 120%

JACK WODELL & ASSOCIATES (Advertising Agency)
1980 to San Francisco, CA
1981 Mailroom Supervisor

EDUCATION: UCLA, Los Angeles, CA
 1980 - Graduate courses in Marketing and Advertising

 University of Denver, Denver, CO
 1980 - BA, History, Political Science

 Golden Gate University, San Francisco, CA
 1981-1982 - Marketing courses

SANDRA NURENBERG . 400 East 77th Street, Apt. 2625 . New York, NY 10162 . (212) 734-2648

OBJECTIVE: TRAVEL SALES/SALES PROMOTION

To apply my broad knowledge of and experience in the travel industry to a position in sales or sales promotion with a solid energetic operation in the travel field.

SUMMARY: Wholly knowledgeable of the travel industry. Experience includes positions in sales and sales promotion in varied phases of the industry. Have lived, worked and traveled in Europe, Latin America, Asia, Africa and 40 of the 50 United States (including Alaska and Hawaii), providing priceless first-hand knowledge about much of the world.

RELEVANT EXPERIENCE:

1987-1991 INTERNATIONAL WOMEN'S CLUB OF COPENHAGEN, Copenhagen, Denmark
President

* Founded the organization in 1985; founded club magazine in 1986

* Responsible for all financial affairs of the organization; raised in excess of $300,000 for philanthropic purposes

* Worked with embassies, tourist offices and airlines to arrange monthly programs and philanthropic projects throughout the world

* Organized and arranged all tours throughout Scandinavia and Eastern Europe

* Chaired meetings of 10-member board and monthly meetings for 250 general members; addressed various organizations and associations regarding functions of Club

* Sold 90% of all advertising to, and received donations from, major international corporations and organizations

* Coordinated editing, proofreading and layout of magazines with staff and printers

* Wrote press releases for use on TV and radio and in magazines and newspapers

1985-1987 AMERICAN WOMEN'S CLUB IN DENMARK, Copenhagan, Denmark
President

* Functions similar to those performed with International Women's Club

* Worked with universities and foundations in Denmark and United States to further club's scholarship program

* As a member of Danish-American Committee, co-ordinated activities with Danish Foreign Affairs Office

* Personally presented club's book to the Queen of Denmark prior to her departure for the United States

* Raised funds for and assisted in planning of student group tour of United States, including housing

1982-1983 ECOLE SUPERIEURE D'AFFAIRES ET de SECRETARIAT, Brussels, Belgium
Business English Lecturer

* Taught American business techniques from letter composition to filing systems to 80 women students from 16 countries

* Gave private consultations to individual students and to interested employers

1980-1981 BELTZ WORLD TOURS, San Francisco, CA
Travel Consultant

* Met with retail accounts and individual clients and formulated plans and made arrangements for transportation, hotel accommodations and tours for business and pleasure

* Sold Asian travel packages including cruises and steamship lines

* Top sales representative for three consecutive months with fewest cancellations

* Travelled extensively to Europe and Latin America; coordinated tours with competitive travel agencies

1979-1980 JAPAN EXTERNAL TRADE ORGANIZATION, Chicago, IL
Administrative Assistant

* Supervised Chicago showrooms and displays

* Arranged special promotions and exhibits for trade shows, state fairs and exhibitions in the Midwest promoting Japanese products

* Hired personnel to work special exhibits

* Worked with management of various hotels in setting up conferences, banquets and receptions

* Created, administered and arranged for public reaction questionnaires to be given out to people viewing products and exhibits

* Worked special assignments in Tokyo, Osaka and Vienna

1977-1979 NORTHWEST ORIENT AIRLINES, Chicago, IL
Reservation Sales/Service Agent

* Processed reservations and tickets for domestic and international flights; maintained passenger manifests

* Handled cancellations; investigated passenger complaints

1972-1977 HERTZ CORPORATION, Chicago, IL
Station Manager

* Supervised 12 employees

* Coordinated all office procedures including processing monthly accounts, acquisition of office supplies and equipment with the main office

EDUCATION: Northwestern University, Evanston, IL
1974-75: Liberal Arts/European History

Loyola University, Chicago, IL
1975-76: Liberal Arts/European History

Florence Utt Business School, Indianapolis, IN
1971-72: Business Administration

LANGUAGES: Danish, German, French (read and write)

LEAH GARST
1182 Hancock Street
Washington, D. C. 20008
(202) 345-7787

OBJECTIVE: ORGANIZATIONAL FUND-RAISER

To apply my experience in fund-raising to a position for a recognized non-profit organization, or foundation, or a privately-endowed educational institution, possibly entailing some travel.

SUMMARY: More than seven years experience in direct fund-raising. Demonstrated expertise working with governmental and non-governmental agencies. Traveled extensively in Europe, Latin America and the United States.

EXPERIENCE: EPICURES CLUB OF NICE, FRANCE

1981 to 1989

President/Founder

Responsible for all financial affairs; raised $300,000+ for philanthropic purposes.
Worked with embassies, tourist offices and airlines to arrange monthly programs and philanthropic projects throughout the world; organized and arranged all tours.
Addressed various organizations regarding Club functions.
Wrote press releases for use on TV and radio and in magazines and newspapers.

HELEN TOURS, Aspen, Colorado

1979 to 1981

Travel Consultant

Top sales representative for two consecutive years with fewest cancellations.
Traveled extensively throughout Europe and Latin America; coordinated tours with competitive travel agencies.

EDUCATION: Vassar College, Poughkeepsie, New York
BA Literature/History 1979

LANGUAGES: Fluent in French, German, Italian and Spanish

REFERENCES: Provided upon request.

Operations

KENNETH CANNON 2403 Needham Street, Brooklyn, NY 11235 (212) 646-7522

OBJECTIVE: INVENTORY CONTROL MANAGER
To employ my expertise in inventory control with a multi-national corporation in a position with growth potential to Operations Manager

SUMMARY: More than five years experience in inventory control and production planning. Strong ability to gain confidence and cooperation of production management to alleviate inventory problems. Knowledgeable about BASIC and COBOL languages and the use of computers. Multilingual, fluent in Swedish, Polish and Russian, with working knowledge of German and Norwegian.

EXPERIENCE HIGHLIGHTS:

1987 to Present WHALEDENT INTERNATIONAL (Dental Products)
New York, NY

Production Controller/Planner

* Charged with the detail planning and release of work orders to four production departments in accordance with Master Schedule

 - Plan material requirements

 - Requisition purchases

 - Interface with production supervisor and materials manager

* Improved planning system through use of MRP principles; introduced use of more efficient instruments for shop floor control

* Pinpointed inventory management problems through use of ABC analysis in estimation of excess inventory

1984-87 THORN LIGHTING DIVISION AB (Subsidiary of Thorn Electrical Ind., London)
Stockholm, Sweden

Inventory Control/Purchasing Supervisor

* Charged with responsibility for purchasing $5-$6 million/year of lighting equipment, reporting directly to financial controller

* Established inventory levels for four regional warehouses

 - Implemented and assisted in designing control system

 - Decreased value of inventory with 40% (approximately $250,000) savings per year

 - Increased inventory turnover and service level

* Controlled procedures for Purchasing Department

 - Set up and followed yearly supplies budget

 - Purchased products from Thorn's factories in England

* Worked with Data Division to computerize order processing procedures with subsequent savings in manpower

 - Implemented ABC Analysis

 - Member of select management team to implement integrated MIS

(Parent company has annual gross of one billion pounds sterling)

1982-84 SIEMENS AB, Stockholm, Sweden (Subsidiary Siemens AG, West Germany)

<u>Inventory Control Planner - Lighting Fixtures Division</u>

* Charged with planning for sales and manufacturing, setting inventory levels for six regional warehouses and planning for future production based on marketing forecasts and production capacity

* Established inventory control system through use of computer reports

* Implemented Master Production Schedule for local factory

* Generated sales statistics for marketing and sales departments

* Promoted from office clerk within six months of employment in recognition of my analytical ability and studies

 - Worked full time while attending school

(Parent company is sixth largest in world in its field with annual gross of approximately $16 billion)

EDUCATION: Stockholm University, Stockholm, Sweden
1986 - B.A., Business Administration

Quantitative Methods for Business Decisions
- Marketing/Management

MEMBER: American Production-Inventory Control Society

BRUCE FREEMAN
720 Ocean Parkway
Brooklyn, New York 11218

Home: (212) 436-9928 Office: (212) 689-7523

OBJECTIVE: SENIOR MANAGEMENT - CONSUMER PRODUCTS

SUMMARY:
- More than 17 years of bottom line responsibility in manufacturing, marketing and merchandising consumer products

- Creative and innovative in product management encompassing purchase of raw materials, design, production, merchandising and sales

- Aggressive and energetic salesman with discerning ability to analyze market trends and forecast consumer demands

- Strong motivator of merchandising team, able to spark imagination and productivity

- Capable of producing quality merchandise in competitive market with excellent cost/profit ratio

CAREER HIGHLIGHTS:

1975 to
Present

SHAPIRO & SON CORPORATION, New York, NY
Vice President, Director of Purchasing and Production (1981-Present)

* Developed cost reduction apparatus and profit improvement systems and set annual production budget

 - Implemented and tightened procedures effecting increase in percentage of net profit

 - Researched and managed installation of computer system components facilitating sophisticated forecasting of piece goods requirements, production scheduling and sales volume

* Created new products and designs, some of which remain as staples in company's line

* Controlled sales of special promotions to major retailers, national chains and catalog houses

 - Maintained close and active contact with top buyers

 - Created products for specific promotions; negotiated sales; worked up sales proposals for account executives

 - Realized $3.5 million in "plus" sales from three orders

* Devised system for merchandising discontinued styles, turning projected losses into net profits exceeding $250,000

* Established more effectual control system over packaging and distribution to more than 3,000 outlets, reducing claim rate to less than ½ per cent

SHAPIRO & SON CORPORATION (Cont'd.)

* Improved control systems of record keeping, retention scheduling and perpetual inventory

* Developed recruitment and training programs; heightened employee interest through education of company services and products

Production Manager (1978-1981)

* Responsible for planning, scheduling and coordinating production for all factories employing more than 700 people

 - Purchased raw materials, scheduled production cycles in relation to marketing trends, consumer demand and seasonal aspects

* Effected ten per cent cost reduction through restructure of converting department procedures and in-house printing of greige goods

* Controlled activity of outside contractors

Purchasing Manager - Raw Materials (1977-1978)

* Negotiated contracts with mills involving $12 to $15 million

 - Established and administered systems resulting in 5% economies

 Scheduled current and future orders of greige goods and printed materials to coincide with production requirements, thereby reducing warehouse inventory costs

Purchasing Agent - Piece Goods (1975-1977)

* Effective handling of this department was directly responsible for assignment to positions of greater accountibility

Prior GREYWOOD KNITWEAR INDUSTRIES, New York, NY

Production Manager

* Hired as Assistant to Production Manager; promoted after two years to Production Manager

* Was responsible for purchase of raw materials, plant scheduling in a cut-and-sew operation, sales and production forecasting and liaison with factory management

EDUCATION Queens College
 1971 - BS, Math/Science

PERSONAL Free to relocate

ETHEL BURKS
300 East 24th Street, 4RW
New York City 10009

Home 212-477-6525
Work 212-751-6216

OBJECTIVE OFFICE MANAGEMENT

SUMMARY Departmental manager with ten years corporate administrative background. Experienced in purchasing, budget forecasting, salary planning and personnel evaluation. Expert at anticipating problems and effecting their resolution. Excellent writing and production skills. Knowledge of telecommunications and word processing.

EXPERIENCE MEDICARE DIVISION OF HUMANA, INC., New York, NY
 Manager, Secretarial Services (1990 - Present)

1988 * Supervise 13 secretaries and typists in completion and daily up-
to dating of all medical records and tests for 17,000 patient base
Present
 - Prepare all correspondence to parent company and physician
 clientele

 - Responsible for departmental budget forecasting, salary planning
 and personnel evaluation

 * Trained and supervised five additional typists to accommodate
 dramatically increased workload over four-month period

 - Created and implemented double shifts to assure completion of
 extra work volume on time and without sacrifice of quality;
 appointed interim supervisors for both shifts

 Executive Administrative Assistant (1988-1990)

 * As right hand to company CEO, responsible for coordination of
 executive office functions

 - Assisted President with confidential matters affecting all company
 activity and managed office during his absences; scheduled meetings
 and appointments

 - Maintained ongoing contact with nationwide sales force; monitored
 activities of managers reporting to President and prepared schedules
 and recommendations for his consideration

 - Prepared executive correspondence and composed internal adminis-
 trative correspondence; composed and distributed minutes and other
 pertinent documents; prepared legal forms, statistical reports and
 contracts

 * Developed methods to streamline office repair and maintenance functions
 affecting comfort and efficiency of 100 employees

3M COMPANY, New York, NY
Publicity Assistant

1984
to
1988

* Composed product and news releases, feature stories and quarterly reports; supervised printing and photography and coordinated national mailings to consumer and trade media

* Made arrangements for press events; researched and selected sites, designed press kits and invitations, monitored responses and prepared guest lists

CORE COMMUNICATIONS IN HEALTH, INC., New York, NY
Script Coordinator/Assistant Director of
Program Development

1981
to
1984

* As first employee in new organization, assisted in start-up and office management, including purchase of all supplies

* Assisted in creating and updating library of audiovisual education programs; researched and edited program material

* Typeset and assisted in design of educational print materials

EDUCATION

QUEENS COLLEGE, Queens, NY
1981 Baccalaureate Degree, English, Writing

- Phi Beta Kappa and magna cum laude
- Honors in English and Creative Writing
- John Golden Award for Creative Writing, 1972
- Fiction Editor, College literary magazine

Professional Programs:

Buffalo University Seminar in "Management Tools"
Katherine Gibbs Entree Program
Betty Owen Word Processing Program
Dale Carnegie Public Speaking Course

SALVATORE ORAZIO . 21 Pine Street . Cresskill, NJ 07626 . 201-568-8770

OBJECTIVE OPERATIONS MANAGEMENT

SUMMARY Operations specialist with excellent track record in coordination of sales and production. Adept at analysis and reformulation of systems to increase profits. Able to establish effective rapport with superiors, colleagues and subordinates. Hands-on knowledge of computer services.

ACHIEVEMENTS IN OPERATIONS MANAGEMENT

BURLINGTON INDUSTRIAL FABRICS, Rockleigh, NJ
Administrative Supervisor, Inventory & Reconciliations (1988-1989)
Sales Coordinator (1988)
Planning Coordinator (1981-1987)
Production Planning Manager, Assistant Planner (1980-1981)

Sales/
Production
Coordination

During period of 15-fold sales expansion, balanced plant production with sales requirements while overseeing planning, scheduling, sales and customer service, distribution and R&D functions

Increased sales 25%-50% by improving liaison between sales and production

* Instituted control sheets with daily updates for individual salesmen
* Developed easy-to-read open contract status record book to aid control, scheduling and sales
* Initiated operations to accommodate on-the-spot requests

Production
Planning

Increased sales and production 25% through careful production scheduling and close liaison with sales department

* Allowed for new business in production scheduling
* Assured customer satisfaction through communication with sales on load conditions and possible substitute orders during heavy load periods
* Instituted daily flow of inventory contracts and coordinated saleable inventory with sales manager

Contracts
Adminis-
tration

Institute measures resulting in same-day service for rush orders and quicker processing of entire order volume

Decreased composition and transmittal period for typed contracts by 50%

* Established capability for telephone credit approval on rush orders
* Set priorities for transmittal of contractions and corrections between northern and southern offices, improving liaison

Developed capability for daily processing of sales notes, cutting four to six days from original procedure; set up system eventually taken over by clerical staff

Inventory
Control/
Purchasing

Through timely purchases of greige goods, saved $40,000 and maintained better control of inventory

Increased efficiency of inventory process, decreasing time required by 66% while effecting one of division's best audited inventories on record

Computer
Operations/
Records

Worked closely with programmers to set up weekly computerized status reports on contracts, inventory available for sale, and case listings

Set priorities for computer services; developed accurate manual and computerized records

H.W. LOUD MACHINE WORKS, INC., Pomona, CA
(Div. of Menasco Manufacturing Co.)
<u>Supervisor</u> (1978-1979)
<u>Material & Systems Control Supervisor</u> (1973-1978)
<u>Scheduling & Records Supervisor</u> (1964-1972)

Personnel
Training

Eased overload conditions and increased output by 50%-66% by cross-training personnel in purchasing, traffic, stock, shipping and receiving

Production
Planning

Coordinated purchasing, outside production and production liaison with Montebello and Burbank plants; supervised production control office

Increased work flow control, eliminated over-issuance of plant and outside production work orders, and promoted planning flexibility

* Created simple, accurate location control system for thousands
 of components in process

Upgraded production coordination

* Instituted system for establishing assembly priorities
* Created procedures for nightly status reports on all components
 of open orders

Computer
Operations

Developed accurate shop load computer reporting system; worked with outside consultant, computer programmer and in-house personnel to set up input and completion data

BURLINGTON INDUSTRIES, New York, NY and Teterboro, NJ
<u>Assistant Department Head, Office Services</u> (1962-1964)
<u>Warehouse Supervisor</u> (1956-1962)

Office
Services
Management

Coordinated and supervised 15-member staff responsible for office moves and services; prepared budgets; directed outside contractors

Developed system for timely delivery of mail between five major New York City office buildings

Warehouse
Supervision

Set up inexpensive and effective location control system for thousands of piece goods in process

EDUCATION

<u>Professional Courses and Seminars</u>

AMERICAN MANAGEMENT ASSOCIATIONS, New York, NY

Various 8-10 week courses in Supervisory Management, Planning, Organization, Standards and Appraisals, Communication, Motivation, Decision Making

Free to travel

ALAN TOULOUSE 150 East 71st Street New York, NY 10021 (212) 838-7777

OBJECTIVE: GENERAL MANAGEMENT/OPERATIONS

SUMMARY: More than nine years experience in day-to-day administration at management level in import/distribution industry. Highly expert at initiating and implementing systems, including data processing, for inventory and cash control. Capable of startup of major installations including warehousing from point of site selection to full operation. Excellent in recruitment and supervision of personnel and in customer relations.

HIGHLIGHTS OF EXPERIENCE:

1985 to Present INTERCO PARTS CORPORATION, Syosset, NY
General Manager

Charged with startup of parts distribution business in 1985; administer all phases of business (accounting, inventory control, data processing and enhancement of management information capability of computer operation)

- Achieved growth to $6 million/year

* Participated in preparation and administration of annual budget

* Installed and implemented in-house computer to perform inventory control, accounts receivable, sales and product analysis

* Created and implemented warehouse operating procedures with internal controls (current 13-man staff); established and maintain paper-flow procedures and internal audit control

1979-85 GEON INTERCONTINENTAL CORPORATION, Woodbury, NY
General Manager-Operations, Woodbury, NY (1984-85)

Had direct responsibility for data processing and transition to in-house EDP capability for company now at $38 million level

* Served as project leader for installation of IBM System 3 computer

- Participated in system design; wrote operating manual, trained operators

- Scheduled procurement of hardware and software

- Eighteen-month project (IBM estimate) delivered on-line in seven months

* Administered New York headquarters with staff of 80 in the office; 130 at warehouses

Concurrent: General Manager-Operations, Richmond, VA/Los Angeles, CA (1983-85)

Had control over two warehouses (280,000 sq. ft.) with 130 personnel and over $20 million/year in sales

* Controlled budget; daily operation and planning (except sales); warehousing; customer service; data collection/transmittal; union negotiations

* Reduced expenses by 30-40% overall through efficient management of employees and information

- Instituted uniform training program to strengthen first-line and middle management

* Carried over expense control systems from Richmond operation to Los Angeles warehouse with same success

* Recalled to New York to head up computer project

Continued

<u>General Manager, Richmond Warehouse, Richmond, VA</u> (6/83-12/83)

Line responsibility for $10 million profit center

* Administered all operations (except sales)

* Instituted cost accounting system to control expense; reduced operating expenses by 40% while maintaining sales level and improving order turn-around time

<u>Assistant to President, Woodbury, NY</u> (1981-83)

Member of "Office of the President"

* Maintained liaison between administration and department managers

* Helped prepare and controlled budget; implemented corporate policies and procedures

* Appointed project manager in movement of warehouse from New York to Virginia

 - Located site; negotiated for purchase; negotiated favorable contract for construction; supervised recruitment of personnel; developed and implemented warehousing procedures

* Assisted in union contract negotiations

<u>Manager, Data Entry, Woodbury, NY</u> (1980-81)

* Supervised staff of 32 data entry operators feeding to outside service bureau

* Helped establish and implement inventory control system for 102 wholly-owned branches

* Developed data reporting systems (sales analysis, stock status and forecasting) in concert with other department managers and service bureau

<u>Customer Service Manager, Woodbury, NY</u> (1978-80)

* Established goodwill and maintained clientele during period of extreme competition

 - Resolved customer complaints; reduced response time from 8-10 weeks to two weeks

 - Established returns authorization and other procedures for issuance of credits to customers

EDUCATION: New York University, New York, NY (On scholarship)
1979 - MA, Latin American History

SUNY, Buffalo, NY
1978 - BA, History (Dean's List)

National Honor Society and Dean's List at Jamaica (NY) High School

American Management Association: Writing of Administrative Manuals
Digital Equipment Corporation: Concepts of Computer Programming
 Programming in DIBOL

LANGUAGES: Spanish

EMILE BERGSON, 220 West 76th Street, New York, N.Y. 10020 (212) 761-2571

OBJECTIVE SENIOR LEVEL OPERATIONS MANAGEMENT

SUMMARY Twelve years direct management responsibility in proposal management, cost estimating, contract administration, scheduling and cost control, quality assurance, engineering, and technical and new product development. Expertise in domestic and international technical and commercial operations including air pollution control systems, fuel cell and solar energy devices, semiconductors, ceramics and catalytic materials.

Principal customer industries: electric utilities; petrochemical; pulp and paper; combustion equipment; coal; and federal, state and local governments.

Published in numerous technical journals; author of various device-oriented patents.

EXPERIENCE FLAKT, INC., Old Greenwich, CT (American Group company of AB Svenska Flaktfabriken, Stockholm, Sweden) Annual Revenues: $40 million
1988 Director of Pre-Contract Operations
to * Direct all Proposal Management, Applications Engineering, Cost Esti-
Present mating, Project Planning and Sales Support
 * Develop and implement technical, pricing and commercial strategies
 for proposals
 * Manage all pre-contract negotiations (bid approximately $300 million,
 capturing approximately $70 million)
 * Convinced management of need for series of procedures manuals; authored
 Proposal Management and Cost Estimating Operations manuals

1983 UOP AIR CORRECTION DIVISION, Norwalk, CT
to Manager of Project Services (1986-1988)
1988 * Created department to serve as support group to Project Management,
 at request of management
 * Directed activities related to Cost Engineering, Scheduling (Multi-
 level, CPM), Contract Administration (Contract Interpreting, Claims
 Preparation and Negotiation) and Project Administration
 * Authored company Project Control manual
 * Formulated division Cost Code of Accounts, remedying lack of
 adequate cost definition seriously hampering cost control efforts

 Manager of Quality Assurance (1985-1986)
 * Created Quality Assurance department at request of management
 * Formulated and directed total division quality program including
 Planning, Inspections and Reliability
 * Created division Operations Auditing Program for identifying and
 solving systematic organization and procedural problems, encompassing
 all departments
 * Formulated Quality Cost Monitoring Program to identify and eliminate
 significant and recurring avoidable costs (Resulted in 70% reduction
 of such costs associated with Engineering, Manufacturing and
 Construction)
 * Authored division Quality Assurance Manual

Manager of Engineering (1984-1985)
* Directed all Engineering activities of department of approximately
 100 engineers and 60 drafters
* Managed entire company product line of Flue Gas Desulfurization
 Systems, Electrical Precipitators and Multi-cyclone Collectors
* Reorganized department from Functional Organization to Matrix Manage-
 ment organization, to better utilize limited manpower resources; pro-
 ductivity increased by 26% as a result
* Authored and developed Engineering Drafting Manuals

Manager of Precipitator Technology (1983-1984)
* Created department to eliminate performance liability situations
* Directed field diagnostic studies and corrective action programs
* Invented and developed proprietary designs for new ancillary product
 lines, now marketed (Sales approximately $15 million)
* Conducted world-wide survey, including site visits to Europe, Asia
 and Australia, evaluated licensing potential for a rigid frame-type
 precipitator (In lieu of licensing, recommended proprietary design
 field tested in 1981)
* Invented, developed and marketed new products

1978
to
1982

UOP CORPORATE RESEARCH CENTER, Des Plaines, IL
Research Administrator
* Served as Air Correction Liaison with Corporate Research, directing
 field studies and developing annual division R&D programs
* Administered and directed research projects in auto emission control,
 energy conversion and materials development
* Nine patents issued

EDUCATION

CITY UNIVERSITY OF NEW YORK, New York, NY
1978 - Ph.D., Physics
1975 - M.A., Physics
1972 - B.A., Physical Sciences

UOP Management Development Program
AMA seminar on Project Planning and Control
American Society for Quality Control seminar "Managing for Quality"
Lincoln Electric Company seminar on Welding
EPA seminar on Gaseous Emission Control
Working knowledge of French and Hebrew

HONORS

Guest speaker at ASME regional conference, "Air Pollution Engineering"
Guest speaker at ASQC Energy Division annual conference
President of employees' Federal Credit Union
Recipient of company award for Outstanding Support of Sales

ARTHUR RINEHART . 1050 Maple Avenue . Bronx, NY 10475 . (212) 994-2770

OBJECTIVE: <u>EXPORT MANAGER/INTERNATIONAL TRADE SPECIALIST</u>

To obtain a position as export manager for energetic, high-volume exporter of consumer or industrial goods or services.

SUMMARY: Broadly experienced in all phases of export and domestic operations. Demonstrated expertise in new market development, sales forecasting, budgeting, inventory control, warehousing and shipping. Knowledgeable about medical and publishing industries specifically.

EXPERIENCE:

1976 to Present

NORTHWESTERN PUBLISHING COMPANY, Brooklyn, NY
<u>Export Manager, Eastern Division</u> (1987-Present)
($15 million annual revenues)

<u>Operations Manager</u> (1976-1987)

* Charged with full responsibility for developing marketing strategies, operations management and the management of combined sales and support staff of 17 for this major branch

MARKETING:
* Expanded foreign sales from base of $150,000 (1976) to $3 million (1987)

* Research and analyze potential markets; project forecasts on which sales are based

* Travel extensively Puerto Rico, Mexico, Central and South America and Africa studying educational systems and determining potential textbook markets

 - Initiate contacts and work out agreements with distributors to promote and distribute products

 - Work out all sales contracts including sales conditions, credit terms, banking, discounts and promotion

* Most recently selected and set up marketing/distribution organizations in Liberia and Nigeria as well as South America

OPERATIONS:
* Prepare annual transportation and distribution budgets (in excess of $1.25 million/year)

* Determine quarterly sales needs; prepare appropriate stock requisitions

* Coordinate physical inventory (two million units monthly)

* Establish agreements with warehousing concerns for consolidation with other publishers for overseas shipments

* Organize special Container/Consolidation Programs with major airlines at reduced rates

* Work closely with U. S. Postal Service in simplifying mail classification and requirements for mailing to foreign countries

* Was instrumental in getting the limit of Custom Free Import Entry amount increased from $250 to $500

* Develop major sales promotions for teachers and educational groups through direct mail and specially designed seminars and workshops

1970-1976 NATIONAL SURGICAL SUPPLY, INC., Westchester, NY
 (Major manufacturer of surgical instruments - $25 million
 annual sales)

<u>Assistant Service Manager</u>

* Responsible for all customer service aspects including problem
solving and handling of customer complaints of highly technical
nature

* Instructed members of medical profession in proper methods of
maintenance, sterilization and application of instruments

* Personally inspected repaired instruments to ensure quality
control

* Supervised technical and secretarial staff

1968-1970 STUDENT'S TUTORING INSTITUTE, Larchmont, NY

<u>Instructor</u>

* Taught Italian and Spanish to businessmen, doctors and
lawyers on individual and group basis

EDUCATION: Instituto Magistrale Lucrezia Della Valle, Cosenza, Italy
BA, Secondary Education/Foreign Languages

Hunter College, Bronx, NY
42 credits in English, History, Marketing, Spanish, Italian

AFFILIATIONS: Tri-State Traffic Management Association (Secretary)

Bronx-Westchester Traffic Club

Latin American Chamber of Commerce

Modern Language Association

LANGUAGES: Fluent Italian; Excellent Spanish; Working knowledge of French
and Portugese

ERNEST CAWLEY • 125 Forest Lane • Radnor, PA 19087 • (215) 293-0151

OBJECTIVE: To establish, develop, and direct an export division or subsidiary for a manufacturer new to exporting.

SUMMARY:
— Astute evaluator of foreign market potential for USA manufactured consumer products

— Proven organizer of export activities for manufacturers without previous overseas sales experience

— Strong connections with worldwide business community through extensive travel and personal contact

— Broad experience in corporate development and financing, investment analysis, venture capital, and business management

BUSINESS HIGHLIGHTS:

1984 to
Present

TREMONT INTERNATIONAL
Bryn Mawr, PA

Founder and Managing Director

• Develop export sales for "new-to-export" USA manufacturers; successful sales in more than 100 countries on 5 continents

— Thoroughly research the industry, product, competition, and client manufacturer, including definitive profitability assessment of potential overseas markets

— Make convincing presentation to acquire client manufacturers' export distribution or representation rights

— Expertly handle all export procedures from creating the sales through distribution, transportation, and collection

— Effectively represent dozens of client companies concurrently

• Personally generate export business and develop overseas markets

— Sell diverse lines of products (mainly consumer), including safety and security equipment, laser-engraved prestige advertising specialties and corporate awards and gifts, specialty housewares and hardware, building materials and interior architectural products; micro-electronic ceramic sub-assemblies

— Process more than 100 pieces of correspondence per week, plus telexes, cables, and overseas telephone calls

— Participate in trade shows and exhibits in market countries

• Established export activities for two corporations and currently serve on their Boards of Directors

| 1978 to 1984 | **HORNBLOWER & WEEKS, HEMPHILL NOYES & CO.** |
| | Bala Cynwyd, PA |

Account Executive

- Managed portfolios of my individual and institutional accounts

- Consistently produced high profit margin business for the firm; responsible for millions of dollars in investments

- Consulted with and did exhaustive investment analysis research for my clients in matters of investment banking, venture capital, and corporate development

- Selected to this nationwide firm's Management Advisory Board (1980) in recognition of consistent professionalism and competence

| 1968 to 1978 | **NEWBURGER & CO.** |
| | Philadelphia, PA |

General Partner (1974 to 1978)

- Among my investment banking responsibilities, structured and raised venture capital for two manufacturing corporations and was co-founder of each; continued the activities below

Investment Analyst (1968 to 1974)

- Managed investment portfolios for my own clients and the firm's investment advisory clients; investment analysis; created venture capital plus merger and acquisition opportunities

- Restructured research department to reflect current methods and practice

- Wrote regular research reports on attractive investment opportunities and edited the monthly bulletin

| 1967 to 1968 | **SHEARSON, HAMMILL & CO.** |
| | New York, NY |

Investment Analyst

- Researched and analyzed investment potential in securities of publicly owned corporations, with emphasis on electronics, aerospace, airline, shipbuilding, and other industries of similar scope; consulted on investment banking and merger and acquisition proposals

MILITARY: U.S. Army and U.S. Army Reserve, 1965 to 1973
Captain, Finance Corps — Finance Regional Accounting Officer

EDUCATION: Wharton Graduate School, MBA 1966 — Finance and Investments, Real Estate

University of Texas, BBA 1965 — Finance and Banking

MEMBER: International Trade Development Association, Greater Philadelphia Region
President, 1985-1986; Director, 1986-present

Manufacturers & Agents National Association (MANA)

Main Line Chamber of Commerce

EDWARD BARTLESVILLE
20 Lincoln Plaza • New York, NY 10023

Home: (212) 247-9827

Office: (614) 475-5070

OBJECTIVE: **SENIOR MANAGEMENT IN AGGRESSIVE RETAIL ORGANIZATION**

SUMMARY: Ten years retail management experience with rapid and consistent record of growth and advancement. Conceptual and creative approach to marketing and merchandising. Sound long- and short-range planning skills. Astute motivator with ability to identify and maximize talent of subordinates.

PROFESSIONAL EXPERIENCE:

1990
to
Present

FEDERATED STORES CORPORATION, Columbus, OH
Director of Merchandise Marketing

- Advise top management regarding incorporation of innovative marketing strategies and concepts for all six divisions of $600 million corporation

- Develop marketing programs to reposition corporation as necessary
 — Created 120-store test to analyze customer buying patterns for purposes of maximizing inventory investment
 (testing validated program implementation in all 489 stores)
 — Initiated and implemented merchandise line plan to fully develop previously non-formalized corporate policy
 (concept to be layered into organization as basis for focusing merchandise purchase in second and third quarters of 1991)

1984
to
1990

SAKS FIFTH AVENUE, New York, NY
Senior Vice President **General Merchandise Manager, Sportswear and Intimate Apparel (1980-1982)**

- As member of Executive Committee and Management Board, participated fully in all marketing and merchandising decisions for $500 million organization

- Generated 22% volume increase ($102 million to $125 million) and 1.2% gross margin increase (46.3% to 47.5%) through restructuring and redefinition of planning, merchandising, marketing, merchandise distribution, and training and development operations
 — Trained, developed and managed five divisional merchandise managers and 21 buyers to achieve their professional goals, as well as company objectives

SAKS FIFTH AVENUE
Vice President **Divisional Merchandise Manager,**
 Intimate Apparel (1987-1988)

- Supervised planning, management, merchandising and marketing operations of $25 million business to achieve annual gross margin objective

- Improved division profit ranking from tenth to first (out of 17 divisions) by broadening customer base, reorganizing resource structure and developing effective marketing strategies

- Generated 26% sales volume increase ($20 million to $25 million) and 2.1% gross margin increase (49.0% to 51.1%)

Divisional Vice President **Managing Director Branch Store,**
 Fairlane Mall, Detroit, MI (1986-1987)

- Assumed total responsibility for start-up and opening of individual store
 — Led and managed all areas (merchandising, operations, personnel and inter-community relations) to achieve sales volume and profit objectives

 — Trained, developed and managed Assistant Managing Director, six operational Department Managers, 13 merchandising Department Managers

 — Established environment of full employee input preparatory to store opening, keeping motivation and morale at optimum levels

- Generated $14 million in sales volume and 2.6% pre-tax profit during first year of operation

Divisional Merchandise Manager **Men's Clothing, Boys' Clothing and**
 Furnishings divisions (1984-1986)

1981
to
1984

BLOOMINGDALE'S, New York, NY
Group Manager **Men's Sportswear and**
 Designer Sportswear (1983-1984)

- Promoted from two Buyer positions after starting as Staff Assistant to Divisional Merchandise Manager in 1973

EDUCATION: **SOUTHERN METHODIST UNIVERSITY**
 1981 — M.B.A., Major: Marketing

 1980 — B.A., Major: History; Minor: Economics
 Dean's List, eight semesters
 Sigma Phi Epsilon Fraternity

HECTOR LOPEZ
7720 Cowne Court
Nokesville, VA 22123
(703) 594-9570

OBJECTIVE: **GENERAL MANAGEMENT — BUILDING TRADES INDUSTRY**

SUMMARY: Twenty years experience in top level management with definitive expertise in creative marketing and sales techniques in the building trades industry. Proven ability to penetrate new markets through establishment and implementation of successful marketing strategies and initiating and maintaining highly effective distribution systems. Outstanding achievement record in start-up and growth situations.

HIGHLIGHTS OF EXPERIENCE:

1980 to Present

ONDULINE, U.S.A., INC. (Subsidiary of Media General, Inc.) Fredericksburg, VA

Senior Vice-President

Charged with responsibility for start-up of company in the United States, dealing with specialized building materials items

- Developed initial market analysis that led to company's establishment

- Initiated, established and implemented marketing strategies; hired and trained field and office personnel; set corporate and financial policies (still in force)

- Directed company's sales effort from zero base in 1980 to $8.1 million in 1987

 - Established markets by selling product through most levels of distribution

 - Generate high volume through wholesale building supply and retail home centers, OEM and agricultural cooperatives

 - Instituted Select Distribution System to permit increased distributor responsibility for product marketing

 - Increased sales volume to extent that construction of $10 million U.S. manufacturing installation was justified

 - Established record of not losing a single distributor during eight-year period

 - Personally field-trained salesmen and developed sales education program

- Developed and direct advertising programs whose success has caused budget increase from $30,000 in 1980 to $600,000 in 1987

 - Achieved product recognition in the industry by trade name

- Won "Drummer Award" for 1983 by Building Supply News in two categories: Unique Educational Literature; Dealer Promotional Literature

- Elevated to Senior Vice-President following acquisition by Media General of 100% of stock of French parent company

 - Immediately assigned additional responsibility of starting up new product line for the residential market and managing full test marketing campaign (still in progress)

1978 - 1980 INTERNATIONAL BOARD SALES, New York, NY

National Sales Manager

- Established marketing arm for European-based plastic laminate manufacturer

 – Redesigned line for U.S. market; reduced line to 40 items

 – Developed copper-clad laminates for decorative purposes (first time in United States)

- Started sales through home centers and retail stores; developed network of manufacturers' representatives for furniture, tabletop and dinette makers to expand market

 – Sales increased from zero base to $1 million in two years

- Assigned additional responsibility to sale of imported products in plywood and furniture divisions (increased sales to $4 million)

1975 - 1978 BUDD COMPANY POLYCHEM DIVISION, New York, NY

Regional Salesman

- Assigned failing territory; effected turnaround with increase in sales from $300,000 to $800,000 in first two years

 – More than tripled sales to large customers including Otis Elevator, Stuart-Warner and Republic Aircraft

- Initiated blanket order system with distributors, locking in both company and buyer on a year-by-year basis (resulted in elimination of competition and improved service)

1974 - 1975 ITEK CORPORATION, New York, NY

Salesman

- Made comprehensive studies of needs of large corporation for in-house printing plants; demonstrated specific savings in cost through use of Itek plate-maker for offset work

 – Made formal presentations to corporate management, documenting accrued savings from purchase of capital items costing from $12,000 to $18,000

 – Success ratio of 80% including such major firms as Booz-Hamilton, Gray Advertising, General Dynamics, Hooker Chemical and Edison Electric Institute

1969 - 1973 JOHNS MANVILLE SALES CORPORATION, New York, NY

Territory Salesman

- Assigned most of New England after service as a trainee and inside sales co-ordinator, and developer of customer relations

- Increased sales from $17,000 to $100,000 in two years (territory had been neglected for several years)

- Received special award for formal presentation to City of Hartford introducing improved line of general building products

EDUCATION: Villanova University, Villanova, PA
1968 — BS, Economics/Pre-Law—Marketing

JUSTINE SHIPLEY 107 HUDSON STREET HOBOKEN, N.J. 07030 (201) 795-9573

OBJECTIVE: **ADMINISTRATIVE MANAGEMENT**
Seeking management level position in corporate administration with potential for advancement to line management.

SUMMARY: Strong administrator in large volume operation with follow-through ability in implementing company policies and programs. Expert in departmental organization for maximum efficiency at minimum cost. Results-oriented salesperson with conceptual marketing acuity. Proven capacity for discharging increasing responsibility and accountability.

CAREER HIGHLIGHTS:

1981-88 *AMERICAN EXPRESS COMPANY,* New York, N.Y.

Administrator — Retail Sales (1986-88)
- Directed flow of detail in operation of credit card retail sales contract negotiations throughout United States

 - Managed agreements, advertising & operational budgets, advertising addendum program, discount re-evaluation programs, sales presentations, repetitive sales activity

 - Administered charge account solicitation and promotional mailing campaigns throughout United States

- Wrote retail section of cardmember newsletter and president's letter in addition to a variety of departmental communications

- Represented department at conventions, meetings and other events locally and throughout United States; prepared agendas

Senior Administrative Secretary (1984-86)
- Coordinated and supervised input from offices reporting to Vice President - Domestic Sales; directed activities to subordinate staff

Secretary to Director — Lodging Sales (1982-84)

Secretary/Back-Up Assistant — Manager Domestic Sales (1981-82)

1980-81 *PATROLMEN'S BENEVOLENT ASSOCIATION,* New York, N.Y.

Executive/Personal and Confidential Secretary to President
- Maintained current intelligence on political & police activities; assisted Public Relations Manager; prepared releases for news media

1979-80 *MERRILL LYNCH, PIERCE, FENNER & SMITH,* New York, N.Y.

Secretary
- Prepared Turnpike & Tunnel & Bridge Association reports, financial statements and prospectus reports

1977 *AMERICAN EXPORT ISBRANDTSEN LINES*

Assistant to Manager — Bill of Lading Department
- Directed functions of office personnel; maintained teletype procedures for overseas communications

1976-77 *CASTELO & SONS, SHIP SERVICING CO., INC.,* Hoboken, N.J.

Assistant to Payroll Supervisor/Secretary
- Prepared manual payroll; posted A/P and A/R journals

LANGUAGE: Bilingual — Spanish-English

EDUCATION: New York University — Courses in Business Administration & Personnel

JAMES CYRUS

250 E. 76th Street, New York, NY 10021 (212) 879-6216

OBJECTIVE: Construction Superintendent, with enough growth opportunity to permit advancement to project manager, and ultimately to General Project Manager.

EXPERIENCE: 1983 to JPD Construction Company
 Present New York, N.Y.

Construction Superintendent (1986-Present)

--Order materials; deal directly with suppliers; schedule payments for sub-contractors

--Supervise electrical, painting, carpentry, masonry, HVAC, flooring, hardware and final cleanup trades

--Deliver all materials to job sites; prepare billing and payroll reports

Accomplishments

* Organized front office; realigned unorganized stacks of blueprints by specific jobs

* Served as Acting General Project Manager for one month in boss's absence

* Originated uniform manner of processing each job from point of sale to final billing; recommended new equipment for field and front office

* Purchased trade manuals at own expense to improve job knowledge

Foreman's Assistant; Estimator; Salesman (1983,1985)

--Started as laborer in 1975; promoted to carpenter's helper; learned estimating at night school; promoted to estimator (time out for military)

1978 to Laborer, Zerep Construction Company
1982 New York, N.Y.

--Drove company truck; assisted in demolition work; acted as mason's helper, carpenter's helper

EDUCATION: Music and Art High School, New York, N.Y.; graduated 1982

Attended Institute of Design and Construction, 1985

Military: USMC, 1983-1985; separated with rank of Lance Corporal; honorable discharge

Demolition and Construction Specialist; demolition instructor; completed Basic Combat Engineer School and refresher course; instructed officers in basic land mine warfare

JUAN S. GEISLER 975 East 44th Street, Brooklyn, NY 11234 212-645-7133

OBJECTIVE BUILDING MANAGEMENT of PRESTIGIOUS OFFICE BUILDING or CORPORATE HEADQUARTERS

SUMMARY Extensive experience in commercial building management, supervision and ad-
 ministration. Excellent track record in energy conservation, cost-effective
 maintenance and minimization of down time for all systems. Able to motivate
 engineering and maintenance staffs and contractors to produce work of high
 quality. Work effectively under pressure. Solid understanding of technical
 details and problems.

EXPERIENCE

1985 to DAKOTA REALTY INC., New York, NY
Present Managing agents for six commercial buildings including 720 Fifth Avenue
 (ICC Building) and 445 Park Avenue (MCA-Universal Pictures)

 Vice President-Director of Operations (1989-Present)

 * Charged with administration of all six buildings
 - Recruit, train and supervise personnel responsible for on-site
 operations and Supervisor of Operations overseeing all six sites
 - Approve interior design, decorating, signage and maintenance
 and service contracts
 - Supervise energy management
 - Interface with owners and principals; assist brokers with leasing details
 - Oversee all electrical billing and surveys

 * Saved thousands of dollars on selection of fire safety system through
 utilization of existing resources
 - Carefully analyzed all contractor bids and received variances
 that eliminated the need to install expensive equipment

 * On a regular basis, assure reconstruction of office space for new tenants
 within critically limited time schedules
 - Through careful planning, maintain revenue level and
 promote good landlord-tenant relationship

 * Interface with City bureaucratic agencies, including Fire Department
 and Departments of Buildings, Air Resources & Environmental Protection,
 and Sidewalks & Highways

 Supervisor of Operations (1988-1989)

 * Oversaw daily operations of six office buildings
 - Analyzed and solved emergencies
 - Supervised six employees and trained new personnel
 - Oversaw all construction, maintenance and repair work
 - Acted as Purchasing Agent

 * Set up schedule for periodic checking of all systems to assure
 interruption-free service

 Building Manager - 445 Park Avenue (1986-1988)

 * Upgraded productivity of maintenance and engineering staffs, resulting in
 improvement in occupancy rate from 65% to 95% and promotion of building
 as company show place

 * Instituted major energy management program that cut steam usage in half
 and resulted in:
 - Letter of commendation to landlord from the City
 - Three attempts by Con Edison to control revenue losses by
 installing new meters

202

JUAN S. GEISLER/2

<u>Building Superintendent & Engineer - 720 Fifth Avenue</u> (1985-1986)

* Established excellent reputation for building security by instituting tenant file and ID card security system

* Operated 300-ton electrical drive centrifugal air condition, heating systems and all other building systems

* Supervised six-person staff

1981 to
1985

WILLIAMS REAL ESTATE, New York, NY
<u>Building Superintendant</u>

* Decreased energy consumption by improving efficiency of boiler and installing flourescent lighting

* Acted on brokers' behalf showing space to future tenants

1979 to
1981

BROWN BROTHERS HARRIMAN, New York, NY
<u>Manager, Air Conditioning Section</u>

* Planned and implemented preventive maintenance program to reduce purchases of major parts, down time and service costs

MILITARY SERVICE

1974 to
1978

US AIR FORCE
Honorably Discharged as Staff Sergeant

* Awarded commendation medal for meritorious service

EDUCATION

Kingsborough Community College, Brooklyn, NY
1982-1983 Liberal Arts Courses

New York City Community College, Voorhees Campus
1982 Environmental Science Courses

<u>Coursework for professional advancement:</u>

Building Owners and Managers Institute: Real Estate Property Administrator
Apex Technical Institute: Certificate in Theory of Thermodynamics;
 courses in Commercial HVAC, Blueprint Reading, Drafting

CERTIFICATIONS AND LICENSES

Certified Fire Safety Director
Licensed Sprinkler Operator
Licensed in Standpipe Maintenance
Licensed as #6 Oil Burner Operator

AFFILIATION

Building Owners' and Managers' Association

GREG MAXWELL
157 Charing Cross Road
Tucson, Arizona 85713
(602) 771-2510

OBJECTIVE:
Security administrator or related management position.

EXPERIENCE:
HAMPTON HILLS COMMUNITY ASSOCIATION, Tucson, AZ
Security Director

1987
to
Present

* Supervise approximately 30 security officers and guard personnel at a four-season recreation community

 - Implement and evaluate all security programs
 - Manage personnel
 - Act as liaison with federal, state and local officials
 - Plan and approve all budgets

FEDERAL BUREAU OF INVESTIGATION, Washington, DC
Special Agent (Retired)

1959
to
1987

* Responsible for extensive investigative, training and supervisory level positions covering all investigative matters and operations

 - Planned, organized and directed investigative staff and interfaced harmoniously and effectively with executives at all levels

 - Commended for excellence in performance on numerous occasions

MILITARY:
U.S. Navy 1952-1954 (Honorable Discharge)

EDUCATION:
Seton Hall University - Graduated with B.S. Degree in 1958.

ORGANIZATIONS:
Society of Former Special Agents of the Federal Bureau of Investigation

Interstate Law Enforcement Association

International Association of Chiefs of Police

Research & Development

MATTHEW SILVERMAN . 45-59 65th St. . Woodside, NY 11377 . (212) 786-3576

OBJECTIVE: <u>INDUSTRIAL MANUFACTURING ENGINEER</u>

Responsible production development opportunity with growth-oriented electronics manufacturer.

SUMMARY: Eight years experience in all phases of electronics manufacturing engineering. Expertise in set-up and planning for entire production process. Capable of reducing costs while simultaneously increasing quality and output. Familiar with development and introduction of new designs. Effective supervisor of engineering staff.

RELEVANT EXPERIENCE:

1987-Present GBC CLOSED CIRCUITS TV CORPORATION, New York, NY

<u>Technician</u>

* Repair, control, adjust, modify and test equipment used in manufacture of closed circuit television systems; equipment includes:

 - B/W and color TV receivers - Video and RF TV cameras
 and monitors - Total darkness TV cameras
 - Video switchers - Amplifiers and Distributors
 - Video/audio minisystems - Intercoms and talk-a-phones
 - B/W VTR - Lenses

* Was recently invited by Company President to tour new production line. As a result of visit:

 - Pinpointed defect in adjustment during initial product run of latest design; modification resulted in major quality improvement at no cost

 - Suggested use of specialized tool, which immediately reduced total assembly time by 5%

 - Advised manufacturing department of change in electronic thermal "cooking" procedures, which could, if adopted, reduce processing time by more than 75%

1981-1986 KOZITSKY TV MANUFACTURER, Leningrad, USSR

<u>Chief Manufacturing Engineer</u> (1983-1986)

* Conceived, planned and organized total structure of new department; planned shop layout and assembly production line; established testing and adjustment procedures; organized work flow and determined equipment and manpower requirements; wrote production manuals

* Successfully solved technical problems in production

 - Production increased from ten to 1,200 units per day over three-year period

 - Overall production costs were reduced by 15% in one year

(continued)

KOZITSKY TV MANUFACTURER (continued)

- Improved quality was achieved in manufacture of color TV
 sets, radio receivers, tape recorders, and other products

* Directly supervised ten engineers and 12 technicians in department of firm with 1,600 employees

* Through "state of the art" production techniques, was able to reduce number of employees required from 50, in initial tests, to 15, in large scale production

* Developed technique for producing new model equipment by utilizing same production used in producing older models

* Evaluated prospective engineers for other departments

* Served as assistant plant manager; monitored four production lines; supervised experimental shop where new models were conceived

Senior Engineer - Experimental Section (1982-1983)

* Responsible for design, assembly and testing of experimental TV models and radio receivers

* Supervised two assistant engineers

Engineer - Experimental Section (1981-1982)

* Participated in experimental assembly, control tuning and testing of electronic equipment

EDUCATION: Leningrad Institute of Mechanical-Electronic Engineering
 Leningrad, USSR
 1981 - MS, Radio-Electronic Engineering

 Advanced training in Manufacturing and Production Technology
 (150 hours)

LANGUAGES: Fluent English (Native Russian)

VISA STATUS: Permanent resident with intent to apply for citizenship

PETER TAGORE
720 Lenox Road
Brooklyn, New York 11203

Home: (212) 469-5971
Message: (212) 270-9630

OBJECTIVE: <u>PRODUCTION ENGINEER/PROJECT ENGINEER</u>
To apply my skills and experience to a position as a planning and production engineer in a machine shop, fabrication shop, or foundry; a construction site manager's position to manage turnkey projects in piping, structurals or machinery installation and commissioning.

SUMMARY: Highly experienced as site manager, works manager and operations manager in directing the performance of turnkey contracts, projects, machine shop and fabrication shop operations and inspections.

RELEVANT EXPERIENCE:

1984-88 UNIQUE BUILDERS, LTD.
<u>Operations Manager</u> (350 Employees) Cuttack, India

* In overall charge of Rourkela works and site in Rourkela steel plant, to direct and coordinate the complete operations of turnkey contracts in piping, fabrication erection and commissioning of heavy structurals and equipment

 - Supervised design-to-completion (turnkey) construction of air line and oxygen line for plant expansion in Rourkela steel plant

 - Designed and supervised fabrication and commissioning of ferro-alloy addition system in steel melting shop

 - Developed door frames and door bodies with improved sealing for coke ovens

* Directed and coordinated sales, contract negotiations, planning, procurement, and sales promotion

* Directed, coordinated and motivated personnel in all phases of manufacturing process including design, layout, foundry, machine shop, fabrication, fitting, assembly, final erection and commissioning and office management

* Maintained quality control of projects from inception through shakedown; provided advisory and practical assistance in the solving of problems occurring subsequent to shakedown

1983-84 EAST INDIA ENGINEERING COMPANY
<u>Projects Manager</u> (300 Employees) Rourkela, India

* Responsible for the management of mini steel project involving labor management, materials management, project planning, supervision and inspection in all phases of manufacture, construction and commissioning including office administration

* Introduced and implemented partial sub-contracting system for labor at a saving of 25% on labor costs, eliminating the problem of providing labor facilities (housing, transportation, etc.) on project sites; introduced sub-contracting for projects reducing capital investment by 50%

* Supervised and coordinated activities of 300 employees

(continued)

EAST INDIA ENGINEERING COMPANY (continued)

1982-83
Project Engineer

* Responsible for the supervision and inspection in all shops of manufacture, erection and commissioning; also responsible for stores inventory and manpower planning for the economy and time schedule of the project

* Introduced and implemented incentive-bonus system for bringing projects in on time with 20% increase in on-time execution of contracts

 - More efficient allotment of manpower resulted in savings of 20% in labor costs

 - Improved raw materials inventory; reduced waste and saved 5% in materials cost

1980-82 PRABHAT IRON FOUNDRY & METAL INDUSTRIES
Planning Engineer Rourkela, India

* Directed department responsible for job planning for machine and fabrication shops

 - Supervised procurement of raw materials, tools and consummables for both shops, and of tools required by inspectors; supervised inspection and quality control

* Introduced incentive-bonus system for more efficient utilization of manpower resulting in 10% increase in production

* Introduced system of stage inspections in production to improve quality control resulting in fewer job rejections; increased profits by 15%

1974-80
Trainee

* Received general training in various units of the company - planning, machine shop, G.I. foundry, non-ferrous foundry and pattern shop

EDUCATION: Regional Engineering College, Rourkela, India
 1978 - BS, Mechanical Engineering

 Specialized Courses:
 Industrial Organizations and Works Management
 Refrigeration Engineering (Theory)
 Automobile Engineering (Theory)

 Sacred Heart College, Ernakulam, India
 1971 - Pre-degree

PETER CHU MING
10 Ashley Avenue
Norwich, NY 10523
(914) 592-6320

OBJECTIVE: ENGINEER - MECHANICAL/THERMODYNAMIC

Seeking staff position with opportunity to advance to consulting engineer

SUMMARY: More than eight years experience in design, fabrication and installation of air conditioning duct and equipment. Expert at taking off specs and bidding from architects' drawings. Knowledge of manufacturer equipment. Shrewd negotiator with sub-contractors. Able supervisor of mechanics and junior engineers. Capable draftsman. Skilled in design and research and quality control of precision mechanical parts.

RELEVANT EXPERIENCE:

1978 to 1986

BIG FOUR ENTERPRISE AND ENGINEERING COMPANY, Taipei, Taiwan

General Manager/Mechanical Engineer

* Operated as prime air conditioning contractor on four textile factories

 - Bid on and negotiated contracts from specifications
 - Designed, fabricated and installed sheet metal duct lines
 - Installed and started up air conditioning equipment ordered from manufacturer
 - Supplied maintenance and repair service after installation and during operation

* Operated service of installation, maintenance and repair for commercial and residential construction, and maintenance and repair service for industrial installations

* Managed plant with supervision of sales force, office personnel and engineering and mechanical specialists

1970 to 1978

RESEARCH INSTITUTE OF TECHNOLOGY (1974-1978)
PRODUCTS SERVICE, COMBINED SERVICE FORCES (1972-1974)
CHINESE GOVERNMENT ARSENAL (1970-1972)
Taipei, Taiwan

Mechanical Engineer

* In high security position of military research and testing

* Supervised control of inventory in factories, and of material purchased from US Government under aid program

* Supervised quality control of manufactured precision mechanical parts for adherence to close tolerance for interchangeability, according to military specifications

EDUCATION: Ordnance Engineering College, Taipei, Taiwan
1968 - BS, Mechanical Engineering
Course work included: Industrial Engineering, Industrial Management, Plant Layout and Time/Motion Studies

Taiwan Provincial Taipei First Professional Technical School
Electrical Engineering

Willing to relocate

ROBERT STEVENS
1573 Palm Springs Blvd.
Miami, Florida 33182
(305) 890-5261

OBJECTIVE: SENIOR ENVIRONMENTAL SCIENTIST

SUMMARY: Experienced in trace element and inorganic compounds
 analysis in particulate and liquid samples.

 Comprehensive knowledge of Atomic Absorption
 Spectroscopy (AA), Ion Chromatography (IC), X-ray
 Photoelectron Spectroscopy (ESCA), and various wet
 chemical methods.

 Working knowledge of EPA methods and Level I and
 Level II procedures.

EXPERIENCE: ENVIRONMENTAL SCIENTIST
 1984 to APR Corporation Jensen Beach, Florida
 Present * Evaluate sampling and analysis techniques used
 in Environmental Assessment Programs

 * Design experimental programs and conduct back-
 ground research on collection techniques for
 volatile trace metals, current uses and potential
 applications of ion chromatography, and the
 effect of ammonia on the sampling and analysis
 of sulfur oxides and nitrogen oxides

 * Participated in design and construction of sample
 steam generator to simulate flue gases of varied
 chemical composition, temperature and flow rate

 * Principal investigator in program to characterize
 total suspended particularities (TSP) for total
 volatiles and selected anions and metals

 * Assisted in development of an ashing-fusion
 technique to prepare cellulose filter samples
 for analysis of silicon by atomic absorption

EDUCATION: HARVARD UNIVERSITY, Cambridge, MA
 1984 - A.B., Engineering and Applied Physics
 Concentration in Environmental Sciences

HERMAN SCHWARTZ . 628 Newbridge Avenue . Staten Island, New York 10310

(212) 727-5321

OBJECTIVE: ENGINEERING MANAGEMENT

SUMMARY: More than 15 years hands-on experience in electronic systems engineering. Innovative conceptual designer, acutely cost-conscious with proven ability to complete project within budget limitations. Capable coordinator of inter-departmental activities. Excellent supervisor of technical personnel. Have security clearance at secret level.

PROFESSIONAL HIGHLIGHTS:

1978 to Present

ISRAEL AIRCRAFT INDUSTRIES, LTD.
Yahud, Israel

Senior Project Engineer MBT Division (1979-Present)

* Manage projects involving the design, development, production and installation of microwave, radar, antenna and other systems for commercial, government and classified military use

* Designed and developed, from prototype through production, microwave system and antenna equipment for EW application in ECCM

 - Wrote proposal, sold it to government and followed through on execution

* Prepare PERT and long-lead programs

* Coordinate purchasing, design and production departments; effect expedited delivery of equipment; supervise staff of ten engineers and technicians

* Updated and maintain accurate testing programs and equipment

Senior Development Engineer - Elta Electronics Div.(1978-79)

* Charged with design and system control of two radar systems - one for ship and land base use and the other for airborne use, in X-band frequency

1975-78

NORDEN DIVISION, UNITED AIRCRAFT CORPORATION
Norwalk, CT

Development Engineer

* Designed Beacon receiver for A-6A radar system and AMTI equipment

* Analyzed F-111D video systems for computer-oriented go-no-go philosophy program; established final acceptance specifications for system

* Met deadlines required for delivery of equipment; executed and manufactured to specifications

* Effected saving of $100,000 in costs through judicious selection of components and vendors

* Supervised test engineers, technicians and production personnel

1970-75 LITCOM DIVISION OF LITTON SYSTEMS, INC.
 New York and Maryland

 <u>Project Engineer</u> (1972-75)

 * Designed and developed HF receivers

 * Ran complete on-site final acceptance testing of
 high-performance SSB communications system and trained
 personnel for U.S. Government installation

 * Credited with saving six months work and a year of
 development time through expedited procedures

 <u>Electrical Engineer</u> (1970-72)

1967-70 RCA COMMUNICATIONS, INC.
 New York, NY

 <u>Electro-Mechanical Designer</u>

 * Designed circuits and worked on packaging and layouts
 (PC boards for amplifiers, transmitters, receivers,
 motor controls, talker hybrid units and ARQ equipment)

1964-67 WESTERN UNION TELEGRAPH COMPANY
 New York, NY

 <u>Senior Electro-Mechanical Draftsman</u>

 * Worked on schematics and finished wiring and assembly
 drawings for cabinets, carrier equipment and switching
 systems

MILITARY: U.S. Army - 1962-63
 Sergeant - Communications

EDUCATION: University of Maryland, College Park, MD
 1970 - BSEE

 Brooklyn Polytechnic Institute
 City College of New York
 Course work toward BSEE

MEMBER: Institute of Electrical and Electronics Engineers

 Willing to relocate and/or travel

CAESAR HABIB . 77-02 67th Avenue . Jackson Heights, NY 11372 . (212) 424-7539

OBJECTIVE: INDUSTRIAL CHEMIST - PHARMACEUTICALS

A production, quality assurance or research/development position in the pharmaceutical field

SUMMARY: More than ten years experience as a chemist involved in drugs, pharmaceuticals and cosmetics. Expert in qualitative and quantitative analysis with thorough knowledge of USP, NF and non-official compendia.

Instruments Used:

Viscometer	Gas/water separation index
UV, GC, IR, TLC	Reid vapor pressure
ORD; CD (Cary 14, 60)	Spectrofluorometer

PROFESSIONAL HIGHLIGHTS:

1982 to Present

NEW YORK POLICE DEPARTMENT, New York, NY

Chemist - Crime Laboratory

* Charged with analysis of physical evidence for use in criminal proceedings

 - Quantitative and qualitative organic analysis of unknown street samples

 - Analysis of illicit pharmaceutical preparations

 - Analysis of intermediates, solvents, reagents and drug products from clandestine laboratories

 - Physical comparison of evidence such as unknown tablets, trace particles and ballistics

* Successfully defended analyses before lower and supreme courts at local and federal levels in establishing guilt or innocence of defendant

* Improved analytical procedures to produce more timely reports

* Direct work of assistant chemists, junior chemists and technicians during periods of heavy activity

Concurrent

ST. JOHN'S UNIVERSITY INSTITUTE OF PHARMACEUTICALS, New York, NY

Pharmaceutical Chemist (Part time)

* Performed analyses for New York State Board of Pharmacy as a consultant

 - Determined legality of dosages and conformation with USP and NF standards in both quality and quantity

 - Acted on customer complaints regarding compliance

* Developed improved analytical procedures and techniques for various non-official pharmaceutical preparations

1979-82 PURDUE FREDERICK PHARMACEUTICAL COMPANY, Yonkers, NY

<u>Analytical Chemist - Quality Control Laboratory</u>

* Worked with vitamins, aspirin, surgical scrub solutions, laxative tablets, capsules, lotions and ointments

 - Thoroughly familiar with all wet methods of analysis

* Ran quality assurance tests on raw materials, intermediates and finished products

* Checked dosages and conducted stability studies

1977-79 ELIZABETH ARDEN COSMETIC COMPANY, New York, NY

<u>Production Chemist</u>

* Developed formulae for lotions, creams, lipsticks, loose powder, pressed powder and foundations

* Supervised manufacture of thousands of pounds of product on production line

* Supervised and directed technicians on problem products; personally checked the operations of large batches

* Became expert in all aspects of color matching and contrasting shades of makeup

* Worked under Director of Quality Control for six month period solving particular problems in color matching

* Developed solution to problem of stability in one cream

EDUCATION: St. John's University, College of Pharmacy, New York, NY
 1988 - PhD Candidate, Industrial Pharmacy
 Thesis: "Microencapsulation"

 St. John's University, School of Chemistry, New York, NY
 1983 - MS, Chemistry
 Thesis: "Effect of Divalent Salts (Magnesium, Calcium) on the
 Confirmation and Configuration of Bovine Serum Albumin"

 Ain Shams University, School of Science, Cairo, Egypt
 1974 - BS, Chemistry

LANGUAGES: Bilingual - English/Arabic

JANET PIERCE

400 Schenck Avenue	Great Neck, NY 11021	(516) 487-9530

OBJECTIVE: Seeking position offering advancement in the field of genetics

EXPERIENCE:

**1985
to 1988**

MONTREAL CHILDREN'S HOSPITAL, Montreal, Quebec, Canada

<u>Cytogenetic Technician</u> and <u>Tissue Culture Technician</u>

* Set up and cultured amniotic fluids; added colcemid and harvested when indicated

* Prepared, stained and screened slides under microscope

* Photographed metaphase cells; enlarged and printed pictures

* Cut the karyotype

* Used tissue culture techniques to make poor growth cultures successful thus eliminating need for repeat taps

* Set up skin biopsies and prepared cells for biochemical analysis

* Maintained cell bank of mutant fibroblast strains and diseases; shipped worldwide on request; thawed and froze fibroblasts

* Participated in diabetic research related to the development and morphology of the fetal pancreas

 - Assisted in removal of fetal pancreas; digested pancreas to obtain islets; cultured islets and prepared them for electron microscopy

* Developed technique for successful growth of bloody amniotic taps

* Initiated quality control of individual bags of flasks

 - Identified cell attachment problem

**1984
to 1985**

CIRCO CRAFT, INC., Granby, Quebec, Canada

<u>Chemical Analysis & Quality Control Technician</u>

* Organized lab for testing and adjusting concentrations of metal solutions for printed circuit board manufacturer

* Tested thickness and quality of electroplated metals

**1983
to 1984**

McGILL UNIVERSITY, Montreal, Quebec, Canada

<u>Microbial Genetics Technician</u>

* Prepared all chemicals and maintained equipment used in 400-student per week laboratory

* Tested mutant bacterial strains and verified necessary calculations by conducting eight separate experiments, among them:

 - UV irradiation and repair of DNA (mutagenesis)

 - Mapping of genes on the E. Coli chromosome by interrupted conjugation

Continued

McGILL UNIVERSITY (Continued)

* Proposed system and adapted equipment for automated method of successfully pouring agar media dishes under sterile conditions

Summer
1982

LONG ISLAND JEWISH MEDICAL CENTER, NY

<u>Microbiology Technician Trainee</u>

EDUCATION: State University of New York, Stony Brook, NY
1983 - BS, Medical Technology

Alton Jones Cell Science Center, Lake Placid, NY
1986 - Seminar in Prenatal Diagnosis

LANGUAGES: French

REFERENCES:

Available upon request

FRANCES DAVISON . 2500 York Avenue . New York, NY 10021 . (212) 288-7356

OBJECTIVE: Seeking a position employing my experience in investigative drug research and project systems design

SUMMARY: Registered professional nurse researcher with intensive experience in clinical administration. Adept at problem analysis with ability to develop systems for efficient records management. Knowledgeable about testing techniques and legal requirements. Demonstrated expertise in human resource management. Highly experienced in research into drug quality control and effectiveness of recommended dosage.

MEDICAL RESEARCH/ADMINISTRATION HIGHLIGHTS:

1981 to Present

MEMORIAL SLOAN-KETTERING HOSPITAL, New York, NY

Clinical Research Coordinator (1984 to Present)

* Responsible for development, coordination and human resource management of federally-funded cancer treatment research project

 - Report directly to board of clinical investigators; determine and initiate appropriate action based on their requests

 - Design systems for administration, record-keeping and control of experimental drug program

 - Develop procedures for patient recruitment, evaluation, dosage administration; follow up testing of participants

 - Organize and work in liaison with participating surgeons, clinics and laboratories

 - Solve special scheduling, transportation and communication problems as well as counseling terminally ill patients and their families

 - Designed toxicity sheet, label for experimental tablet and patient schedule cards to facilitate and simplify record-keeping and communications

 - Train medical fellows as back-up administrators

* Assist with clinical administration of 30 additional protocols

 - Coordinate appointments; document tests and dosages according to legal and protocol requirements

 - Monitor patients and assess dosage requirements and referrals

 - Developed systems for identification of incomplete records, indexing and chart procurement; evaluated information required for efficient usage of records desk

* Developed and administered two-year breast study

 - Wrote problem analysis and offered solutions in paper submitted to Chiefs of Staff and discussed in interdepartmental meeting

 - Initiated system for following day-to-day changes in patients' toxicity levels

Continued

MEMORIAL SLOAN-KETTERING HOSPITAL (Continued)

- Designed label for medication vials according to legal specifications; organized effective systems for patient follow-up

* In addition to official job responsibilities, accomplished extensive reorganization of general record-keeping

- Set up log book to document work flow and staff use of time for funding

- Designed and re-designed numerous charts, forms, cards and labels

- Reorganized responsibilities of entire staff to achieve full productivity during crisis caused by 40% personnel shortage

- Simplified reordering of supplies and drugs by preparing coded catalogs

Clinical Research Nurse/Chemotherapy Department (1981-1984)

* Prepared and administered experimental drug therapy; monitored and evaluated patient status both in and out of hospital

NURSING EXPERIENCE:

1977-1981 NEW YORK STATE REGISTRY, New York, NY
Private Duty Nurse

KINGS COUNTY HOSPITAL CENTER, Brooklyn, NY
Assistant Clinical Instructor (1978-1979)

* Taught respiratory medicine and respiratory intensive care to senior nursing students (both theory and practice); designed techniques for teaching decision-making skills

* Supervised student nurses in clinical care; assessed and graded performance; conducted individual evaluation conferences

Staff Nurse/Intensive Care Unit (1977-1978)

* In charge of intensive care unit; supervised entire night staff for 600-bed service

1975-1976 DOCTORS HOSPITAL, Freeport, NY
Nurses Aide/Medicine and Surgery (while in school)

EDUCATION: Current - Marymount Manhattan College, New York, NY
(Earned 99 credits toward BS in Nursing, attending school part time)

Kings County Hospital Center School of Nursing, Brooklyn, NY
1977 - Nursing Diploma

Nassau Community College, Garden City, NY
1974 - Liberal Arts/Nursing Program

CERTIFICATION:
Registered Professional Nurse

MICHAEL FRIER 120 West 86th Street, #4A Home 212-724-6572
New York, NY 10025 Work 212-650-7530

<u>FACILITIES PLANNING</u> for consulting and development, real estate, construction firm or government planning agency.

SUMMARY Facilities Planner with over 10 years in planning and development for major New York City medical center. Management authority over as many as ten ongoing projects with combined budgets of up to $750,000, involving sophisticated medical and research facilities. Experienced at obtaining government approvals, certificates of need and variances. Effective client consultant and director of architects, engineers and general contractors.

1979 to Present

MONTEFIORE HOSPITAL, New York, NY
Office of Facilities Planning & Design
<u>Project Manager</u>
Responsible for all phases of the planning and implementation of major facility changes.

Facilities Planning

* Create and direct construction, renovation and space utilization projects to facilitate institutional development
 - Design programs which reconcile desires of client departments with facility objectives
 - Determine available resources and administer budgets ranging from $50,000 to $100,000
 - Review architectural and engineering proposals to achieve maximum cost-effectiveness
 - Schedule, direct and monitor work of architects, engineers, consultants and interior designers

* Fully knowledgeable about New York Department of Health Building codes and other state regulatory agencies and local planning regulations

Major Building Programs

* Assisted Director of Planning with development of major building programs
 - These included a $100,000,000 500-bed hospital facility, a 30 story, $10,000,000 residence and a 10 story, 100 suite professional practice building

* Wrote and presented proposal to New York City Environmental Agency for $3,000,000, 600-car garage
 - This was the only such proposal approved by Agency since its inception

Long Range Planning

* Developed currently implemented long range plan in 1983 for future development of hospital and its building

(MONTEFIORE Cont'd)

Space Planning	* Designed comprehensive computerized 2 year, $100,000 space inventory to achieve efficient space management
Construction Management	* Projects up to 15,000 square feet with budgets ranging to $750,000 - Put projects out to bids - Negotiate contracts and approve changes - Monitor costs and schedules - Inspect work to ensure adherence to plans and specifications - Deal with general contractors and subcontractors
1978-1979	Stevens, Smith & Partners, New York, NY Architects and Hospital Consultants <u>Health Planner</u>
Long-Range Planning	Developed long-range plans for Bronx Municipal Hospital Center, NY, Norwich Hospital, Norwich, CT, Backus Hospital, Greenwich, CT. * Prepared comprehensive studies serving as basis for long-range building programs: - Studied demography, patient origins, physician manpower, community objectives, transportation, ambulatory care, delivery systems, long term care and available health and community resources
1974-1978	Taught for New York City Board of Education, served in Peace Corps in India, traveled through Mid East, Europe and Mexico
<u>Education</u>	NEW YORK UNIVERSITY, New York, NY 1973-1974 Completed course work for MA, Philosophy New York University Fellowship KENYON COLLEGE, Gambiar, OH 1973: BA, Philosophy (<u>cum laude</u> with high honors in Philosophy) Woodrow Wilson Scholar <u>Professional Courses:</u> New York University - Urban and Health Planning, Construction Technology and Management New School for Social Research - Urban Planning and Real Estate Willing to relocate, free to travel

BERNARD REESE 600 Rosedale Avenue White Plains, New York (914) 946-7357

OBJECTIVE: <u>PHARMACEUTICALS: Market Research and Development</u>

SUMMARY: Eight years diversified experience in clinical and immu-
nological cancer research. Candidate for Master's degree
in marketing. Master's degree in immunology and Bachelor's
degree in biology/chemistry

EXPERIENCE: INMAN INSTITUTE, New York, NY

1977 to
Present

<u>Senior Research Assistant</u> (1982 to Present)

* Conduct experimental immunological research (in-viro
 and in-vitro)

* Write experimental papers

* Direct laboratory and staff of approximately 15 MDs,
 PhDs, technicians, students and volunteers

* Prepare annual budget of $250,000

* Administer $100,000 annual laboratory purchases from
 pharmaceutical companies

* Write grant papers

* Interview job applicants

<u>Research Assistant</u> (1977 to 1982)

* Developed formally adopted creative procedures for per-
 forming perfusion techniques in live animals

 - Performed immunological preparation associated with
 liver and pancreas transplantation surgery in dogs
 and cats

 - Performed microsurgery in rats

 - Ran Alpha Feto Protein Immune-Electropheresis of
 serum proteins from patients suspected of having liver
 malignancy

* Responsible for some laboratory administration labora-
 tory administration

EDUCATION:

NEW YORK UNIVERSITY, New York, NY
Present – MBA candidate, Marketing
1986 – MS, Immunology

BOSTON UNIVERSITY, Boston, MA
1977 – BS, Biology

UNIVERSITY OF ROME, Rome, Italy
1977 – Summer courses at School of Medicine

FAIRLEIGH DICKINSON UNIVERSITY, Teaneck, NJ
1976 – Summer course in Advertising

EXTRA-CURRICULAR ACTIVITIES:

Worker in University Hospital Volunteer Plan
Orientation advisor and guidance counselor

President, Boston University International Folk Dance Club

LANGUAGES: Italian – read/speak

ECONOMIST

LEWIS LEE SHUN

200 Smithtown Road Yorktown Heights New York NY 10598 (914) 245-5662

OBJECTIVE: To obtain a research or management position utilizing my education and expertise in international economics, monetary economics, and finance.

SUMMARY: MA in Economics with specialization in International and Monetary. Economist, Government of Republic of China. Research at University of Florida. Bilingual: English, Mandarin Chinese.

RELEVANT EXPERIENCE:

1984 - 1986 <u>Research Assistant</u>, UNIVERSITY OF FLORIDA
Gainesville, FL

--Assistant to economist Michael Connelly, performing the research function for papers and projects on foreign exchange, economics, and other international studies.

--Sole responsiblility for evaluation and selection of new source books for economics, international finance, and business administration for University of Florida library.

--Simultaneously worked toward MA in the fields of International and Monetary Economics.

1983 - 1984 <u>Economist</u> (GS-11 equivalent level)
ECONOMIC PLANNING COUNCIL OF REPUBLIC OF CHINA. Taipei, Taiwan

--Organized, wrote, and edited reports for the director of the Council on international trade, new developments, and the effect of monetary devaluation--much of it having to do with the United States, Canada, Asia, and Europe.

--Published two reports for the Republic of China: (1) "The Effects of Devaluation" (2) "A Comparison of Taiwan-Korean Trade Patterns."

<u>Instructor</u>, THE NATIONAL CHUNG-HSING UNIVERSITY
Taiwan

--In addition to my position as a staff economist, taught "Money and Banking" and "International Economics" courses at the University.

--Developed curriculum for both courses, based upon U.S.-published texts.

OTHER EXPERIENCE:

1986 - 1987 <u>Part-time retail sales work</u>
Washington, DC

EDUCATION: MA, University of Florida, 1986
Major: Economics, International & Monetary

Graduate Work, Cornell University, 1981-1982

BA, National Taiwan University, 1979
Major: Economics

PERSONAL: Married. No children. Willing to travel. Permanent U.S. resident

Developing a Successful Marketing Plan

You have followed all the rules. Your résumé is as good as it can be, for the specific audience you had in mind. Let's now determine how to make the best possible use of it. This will depend, as mentioned in Chapter 2, on why you wrote it.

First of all, are you accelerating or changing careers? The strategies are different. Accelerating is much easier, so let's deal with it first.

Strategies for Accelerating

If you are trying to get further faster in the same field, you probably are seeking an interview for a position you either *know* is available or you think *might* be, now or in the near future. For either option, the most effective approach is to keep in mind and utilize the three levels of information listed in Chapter 3: knowledge of industry, knowledge of company, and knowledge of position.

Knowing what's out there obviously maximizes your chances of getting the job you want. Moving from the obvious to the less obvious, consider the following sources:

- [] Employment agencies
- [] Executive recruiters
- [] Newspaper want ads and business section display ads
- [] Business and trade publication articles and want ads
- [] Industry or function journals and newsletters
- [] Industry association officers
- [] Former colleagues and "friends of friends" networks

Let's take them in turn.

Employment agencies. Reputable agencies specializing in your field are worth contacting, but should not be depended on too heavily. Send a résumé and letter to those you've identified as the best of them, call within a decent interval for an interview (so at least one placement counselor knows you personally), and then forget about it.

Employment agencies work for the corporations and private institutions that give them job orders, and therefore can't be expected to go out of their way for you. It's important to take enough time to interview with each agency to which you send a résumé, though, so that it has a "card" on you, filed with each résumé. Each applicant is rated by appearance (so dress as you would for a job interview), personality, and experience. A résumé by itself will get lost in any agency's voluminous files. When stapled to a card indicating that you have interviewed there, however, it permits you to remain "live" for any openings the agency gets in the next several months.

If you are in the following fields, there is likely one or more agencies

in your metropolitan area specializing in positions appropriate for you:

Accounting/Finance	Personnel
Advertising	Public Relations
Banking	Publishing
Brokerage	Retailing
Data Processing	Sales
Health Care/Pharmaceutical	Technical/Scientific
Legal	Textile/Apparel

Executive Recruiters. Our advice regarding "headhunters" is similar to that for employment agencies. Their allegiance is to their clients, understandably, rather than to any individual applicant. If you are willing to come up with 30 percent of your current annual salary as a "finder's fee," on the other hand, you can probably be assured of the same level of attention the recruiters afford their corporate clients.

Some of you who have been contacted by a recruiter may remember being vaguely irritated that first time to be told about a great new job just as you were beginning to enjoy the best one you ever had. That happens. Don't expect them to be there when you need them. Most recruiters lure "fast trackers" from their clients' competitors and companies with similar product/service lines to that of their clients.

Recruiters like to *solicit* résumés, not receive them unasked. If they hear from you first, you are perceived to be vulnerable with your current employer, or even unemployed (even though you may not have alluded to your job status in a cover letter). The reason is not so much that you are tainted professionally by being—at worst—between jobs, but that you are a tougher "sell" to the client. Most recruiters would rather not spend the extra time it takes to neutralize the negatives of pitching an out-of-work applicant or one whose job is in jeopardy. An executive who has to be pried from his current position is a much lower risk and a more prized commodity.

Most recruiters do accept résumés, however, and indeed keep them. And because they have to stay on top of industry/company/position trends, they can be excellent source people.

Call the recruiter for an interview a week or so after you send in a résumé, and see if you can steal a half hour of time. Do enough brain picking to get a sound estimate of your intrinsic marketability and the current state of the market for someone with your background and aspirations.

Newspaper ads. Responding to a newspaper ad is much like buying a lottery ticket: the cost is low and the payoff high, but the odds of winning are even higher. The employers' screeners first scan résumés as much to exclude the unacceptable as to identify the qualified. Their instructions usually are to pick out the top ten or twenty-five résumés from the hundreds they read, so that interviews can be set up accordingly.

Their checklist usually is inviolable, because they are simply following orders. So if you like the sound of the job but fall short on more than one of the stated criteria, applying probably will be a waste of your time. Papering the gap between your qualifications and the minimum listed by writing a long cover letter won't help either. Either rewrite your

résumé to fit the specifications of the opening (honestly, that is—anything less will catch up to you, eventually), or keep looking until you find a better match.

As to want ads in particular, be sure you look under all the appropriate categories, and do it consistently. Some companies advertise by function, others by industry, still others by job title. A public relations writer, for example, conceivably could find openings appropriate to ability under "Public Relations," "Corporate Communications," "Corporate Relations," "Copywriter—Public Relations," "Speechwriter," and "Writer," as well as under the various industry and individual agency listings. Get in the habit of regularly cross-checking all categories that could pertain to you.

Be familiar with those weekdays your metropolitan papers gang their display ads in a discrete employment section. The *Wall Street Journal* lists employment opportunities and services every Tuesday, for example; The *New York Times* on Tuesdays, Wednesdays, and Sundays.

Business and trade publication articles and want ads. Spend a half-day every week at the best public library available to you, so you can assemble an intelligence system effective enough to anticipate trends that may in turn trigger job openings.

Go through business magazines such as *Fortune*, *Forbes*, and *Business Week* regularly, as well as your particular trade magazines. Take notes on companies that interest you and individuals in them who may make good contacts for you some day. Check the back-of-the-book classifieds for openings you may want to follow up.

Industry or function journals and newsletters. Those you can't find at the library, subscribe to. Use them as you would business and trade publications.

Industry and function association officers. Membership directories are great sources for identifying leaders in your field who could be valuable contacts for you. If you don't know of a directory listing your industry or function membership, talk to a reference librarian or consult the *Directory of Directories* (Gale Research Company), published semi-annually.

Networks. To draw a lead on companies where you have discovered openings or believe they are about to occur, contact former colleagues or friends in other companies to see who knows somebody in power at each target company.

Raised to its highest, most organized form, this systematic contacting is called "networking." (It's an effective strategy for career changers as well, so you'll be referred back to this section if you're thinking of plunging ahead to those paragraphs.)

Most female executives and professionals are great networkers. Many males don't even know the term. One reason for this is that women as a group have had it far rougher in the business world than have their male counterparts, owing to various forms of sexual discrimination. They've been the Outs; men the Ins. As a result women have learned to cope and scramble in an alien world, a bit like fish learning to walk on land. So they're less reluctant to ask the right questions of anyone who can help them break down the barriers.

Male executives generally talk to a handful or so of former colleagues to see where the jobs are, but rarely do they exploit the networking technique to its fullest. Many groups of female executives meet regularly just to exchange business cards and broaden their network base.

But the technique is beginning to spread. A noted former radical, excoriated in the sixties by a large segment of society for his anti-establishment behavior, helped broaden the networking concept in the early eighties by taking over a large New York discotheque on off-nights. By promising both professional and social introductions to attending male and female executives, he generated the exchange of thousands of business cards leading to proposals of various kinds—many of them for jobs.

Male reluctance to networking has been partly attributed to the eggshell egos some say go with the gender. This is probably true, although the job hunt exposes anyone—male as well as female—to vulnerability in the extreme. And this is the case even for those changing positions of their own volition. Most executives feel best about themselves when they are secure, productive, well-compensated team members. They feel worst about themselves, understandably, when this security is taken away.

Strategies for Career Change

A complete analysis of career change requires a book of its own, but several basic steps will help point you in the right direction.

You're probably thinking of a change because you're bored beyond belief; are burned out; are miscast; or just would prefer a different professional way of life after ten or fifteen years doing what you're doing.

Jumping *from* is easy. You just quit, or—consciously or subconsciously—get or allow yourself to be fired. Jumping *to* is the tough part.

First you need to make two lists. List A should contain all of the things you like about your existing function, company, position, and industry. List B should contain all of the things you can't stand about what you are doing, in these same categories. The ideal change, it will come as no surprise to you, will include all of the List A items and none from List B. This won't happen, of course. To come as close to this ideal as you can, though, is your reasonable goal.

If you're lucky, the adjustment will be a minor one: moving to a company that gives you a freer hand in the same function and industry, for example; doing what you do for an organization larger—or smaller—than yours, or in a different geographical setting.

Slightly more difficult, but manageable, are position changes other than "straight ahead." One of our clients who had risen through the commercial real estate and building management ranks to vice-presidency of a large New York commercial real estate concern said the fun had gone out of his work. His most challenging years, he said, were at the building management level where he had to juggle working relationships with various unions and state and local regulatory bodies, as well as solve dozens of variegated day-to-day problems. His more elevated executive position gave him considerable policy-making power

and paid extremely well, but bored him to the point that he hated to come to work in the morning. He wanted to return to where the action was, even if it involved a pay cut.

His problem was to find such a job without appearing to have lost his drive and ambition. It might seem to some, for example, that he had peaked professionally and was willing to settle for fewer responsibilities and less challenge—when in fact the opposite was true. With the appropriate résumé, cover letter, and list of targeted prospects, he reached his goal. (His résumé appears on pages 202-203; his cover letter on page 250.) Within three months he was appointed building manager of the Empire State Building.

More difficult, and impossible to cover in a book of this scope, are changes that involve function or—in many cases—industry. If you realize after working with data or "things" for ten years that you would prefer to work more with people, you may have to complete additional necessary training or appropriate courses in your spare time. Plan to spend a year or more making this happen, including enough networking and information interviewing to be sure you remain on the right track.

Putting It Together

You've heard of the hidden job market? No need to pay thousands of dollars to the large career service companies that advertise access to the "90 percent of job vacancies...available that the average job searcher does not know about." Their claims of inside information from corporations that for some reason share this knowledge with them but don't get the word out to "the average job searcher" are false.

The hidden job market is simply the wealth of positions that don't get advertised because they are filled first by individuals who have done the homework outlined in this chapter, and are tapped into the networks we've mentioned. There is no need to advertise, after all, if one or more qualified candidates for a position are *known* to exist and be available.

Be that candidate. In any company you'd like to work for, find one or more people in a position to provide inside information. To help you determine whether an opening exists or might be coming up, get answers to the following questions, and any others you can think of:

☐ Is there an impending merger or acquisition?
☐ Is expansion a probability—or the addition of one or more product or service lines?
☐ Are sales up—and staying there?
☐ Is activity scheduled that leads to one of your strengths?
☐ Have you identified a problem area that your background would help solve?

Set up an interview with your contact person if you need additional information, then send your résumé and an appropriate cover letter to the line officer or department head who will be doing the hiring.

Cover Letters That Sell

A cover letter is a personal letter in the sense that it introduces you *personally*—whether it is addressed to a box number in answer to an ad or sent to an individual who has personally requested it. As such, each must appear to have been written solely for the eyes of the addressee, even if it is but one of five hundred you have sent out.

This is important because it gives you the opportunity to neutralize the impersonally written résumé by introducing you in more human terms. Each cover letter should highlight your strengths specifically in light of the opportunity you are addressing.

No better model exists for constructing your cover letter than the four-paragraph sales letter prescription offered in Business English classes decades ago: 1. command attention; 2. sustain interest; 3. assure conviction; 4. incite action. Whether you do this in more or fewer than four paragraphs will depend on the circumstances. Those four components, however, should all be there.

Command attention. The most effective way to get the reader's attention is to state your business in as forceful and succinct a way as you can. Are there exceptions? Of course. An advertising copywriter, for example, expected to write winning copy every time she puts typewriter to paper, might start off with her best headline, followed by a couple of sentences telling how well it sold the product. Other situations will vary with the purpose of the letter, as described later in the chapter.

Sustain interest; assure conviction. Consider these not as discrete paragraphs, but rather two inherent elements often combined in the body of the letter. Those of your credentials—accomplishments, responsibilities, skills, professional record, and education—that you know to be of particular importance to your reader should be laid out with the appropriate emphasis and in appropriate sequence, with specific examples as they apply. See the samples included later in the chapter for varying kinds of circumstances.

Incite action. Notice in all of the sample letters that follow (except for replies to blind newspaper ads) that the writer requests an interview—and further, indicates his or her intention to follow up with a phone call to personally petition for an interview.

This is important. First of all, with the number of résumés hitting the desks of hiring line executives or institutional supervisors, it is unlikely your letter will trigger an immediate return call unless the opening is current and you are right for it. Essential as it is for an organization to seek out the best people, the press of day-to-day responsibilities often pushes this need down the list of professional priorities.

Saying you will call to request the interview increases your chances of getting it. The absence of a reply to your letter is of itself a negative response, obviously. By calling, you force a *direct* negative response (if

this be the case) and eliminate the possibility of *passive* rejection. No chance now that the addressee lets your letter work its way down to the Pleistocene level of his In box and dooms it to inaction.

Cover Letter Situations

Most of your mailings will fall under one of the five following categories, so the remaining pages of this chapter consist of specific tips for each situation, followed by sample letters written for Career Clinics clients under the same circumstances:

☐ Newspaper ad replies
☐ Executive recruiter/employment agency inquiries
☐ Corporate/institutional cold calls
☐ Slight-career-change cold calls
☐ "I'm back in the job market" re-introductions

Newspaper ad replies. All ads won't require your attention in equal measure. When you see one you think you are perfect for, though, give it an extra effort.

Go over the ad's requirements thoroughly. Assume that they have been rank ordered, and deal with each as sequenced in the ad. Write and rewrite a description of those accomplishments, skills, and responsibilities that relate specifically to each requirement, until you have eliminated all excess words. Communicate your strengths clearly and succinctly. Work on your transitions until each idea flows effortlessly to the next. Below is an ad from the Business section of the *Sunday New York Times* that was of particular appeal to a client. The letter he sent in reply can be found on page 235.

You might try experimenting with a mailgram for the occasional ad meriting special attention—and also likely to attract résumés in the hundreds. One done for an export executive can be found on page 232.

Finally, don't send your ad response off immediately. Letting it sit for a few days will give you a chance to read it with a fresh eye and make improvements at leisure. The first week or so after the ad's publication, it will attract bagfuls of replies. Wait until the first wave subsides, in about a week or so. Your letter and résumé will get more attention and be more carefully read.

Executive recruiter/Employment agency inquiries. Get in touch with the best of each (the quality and quantity of jobs they list is a good clue), keeping in mind that few employment agencies handle many jobs above the $50,000 salary level. To check out recruiters who are likely to have something at your level and in your field, write or call the American Management Associations (135 W. 50th Street, New York, NY 10020; (212) 586-8100) for a copy of their *Executive Employment Guide.* For $15.00 they'll send you a list of more than 125 executive recruiters nationwide (several with offices worldwide), including addresses, phone numbers, special fields covered if any, minimum salaries of positions handled, and an indication as to whether each accepts résumés or will accede to an interview regarding opportunities in general.

Make the principal purpose of your letter to set up a conversation with one recruiter in each firm—best, in person; second best, by phone. Reconcile yourself to the reality that your chances of matching the specifications of any current search assignment are probably one in one thousand. What you want is information, as well as the opportunity to favorably impress an individual with the power to call you about a client opening six months from now.

Start by calling each target search company within visiting distance, and talk with—or get the name of—the highest ranking individual available. Just get a name and title, and "permission" to send in a résumé. Make your cover letter brief, highlighting major strengths, and follow with a phone call in ten days to set up an interview if you can. On page 237 is a sample letter sent to a recruiter for this reason.

Corporate/Institutional cold calls. If your universe of prospects is a large one, it will be impossible to include a paragraph or more tailored to the express needs of every organization. Decide first how much research on individual companies you are willing to undertake.

Let's say there are ten companies you are extremely interested in, and another fifty you want to contact because a real possibility exists that there is a spot for you—or soon will be. Thoroughly research the top ten companies and write letters indicating your awareness of a particular—and recent or imminent—expansion, merger, acquisition, or market repositioning, and your ability to help the company implement or maximize it. On page 238 is an example of this type of letter.

For the remaining fifty or more organizations it may be enough to simply address each letter to the appropriate person, and then mention the company's name once or twice during the body of the letter. More effective, if you can take the time, is to rank order the companies,

complete in-depth research on them, ten at a time, and write your letters as you would for the top ten. Most letter houses with word processing equipment can do this for you for about $1 per letter, including addressing the envelopes. Obviously it is important to have the letters typed individually rather than printed, even if you do go to a word processor. Form letters get thrown out before they're read. On pages 238-246 are some corporate cold call letters for the two situations described above.

Slight-career-change cold calls. If you are making a transition between two related fields, your résumé obviously should be written to minimize the differences between your current and future professions or positions—and indeed use the terminology of the field you are working to get into. The letter you write to accompany the résumé, similarly, should pick up on accomplishments valued equally by current and future employers and stay away from the differences.

The closer your new career is to the old one the easier your task is, obviously. There will be more to draw from your past, and less to hypothesize about your future. In any case the format of the letter accompanying your résumé is basically the same as for any other cover letter. On pages 247-252 are a few examples.

"I'm back in the job market" re-introduction letters. Most executives and professionals make at least one dreadful career mistake during their forty and more years of ladder climbing and tightrope walking. Now and then the greener grass wilts without warning. A pre-employment promise goes unfilled; an unanticipated personality or workplace conflict sours an otherwise promising venture. These things happen.

Many of them, sadly, don't have to happen. Sometimes asking the right question in the final interview will uncover a potential stumbling block large enough to change an acceptance to a rejection. But that's another story, touched on in a bit more detail in Chapter 7.

If you find yourself in an untenable position, get out as gracefully and as quickly as you can—in a way that doesn't arouse your current employer's suspicions in the process, obviously. Don't bite the bullet and do a miserable three to five when you could be advancing professionally and happily elsewhere. Re-establish your network and get the word out subtly that you'd rather be somewhere other than where you are. The letter on page 253 is one way to do this.

ROBERT M. SMICK
590 Mordeca Street Silver Spring, MD 20850
Home: [301] 968-2402 Office: [202] 747-9201

July 6, 1991

Y7427 TIMES 10108
C/O The New York Times
229 West 43rd Street
New York, NY 10036

Ladies/Gentlemen:

This letter is in response to your ad in the June 21 Business Section of
The New York Times for someone to head up your Community Relations/Public
Participation program.

For the past six years I have served as Executive Director for the Board on
Minorities in Engineering & Sciences, National Academy of Sciences. In this
position I am responsible for coordinating the efforts of 65 corporations,
15 federal agencies, and 112 universities to implement a science manpower
policy utilizing $4,000,000 annually. I call upon the cooperation of promi-
nent leaders from government, industry, academic institutions, and civic
organizations to accomplish the Board's goals.

The public participation techniques I find most useful flow from an identi-
fication of the issues and the subsequent identification of competent, expert
witnesses to present informed views regarding these issues. These data
result in reports, symposia, and news conferences to inform the public. I
have worked closely with the print media, and have appeared on television
and radio talk shows in support of various issues espoused by the Board.

My background in chemistry and the Board's relationship with other divisions
of the Academy have provided me with the basic tenets of hazardous waste
management. A short time ago, in fact, I brokered a contract between DuPont
and a small environmental engineering firm for an environmental impact study
on waste disposal that resulted in a mutually satisfying relationship for
both parties.

My resume is enclosed. I look forward to hearing from you so that we may
take the discussions of this challenging position one step further.

Sincerely,

Robert M. Smick

Robert M. Smick
RMS/mg

THE WALL STREET JOURNAL
BOX EJ-991

MY QUALIFICATIONS MATCH YOUR NOVEMBER 17 AD FOR CORPORATE VICE PRESIDENT

AND DIRECTOR OF INTERNATIONAL SALES. HAVE 20 YEARS EXPERIENCE COVERING

EXPORT SALES, CORPORATE DEVELOPMENT, INVESTMENT ANALYSIS, VENTURE CAPITAL,

AND STOCK BROKERAGE. EARNED WHARTON MBA 1966 AND UNIVERSITY OF TEXAS BBA

1965, BOTH MAJORS IN FINANCE AND BANKING.

FOR PAST THREE YEARS HAVE BEEN OPERATING OWN CORPORATION, A MANUFACTURERS'

EXPORT DISTRIBUTION AND REPRESENTATIVE FIRM. HAVE ALSO SERVED AS PRESIDENT

OF GREATER CLEVELAND REGION INTERNATIONAL TRADE DEVELOPMENT ASSOCIATION.

EARLIER INITIATED EXPORT SALES FOR A NORTH CAROLINA MANUFACTURER OF

BUILDING MATERIALS AND AN OHIO MANUFACTURER OF LASER-ENGRAVED PRESTIGE

ADVERTISING SPECIALITIES AND CORPORATE GIFTS. WAS A CO-FOUNDER FOR BOTH

IN 1977 AND REMAIN AN ACTIVE DIRECTOR.

KINDLY TELEPHONE (414) 298-4133 TO DISCUSS THIS POSITION.

Rollin Payne

ROLLIN PAYNE

14 Panther Place
Stamford, Connecticut 06814
August 15, 1991

Dear Sir:

Among your clients may be one or more contemplating entry into the export market, or who has limited experience therein.

As founder and managing director of Tremont International, I currently represent or distribute for dozens of manufacturers who, until our relationship, had never before sold overseas. My intention is to take this expertise -- together with more than 20 years of financial and investment management background -- to a manufacturer ready to begin exporting.

My concept of exporting is designed to minimize cost and red tape, and at the same time maximize profit. You can see by the attached resume that my specific accomplishments in this area are considerable, and range over a variety of consumer and industrial product areas.

Within the next few days I will call to see when you might be available to discuss with me what prospects exist for meeting principals of firms you now represent.

Thank you for your consideration.

Sincerely,

Jarvis Henry
Jarvis Henry

JH/rm

10 Tyrolia Lane
Lawrence, New York 11559
September 3, 1991

Mr. Paul Bergeson
President
Acme Stores, Inc.
655 Fifth Avenue
New York, New York 10036

Dear Mr. Bergeson:

Your recent acquisition of the Bandow chain would indicate an intent to pursue southeastern market opportunities more vigorously than you have in the past several years. I believe that my retail management background would complement your long-range strategy for Acme very effectively.

For the past 10 years I have put together a record of which I am quite proud, including six years at Loud & Schwartz culminating in a senior vice presidency and membership on both the Executive Committee and Management Board.

As you will see on the enclosed resume, most of my accomplishments are quantifiable, including sizable volume and gross margin increases in every position of leadership I have held. In a single year at Loud & Schwartz, for example, the profit ranking of the division I led improved from tenth to first.

These are far from single-handed achievements, obviously. One of my strengths is the ability to recognize and utilize the best talent available, and to extend the decision-making process so as to offer middle managers--and sometimes even those below them--a stake in determining or refining company policy.

I will call within the next week or so to see if you agree that our mutual interest would be served by a personal meeting, and if so, to see when your schedule permits it.

Sincerely,

Douglas Frisk

Douglas Frisk

Encl.

859 Hobart Street
San Francisco, CA 94110
(415) 875-0922

Mr. Kenneth Rivera
Senior Vice President
Florida State Bank at Orlando
801 N. Lemon Avenue
Orlando, FL 32800

Dear Mr. Rivera:

In approximately three months I am moving to Orlando with my family, and am bringing with me 15 solid years banking experience--the last eight in branch operations management. I would like particularly to utilize this experience with the Florida State Bank at Orlando.

As Branch Manager I currently supervise 20 employees, including nine tellers, at the largest branch of the Federal Mutual Savings Bank, in San Francisco. I serve as an officer of this bank, as well.

As you will see from the enclosed resume, I am well rounded in the workings of NOW and money market accounts, and am extremely strong in the use of systems to reduce overtime and increase both efficiency and customer relations.

I am in the process of planning an exploratory trip to Orlando sometime in late May, and would like very much to meet you and learn of any opportunities that may exist at the Florida State Bank at Orlando for someone with my background and potential. I look forward to hearing from you. Because the precise timing of my move is not certain, I have not yet informed my employer of my intention to move. I would, therefore, appreciate your confidentiality in this regard.

Sincerely,

Marcia J. Shin

Marcia J. Shin

Encl.

24 West 65th Street
Brooklyn, New York 11020
September 12, 1991

Mr. R. B. Ashton
Vice President for Merchandising
Loud & Schwartz
1821 Broad Street
Philadelphia, PA 20171

Dear Mr. Ashton:

For the past four years I have assumed positions of increasing responsibility for both domestic and import retail furniture buying, and am now ready for additional challenge.

At G. Dixon and Company I supervise all aspects of retailing from product purchase to merchandising for bedroom, dining room, occasional and lifestyle furniture. Revenues in this department run in excess of $2 million annually. In the Lifestyle Department alone I increased volume from $400,000 to more than $1 million in one year.

I have a particularly strong color and design sense and am able to identify a potentially successful product with a high degree of accuracy. As you will see from the enclosed resume, another of my strengths is in the area of effective and creative merchandising.

It is my hope to bring these qualifications to Loud & Schwartz. Toward this end I will call you within the next week or so to see when your calendar permits a personal interview.

Sincerely,

Phyllis Sublett

Phyllis Sublett

Enc.

FRANCIS C. HOLLAND P.O. BOX 663 NORTHPORT, CT 06490

October 29, 1991

Mr. Frederick R. Gloeckner
Vice President & General Manager,
 Export Sales & Services
General Electronics
3135 Weston Turnpike
Northfield, Connecticut 06431

Dear Mr. Gloeckner:

I would like the opportunity to put my nine years of marketing and sales
experience to work for General Electronics.

My years with the Learning Corporation of America have been marked by
consistently increasing levels of responsibility and achievement. In
each of the three positions I have held, departmental sales have in-
creased dramatically. Moreover, I have been responsible for opening
market areas previously unknown to the company. The problem is that
my current product line -- educational films -- is not in a growth stage,
nor is it likely to be so in the foreseeable future.

For this reason I am seeking new challenges, and have selected General
Electronics as one company whose dynamic marketing position is unparalleled.
Within the next few days I will be calling you to determine when your
schedule will permit us to discuss a sales or marketing management position
with your firm.

Sincerely,

Francis C Holland

Francis C. Holland

43 Racine Avenue
Skokie, Illinois 60076
January 3, 1991

Mr. Russell Hendrickson
Executive Vice President
Thatcher and Thatcher
48 Greenwich Avenue
Greenwich, Connecticut 06830

Dear Mr. Hendrickson:

The enclosed resume summarizes my background as follows:

> Extensive experience working directly with heads of Fortune 500
> corporations, federal agencies and the Congress. Skilled in
> assessing importance of specific issues and designing successful
> issues-oriented actions.

This is the strongest two-sentence case I can make toward convincing you of
my potential value as a key public affairs or government relations manager
for Thatcher and Thatcher.

What I do best is to analyze problems accurately, and then marshal the ap-
propriate resources to solve them. The arena in which I am most effective
is in the protection and fostering of corporate interest--either as a
spokesman to the public, or in influencing the passage of legislation or
regulations best reflecting that corporate interest. One of my major res-
ponsibilities as Executive Director, Board on Minorities in Engineering and
Sciences is to work with Cabinet and federal agency heads, as well as with
members of Congress, to formulate and influence the passage of laws and
regulations regarding issues affecting the Board's objectives and policy.

On both a day-to-day and long-range basis I direct the planning, organization
and administration of the Board. I organized a national symposium that
included 800 prominent leaders from government, industry, academic institu-
tions, and civic organizations. I plan and chair semi-annual meetings for
35 corporate leaders to address national manpower problems.

I am particularly interested in working for a company like Thatcher and
Thatcher because it will allow me to use all of my background--technical,
scientific, educational, and public and legislative affairs.

I look forward to discussing with you the possibility of a position with
Thatcher, and will call within the next week or so to see when your schedule
might permit a personal interview.

Sincerely,

Harry K. Ellis

Harry K. Ellis

Enc.

35 Lyndon Way
Cromwell, New Jersey 07841
November 10, 1991

Dear _____:

Within the next six weeks my wife and I will be moving to Ventura
County, where I intend to put to use my 20 years of financial
management experience in the health care field.

I am writing to see if there is an opening--either now or in the
immediate future--for a professional with the skills and achieve-
ments I have to offer.

My strengths include a heavy background in grants application and
analysis, budget forecast and maintenance, staff supervision, and
problem solving.

Upon my arrival in California I will call to see if you believe
our mutual interest might benefit from a personal meeting.
Enclosed is a copy of my resume for your information.

Sincerely,

Barton R. Nelson
Barton R. Nelson

Encl.

455 Ocean Parkway, Apt. 1C
Brooklyn, New York 11218
September 15, 1991

Mr. Harry Martinez
Executive Director
Foster Labs, Inc.
Anderson Blvd.
St. Charles, IL 60134

Dear Mr. Martinez,

With more than ten years clinical chemistry experience as a graduate biochemist in hospital settings, I am seeking a position as a technical representative or specialist. I am thoroughly familiar with the chemicals used for general and special tests in hospitals and doctors' offices and all of their applications. I am also expert in the use and promotion of testing equipment.

My resume can only highlight my qualifications. A personal interview will assure you of my potential value to your company. I will call you in a few days to set an appointment.

Sincerely yours,

Irene Seanor

Irene Seanor

Enc.

310 West 30th Street
New York, New York 10001
April 20, 1991

Mr. Phillip Mitchell
Director of Marketing
Worthington Electronics
Manheim Road
Secaucus, N.J. 02471

Dear Mr. Mitchell:

The state of the art in the electronics market changes at such
a rapid pace that aggressive marketing and astute product
management are essential if high profitability is to be achieved.
I offer a background of more than twenty years in the field of
electro-mechanical products.

My ability encompasses concept and design and includes complete
product management through the entire production process. In
addition, I have worked with engineers, designers and product
managers in U.S. and foreign manufacturing plants to bring in
production schedules for high volume sales of most profitable
items.

The enclosed resume hits the high points. Perhaps we can get
together and talk in detail of my potential value to your
organization. I will call you in a few days to arrange an
appointment for a personal interview.

Sincerely yours,

Clarence Weber
Clarence Weber

Encl.

19 Wingate Road
Cleveland, Ohio 12345
February, 1 1991

Mr. Charles Close
Executive Vice President
T. Clark and Company
Sugar Grove, IL 60134

Dear Mr. Close:

The enclosed resume highlights significant accomplishments of my 11 years of sales and marketing management. I am looking now for a greater challenge, and believe you will agree that my record justifies such an expectation.

In seven years with Foraldo Corporation I rose from western regional manager of the Epcraft Division to vice president of a group overseeing all five of the firm's tool divisions. This position involved the development and management of a nationwide organization of 92 manufacturers' rep firms and 10 direct sales managers, and supervision of a staff of 250.

The sales incentive program I established at Foraldo resulted in a 13% increase in annual sales and helped set new corporate records in gross profit levels. I have a keen sense of cost control, and am particularly strong in the structural reorganization of profit centers to increase efficiency and productivity.

My goal is to join a firm that requires the immediate use of these skills whether to increase a rate of established growth or to effect a turnaround situation.

Within the next week or so I will call to see whether you agree that our mutual interests would be served by exploring this matter further, and if so, when your calendar might permit time for a personal interview.

Sincerely,

John A. Larson

Encl.

John A. Larson

411 Market Place
Boston, MA 09296
May 12, 1991

Mr. Samuel Insull
Vice-President for Corporate Affairs
Sunco Oil Company
60 West 42nd Street
New York, NY 10042

Dear Mr. Insull:

After four years of public affairs and press work with both the White House
and as an aide to the Governor of Massachusetts, I am eager to return to cor-
porate life once again.

I offer a unique combination of public and private sector experience. Most
recently, my work as lead advance for Vice President Mondale, Rosalynn Carter,
and Mrs. Mondale has given me the opportunity to handle press and protocol
matters both domestically and abroad. My charge has been to manage the sen-
sitive--and potentially inflammatory--relationships when representatives from
different cultures, societies and religions meet and mix. This calls for a
high order of organizational skills, tact, and attention to detail.

As special assistant to the president of Arnoco Industries I single-handedly
organized a Government Relations conference at which were set industry stan-
dards that ultimately influenced crucial federal legislation. My corporate
experience also includes five years with Dean Witter as both a registered
representative and Executive Assistant to the President, and a customer ser-
vice position with Merrill Lynch.

This combination of public and private sector experience has been excellent
preparation for a position in corporate communication/public affairs--possi-
bly involving legislative liaison at federal, state and local levels. I look
forward to discussing this prospect with you, and will call within the next
few days to see when your schedule permits such a conversation to occur.

Sincerely,

Martha Buchanan

Martha Buchanan

Encl.

43 Crescent Lane
Port Washington, New York 11050
June 5, 1991

Mr. Jake Smith
Editor-in-Chief
The Viking Press
16 E. 46th Street
New York, New York 10077

Dear Mr. Smith:

Is one of your new publications being delayed in startup for lack of
qualified editorship? Is one of your existing periodicals foundering,
or not running at peak efficiency or quality for a similar reason?

If the answer is "yes" in either case, I think it would be to our mutual
advantage to talk. I have a solid 20 years writing and editing experience
to draw on -- all in the areas of business, finance, and insurance. I
have conceived new magazine ideas, managed the gestation periods, and
brought inaugural issues to the black of print.

Moreover, as you'll see from page two of the enclosed resume, my current
freelance client base is both varied and prestigious.

I have considerable talent and commitment to offer some very special and
specialized audiences, and would appreciate the opportunity to discuss
this with you personally. I'll give you a call within the next week or
so to see when it might be convenient for us to meet.

Sincerely,

Albert Magnus

Albert Magnus

Encl.

2803 Chesapeake Street
Washington, D.C. 20008
April 3, 1991

Mr. James Clark
Vice President for Programming
Extension Cablevision, Inc.
1007 Post Road East
Westport, CT 06880

Dear Mr. Clark:

For the past three years I have been involved in television programming and production at Hayden Lurch Associates, as part of my job as Manager of the Audio-Visual Department. My immediate goal is to apply this valuable background--as well as my current freelance videotape producing experience--to the needs of station WXYZ.

While at Hayden Lurch I have coordinated productions from start to finish for such clients as Sun Company, Inc. and Burroughs, including budgeting, scripting, editing, production work, and talent coordination. In addition I prepare departmental budgets, develop concept proposals for client selection, and supervise both creative and administrative personnel.

I have the respect of both colleagues and clients for overall effectiveness, on-schedule and under-budget performance, and quality of final product. My reason for wanting to leave Hayden Lurch--and public relations in general--is an intense desire to focus my skills and expertise full time in the field of television.

Within the next few days I will call to see if you agree that it would be advantageous for us to meet and discuss a position with WXYZ, and if so, to schedule a time that is convenient for you. My resume is enclosed.

Sincerely,

Rollin Ashton

Rollin Ashton

Enc.

465 West End Avenue
New York, New York 10023
January 23, 1991

Mr. Richard Fairbank
Vice President for Operations
Ackroyd and Fisher
369 Lexington Avenue
New York, New York 10010

Dear Mr. Fairbank:

Over the past five years I have grown at Dakota Realty from
Building Superintendent of a single building to Vice-President
and Director of Operations for six commercial buildings--
including the ICC Building on Fifth Avenue and the MCA-
Universal Building at 445 Park Avenue. My accomplishments over
this period are considerable, as you will see from the enclosed
resume, and include responsibility for a 55% increase in revenue
for the 445 Park building during my tenure there as building
manager.

My purpose for writing is to acquaint you with my background
and indicate my availability for a building management position--
for either a prestigious office building or a corporate head-
quarters. My credentials are impeccable, and I am willing to
discuss any current or imminent openings with you at your
convenience.

I will call you over the next week or so to see when you might
be available for a personal interview.

Sincerely,

Juan S. Geisler

Encl.

62 Marsh Street
Chicago, Illinois 60602
December 7, 1991

Mr. Verner Anderson
President and General Manager
WGBW TV
14 Rockville Plaza
Detroit, Michigan 51073

Dear Mr. Anderson:

For the past 15 years I have co-directed Datus Productions, a film, television and audio/visual production company I co-founded to serve clients in publishing, advertising, and other manufacturing and service industries. As you will see on the enclosed resume, my clients include McGraw-Hill, Young & Rubicam, Amerada Hess, and American Express.

My interest at this point of my career is to devote fewer energies to building a business and more to developing product. I have determined that the way to do this is to work with one "client" only--and do it full time.

This decision is reached from a position of strength: I have eight active clients and a number of additional projects under development. The point is, I have product development skills I am not utilizing as much as I want to.

Please look over my resume to see if any of my skills and accomplishments match your current or imminent needs. I'll call you in a week or so to see when your calendar permits a personal meeting.

Thanks for your time.

Sincerely,

Tilden Meyers

Encl. Tilden Meyers

15 Cayaka Street
Los Angeles, CA 90057
December 29, 1991

Dear_____:

For more than twenty years I have built a record of solid accomplishments
in the business of education--as a financial officer, a human resources
manager, and as a senior operating executive. I would like to offer this
experience to the executive management or human resources operation of
(name of company) .

At two colleges in the past twelve years, I devised a considerable number
of bold, innovative management programs. They improved efficiency, reduced
costs, eliminated problems, and unsnarled administrative tangles. At the
same time, the academic programs were maintained and improved. My com-
petencies range from administering complex federal programs to negotiating
labor contracts and disputes; from supervising the revision of a school's
complete legislative structure to instituting and administering a college-
wide energy conservation and deferred maintenance program.

I look forward to discussing with you the several ways in which my experience,
talents, and services could be of use to (name of company). I will call
next week to see when your calendar permits scheduling an appointment.

Sincerely,

Robert O. Levinson

Robert O. Levinson

45 Hunter Lane
Grand Rapids, MI 49505
April 18, 1991

Mr. Clarence Halter
President
Animated Industries, Inc.
4641 Boardwalk
Dallas, Texas 41414

Dear Mr. Halter:

Four months ago you and I discussed an opportunity at
Animated, and you were kind enough to set up meetings
with Jack Conde and Ernest Soderstrom. Shortly there-
after, as you know, I accepted a position with Spring-
born & Sons, where I am now.

For reasons I will go into when we meet, I would like to
re-open our discussions. If you think such a conversation
would be mutually beneficial, I'll call next week to see
when you have a half hour or so of free time.

Sincerely,

Jerry Lake

Jerry Lake

227 Jefferson Street
Geneva, IL 60134
March 13, 1991

Ms. Mary Pearson
Director of Marketing
Follett Publishing Company
433 N. Michigan Avenue
Chicago, IL 60607

Dear Ms. Pearson:

Thank you for considering me for the Director of Marketing Services position
we discussed on Monday. By way of verifying my continued interest in this
opening, I'd like to review those of my responsibilities and accomplishments
I feel would insure a level of performance fully meeting your needs.

Division-wide responsibilities, carried out by a staff of nine reporting to me:

> *Sales training and sales information
> *Advertising and promotion
> *Professional services, including speakers' bureau
> *Conventions and exhibits
> *Controlled circulation magazines
> *Software service center
> *Telemarketing

Relevant recent accomplishments:

> *As senior marketing manager, developed marketing action plans
> for all state and city adoption campaigns for past three years

> *Developed marketing action plans for Texas high school typing
> adoption, netting more than $3.5 million in textbook sales--
> a 30% market share

> *Total marketing responsibility for elementary school product
> in adoption situations, as well as open market

> *Continuing supervision of marketing efforts for software,
> basic skills, and titles for the learning disabled--the
> company's three most profitable product lines

Some of these accomplishments came out during our meeting; others did not.
In any case, I thought you should know the full range of my qualifications
as you deliberate your selection of a Director of Marketing Services.

Thanks again for the opportunity to meet with you.

Sincerely,

Philip Chapman

Philip Chapman

Winning Interview Techniques

7

You were asked to be interviewed because an executive, personnel director, or other representative of the employer felt that the company's interest would be served by knowing more about you. Your résumé indicates to them that you are qualified; now they are trying to determine if you are the *best* qualified.

With this in mind, you must now convince them that it is in their best interest to hire you. You must present yourself in such a manner that the interviewer will feel that your assets and abilities are superior to those of any other candidate.

Surprisingly, and sadly, the job does not always go to the most qualified. It is possible to predict with some reliability which candidates will receive not just one, but many job offers. We have analyzed the common denominator each of these "winners" possesses: It is a first impression that projects honesty, sincerity, and enthusiasm. Given two or more candidates with virtually indistinguishable credentials, the job will almost invariably go to the individual projecting the more positive and enthusiastic image.

Creating the Right Impression

Because the first impression you make will carry through the entire interview and greatly determine its outcome, it is of vital importance to create the most positive image possible. Your physical appearance, mannerisms, vocabulary, attitude, and nonverbal communication all contribute to the impression you make.

How does one convey sincerity? By being honest, open, and real. Be yourself. Take the attitude that the company needs you, and feel confident. This starts the self-fulfilling prophecy. *Feel* successful and chances are better that you *will* be successful.

Any form of role-playing that projects a personality other than your own will likely lead to a disastrous interview. There is no way to predict what kind of person the employer is looking for, and if in fact you knew, it is highly unlikely you could keep up the charade for the duration of the interview.

Do Your Homework

Because the interview is such a crucial part of the hiring process, take the time to prepare yourself completely. This preparation will add to your feeling of self-confidence and generate a positive, successful interview with the best chance of a job offer.

Learn as much as possible about your prospective employer—who the officers, directors, or partners are and what the firm's complete product or service line is. Be sure of the company's reputation, and get as much information as you can about past and upcoming mergers, acquisitions, and new market possibilities.

Any library can offer a wealth of information. Use such directories as *Standard and Poor's*, *Dun and Bradstreet*, and *Moody's*. (Names of additional business directories can be found on page 263.) The business periodical Index will help you find any recent press coverage.

Try to read both current and back issues of any trade journals that deal with your industry and the company or companies you are interested in.

Handling Tough Questions

Though every interview is different, all will include one or more questions you'd just as soon not have to answer. The interviewer will be listening not only for content, but sincerity, poise, and ability to think quickly, as well.

Spend some time before the interview developing answers to those of the following questions you think might give you trouble. Some of them are tough and fair. Some of them are tough and unfair.

Be mindful of the fact that everyone has an "obnoxious question threshold" past which he or she cannot, *should* not go. A question you consider opprobrious calls for an appropriate response. For example, if you find it offensive to take a lie detector test, say so. Never compromise strongly held values to make interview points. It may be that your resolve, not your honesty, is being tested. But if it *is* your honesty that is being tested, feel perfectly comfortable to politely end the interview forthwith, on the appropriate grounds that you prefer not to work for a company whose values obviously differ so markedly from your own.

With a friend, your husband or wife—or even a tape recorder—go through questions you think you might be asked. Prepare answers you can give extemporaneously. The wording and substance of these questions will vary to reflect your particular set of circumstances. Review them in light of potential trouble spots in your background, and prepare for those few that may cause you problems in an interview.

1. What did you enjoy most about your last position?
2. What did you like least about your last position?
3. What do you consider your most outstanding achievement?
4. How well do you work under pressure?
5. How well do you get along with your peers?
6. How ambitious are you?
7. How good are you at motivating other people?
8. What kinds of problems do you enjoy solving?
9. What do you think you could contribute to the company (or association, hospital, etc.)?
10. How often have you been ill in the past five years?

11. Are you willing to take a physical exam?
12. Are you willing to take a series of personality (intelligence, aptitude) tests?
13. Are you willing to take a lie detector test?
14. What do you consider your greatest strengths?
15. What do you consider your greatest weaknesses?
16. In what ways do you think your weaknesses would interfere with the position we're trying to fill?
17. Why do you want to change jobs?
18. Were you ever fired? If so, why?
19. Would you consider relocating?
20. How do you explain the gaps (if any) in your employment record?
21. How do you spend your free time?
22. Are you active in community affairs? If so, describe your participation.
23. What were the last three books you read?
24. What newspapers do you read?
25. To what magazines do you subscribe?
26. What is your definition of success?
27. Where do you expect to be with your career in five years?
28. What is your attitude about working for a woman (man, if female) or a younger person?
29. What did you learn from your last position?
30. How did you get along with your previous boss (or staff)?
31. Why do you want to work for this company?
32. What are your hiring techniques? Describe some of the people you've hired, their positions, and why you hired them.
33. What skills do you think you possess that would be beneficial to this company?
34. What motivates you?
35. Do you work better alone, or as part of a team?
36. What are your long-range career objectives?
37. What are your short-term objectives?
38. Would you describe yourself as creative? What are some examples of your creativity?

Other Interview Potholes

If you have sent out several different versions of your resume, each targeting your achievements and experience to a particular kind of employer, review the appropriate version—and cover letter—to help you anticipate any tough questions as effectively as possible.

If you are between jobs, your reasons for leaving the last one will undoubtedly come up at the interview. Organize your thoughts on this subject before the interview. Preparing for the toughest possible questions will provide you with the confidence you need to do your best.

If you were fired, tell the simple truth. In these times of retrenchment, bankruptcies, mergers, relocations, and layoffs, firing is replacing baseball as the national pastime. Chances are that your prospective

boss is no stranger to the experience and will find it easy to empathize if you deal with your situation honestly.

If you were fired because your performance was in question, answer truthfully and try to transmit the extent to which you made this a learning experience. Never offer unsolicited negative comments about any staff member, or about your former or present employer.

If you are presently employed, you will be asked why you want to change jobs, and specifically why you would like to work for the company you're visiting. Again, be brief, exact and direct. Wanting to move up, earn a higher salary, join a larger (or smaller) organization, a desire to relocate, or make a career change—all are appropriate reasons to be looking for a new job. The research you have done about the particular employer will help you point out why you feel positive about the interviewing company and how you think you can make a positive professional impact on it soon after coming on board.

To sum up, be as honest during your interview as you were writing your résumé. It is tempting to exaggerate, distort a little, tell a little lie or a half truth, but making yourself seem better or other than you are is a dangerous game. First of all, it's going to be virtually impossible for you to be consistent once you've injected a shot of fiction into your autobiography. Second, and more importantly, once you're caught in a lie—no matter how slight—you've lost your credibility; maybe even your reputation.

We remember referring a publicist to a major corporation. Her résumé was first-rate, and the interview good enough for her to accept a splendid offer. After six months she received a 20 percent salary increase. Several months later, however, the personnel department checked out the information on her résumé and on the company's application form. She had said she had worked for a certain employer for three years when in reality she had been there for only one year. Even though she was doing a fantastic job and her boss respected her work highly, she was fired. The company—not unlike many other employers—had a policy of terminating any employee found to be untruthful on the application form. The vice-president who had hired her was as upset as she, the irony being, he revealed, that he would have taken her on even if he had known she had worked for company X for only one year. And though he was high on the company ladder, he couldn't change company policy.

Nervous is Natural

If you experience a slight case of the jitters before and during your interviews, you're in good company. Though you've gone through the experience a dozen times or more, putting yourself in this vulnerable position can be an unsettling experience. We've found, as have colleagues all over the country, that an overwhelming majority of job-seekers view the interview as the most stressful phase of the job search.

Unfortunately, most job candidates experience the interview as an acid test of their abilities and self-worth. Such an attitude is extremely anxiety-producing and tends to create a negative reaction from the

interviewer. If you're nervous, don't get more nervous about being nervous. (Easy for us to say, right?) But just go with it. The interviewer expects some nervousness on your part and usually he or she will try to help you through it.

It may help for you to view the interview as a meeting between two equals, a buyer and a seller, to explore what each has to offer the other. If you can convey the feeling early that you have something the company wants, you will establish parity in a hurry. Always keep in mind a feeling of equality between you and the interviewer. Being too humble or subservient is as bad as being arrogant. Be a good listener, but ask any questions that will help you find out how close you and the company are to a possible match—and what you can tell them that might tip the scales in your favor, if this is a job you want.

Second and Third Interviews

As soon as you leave an interview for a job that interests you, get to a quiet place to record your impressions while they're fresh in your mind. Your objective now is to get a job offer—or at least a second interview. Be sure you ask for a business card from the interviewer so you can write a followup letter with an accurate title and address.

The best followup letter will:

☐ Indicate your continued interest
☐ Correct any mistaken impressions you may have left in the interview
☐ Volunteer any additional reasons you can think of for you to be hired
☐ Reinforce your strengths for the position that got you the first interview. (For a sample letter, see page 254.)

Next, write down the attributes you have that match the description of the job for which you interviewed. Next to each of these indicate the degree to which you feel you transmitted these skills and accomplishments. Next to this identify the aspects of each attribute you feel you did not transmit to the interviewer.

Below these lists, identify your perceived weaknesses for the position in a similar way. First column: specific weakness. Second column: the extent to which you believe you neutralized this weakness in the interview. Third column: what you yet need to do.

If the negatives outweigh the positives, you probably won't need to complete your lists to realize it. If you still feel that this is the job for you, however, you have enough data for an action plan.

Your competition for the opening will consist of from one to five other candidates, so your task is to reinforce the positives and eliminate the negatives illuminated above, without overselling at either extreme. At one end, for example, you could convey an anxiety that knocks you out of the running. At the other end, a defensiveness could creep into your presentation and cause the same result.

At the end of the interview, it is a good idea to find out where you

stand so you don't get lost among several other good candidates. Ask the interviewer where you stand vis à vis your competition. Find out what is deterring an offer before you leave. Depending on the circumstances, this might be an appropriate time to volunteer a trial assignment for an area where you are perceived to be weak, but where you have confidence in your ability.

Compensation

Never begin salary negotiations until you are relatively certain you have a job offer. When asked about your present or last compensation packages, answer concisely, including all bonuses and perquisites. If you feel you were or are underpaid, mention that as one reason for wanting to change jobs. Never, however, insinuate that you were exploited or victimized by an employer. Playing victim can backfire on you.

When discussing your present minimum salary requirements, stay flexible. If you know what salary range is being offered, put your salary expectations at the high end of that range. Remember, the interview is a screening process. If your minimum salary requested is considerably higher than the employer intends to pay, this alone could knock you out of the running.

Don't get boxed into a specific figure before you have to. Always talk in $5,000 to $10,000 ranges. If the interview has gone superbly, aim high and then negotiate. If you are in doubt about the range the employer is considering and are asked what your salary expectations are, answer the question with one of your own. "I'm glad you brought up the subject of compensation. What range do you see for this job?" Then negotiate from there.

Finally, never make a decision at the interview—whether it's the first, second, or third. Say: "I appreciate your offer, and will give it serious consideration. May I call you on Tuesday with my decision?" This gives you a chance to weigh any other serious offers, and also to reflect more thoroughly on this one. You may come up with a question that affects your decision—and even the composition of the job itself.

Which Job Do You Take?

8

The tricky thing about handling your first job offer is knowing whether to hold out for a better one, or squeeze that bird senseless while it's still in your hand. Odds are you won't have to decide in isolation, unless this is the first solid opportunity you've had since severance pay ran out three weeks ago. And even then, unless you're down to zero cash reserves, you'll be better off saying no if the position is dead wrong for you and you realize it before the employer does. No point in reaching for this book again before you need to.

How to decide, then, supposing subsistence is not your number one problem? Even if you feel you've been offered a dream position, delay your final decision for a few days to provide some perspective. Thank your prospective boss for the offer, as we said in the last chapter, and tell him or her you'll call back by "Friday"—mentioning a specific day 48 to 72 hours from then. Unless the organization is in a crisis condition (which if you're hearing for the first time is an even better reason to stall), your request will be honored and you'll have a chance to weigh the offer both intrinsically and against any others you may have.

What You Need to Know

Complete your research. Any open questions about the organization and the position that are either hanging fire or to which you haven't received satisfactory answers should be resolved now. For example: Under what circumstances did your predecessor leave—if this is not a new position. If the reason was one of chemistry or personality conflict between him and your new boss, get to the bottom of it. Ask the person who held the job previously, if he is accessible. Any workways or points of view the two of you share that may have been inimical to his corporate health could serve you up the same fate. Decide which is more important to you, those particular values or the job.

Make sure you have a copy of the company's annual and 10-K reports (and know how to read them) and all pertinent product information, as well as any negative (or positive) coverage in the financial press the company has received within the past year. Your local librarian will help you.

Dollar signs bedazzle. Look carefully at the flip side of your highest paying offer. Don't give up in potential and prestige what you might be gaining in a monthly paycheck. Analyze the entire compensation package, including benefits and perquisites, to be sure that a lower salary with excellent fringes may indeed not be more remunerative in the long run. Ask your accountant or lawyer to help steer you through

the thornier issues.

If you view this position as a way station to greater professional advancement down the road, be sure the experience and accomplishments you stand to attain aren't clouded by accepting more money for a position that may weaken your next résumé.

Trust your instincts. When all the evidence is in, count on your gut reaction to deliver a decision in your best interests. Maintain the professional ties that bind, however, so if you realize in six months that you've made a terrible mistake you can swallow your pride and announce your renewed availability (as in the Chapter 6 "I'm back in the job market" re-introduction letters).

May the best possible position be yours.

Appendix: Corporate Information Directories

Most of these directories can be found in the reference section of any good library. Some may be available only in a business library.

General Interest

Business Organizations, Agencies, and Publications Directory
Corporate 1000
Directory of Corporate Affiliations
Directory of Directories
Dun's Million Dollar Directory (Volumes I, II, and III)

Encyclopedia of Business Information Sources
International Corporate 1000
Macmillan Directory of Leading Private Companies
Small Business Sourcebook
Standard Directory of Advertisers

Industry-Specific

American Architects Directory
American Hospital Association Guide to the Health Care Field
American Library Directory
Automotive News Market Data Book
Chemical Engineering Catalog
Commercial Real Estate Brokers Directory
Conservation Yearbook
Corporate Finance Bluebook
Design News
Directory of the Computer Industry
Dun & Bradstreet Reference Book of Transportation
Dun's Industrial Guide: The Metalworking Directory
Editor and Publisher Market Guide
Electrical/Electronic Directory
Electronic Design's Gold Book
Fairchild's Textile and Apparel Financial Directory
International Petroleum Register
Kline Guide to the Paper & Pulp Industry
Literary Market Place: The Directory of American Book Publishing
Magazine Industry Market Place

Moody's Manuals (for various industries)
O'Dwyer's Directory of Corporate Communications
O'Dwyer's Directory of Public Relations Agencies
Polk's World Bank Directory
Printing Trades Blue Book
Progressive Grocer's Marketing Guidebook
Standard & Poor's Security Dealers of North America
Standard Directory of Advertising Agencies
Telephony's Directory of the Telephone Industry
The Uncle Sam Connection, a Guide to Federal Employment
Thomas Register of American Manufacturers
Whole World Oil Directory
Who's Who in Advertising
Who's Who in Composition and Typesetting
Who's Who in Electronics
Who's Who in Insurance
Who's Who in Water Supply and Pollution Control
World Airline Record

More selected BARRON'S titles:

More selected BARRON'S titles:

DICTIONARY OF COMPUTER TERMS, 3rd EDITION
Douglas Downing and Michael Covington
Nearly 1,000 computer terms are clearly explained, and sample
programs included. Paperback, $8.95, Canada $11.95/ISBN 4824-5,
288 pages

DICTIONARY OF FINANCE AND INVESTMENT TERMS,
3rd EDITION, *John Downs and Jordan Goodman*
Defines and explains over 3000 Wall Street terms for professionals,
business students, and average investors.
Paperback $9.95, Canada $13.95/ISBN 4631-5, 544 pages

DICTIONARY OF INSURANCE TERMS, 2nd EDITION
Harvey W. Rubin
Approximately 3000 insurance terms are defined as they relate to
property, casualty, life, health, and other types of insurance.
Paperback, $9.95, Canada $13.95/ISBN 4632-3, 416 pages

DICTIONARY OF REAL ESTATE TERMS, 2nd EDITION
Jack P. Friedman, Jack C. Harris, and Bruce Lindeman
Defines over 1200 terms, with examples and illustrations. A key
reference for everyone in real estate. Comprehensive and current.
Paperback $10.95, Canada $14.50/ISBN 3898-3, 224 pages

ACCOUNTING HANDBOOK, *Joel G. Siegel and Jae K. Shim*
Provides accounting rules, guidelines, formulas and techniques etc. to
help students and business professionals work out accounting problems.
Hardcover: $24.95, Canada $33.95/ISBN 6176-4, 832 pages

REAL ESTATE HANDBOOK, 2nd EDITION
Jack P. Friedman and Jack C. Harris
A dictionary/reference for everyone in real estate. Defines over 1500
legal, financial, and architectural terms.
Hardcover, $21.95, Canada $29.95/ISBN 5758-9, 700 pages

HOW TO PREPARE FOR REAL ESTATE LICENSING
EXAMINATIONS-SALESPERSON AND BROKER, 4th EDITION
Bruce Lindeman and Jack P. Friedman
Reviews current exam topics and features updated model exams and
supplemental exams, all with explained answers.
Paperback, $11.95, Canada $15.50/ISBN 4355-3, 340 pages

BARRON'S FINANCE AND INVESTMENT HANDBOOK,
3rd EDITION, *John Downes and Jordan Goodman*
This hard-working handbook of essential information defines more
than 3000 key terms, and explores 30 basic investment opportunities.
The investment information is thoroughly up-to-date. Hardcover $29.95,
Canada $38.95/ISBN 6188-8, approx. 1152 pages

FINANCIAL TABLES FOR MONEY MANAGEMENT
Stephen S. Solomon, Dr. Clifford Marshall, Martin Pepper,
Jack P. Friedman and Jack C. Harris
Pocket-sized handbooks of interest and investment rates tables used
easily by average investors and mortgage holders. Paperback
Savings and Loans, $6.95, Canada $9.95/ISBN 2745-0, 272 pages
Real Estate Loans, $6.95, Canada $9.95/ISBN 2744-2, 336 pages
Mortgage Payments, 2nd, $5.95, Canada $7.50/ISBN 1386-7, 304 pages
Bonds, 2nd, $5.95, Canada $7.50/ISBN 4995-0, 256 pages
Comprehensive Annuities, $5.50, Canada $7.95/ISBN 2726-4, 160 pages
Canadian Mortgage Payments, Canada $9.95/ISBN 3939-4, 336 pages
Adjustable Rate Mortgages, $5.95, Canada $8.50/ISBN 3764-2, 288 pages

All prices are in U.S. and Canadian dollars and subject to change without notice.
At your bookseller, or order direct adding 10% postage (minimum charge $1.75,
Canada $2.00), N.Y. residents add sales tax. ISBN PREFIX: 0-8120

Barron's Educational Series, Inc.
250 Wireless Boulevard, Hauppauge, NY 11788
Call toll-free: 1-800-645-3476
In Canada: Georgetown Book Warehouse
34 Armstrong Ave., Georgetown, Ontario L7G 4R9
Call toll-free: 1-800-247-7160